Cézanne and Beyond

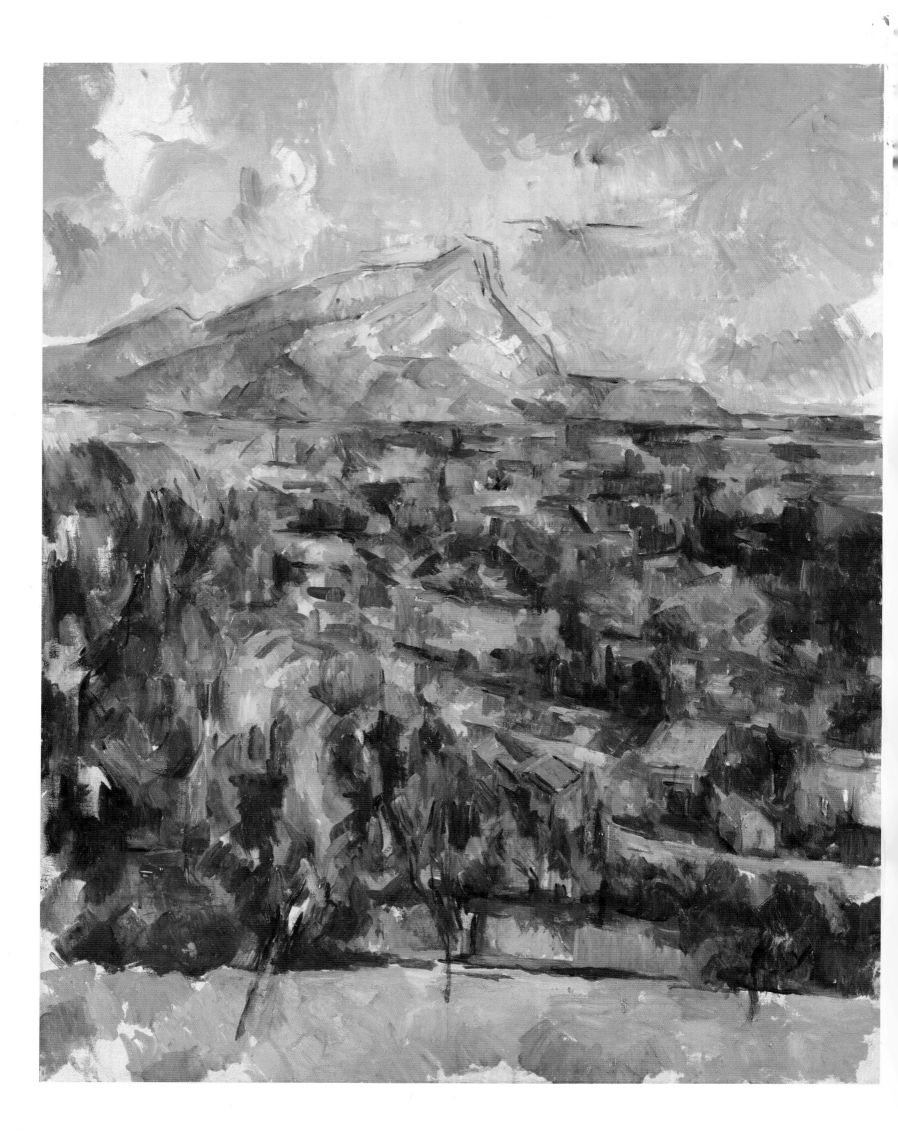

Cézanne and Beyond

Organized by

Joseph J. Rishel and

Katherine Sachs

With essays by

Roberta Bernstein

Yve-Alain Bois

Jean-François Chevrier

John Elderfield

John Golding

Christopher Green

Jennie Hirsh

Joop M. Joosten

Anabelle Kienle

Albert Kostenevich

Carolyn Lanchner

Mark D. Mitchell

Joseph J. Rishel

Katherine Sachs

Richard Shiff

Robert Storr

Michael R. Taylor

Philadelphia Museum of Art

in association with

Yale University Press

New Haven and London

Front cover (left to right): Henri Matisse, *Woman in Blue*, 1937 (plate 21); Paul Cézanne, *Madame Cézanne in a Red Armchair*, c. 1877 (plate 60); Pablo Picasso, *The Dream (Marie-Thérèse)*, 1932 (plate 61)
Back cover (left to right): Alberto Giacometti, *Still Life with Apple*, 1937 (plate 134); Paul Cézanne, *Curtain, Jug, and Compotier*, 1893–94 (plate 90); Jasper Johns, *Drawer*, 1957 (plate 175)
Frontispiece: Paul Cézanne, *Mont Sainte-Victoire*, c. 1902. Oil on canvas, 33 x 25⅝ inches (83.8 x 65.1 cm). The Henry and Rose Pearlman Foundation, Inc.; on long-term loan to the Princeton University Art Museum
Page v: Paul Cézanne, *Study of Three Trees*, 1890–95. Watercolor on paper, 18⅞ x 12¼ inches (47.9 x 31.1 cm). Collection of Kate Ganz

This book was published

on the occasion of the exhibition

Cézanne and Beyond

Philadelphia Museum of Art

February 26 – May 17, 2009

The exhibition was made possible by

ADVANTA

Additional funding was provided by the Commonwealth of Pennsylvania, The Annenberg Foundation Fund for Exhibitions, The Florence Gould Foundation, The Pew Charitable Trusts, The Andrew W. Mellon Fund for Scholarly Publications, the National Endowment for the Arts, and an indemnity from the Federal Council on the Arts and the Humanities. Promotional support provided by NBC 10 WCAU; the Philadelphia Convention & Visitors Bureau; *The Philadelphia Inquirer, Daily News,* and Philly.com; and Amtrak.

The catalogue was generously supported by the Davenport Family Foundation and the Lenfest Foundation.

Produced by the Publishing Department
Sherry Babbitt, Director
Philadelphia Museum of Art
2525 Pennsylvania Avenue
Philadelphia, PA 19130 USA
www.philamuseum.org

Editorial Coordination: David Updike
Editorial Assistance: Kathleen Krattenmaker and Mary Cason
Design: Katy Homans
Production: Richard Bonk
Printed and bound in Belgium by Die Keure, Brugge

Published by the Philadelphia Museum of Art in association with Yale University Press, New Haven and London

Yale University Press
302 Temple Street
P.O. Box 209040
New Haven, CT 06520-9040
www.yalebooks.com

Library of Congress Cataloging-in-Publication Data
Cézanne and beyond / organized by Joseph J. Rishel and Katherine Sachs; with essays by Roberta Bernstein . . . [et al.].
 p. cm.
 "This book is published on the occasion of the exhibition *Cézanne and Beyond*, Philadelphia Museum of Art, February 26 – May 17, 2009."
 Includes index.
 ISBN 978-0-87633-208-5 (PMA hardcover) — ISBN 978-0-87633-209-2 (PMA pbk.) — ISBN 978-0-300-14106-1 (Yale hardcover)
1. Cézanne, Paul, 1839–1906—Exhibitions. 2. Cézanne, Paul, 1839–1906—Influence—Exhibitions. I. Rishel, Joseph J. II. Sachs, Katherine. III. Bernstein, Roberta. IV. Cézanne, Paul, 1839–1906. V. Philadelphia Museum of Art.
 N6853.C45A4 2009
 759.4–dc22 2008050358

To Anne d'Harnoncourt

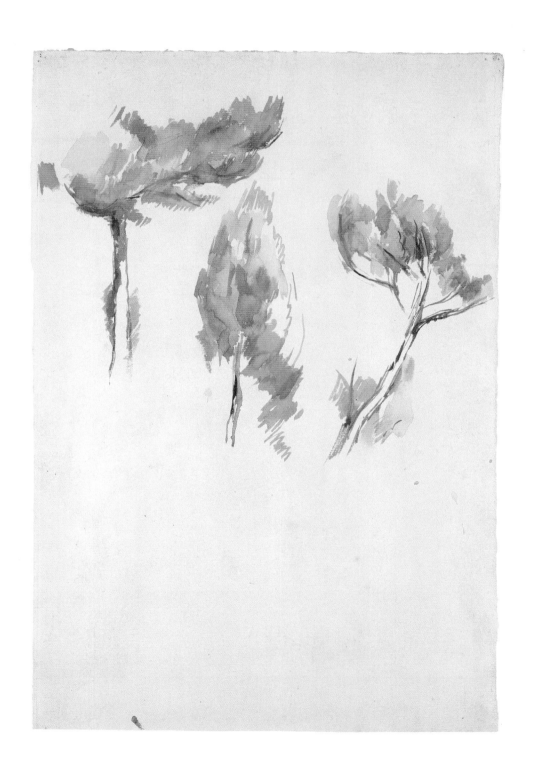

Lenders to the Exhibition

Albright-Knox Art Gallery, Buffalo, New York

The Art Institute of Chicago

Babcock Galleries, New York

The Baltimore Museum of Art

The Barnes Collection, Merion, Pennsylvania

Beyeler Collection, Basel

Ivor Braka Limited

The Brooklyn Museum

Carnegie Museum of Art, Pittsburgh

The Cartin Collection

Chrysler Museum of Art, Norfolk, Virginia

Columbus Museum of Art, Ohio

The Samuel Courtauld Trust, The Courtauld Gallery, London

The Detroit Institute of Arts

Friedrich Christian Flick Collection

Debra Force Fine Art, New York

Gail and Tony Ganz, Los Angeles

Kate Ganz

J. Paul Getty Museum, Los Angeles

The Solomon R. Guggenheim Museum, New York

Hamburger Kunsthalle

Harvard University Art Museums–Fogg Museum, Cambridge, Massachusetts

Hirshhorn Museum and Sculpture Garden, Smithsonian Institution, Washington, DC

Jasper Johns

Ellsworth Kelly

Kimbell Art Museum, Fort Worth, Texas

Wanda Kownacki

Kröller-Müller Museum, Otterlo, The Netherlands

Kykuit, National Trust for Historic Preservation

Los Angeles County Museum of Art

The Metropolitan Museum of Art, New York

The Minneapolis Institute of Arts

Moderna Museet, Stockholm

Munson-Williams-Proctor Institute, Museum of Art, Utica, New York

Musée d'Art Moderne de Lille, Villeneuve d'Ascq

Musée d'Orsay, Paris

Musée National d'Art Moderne, Centre Georges Pompidou, Paris

Musée National de l'Orangerie, Paris

Musée Picasso, Paris

Museum Boijmans Van Beuningen, Rotterdam

Museum Folkwang, Essen

Museum Kunst Palast, Düsseldorf

Museum of Contemporary Art, Chicago

Museum of Fine Arts, Boston

The Museum of Fine Arts, Houston

The Museum of Modern Art, New York

Raymond and Patsy Nasher Collection, Dallas

The Trustees of the National Gallery, London

National Gallery of Art, Washington, DC

National Gallery of Canada, Ottawa

The National Museum of Art, Architecture and Design, Oslo

The Nelson-Atkins Museum of Art, Kansas City

Öffentliche Kunstsammlung Basel, Kunstmuseum Basel

James and Barbara Palmer

The Henry and Rose Pearlman Foundation, Inc., New York

Petit Palais, Musée des Beaux-Arts de la Ville de Paris

Pinacoteca Provinciale, Bari, Italy

Pushkin Museum of Fine Arts, Moscow

Rose Art Museum, Brandeis University, Waltham, Massachusetts

Saint Louis Art Museum

Staatliche Museen zu Berlin

State Hermitage Museum, St. Petersburg

Michael and Judy Steinhardt, New York

Mr. and Mrs. Eugene V. Thaw

Jeff Wall

Williams College Museum of Art, Williamstown, Massachusetts

Steve and Elaine Wynn

Yale University Art Gallery, New Haven, Connecticut

And anonymous lenders

Advanta has been privileged to enjoy a long and fruitful relationship with the Philadelphia Museum of Art and is proud to sponsor the magnificent exhibition *Cézanne and Beyond*.

Creativity has been the cornerstone of Advanta's success since our company began in 1951 with $30 in seed money in founder Jack Alter's spare bedroom. Since then, Advanta has grown into one of the nation's largest credit card issuers in the small business market.

Visitors from around the world will draw inspiration from *Cézanne and Beyond* as they reflect upon the legacy of creativity and innovation that extended from the great French master to succeeding generations of remarkable talents.

In 1996, Advanta was the proud sponsor in Philadelphia of *Cézanne*, a major retrospective that was also seen in Paris and London. The present exhibition moves the artist's remarkable impact forward, into the twentieth and twenty-first centuries. It's a story that resonates with Advanta, a company built on the fresh thinking and new ideas of the generations of entrepreneurs whom we serve and continue to be inspired by.

Philadelphia is the only city to host *Cézanne and Beyond*. As a company headquartered in the Philadelphia area and focused on the small business market, Advanta celebrates the tourism and economic impact that the exhibition will bring to our region. We join with our Museum and city in welcoming international visitors to share in this inspiring and much anticipated cultural experience.

Advanta's sponsorship of *Cézanne and Beyond* is part of our longstanding commitment to the communities in which our employees live and work, primarily the Greater Philadelphia Region and Salt Lake City, Utah. We believe *Cézanne and Beyond* is an exhibition that reaches beyond art to celebrate the power inspiration has on the canvas of our lives. In these challenging economic times, this is an important notion. After all, who knows what new and important ideas this exhibition may inspire in those who experience it, helping to lift us all above the challenges we are facing today.

We are grateful for the hard work and dedication of all those who helped bring this ambitious exhibition to life. Very special thanks go to the staff of the Philadelphia Museum of Art, with whom we are extremely proud to partner in this magnificent project.

DENNIS ALTER
Chairman and Chief Executive Officer

BILL ROSOFF
Vice Chairman and President

Contents

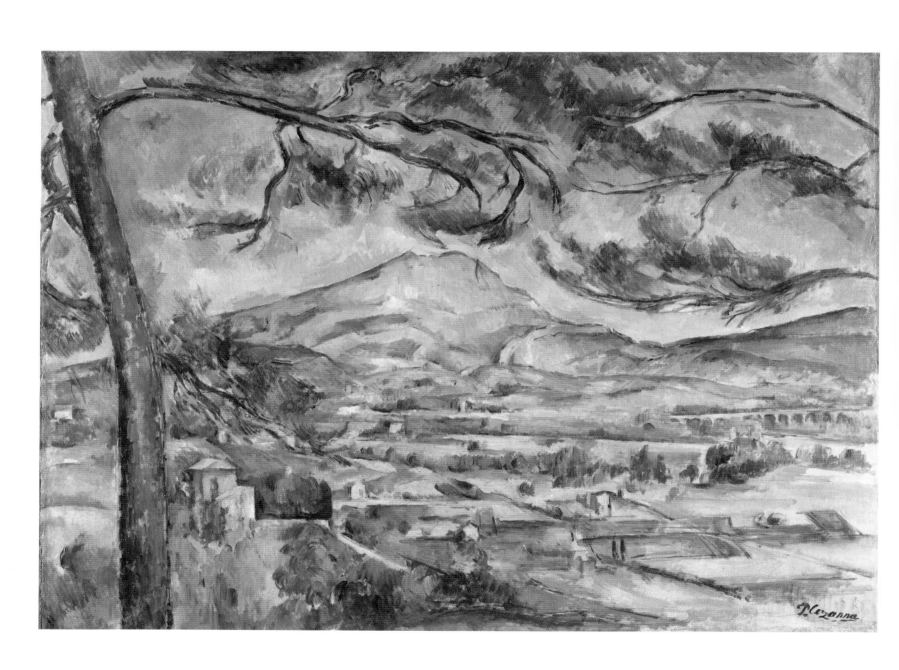

Foreword

Cézanne and Beyond is the latest manifestation of the enthusiasm of this Museum, and the city of Philadelphia, for the art of Paul Cézanne. The fifteen paintings by Cézanne held by the Philadelphia Museum of Art, together with an astonishing sixty-nine paintings at the Barnes Foundation, establish this area as a pilgrimage site for anyone interested in Cézanne. The Museum's retrospective of 1995–96, tracing Cézanne's evolution as an artist, which we co-organized with colleagues in London and Paris, was the origin of *Cézanne and Beyond*, but the institution's commitment to showing the artist's work is longstanding, with our first exhibition dating back to 1934.

Joseph J. Rishel and Katherine Sachs, in company with Anne d'Harnoncourt, were the Museum's principal organizers of the 1995–96 retrospective, and since then have been musing about how best to track Cézanne into the twenty-first century. Together, they have partnered with their Philadelphia curatorial colleagues Carlos Basualdo and Michael R. Taylor, and others who offered their insights, especially Innis Howe Shoemaker, Kathleen A. Foster, and Mark D. Mitchell.

Whenever a curator undertakes a project such as this, he or she knows well that its success depends in large part upon borrowing the works of art that will drive the narrative. Many of the objects included in this exhibition and catalogue are the prized possessions of their owners, and we are exceedingly grateful for their generous willingness to share their treasures with us. We are particularly pleased to have had the ongoing cooperation of several of the artists who are themselves among those featured in the current project, namely Jasper Johns, Ellsworth Kelly, Brice Marden, and Jeff Wall.

This catalogue was likewise a collaborative effort, and it has profited from the contributions of a host of scholars from within and outside the Museum. To them we extend our deeply felt gratitude for their thoughtful explorations of the ongoing "conversations" between Cézanne and the many other artists presented in this selection.

An endeavor of this scope is of course indebted to the sponsors, without whom no curatorial vision, no matter how cogent, can ever be realized. The Museum's heartfelt thanks go to Advanta, which also sponsored the 1996 Cézanne retrospective and the 2004 Salvador Dalí exhibition, and has been a longtime partner of the Museum as well as an enlightened member of the region's corporate community. We would also like to thank Advanta's Chairman, Dennis Alter, and his wife, Gisela, not only for their support of the Museum and this exhibition, but for their deep commitment to social and cultural causes that enhance the quality of life in the Greater Philadelphia region. Perhaps it is not too surprising, given the bond between the Alters and the Museum, that Joe Rishel's position is endowed by them and bears their name. Therefore it was with particular pleasure that Anne d'Harnoncourt approached the Alters as the present show was being organized, and again was warmly and enthusiastically received. In the support of this important exhibition, they are joined by the Commonwealth of

Paul Cézanne

French, 1839–1906

Mont Sainte-Victoire with Large Pine, c. 1887

Oil on canvas
26⅜ x 36⅜ inches (66.9 x 92.2 cm)
The Samuel Courtauld Trust, The Courtauld Gallery, London

Pennsylvania, The Annenberg Foundation Fund for Exhibitions, The Pew Charitable Trusts, The Andrew W. Mellon Fund for Scholarly Publications, and the National Endowment for the Arts and the Federal Council on the Arts and Humanities, all of which have contributed so much to the Museum's exhibition program, and we are delighted to have once again a generous grant from The Florence Gould Foundation. We are also grateful for the promotional support provided by NBC 10 WCAU; the Philadelphia Convention & Visitors Bureau; *The Philadelphia Inquirer, Daily News*, and Philly.com; and Amtrak. The catalogue was generously supported by the Davenport Family Foundation and the Lenfest Foundation.

Cézanne will no doubt continue to inspire artists for generations to come. It is the honor of this Museum and others that make accessible to our publics the works of great masters to play such a crucial role in that process.

ALICE BEAMESDERFER
Associate Director for Collections and Project Support
and Interim Head of Curatorial Affairs

GAIL HARRITY
Chief Operating Officer and
Interim Chief Executive Officer

Looking Back and Beyond

Every exhibition is a labor of love for both its organizing curator and the institution. This one, coming so soon after the sudden and tragic loss of Anne d'Harnoncourt, our Museum's George D. Widener Director and Chief Executive Officer, has been a kind of salvation, most especially for her husband, Joseph J. Rishel, the force behind *Cézanne and Beyond*. To Anne, nothing was more fundamental than the encounter between an individual and a work of art, whether that person is a lover of old master paintings who finds unexpected meaning in a contemporary installation or a toddler who playfully strikes the pose of Rodin's *Thinker*. *Cézanne and Beyond* provides insight into the most rarefied of such encounters—those of an artist responding in a profound way to the work of a predecessor and the forward movement of art history itself.

The complexities of presenting a major exhibition like *Cézanne and Beyond* can seem insurmountable at times. Joe Rishel's buoyancy and optimism in the face of challenges both personal and organizational were critical to the success of this project, as was the steady support of a staff working in unison to help Joe and the Museum realize its mission. Over the past several months, that singularity of purpose, which Anne d'Harnoncourt instilled in every Museum employee and volunteer, has been particularly evident, as so many staff members have turned their grief into the affirmative work of bringing *Cézanne and Beyond* to a broad public. Anne's famously melodic voice is also present throughout, and those of us who were lucky enough to know her and Joe can almost hear their urbane and spirited, but always affectionately respectful, conversations about this project.

The concept of "beyond" has special poignancy for the Museum at this moment. Just as generations of artists have transformed the art of those who preceded them into new modes of expression, this great institution looks forward to a future that takes its cue from a truly extraordinary past.

ALICE BEAMESDERFER

The Making of an Exhibition

Joseph J. Rishel and Katherine Sachs

An artist is answerable only to himself. He promises nothing to the centuries to come save his own works. He stands caution only for himself. He dies childless. He has been his own king, his own priest, and his own god.
— CHARLES BAUDELAIRE, 1855[1]

Lionello Venturi quoted this dictum of Charles Baudelaire in the introduction to his monumental catalogue raisonné of Paul Cézanne's paintings, published in 1936, in support of his plea to detach Cézanne from his critics and from the history of taste, "to adopt a stance against modernity and contemporary character."[2] Baudelaire's words are, of course, echoed in Cézanne's own famous caveat, "Beware of the influential master!"[3] Yve-Alain Bois reminds us that Henri Matisse was fond of quoting Cézanne's warning when addressing "the issue of inheritance and tradition."[4] Matisse was equally proud that he himself "never avoided the influence of others," and he often emphasized the particular importance Cézanne had for him as "the master of us all," "a sort of god of painting," and, finally, coming full circle, "If Cézanne is right, I am right."[5]

The present exhibition is poised somewhere within these poles, between Venturi's Apollonic Cézanne—aloof, constant, timeless, self-defining—and a more mortal (but equally protean) creature, animating in very concrete ways artists right up to the present. As alert as we were to Cézanne in a broader artistic context in the 1995–96 Cézanne retrospective,[6] done in collaboration with colleagues in Paris and London, the central emphasis was on his own evolution in terms of himself, and while the gathering of some fifty works by Cézanne in the present exhibition could comfortably serve as a miniature retrospective, the game plan now is quite different than it was in the mid-1990s. In the text of that catalogue we traced the critical fortunes of Cézanne up to the present through his literary reception, whether by critics, art historians, or those who organize exhibitions. Our approach here focuses on the artistic reception of Cézanne, which—while closely linked to the evolution of critical opinion—has a quite different and, may one say, more vivacious, non-temporal life. Matisse's self-assured reference to Cézanne—if he is right, I am right—has served as our compass. Our mixing of some nineteen other artists with Cézanne is an exploration of the reliability of Matisse's confidence in how an artist may use Cézanne as a measure of his or her own achievements from the perspective of completely contemporary references, well outside

Luc Tuymans
Belgian, born 1958
***Untitled (Still Life)*, 2002**

Oil on canvas
136¹¹⁄₁₆ x 196⅞ inches (347 x 500 cm)
Courtesy of David Zwirner, New York, and
Zeno X Gallery, Antwerp

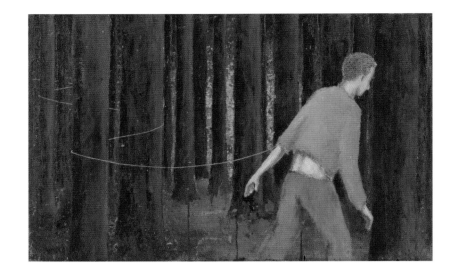

Fig. 1.1. **Francis Alÿs** (Belgian, born 1959), *Fairy Tales, Stockholm,* 1998. Left panel: Oil on canvas on wood, 7 3/16 x 11 1/4 inches (18.2 x 28.6 cm); right panel: oil on wood, 7 1/8 x 11 5/16 inches (18.1 x 28.7 cm). Philadelphia Museum of Art. Purchased with the Edith H. Bell Fund, 2007-203-1a,b

of any fabricated impressions of art-historical progressions or critical predisposition — to quite physically, in the galleries, reenact the defining moment of artistic encounters that rest well outside conventional chronology. As concerned as we are with notions of influence and legacy — and the patterns of artistic dissemination form a wide field of activity — we are equally intent, in this experiment, on demonstrating just how much later artists have brought us to see and understand Cézanne through what they needed, and took, from him, often through judgments as selective as they are revealing. The key to our method, such as it is, was the active participation in the planning of the exhibition since its beginning of Anne d'Harnoncourt, Michael Taylor, and Carlos Basualdo, all colleagues at the Philadelphia Museum of Art who are (and were) in constant rapport with contemporary artists, many of whom laid the foundations for the selection shown here. "Back to the future" has been the office joke, but we are serious.

The Process of Selection and Criteria

In ways that may seem shamelessly evident, the selection of the nineteen artists we have put into play with Cézanne was established with relatively swift accord in a pattern of "begats" that deviates little from canonical modernist wisdom. Our organizing team, comprising ourselves and those members of the Museum staff listed above, was quickly joined by recruits who agreed to write a critical essay on Cézanne's relationship to one of the chosen "sixteen," as well as to advise us on the specific selection of works to demonstrate their observations. This was done in the company — over the decade that this enterprise evolved — of a myriad of friends and colleagues (very often artists) who offered advice, opinions, and stern criticism and who are gratefully acknowledged elsewhere in this volume (pp. 573–74).

Our essential criterion was to gather artists who are on a par with Cézanne in terms of magnitude and complexity, and who inevitably, over the century and then some since 1907, kept score on one another as much as they looked over their shoulders at Cézanne from time to time. The tracing of these intricate patterns of interaction and exchange, which are as much poetic and expressive as they are formal, is our principal subject. Finally, by engaging a handful of younger artists to respond to the exhibition with new works, we have hoped to underscore that a synoptic dynamic of speculative looking and nurturing continues apace.

While hundreds of consequential artists embraced Cézanne in their youths as a critical point of departure, for those whom we selected Cézanne was a recurring source throughout their careers, albeit in a myriad range of engagements, as differing as Pablo

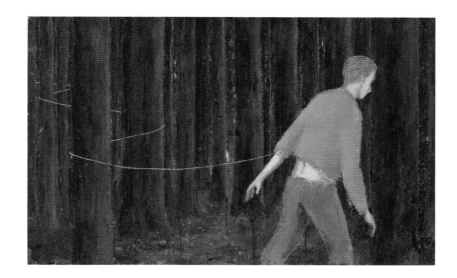

Picasso's late sculpture of *Bathers* (see plate 67), Georges Braque's *Studio with Skull* (see plate 83), Marsden Hartley's figures (see plate 42), Alberto Giacometti's landscapes (see plate 142), Ellsworth Kelly's *Lake II* (see plate 165), or Jasper Johns's tracings of the Barnes Foundation's *Large Bathers* (see plates 176–81). All are demonstrations of profound and fully digested absorptions that outdistance even the most intense, and often more obvious, youthful encounters. And as much as we would like this formation—synthetic, but real enough—of our brotherhood (with one sister) to be shown out of time, the direction is continuous and remains remarkably stable and constant up to the present century, albeit enacted primarily through acts of painting and, by extension, sculpture,[7] in our case heroically through the work of Ellsworth Kelly, Jasper Johns, and Brice Marden. A whole different pattern of meaning and investigation has emerged in the generation that matured in the twenty-first century, in many cases through artists working in different mediums, such as the photographer Jeff Wall, who both uses and expands the notion of photography in his works, and to whom we have given a fairly high representation with three major works, demonstrating his lifelong engagement with Cézanne in ways both obvious and humorous as well as profound.

The three younger artists we asked to participate—Francis Alÿs, Sherrie Levine, and Luc Tuymans—helped us to select recent works or made new ones for this occasion, bringing the dialogue completely up to the present. Francis Alÿs, in his unhurried but constant dedication to an evenhanded, nonhieratic take on all art making, for us parallels many essential components of Cézanne's own constancy to his tasks. For Alÿs, be they acts of the hand or of the camera, his remarkably calm and deliberate gestures and actions align with a long series of what he sometimes calls rehearsals, always somehow in anticipation of the next step, while always rethinking elements of past sequences, ever resolving and evolving in a deeply human way (fig. 1.1). This gives his work, to our minds, a deep resonance with that of Cézanne, who was equally focused and steady, and equally passionate about all possible explorations of the paths that could take him to that elusive Promised Land of which he dreamed and to which he was directed through steady labor.

The notion of originality and the various permutations it has undergone during modernism are systematically addressed by the American artist Sherrie Levine. Her work has been characterized as "appropriation," implying a strategic use of existing images that goes beyond any conventional definition of influence. Often taking canonical works of art and re-presenting them, Levine both reflects on and contradicts the centrality of originality in the definition of the modern artistic canon, essentially a historically based construct mostly fashioned around the time when modernism emerged.

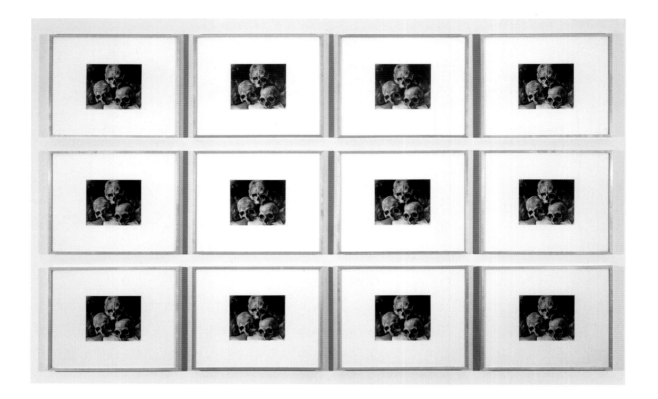

Fig. 1.2. **Sherrie Levine** (American, born 1947), **Pyramid of Skulls: 1–12,** 2002. Black-and-white photographs, set of twelve; each 8 x 10 inches (20.3 x 25.4 cm); overall 52⅝ x 88⅝ inches (136.2 x 225.1 cm). Collection of Wanda Kownacki; courtesy of Edward Boyer Associates Fine Art Advisory

Her earliest take on Cézanne was a series of black-and-white photographs of his still lifes, *After Cézanne: 1–9,* in 1993. In 2002 she created another Cézanne-based work, *Pyramid of Skulls: 1–12* (fig. 1.2; see plate 114), and, in 2007, *After Cézanne: 1–18,* a series of pixilated photographic prints that abstract the color patches in Cézanne paintings.

Luc Tuymans is a committed painter *sur la motif,* as true to his subject in terms of empirical observation as he is engaged in the adjustment of that subject — through focus, enlargement, or recoloration — to his own powerful political and social ends. In this he is, by his own statements, alert to Cézanne's continuing artistic importance. This is shown here by his 2002 *Still Life,* made shortly after 9/11 (illustrated on p. xiv), a gigantic canvas that is both an homage to and departure from Cézanne in its magnification, and which somehow stays clear of caricature or distortion and is completely — and somewhat disturbingly — new.

The Story Line

Cézanne as a point of reception and inspiration is a very current subject, with our efforts resting somewhere in the center of a broad range of recent exhibitions and scholarly efforts. Cézanne's relationship to past masters, Nicolas Poussin in this case, was the focus of an important show in Edinburgh in 1990 organized by Richard Verdi, *Cézanne and Poussin: The Classical Vision of Landscape.* In the initial discussion for our exhibition we considered and discussed with Françoise Cachin a section on Cézanne and the past, with particular emphasis on the attraction seventeenth- and eighteenth-century sculpture held for him. This we sadly had to drop, simply because it essentially deserves (and will, we hope, have) its own separate exhibition. Joachim Pissarro's 2005 exhibition *Pioneering Modern Painting: Cézanne and Pissarro, 1865–1885,* at the Museum of Modern Art, New York, exploring the critical working relationship between these two artists, put to rest once and for all the notions of Cézanne as a product of provincial and isolated development, placing him very much at the center of a vital collaboration with his contemporaries. In 2004 the Museum Folkwang in Essen staged an ambitious exhibition, *Cézanne: Aufbruch in die Moderne,* which had the virtue of a sharp and pen-

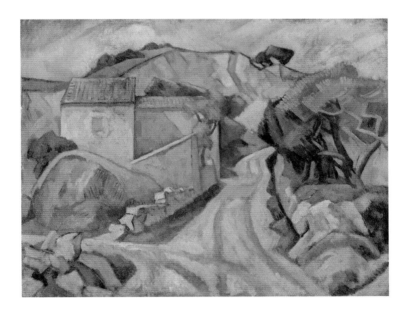

etrating focus on a short time frame within a Parisian formation of artists starting with Paul Gauguin in the late nineteenth century and continuing through 1920, which gave full place to the importance of André Derain and Maurice de Vlaminck. A more embracing show, placing Cézanne at the center of a broad pattern of resonance, *Cézanne und die Moderne,* was staged by Ernst Beyeler at his foundation in 1999. And two important exhibitions are pending as this one opens, namely, a highly appropriate pairing of Cézanne and Picasso at the Musée Granet in Aix-en-Provence, and a traveling show organized by Gail Stavitsky at the Montclair Art Museum in New Jersey that will explore in depth Cézanne's meaning for early American modernists, a group from which we have focused on only two, from the circle of Alfred Stieglitz: Charles Demuth and Marsden Hartley.

The starting point for nearly all these endeavors is the large 1895 exhibition staged by Ambroise Vollard at his gallery on the rue Laffitte, which served as the centenary point of departure for our own retrospective of 1995–96. Maurice Denis's famous declaration of Cézanne's centrality for this generation of artists was painted in 1900 (fig. 1.3), dramatically proclaiming their devotion, which in the next seven years would evolve

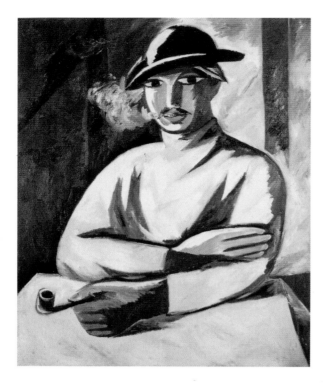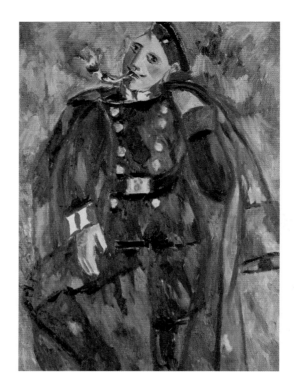

radically. Thereafter, there was a "rising tide" of works accessibly on view and in circulation (to use Émile Zola's phrase),[8] with the thirty-one paintings by Cézanne shown at the Salon d'Automne in 1904 and, particularly for the generation of Matisse and Picasso, the posthumous exhibition of fifty-six of Cézanne's works at the Salon d'Automne of 1907 essentially bringing him into position at center stage, which is the beginning of our story. Maurice Denis's 1907 essay on Cézanne, which proved so critical to that generation's understanding of the artist, was almost immediately translated into English and published in *The Burlington Magazine* by its editor, Roger Fry (fig. 1.4).[9] To Fry can be given the credit, for better or worse, for that particularly—and extremely potent in the formation of not only critical theory but also the art market's fervor—Anglo-American placement of Cézanne as the linchpin in the history of modernism. Suffice it to note that already by 1922 the English critic Clive Bell could bluntly declare: "Cézanne is the full-stop between impressionism and the contemporary movement. . . . [I]t is true that there is hardly one modern artist of importance to whom Cézanne is not father or grandfather, and that no other influence is comparable with his."[10]

By the time of Bell's writing, works by Cézanne, watercolors as abundantly as paintings (although drawings would take longer), were in wide circulation through dealers, collectors, and public exhibitions, with energy building throughout Europe, including Russia, as well as in the Americas and Japan. The artistic food chain was quick to take on definition, often along national boundaries but with many leaps and detours along the way. The sixteen monographic essays in this volume clarify this traffic in all its virility. As an introduction, let us swiftly sketch a chronology here.

Paris: Matisse and Picasso

The rising tide that began in Vollard's historic exhibition of Cézanne's paintings in 1895 was still gaining in 1904 and 1907, when Cézanne became central to Parisian progressive artistic sensibilities, taking nearly everyone under his spell (as Bell noted even from London). An early hope—fantasy in fact—for the opening of this exhibition was to have one room containing Cézanne's *Large Bathers* from Philadelphia (see plate 66), Picasso's *Demoiselles d'Avignon* from New York (see fig. 8.15), and Matisse's *Bathers by the River*

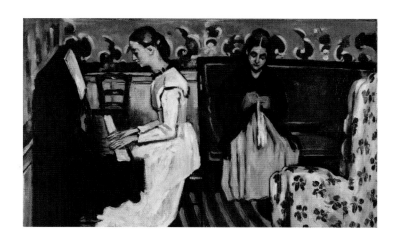

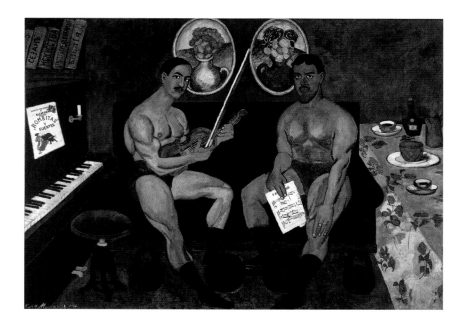

Fig. 1.7. **Paul Cézanne** (French, 1839–1906), ***Girl at the Piano, Tannhäuser Overture,*** c. 1869. Oil on canvas, 22¾ x 36⁷⁄₁₆ inches (57.8 x 92.5 cm). State Hermitage Museum, St. Petersburg

Fig. 1.8. **Ilya Mashkov** (Russian, 1881–1944), ***Self-Portrait with Pyotr Konchalovsky,*** 1910. Oil on canvas, 81⅞ x 106⁵⁄₁₆ inches (208 x 270 cm). State Russian Museum, St. Petersburg

from Chicago, the latter two sprung fully formed from the Zeusian brow of Cézanne. Nature and contingencies soon intervened to make such a wedding mechanically impossible, although we think we have compensated nicely with the assembly of prewar Picassos and Matisses we have managed to gather, which properly open the way for the firestorm of creativity that followed in Paris, much provoked by this triangle. The swift and magical evolution of Cubism, as well examined and much honored as it has been, is laid out in a wonderful domino game of Picasso and Braque onto Fernand Léger and, in a different genetic mix, Piet Mondrian. Matisse of course provoked another strain that would find its rejuvenation in Paris after the war with Giacometti's appearance in the city in September 1945 and the arrival, first in 1944 and for a longer spell from 1948 to 1954, of the young Ellsworth Kelly, who nobly picked up the thread and distilled to his own liking and with remarkable prescience much of what came before.

Russia

The upheaval in Paris before World War I, prompted and in some cases provoked by Cézanne, was not lost on the rest of the world. Liubov Popova first came to Paris from Moscow in 1913 to get her initial taste of modernity at the Académie de la Palette with Jean Metzinger and Henri Le Fauconnier, returning home to enrich her strong encounter with Cubism and Futurism with the deliciously accessible Cézannes in the collections of Sergei Shchukin and Ivan Morosov. She was somewhat better suited than many of her equally ambitious contemporaries to navigate between her encounters with Cézanne and the spirit of New Russia. This enforced the swiftness of her decision in the late 1910s and 1920s to move toward abstraction, a decision paralleled by her friends, in particular Natalia Goncharova and Mikhail Larionov (figs. 1.5, 1.6). The interplay of Cézanne and Russian modernism forms a long and complex history, in a time and a place that was perhaps hit hardest by Cézannism. This subject was beautifully considered by Albert Kostenevich in the 1998 exhibition *Paul Cézanne and the Russian Avant-Garde at the Beginning of the Twentieth Century* in St. Petersburg, in which he examined the currents that Cézannism would propel during that vivacious revolutionary decade.[11] In the recent exhibition *From Russia: French and Russian Master*

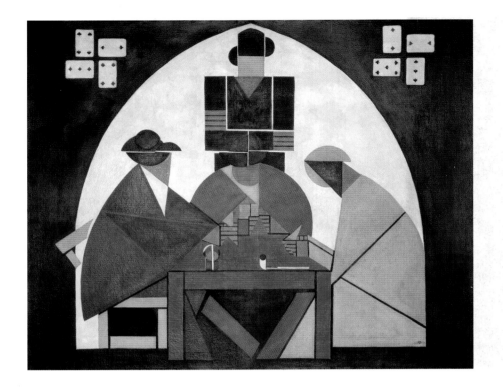

Paintings, 1870–1925, from Moscow and St. Petersburg at the Royal Academy of Arts in London, Cézanne's *Girl at the Piano, Tannhäuser Overture* was parodied by a reminder of the sophisticated self-assurance and wit that magical generation briefly enjoyed (figs. 1.7, 1.8). As much as "Cézanne's art would seem to have no direct correlation with Russia's national traditions," Kostenevich wrote in the catalogue, "it was one of those short and rare periods in our national history when a prophet not from our homeland not only called, but was heard."[12]

Holland and Germany

Yet to be fully examined is the role Cézanne played in German art of the twentieth century. The penchant for progressive French painting exemplified by figures such as Max Liebermann in Berlin and Karl Ernst Osthaus in Hagen, along with the transient Julius Meier-Graefe in Paris, attests to a cosmopolitan progressive—read French—taste in Germany. The forthcoming publication being compiled by Christina Feilchenfeldt and her father, Walter, about the Berlin dealer Paul Cassirer, who was second in scale and quality only to his contemporary Vollard in his transactions, should make clear the remarkable concentration of works by Cézanne in that city, early on and continuously until the mid-1930s, all of which were readily available to artists. This said, other than for Beckmann, who found his one vein to mine, Cézanne seems to have been a rather minor stimulant in the modernist evolution in the German-speaking world. The same cannot be said of Holland, where, as Joop Joosten points out in his essay, Cézanne made a major beachhead in Amsterdam, particularly in the Hoogendijk collection, which was put on public display before any comparable collection in Europe and on a grand scale at the Rijksmuseum, serving as a mighty impulse early on.[13] This is still an open field for investigation, and we illustrate here, as a small act of provocation, a charming and perfectly heartfelt painting of one of the Dutch modernists engaged with Cézanne, Theo van Doesburg's *Cardplayers* of 1916–17 (fig. 1.9).

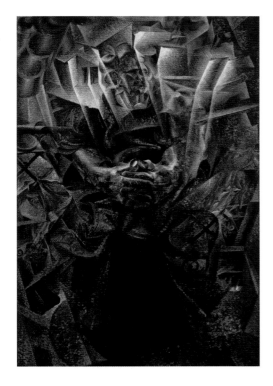

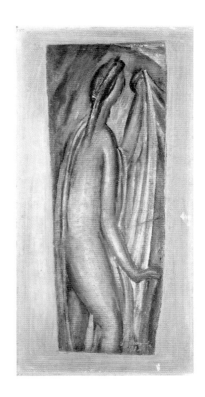

Fig. 1.10. **Umberto Boccioni** (Italian, 1882–1916), **_Materia,_** 1912. Oil on canvas, 88⅝ x 59 inches (225.1 x 149.9 cm). Gianni Mattioli Collection. Long-term loan to the Peggy Guggenheim Collection, Venice

Fig. 1.11. **Umberto Boccioni,** _Portrait of Ferruccio Busoni,_ 1916. Oil on canvas, 69¼ x 47¼ inches (176 x 120 cm). Galleria Nazionale d'Arte Moderna di Roma, Rome

Fig. 1.12. **Giorgio Morandi** (Italian, 1890–1964), **_Fragment,_** 1914. Oil on canvas laid on canvas, 26 x 11¹³⁄₁₆ inches (66 x 30 cm). Gianni Mattioli Collection. Long-term loan to the Peggy Guggenheim Collection, Venice

Fig. 1.13. **Lorenzo Bonechi** (Italian, 1955–1994), **_Bathers,_** 1993. Oil on canvas, 52⁹⁄₁₆ x 78¾ inches (133.5 x 200 cm). Collection of Stefania Bonechi Papi, Castelfranco de Sopra, Italy

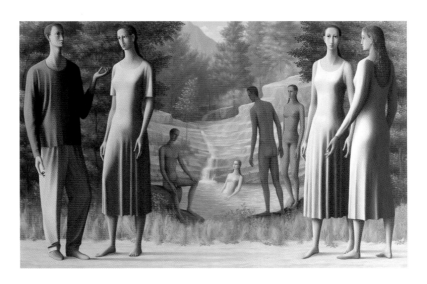

Italy

As was made beautifully apparent in the recent exhibition at the Palazzo Strozzi in Florence, _Cézanne a Firenze_ (2007), a sweet chapter of Cézannism played out in Italy, or rather Tuscany, in the early twentieth century, following the interactions of a handful of major Cézanne works available in two Florence collections (both of American ex-patriots, Charles A. Loeser and Egisto Fabbri) under the happy influence of the critic and painter Ardengo Soffici. Cézanne's role in the development of Italian modernism, via examples seen in Paris and at the Venice Biennale, is often lost in the dynamic intel-lectual discourse over contemporary art and a sense of standing true to one's time with little looking back. This is of course most vividly illustrated by the issue of Cézanne's meaning for the Futurists, and particularly for Umberto Boccioni, who was certainly alert, and exposed (at least one visit to Auguste Pellerin's collection with Carlo Carrà in 1914 seems evident),[14] to Cézanne early on. It is tempting to see his heroic masterpiece _Materia_ of 1912 (fig. 1.10) as perhaps a defiant response to Cézanne's seated portraits of his wife. Yet, as Laura Mattioli (supported by Anne d'Harnoncourt, no less) has win-ningly argued, in 1912 Boccioni was independent of Cézanne, whose shadow (not for the better) began to fall over him after his retreat to more passive and certainly more

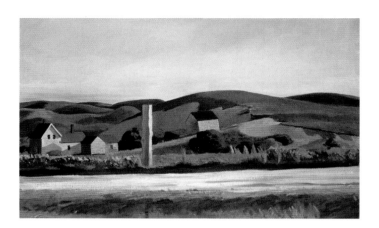

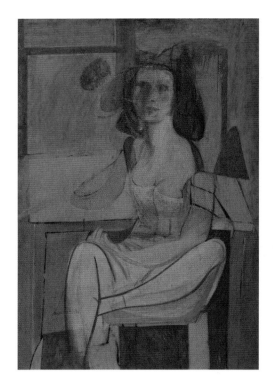

Fig. 1.14. **Edward Hopper** (American, 1882–1967), ***Road and Houses, South Truro,*** 1930–33. Oil on canvas, 27 x 43 inches (68.6 x 109.2 cm). Whitney Museum of American Art, New York. Josephine N. Hopper Bequest

Fig. 1.15. **Willem de Kooning** (American, born Holland, 1904–1997), ***Seated Woman,*** c. 1940. Oil and charcoal on composition board, 54 x 36 inches (137.2 x 91.4 cm). Philadelphia Museum of Art. The Albert M. Greenfield and Elizabeth M. Greenfield Collection, 1974-178-23

evidently Cézannesque works, such as his *Portrait of Ferruccio Busoni* of 1916 (fig. 1.11). These issues, Milan versus Paris, were tackled with open-minded vigor by Anne d'Harnoncourt in the exhibition *Futurism and the International Avant-Garde* at the Philadelphia Museum of Art in 1980, and can stand as a useful caveat of overextending Cézanne's power into all camps of European modernism.

Giorgio Morandi presents no such problems. His grasp of Cézanne, beginning with his stay in Rome from 1911 to 1914 while still a young man, was as firm and persuasive as it was absorbed in his own deep self-knowledge (fig. 1.12). Steeped in the severity of central Italian art exemplified by Piero della Francesca, this sensibility was beautifully extended into the late twentieth century by the Tuscan painter Lorenzo Bonechi, as seen, for example, in his *Bathers* of 1993 (fig. 1.13).

The Americas

In the early years of the twentieth century, young Americans, if new art was their bent, were highly likely to find safe harbor in Paris with the Steins at the rue de Fleurus. It is hard to think of any émigré circumstance that provided such hospitality and support, as well as stimulation and criticism, as the salons of Gertrude Stein, Alice B. Toklas, and Leo Stein. Maurice Prendergast, William Glackens, Charles Demuth, and Marsden Hartley, who were all alerted in New York to a new, progressive art in Paris, passed through their rooms, along with collectors such as Albert Barnes. Of course the place was full of Cézannes,[15] and, if one were lucky, Picasso might be there on any given evening. There were other paths, of course. The loner Edward Hopper was in Paris in the critical years of 1906 and 1907, as much occupied with the picturesque sights of boats on the Seine as with the origins of Cubism, yet he seems to have come to a reckoning with Cézanne on that first trip (there would be two other brief ones, the last in 1910), which held him in good stead for the rest of his life (fig. 1.14). Some, like Max Weber, entered into this new cosmopolitan life with their energies at a very high pitch, keeping their own art at a modal pace with the newest currency. Others, such as Hartley, came and looked and participated to some degree, but soon found their own centers elsewhere, in his case in Berlin, though he returned to Provence with lasting

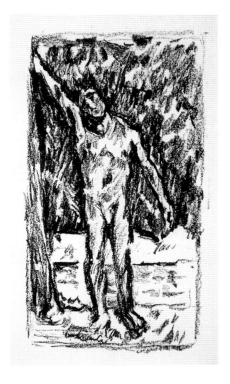

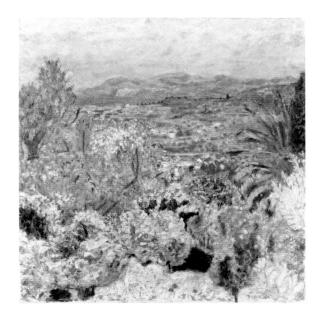

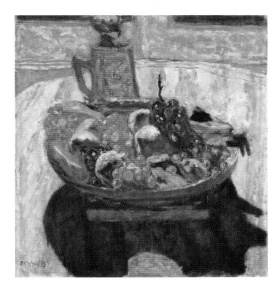

Fig. 1.16. **Pierre Bonnard** (French, 1867–1947), ***Bather: Homage to Cézanne,*** 1914. Lithograph, 5¹³⁄₁₆ x 3³⁄₁₆ inches (14.8 x 8 cm). Courtesy of Spaightwood Galleries, Upton, Massachusetts

Fig. 1.17. **Pierre Bonnard, *The Riviera,*** c. 1923. Oil on canvas, 31 x 30 inches (78.7 x 76.2 cm). The Phillips Collection, Washington, DC

Fig. 1.18. **Pierre Bonnard, *Still Life with a Bowl of Fruit,*** 1933. Oil on canvas, 22¹³⁄₁₆ x 20⅞ inches (57.9 x 53 cm). Philadelphia Museum of Art. Bequest of Lisa Norris Elkins, 1950-92-1

effect in 1926.[16] And Gorky would in the 1920s begin his own very independent exploration of Cézanne without leaving the United States, studying and absorbing the master's lessons in books and reproductions as well as American collections.

By the 1930s, the United States had become a dynamic center for the sale and exhibition of works by Cézanne, as reflected in Henry McIlhenny's exhibition *Cézanne in Philadelphia* in 1934, Ted Rousseau's *Cézanne: Paintings, Watercolors, and Drawings* at the Metropolitan Museum of Art, New York, and the Art Institute of Chicago in 1952, and William Rubin's critical *Cézanne: The Late Work* at the Museum of Modern Art, New York, in 1977.[17] How this fits with Abstract Expressionism—particularly in our case with Gorky and Willem de Kooning (fig. 1.15)—is a big story about to be addressed in the forthcoming Gorky retrospective.[18] But we pick up the thread again with complete confidence in the newer activity of the late 1950s and early 1960s with Kelly, Johns, and Marden.

Roads Not Taken, Trains Missed

This brief overview provides some notion, we hope, of our principles in organizing the show and in making our selections. It may clarify our intentions a bit more if we briefly step back and review those artists whom we either chose finally not to include—the roads not taken—and those with whom we had a major flirtation but for one reason or another had to abandon, either because of the impracticality of sheer quantity or because, with regrets in some cases, we simply did not win the day—our trains missed.

From our earliest discussions we plotted how best to include Pierre Bonnard in the exhibition, given his interplay with Cézanne on and off throughout his long career (figs. 1.16–1.18). His early engagement with Cézanne is confirmed by a lithograph he did directly after a male bather study he owned for a limited-edition art anthology (fig. 1.16).[19] And he can serve as a reminder that those gathered in Denis's 1900 *Homage to Cézanne* (Bonnard is to the right, smoking a pipe), who were as aware as Picasso and Braque were of Cézanne's formal structures, chose to draw just as much from Cézanne's position as a great and disciplined colorist, establishing quite different alternatives from the monochromatic Cubists.[20]

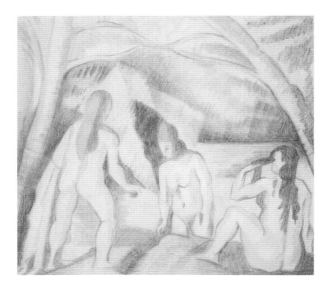

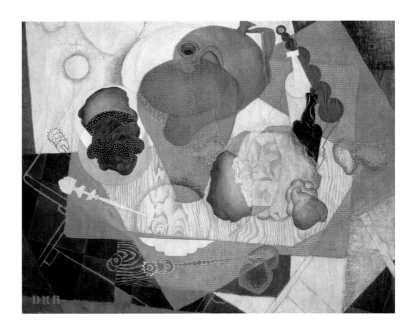

Fig. 1.19. **Juan Gris** (Spanish, 1887–1927), **Bathers after Cézanne,** 1916. Pencil on paper, 11¹/₁₆ x 15⅜ inches (28 x 39.1 cm). Private collection

Fig. 1.20. **Diego Rivera** (Mexican, 1886–1957), **No. 9, Spanish Still Life,** 1915. Oil on canvas, 35⅝ x 43½ inches (90.5 x 110.5 cm). National Gallery of Art, Washington, DC. Gift of Katharine Graham, 2002.19.1

Another sad fatality has been Juan Gris, who, we concluded fairly early, found his essential way quite apart from Cézanne—a fair distance, in fact, from any Parisian currency, which Gertrude Stein quickly attributed to his profound Spanishness (fig. 1.19). In turn, Derain was attractive for his obvious delight in Cézanne, but his long interplay with the artist not only defined but finally limited his career, in our judgment.

In the prewar Russian burst of energy, Popova has had to stand as our flagship, even as we have made quick asides to Goncharova and Larionov (see figs. 1.5, 1.6). Early on in our discussions (in ways that now seem somewhat naive) we pressed hard to include Kazimir Malevich as our second Russian player, only to be convinced that to include him here would in certain ways seriously distort his foundations with a rather American bias that assumes a climax into abstraction via Cézanne. This seems, on consideration, a falsification of what his art would become later in his career, which in fact is profoundly based on quite different and deeply Russian impulses.

Of that prewar generation, arguably the boldest and most sophisticated transatlantic visitor was not from the United States but rather from Mexico. Diego Rivera arrived first in Paris in 1907 and stayed until 1910, to return for a longer spell from 1911 to 1919. Although he was a lifelong spinner of tales, one nonetheless longs to believe every word of his anecdote concerning his first encounter with Vollard:

> As I have previously said, I came to Europe as a disciple of Cézanne, whom I had long considered the greatest of the modern masters. I had hoped to study under him, but Cézanne having died before I reached France, the best I could do was look for his paintings. I was still too shy to go where they were mostly to be found, in the homes of private collectors. I, therefore, did my hunting on the Rue Lafitte where the more celebrated dealers in modern paintings had their shops. When I came upon a Cézanne, I would stand rooted before it, studying and enjoying it.
>
> One day I saw a beautiful Cézanne in the window of Ambroise Vollard, the dealer who, I learned later, had been the first to take an interest in Cézanne. I began looking at the canvas at about eleven o'clock in the morning. At noon Vollard went out to lunch, locking the door of his gallery. Returning about an hour later and finding me still absorbed by the painting in his window, Vollard threw me a fierce glance. From his desk in the shop he looked up, from time to time, and

Fig. 1.21. **Howard Hodgkin** (British, born 1932), **The Cylinder, the Sphere, the Cone,** 1978–84. Oil on board, 36¼ x 46 inches (92.1 x 116.8 cm). Carnegie Museum of Art, Pittsburgh. Gene Baro Memorial Fund and Carnegie International Acquisition Fund, 1984

Fig. 1.22. **R. B. Kitaj** (American, 1932–2007), **Los Angeles No. 4,** unfinished 2000. Oil on canvas, 72 x 36 inches (182.9 x 91.4 cm). Collection of the artist, courtesy of Marlborough Fine Art, London

glared at me. I was so shabbily dressed he must have taken me for a burglar.

Suddenly Vollard got up, took another Cézanne from the middle of the shop and put it in the window in the place of the first. After a while, he replaced the second canvas with a third. Then he brought out three more Cézannes in succession. It had now become dark. Vollard turned on the lights in the window and inserted still another Cézanne.

Though his expression remained glowering, he finally turned on all the lights in the gallery, and with hungry, affectionate gestures, began to remove paintings from the walls and arranged them on the floor where I could see them from the doorway. Among these was the wonderful "Card Players." I stared enraptured, oblivious of a hard rain which had begun to fall and was now drenching me to the skin.[21]

As much as one may argue that the monumentality of his later frescoes is in part Cézanne filtered through Giotto, in fact, upon his return to Mexico other social and political passions engaged Rivera, with Cézanne essentially a youthful memory.

However, the validity of his tale is certainly supported by the intensity and degree of Rivera's comprehension of Cézanne (and much else current and old), which he turned to new ends in such works as the grand *No. 9, Spanish Still Life* of 1915, now at the National Gallery of Art, Washington, DC (fig. 1.20).

In England, Roger Fry and his followers did much to bring French art into recognition, confronting a rather barricaded opposition, with collections such as Samuel Courtauld's or Gwendoline E. Davies's to testify to the depth of this inoculation. Cézannism triumphed over more profound explorations in that generation, Clive Bell being an exception. Nonetheless, Cézanne has stood firm in English artistic workings since Fry, to the point that he is fully abroad there today. Howard Hodgkin was an early friend of this project, full of sage advice. We illustrate here a work completed in 1984 that underscores his long engagement with Cézanne (fig. 1.21). R. B. Kitaj's relationship with bather subjects, particularly late into his life, put him literally—in the exhibition *Kitaj in the Aura of Cézanne and Other Masters* at the National Gallery, London, in 2001—in direct confrontation with his longtime love (fig. 1.22). *After Cézanne* by Lucian Freud, nearly a year in the making, is his haunting reconsideration of Cézanne's painting on this erotic theme (figs. 1.23, 1.24).[22] The same energy and

Fig. 1.23. **Paul Cézanne,** *Afternoon in Naples,* c.
1875–77. Oil on canvas, 14⁹⁄₁₆ x 17¹¹⁄₁₆ inches (37 x 45 cm).
National Gallery of Australia, Canberra

Fig. 1.24. **Lucian Freud** (British, born Germany 1922),
After Cézanne, 1999–2000. Oil on canvas, 84¼ x
84⅝ inches (214 x 215 cm). National Gallery of Australia,
Canberra

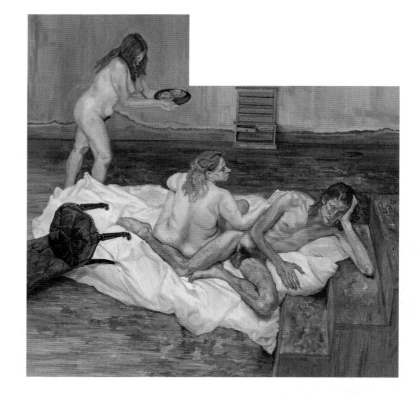

Fig. 1.25. **Cecily Brown** (British, born 1969), *The
Quarrel,* 2004. Oil on linen, 72 x 96 inches (182.9 x
243.8 cm). Courtesy of Gagosian Gallery, New York

Fig. 1.26. **Richard Hamilton** (British, born 1922),
Soft Pink Landscape, 1980. Lithograph and screen-
print on paper, 28¾ x 36⅛ inches (73 x 91.9 cm). Tate
Modern, London. After *Soft Pink Landscape*, 1971–72, oil
on canvas, Ludwig Múzeum, Museum of Contemporary
Art, Budapest

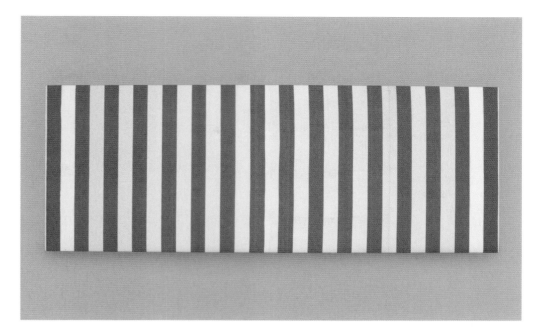

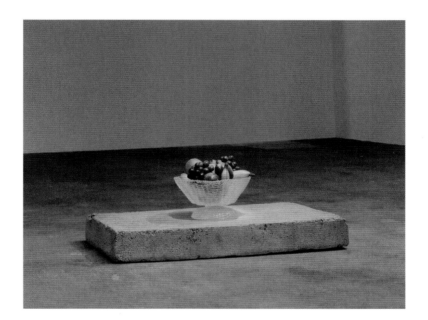

Fig. 1.27. **Dan Flavin** (American, 1933–1996), **Paul Cézanne**, 1959. Charcoal on paper, 8⅞ x 11¹⁵⁄₁₆ inches (22.5 x 30.4 cm). Courtesy of Dan Flavin, Ltd., New York

Fig. 1.28. **Daniel Buren** (French, born 1938), **White and Red Painting**, 1971. Acrylic on white and red striped cotton canvas, 41⁵⁄₁₆ x 109¹⁄₁₆ inches (105 x 277 cm). Courtesy of the artist and Bortolami Gallery, New York

Fig. 1.29. **Robert Gober** (American, born 1954), **Untitled**, 2004–5. Bronze, beeswax, lead crystal, and oil paint; approximately 20½ x 46½ x 25¼ inches (52 x 118 x 64 cm). Collection of the artist, courtesy of Matthew Marks Gallery, New York

engagement with Cézanne continues in the work of Cecily Brown, particularly in her bather subjects, which one is so tempted to think reflect the championing of the master of Aix by her father, the critic David Sylvester (fig. 1.25). We had several long talks with Richard Hamilton, who has admitted that as much as Cézanne is central to his affections, he is but one potent element in a very complex mix of animating references. This said, a painting such as *Soft Pink Landscape* (fig. 1.26) is redolent of Hamilton's youthful memories, when Cézanne provided an "example . . . [of] commitment to the perfect integrity of the painted surface" and gave him a love of painting that is always present, even in his most ethereal explorations.[23]

We know that by featuring Kelly, Johns, and Marden, three American painters of established fame, we run the danger of being not only canonical but also even somewhat jingoistic. Since the 1996 retrospective, we have always talked of the current exhibition as an even playing field with no climaxes or highlights—national, chronological, or otherwise. Our questioning along these lines (among ourselves and with friends) led, for example, to Anne Rorimer, a former curator at the Art Institute of Chicago, referring us to a drawing of Cézanne by Dan Flavin (fig. 1.27). She also championed Daniel Buren "as an artist firmly in the disciplined tradition of Cézanne, particularly in terms of his ongoing interest in spatial reality with reference to, but beyond,

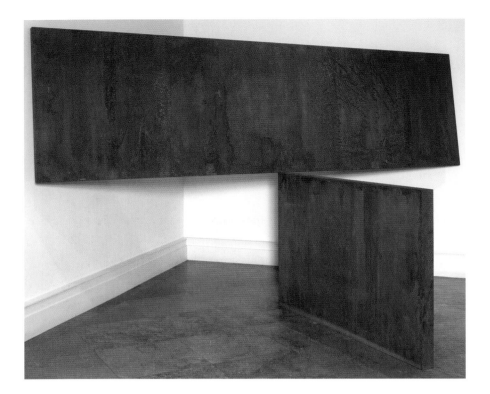

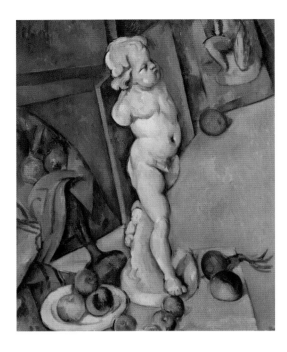

Fig. 1.30. **Richard Serra** (American, born 1939), *Kitty Hawk,* 1983. Cor-ten steel, 48 x 72 x 4 inches (121.9 x 182.9 x 10.2 cm). Albright-Knox Art Gallery, Buffalo, New York. Mildred Bork Connors, Edmund Hayes, George B. and Jenny R. Mathews and General Purchase Funds, 1991

Fig. 1.31. **Paul Cézanne**, *Still Life with Plaster Cupid,* c. 1894. Oil on paper, laid on board; 27¹³⁄₁₆ x 22⁹⁄₁₆ inches (70.6 x 57.3 cm). The Samuel Courtauld Trust, The Courtauld Gallery, London

the canvas surface,"²⁴ a suggestion that was happily responsive to Philadelphia's recent engagement with Buren (fig. 1.28). We chose instead to refocus on Europe through the next generation: Alÿs and Tuymans.

Since the 1996 show we have cheered ourselves with the knowledge that the artist who seemed to visit Philadelphia the most during the exhibition's run was Robert Gober, removing any thoughts that an artist's interests have to find correlations in his own creations, although Gober's 2004–5 *Untitled* has often played through our minds in a prescribed context (fig. 1.29). (It is also interesting to note that Brice Marden came to Philadelphia and spent many hours looking at Cézanne's London *Large Bathers* during the 1996 Cézanne exhibition, and soon after began a series of paintings inspired by his reacquaintance with this painting, which had always fascinated him [see plate 204].)²⁵

We were for some time keen to engage Richard Serra in our dance (figs. 1.30, 1.31). Yet as kind as he was in sharing his opinions about the show, he finally withdrew from consideration, observing that he was more influenced by Matisse through Barnett Newman than directly by Cézanne, although in a conversation with Lynne Cooke on October 25, 2007, he had this to say:

> I think Cézanne structures things with gravity, so when you're looking at an apple it's like a weight, and I've always looked at Cézanne for the disparity between the weight and the structure. And I remember I went to the Courtauld [Gallery] in London . . . and this is one of the few times it's happened to me, and now I actually have a photograph of the painting on the wall right near where I sleep—but he painted a painting of a little cherub on a table, and if you look at the painting the floor is tilting up, and then the floor connects to the table, which connects to the wall behind. So it punches a hole in the space, and yet everything that you're look-ing at in the painting is contradictory, and even though the cherub is vertical. And I was looking at the painting and I was wondering who the person was that con-structed this kind of space. What must have been going on in his mind's eye to construct a space of this kind of tension and disequilibrium. And as I was musing this to myself, the hair on the back of my neck stood up; it frightened me. And I

think that things that evoke . . . sensations through perception or through thought or through thought and perceptions, . . . bring you back to experiences that are private and personal and have to do with differentiating sensibilities, and Cézanne's sensibility is one I connect to.

Now, I have admiration for a lot of other artists, but I don't find that their sensibility feeds me in the way that I need in order to experience my own work. And I think what artists do is they look to other artists who they can align their sensibilities with to learn from; no one starts with a blank slate.[26]

Such an apt statement, so convincing in its direct reference to Cézanne, by an artist who withdrew himself from our exhibition may seem to place into doubt our selection process. And while we hope to get some credit for trying, we also remind ourselves that, in good part, the spirit of our enterprise derives from our residence in the house of Duchamp, where didactic polemics and argued patterns of artistic exchanges are often set aside by chance and distractions, and sometimes outright flirtations. Activities webbed together with a sense of direction and intention that is sometimes only discovered in the actual encounters themselves are perhaps best left wordless. We therefore await, with anticipation but with certainty, the satisfactions and pleasures this mix of Cézanne with other artists will provide once the players form a kind of internal unity that only exhibitions can offer, however artificial and transient such an experience may be. We also anticipate some moments of revelation and even exaltation, bringing us back to Matisse's "If Cézanne is right, I am right."

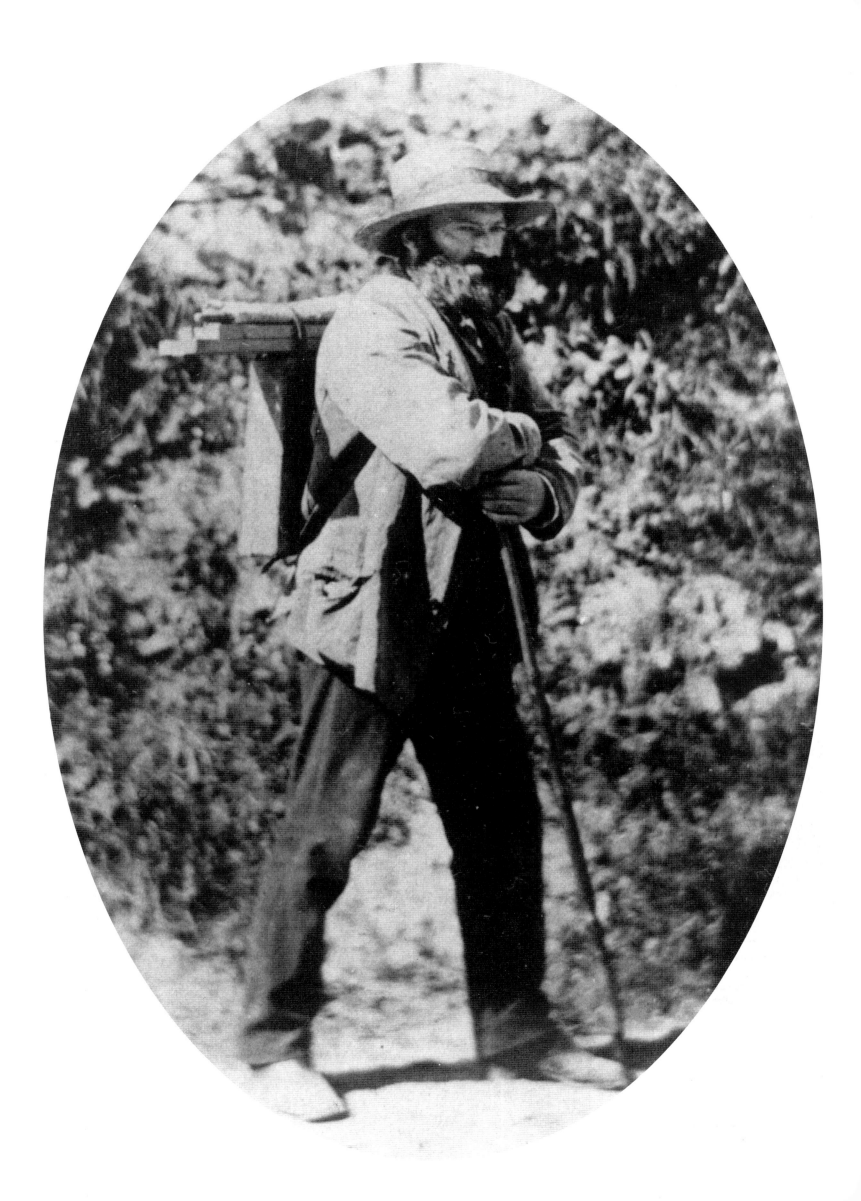

Chronology

Adrianne O. Bratis

Cézanne (center) and Camille Pissarro (right) with two other artists near Auvers, France, c. 1873. Musée d'Orsay, Paris. Service de documentation

Opposite page:
Cézanne setting out to paint in Auvers, France, 1874. Musée du Louvre, Paris

1839
JANUARY 19: Paul Cézanne is born in Aix-en-Provence.

1861
APRIL: Cézanne makes his first trip to Paris and lives there for several months, attending art school, copying paintings and sculpture at the Louvre, and meeting other artists, including the Impressionist Camille Pissarro, who will be a longtime friend and mentor and an important artistic influence. Cézanne will travel between Aix and Paris many times over the course of his life.

1863
MAY 15: The Salon des Refusés opens in Paris, showing paintings refused by the official French salon, including Cézanne's, and is widely ridiculed. Cézanne's childhood friend Émile Zola will include a fictionalized account of the scandal in his 1886 novel *L'Oeuvre*.

1864
SUMMER: Cézanne visits L'Estaque on the Bay of Marseille in southern France, which will become an important motif throughout his career and one that will impact many later artists, including Ellsworth Kelly and Brice Marden.

1869
DECEMBER 31: Henri Matisse is born in Le Cateau-Cambrésis in northern France.

1872
MARCH 7: Pieter Cornelis Mondrian is born in Amersfoort in the central Netherlands.

1873
Cézanne meets Julien-François Tanguy, owner of a painting supply shop at 14, rue Clauzel, Paris. "Père" Tanguy begins to show Cézanne's paintings in his shop window, where many artists will come into contact with his work for the first time.

1874
APRIL 15 – MAY 15: The first Impressionist exhibition is held in Paris. Cézanne shows three paintings.

1877
JANUARY 4: Marsden Hartley is born in Lewiston, Maine.

APRIL: Cézanne shows sixteen paintings in the third Impressionist exhibition.

1881
FEBRUARY 4: Fernand Léger is born in Argentan, France.

OCTOBER 25: Pablo Ruiz Picasso is born in Málaga, Spain.

1882
SPRING: Cézanne has a portrait accepted at the official Paris Salon after years of having his submissions rejected.

MAY 13: Georges Braque is born in Argenteuil-sur-Seine, outside Paris.

1883
NOVEMBER 9: Charles Demuth is born in Lancaster, Pennsylvania.

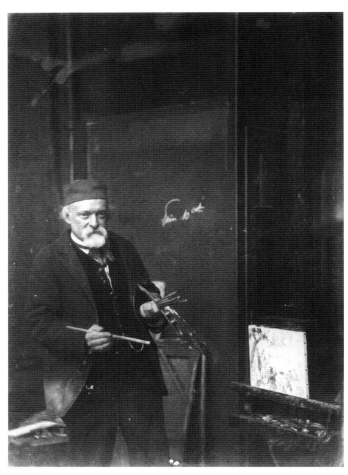

Cézanne in his studio in Paris, 1894.
Art Resource, New York

1884

FEBRUARY 12: Max Beckmann is born in Leipzig, Germany.

JUNE: The Salon des Indépendants, a juryless and prizeless exhibition that artists can pay to enter, is established in Paris in reaction to the official Paris Salon and becomes an important yearly venue for the Impressionists and Post-Impressionists.

1885

AUGUST: Cézanne paints at Gardanne, a village outside Aix, for the first time. His pyramidal paintings of the houses there will serve as a jumping-off point for later artists, particularly Picasso and Braque as they begin their Cubist explorations.

1889

APRIL 24: Liubov Popova is born in Ivanovskoye near Moscow.

1890

JULY 20: Giorgio Morandi is born in Bologna, Italy.

1894

FEBRUARY: The collector Gustave Caillebotte dies and bequeaths many contemporary paintings to the French state, including four Cézannes. Under pressure from traditionalists, the state rejects two of the Cézannes, as well as works by Auguste Renoir, Édouard Manet, Claude Monet, and Pissarro. In the spring of 1897, the Musée du Luxembourg will exhibit the bequest in their new annex, which Matisse and Pissarro will visit together.[1]

1895

NOVEMBER – DECEMBER: Prompted by the perceived injustice of the French state's rejection of Cézanne's work in the Caillebotte estate, the dealer Ambroise Vollard mounts Cézanne's first one-person exhibition at his gallery, showing more than 150 paintings and watercolors on a rotating basis. The artists Edgar Degas, Monet, Renoir, and Pissarro purchase paintings, and possibly also Auguste Pellerin, who will become a major collector of Cézanne's work. Pissarro writes to his son about the Cézannes: "There are some exquisite things, some still-lifes of irreproachable perfection, others much worked on and yet left unfinished, and, even more beautiful than the rest, some landscapes, some nudes, some unfinished heads which are, however, truly imposing and so artistic, so supple . . . Why?? Because sensation is there."[2] Matisse also attends the exhibition,[3] and so, probably, does the German critic Julius Meier-Graefe, who will go on to write a number of important essays and books on Cézanne, including, in 1910, the first monograph devoted to the artist.

DECEMBER 1: The critic Thadée Natanson urges readers to see the Cézannes at Vollard's gallery, calling the painter's influence "profound."[4] He will become a major proponent of Cézanne's work.

1897

OCTOBER: The painting *Mill on the Couleuvre at Pontoise*, 1881 (R483), is the first work by Cézanne to enter a public collection when it is purchased by the Alte Nationalgalerie, Berlin (then directed by Hugo von Tschudi), from the Durand-Ruel gallery in Paris. When Tschudi hangs the painting, the Prussian Parliament reacts in fury, asking Kaiser Wilhelm to intervene.

1898

MAY 9–JUNE 10: Vollard mounts another important one-person exhibition of more than sixty Cézanne paintings. Matisse likely sees the show.

The French press, referring to the Caille-botte bequest, publicizes the National-galerie purchase of the previous year: "Isn't the relevant point that in 1897 a foreign administration purchased a painting that none of this country's own museums would have had anything to do with, even as a gift, in this same year of 1897?"[5]

The announcement of Cézanne's exhibition at Ambroise Vollard's gallery, Paris, 1898. Musée d'Orsay, Paris. Service de documentation

1899

JULY 1–4: The widow of Victor Chocquet, a collector and frequent commissioner of paintings by Cézanne, dies, after which the estate is auctioned off at the Galerie Georges Petit in Paris. In the preface to the auction catalogue, the critic Théodore Duret writes of Chocquet: "He was especially tireless on the subject of Cézanne, whom he placed in the very first rank."[6] Many collectors attend the auction, where they see Cézanne's work for the first time. Among them is the Comte de Comondo, whose Cézanne paintings will be bequeathed to the French state and eventually hang in the Louvre.

DECEMBER: Vollard buys the entire contents of Cézanne's studio, as he informs Gauguin in a letter.[7] He mounts another exhibition devoted to the artist, from which Matisse purchases his first Cézanne, *Three Bathers*, 1879–82 (see plate 10;

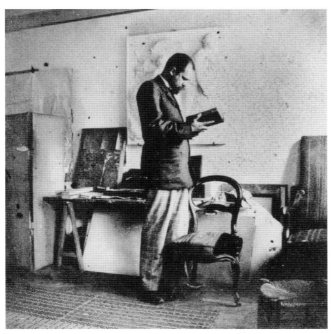

Ambroise Vollard, Paris, c. 1899, around the time Cézanne painted his portrait. Private collection

R360). Around this time, Cézanne begins painting a portrait of Vollard, which he will work on for several months, visiting the Louvre in the afternoons for inspiration.

1900

NOVEMBER 2–EARLY JANUARY 1901: A group exhibition at Paul Cassirer's gallery in Berlin includes twelve Cézanne paintings on loan from Durand-Ruel, all of which will be returned unsold. These are the first Cézannes to be exhibited in Germany. The poet Rainer Maria Rilke discovers Cézanne's work at this show and will make a point of visiting the artist's retrospective at the 1907 Salon d'Automne, leading to a now famous series of letters on the artist.

Maurice Denis paints *Homage to Cézanne* (now at the Musée d'Orsay, Paris; see fig. 1.3), a group portrait of Nabi and Symbolist painters gathered reverently around a Cézanne still life. Cézanne writes to Denis thanking him for this expression of "artistic sympathy." Denis writes back: "Perhaps you will now have some idea of the place you occupy in the painting of our time, of the admiration you inspire, and of the enlightened enthusiasm of a few young people, myself included, who can rightly call themselves your students."[8]

Matisse sees Cézanne's work at the Durand-Ruel gallery, later recalling: "At Durand-Ruel's I saw two very beautiful still-lifes by Cézanne, biscuits [R329] and milk bottles and fruit in deep blue [either R426 or R427]. My attention was drawn to them by old Durand to whom I was showing some still-lifes I had painted. 'Look at these Cézanne's that I cannot sell,' he said, 'you should rather paint interiors with figures'"[9]

1901

APRIL 20–MAY 21: The Salon des Indépendants exhibits paintings by Cézanne and Matisse, as well as Maurice Denis's *Homage to Cézanne.*

OCTOBER 10: Alberto Giacometti is born near Stampa, Switzerland.

1902

MARCH 29–MAY 5: The Salon des Indépendants this year includes paintings by Cézanne. Matisse sees the exhibition and later recalls: "I can still hear old Pissarro exclaiming at the 'Indépendants,' in front of a very fine still-life by Cézanne representing a cut crystal water carafe in the style of Napoleon III, in a harmony of blue [possibly *Still Life with a Dessert*, 1877–79, plate 78 (R337)]: 'It's like an Ingres.' When my surprise passed, I found, and I still find, that he was right. Yet Cézanne spoke exclusively of Delacroix and of Poussin."[10]

1903

JANUARY: Cézanne moves into a new studio in Les Lauves, outside Aix, and writes to Vollard: "I work obstinately, I glimpse the Promised Land. Will I be like the great leader of the Hebrews, or will I really penetrate it? . . . I've made some progress. Why so late and so painfully! Is Art, then, a priesthood demanding pure beings who belong to it completely?"[11]

MARCH 9–13: An auction of the estate of Émile Zola at the Hôtel Drouot, Paris, includes nine important paintings by Cézanne, five of which are purchased by Pellerin.

SEPTEMBER: Beckmann visits the Durand-Ruel gallery in Paris, where he sees work by Manet, Renoir, Alfred Sisley, and Cézanne. He will later say: "My greatest love already in 1903 was Cézanne."[12]

OCTOBER 31: The first Salon d'Automne, another exhibition established as an alternative to the official French Salon, is held at the Petit Palais, Paris, and includes works by Cézanne, Bonnard, Matisse, and Paul Gauguin.

1904

FEBRUARY 21–MARCH 24: The Salon des Indépendants this year includes a special exhibition of Cézanne's work.

The art historian Bernard Berenson, on a visit to Paris, advises the collector Leo Stein to go to Vollard's gallery and see the Cézannes there. Stein, who had never heard of Cézanne, ends up buying a landscape painting before the end of spring.

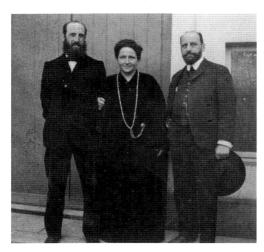

Leo, Gertrude, and Michael Stein in the courtyard of their apartment at 27, rue de Fleurus, Paris, c. 1905. The Baltimore Museum of Art. The Cone Archives

He and his sister, Gertrude, and brother, Michael, host a weekly salon in their apartment where artists, scholars, and collectors meet. They will become major collectors of Cézanne's work.

APRIL: Vosdanig Manoog Adoian (who will later call himself Arshile Gorky) is born in the Lake Van region of Turkish Armenia.

After three visits to Paris, beginning in 1901, Picasso moves there permanently, settling in the complex of artists studios known as the Bateau-Lavoir in Montmartre.

JUNE 1–18: In the catalogue for Matisse's first one-person exhibition, at Vollard's gallery, the critic Roger Marx writes: "The art of Henri Matisse harmoniously reveals the synthesis of the combined teachings of Gustave Moreau and Cézanne; it captures the curiosity of the historian as well as that of the enlightened amateur."[13]

JULY: The painter and writer Émile Bernard describes Cézanne in the journal *L'Occident* as "the only master" from whom "the fruit of the art of the future can emerge." Bernard includes in his essay a number of Cézanne's statements about art, which become quite famous. Matisse reads Paul Signac's copy and is particularly fond of such aphorisms as "To paint is to record the sensations of color," "Drawing and color are not distinct from one another; gradually as one paints, one draws," and "Penetrate . . . what lies before [you] and . . . strive to express [your]self as logically as possible."[14]

OCTOBER 15–NOVEMBER 15: The Salon d'Automne includes thirty-three paintings (including the *Three Bathers* that Matisse had purchased) and two drawings in individual galleries devoted to Cézanne, who is listed in the catalogue as one of the Salon's founding members. For the first time there is a separate photography section in the exhibition, which includes photographs of Cézanne's paintings.[15]

Braque is living in Paris, where he frequents the Musée du Luxembourg, the Galerie Vollard, and the Durand-Ruel gallery, seeing Cézanne's work for the first time.

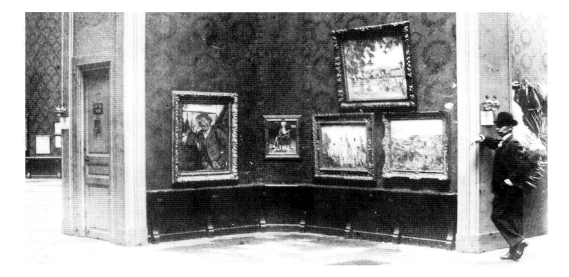

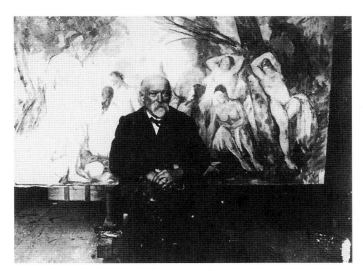

Bonnard paints a portrait of Ambroise Vollard in which Cézanne's *Four Bathers*, 1877–78 (R363), can be seen hanging on the wall behind the collector. According to the later account of the Cézanne biographer John Rewald: "Bonnard apparently wished to associate Vollard with the artist whom he was so actively defending and who was then still alive. Since Bonnard did not own this picture, he must have asked Vollard to bring it along for this portrait (unless Vollard himself suggested that it appear in the background)."[16]

1905

JANUARY: Cézanne writes to thank Roger Marx for his positive articles about his work in the *Gazette des Beaux-Arts*: "In my thought one doesn't replace the past, one only adds a new link to it. Along with a painter's temperament and an artistic ideal, in other words a conception of nature, sufficient means of expression are necessary to be intelligible to the average public and occupy a suitable rank in the history of art."[17]

JANUARY–FEBRUARY: A group exhibition at the Grafton Galleries in London, organized by Durand-Ruel, includes the first Cézanne paintings to be shown in Great Britain.

OCTOBER 18–NOVEMBER 25: The Salon d'Automne includes ten of Cézanne's paintings. Max Weber, an American artist who will help bring Cézanne's work to awareness in the United States, sees the show and later recalls: "I had heard of Cézanne before, but when I saw the first ten pictures by this master, the man who actually . . . brought an end to academism, I said to myself . . . 'this is the way to paint. This is art and nature reconstructed by what I should call today an engineer of the geometry of aesthetics.'"[18]

The critic Charles Morice surveys young artists about the current state of French art. His questions include "What opinion do you have of Cézanne?" and "Do you think that the artist should expect everything to come from nature, or should the artist only ask of nature the plastic means to realize the thought that is within him?"[19] The fifty-seven responses indicate that Cézanne is currently the chief subject of discussion in artists' studios.

Picasso purchases a copy of Cézanne's lithograph *Large Bathers*, made after the painting *Bathers at Rest*, 1876–77 (R261) now in the Barnes Foundation in Merion, Pennsylvania. Braque and other artists who visit Picasso's studio see it there.

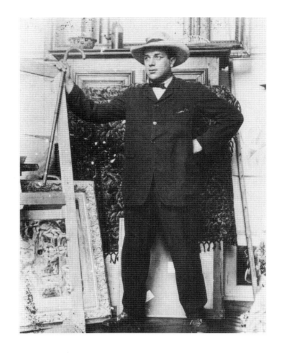 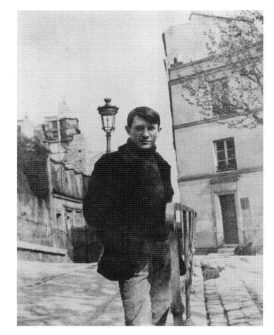 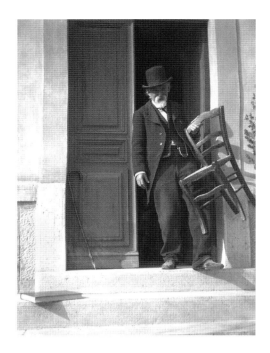

Georges Braque in Picasso's studio at 11, boulevard de Clichy, Paris, with Cézanne's lithograph *The Large Bathers* (after *Bathers at Rest*, now at the Barnes Foundation) on the floor, c. 1909–10. Photograph by Pablo Picasso

Pablo Picasso at Montmartre, place de Ravignan, Paris, c. 1904. Musée Picasso, Paris

Paul Cézanne outside his studio at Les Lauves, Aix-en-Provence. The photograph was taken during a visit with Karl Ernst Osthaus on April 13, 1906. Photograph by Gertrude Osthaus. Bildarchiv Foto Marburg / Art Resource, New York

1906

APRIL 13: The German collector Karl Ernst Osthaus, founder and director of the Museum Folkwang Essen, visits Cézanne in Aix and acquires two paintings for the museum, *The House at Bellevue and the Dovecote* (R690) and *Bibémus Quarry* (plate 116; R797).

SEPTEMBER: Beckmann travels to Paris on his honeymoon, where he meets with Vollard. The two discuss their mutual admiration for Cézanne, and Vollard gives Beckmann a large photograph of the painter.

OCTOBER 6–NOVEMBER 15: The Salon d'Automne this year includes ten Cézanne paintings.

OCTOBER–FEBRUARY 1907: Braque goes to paint at L'Estaque for the first time and will return repeatedly in the coming years. Much later, in response to a question by the interviewer Jacques Lassaigne —"Was it because of Cézanne that you left for L'Estaque?"—Braque will answer: "Yes, and . . . I can say that my first pictures of L'Estaque were already conceived before my departure. I nonetheless applied myself to subjecting them to the influences of the light and the atmosphere, and to the effect of the rain which brightened up the colors."[20]

OCTOBER 23: Paul Cézanne dies in Aix-en-Provence.

1907

MAY–JULY: Inspired by Cézanne's *Large Bathers* paintings and African sculpture, Picasso paints *Les Demoiselles d'Avignon*, a work that will have an enormous impact on art from this point on.

JUNE 17–29: The American artist and gallery owner Alfred Stieglitz first sees Cézanne's work at a watercolor exhibition at the Galerie Bernheim-Jeune in Paris and is "flabbergasted" by what he sees. When he learns that the works cost 1,000 francs apiece, he responds: "Why there's nothing there but empty paper with a few splashes of color here and there."[21] Stieglitz will become a major proponent for the artist, his galleries the first to show Cézanne's work in the United States.

OCTOBER 1–22: The Salon d'Automne this year is devoted to a retrospective of Cézanne's work that comprises fifty-six paintings and several watercolors. Max Weber will later recall that, prior to the exhibition, "almost everywhere in Montmartre and Montparnasse . . . one could find groups of young painters in heated discussion on Cézanne's art. So great was the anticipation of the event, that students postponed their trips to Spain, Italy or other parts of the Continent."[22] Many artists see the exhibition, including Picasso, Braque, and Léger. The latter writes of the show to his fellow painter André Mare: "The second revelation [was] Cézanne. Ah! my old fellow, stunning things [placed] next, of course,

to incomplete things. Among other works, a canvas representing two working class chaps playing cards. It cries out with truth and completeness, do you understand, [it's] modelled in terms of values, and what facture! It's unaffected, clumsy, one would think one was looking at the work of some decent, simple man who had just invented painting two thousand years before Jesus Christ."[23] Of this time, Léger will later declare: "Cézanne allowed me to find my way in a more conscious manner. . . . For two years I manipulated shapes. I built, I was the most scrupulous bricklayer. . . . Slowly, color reappeared, blended, shy, calculated, as in Cézanne, by whom I was influenced."[24]

The artists Henri Rousseau and Max Weber attend the Cézanne exhibition together. Standing in front of the *Large Bathers*, 1906 (plate 66; R857), now in the collection of the Philadelphia Museum of Art, Rousseau comments: "You know, this is an extremely interesting canvas. I like it very much. Too bad he left so many places unfinished. I wish I had it in my studio, I could finish it nicely."[25]

The Steins also visit the show. Recalling it years later, Leo states: "Hitherto Cézanne had been important only for the few; he was about to become important for everybody. At the Autumn Salon of 1905 people laughed themselves into hysterics before his pictures, in 1906 they were respectful, and in 1907 they were reverent. Cézanne had become the man of the moment."[26]

Rilke visits the Salon d'Automne repeatedly and records his impressions of Cézanne's paintings in letters to his wife that will later be published as the influential volume *Lettres sur Cézanne,* or *Letters on Cézanne.* In one letter he writes: "I again spent two hours in front of a few pictures today; I sense this is somehow useful for me. . . . One can really see all of Cézanne's pictures in two or three well-chosen examples, and no doubt we could have come as far in understanding him somewhere else. . . . But it all takes a long, long time. When I remember the puzzlement and insecurity of one's first confrontation with his work, along with his name, which was just as new. And then for a long time nothing, and suddenly one has the right eyes."[27]

Braque abandons the bright, Fauvist hues of his previous work for a more subdued palette, possibly in response to the Cézanne exhibition.

OCTOBER 1 AND 15: Émile Bernard publishes his correspondence with Cézanne in the journal *Le Mercure de France.* Braque and Picasso read the letters, the former even learning some of the passages by heart. The most famous lines come from a letter dated April 15, 1904: "Treat nature by means of the cylinder, the sphere, the cone, everything brought into proper perspective so that each side of an object or a plane is directed towards a central point. . . . But nature for us men is more depth than surface, whence the need to introduce into our light vibrations, represented by the reds and yellows, a sufficient amount of blueness to give the feel of air."[28] Another much-quoted passage is from a letter of July 25, 1904: "In order to make progress, there is only nature, and the eye is trained through contact with her. It becomes concentric through looking and working. I mean to say that in an orange, an apple, a ball, a head, there is a culminating point; and this point is always—in spite of the tremendous effect; light and shade, colour sensations—the closest to our eye; the edges of the objects flee towards a centre on our horizon."[29]

Leo and Gertrude Stein's apartment at 27, rue de Fleurus, Paris. On the wall at bottom left is Cézanne's study for *The Smoker.* Pierre Bonnard's *Siesta* is the large horizontal painting at center, with Picasso's *Girl with a Basket of Flowers* to its right and his *Head of a Boy* at bottom center. The Baltimore Museum of Art. Dr. Claribel Cone and Miss Etta Cone Papers

Henri Matisse with his students at the Académie Matisse, Paris, c. 1910. Archives Matisse, Paris

André Derain in his studio, Paris, c. 1908. From Gelett Burgess, "The Wild Men of Paris," *Architectural Record* (New York), May 1910

OCTOBER 4: Demuth sails from Philadelphia to Paris, possibly arriving in time to see the final days of the Salon d'Automne. He will stay until March 21, 1908.

Popova enrolls in the painter Konstantin Yuon's private art school in Moscow, where she is introduced to the work of Cézanne and Gauguin as well as to Japanese prints, Fauvism, and other styles popular at the time.

A year after Cézanne's death, his son Paul sells half the contents of his studio to Vollard and Bernheim-Jeune.

DECEMBER 25: In the United States, the journalist and critic James G. Huneker writes to his friend Charles J. Rosebault: "The Autumn Salon must have blistered your eyeballs. Nevertheless Cézanne is a great painter—purely as a painter, one who seizes and expresses *actuality*. This same actuality is always terrifyingly ugly (fancy waking up at night and discovering one of his females on the pillow next to you!). There is the ugly in life as well as the pretty, my dear boy, and for artistic purposes it is often more significant and characteristic. But—ugly is Cézanne. He could paint a bad breath."[30] Huneker will publish several articles in the *New York Sun* the following year, expanding awareness of Cézanne's work in the United States.

1908

EARLY JANUARY: Matisse opens his art school, the Académie Matisse, in Paris, where he instructs pupils on the principles of Cézanne's painting. Max Weber will

later recall of one of his classes: "With great modesty and deep inner pride he showed us his painting *Bathers* by Cézanne. His silence before it was more evocative and eloquent than words. A spirit of elation and awe pervaded the studio at such times."[31] He will also remember Matisse speaking of Cézanne as "the father of us all."[32]

MARCH: The first Cézanne illustrations to be reproduced in an American periodical appear in *Burr-McIntosh Monthly*.[33]

MARCH 20–MAY 2: Maurice Denis notes a growing confirmation of Cézanne's impact on painting in his review of the Salon des Indépendants: "It is apparent that there is much less influence of Matisse here than of Cézanne."[34]

APRIL 18: The *Salon de la Toison d'Or*, an exhibition of Impressionist, Post-Impressionist, and Fauvist art, is held in Moscow, organized by the Russian symbolist journal *The Golden Fleece*. Popova most likely knows of the exhibition, as her father subscribes to the magazine.

OCTOBER 26: Matisse acquires six Cézanne watercolors from Vollard.

Morandi sees photographs of the work of Cézanne and the French Impressionists in a book by Vittorio Pica, and he also reads Ardengo Soffici's reports from Paris in the magazine *La Voce*, in which Soffici calls Cézanne a "born-again Italian."[35]

1909

WINTER: Picasso and Braque begin a closer dialogue as their mutual interest in Cézanne grows. Picasso's painting *Still Life with Hat (Cézanne's Hat)* shows the Kronstadt hat Braque had purchased in homage to Cézanne.

APRIL: In his review of the Salon des Indépendants of this year, the critic André Salmon writes: "Although Cézanne's spirit wanders through these rooms, many of the artists who came under his influence affirm their temperament to be entirely original."[36] The term "Cubism" first appears in print in another review of the exhibition, by Charles Morice: "I believe I do see that Mr. Braque is on the whole

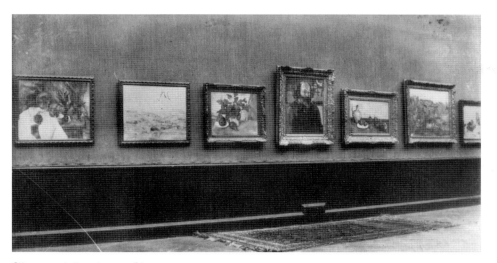

Cézanne paintings in one of two rooms devoted to the artist at the first Moderne Kunst Kring (Modern Art Circle) exhibition, Stedelijk Museum, Amsterdam, 1911

a victim — setting 'Cubism' aside — of an admiration for Cézanne that is too exclusive or ill considered."[37]

DECEMBER 3: Cornelis Hoogendijk's collection of old master paintings and contemporary art is displayed on permanent loan to the Rijksmuseum, Amsterdam. Included are eleven of the thirty-one Cézannes Hoogendijk acquired from Vollard during his lifetime.

Morandi studies at the Accademia di Belle Arti, Bologna, where he sees reproductions of Cézanne's work.

1910

Julius Meier-Graefe's monograph on Cézanne is published in Germany.

JUNE 27 – JULY 23: Vollard's exhibition *Figures de Cézanne* includes twenty-four paintings. The poet and writer Guillaume Apollinaire sees the show and writes: "Most of the new painters admit their debt to this sincere and candid artist."[38]

NOVEMBER 8 – JANUARY 15, 1911: The exhibition *Manet and the Post-Impressionists* at the Grafton Galleries, London, includes twenty-one Cézanne paintings as well as works by Matisse, Picasso, Gauguin, and Vincent van Gogh. The exhibition is poorly received by the public. The art historian and critic Roger Fry writes in the journal *The Nation*: "[Picasso] is possessed by a peculiar passion for geometric abstraction and executes things that are already familiar to us from Cézanne with almost desperately rigorous persistence."[39]

NOVEMBER 18 – DECEMBER 8: Alfred Stieglitz shows a collection of lithographs and drawings at his gallery at 291 Fifth Avenue in New York, including both color and black-and-white lithographs by Cézanne. Also on display are about a dozen black-and-white photographs of Cézanne's paintings that the artist Max Weber purchased from the Paris gallery owner and photographer Antoine Druet.[40]

Mondrian, along with the Dutch painters Conrad Kikkert and Jan Sluijters, founds the Moderne Kunst Kring (Modern Art Circle), with fellow artist Jan Toorop acting as chairman. Following the model of the Salon d'Automne in Paris, the group plans to mount annual exhibitions of work by avant-garde artists. The following fall they will organize an exhibition in honor of Cézanne at the Stedelijk Museum in Amsterdam, also showing works by Mondrian, Picasso, Braque, and others. At the show's opening, Toorop refers to Cézanne as "the father in France and even, dare I say it, in all of this brave Europe of painting, the precursor of the modern school; the laborer; the profound, subtle, and majestic tonalist; precursor, after Manet, of this modern school."[41] The exhibition will have a huge impact on Mondrian's work in the year to come.

1911

MARCH 1 – 25: The first exhibition in the United States dedicated to Cézanne's work, *Watercolors by Cézanne*, opens at Stieglitz's 291 gallery, where both Demuth and John Marin see it. Later in the year, an anonymous essay on Cézanne appears in Stieglitz's journal *Camera Work*. The author (likely Stieglitz himself) asserts: "On first glancing at the few touches of color which made up the water-colors by Cézanne . . . the beholder was tempted to exclaim, 'Is that all?' Yet if one gave oneself a chance, one succumbed to the fascination of his art. The white paper no longer seemed empty space, but became vibrant with sunlight. The artist's touch was so sure, each stroke was so willed, each value so true."[42]

The "Matisse Room" in the home of Sergei Shchukin, Moscow, 1912. The Museum of Modern Art, New York

APRIL: Matisse purchases Cézanne's painting *Fruit and Leaves*, c. 1890 (see fig. 4.10; R647).

SUMMER: In Maine, Hartley paints works inspired by black-and-white illustrations of Cézanne's paintings in Meier-Graefe's monograph on the artist (published the previous year) and on ideas about Cézanne he gleaned from Weber.

AUTUMN: The American artist Arthur B. Davies takes Hartley to the home of Louisine Havemeyer, an influential New York collector, who along with her husband had amassed an important collection of contemporary paintings, including, by 1907, thirteen Cézannes, the first Hartley sees in person. In his autobiography, *Somehow a Past*, Hartley will later elaborate: "It was an amazing afternoon — one needed strength to be with all the great pictures for everyone now knows the Havemeyer Collection in the Metropolitan Museum. I was sorry when the collection was finally put on view not to find the Cézannes I had remembered most of all."[43]

Sir Michael Sadler purchases *The Abandoned House*, 1878–79 (R351), the first Cézanne painting to enter a British collection. In November he organizes a show in London assembled around his recently acquired paintings by Cézanne and Gauguin.

Morandi visits the *International Exhibition of Rome*, which includes work by Cézanne.

DECEMBER 18: Stieglitz writes a letter to the editor of the *New York Evening Sun*, saying that the Metropolitan Museum of Art "owes it to the Americans to give them a chance to study the work of Cézanne . . . [which] is the strongest influence in modern painting. . . . I firmly believe that an exhibition, a well-selected one, of Cézanne's paintings is, just at present, of more vital importance than would be an exhibition of Rembrandts."[44] He also tells a New York critic that "without the understanding of Cézanne . . . it is impossible for anyone to grasp, even faintly, much that is going on in the art world to-day."[45]

1912

Léger paints *The Woman in Blue* (see plate 44) and *Railway Crossing* (see fig. 5.3). Of this period, he will later say: "I fought the battle to abandon Cézanne. His influence was so strong that in order to free myself I had to move all the way to abstraction. In *La Femme en bleu* [*Woman in Blue*] and in *Le Passage à niveau* [*Railway Crossing*], I felt I was breaking free from Cézanne."[46]

Popova visits the collection of Sergei Shchukin, open to the public since the spring of 1909, and sees paintings by Cézanne, Matisse, Braque, and Picasso. By this time, Shchukin owns eight important Cézannes, including *Mardi Gras*, 1888 (R618), which will have a direct impact on Popova's figural painting.

Mondrian moves to Paris, initially sharing a studio with Conrad Kikkert.

MARCH 14: Beckmann publishes "Thoughts on Timely and Untimely Art" in the journal *Pan*, in response to comments by Franz Marc regarding Cézanne. Beckmann refers to Cézanne as a great inspiration: "I myself revere Cézanne as a genius."[47]

MID-APRIL: Hartley arrives in Paris and immediately visits many museums and galleries. He writes to Stieglitz on April 13: "I saw 8 Van Goghs this afternoon — several fine, one 'La Berceuse' a beauty — others — landscapes — four Cézannes at Vollard's (funny place). Tomorrow I shall go on to the Louvre — then the Salon des Indépendants."[48] Shortly after his arrival,

he attends one of Gertrude and Leo Stein's Saturday evening gatherings at 27, rue de Fleurus, where he sees their collection. Hartley remembers that the walls were "crowded with the new Picassos—many of the 'collage' epoch, with piece[s] of the daily papers stuck in, or perhaps oftener painted in, pieces of the words 'jour'nal—'trans'igaient too perhaps—and there were still a few Cézannes and a Matisse or two."[49]

MAY 25–SEPTEMBER 30: The Sonderbund westdeutscher Kunstfreunde und Künstler (Separate League of West German Art Lovers and Artists), founded in 1909, mounts an influential exhibition in Cologne of avant-garde art, including works by Cézanne, van Gogh, Gauguin, Picasso, Paul Signac, and Edvard Munch.

FALL: Hartley writes to Stieglitz that he has "been thrilled of late with Cézanne water colors" and that he has discovered in them a "new aspect of vision the which I am intensifying in myself in connection with what I want to do." He calls the watercolors in the current Bernheim-Jeune show Cézanne's "finest expression as pure vision. . . . registrations of pure sensation out of a peaceful state of mind."[50]

DECEMBER: Demuth embarks on his second and most extended European visit, where he meets Hartley (with whom he will later travel to Berlin) and the Steins. He will stay in Europe until the spring of 1914, attending art academies and absorbing the Paris art scene.

Dr. Albert C. Barnes, a Philadelphia businessman, makes his first visit to Paris and acquires two Cézanne paintings, the beginnings of what will become a world-renowned collection of Impressionist, Post-Impressionist, and modern art. He will eventually amass a collection of sixty-nine Cézannes.

1913

FEBRUARY 17–MARCH 15: Modeled on the Sonderbund exhibition in Cologne the previous year, the *International Exhibition of Modern Art* (popularly known as the Armory Show after its venue at the 69th Regiment Armory) opens in New York. The exhibition, which includes fourteen paintings and one watercolor by Cézanne, brings European modern art to the United States on a large scale and forever changes the American art scene, especially in New York. The Metropolitan Museum of Art purchases their first Cézanne painting from the show, *View of the Domaine Saint-Joseph*, 1888–90 (see fig. 15.1; R612). The exhibition will travel to the Art Institute of Chicago and the Copley Society of Boston in the coming months.

SPRING: Hartley visits the Berlin Secession, an annual exhibition founded in 1899 in opposition to the official salon and aiming to support avant-garde art and artists in Germany, which this year features Cézanne and the Expressionists. He sends a postcard to fellow artists Vasily Kandinsky and Gabriele Münter in May: "I have seen the Secession—Nothing of any consequence outside of Matisse, Cézanne—Van Gogh—Seurat—Kokosehka [sic] & the Refusierten der Secession a few doors below is ridiculous."[51] Max Beckmann probably visits the show as well.

The *International Exhibition of Modern Art* (the Armory Show) at the Art Institute of Chicago, Spring 1913

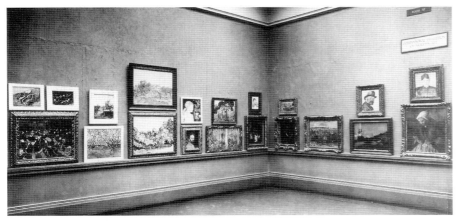

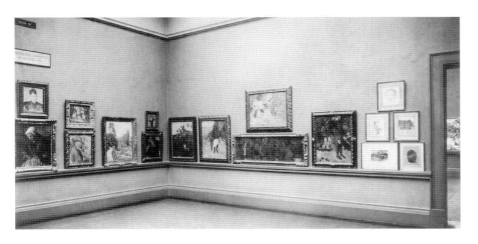

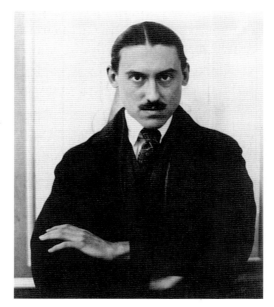

Henri Matisse in his studio at Issy-les-Moulineaux, May 1913. Photograph by Alvin Langdon Coburn

Charles Demuth, New York, 1915. Photograph by Alfred Stieglitz. National Gallery of Art, Washington, DC. The Alfred Stieglitz Collection

Liubov Popova in her studio, Moscow, 1919–20

1914

MARCH: Beckmann publishes an article titled "The New Program" in the journal *Kunst und Künstler*, in which he writes: "Rembrandt, Goya, and the young Cézanne strove for important sculptural effects without succumbing to the danger of naturalism in the least. It makes me sad to have to emphasize this, but thanks to the current fad for flat paintings, people have reached the point where they condemn a picture a priori as naturalistic simply because it is not flat, thin, and decorative. . . . I am of the opinion that not one of all the French followers of Cézanne has vindicated the principle of two-dimensionality that followed the inspired clumsiness of the late Cézanne, the holy simplicity of Giotto, and the religious folk cultures of Egypt and Byzantium."[52] Beckmann's comments are inspired by several Cézannes he sees in Germany at this time, including *Rocks, L'Estaque*, 1865–66 (R86), *Portrait of Anthony Valabrègue*, 1866 (R94), *Portrait of a Monk (Uncle Dominique)*, c. 1866 (R108), and *Still Life*, 1867–69 (R138).

Vollard publishes a monograph on Cézanne, anecdotally recounting his first-hand experiences with the artist. It will later be translated into English and released in several editions. Morandi will purchase the book in 1919.

The Galerie Bernheim-Jeune publishes an album honoring Cézanne, which includes original lithographs by several prominent artists after his work. Bonnard contributes a lithograph after the bather painting he owns, and Matisse creates one after his Cézanne painting *Fruit and Leaves* (see figs. 3.10, 3.11). The book also includes an original etching by Cézanne.

APRIL 13–JUNE: Morandi attends the Rome Secession, which includes thirteen Cézanne watercolors as well as paintings and prints by Matisse. He also sees reproductions of works by Cézanne and Picasso in illustrated monographs published by *La Voce* around this time.

AUGUST: Following the outbreak of war in Europe, a number of artists join or are mobilized to serve in the army or medical or engineering corps of their countries, including Beckmann, Braque, and Léger. Hartley is forced to return to the United States, and Mondrian to the Netherlands.

1915

Morandi paints several canvases related to Cézanne's bather paintings, particularly his *Five Bathers*, 1885–87 (see fig. 7.2; R554), which is in the collection of Egisto Fabbri, an American painter and collector then living in Florence. Morandi sees *Five Bathers* in reproduction in *Sedici opere di Cézanne* (*Sixteen Works by Cézanne*), published by Libraria della Voce in 1914. The previous year, the Italian journal *Lacerba* had published an article on Cézanne by Vollard with a reproduction of a bathers drawing.

1916

JANUARY 1–31: Demuth sees an exhibition of seven paintings and twenty watercolors by Cézanne at the Montross Gallery in New York, which contributes to a dramatic stylistic change in his work the following year, particularly in his watercolors.

Matisse paints his first portrait of Auguste Pellerin. While visiting the collector, he likely sees Cézanne's *Portrait of Gustave Geffroy*, 1895–96 (R791), and other Cézanne paintings in the Pellerin collection, sparking a renewed interest in the artist and a reworking of his landmark painting *Bathers by a River* (now at the Art Institute of Chicago) and the *Back* sculpture series (see plate 11).

1918

SEPTEMBER: Perhaps inspired by Meier-Graefe's *Cézanne and His Circle* (published in Munich this year), Beckmann publishes his "Creative Credo," in which he explains: "Most important for me is volume, trapped in height and width; volume on the plane, depth without losing the awareness of the plane, the architecture of the picture. . . . I certainly hope we are finished with much of the past. Finished with the mindless imitation of visible reality; finished with feeble, archaistic, and empty decoration, and finished with that false, sentimental, and swooning mysticism! I hope we will achieve a transcendental objectivity out of a deep love for nature and humanity. The sort of thing you see in the art of Mälesskircher, Grünewald, Brueghel, Cézanne, and van Gogh."[53]

The Metropolitan Museum of Art's *Loan Exhibition of Impressionist and Post-Impressionist Paintings*, New York, 1921

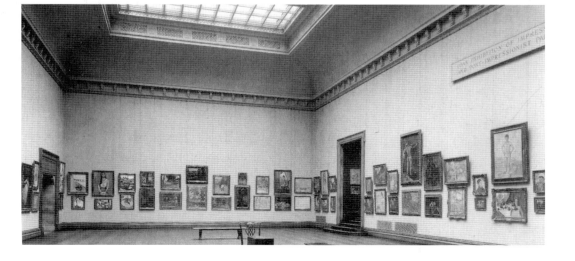

1920

MARCH: Gorky arrives in the United States with his sister and settles in Watertown, Massachusetts, where his sister is living.

APRIL 17–MAY 9: The first showing of Cézanne's work in Philadelphia—eight paintings and six watercolors—takes place in the exhibition *Paintings and Drawings by Representative Modern Masters* at the Pennsylvania Academy of the Fine Arts.

MAY–OCTOBER: An exhibition dedicated to Cézanne in the French Pavilion at the Venice Biennale, organized by Paul Signac, includes twenty-eight of his paintings. Morandi sees the exhibition, and Giacometti attends with his father, the painter Giovanni Giacometti, who is a member of the Swiss Art Committee for the Biennale. During this trip to Italy, the younger Giacometti is fascinated by Cimabue, Giotto, and Tintoretto. He will later notice the same qualities he admires in these artists in Cézanne, stating that this "gives him for me a unique position in the whole painting of recent centuries."[54]

1921

SPRING AND SUMMER: Two New York exhibitions of Impressionist and Post-Impressionist paintings—one at the Brooklyn Museum and another at the Metropolitan Museum of Art—stir controversy, with some wondering whether museums, as "bastions of good taste," should even show modern art. In the Met's bulletin, curator Bryson Burroughs calls Cézanne the "strongest influence among the younger painters of our time."[55] His stated objective in presenting the exhibition is to display paintings by Cézanne, Gauguin, van Gogh, and other avant-garde artists near galleries housing the museum's accepted masterpieces so that audiences can draw their own conclusions about their merit. The debate surrounding the shows significantly increases attendance.

SUMMER: An anonymous pamphlet is published denouncing the modern art on display at the Metropolitan Museum and calling for a boycott of the exhibition. The authors cite an article written by a group

of Philadelphia physicians claiming to have found evidence of psychological degeneracy in certain modern artists. Applying the doctors' theories, the pamphlet's authors find several of the exhibited paintings, including one by Cézanne, to be "pathological in conception, drawing, perspective and color."[56] The collector Albert C. Barnes defends the artists in the show, offering his entire collection of modern art and a gallery in which to house it to the city of Philadelphia if the local physicians can prove themselves qualified in the science of normal and abnormal psychology. His offer is ignored.

1922

Barnes establishes a foundation in his name and three years later will open a gallery in Merion, Pennsylvania, dedicated to his collection, including his sixty-nine Cézannes.

1923

MAY 31: Ellsworth Kelly is born in Newburgh, New York.

Gorky bases several paintings on reproductions in Meier-Graefe's *Paul Cézanne*, published in its fifth edition this year.

1924

MAY 25: Liubov Popova dies in Moscow.

Gorky moves to New York this year and begins working as an instructor at the New School of Design, making trips to the Metropolitan Museum of Art and then lecturing his students on the techniques of

the old masters as well as those of Cézanne and other modern artists.

1925

JUNE–JULY: Cézanne's first one-person exhibition in Great Britain, held at the Leicester Galleries, London, includes twelve paintings as well as watercolors and drawings. Roger Fry says of the show: "By now the perspective [on Cézanne] has changed, and he appears to us altogether *hors concours* . . . to stand in a class apart, to be related no longer to the other artists of his day, but rather to the great names of a remoter past."[57]

1926

JUNE 1–30: The *Rétrospective Paul Cézanne* at the Galerie Bernheim-Jeune, Paris, includes a large group of paintings and watercolors. Hartley sees the show during a trip to Paris from the south of France, where he has been staying.

SEPTEMBER: Gorky begins teaching at the Grand Central School in New York, where he will remain on the faculty until 1930. Over the next couple of years the self-taught Gorky will study Cézanne closely, seeking out books and articles on the artist at libraries and bookstores and painting in his manner. One student, Revington Arthur, will later recall: "Gorky was always speaking about Cézanne, so we looked at the book by Meier-Graefe."[58] As Gorky explained many years later: "I was *with* Cézanne for a long time . . . and then naturally I was *with* Picasso."[59]

Marsden Hartley, Ezra Pound, and Fernand Léger at the Café du Dôme, Paris, 1924. Bates College, Lewiston, Maine. Marsden Hartley Memorial Collection

Arshile Gorky painting a Cézanne-inspired still life in his studio on Sullivan Street, New York, c. 1927. Courtesy of Maro Gorky

OCTOBER: On his way to Paris to see an exhibition of his own paintings, Hartley spends a day in Aix-en-Provence and then three more days on his return. He takes long walks in the country to visit Cézanne's studio on the Chemin des Lauves and toward the Château Noir, along the Route du Tholonet, always seeing Mont Sainte-Victoire in the distance. He soon moves outside Aix on the Petite Route du Tholonet, where from his windows he can see Mont Sainte-Victoire. He will later write: "I couldn't believe my eyes for what I saw in the way of dignified beauty . . . and one mountain—which in one time or another would have brought worshippers for the sense of grandeur & majesty it possesses." He notes a "general opulence of nature" that accounts for the qualities in Cézanne's work. Of Aix, he writes: "Such color exists nowhere outside of the windows of Chartes & St. Chapelle—the earth itself seems as if it were naturally incandescent & seems fired from underneath somehow—yet withal so restrained & dignified. & How remarkable that Cézanne should have found it to be so complete."[60]

The Picasso scholar Christian Zervos launches the journal *Cahiers d'art*. Giacometti collects a series of issues that contain reproductions of important works by Cézanne, Picasso, Matisse, and Mondrian.

Marsden Hartley with his dog in southern France, c. 1926–27. Marsden Hartley Collection, Yale Collection of American Literature, Beinecke Rare Book and Manuscript Library, Yale University, New Haven, Connecticut

1927

Roger Fry's *Cézanne: A Study of His Development* is published in London by Hogarth Press. Gorky reads the book and studies its images.

Hartley moves into the Maison Maria—Cézanne's second studio and a frequent subject of his paintings—just outside Aix.

1928

JANUARY: The *Loan Exhibition of Paintings by Cézanne* opens at the Wildenstein Galleries in New York with paintings from public and private collections in the United States and some from the collection of Egisto Fabbri. Gorky most likely visits the exhibition, since this year he paints a self-portrait seemingly modeled after one of Cézanne's portraits in the show (see figs. 15.10, 15.11).

1929

JANUARY: Hartley exhibits still lifes and landscapes created during his stay in the south of France at Stieglitz's Intimate Gallery. The public and critics reject the paintings, with one critic, Murdock Pemberton, disapproving of Hartley's travels outside the United States and his "worship[ping of] Cézanne at the foot of his own shrine [Mont Sainte-Victoire] and not being ashamed of it."[61] Hartley returns to Aix in April.

JANUARY 29: The Havemeyer bequest to the Metropolitan Museum of Art includes thirteen Cézanne paintings.

NOVEMBER: The Museum of Modern Art, New York, opens with its first exhibition of Post-Impressionist art, including twenty-nine paintings and six watercolors by Cézanne. The museum's founders include the collector Lillie P. Bliss, a major contributor of Cézanne paintings to the museum.

Gorky sees a small number of Cézannes at the Museum of Fine Arts, Boston. He also frequents the Metropolitan Museum of Art in New York, certainly seeing Cézanne's *View of the Domaine Saint-Joseph* (R612), which is on view there during the 1920s.

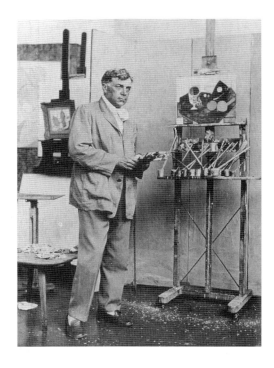

Geo·ges Braque in his studio, Paris, 1931

Henri Matisse in his fourth-floor apartment, 1, place Charles-Félix, Nice, 1932, with Cézanne's *Portrait of Madame Cézanne* (1888–90; see fig. 4.9), behind him. Photograph by Albert Eugene Gallatin. Philadelphia Museum of Art. A. E. Gallatin Collection

Piet Mondrian in his studio at 26, rue du Départ, Paris, June 1934. Photograph by Albert Eugene Gallatin. Philadelphia Museum of Art. A. E. Gallatin Collection

1930

MAY 15: Jasper Johns is born in Augusta, Georgia.

1931

MAY 17–SEPTEMBER 27: Lillie Bliss's collection, following her death this year, is on display at the Museum of Modern Art in a memorial exhibition that includes all eleven of her Cézanne paintings. The show will travel to Andover, Massachusetts, and Indianapolis.

JUNE 3–JULY 3: An exhibition of modern art at the Städelsches Kunstinstitut, Frankfurt, includes eleven Cézanne paintings. Beckmann, who is teaching at the Städel School of Art there, probably visits the show.

1933

JUNE 1–NOVEMBER 1: The Art Institute of Chicago organizes the exhibition *A Century of Progress* to coincide with the World's Fair and includes eighteen Cézanne paintings. They will host another iteration of the show the following year.

1934

FEBRUARY: Gorky travels to Philadelphia and visits the Barnes Foundation in nearby Merion. His wife will later recall: "When Gorky went to the Barnes Foundation he was in such a state of excitement over the Cézannes, but Mr. Barnes fol-

lowed him around and stood just behind him and whistled and made little noises— 'sh, sh, sh,' and it drove Gorky mad so he left."[62]

NOVEMBER–DECEMBER: The first one-person exhibition devoted to Cézanne in Philadelphia opens at the Pennsylvania Museum of Art (now the Philadelphia Museum of Art). It includes forty-five paintings as well as numerous watercolors, prints, and drawings.

1935

OCTOBER 23: Charles Demuth dies in Lancaster, Pennsylvania.

1936

MAY–OCTOBER: To commemorate the thirtieth anniversary of Cézanne's death, the Musée de l'Orangerie, Paris, mounts a major exhibition of his work, including 113 paintings and 32 watercolors. During this time, Matisse gives his Cézanne painting *Three Bathers* to the Petit Palais, Paris, accompanied by a letter: "In the thirty-seven years I have owned this canvas, I have come to know it quite well, though not entirely, I hope; it has sustained me morally in the critical moments of my venture as an artist; I have drawn from it my faith and my perseverance; for this reason, allow me to request that it be placed so that it may be seen to its best

George Platt Lynes (American, 1907–1955), *Artists in Exile*, 1942. Photographed on the occasion of an exhibition at the Pierre Matisse Gallery, New York, March 1942. From left to right, in the front row: Matta Echaurren, Ossip Zadkine, Yves Tanguy, Max Ernst, Marc Chagall, and Fernand Léger; in the second row: André Breton, Piet Mondrian, André Masson, Amédée Ozenfant, Jacques Lipchitz, Pavel Tchelitchew, Kurt Seligmann, and Eugène Berman. The Museum of Modern Art, New York. © Estate of George Platt Lynes

advantage. For this it needs both light and adequate space. It is rich in color and surface, and seen at a distance it is possible to appreciate the sweep of its lines and the exceptional sobriety of its relationships. I know that I do not have to tell you this, but nevertheless I think it is my duty to do so; please accept these remarks as the excusable testimony of my admiration for this work which has grown increasingly greater ever since I have owned it."[63]

Picasso purchases Cézanne's painting *Château Noir*, 1903–4 (R941), around this time.

The Cézanne scholar Lionello Venturi publishes the first catalogue raisonné of Cézanne's work, including paintings, watercolors, drawings, and prints.

1937

JULY 6: The Pennsylvania Museum of Art purchases Cézanne's *Large Bathers*, the largest canvas in Cézanne's oeuvre, from the Pellerin family. This is the first Cézanne bather painting acquired by a museum.

1938

OCTOBER 15: Nicholas Brice Marden, Jr., is born in Bronxville, New York.

1939

SUMMER: Two exhibitions in London feature Cézanne's paintings, watercolors, and

drawings. At the time of these exhibitions, the British novelist Virginia Woolf writes: "It is difficult in 1939, when the gallery is daily crowded with devout and submissive worshippers, to realise what violent emotions those pictures excited less than 30 years ago. The pictures are the same; it is the public that has changed. . . . The public in 1910 was thrown into paroxysms of rage and laughter."[64]

1940

Following the outbreak of World War II in Europe, and the fall of Paris in June, a number of artists leave for the United States, including Mondrian and Léger. Others flee to the countryside or to neutral cities such as Geneva.

1943

SEPTEMBER 2: Marsden Hartley dies in Ellsworth, Maine.

1944

FEBRUARY 1: Piet Mondrian dies in New York City.

1946

APRIL 5: The documentary film *Fernand Léger in America—His New Realism*, by the photographer Thomas Bouchard with a soundtrack by Edgard Varèse, premieres at the Sorbonne in Paris. As the writer Peter de Francia describes it: "The film shows Léger in his New York flat, surrounded with his paintings, moving from room to room, discussing a reproduction of Cézanne's *Women Bathing* and pointing out the 'Feeling for the Object' that the painting contains."[65]

SEPTEMBER 29: Jeff Wall is born in Vancouver, British Columbia.

1947

Beckmann moves to the United States from Amsterdam, where he had been living since 1937, and takes a teaching position at the School of Fine Arts, Washington University, in Saint Louis, Missouri.

1948

Beckmann and his wife Quappi travel to American colleges and universities visiting

Ellsworth Kelly in his studio at the Hôtel de Bourgogne, Paris, 1949. Photograph by Ellsworth Kelly

Max Beckmann with one of his students at the Brooklyn Museum Art School, 1950. Photograph by Paul Weller. Max Beckmann Archive, Munich

Roland Brice, Georges Bauquier, Pablo Picasso, André Verdet, Nadia Khodossievitch, and Fernand Léger at Picasso's home in Vallauris in southeastern France, 1952

art students and presenting his lecture "Letters to a Woman Painter," which Quappi delivers because of Beckmann's limited English. In the lecture Beckmann declares: "I must refer you to Cézanne again and again. He succeeded in creating an exalted Courbet, a mysterious Pissarro, and finally a powerful new pictorial architecture in which he really became the last old master, or I might better say he became the first 'new master.' . . . Don't forget nature, through which Cézanne, as he said, wanted to achieve the classical."[66]

MARCH 13: Beckmann visits the School of the Museum of Fine Arts, Boston, which Ellsworth Kelly is attending on the GI Bill. Kelly will later recall the lasting impact the visit had on him: "I admired the intensity of [Beckmann's] colours against their black outlines and his often brutal and erotic subjects. He was able to

express the most disturbing subjects with great virtuosity. . . . At that time he was the most important painter that I had come in contact with. It was a very significant event in my life. . . . Picasso and Beckmann were the most important artists to me during my student years. Every time I see a Beckmann, I'm impressed by the content of his work, his structure, colour, and especially his brushwork. Even though my work is not Expressionist, Beckmann's visual force has informed my painting and my admiration for his art only grows with time."[67]

JULY 21: Arshile Gorky dies in Sherman, Connecticut.

OCTOBER: Kelly arrives in Paris, where he meets Gertrude Stein's companion, Alice B. Toklas, and views the Stein collection. While in the city, he will also see exhibitions of work by Picasso and Matisse.

1950

DECEMBER 27: Max Beckmann dies in New York, just outside his building at Sixty-first Street and Central Park West, while on his way to the Metropolitan Museum of Art to see his most recent self-portrait in an exhibition there. Kelly goes to New York shortly thereafter: "I read the story of his dying. . . . When I finished reading, I went down to New York and just stood on the corner."[68]

1952

FEBRUARY 7–MAY 16: The major exhibition *Cézanne*, which opens at the Art Institute of Chicago and travels to the Metropolitan Museum of Art, includes approximately eighty paintings and thirty-three watercolors. Johns attends the exhibition and later states in an interview: "It's very hard for me to play with that word [influence], because one is influenced by everything. . . . My familiarity with Cézanne in the flesh dates from the show the Metropolitan did. They did a huge Cézanne show. . . . A beautiful, big show."[69]

Around this time one of Cézanne's views of L'Estaque is acquired by Picasso, who shows it off to visitors, rapping on the central area and saying: "Look at the sea, it's solid as a rock."[70]

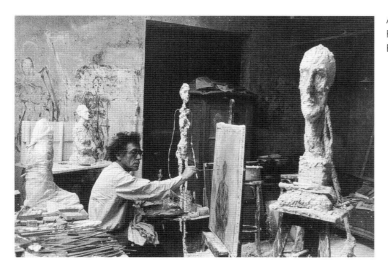

Alberto Giacometti in his studio, Paris, c. 1954–60. Photograph by Ernst Scheidegger

Giorgio Morandi's studio in Bologna with a still life set up, 1950s

1954

JULY–OCTOBER: The exhibition *Homage to Cézanne* at the Musée de l'Orangerie, Paris, includes sixty-four paintings and nine watercolors. Picasso probably sees this exhibition, which includes Cézanne's *Five Bathers*, 1877–78 (see plate 2; R365), a painting he will purchase in 1957.

NOVEMBER 3: Henri Matisse dies in Nice, France.

1955

AUGUST 17: Fernand Léger dies in Gif-sur-Yvette, outside Paris.

1956

JUNE: Morandi visits Winterthur, Switzerland, and sees the collection of Oskar Reinhart, which includes many works by Pieter Bruegel, Peter Paul Rubens, Francisco de Goya, El Greco, Jean-Siméon Chardin, Nicolas Poussin, and Cézanne. Heinz Keller, then director of the Kunstmuseum Winterthur, will later remember of this visit: "Morandi's

attention was always selective. . . . He was highly impressed, as were the other two visitors [Vitale Bloch and Lamberto Vitali], by the overall view of the Manet-Cézanne room. Morandi was particularly taken with the three still lifes by Cézanne."[71]

1957

APRIL 16: In an interview with Radio Télévision Française, Giacometti talks about Cézanne, who he says "threw a bomb at . . . vision by painting a human head like an object. He said, 'I paint a head like a door, like it's nothing.'"[72]

1958

Picasso purchases the Château de Vauvenargues in southern France. Picasso scholar Pierre Daix later recounts the event: "[Picasso] stopped painting and vanished abruptly with [his wife] Jacqueline. When he reappeared, he informed [the dealer Daniel-Henry] Kahnweiler that he had 'bought the Sainte-Victoire.' 'Which one?' Kahnweiler asked, unaware of any Cézanne on the market. 'The real one!' Picasso was crowing with pleasure. He had, in fact, just bought the Château de Vauvenargues, whose grounds include the famous mountain."[73]

Jasper Johns reads the artist Robert Motherwell's *Dada Painters and Poets*, an anthology of essays about modern art, prompting his first visit to the Arensberg Collection at the Philadelphia Museum of Art, which includes works by Cézanne, Picasso, Braque, Mondrian, and Léger.

Brice Marden attends the School of the Museum of Fine Arts, Boston, where he frequents the galleries of Cézanne paintings.

Giacometti is in Zurich and probably visits the Kunsthaus Zurich's exhibition of the Emil G. Bührle collection, which includes Cézanne's *Vase with Flowers and Apples* of 1889–90 (R660). In 1961 he will paint his own *Bouquet of Flowers and Three Apples*.

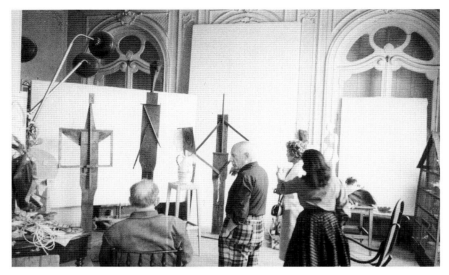

Pablo Picasso with figures from his sculptural group *Bathers* (plate 67; original wooden sculptures now in Stuttgart) in the studio at La Californie, France, 1956. Photograph by Edward Quinn

Jasper Johns in Edisto Beach, South Carolina, working on one of the *Map* paintings, 1965. Photograph by Ugo Mulas. © Uço Mulas Estate

1960

Around this time, Johns conceives the idea of copying in gray Cézanne's *Bather* in the Lillie Bliss collection at the Museum of Modern Art (see plate 64), but never realizes it.

The sculptor Henry Moore purchases Cézanne's *Three Bathers*, c. 1875 (R361). He says at the time: "To me it's marvellous. Monumental. It's only about a foot square, but for me it has all the monumentality of the bigger ones of Cézanne. . . . Each of the figures I could turn into a piece of sculpture, very simply."[74] In 1978 he will in fact create a bronze bather grouping entitled *Three Bathers—After Cézanne* and later make several drawings of the maquette from different angles.

1963

AUGUST 31: Georges Braque dies in Paris.

1964

JUNE 18: Giorgio Morandi dies in Bologna, Italy.

SPRING AND SUMMER: Marden visits Paris, where he sees Cézanne's *The Gulf of Marseille Seen from L'Estaque*, 1876–79 (see fig. 3.15; R390) at the Jeu de Paume. In his notebook for the series *The Grove Group* in the 1970s, he will note the "weightiness" of the water and sketch a two-unit, two-tone grid to represent sea and sky.

1966

JANUARY 11: Alberto Giacometti dies in Chur, Switzerland.

1969

SEPTEMBER: Johns visits the Barnes Foundation in Merion, Pennsylvania, with friends, including Roberta Bernstein, who will later write that Johns "was most interested in the Cézannes."[75] The group also visits the Philadelphia Museum of Art, where curator Anne d'Harnoncourt shows them Marcel Duchamp's *Étant Donnés*.

1970

MAY 23: Johns revisits the Barnes Foundation, again with Bernstein, and points out Cézanne's *Boy with Skull*, 1896–98 (see fig. 17.1; R825), as one of his favorite paintings.

In a conversation with the artist and curator Willoughby Sharp and three other artists, Marden, who is having a one-person exhibition at the Bykert Gallery in New York, says: "There's a big difference between being realistic and depicting realistic subject matter. . . . I think Cézanne was painting, and not painting anything, just painting."[76]

1973

APRIL 8: Pablo Picasso dies in Mougins, France.

Cézanne scholar Adrien Chappuis publishes his catalogue raisonné of Cézanne's drawings.

Jeff Wall visits the Philadelphia Museum of Art and sees Duchamp's *Étant Donnés* as well as other important works in the collection. He later describes the visit as "crucial."[77]

1974

JULY 19–OCTOBER 14: An exhibition of Cézanne's works in French museums opens at the Musée de l'Orangerie, Paris. Johns sees this show, which he calls "very beautiful."[78]

1977

OCTOBER 7: The exhibition *Cézanne: The Late Work* opens at the Museum of Modern Art, New York. It includes sixty-seven paintings and fifty-five watercolors and will travel to the Museum of Fine Arts, Houston, and the Grand Palais, Paris. Johns, who is having a retrospective of his work at the Whitney Museum of

American Art at the same time, sees the show in New York and remembers in particular the National Gallery of London's *Large Bathers*, 1894–1905 (see plate 203; R855). Before the end of the year, he will use a postcard of this painting to make his first tracing from another artist's work.

1981

Johns purchases a Cézanne drawing of roses from the auction of the Leigh B. Block collection.

1982

JANUARY 16: An important exhibition of 125 of Cézanne's watercolors opens at the Kunsthalle Tübingen before traveling to the Kunsthaus Zurich. Its catalogue becomes a landmark for the study of Cézanne's watercolors.

1983

John Rewald publishes his catalogue raisonné of Cézanne's watercolors, which will become a major reference work for Cézanne scholarship.

1988

APRIL 22: The exhibition *Cézanne: The Early Years*, with sixty-seven paintings, opens at the Royal Academy of Arts, London. It will travel to the Musée d'Orsay, Paris, and the National Gallery of Art, Washington, DC.

SPRING: Johns purchases a work of Cézanne's that he originally saw in the summer of 1978, a two-sided drawing with studies for three male bathers on one side

The exhibition *Cézanne: The Late Work* at the Museum of Modern Art, New York, 1977

and a copy of the Venus de Milo on the other. He also acquires a Cézanne painting, *Bather with Outstretched Arms* of 1877–78 (see plate 191; R369), once owned by Degas, who bought it from Vollard in March 1896. After the deaths of Picasso and Henry Moore, Johns is the last living artist to own one of Cézanne's Bathers.

1989

SEPTEMBER 10–DECEMBER 10: The exhibition *Paul Cézanne: Bathers* at the Kunsthalle Basel includes seventy-two paintings. Johns sees the show, to which he lends Cézanne's *Bather with Outstretched Arms* and the drawing *Studies for Bathers*, c. 1877–80.

1990

JUNE 15–SEPTEMBER 4: Kelly organizes the exhibition *Fragmentation and the Single Form* as part of the Museum of Modern Art's *Artist's Choice* series, in which contemporary artists select objects from the museum's collection for exhibition. Kelly includes the Cézanne watercolor *Foliage* (1895–1900) as well as works by Matisse, Picasso, Braque, Mondrian, and Léger. In the exhibition catalogue, he writes: "I feel that one of the most important developments in the history of abstraction has been the artist's struggle to free form from depiction and materiality. . . . In the making of art, fragmentation of forms, whether willfully or by chance, is related to vision. Wherever we look in the world, objects are layered, jumbled together, spread out before us. The Impressionists, Georges Seurat, and Paul Cézanne were among the first artists to try to come to terms with this visual chaos. . . . Cézanne tackled and conceptualized the three-dimensional world in terms of its underlying structure and our uncertain relationships to it."[79]

1991

MARCH 23–JULY 21: The Museum of Fine Arts, Boston, asks Marden to curate an exhibition as part of its *Connections* series, using works from the museum's permanent collection. Marden includes Cézanne's *Fruit and Jug on a Table*, 1890–94 (R741), as well as the painting

Head of Diego by Giacometti and Beckmann's *Still Life with Three Skulls* (see plate 113). Marden writes a poem for the catalogue, of which the last lines are: "NOW / Rows of charged mysterious objects. A room of / things with no known author, excepting / Cézanne, my hero."[80]

1993

MAY 2–AUGUST 15: The exhibition *Great French Paintings from the Barnes Foundation* at the National Gallery of Art, Washington, DC, includes twenty Cézanne paintings. It will travel to Philadelphia, Fort Worth, Toronto, Paris, and Tokyo. Johns sees the exhibition in Washington, and again at the Philadelphia Museum of Art, and the following year makes a series of tracings of the Barnes's *Large Bathers* using a poster from the show.

1995

SEPTEMBER: Johns acquires Cézanne's drawing *Self-Portrait*, c. 1880.

SEPTEMBER 26: The major retrospective exhibition *Paul Cézanne* opens at the Grand Palais, Paris, before traveling to the Tate Gallery, London, and the Philadelphia Museum of Art. The show includes 127 paintings as well as watercolors and drawings. Marden, Kelly, and Johns all attend at the Philadelphia venue.

1996

Rewald publishes his catalogue raisonné of Cézanne's paintings, updating Venturi's dating of many works and providing full references for nearly one thousand paintings.

1998

AUGUST 9–NOVEMBER 18: The exhibition *Cézanne and the Russian Avant-Garde* at the State Hermitage Museum, Saint Petersburg, and the Pushkin Museum of Fine Arts, Moscow, traces Cézanne's influence in Russia and includes works by Popova.

1999

OCTOBER 10–JANUARY 9, 2000: The Fondation Beyeler, Basel, in their exhibition *Cézanne und die Moderne*, places forty-six paintings by Cézanne alongside works by Matisse, Mondrian, Léger, Picasso, Braque, Giacometti, and Kelly to more closely examine his effect on later generations of artists.

2000

JANUARY 28–APRIL 22: The exhibition *Modern Art and America: Alfred Stieglitz and His New York Galleries*, at the National Gallery of Art, Washington, DC, includes works by Cézanne, Matisse, Picasso, Hartley, and Demuth, exploring Stieglitz's influence on modernism in the United States.

Brice Marden in his Pennsylvania studio near Eagles Mere, 1995, working on *Skull with Thought* (see plate 196). Photograph by Nan Goldin

The Cézanne retrospective at the Philadelphia Museum of Art, 1996

Jeff Wall in his studio,
Vancouver, Canada, 2007.
Photograph by Justine Kurland

Kelly visits Aix-en-Provence and Mont Sainte-Victoire, making drawings of the mountain.

2002

MARCH 7–JULY 7: The exhibition *Cézanne: il padre dei moderni* (Cézanne: The Father of Modernism), at the Complesso del Vittoriano, Rome, includes more than sixty works by Cézanne, including drawings and watercolors.

2004

OCTOBER 12–JANUARY 2, 2005: The exhibition *Cézanne in the Studio: Still Life in Watercolors* at the J. Paul Getty Museum, Los Angeles, includes twenty-three Cézannes. Kelly sees the show and is fascinated by the infrared photographs of *Still Life with Blue Pot* in the Getty's collection.

2006

JANUARY 29–SEPTEMBER 17: The exhibition *Cézanne in Provence* at the National Gallery of Art, Washington, DC, which commemorates the hundredth anniversary of the artist's death, includes 168 works. It travels to the Musée Granet in Aix-en-Provence.

SEPTEMBER 13: The exhibition *Cézanne to Picasso: Ambroise Vollard, Patron of the Avant-Garde* opens at the Metropolitan Museum of Art, New York. The show investigates the importance of Vollard as a dealer and proponent of modern art and includes twenty-four works by Cézanne, along with art by a number of his contemporaries and those that followed, including Matisse and Picasso. It will travel to the Art Institute of Chicago and the Musée d'Orsay, Paris.

OCTOBER 24–JANUARY 14, 2007: As part of the Musée d'Orsay's exhibition series *Correspondences*—for which contemporary artists choose a work from the museum's permanent collection with which to create a dialogue—Jeff Wall selects Cézanne's *The Pont de Maincy*, 1879–80 (see plate 160; R436), to show with his *Rear View, Open Air Theater* (see fig. 19.8), 2005. Of the pairing, Wall states: "Cézanne led the way in the reduction of the intensity of the subject in painting. . . .

Rear View is simply a documentary photograph, made rather quickly on an overcast day in July, after a bit of summer rain."[81]

2007

MARCH 2–JULY 29: The exhibition *Cézanne a Firenze: due collezionisti e la mostra dell'impressionismo del 1910* (Cézanne in Florence: Two Collectors and the 1910 Exhibition of Impressionism) opens at the Palazzo Strozzi. It includes twenty-one works by Cézanne and explores his impact on Italian artists in the early twentieth century, particularly through the collections of the Americans Eggisto Fabbri and Charles Loeser.

2008

FEBRUARY 20–JUNE 29: The exhibition *Cézanne and Giacometti: Paths of Doubt* at the Louisiana Museum for Moderne Kunst, Denmark, places sixty works by Cézanne in conversation with more than one hundred by Giacometti.

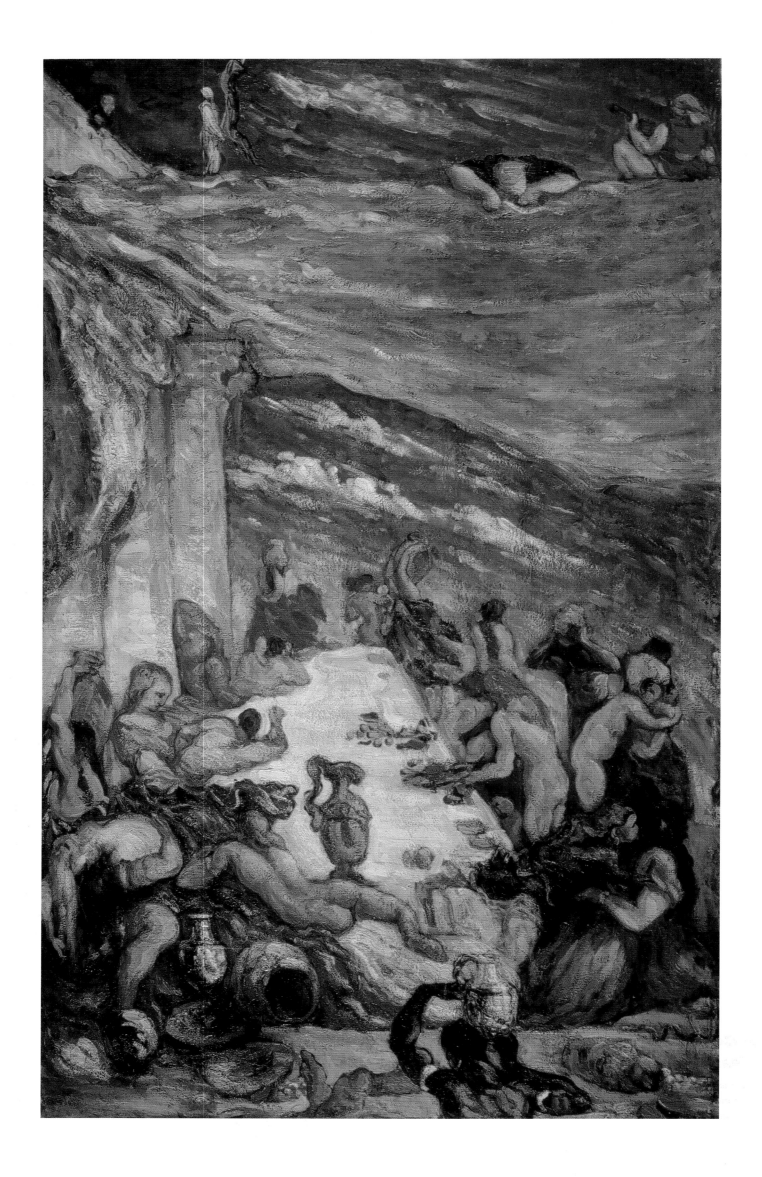

La Famille Cézanne

Robert Storr

> You can wrap up your "family Cézanne." . . . He was my one and only master! Don't you think I looked at his pictures? I spent years studying them. . . . Cézanne! It was the same with all of us—he was like our father. It was he who protected us.
> —PABLO PICASSO TO BRASSAÏ, 1966[1]

Among art history's blood sports is the academic contest over modernity's origins and its demise. Once upon a time this was not just an academic game: The public, whether shocked or seduced by new art, wanted to know when it started and where it came from. Then, as pioneering generations were superseded by younger ones whose lineage and legitimacy those confirmed in their taste for the classic "new" found it hard to recognize, and as the new "new" proceeded to entrench itself in consciousness and culture, the public began wondering where the "good old modern" had gone to die—and when?

Answers to the second set of questions—to which some demur to the effect that modernism has yet to die—are as various as answers to the first set. Paraphrasing T. S. Eliot, one might say that in modernism's beginning is its end, and proceed from that assumption to look for formulations that, while being impossible to demonstrate beyond the shadow of empirical doubt, nevertheless have the persuasiveness of symmetry and closure. After all, art history is not a science based on proof, nor even a philosophical edifice built upon strict, incontrovertible logic; it is a myth-making system bedeviled by often inconvenient material, social, political, and biographical facts, a system whose ultimate purpose is, or should be, less to explain the past or predict the future of art than to aid viewers in grasping the complexity and experiencing the aura—that is, the unique temporal, spatial, and phenomenological particulars—of unique works of art to which they, as individuals and in groups, are directly exposed.

Various schools of thought ascribe modernism's paternity to Édouard Manet, Gustave Courbet, or, as is the case with this writer, Francisco de Goya. (Needless to say, its maternity is an even more vexed question, one that I will unapologetically sidestep here, while noting that women artists have played an increasingly central role in modernism from the second decade of the twentieth century onward and that one will be a key example in this essay.) Each choice issues from a judgment or series of judgments on what, in essence, makes modern art modern and when such qualities initially revealed themselves. Even less agreement can be found on when those defining characteristics ceased to be distinguishable from other, ostensibly pre- or postmodern ones. For, like those of any family, modernism's distinctive features have undergone frequent and dramatic mutations and diminutions without necessarily becoming unrecognizable

or disappearing entirely. Sometimes, thanks to genetic diversity occasioned by inter-breeding, those features have been marked by surprising accentuations or fortuitous improvements. And, with the same suddenness, modernism's once recessive traits have sometimes come to the fore with the clarity of revelation.

But if consensus on modernism's founding father or fathers is lacking, there is no disputing that Paul Cézanne was the quintessential modernist at the advent of its glory days. As evidence, we have not only Picasso's declaration of filial piety cited above, but also the work gathered in this exhibition. If, as the curators of this survey, Joseph Rishel and Katherine Sachs, have done, one dates the first signs of Cézanne's influence on other leading artists of the modern movement to 1906 — paintings by Henri Matisse and Picasso share that pivotal position — then it is safe to say that for roughly fifty years thereafter, Cézanne was viewed by vanguard artists in Europe and the Americas as *the* indispensable point of reference, thereby making them members of his vast, extended family. As Rishel and Sachs would doubtlessly concur, had space permitted — and it is to be stressed that we are dealing here with a proportionate exhibition of paintings and not with a gargantuan archive of reproductions — the names on the checklist could have been greatly expanded, and at various stages in the curatorial process alternative choices were considered. Doubtlessly, as well, contestants in the sport of adding and subtract-ing from checklists will have a field day criticizing Rishel and Sach's final selections. But in the light of the dazzling array of works on view, their protestations will, in the main, make them appear like as clowns at the rodeo.

I have chosen the fifty-year interval with Jasper Johns uppermost in mind. There are two reasons: First, few painters of the late twentieth and early twenty-first centuries have signaled their continued preoccupation with Cézanne more explicitly than Johns has in his early interviews and studio notes on through to his *Tracings after Cézanne* of 1994 (see plates 176–81),[2] which were first shown in the retrospective of his work organized by Kirk Varnedoe at the Museum of Modern Art, New York, in 1997. That fascination has also prompted Johns to acquire a small but exceptional group of draw-ings and watercolors by the master of Jas de Bouffan, as well as a physically tiny but pictorially monumental study for his *Bather* of 1885 (see plate 64). The second reason is Johns's correspondingly paradoxical devotion to his other, prior, and much more dis-cussed father figure, Marcel Duchamp, whose disdain for "retinal art" — not to mention the entire tradition of direct, observational painting of which Cézanne is arguably the greatest and certainly the most intransigent exponent — set in motion the longest-lasting rebellion against perceptual mimesis and, not incidentally, blinded those who read the vast Duchamp literature in ill-lit study carrels to the manifest visual qualities of the work not only of Cézanne and his heirs, but also of prodigal sons such as Duchamp. (If I have my own quibble with this exhibition, it is the absence of examples of Duchamp's own Post-Impressionist and Cubo-Futurist works, all of which owe a debt to Cézanne. The intensity of Duchamp's disavowal of purely perceptual art may be used as a meas-ure of the depth of his Oedipal anxiety about belonging to Cézanne's family — a family his brother Jacques Villon openly embraced — despite the fact that Cézanne's art was never purely perceptual.)

Looking back now, Johns's centrality in postwar American art history seems to have had more to do with his repeated defiance of the ideological Neo-Dada notions frequently ascribed to him and his ever more pronounced affinity for Cézanne and Picasso than with his merely following through in splendid isolation on the first, jar-ring gambits of his most Duchampian phase. In fact, the measure of his ambition and ultimately of his accomplishment in the second half of his career is the nature of his

Fig. 2.1. **Richard Hamilton** (British, born 1922), *Just What Is It That Makes Today's Homes So Different, So Appealing?*, 1955. Collage, 10¼ x 9¾ inches (26 x 24.8 cm). Kunsthalle, Tubingen, Germany

Fig. 2.2. **Richard Hamilton**, *Hommage à Chrysler Corp.*, 1957. Oil, metal foil and collage on wood; 58³⁄₁₆ x 42¼ inches (147.9 x 107.4 cm). The Tate Gallery, London. Purchased with assistance from The Art Fund and the Friends of the Tate Gallery 1995

effort to align the supposedly incompatible poles of Duchampian postmodernism and Cézannesque and Picassoid modernism. And are not incommensurability and contradiction rendered as inevitability and continuity fundamentally Dada in their absurdity — and wondrous by the same token?

Of course, Duchamp's radical apostasy — with the invention of the ready-made, "still life" bypassed representation altogether and became the re-presentation of the thing itself — roughly coincided with Cubism's radical recasting of Cézanne's perceptually constructed pictorial language into a conceptually reconstructed idiom. That said, Cézanne's approach was inherently and avowedly conceptual as well, and to that extent it arose from the conscious undoing of conventions as much as from the study of nature. Indeed, it was Cézanne's status not only as the primary form maker of his era but also as its primary form breaker that accounts for his unique importance in the history of modernism.

In modern art, there is a negative for each positive and a positive for each negative. Sometimes they come from the least expected source — that is to say, from the same source. Thus, Piet Mondrian, apparently the most unconflicted and affirmative of artists and the one who transformed the scintillating, faceted volumes of Cézanne into the implacably rigid, flat armatures of total abstraction, said: "I think the destructive element is too much neglected in art."[3] In like fashion, for every imaginative leap forward there is a backward look, frequently of long duration. Something of the kind describes Richard Hamilton's early paintings. In 1956, following a long artistic apprenticeship, Hamilton shared honors with others of his rising postwar generation as the organizer of the seminal exhibition *This Is Tomorrow*, which affirmed as never before an unapologetic infatuation with commercial culture as a predicate for art. The hallmark work of the exhibition was Hamilton's 1955 collage *Just What Is It That Makes Today's Homes So Different, So Appealing?* (fig. 2.1). In it appears a muscle-bound man holding a Tootsie Pop barbell on which the last syllable is featured in isolation — "Pop." In that word a movement was born.

Yet, simultaneously with punchy graphic appropriations of this sort, Hamilton was painting similar subjects in a wholly different manner. His first Pop painting, *Hommage à Chrysler Corp.* (1957; fig. 2.2), was a shocker for its time, incorporating bits and pieces

culled from Chrysler's magazine ads that were elided, in the artist's words, with the shapes of "the exquisite form bra diagram and volupta's lips."[4] However, the canvas was painted two years after his more obviously avant-garde "Pop" collage and one year after he first met Duchamp, whose scholarly acolyte he became. (So close was the relation between the two and so crucial was Hamilton's role in nurturing the Neo-Dada spirit in Britain that in 1966, two years before Duchamp's death, he served as curator of *The Almost Complete Works of Marcel Duchamp* at the Tate Gallery.) Nevertheless, the anomalous fact remains that despite its cheeky title and aggressively vulgar imagery, *Hommage à Chrysler Corp.* was executed in a patently Cézannesque style, and other of Hamilton's works—among them, prints of the 1970s!—would involve the same patchwork articulation of contour, form, and color. Thus, as visionary as he was, Hamilton employed an anachronistic painterly idiom well into his career, and traces of it may still be found in his late paintings.

The truth is that Cézanne, in his obsessive and uncompromising pursuit of his "petite sensation," dismantled the classical mode by way of a restructured Impressionism. Critical of the purely "retinal" Claude Monet—to borrow Duchamp's pejorative label—Cézanne paid his elder the backhanded compliment of saying, "He is nothing but an eye, yet what an eye!"[5] However, for all that he labored over his motifs, he did so with an unceasingly systematic drive, which he summarized in conversation with his protégé Charles Camoin with the remark that "all things, particularly in art, are theory developed and applied in contact with nature."[6] For Cézanne to achieve his ideal of a new classical painting and "redo Poussin after nature"[7] then involved going both nature and Poussin one better by reducing the elements of the former to "the cylinder, the sphere, the cone, everything in proper perspective so that each side of an object or a plane is directed towards a central point."[8] This was the recipe that Cubism adapted to its purposes by dislocating or abolishing that central point, and that Juan Gris in particular inverted as a part of the post–World War I backlash against Cézanne that spread outward from the studio of Picasso around the world. Reacting against the birth of abstraction that Cézanne had presaged, Gris claimed in 1921 to have "humanized" Cézanne's mathematical tendencies: "I begin with a cylinder and create an individual of a special type. . . . Cézanne tends towards architecture, I tend away from it."[9]

Otherwise known as "the return to order"—the phrase is Jean Cocteau's—the backlash against Cézannism was the predicate for the German Neue Sachlichkeit (New Objectivity), the Italian Novecento (1900s) movement, French Purism and L'Esprit Nouveau, and much else. Formal consolidation rather than further formal disarticulation and experimentation were the crux of all these tendencies, and in each might be seen harbingers of the postmodern age. In that framework, the counterpoint to Cézanne's example within Post-Impressionism was Georges Seurat, though Cézanne himself most keenly felt the rivalry of Paul Gauguin and Vincent van Gogh, the principal progenitors of Fauvism and Expressionism, warning another protégé, Émile Bernard, against both.[10] With his small production and comparatively slow rise to prominence, Seurat has often been regarded as the "sleeper" hit of modernism, but his impact on or popularity with Purists such as Le Corbusier and Amédée Ozenfant, Novecento painters like Carlo Carrà, and the more staid artists of the Neue Sachlichkeit make him a "sleeper" agent of diverse tradition-minded styles of the 1920s and 1930s, or, as the tendentious art-historical reasoning of Harvard professor Benjamin H. D. Buchloh would have it, "figures of authority and ciphers of regression."[11]

In sum, Cézanne's unique position among modernists is confirmed not only by the attitudes of those who have admired and emulated him, but also by those who have

Fig. 2.3. **Ilya Kabakov** (American, born Russia 1933), ***Hello, Morning of Our Motherland!,*** 1981. Oil and enamel on masonite; tryptich, three panels, overall 102⅜ x 190 inches (260 x 570 cm). Part of the Installation *The Untalented Artist*, 1988. Collection of John L. Stewart, New York

openly rebelled against what he stood for, or was thought to stand for. Chief among the contemporaries who have had the latter response is the German artist Gerhard Richter. One must preface any statements about Richter's views with a reorientation of historical and cultural perspectives. For artists who came of age in the Eastern Bloc after 1917 and before 1989, as he did, awareness of modernism fluctuated dramatically from none to very little, according to the collective wisdom of prevailing factions within the Communist party and the Communist state apparatus. During some periods virtually all of Western modernism was condemned as bourgeois formalism. During others, select artists were celebrated or at least tolerated, either because they belonged to periods remote from the revolutionary era and hewed to practices close enough to realism that they could be forgiven their "aesthetic errors," or because they were fellow travelers and their artistic deviations could be excused because of their active solidarity with the cause of building socialism. In the former category fell the Post-Impressionists, Fauves, and Cubists in the expropriated collections of Ivan Morosov and Sergei Shchukin now at the Hermitage in St. Petersburg and the Pushkin Museum in Moscow, and in the latter were Picasso, Fernand Léger, and others of their cohort. During the Hitler years, all of these artists were anathema wherever the Nazis held sway.

Consequently, Richter—who was born in 1932, a year before Hitler became Chancellor of Germany—grew up without exposure to Cézanne or the artists he influenced until after 1945, and it was not until after Stalin's death in 1953 that such "decadent" formalists were substantially rehabilitated. When they were, they became symbols of "good painting"—how else could the state justify their return to the fold—and representatives of the continuity of the "great tradition." A brief digression is in order at this juncture: Many of the "failed artists" who figure in the installations and pictorial narratives of the former Moscow Conceptualist Ilya Kabakov work in a Cézannesque manner—that is to say, in a patchwork of strokes keyed to a simplified palette of warm and cool tones—while otherwise depicting scenes of Soviet life in accordance with party doctrine. Their failure was not that they painted badly, although Kabakov has perfected a prosaic awkwardness that deadens his images exactly as much as a given case and context require, but that they tried unsuccessfully to salvage modernism by giving it an "uplifting" socialist subject matter while at the same time redeeming Socialist

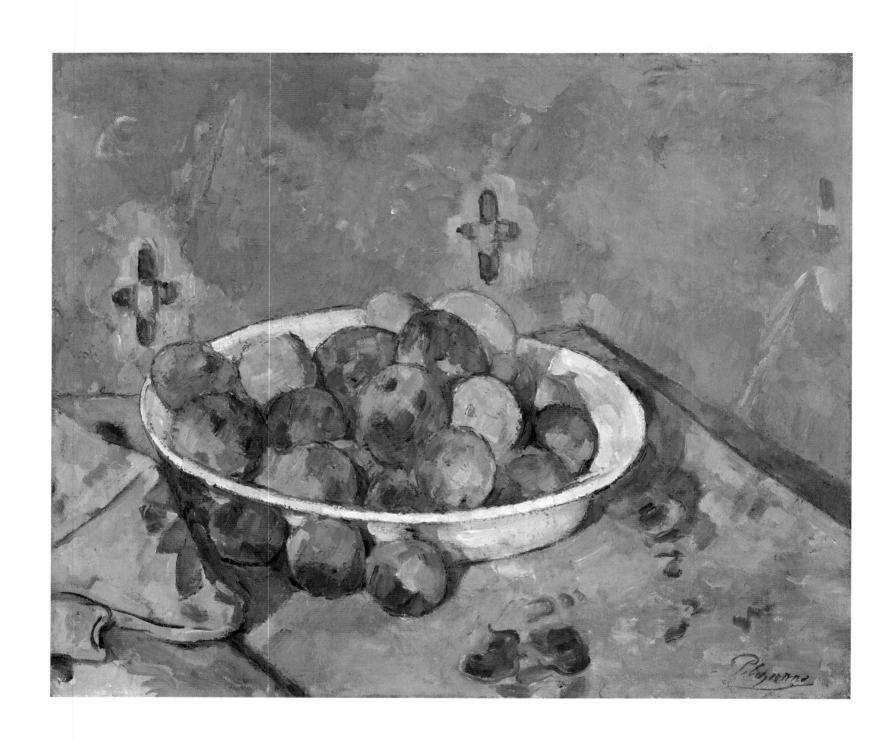

Fig. 2.4. **Paul Cézanne, *The Plate of Apples*,** c. 1877,
Oil on canvas, 18⅛ x 21½ inches (45.8 x 54.7 cm). The Art
Institute of Chicago. Gift of Kate L. Brewster, 1949.512

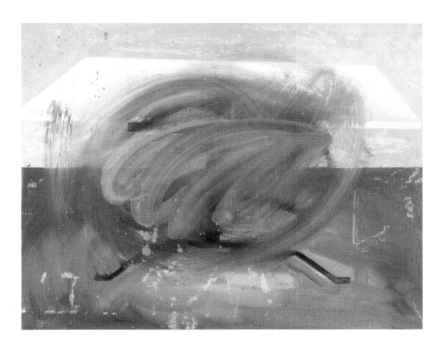

Fig. 2.5. **Gerhard Richter** (German, born 1932), **Table,**
1962. Oil on canvas, 35⅟₁₆ x 44½ inches (90 x 113 cm).
Private collection

Fig. 2.6. **Gerhard Richter, Skull,** 1983. Oil on canvas,
21¹¹⁄₁₆ x 19¹¹⁄₁₆ inches (55 x 50 cm). Private collection

Realism by lending it modernist accents. The compromise in both directions defeats both ambitions. Anyone familiar with Russian art of the kind that Kabakov critically pastiches will immediately recognize the abjectness of his renditions, and their poignant, pitiless truth (fig. 2.3).

Richter is also engaged in a critical enterprise, but his strategy is utterly different from Kabakov's though no less conceptual, while at the same time being no less perceptual in its own fashion than Cézanne's. Nor is Richter any less ambivalent toward Cézanne than is Kabakov, who is his junior by only a year and who shares some of the same experiences of the postwar and Cold War era on the other side of the Iron Curtain. If anything, Richter would seem to be more conflicted, more beset by what the literary critic Harold Bloom called "the anxiety of influence,"[12] more torn between fixation and rejection. When, in the 1960s and 1970s, "painting well" became an issue if not a provocation for critics dedicated to the proposition that vanguard art was necessarily a negation of old artistic values, Richter replied:

> Early on, at the Academy, I would have loved to paint like the artists I admired at that time: Manet, Cézanne or Velázquez. But I couldn't. And later on I realized that it's a good thing I can't, because that's beside the point. I'm sure that's what he [Klaus Honnef] meant by "bonne peinture." . . . In the first place, the basis is an intention—that of picturing the world. And painting is only a means to this end (which is why you can't ever say that a bad picture is well painted). . . . As Duchamp showed, it has nothing to do with craftsmanship. What counts isn't being able to do a thing, it's seeing what it is. Seeing is the decisive act, and ultimately it places the maker and the viewer on the same level.[13]

Ever eager to keep Cézanne in his place and to dissociate himself from his cult, Richter had previously said, with regard to his habit of painting from low-grade snapshots of press pictures supposedly chosen at random: "I consider many amateur photographs better than the best Cézanne."[14]

The irony here is that Cézanne also proclaimed the primacy of seeing over elegant execution. That Cézanne's facture was long regarded as clumsy or inferior, if not downright inept, in comparison to that of the average academician further reminds us of

how the triumph of the new has resulted in the creation of new academies—generations of teachers and students earnestly aping Cézanne's distorted proportions, collapsed volumes, and warping contours—including the secondhand modernist scholasticism Richter resisted as a young man, even though as a mature one he has proven himself capable of painting with a Vermeer-like technical finesse Cézanne never dreamed of. That is to say, the "good painting" Richter spurned was the "bad painting" of its day. Nevertheless, like that of Duchamp—and with Duchamp explicitly in mind—Richter's response has been an index of Cézanne's abiding gravitational pull on him. So, too, is the fact that he continues to work in the genres that enthralled the very man he has turned away from—portraits, still lifes, and landscapes—and that in the second of these two he has explicitly invoked Cézanne several times by painting wine bottles, apples, candles, and skulls on a table (figs. 2.4–2.6).

Meanwhile, Richter's dismissal of Cézanne is, in his own words, the basis for his dismissal of more recent artists. Asked by Buchloh in 1986, "What was it that you didn't like about Johns? Was it the complicated technique, the artistry?" Richter answered, "Yes, because Johns was holding on to a culture of painting that had to do with Cézanne, and I rejected that. That's why I painted from photographs, just in order to have nothing to do with the art of 'peinture', which makes any kind of contemporary statement impossible."[15]

Of course, Johns's recourse to letters, numbers, targets, maps, and other "things the mind already knows" is the ready-made Duchampian counterweight to the painterly elegance of his touch,[16] though it is important to recall that the close values, obsessive repetition of forms, allover patterning, and other qualities that are now regarded as revealing of Johns's underlying aestheticism were widely viewed as emblems of a dispassionate if not coldly mechanical anti-aestheticism when he first appeared on the scene in the afterglow of Abstract Expressionism. What made Johns quintessentially contemporary to American eyes was his detachment. The use of ready-made photographs and the apparent indifference with which he painted them were, by much the same token, what initially caused Richter to stand out in contrast to the Sturm und Drang of *Art informel* painting—Abstract Expressionism's European equivalent and Richter's principal artistic nemesis. Yet like Johns's, Richter's way of eroding his borrowed imagery by blurring and raking it has resulted in refinements for which he is often reproached by anti-aestheticians, who, through ideological inversion, become inverse connoisseurs of painterly cuisine by reserving for themselves the right to decide when the defiantly bad has become complacently good, the formerly raw has become too well cooked.

Categorically separating Richter and Johns, however, is Richter's determination to make the viewer doubt the semiotics of photography as much as the sign value of painting, for even when his manner of draining a picture of its vitality or of dimming, depleting, or outright canceling the information it once contained achieves exquisite technical effects, those effects have more to do with a kind of anti-rendering than with traditional painterliness. As Richter himself has indicated, that tradition links Cézanne to Velázquez via Manet, and rests upon an accumulation of deft notational strokes whose aggregate bodies forth an illuminated form in space. In that respect, the Belgian painter Luc Tuymans, having set out from Richter's point of departure by copying banal photomechanical sources, has doubled back by way of tactile groping and visual condensation to something resembling a Cézannian niche in the monolith of mass-media culture (fig. 2.7). Tuymans's pictures introduce what might be called Posthumous Impressionism, a style of retrospection saturated with malaise whose inspiring "petites sensations" are as much internal and ulcerous as they are external and fading to polluted

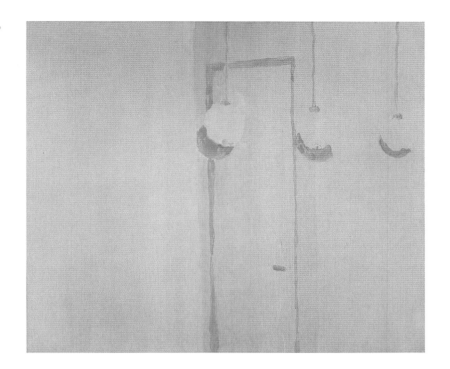

Fig. 2.7. **Luc Tuymans** (Belgian, born 1958), *Lamproom,* 1992. Oil on canvas, 19⅛ x 21⅞ inches (48.5 x 55.7 cm). Courtesy of David Zwirner, New York, and Zeno X Gallery, Antwerp

grays. And if for Cézanne the sun of Provence crystalized reality, for Tuymans the chill humidity of the Lowlands is always on the verge of dissolving it.

It is impossible in such a brief tour of the horizon to account for all the permutations of Cézanne's influence on modernism as a means for gauging modernism's fluctuating vigor over the century since his death in 1906. In light of that constraint, I have attended to key examples of his direct and readily recognizable impact on artists who have explicitly associated or disassociated themselves from him, while staying alert to the reductive tendency of applying simplistic ideas of cause and effect to individual artistic development, as well as to the inherent flaws in any linear notion of art history. Let me conclude by turning to a contemporary artist who has repeatedly acknowledged how profound an experience her discovery of Cézanne was, but whose work may, on the face of it, seem the furthest from his of those discussed until now: Elizabeth Murray.

In speaking about Cézanne, and more particularly about what inspired her to make a comic strip–like variation of one of his portraits (figs. 2.8, 2.9), Murray said:

> It was about paying homage. I was reading about Cézanne and his relationship with his wife, and I was very intrigued with him, not just his paintings. What was his life like? What did he do, besides go up the mountain and paint every day? . . . It's a riff on his portraits of his wife, and my idea of her. . . . I think Madame Cézanne is me, kooky as that may sound. I think that's what I was thinking, that I was her and I was falling forward in the rocking chair.[17]

It was a kooky idea — the first of many that literally animated Murray's paintings and gave a jolt to painting in general from the 1970s onward — and, with echoes of Cole Porter, just as kooky was her ultimate declaration of devotion to the prickly patriarch of her medium: "I'm always true to you, Cézanne."[18] Musical-comedy mavens will of course recall that Porter's lyric is, "But I'm always true to you, darlin', in my fashion, Yes, I'm always true to you, darlin', in my way." Murray did things very much her own way, but her tongue-in-cheek tribute to Cézanne directs our attention to their common concerns as much as to the divergent manner in which they handled them (figs. 2.10, 2.11). Of all the genres Cézanne practiced, only still life fascinated Murray as much as it did him. Since antiquity, the still life has been a laboratory for formal experimentation, whether one renders cups, bottles, and glasses more or less as the eye sees them, or as

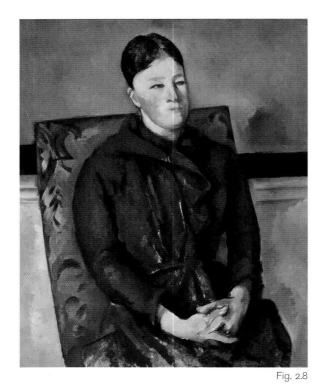

Fig. 2.8

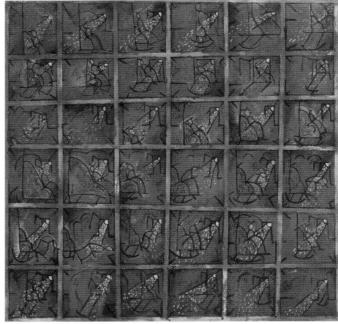

Fig. 2.9

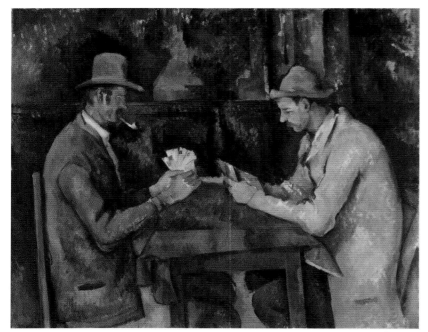

Fig. 2.10

Fig. 2.11

Fig. 2.8. **Paul Cézanne, _Madame Cézanne in a Yellow Chair,_** 1893–95. Oil on canvas, 31¹³⁄₁₆ x 25⁹⁄₁₆ inches (80.9 x 64.9 cm). The Art Institute of Chicago. Wilson L. Mead Fund, 1948.54

Fig. 2.9. **Elizabeth Murray** (American, 1940–2007), **_Madame Cézanne in Rocking Chair,_** 1972. Oil on canvas, 25¼ x 35½ x 1⅛ inches (89.5 x 90.2 x 2.9 cm). Collection of Katy Homans and Patterson Sims

Fig. 2.10. **Paul Cézanne, _Card Players,_** c. 1892–95. Oil on canvas, 23⅝ x 28¾ inches (60 x 73 cm). The Samuel Courtauld Trust, The Courtauld Gallery, London

Fig. 2.11. **Elizabeth Murray, _Untitled,_** 1970. Oil on canvas, 20 x 30 inches (50.8 x 76.2 cm). Courtesy of Paula Cooper Gallery, New York

cylinders and cones, or as cones and cylinders morphing back into cups, bottles, and glasses; and it has been a metaphor for stability and domesticity, whether one is looking at a Roman fresco or mosaic or a canvas by Francisco de Zurbarán or Jean-Siméon Chardin. Cézanne called such stability into question—and by implication the equilibrium of the household as a retreat from the turmoil of the wider world—by skewing perspective and tipping planes to the point that some forms in his still lifes are contorted and verge on collapse, even as they or others adjacent to them seem about to slide off the tables where they have been placed. Although seeking the permanence of the classical art he saw in museums, Cézanne grasped that such permanence was nonexistent in nature, and, consonant with his study of nature, he sharpened his focus not only on the contingency of visual phenomena, but also trained his gaze on the underlying precariousness of "natural" order.

Murray gave that order a shove. Then, having successfully upended it like a magician who rips a tablecloth out from under a dinner setting, not caring if the dishes and silverware fall, but watchful of the patterns they make when they do, she gave that order a twist, as if everything within her reach, from the crockery to the table itself, was as pliable as the tablecloth gripped in her fingers. By virtue of close observation, Cézanne was the herald of the _un_still life; by virtue of a restless soul and a dynamic feel for the structures of painting, Murray was the mother of all _un_still lifes. Made in the spirit of all women who have gone out into the world on their own, the pictures she created and the formal innovations for which she is responsible redeemed this "domestic" genre by confounding false gender dichotomies and false separations between private and public reality, even as they became a lever for springing the locks that bound the painting on canvas to the rack of Euclidian geometry. Shaken by tremors and stirred by whirlwinds, Murray's tables, chairs, cups, glasses, and bottles fold modernist space into new, yet still palpably modern, shapes and dimensions: shapes and dimensions whose features vividly recall those found in Cézanne but whose presence is entirely fresh and whose promise is that of a pivotal stage in a great collective endeavor the end of which remains—unforeseeably, unpredictably—around the corner.

Lucky Cézanne (Cézanne *Tychique*)

Richard Shiff

Tyche [Fortune], of men the beginning and the end, . . . there are more blessings from you than evils.

—ANCIENT GREEK CHORAL FRAGMENT[1]

Paul Cézanne died in October 1906—too soon to become a twentieth-century artist. He developed no liking for the emerging technologies and institutions of the era he hardly entered; by his reckoning, the contemporary world reflected few of his values, whether aesthetic or moral. He objected to the pedestrian sidewalks and electric street lighting appearing in Marseilles and Aix in 1902. The one altered the organic character of established urban space; the other spoiled the twilight. Observing life along these modernized streets, Cézanne criticized the everyday dress and demeanor of young women.[2] His annoyance with the times extended even to his postman, whose offense was to speak of socialism.[3] The physical environment, the local society, its politics and mores—all was changing. Cézanne responded with a barrage of complaints, seeking shelter in the traditions of his Catholicism as well as in his painting.[4]

Most likely, he never comprehended how revolutionary, how utterly modern, his painting was. This judgment belonged to others, to whom history consigned him. Cézanne's historical fate lay in their vision. Many younger artists concluded that their modernist values either derived from or were reflected in his, not through Cézanne's conduct and beliefs but by the gauge of sensation. "Sensation above all else," he told painter-theorist Maurice Denis, who visited him in January 1906.[5] To outsiders it appeared that art alone had constituted the strange man's life. "We hardly dare say that Cézanne lived," critic Charles Morice wrote in 1907, offering a sympathetic but ambivalent summation: "He painted."[6] That was it. Cézanne had excelled in art, though not in life, unless the two were to be merged—a common solution to evaluating this problematic case on the part of supporters (and itself a modernist trope: life becomes art). In 1899, Georges Lecomte commented: "He painted in the way that he walked, in the way that he ate, because the core of his being [*son tempérament*] directed him toward the pictorial rendering of things."[7] Every sensation that Cézanne felt, no matter what the cause, would be the equivalent of a painting sensation; every physical gesture, a potential paint mark. A hike into forested land and among primordial rocks assumed experiential and associative meaning—he was known for his long walks,

Fig. 3.1. **Paul Cézanne, *The Sea at L'Estaque,*** 1878–79, Oil on canvas, 28¾ x 36¼ inches (73 x 92 cm). Musée Picasso, Paris, R.F. 1973-59

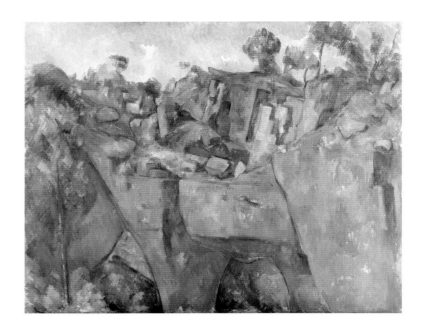

Paul Cézanne, *Forest,* 1894 (plate 141, p. 402)

Paul Cézanne, *Bibémus Quarry,* c. 1895 (plate 116, p. 342)

reaching isolated sites—but each foray became all the more emotionally intense as the artist converted aspects of his experience to marks of color on canvas or paper.[8] Rather than fade gently into senility, Cézanne promised to die painting.[9]

Marking a Life

The Symbolist artist Paul Sérusier directed Cézanne's vision beyond his death toward a promising future: "He points the way for those to come."[10] If not the Impressionist way of Claude Monet and Pierre-Auguste Renoir, both of whom survived him, which way was it? His art intrigued and inspired certain viewers, while others targeted it for ridicule. But nearly all concluded that Cézanne's painting remained in an unresolved state, more suggestive than definitive. Its insistent stroke was its most evident feature. Each mark remained separate from the next, only occasionally altered by fine adjustments, so the eye could perceive with comparable directness what the artist felt and his hand recorded—one mark after another striking the canvas or paper. In Cézanne's late images of Mont Sainte-Victoire, viewed from the hill where he built a new studio, the pictorial details of the massive geological formation and the table of land before it reveal little of their natural diversity. Even the sky above acquires the same bold touches of paint-matter.

This pervasive materiality contributed to the reality-effect of Cézanne's art, though it hardly agreed with the qualities expected of the nominal subject matter. Sky and water were likely to appear as substantial as stone, the trunk of a tree, or the corpulent bodies of bathers. Around 1952, Pablo Picasso acquired for his growing collection of Cézanne's art a view of the bay of L'Estaque (fig. 3.1). Showing it off to visitors in 1971, he rapped his hand against its central area thick with strokes of blue, blue-green, and blue-violet and said: "Look at the sea, it's solid as a rock."[11] Literally, it was: The canvas was stiff with compacted paint. It was also "solid" in a figurative or metaphoric sense because Picasso had chosen a densely structured work in which each mark bore down on the next; the pressure is most perceptible, tangible, at the right side of the composition, where several bands of diagonal strokes form foliage and other vegetation.[12] Perhaps with a sly irony, Picasso intended his word *solid* to resonate with the widely

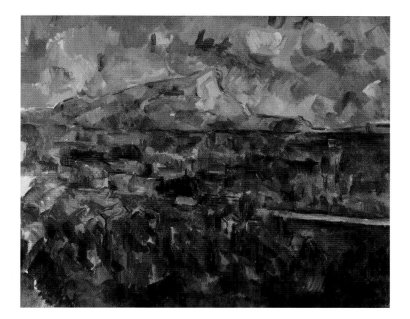 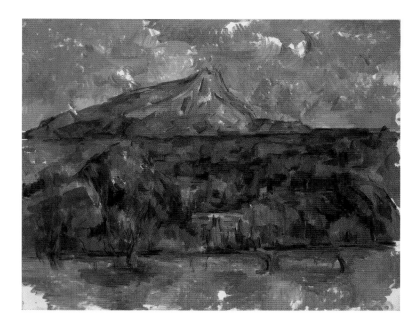

Paul Cézanne, *Mont Sainte-Victoire Seen from Les Lauves,* 1902–6 (plate 184, p. 478)

Paul Cézanne, *Mont Sainte-Victoire Seen from Les Lauves,* 1902–6 (plate 186, p. 480)

held belief that Cézanne, as reported by Denis, "wanted to make of Impressionism something solid and durable like the art of the Museums" (the sanctifying upper-case *M* is Denis's).[13] Although his painting might be solid in the material sense — hardly yielding as Picasso struck it — it was neither rigid nor static in any other sense. Denis's recollection of Cézanne's statement may or may not have been accurate; the notes he kept in his daybook for his brief sojourn in Aix do not include it, only the published article of about a year and a half later. But even if Cézanne did allude to an art "solid" enough to match the time-tested standards of "the Museums," what he meant by this remains uncertain.

Relative to typical late-Impressionist paintings with refined overlays of diverse kinds of brushwork, Cézanne's passages of repetitive marking, often only a single layer, gave his surface a coarse yet direct, self-revealing appearance. On seeing this art for the first time, whether reacting with fascination or dismay, most observers were drawn to the pulse of the strokes. They gave less notice to the integrating effect of the rich color harmonies that these same strokes in the aggregate created.[14] The artist's cultural value would rise or fall according to the response to his mark. In 1899, painter-theorist Paul Signac linked this mark-by-mark technique to two conditions that cast it in a positive, avant-gardist light: Cézanne's strokes were "rectilinear and pure, neither determined by mimeticism nor concerned with artfulness."[15] Reading this description today — "strokes rectilinear and pure" [*touches carrées et nettes*] — we think of any number of paraphrases: "pure" in the sense of being distinct, self-contained, clear or clean of all else, quintessential, abstract. A "pure" mark elicits too many concepts to escape interpretive ambiguity. It can be regarded materialistically, pure in its utter baseness like pure paint or pure dirt, or idealistically, pure in the efficiency of its cultural function and in the transparency of its references. Signac, a primary advocate of Georges Seurat's pointillist technique, touted the hatch mark as Cézanne's efficient device, just as the dot (still better) was Seurat's. In either case, the material character of the preferred mark and the personality it projected were anonymous. It seemed that others might do something of their own with Cézanne's technique, as Signac did with Seurat's. A repetitive mark or stroke is always available, thoroughly versatile, adapting equally to sensations of an apple, a face, or a rock. It also adapts to a variety of hands.

In the view of early observers, Cézanne's mark was self-sufficient, independent of reference to the shape and texture of things, and had no calligraphic distinction. If neither conventional mimetic representation nor an appeal to traditional beauty were guiding the artist's hand, what was? In a letter of 1905, Cézanne referred to having difficulty with "abstractions" but did not elaborate. The problem had something to do with the way he was perceiving color in nature. We wonder whether he was admitting failure or recognizing a hard-won truth. Whatever type of phenomenon the "abstraction" was—some unfathomable feature of nature, a factor of the aging man's weakening eyesight, a consequence of the way he handled the materials available to him—Cézanne complained that he was "prevented from covering the canvas, and from pursuing the delimitation of objects when the points of contact are precise and delicate." He added: "That's the reason my image or painting is incomplete."[16] The statement evokes the blank spots he left in his pictures (not only in 1905 but also in the years before), the blurring he created by retracing contour lines off-register, and the abruptness of many of his shifts in color from one mark to the next: all failures in definition or "delimitation." These effects are instances of discontinuity, loss of focus, and a general coarseness. Yet they might have been registering the artist's felt experience—emotional as well as optical.

The mark-by-mark structure of the picture indicated that the artist's hand would paint no more than the eye could see at any instant, just as the eye itself would focus on no more than the hand could paint. It was as if "the points of contact" in a natural scene had to be understood as much by touch as by sight. "Contact" itself suggests this. Cézanne's sensory coordination—touch following vision and vision following touch—guaranteed that his pictures represented "reality." The pictorial experience he created was as close to reality as the real circumstances of painting would allow. "Artists don't perceive all the relationships directly," a witness reported Cézanne saying during his last years; "they sense them."[17] The implied contrast was between the precision of the organizing intellect and the unruliness of immediate sensation. Although sensations felt at least as real as ideas, they were hardly as stable. If there had been words or concepts corresponding to the sensory abstractions Cézanne experienced, perhaps he could have painted in all fullness what he saw.

No one can say that sensory experience should reach us in an untroubled state and submit to rational order. Cézanne's problematic technical features suggest continuity as well as discontinuity, for an interrupted or fragmented configuration of marks can resume with either the same or a new direction, rhythm, and pace. The structure of Cézanne's marks fixed nothing in place. In 1904, a German critic responded sympathetically—corporeally, viscerally—noting that he felt movement, a quivering in his eye, when he viewed a Cézanne still life.[18] As a mere painting, it should not have been moving. Human beings, perhaps even trees, things that live, move. But when the sensation is in the eye, is it the thing seen or the animated sensorium that moves? We can imagine Cézanne intuiting that the answer must be "both" and simplifying his dilemma by choosing to paint a still life or the ever so solid Mont Sainte-Victoire, reducing the conflict in motion. With live portrait subjects, the model would have to remain fixed. According to Ambroise Vollard, who posed in 1899, Cézanne demanded: "You must keep still like an apple. Does it move—an apple?"[19] It was the kind of wry, ironic statement that the painter might actually have made. Before Vollard recorded his amusing vignette ("Cézanne Does My Portrait"), critics pro and con noted that this artist painted the human head as if it were an apple, and painted apples with the emotional investment others would have reserved for the human head.[20] The conclusion followed from the perceived significance of the mark-by-mark technique—applied to every subject

equally, it dominated every subject. Consistent with theories of visual expression now known as "formalist," it was generally agreed that "with Cézanne, the purely pictorial thought is less and less camouflaged by anecdote. . . . [His] pictorial inspiration is indifferent to the particular character of each object."[21] This statement is from painter-theorist André Lhote, but there are innumerable similar ones from others, applied to this or that early twentieth-century position. Here is Georges Braque: "The goal is not to reconstitute an anecdotal fact but to constitute a pictorial fact."[22] And here, Alberto Giacometti: "Cézanne threw a bomb at [traditional] vision when he painted a human head like a mere object."[23]

The act of painting joins two living forces—the state of the model (human or otherwise, even imaginary) and the artist's sensation. The connection is obvious: Something external (or projected as external) stimulates internal feelings. Less obvious is a complication likely to be universal: The feelings become self-stimulating once the artist has engaged in the representational process. A certain pattern or rhythm perceived either in nature or within an emergent representation sustains and reinforces itself. Cézanne called this double-sided experience his "motif." A motif was the represented view or invented, imaginary composition; more significantly, it was the concatenation of sensations through which Cézanne developed his picture. He might have called the motif his abstraction, but he tended to associate the latter term with intellectualism, often pejoratively.[24] Aspects of the concept of abstraction within the Cézanne tradition will emerge gradually as this essay develops. What I have said at this point already indicates that the term is fluid; it should not be fixed to a single sense. A mark can be abstract. A thought can be abstract. The "abstractions" Cézanne experienced in 1905 disturbed a process of looking and touching, distracting him from his motif. Or, "abstractions" may have forced him to regard the painting he was making as the very motif he was representing—sensation turning in on itself to catch up with itself.

Appropriately, the term *motif* connotes movement.[25] Cézanne's motif could not be Mont Sainte-Victoire regarded solely as a concept or an ideal; it was instead a movement associated with a particular experience of the mountain, as this experience played out in an active process of painting. Although sensation needed to catch up with itself, it would be wrong to expect that a stable image would result if it did, for living, human sensation is not divisible into moments. It merely feels like an instant or moment, that is, it feels momentary, transient, changing. The mechanistic, cinematic metaphor that critics often applied to it—sensation as "an instant of a cinematographic film"—is misleading, because it stills what never ceases to be in motion.[26] What Cézanne understood of the changing aspect of Mont Sainte-Victoire he understood of apples and human figures. Many of the details of a work such as *Madame Cézanne in a Yellow Chair* (see plate 143) seem tentative, as does the entire off-axis composition. Look especially at the figure's hands—all the more affecting because of a sense of animation conveyed by the wavering contours and faceted planes continually adjusted with successive applications of the various colors. Those hands are moving, but by what source of energy?[27] We usually expect portraits to remain still, like good studio photography. Here, Cézanne may have found his affective motif rather than lost it.

A general theory of human consciousness, a theory of life, would be needed to determine the relation of Cézanne's manner of painting to his lived experience—a theory of life for this artist who, ironically, "hardly lived." We reasonably conclude that life itself should be, must be, whole and continuous. It may seem otherwise to psychotics, but the rest of us live our lives assured that we are one and the same person at all times. Many early viewers regarded Cézanne's paintings as excessively divided, fragmentary,

Paul Cézanne, *Madame Cézanne in a Yellow Chair*, 1893–95 (plate 143, p. 404)

incomplete. Why could he not resolve a practice in which he had so thoroughly invested his soul? Logic suggests that there may have been a division within him, a serious psychological rift. One of the most distinguished commentators, Maurice Merleau-Ponty, called Cézanne "schizoid."[28] The painter's example may have been a warning to his contemporaries not to be so complacent about their entry into modern life: All individuals are divided, if only because they struggle to conform to what they imagine their culture expects from them. They want to be the representation of themselves. Sooner or later, they encounter an "abstract" demand that their practice and behavior leaves unsatisfied. In 1905, the same Charles Morice who questioned the psychological health of Cézanne's existence, perceived the problem throughout his modern society: "I see a lack of lovingness in daily life, etched on the contorted, hardened faces of my contemporaries. This is a consequence of the fragmentation and atomization that not only separates one person from another, but beyond that, divides each of us internally and divorces our feeling from our thinking."[29]

If Cézanne was not enough of a social and political being to have formulated this issue for himself, perhaps he realized through his studies of nature the same unfortunate conflict. Morice called Cézanne's results "an art of separation." The painter had isolated the material end of his practice from any humanistic concern: "Nothing of all that: painting in itself . . . painting with the aim of painting."[30] Monomania of this sort leads to interruption and imperfection as much as to perfection. The man who hardly lived was so involved with painting that he could perceive all the conditions and situations in which it would fail. As Cézanne stated in his letter of 1905, failure occurred "when the points of contact are precise and delicate." At that moment, he understood that seeing and painting are incommensurable experiences. He acknowledged the inadequacy of his material process—and by implication, any material process—in relation to representational and expressive ideals. A less scrupulous painter would have disguised the crisis, devising a way for the medium to mask every unwelcome truth. This would be the academic solution, suitable for the painting schools. But during Cézanne's lifetime, the

academic system with its state patronage was disintegrating, displaced by an international private market (probably contributing to the social "atomization" that disturbed Morice).

Beyond Cézanne's lifetime, his "failure" converted into remarkable success. He had been in no position to predict this, since he shared most of the cultural prejudices of his contemporaries. His conceptual framework for explaining his art was just as inadequate to the task as his practice was to the abstractions he sensed in his animated vision: hence, the self-doubt he expressed, which later admirers accepted as entirely sincere.[31] In 1913, Robert Delaunay, contributing to the lore, wrote to Franz Marc of "Cézanne's doubts . . . his bruised feelings."[32] A number of Cézanne's well-known remarks—including his assertion that his efforts amounted only to "slow progress"— may have been self-deprecating deceptions.[33] Historians familiar with the documentation rarely read Cézanne's ambiguous statements in an ironic tone, yet they might. Like the assessment of his modernity, the final word on the relation of his art to fundamental human questions—concerning wholeness, truth, separation, failure—remains undetermined. Cézanne became a piece of collective cultural property that successive generations shaped according to their needs, as they wrestled with *their* doubt. If we accept the notion that life and its conditions keep changing, then we can take little guidance from truths established in the past. The truth of any artist, our view of the truth, must be open to change. For many, then and now, Cézanne has been the figure of change, if only because (still) he receives no final interpretation. Critic Octave Maus, writing two months after Cézanne's death, addressed the matter in passing: "The artist renders concrete the creative energies nourished by life, as life ceaselessly changes. . . . To settle into yesterday's truth is to lie today."[34]

At the negative end of a diverse record of response, Camille Mauclair resorted to a comparison from the field of dance. It indicates that the coarseness perceived in Cézanne's mark-by-mark painting was the crux of the matter for early observers. Cézanne was no Isadora Duncan, Mauclair wrote, but a crude peasant who "performs in wooden shoes," combining colors "chaotically."[35] Ironically, Duncan herself returned dance to primitivist fundamentals.[36] In effect, Mauclair distinguished good primitivisms from bad ones, including Cézanne among those who foolishly believed that the well-being of society required living in willful ignorance—*le salut, c'est l'ignorance*—admiring the art of the caves and of children.[37] Here, the operative principle was not merely "primitivism" but something more threatening to respectable aesthetic practice and more lasting as a modernist principle: "anti-virtuosity."[38] Artists were abandoning elements of conceptual and material sophistication (perspective systems, elaborate preparation of the canvas) to enhance the sense of immediate emotional expression. There were political implications to this new standard, or anti-standard: To inaugurate a specifically modern art, devoid of authoritative antecedents as models for accomplished practice, was to reject old aristocratic and oligarchic social orders for the sake of radical democracy. Technical virtuosity, like exquisite manners, connoted distinction and privilege. Coarseness implied a base level of equality, not so much an aesthetic peasantry, but a class of those who acquired their aesthetic from unadulterated, immediate experience, hypersensitive to the present moment. Virtuosity was "yesterday's truth."

Mauclair directed his analysis at the situation in Paris during the autumn of 1905, just when Cézanne was encountering his "abstractions," a term that signaled much of the trouble, one way or another. Despite the unsettled state of affairs, Mauclair was already on the defensive, because the battle for the allegiance of the younger generation of artists, if not lost, was nearly lost. Henri Matisse and a few others would soon be labeled Fauves, the "wild ones"; they acknowledged Cézanne as one of their primary

models, an artist whom critics already associated with wildness, both natural and prim-itive, because his pictorial sensations seemed raw, unfiltered by culture.[39] Within about a year Cézanne died. It was then that Sérusier said, "He points the way." By using a familiar metaphor—Cézanne as *un jalon*, a surveyor's stake—Sérusier implied that the painter might be innocent of the effects others derived from him. Surveying suggests tentativeness, as if the indicated path were no more than a virtual one into aesthetic territory incompletely charted. Sérusier tacitly confirmed Cézanne's self-assessment that he was, in so many words, "the primitive of his own way."[40] His mission had not been ideological, a theory demanding either acceptance or rejection, yes or no. It had been exploratory and open—make of it what you will.[41]

According to Denis, Cézanne used the same term, calling himself *un jalon*: "I point the way; others will come after."[42] They still come. Only rarely does an artist have such a profound effect on contemporaries and succeeding generations, and cases as persistently ambiguous as Cézanne's, like an unsolved cultural crime, are rarer still. Despite the evidence from numerous witness accounts (like those I have been citing), scholars remain unsure of Cézanne's conceptual framework, psychological make-up, and intended purpose. When pressed, he would make theoretical statements, but these often amount to little more than commonplaces, and just as often they seem obscure or inconsistent. Because many are indeed commonplaces, it was easy for others to find confirmation of their own thinking. Interpretation relies on such statements at its peril. Around 1904 to 1906, the theoretically minded painter Émile Bernard attempted to probe Cézanne's intellect as well as his art. One of Cézanne's letters to Bernard indicates his belief that he could explain himself only in the act of painting, by visual rather than verbal example, when the two artists would work together.[43] Even in visual practice, however, the points that Cézanne may have been deciding empirically hardly seem clear or conclusive. A nagging question remained at his death as to whether his art had ever attained its ends or, worse than a failure of incompletion, had attained only ends he never sought. "He takes his secret to the grave," Bernard said, resigned.[44]

Cézanne's early supporters, Bernard and Sérusier among them, argued as if they expected the public to balk (Mauclair, for one, did). The period of sustained public exposure began only in November 1895 when Vollard first exhibited Cézanne at his Paris gallery. In response, critic Gustave Geffroy directed viewers to attend initially to canvases that appeared finished and stable. *The Card Players* (see plate 210, one of several versions) might qualify for this category of Cézannes of relative safety. Its degree of coarseness—its choppy surface of hatch marks—seems redeemed by the secure positioning of its four figures, each identified by a garment with a distinctive color or tone: One is reddish brown, another grayish blue, another a mottled buff, the last a brighter blue. The technique of *Madame Cézanne in a Yellow Chair* is the same, but far more irregular in effect because some areas remain more thinly and tentatively painted than others.

Geffroy suggested that Cézanne's problem cases, his most searching and unsteady efforts, reflected his struggle to tap into nature's ultimate truths.[45] If resolution was lacking, the cause was noble. Despite a completely covered surface, *Compotier and Plate of Biscuits* (see plate 81), with its heavy texture, curious interlacing of angled and rounded forms, and intrusively positioned bottle, must have appeared antithetical to a conventionally resolved still life. Rather than settling the senses, it would agitate them. Geffroy anticipated the problem in reception and offered a clever argument: "Who will say at what precise moment a canvas is finished? Art does not proceed without a cer-tain incompleteness, because the life it reproduces is in perpetual transformation."[46] In

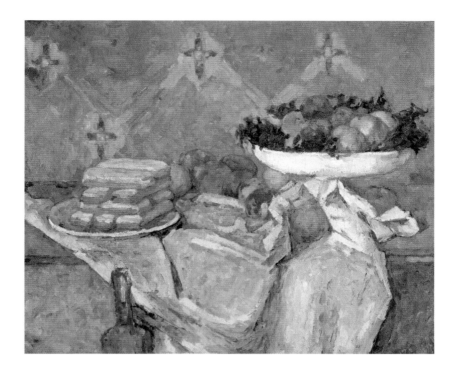

a backhanded way, the critic brought unity to the unyielding division between the life of nature and the sensory life of the artist. This was the division that Cézanne's painting practice, given its inadequacies and incompleteness, seemed to demonstrate or exemplify—the division brought into relief every time the painter lay one small stroke next to another, leaving each clearly separate. A tension in one area of life experience was responding to a tension in another. Instability resulted. Justifying the artist's results, Geffroy suggested that "perpetual transformation" was an inescapable fact of human existence. He shamed his readers into accepting the risk of Cézanne's temerity for the sake of his realism, for the likeness to life of his paintings, regardless of the sensory and psychological discomfort that would accompany them.

Likeness

We like what we feel is like us, what bears an affinity. The good is what *we* do or would wish to do. We approve of others when their acts mirror our actuality or our projections and fantasies, the likeness reassuring us of the justness of our ways. Recognizing an affinity of this kind encourages one artist to regard the work of another as true to life.

In 1935, after years of experience with Cézanne's painting, Picasso remarked that he appreciated the emotional anxiety he perceived there, which gave this art an expressive force beyond its substantial technical interest.[47] Picasso may have responded this way because experience had taught him that all human life is tragic: hence, a universal cause of anxiety (this was a period of grave political conflict in Spain). Cézanne, the painter who had no life, produced an art that seemed closer to the core of life than any other —yet not close enough for his own satisfaction. This gave his painting its aura of anxiety, its *inquiétude*, the disquieting effect it had on the mind and senses of others. The fact that Cézanne believed he failed to attain aesthetic resolution was a lesser consideration for Picasso, hardly a problem he found sympathetic (at least this was his public stance). He refused to view himself as pursuing an ever evasive end, his desires destined to be frustrated; rather, his superior capability would lead him straight to whatever he was seeking.[48] If Cézanne had been "the primitive of his own way," Picasso became far more than the primitive of *his* way. He returned representation to fundamentals and then went beyond, eventually deciding that the entire history of art that preceded him

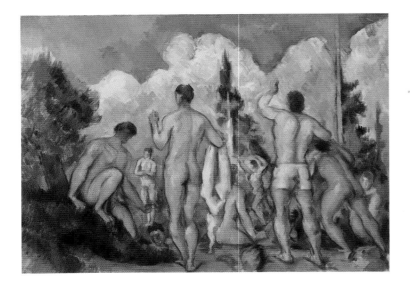 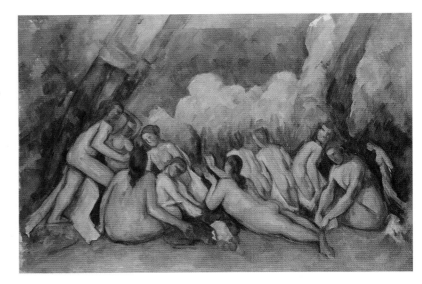

Paul Cézanne, *Bathers,* c. 1890. Musée d'Orsay, Paris
(plate 40, p. 180)

Paul Cézanne, *The Large Bathers,* 1894–1905 (plate
203, p. 508)

was no more than a beginning.[49] Cézanne, too, was only a beginning. The force of his technical fundamentals—their connotative value in pointing an indeterminate way (Sérusier's *jalon* effect)—encouraged Picasso's belief that pictorial representation was an open field without known limitations. Along with other devices associated with "primitive" forms of rendering—that is, straightforward, rudimentary, anonymous devices for mark-making and picturing—Picasso developed variations on Cézanne's all-purpose use of hatch marks. With Cézanne, these sets of short parallel strokes repeated a single color or family of colors (such as blue, green, yellow) to define an area, or, producing a very different effect, abruptly juxtaposed hues of strong contrast. Picasso and other twentieth-century painters could have turned to any number of predecessors to derive similar fundamentals, but Cézanne had made his mark-by-mark technique the issue by allowing this procedural device to remain so prominent in each of his works. Picasso's contemporary Lhote stated in 1920: "A large part of the emotive power of Cézanne's canvases derives from the fact that the painter, rather than hide them, *shows his means.*"[50] Merleau-Ponty must have concluded the same when he defined the essential problem of painting in 1952: "There are two sides to the act of painting: the spot or line of color put on a point of the canvas, and its effect on the whole, which is incommensurable with it, since it is almost nothing yet suffices to change a portrait or a landscape."[51] Where an act and its result are truly incommensurable, we would expect to see, or at least to sense, something remaining to be done. Realizing how effective the slightest material adjustment might be, an honest painter would not only show the means but would feel compelled to probe materiality as a resource as yet virtually unexplored. This is why Sérusier referred to Cézanne as *un jalon*—a marker of new territory.

Cézanne's marks constructed the picture as a tactile action rather than a series of illustrational features. One and the same type of mark was as effective in animating a composition of bathers as in articulating the bends, angles, and planes of a still life (plate 2). Picasso used his version of the Cézanne stroke with comparable flexibility. Yet, in his very Cézannian *Nudes in a Forest* (see plate 69), there is a difference in sensory character and in emotional valence: Picasso seems to decrease the incommensurability factor; he shows his means, though as if he would wish to, rather than be forced to. He pulls, tugs, and molds the figures into their pictorial space, with results not unlike the deformations that occurred as Cézanne worked his own bathers into patterns of color and shape across a mural-like surface. But in Picasso, even in a modest study, we have the sense of a process being engaged, a result being sought, and, almost without fail, a desirable end appearing. It need not be an expected end, yet it brings at least temporary

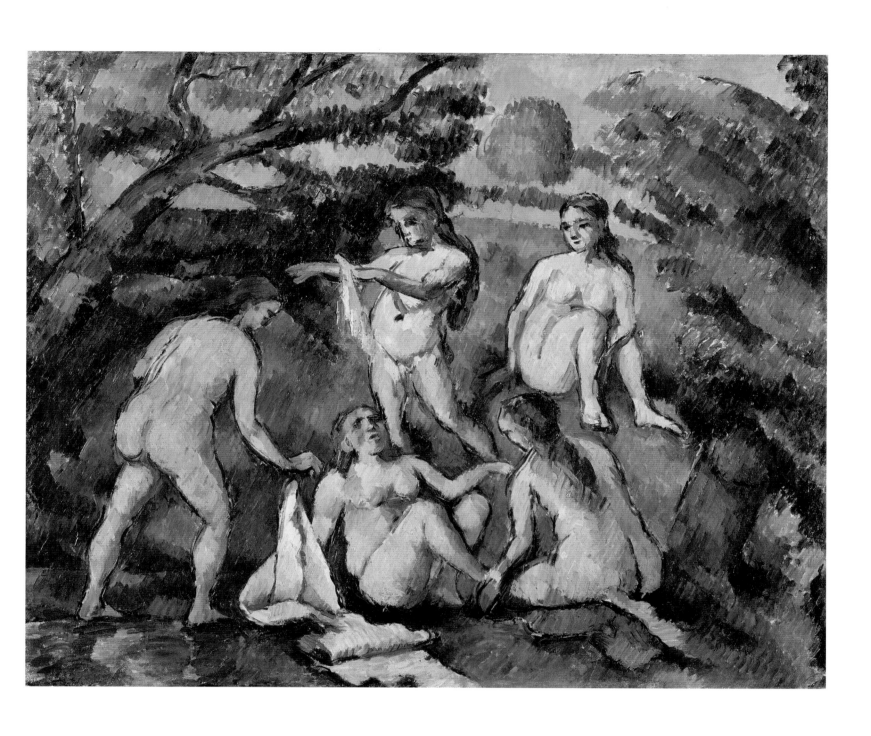

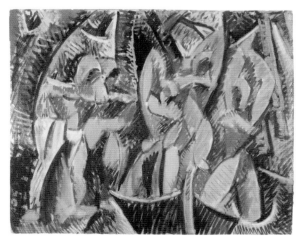

PLATE 2

Paul Cézanne

Five Bathers, 1877–78

Oil on canvas
18⅛ x 21¹⁵⁄₁₆ inches (45.9 x 55.8 cm)
Musée Picasso, Paris

Pablo Picasso, *Nudes in a Forest*, 1907
(plate 69, p. 243)

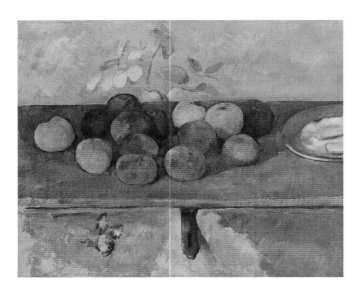

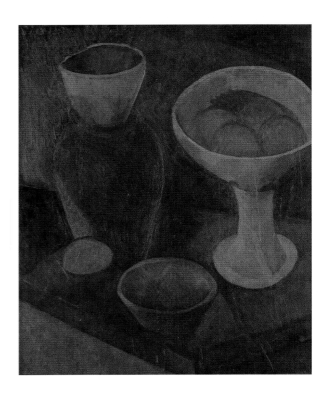

Paul Cézanne, *Apples and Biscuits,* 1885–90
(plate 189, p. 483)

Pablo Picasso, *Still Life with Bowls and a Jug,*
1908 (plate 82, p. 255)

closure. As Picasso claimed, his art falls on the side of finding a solution rather than seeking one. In his case, the mark-by-mark effect does other than evoke a succession of sensations (as it would have with Cézanne, according to Geffroy). Picasso's hatchings become more of a productive technique than an index of feelings. They accentuate a plane, articulate an edge, alter a local color—all as if they were establishing the several qualities of a specific object rather than recording moments of a life in sensation. Picasso's marks are graphic signs, a painter's device. Cézanne's marks are likely to appear more immediate (even if delayed in coming), closer to unprocessed vision and touch, "pure." Acting as marks, not meta-marks, they neither ironize, subvert, nor otherwise play on some other type of mark or practice.[52] This is not to say that Cézanne's marks and their method of application were signs of nothing: They were signs of direct observation—sensation coupled with its corporeal and emotional response.[53]

With both Cézanne and Picasso, despite a base in applied vision, the mark can stray from the object it would describe or articulate. The top of the table-like storage chest in Cézanne's *Apples and Biscuits* (see plate 189) as well as the wall behind seem to buckle, bend, or project according to the clusters of directional strokes that establish these nominally flat surfaces; the marks respond to each other in local rhythms as much as they accord with the natural character of the wood or the papered wall. If Cézanne takes formal liberties, they become all the more pronounced in Picasso. His application of hatch marks in *Green Bowl and Black Bottle* of 1908 accentuates a number of edges and planes selectively, willfully (fig. 3.2). To the left of the central table, alternating parallel and perpendicular strokes of red compete to establish a dominant plane—but of what? With no clear indication that the marks describe an object, it seems that they merely activate empty space: empty with respect to the depicted studio items, but hardly vacant within the materially active composition. Spatial voids become solids when painted—solid like tactile substance. In a late interview, Braque was explicit, as if to explain Picasso's practice, his own, and even Cézanne's in retrospect: "What lies between the apple and the plate is also painting. And, I must say, it seems just as hard for me to paint the between as the things themselves."[54] Cézanne projected the voids, "the between," although rarely as blatantly as those who followed.[55] Picasso alluded to this quality when he knocked against the painted bay of L'Estaque, not to

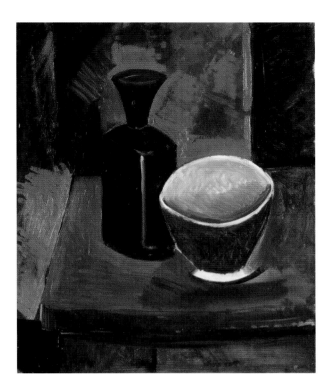

Fig. 3.2. **Pablo Picasso** (Spanish, 1881–1973), ***Green Bowl and Black Bottle,*** 1908. Oil on canvas, 24 x 20⅛ inches (61 x 51 cm). State Hermitage Museum, St. Petersburg

force the spatial depth of the scene back to flat reality, but to affirm the tactile presence that he sensed from the look of the accumulated marks.

Perhaps all of this is to say that however aggressive Cézanne's sensory marking could be, Picasso could act analogously but with more control. He was less tentative in transforming his sensations into pictures. He knew how to remove himself from the process, completing the image and finishing the work. Yet, on one occasion late in life, he acknowledged that Cézanne had no need to finish, which, conceivably, might entail that the older master was the greater of the two: "As soon as he puts down a stroke, the whole painting is already there."[56] Here the context is significant. Picasso was contrasting Cézanne to painters of previous eras who created their work in distinct stages, with preliminary layers to be covered by layers of finishing. In the modern master's case, the initial stroke conveyed the same gravitas as the final one. It was as if the entire process had neither a beginning nor an end but appeared caught in the act, compressed into the moment — or into a succession of moments, each as intense as the others. We think again of the hands of Madame Cézanne, their tentativeness, their intensification of an instant, their ultimate ambiguity with regard to what might follow. The aesthetic animation of these hands exhilarates — and also induces anxiety.[57]

In Cézanne, Picasso perceived a life-anxiety he shared, while he overcame the art-anxiety that accompanied it, perhaps bettering his predecessor at developing the same representational themes: bathers, still life, landscape, portraiture, studies after art itself. Around the time of Cézanne's end and Picasso's beginnings, some critics argued that the older painter's concentration on fundamentals represented his disillusion with life. He retreated into art in reaction; it became his material salvation. According to Morice in 1905, Cézanne resisted the changing standards of modern society, purging his personal life of all "moral values," for which he substituted only "color values [*valeurs*]."[58] This exchange of "values" (a pun in both French and English) converted Cézanne's philosophical and ethical problems into paint-mark problems. Morice was maintaining a line of commentary that had come not long before from Bernard, following an extended visit with Cézanne in Aix: "The more he works, the more his work removes itself from the external view [and] the more he abstracts the picture."[59] Yet, as much as younger admirers like Bernard saw color and form as the detached content of

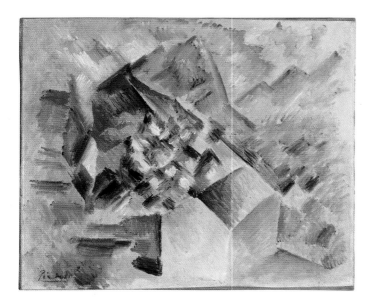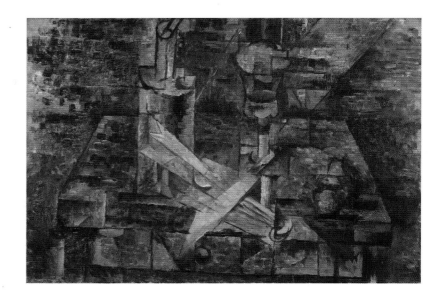

Pablo Picasso, *Santa Bárbara Mountain,* 1909
(plate 53, p. 227)

Georges Braque, *The Table (Still Life with Fan),*
1910 (plate 91, p. 277)

Cézanne's painting—and as much as these studio abstractions became the crux of a debate over whether Cézanne represented an advance or a decline in art as a force for social benefit—the painter insisted that the direct experience of nature, the God-given worldly environment, remained for him the foundation of his technique and his art's sole motivation.[60] Frustrated with Bernard's theorizing, Cézanne said that he "would have liked to have forced him to work from nature."[61] Concerning these matters, Picasso was in agreement, more or less: "Abstract art is only [the material end of] painting. Where is the human drama? There is no abstract art. You always need to begin with something."[62]

Despite parallels, a past (Cézanne) and a present (Picasso) do not become reciprocal and symmetrical; the adage "history repeats itself" is true only for those who lack a sense of historical dynamic. Fate is an unpredictable force of chance and change. Cézanne would not have accepted what Picasso did with hatch marks, angles, and curves, as he converted his primitive rendering of the "something" with which he began into an elaborate exploration of various primitivistic possibilities. These included the Cubist fantasy of returning a fully developed system of pictorial illusion to its origin in the basic properties of the materials and the means of representation. Picasso, Braque, and their like-minded colleagues treated what ought to have been familiar territory (because fundamental) as if it were new. As Cézanne was *un jalon,* Picasso and Braque were the Orville and Wilbur Wright of painting.[63] During their early years of Cubist practice—marked by such works as Braque's particularly Cézannian *Houses at L'Estaque* of 1908 (see fig. 9.2), Picasso's *Santa Bárbara Mountain* of 1909 (see plate 53), and Braque's *The Table* of 1910 (see plate 91)—they set the traditional signs of illusionistic rendering in exaggerated isolation. Shading and highlighting, for example, were exposed in their abstract (that is, essential, real) material nature as well as in their multiple pictorial functions within the representational context. A late comment from Picasso suggests that it would be wrong to impose too orderly an understanding on the play of these devices. Cubist "reality," he said, is "not a reality you can take in your hand. It's more like a perfume—in front of you, behind you, to the sides. The scent is everywhere, but you don't know where it comes from."[64] Cézanne might have said the same of his sensation and its abstractions, but without Picasso's equanimity.

Fig. 3.3. **André Lhote** (French, 1885–1962), **Head of a Woman,** c. 1921. Oil on canvas, 24 x 18⅛ inches (61 x 46 cm). Philadelphia Museum of Art. Gift of Benjamin D. Bernstein, 1978-172-3

In a series of publications, Lhote captured the nature of the general historical development in a succinct opposition: "Italianate," "academic," or "intellectual" perspective was being displaced by "sensory," "emotional," or "felt" perspective: *la perspective sensible.*[65] Lhote's own painting follows the Cézannian and Cubist precepts he articulated but in a curiously literal way, with little sensitivity to the perfumy ambiguity of "feeling." As if to make a number of didactic points, one of his portraits of around 1921 renders passages of illumination and devices of geometrical structure all too obviously — for example, the clear echo of the framing rectangle in the rectilinear organization of the figure's forehead (fig. 3.3). This is a work by the same person who wrote: "The Italianate master, in the midst of his anxieties, seeks certitude, [whereas] the Frenchman, not as pressed to eliminate his beautiful torment, rediscovers at each moment of experience its capricious accidents."[66] Though it may not have reflected his own practice, Lhote's formulation put a Cézannian spin on what Cubism would accomplish. The French solution, *la perspective sensible*, alluded to the happenstance character of sensation as opposed to the deliberateness of analyzing the painter's means: "Sensation, for [Cézanne], means transforming objects submitted to a number of [sensory] reactions. . . . The scrupulous observer sees that a house leans if the roadway descends, that a serving plate appears wider at the more illuminated end . . . [that] phenomena never repeat in the same way."[67] Cézanne became Cubism's absent-minded initiator, who chanced on his discoveries. Lhote argued that the shift from conventional perspective to a felt perspective applied to Picasso because he had learned "Cézanne's lesson."[68] The bottom line in 1929 for art historian Carl Einstein was similar: "The motif is no longer an objective thing separate from the viewer. . . . We cannot render the sensations of a table itself, but only our own sensations."[69] Braque had already reduced this line of thought to an aphorism, which drew a motivating sensation from the pictorial process: "The subject is not the object [represented], it's the new unity, the lyricism that derives wholly from the means."[70]

What can be concluded? At least this: Cézanne understood — not from theory, but from experience — that the circumstances of looking induced a primitive (unregulated, unrefined, coarse) technique, a way of painting that nevertheless proved inadequate to vision and every other sensation. As he realized in 1905, abstractions forced him to

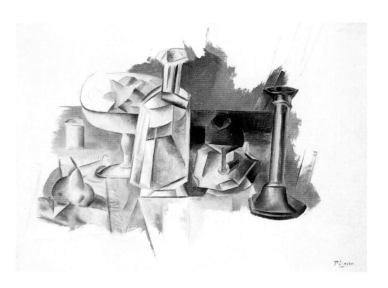

Pablo Picasso, *Carafe, Compote, and Candlestick,* 1909 (plate 79, p. 253)

Paul Cézanne, *Gardanne,* 1885–86 (plate 56, p. 230)

accept blank spots and unresolved details. One way or another, his art had to circumvent these points of failure without eliminating them. To the contrary, Picasso selected primitivistic effects and any number of other pictorial conceits as a conscious field of aesthetic and emotional exploration. His *Carafe, Compote, and Candlestick* (see plate 79) appears with the look of a process in suspension—deliberately. In Cézanne the analogous effect would be accidental, his having abandoned the canvas because of dissatisfaction, distraction, or moodiness. Unlike Cézanne, Picasso also used his imagistic devices as points of thematic, cultural reference.[71] He did learn "Cézanne's lesson": the motif lies in the painter's address to the painting. It opened doors for him, leading him where his putative master would never have gone. Ironically, we cannot be certain that Cézanne himself consciously assimilated this lesson, even though it was his.

Like Cézanne, like Picasso, Max Beckmann was committed to representational imagery. Early in his career, he questioned the looseness of Picasso's range of cultural reference, yet his own spatial devices and manipulations of the human figure resemble features to be seen in early Cubist art as well as in Picasso's classicism and Surrealism of the 1920s and 1930s (see plate 61).[72] Beckmann developed a certain procedural mannerism related to the oddly materialized space in both Cubist paintings and Cézanne's: He extended bits of what ought to have been a ground plane so that the ground—the paint-mark signifying it—obscured a fraction of the object or figure appearing in front of it. With respect to representing space as ordinarily conceived, this is a contradiction. Where similar situations occur in Cézanne, they seem happenstance, as *la perspective sensible* would entail, except when it becomes a deliberate program. With Beckmann, the effect indeed was self-conscious. In *Still Life with Musical Instruments* of 1926, the quirky pictorial device is especially obvious at the juncture of two tubular clarinets with the surface of the table beneath them (fig. 3.4). Paint strokes that continue the color of the table pass over the rims of the instruments, violating their integrity and the illusionistic continuity of the space. The marks read as paint on a canvas support rather than as the color or texture of a supporting table—mark-as-material rather than mark-as-image. In many of Beckmann's paintings, this feature becomes pervasive. He would subtly rework the edges of forms wherever one represented object lay in front of another. The edges or contours seem to waver, neither here nor there in the imaginary—or

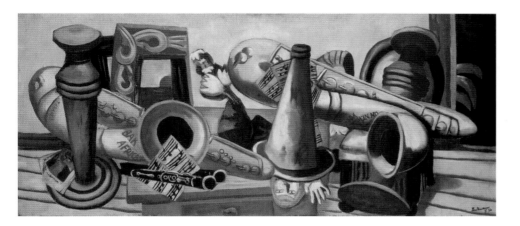

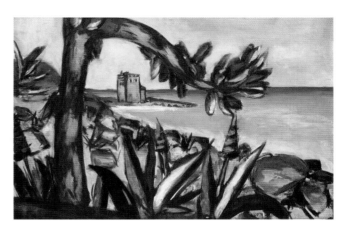

Fig. 3.4. **Max Beckmann** (German, 1884–1950), *Still Life with Musical Instruments,* 1926. Oil on canvas, 33½ x 76¾ inches (85 x 195 cm). Städel Museum, Frankfurt

Max Beckmann, *Seascape with Agaves and Old Castle,* 1939 (plate 108, p. 319)

real—space of the picture. These crucial edges approach and recede, then approach and recede, as if the entirety of Beckmann's picture, despite the characteristic angular breaks in its forms, existed in a fluid state: Compare the confusing play of vegetation and sand in the foreground of *Seascape with Agaves and Old Castle* of 1939 (see plate 108).[73] Affected by war, political persecution, and self-exile, Beckmann expressed anxiety through narrative themes of human tragedy; but there was also Cézannian anxiety in the ambiguity of his commitment to representational illusion. As in Picasso's case, "there is no abstract art"; yet Beckmann, like Picasso himself, approached the condition of abstraction with his blatant materiality. By using a coarse brush technique and building numerous contradictions into his illusionistic order, he asserted the presence of his process.

An astute observer, Lhote described Cézanne's practice in a way relevant to the kind of compromise between representation and abstraction that Beckmann and so many others (including Lhote himself) felt compelled to make: "[He] devised a stroke that . . . does not stick to the actual contour but captures its essential articulation, achieving a kind of overview."[74] As with Cézanne, Lhote might have said of Beckmann, he "shows his means." But Beckmann took matters only so far. He carefully preserved the overall legibility and order of his representational image. Like Picasso, he would have his illusion and destroy it, too: a double reality—the illusion of materiality (the clarinets, the agave plants) and a real materiality that violated this fictive illusion (bits of paint obscuring the clarinets, edges wavering between the agave leaves and the sand). In Cézanne, the two considerations—the order of the image and the order of the materials—often conflicted blatantly. To resolve the situation one way or another, critics such as Geffroy and Morice enlisted integrating concepts of "sensation" and "life"— intellectual abstractions that would eliminate a problem in living perception.

Beckmann maintained a referential or metaphorical reality (the order of his representation) and a literal reality (the material order of his paint). This coupling was not without tension, most likely one that attracted Beckmann to Cézanne in the first place. In 1912, referring to the "genius" of his predecessor, he identified artistic quality with the capacity to convey sensuality in every conceivable dimension; a modern artist would represent "the depth and gradation of space" as well as yield to "the fascination

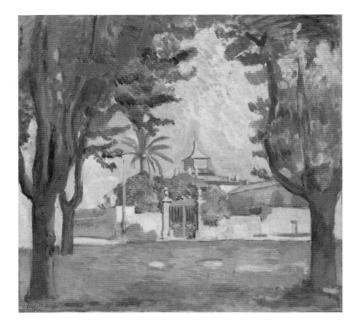 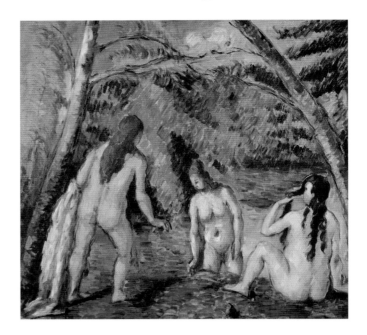

Fig. 3.5. **Henri Matisse** (French, 1869–1954), **Place des Lices, Saint-Tropez,** 1904. Oil on canvas, 20¼ x 21⅝ inches (51.5 x 55 cm). Statens Museum for Kunst, Copenhagen

Paul Cézanne, *Three Bathers,* 1879–82 (plate 10, p. 123)

of the material[,] the lushness of oil paint."[75] Beckmann wished to avoid converting the example of Cézanne into flat, decorative painting, as he believed many of his contemporaries, including Picasso, were doing at the time.[76] His dualistic technique — pictorial depth joined with painterly materiality — may or may not have been adequate to the modern problem of representation. In any event, the problem itself had been set up by Cézanne — or rather, by Cézanne's art and the twentieth-century perception of it by the likes of Picasso and Beckmann. Neither accepted the "pure" materialism of abstract painting as an answer.

"If Cézanne is right, I am right," Matisse often told himself.[77] What could *he* have been thinking? In 1899, he purchased one of Cézanne's small pictures of bathers and kept it with him until 1936 (*Three Bathers*; see plate 10). In 1943 he expressed his understanding: "I remember that everything there was set in order, that the hands and the trees assumed equal significance with the sky."[78] Matisse appreciated how the elements of Cézanne's representation became subtle but compelling variations of each other, as if moving to the same rhythm. Some of his early paintings make use of hatch marks that relate quite directly to Cézanne's method (see *Place des Lices, Saint-Tropez* [1904]; fig. 3.5). Cézanne's results, let alone Matisse's (said at the time to be "more Cézannian than Cézanne"), were not easy to accept, even among those open to aesthetic adventure.[79] Around 1900 or not long afterward, when painter Jean Puy first saw the picture of bathers his friend Matisse had purchased, its lack of differentiation troubled him; Cézanne had given the human figures no more articulation than elements of the surrounding landscape. The nudes seemed "formless" to Puy, lacking the sense of "youthfulness, grace, and sexuality" that would have contributed to an appropriate beauty.[80] His response was similar to those who complained that a face painted by Cézanne looked no more human than one of his apples.

Puy had a point. In Cézanne's *Three Bathers*, the leg of the striding figure at the left mimics the form of her towel (or vice versa), and both acquire the angle of the adjacent tree. Segments of sky assume the patterns of the trees and foliage. These combinations of marks link up with the figures, as if sequences of similar marks were passing through material and spatial barriers. Cézanne secured the connections by the directional force of individual strokes of color as well as by the coordination of composite shapes, which give no indication of having been planned to settle into place as they do. All of this might still have been seen as a sign of traditional compositional skill were it not

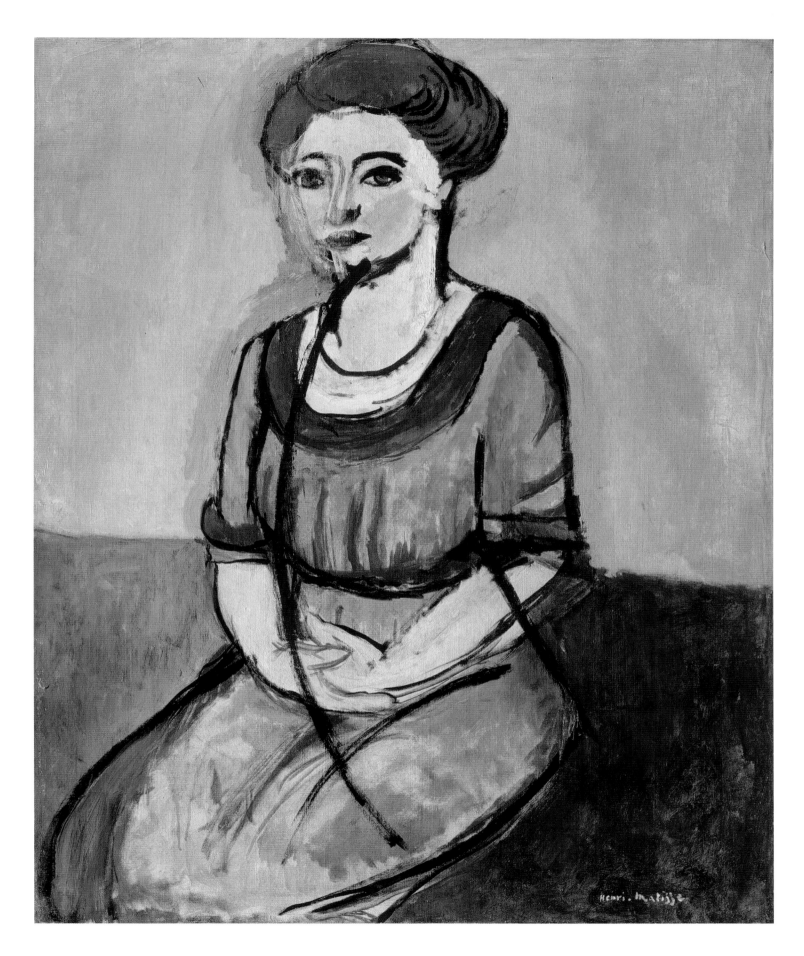

PLATE 3

Henri Matisse

Portrait of Olga Merson, 1911

Oil on canvas
39½ x 32 inches (100.3 x 81.3 cm)
The Museum of Fine Arts, Houston. Purchase with
Funds provided by the Agnes Cullen Arnold
Endowment Fund

for the way that the brushwork dominates each element of the representation—the painting appears to be of marks, not figures in a landscape. Cézanne's results struck a chord with Matisse's sense of experiential continuity. He recognized an affinity to the type of bond that Cézanne established not only between artist and work (by the material vigor of his paint application), but also, within the specific picture, between all parts of the image, each energized by the play of texture and color. This sense of continuity agrees with what Matisse said of his creative representation in 1908: "I cannot distinguish between the feeling I have of life and the manner in which I translate it."[81] For his *Portrait of Olga Merson* (1911; plate 3), he imposed broad, sweeping lines over the figure, which present it in graphic summary, as if to capture its pictorial feel in a gesture scaled to the artist's body. Matisse shared with Cézanne this quality of summary movement. Looking at the little picture of bathers, we imagine its construction as a sustained corporeal rhythm regulated less by the subject matter—is it classical? arcadian? romantic?— than by the material dimensions of the format and the physical capacities and inclinations of canvas, paint, brushes, and, most importantly, the human hand.

Chance Affinities

Like Matisse, several generations of artists acknowledged their affinity to Cézanne, identifying his art as their guide or source. When questioned, they sometimes justified their actions through an interpretation of his. In this respect, he slipped—or *was* slipped, at fortunate moments—into the historical currents flowing around him but not necessarily from him. Here, briefly considered, are a number of examples from among many.

During the 1910s, most of Giorgio Morandi's experience of Cézanne derived from black-and-white reproductions; this limitation did not prevent him from realizing the advantage of the mark-by-mark technique. It suited his inclination to a restrained yet fundamental materiality that would characterize whatever image he produced (see *Landscape* [1914]; fig. 3.6).[82] Cézanne, sometimes profligate in his marking, quipped that he expended tubes of pigment as if he were a Rothschild.[83] Even his watercolors could be surprisingly robust, given the physical delicacy of the medium (plate 4).

PLATE 4

Paul Cézanne

The Balcony, 1890–1900

Watercolor and graphite on wove paper
22¼ x 15⅞ inches (56.5 x 40.3 cm)
Philadelphia Museum of Art. A. E. Gallatin
Collection, 1943-75-1

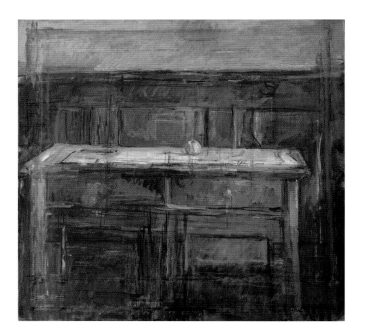

Alberto Giacometti, *Still Life with Apple,* 1937
(plate 134, p. 397)

Alberto Giacometti, *Diego in a Plaid Shirt,* 1954
(plate 133, p. 380)

Morandi, too, developed a density of surface within works that were typically modest in theme, format, and manner of marking. He learned from Cézanne's physicality but in his mature work cultivated a more varied touch, which he would nudge this way or that, giving a wavering character to the contours, surfaces, and backgrounds of his deceptively simple still lifes. Despite their subtleties, Morandi's strokes produce more of a direct kinesthetic effect than a description of the edges or textures of objects. In this sense, his marks remain Cézannian. But where they convey some of Cézanne's ambiguity, this amounts to a play on ambiguity, Morandi's reference to the unsteady character of sensation by marks securely placed and steady in themselves.

By comparison to Morandi, Alberto Giacometti, early and late, may be the more faithful to Cézanne, at least with respect to painting. His additive strokes accumulate only to connote a state of suspension, because other, similar marks might still be made. Giacometti's sculptural technique bears analogous results: sculpture bit by bit, in which the many slight protuberances and depressions at the surface of a figure correspond to a sequence of sensations that Cézanne would capture with his marks. Both faced the failure of representational systems to match immediate feeling. In Giacometti's terms, Cézanne's sensations become existential incidents. In 1957, he remarked: "For [Cézanne], the apple on a table is always far beyond any possible depiction. . . . But, rather than perceive the totally new aspect of his vision, people have seen a new way of painting."[84] Without quite approving it, Giacometti alludes to transferring experience from the situational space of the world to the space of a picture. The problem is that pictorial practice always threatens to become codified. Leaving it open, as both he and Cézanne did, was the only defense.

Marsden Hartley made trips to Aix in 1926 and 1927, renting the Maison Maria, one of Cézanne's studios.[85] Believing that the two painters were linked by "an association of fates," he took Cézanne as a model of anonymity—painting directed at expressing a vision rather than an ego, painting as far from codification as possible, including the codification of one's own personality. Hartley's aim was to "annihilate [himself] in the subject—to become one with it."[86] Like many twentieth-century painters, he remained committed to representational subjects but used a coarsened technique resulting in a nonmimetic abstraction of the means. Curator Alfred Barr's definition of

Marsden Hartley, *Mountains in Stone, Dogtown*, 1931 (plate 43, p. 183)

abstraction belongs to Hartley's American generation. It can accommodate representational subjects so long as the materiality of the rendering receives expressive priority. In 1936, Barr stated that abstract work "confines the attention to its immediate, sensuous, physical surface far more than does [representation]."[87] The definition remains open to exceptional representational painting that would be "immediate, sensuous, physical"—not a bad characterization of, say, Cézanne and Hartley. Cézanne's representational painting, Hartley suggested, had no thematics of real consequence, only feeling: "He felt this 'movement' in and about things, and this it is that gives his pictures that sensitive life quality which lifts them beyond the aspect of picture-making or even mere representation. They are not cold studies of inanimate things, they are pulsing realizations of living substances . . . ensembles of animation, orchestrated life."[88] Other writers would call such "life" an abstraction.

Erle Loran, another American, came to Aix around the time of Hartley's departure. He painted and photographed in the Cézanne landscape, and eventually used the experience as the foundation for an immensely influential study, *Cézanne's Composition*, published in 1943 and still in print. Aided by diagrams of counterbalancing planes and vectors, Loran analyzed the structural relations that he believed accounted for the power of Cézanne's paintings.[89] He wrote elsewhere that Cézanne "draws his vision into space" and "brings it back to the surface"—for Loran an effect of composition, but for others more likely a forceful effect of the mark.[90] Hartley praised Loran's understanding, particularly the value of his photographs, concluding that his study demonstrated "just how true Cézanne was to his nature—and how he understood the laws of each composition—producing the true rhythmic sensation of all of [a] highly original scene in nature."[91] Referring to the "laws of each composition," Hartley concurred with the way Loran shifted the presumed object of Cézanne's attention from the interaction of his external vision and internal emotions to the way he struggled to represent both of these forces in a painting that would be coherent in its own formal terms. Consistent with his analysis, Loran as a painter concentrated on the structural end of the process, as if accepting the general thrust of Cézanne's results rather than reliving the anxieties of his procedure. His *America at War* (1942; fig. 3.7) establishes its composition by repeating diagonals in both foreground (ships and docks) and background (bridge and

Fig. 3.7 **Erle Loran** (American, 1905–1999), ***America at War,*** 1942. Oil on canvas, 30 x 36 inches (76.2 x 91.4 cm). Collection of Jason Schoen, Princeton, New Jersey

distant hills)—the kind of integrative pictorial structure Loran promised to reveal in Cézanne, here hardly hidden at all.

Willem de Kooning understood Cézanne in terms of *la perspective sensible*: feeling the position of the form as a moving mark, rather than seeing it as a fixed image. "I think Cubism went backwards from Cézanne . . . [by] laying it out beforehand," de Kooning said in 1971. He ranked Cézanne's doubt ahead of Picasso's self-assurance: "You are not supposed to see it, you are supposed to feel it. . . . Cézanne said that every brush-stroke has its own perspective[,] its own point of view."[92] More power to the brushstroke: "Perspective" and "point of view" refer to both physical position and intellectual position. The words themselves indicate how physical sensation and mental judgment merge in experience. When we say "I feel," we often mean "I think." "I believe"—a mental state backed up by "gut" feeling—substitutes for both. Our inability to distinguish believing, reasoning, and feeling within the course of experience is a Cézannian problem. De Kooning was not afraid to deal with these ambiguities; they stimulated him.

De Kooning frequently drew from memory with his eyes closed. In a similar spirit, he also attempted to capture moving images that passed before him on television, keeping his eyes on the screen, not the drawing paper. His procedures led to eccentric results, as if each graphic detail were sensing and thinking for itself—an anarchy of feelings that freed the orientation of the mark from most of the constraints of the representational subject and its rectilinear format. As de Kooning felt his way around the image in the act of drawing it, using a tactile perspective rather than a visual one, his figures often shifted off-axis or hit framing edges abruptly, effects common in Cézanne, who had kept his eyes open (see plates 81, 143). Both artists sometimes jammed representational elements against the limits of their pictorial space, but with differing motivation. In Cézanne's case, the effect belongs to his thematic invention of studio compositions of bathers, where it extends the sensory motif: See the trees to the left and right in *Three Bathers* (see plate 10) or the tree to the left in *Bathers* (see plate 40); these elements respond to the pictorial format without referring to a particular site. In de Kooning's case, similar effects result from feeling an image—not seeing it—as it comes into being. An untitled drawing made sometime during the late 1960s or the 1970s shows a female figure, probably more active than stationary (fig. 3.8). De Kooning wedged this body against the top and right edges of its rectangle. This was not

Fig. 3.8. **Willem de Kooning** (born Netherlands 1904–1997), **Untitled,** c. 1965–80. Charcoal on ruled yellow paper, 12½ × 8 inches (31.8 × 20.3 cm). Courtesy The Willem de Kooning Foundation.

by design but by happenstance, as his drawing hand reached its enframing limitations. His remark from an interview of 1968 is relevant: "A model can take many different poses, but the only thing that counts is how the hand sets her on the paper. How she lives on the paper. I draw while she lives on the paper."[93] The woman, the model, has lost her independent identity; "she" exists for the artist as the drawing on the paper, the Cézannian motif. When de Kooning's hand ceases to feel urgency in its linear marks, his drawing is finished, regardless of how regular or complete it appears. With his "closed eyes" technique, he was confronting chance: "The results surprise me. I always learn something new from this experience."[94] Like Cézanne, he was only trying to catch up with what his senses were showing.

Ordinary representation (eyes open, television off) takes the view of an object situated at a distance, bringing the painter's touch to bear on the visual sensation. It might be argued that abstraction inverts the hierarchical order: It creates its object by material means, integrating distinct tactile marks to form a visual image. In 1977, Jasper Johns indicated Cézanne's centrality for understanding how visual representation and tactile abstraction relate. He observed of Cézanne's *Bather* (see plate 64) that it seemed to synchronize the two processes so that the difference hardly mattered: "It has a synesthetic quality that gives it great sensuality — it makes looking equivalent to touching."[95] Presumably, Johns observed that the represented body seemed present, yet the marks that rendered it were arbitrarily applied with respect to illusionistic consistency. For example, Cézanne let the fingers of the bather project outward as an independent pattern of touches, as if feeling this projection as much as seeing it. Analogously, when Johns uses arrays of marks to render planometric images such as flags, targets, and maps, the individual touches acquire qualities of spatial projection that have nothing to do with the flatness of the objects represented — they project touch for visual appreciation as much as they trace the image. In this way, Johns's maps hardly remain still; they become as animated by sensation as Cézanne's subjects, whether heads or apples.

Jasper Johns, *Map,* 1963 (plate 185, p. 479)

Jasper Johns, *Map,* 1962 (plate 187, p. 481)

With such a diverse group of artists extending his precedent ever farther, it seems that Cézanne had remarkable posthumous luck. Is luck a valid historical concept? Perhaps interpretation resorts to it only when incapable of providing a better explanation. Yet luck has its proper sphere of influence, operating in a different register from other types of cause. The more rational modes of explanation overgeneralize what a concept of luck or chance allows to remain specific. Those who receive the blessings of Tyche are all the more likely to remain in the historical record. In this sense, it may be that history inevitably brings more good fortune than bad. It will seem so because those who have been attributed cultural significance are the only ones lucky enough to remain in the record. As for the others—tough luck—they vanish. Luck becomes a self-justifying phenomenon. To have it, good or bad, is to deserve it. Yet we know otherwise, for luck by definition is the cause that has no reason.

Tychism, *Tychique*

There must be luck or fortune in life because chances are not always even. Any occurrence whatever has beaten the odds that it would never occur at all; so far, the events that never happened far outnumber the ones that did. Cézanne did not plan to be himself; the odds would be against it. Here, to advance the argument, is Paul Valéry, who chanced on the fate of mollusks:

> Viewed from the tip, there are few shells that spiral right to left, counterclockwise. To call *accidental* this inequality in directional preference merely restates that the condition exists. . . . We cannot fathom that certain originals among the mollusks take to the left what the others take to the right. . . . The production of the shell is a lived thing, not a made thing [*chose vécue et non faite*]: Nothing is more contrary to our articulated act, preceded by a goal and operating as a cause.[96]

To say that each mollusk spiral, right or left, is an accident explains nothing. More to Valéry's point (and Cézanne's), the mollusk builds its shell by living it, by experiencing life, not by making something that, to be made, would have to be conceived. What can be conceived can be altered purposefully. Not so the shell: The mollusk does not know its shell until it lives it. The thought of living *in* a shell, as if we might also live out of it, amounts to a fantasy of self-knowledge. This is our fantasy, not the creature's.

Cézanne's art was mollusklike; he lived it as it appeared to his senses. He and it were not separate, even though each mark was separate from the next, continuous but detached. His "tychism" is twofold. On the one hand, he was lucky in his historical

reception, lucky to become a resource for diverse types who would keep his art so current. On the other hand, his aesthetic achievement involved a certain element of chance, inherent in his process of painting. His respect for his own sensation compelled him to forsake available pictorial conventions that would have given him greater control over his results, making them more organized and predictable from the start, not only to him but to others. Often it seems that he hardly edited a scene. Rather than a plan or vision of the whole, the material barrier of a framing edge brings the painting to its close. A composition of fruit on Cézanne's table includes books in the upper left corner; they give the impression of entering the picture only because they were already in place in the studio (see plate 147).[97] With respect to portraits, critics remarked on the same: "The corners of the rooms that form the backgrounds . . . offer a striking collection of plastic accidents, scrupulously recorded."[98] The fragments of wallpaper pattern and decorative woodwork to the left of the figure in *Madame Cézanne in Blue* (see plate 111) introduce the kind of "plastic accident" and happenstance complexity that puzzled viewers. They had to choose between attributing the effect to "pure" vision or to willful contrivance. Whatever the case, to inspect the painting mark by mark (the way it came into being) is to see numerous Cézannian motifs emerge—continuities and analogies of form involving adjacent parts of the image. In the portrait, segmented strokes that define the wooden sideboard turn a gentle corner, change color, and become the shoulder of the figure's dress; elements of the collar connect to a lozenge from the wallpaper. Such effects are to be expected in compositional painting but not to the degree that they confuse the spatial illusion, as they do here. We imagine Cézanne concentrating on the painted surface to such an extent that he could not resist moving with its movement once the basic image had established a few points of compositional reference. He would then follow the rhythmic flow to right or to left, wherever—not by accident, but, like the mollusk in its shell, in the direction that living sensation seemed already to be going.

Some of Matisse's portraits integrate unrelated representational elements with a similar excess (see plate 13). Giacometti noticed what had been happening: "By establishing more of a relationship of the left ear to the background than to the right ear, [Cézanne] completely overturned the conception of the [representational] whole that existed before him."[99] This did not mean that painting after Cézanne became pure abstraction, rather that art had gained a new sense of realism. Like Johns, Giacometti

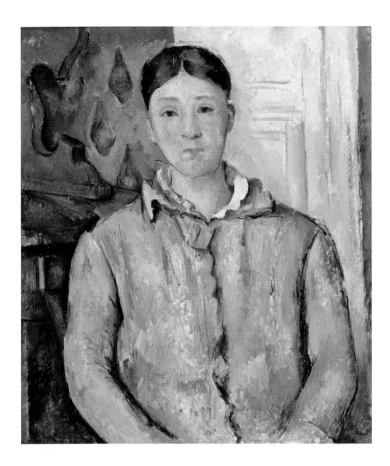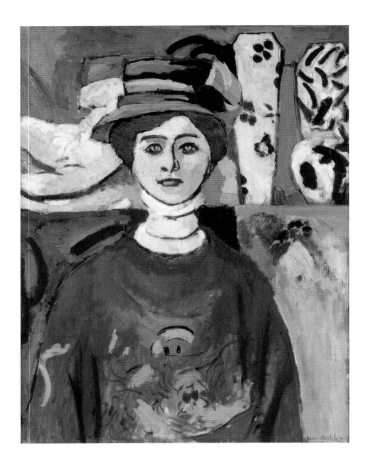

Paul Cézanne, *Madame Cézanne in Blue,* 1888–90
(plate 111, p. 322)

Henri Matisse, *The Girl with Green Eyes,* 1908
(plate 13, p. 126)

did not want to separate realism from abstraction, abstraction from realism. If we look for a tendency to this kind of synthesizing response, it is not hard to find; many resisted the categorical division. Joseph Ravaisou, a painter from Aix who belonged to Matisse's generation, had occasionally accompanied Cézanne on plein-air excursions around 1899–1900. He gave a eulogy for the deceased artist (published in January 1907), in which he noted the purity and intensity of Cézanne's blues. His thoughts of that color led to this: "[Cézanne] preserves what is immaterial in the [blue] atmosphere, taking farther than any plein-air painter the art of expressing abstractions. But these abstractions [correspond to] the amount of truth extracted from objects by the artist's vision. Thus, between the word *abstraction* and the word *realism*, the contradiction is only an apparent one."[100] To paraphrase: Cézanne presented features of the landscape in an intensified and perhaps reduced form, so the result was abstraction. But this was no fantasy: It was what the painter actually sensed and felt; it was reality. How should we take such a statement? It anticipates later views, but also represents an update of classical theory.[101] A mainline nineteenth-century text on aesthetics defined the classic moment: "It remained for the Greeks to marry the two elements, the ideal and nature, the purity of the essence and the charm of life. It remained to them, a thing unheard of, a thing forever admirable, to create living abstractions [*des abstractions vivantes*]!"[102] "Charm," as in "the charm of life," is not a surprising characterization: It connotes luck. Life is the location of luck, its situation. "Living abstractions" are not fixed essences, for this would be dead abstraction, like a geometric diagram. A living abstraction is changeable, subject to luck and historical fate.

In many instances, it seemed that Cézanne, like a camera obscura, filled his image with whatever fell within the field of his vision—dense with the charm of life, its vicissitudes and variations. But the mark itself had a different origin: It was repetitive, an abstraction. It was never as quick as the camera at recording the scene, however much the view may have motivated the mark: "I cannot reach the intensity that develops in my senses," Cézanne wrote in 1906, already at the end of his years of trying.[103] As I

have stated, the problem was to establish a method that would track the transiency of sensory experience, the range of qualities the senses presented, as well as the artist's changing emotional state, which might be confused (rightfully) with the state of the surrounding environment. Sensations and emotions are always there to be represented: in fast time, in slow time. There were days when Cézanne was deliberative—one of his young friends in Aix reported that the painter "sometimes remained still for twenty minutes between two strokes of the brush."[104] Renoir recalled that his old Impressionist colleague used paper flowers as a studio prop because live ones would fade faster than he could develop his painting.[105] Yet deliberation over the marks did not prevent Cézanne from shifting to impulsive and spontaneous behavior, perhaps an aspect of his futile attempt to keep pace. Bouts of self-criticism followed prolonged, intense engagement: "Cézanne at his easel, painting, viewing the countryside: He was truly alone to the world, ardent, focused . . . and sometimes he would [abruptly] quit the site dispirited, abandoning his canvas on a rock or in the grass."[106] On a good day, the direction of a painting might settle into a compelling rhythm. On a bad day, the process became unworkable. The changes in attitude, in behavior, and in the painting itself might occur for something less than an articulate reason, by a cause beyond logical reach—a feeling.

Chance, luck, is less than a reason and as hard to explain as the feeling you suddenly have. Most mollusks live to the right, some live to the left. Cézanne moved left and induced others to follow. I use the adjective *tychic*, a neologism, to describe his condition—both aesthetic and historical. This is in recognition of two theorists who introduced etymologically linked neologisms of this type. Their relation to each other and to me is accidental. The first of these figures is the American pragmatist Charles Sanders Peirce, who coined the noun *tychism* in 1892, deriving it from the Greek word for chance (personified by the Tyche of the ancient fragment "of men the beginning and the end").[107] In Peirce's philosophy, absolute chance is a fundamental principle. Given this, a certain historical accident seems like a stroke of luck: Peirce was born in 1839, and so was Cézanne. This, of course, leads nowhere. Coincidence and other forms of similarity are not causes; they explain nothing.

Peirce took chance as an answer to the question of the origin of life. He regarded sentient life as an organized form of disorganized, primordial feeling. His theory of the evolution of life had the advantage of requiring neither an external plan nor divine intervention. Instead, the order of the Peircean world would derive from a factor of growth implicit in the difference between spontaneity and habit, forces antithetical to each other. Regularity, the formation of habit, wherever it appears, is the result of its own mollusklike growth, the furtherance of its own tendency. Habits grow; they intensify; they breed more of the same. Spontaneity cannot grow; were it to repeat itself, it would fail as spontaneity.[108] So tendencies that arise spontaneously do not spontaneously reinforce themselves. It would be absurd to regard a living being as spontaneous and original in every instance, a personality split innumerable times.

How does Peircean evolution actually occur? It requires an organic mechanism to move the process from the chaos (the biblical *tohu bohu*) of endless differentiation to an inchoate order of similarities.[109] The mechanism is association, the linkage of like with like in an accumulating series of chance contiguities and alignments. From the slightest chance associations, self-perpetuating habits of conduct and the laws of nature result. For Peirce, the play of like-with-like accounts for everything: "The principle of evolution requires no extraneous cause, since the tendency to growth can be supposed itself to have grown from an infinitesimal germ accidentally started. . . . The first chaos

consisted in an infinite multitude of unrelated feelings. . . . In this chaos of feelings, bits of similitude had appeared, been swallowed up again. Had reappeared by chance. . . . Like had begun to produce like."[110] Peirce takes up his description of evolution at a moment near its origin but not at the very birth of mind and matter. His concern was with process, not beginnings: "You must not ask me what happened first." As he imagined it, so many diverse bits of feeling must have occupied the state of chaos—he called it a "powder of feelings"—that there would be no point in differentiating them by category; each would be a class of one.[111] Yet he also recognized in himself a sentient being allied with certain organic patterns and a capable interpreter of established cultural signs. Something had happened in the world, something was happening in the present, things were continuing, and he was participating in the movement. How it all began was hardly a pragmatic concern since the threshold of this evolution had long been crossed. He was living like Cézanne—among sensations, abstractions, bits of experience that could be separated out like marks on a greater surface.

Within the Peircean process of evolution, areas of continuity of feeling would appear, random intersections of likeness, one thing acknowledging its affinity with another—like the continuity of feeling that Matisse perceived in Cézanne's *Three Bathers*. In a draft manuscript composed around 1893, Peirce wrote: "The feeling at any point of space appears to spread and to assimilate to its own quality, though with reduced intensity, the feelings in the closely surrounding places. In this way, feeling seems to act upon feeling continuous with it."[112] He added the qualifier "though with reduced intensity" because every association of similars was a move in the direction of habit, regularity, and eventual stasis. The trick to Cézanne's painting—what made it so mystifying—was its capacity to develop likeness and continuity of the parts without perceptible loss of intensity of the individual elements, the marks. This consideration might explain an observation made by Renoir (similar to what Picasso later said): "He can't put two strokes of color on a canvas without it already being very good."[113] If each of Cézanne's paintings began spontaneously only to fall into habit and regularity, organizing itself, it remained the case that the resultant motif was specific to the space and time of the particular picture. Cézanne's regularity was tantamount to intensification, concentration, and profundity.

Peirce conceived of historical time as a regulatory feature of a world that was evolving from total chaos (beginning of time) to total stasis (end of time). Like Cézanne, he realized that there might be something contradictory or destructive about reaching the end of the creative process: "Deadened by the development of habit . . . the state of things in the infinite future is death, the nothingness of which consists in the complete triumph of law and absence of spontaneity."[114] You would not want the meaning of your life to be your death. In 1945, Merleau-Ponty published "Cézanne's Doubt," arguing that the historical course of an artist's life does not determine the meaning of the work. The life makes the work possible, but each moment of the work gives the life "a figurative sense" it would not otherwise have.[115] All is subject to change in relation to the artist's immersion in the sensations of the instant. Concerning Matisse, Merleau-Ponty remarked that rather than making an analytical decision as to which way to extend his stroke, the painter "brought his brush toward the line which called for it in order that the painting might finally be that which it was in the process of becoming."[116] With the bold, superimposed lines of his *Olga Merson*, Matisse snapped the more detailed elements of form into accord with the condition the picture in its totality was seeking (see plate 3). He stepped out of his picture to draw an abstraction of the shell he and the picture together were living.

Imagine this possibility: The Peircean bits of tychic similitude, the feelings that associate and link up with each other, are analogous to a painter's sensations—Cézanne's, Matisse's. The evolution of these feelings parallels the greater evolution. Chance determines the order of occurrence of the painter's sensations in space and time; we do not choose what we feel, whatever presents itself to us in the form of a feeling we endure. But the painter's established habits of mind—predispositions of feeling more than of thinking—set these sensations into rhythms and patterns, producing the semblance of a meaning, a clue for others to recognize. It is merely a semblance, because the meaning resists translation and dissemination: Cézanne's art, Sérusier insisted, "cannot be described with words."[117] When Cézanne painted with discrete strokes of color laid down one after another, it was a case of like-with-like—a red beside a blue beside a green, mark to mark to mark, all very Cézanne and yet anonymous, as if the marks were elements of pure matter. Peirce believed that matter and feeling were polar extremes of a single dynamic. Feeling must have its material foundation, just as pure matter would possess at least some slight feeling.[118] Cézanne's painting brought the qualities of objects and environments into contact with the qualities of feelings, crossing the divide between traditional concepts of representation and abstraction.

As I indicated, the tychism in this essay has a second source: the mid-twentieth-century psychoanalytic theorist Jacques Lacan. *Tychic* is the English translation of Lacan's French term *tychique*. Lacan introduced this neologism in 1964, deriving it (like Peirce with his *tychism*) by allusion to the Greek figure of demonic luck or fortune.[119] A tychic element or event in life is a chance encounter that proves significant, an interaction with an object through which the human subject recognizes the projection of its own subjectivity, its desire. The tychic encounter—tychic, because the object can be anything, anywhere, a universal surrogate—facilitates the externalization of feeling, as in an act of painting. A mark of paint can be the tychic object. When painting, artists project something of themselves outside themselves to recognize their feeling. Simultaneously, the painting becomes a source of that state of feeling—an independent, alien source, not a mere derivative. As an example, Lacan used what he knew of Cézanne, much of it from reading Merleau-Ponty. "The little blues, little whites, little browns of Cézanne . . . fall like rain from the painter's brush [and each] brushstroke is something in which a movement is terminated [producing], behind it, its own stimulus."[120] Each distinct brushstroke, as one follows another, shows Cézanne what he is trying to see, what he wants to see, which is something other than what his conscious intellect, with its cultural indoctrination, tells him he ought to see. A work of art surprises its own creator. Its relationship to the historical trends appropriating and containing it is dicey. Nothing guarantees a fit.

Surviving History (from the Beginning)

Cézanne left his mark—on Matisse, on Picasso, on history—because the prevailing critical generalities of the early twentieth century and beyond could be adjusted to fit his case convincingly. Geffroy, for example, compared him to a "primitive soul concerned with the truth."[121] This aligned the bourgeois, socially conservative Cézanne with the sense of authenticity that more rebellious types exemplified—Mauclair notwithstanding, admirers of Isadora Duncan, such as Leo and Gertrude Stein, could appreciate Cézanne as well.[122]

According to Lecomte in 1899, the flow of fortunate ironies began relatively early: "During the heroic years of naturalism, [Cézanne's] signs of awkwardness were most appreciated. . . . [He] was allowed mistakes committed in ignorance, which he would

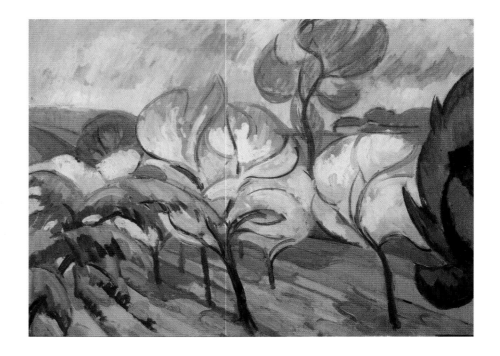

Fig. 3.9. **André Lhote, *Flowering Trees,*** 1908. Oil on paper, 23⅝ x 31⅞ inches (60 x 81 cm). Musée National d'Art Moderne, Centre Georges Pompidou, Paris

have wanted to be able to avoid."[123] The faults were to be excused as evidence of a welcome gesture toward recording immediate sensation, an aim of naturalist-Impressionist practice. Today, we would hardly regard as awkward or mistaken the interlocking rhythms of strokes within Cézanne's figure compositions—for example, the range of effects that attracted Picasso to *Five Bathers* (1877–78), which he added to his personal collection in 1957 (see plate 70). But the terms of the evaluative discourse were quite different in 1899, at the beginning of the period of aesthetic development that historians would later say Cézanne inaugurated. At least within certain circles, Cézanne's luck was continual; Lecomte argued that the "lack of spatial depth" evident in his landscapes acquired a favorable light with the vogue for a simplified, abstracted, Symbolist style. Then, with a renewed interest in the early Italian Primitives, "Cézanne was hailed as a precursor. People liked him for his imperfections, as if he were committed to them, while with all his strength, he was trying to escape them." In summation, Lecomte resorted to invoking tychic fate: "At two successive stages of [modern] art, it was Cézanne's strange destiny to be praised less for his [good] qualities than for his failings."[124]

The success—if this is the suitable word—became a true fashion. In 1910, Lecomte wrote that there were "at least two hundred painters trying to pastiche Cézanne."[125] In 1920, Lhote noted the prevalence of the Cézanne stroke: "Every day I see featured in the display windows . . . still lifes and landscapes constructed from hatch marks, with Cézannian pretentions."[126] He might have confessed to the weakness himself, for his early work had indulged in this feature (fig. 3.9). "Lhote does Cézanne," his dealer Clovis Sagot had said in 1908, worried over the fact that "the whole Salon d'Automne was full of Cézanne from top to bottom."[127] Still later, in 1939, writer André Suarès confirmed the continuing prophecy: "Cézanne generated a revolution: He reconciled the future with the tradition. . . . For the past four decades, all modern painting, good or bad, in every country, has issued from and depended on Cézanne."[128] And in the same year, Denis, one of Cézanne's strongest champions at the initial stages of his acceptance, joined in again, but with tychic irony: "The fate of Cézanne is to have been the slave of nature and the model"—that is, he was an objective realist—"and at the same time to have authorized every audacity, every abstraction, every looseness, every schematism, and to have fathered generations of improvisers who believe irrationally in a lack of finish."[129] These were not Cézanne's faults; they only became his mistakes when others appropriated his manner.

Paul Cézanne, *Still Life with Fruit Dish,* 1879–80
(plate 84, p. 270)

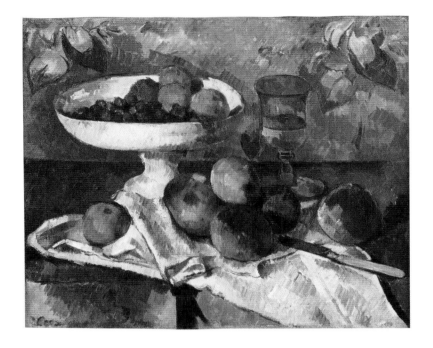

If the Cézanne habit must have formed first in some chance affinity, it was through Paul Gauguin, whom Sérusier identified as leader of the initial Cézanne following.[130] Gauguin became involved with Cézanne's methods in 1881 when his artistic mentor Camille Pissarro (who a decade earlier had mentored Cézanne) facilitated their working together on landscape views around Auvers and Pontoise. Gauguin then introduced his understanding of Cézanne to younger artists in his orbit, including Sérusier and Bernard, who began to mythologize their source of inspiration. "He opened to art this amazing door," Bernard said, "painting for itself."[131] Gauguin spoke also to sympathetic writers, Morice for one, and to whoever else was willing to look and listen.[132] Sérusier, returning from a summer campaign with Gauguin in 1888, passed his new understanding on to Denis. Two years later, Denis developed it into a radical conception of painting. He argued that the meaning of a work depended first on relations of form and color, and only secondarily on considerations of genre, narrative intent, and other thematic factors. Upon Gauguin's death, Denis reported the essence of his teaching as Sérusier had conveyed it: "Does the shadow look rather blue? Don't be afraid to paint it as blue as you can."[133] It was a license to exaggerate or distort normative appearances for the sake of emotional expression.[134]

Denis captured some of this thought in his own most commonly quoted statement, his definition of painting as "a flat surface covered over with colors arranged in a certain order."[135] But the crux of the matter was to locate aesthetic expressiveness, and a second statement is more to the point: "From the canvas itself, a planar surface, endowed with colors, emotion springs forth, bitter or consoling."[136] Denis and Sérusier understood that Cézanne's art (not necessarily Cézanne himself) had inverted the conventional aesthetic hierarchy, displacing thematic or conceptual content with material or sensory content. Perhaps their translation of Gauguin's lesson transformed it into something too principled and stable, removing the mystery of Cézanne that was Gauguin's obsession. He had seized on his encounter with Cézanne's mark as his fated tychic moment. This attention made Cézanne uncomfortable and provoked sarcasm in return. "I had a little sensation, just a little, little sensation," he told Monet in 1894, "but it was mine. One day this guy Gauguin, he took it from me."[137] There was material truth to this irony: Gauguin had become the owner of several Cézannes, of which his favorite was a still life of apples. Using it as his example, he gave impromptu lectures on Cézanne's unreserved use of color, accentuated by his separate, parallel strokes of the

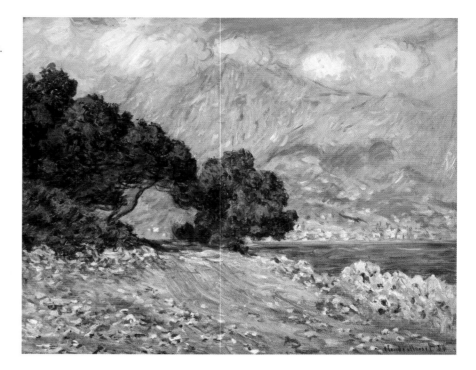

Fig. 3.10. **Claude Monet** (French, 1840–1926), *Cap Martin, near Menton,* 1884. Oil on canvas, 26½ x 32⅛ inches (67.3 x 81.6 cm). Museum of Fine Arts, Boston. Juliana Cheney Edwards Collection, 1925 (25.128)

brush.[138] This was the "sensation" that Gauguin "took"—not so much the color, but its process of application—the dynamic of Cézanne's mark.

If Gauguin had a eureka moment, it probably came in early summer 1884 when canvases by Monet, the most successful of the Impressionists, as well as others by Cézanne were simultaneously available in Paris—Monet could be viewed at the Durand-Ruel gallery, Cézanne at the shop of his paint merchant Julien Tanguy.[139] In a note to Pissarro, Gauguin suggested that Monet's "stunning execution" would be his downfall, that his superior technical accomplishments were "dangerous" with respect to the future of his art.[140] Gauguin was thinking of works similar to *Cap Martin, near Menton* (fig. 3.10), in which Monet used a variety of loosely related strokes that change direction, flow, and pressure according to the substances represented: vegetation, rock, earth, water, atmosphere. Monet's facility, his gestural finesse, distinguished him from Cézanne, whose mark by comparison must have seemed repetitious and plodding.[141] This difference sparked Gauguin's insight, allowing him to perceive the risk factor in Monet's Impressionism, not likely to work to his benefit: The technique was ripening into its own perfection. Monet's refined hand-and-wrist action bore his art along. He was indulging in his skill, drifting into mannerism, becoming ever more removed from the raw emotional force of sensory experience that should otherwise have remained his aesthetic foundation.[142]

Gauguin applied this distinction to himself: His art was like a primitive language spoken without inflection, a rusticated wall built without mortar.[143] Probably during summer 1884, the time of his Monet-Cézanne intuition, he painted *Clovis Asleep*, an interior scene that includes a fanciful group of images set against a mottled background wall, as if papered with an irregular pattern of curving forms (fig. 3.11). The side-by-side orientation of the separate strokes that constitute the curves does not correspond to their linear direction. Gauguin was exposing himself to Cézanne's disturbance: His figurative representation and his literal mark were now in conflict. They would strike a balance one way or another, depending on the prominence of the mark relative to the more general image. But the judgment of such a balance—how aggressively apparent a mark should be—was not something that could be definitive. It would depend on the habits of viewing and standards of critical evaluation in force at a particular time. Mauclair, for one, facing Gauguin, Cézanne, and rampant "primitivism," referred it all

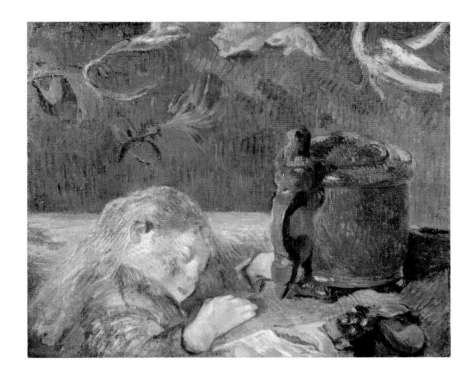

Fig. 3.11. **Paul Gauguin** (French, 1848–1903), *Clovis Asleep,* 1884. Oil on canvas, 18⅛ x 21⅞ inches (46 x 55.5 cm). Private collection

to the vogue for "anti-virtuosity"; resisting this fashion, he found the coarse surfaces of Cézanne's still lifes "repulsive."[144] Braque later took up the idea from the other side, contrasting Édouard Manet's talent and finesse to Cézanne's lack of the same; it was Cézanne who triumphed.[145]

Cézanne was repulsive (Mauclair); Cézanne was beautiful (Sérusier).[146] His apples approximated a circle in their profile, yet their constituent marks might be vaguely rectilinear, lining up in ways that undermined the integrity of the imagined spherical volume. The marks of the leftmost piece of fruit in *Five Apples* (see plate 168) respect the rounded contour but are layered like shingles and stacked like bricks. Cézanne's angular dabs are extraordinarily assertive—too bright, too red, or too green to coalesce into apple-like skin. "He makes apples his own," a critic wrote in 1895, offering a sympathetic explanation.[147] The visual illusion of an apple remained, but by unexpected means, either to be associated with the idiosyncratic temperament of the artist— Cézanne as a romantic naturalist or Impressionist—or to be associated with the material practice of art itself—Cézanne as painter of red, green, faceted abstractions.

Gauguin believed that Cézanne's technique would convey a surplus of feeling beyond what the nominal subject might indicate. What counted above all was the force of the painter's color, his "intense blue and astonishingly vibrant red . . . drawn from the imagination as much as from reality"—or, in words Gauguin applied to his own art, "unblended colors, set one beside the other . . . green against red."[148] "Is the sycamore sad because we place it in cemeteries," he asked; "No, it's the color that's sad."[149] The notion that emotional content might be set free of the identity of the representational subject of a picture—the expressive mark or color disjoined from the connotative theme, the deep green of the sycamore distinct from the association of this tree with the grave—proved critical to much that would happen later. One of Gauguin's pronouncements epitomizes his argument as well as any other: "Emotion first! Understanding to follow."[150]

Denis credited Gauguin for recognizing an autonomous beauty in Cézanne's material technique and understanding its "primitive" and "abstract" implications.[151] He too admired Cézanne's paintings for the aesthetic priorities he associated with them. As years passed, however, his French nationalism led him to attempt to defuse aspects of overcharged emotion that he believed others were deriving from Cézanne's abstraction.[152]

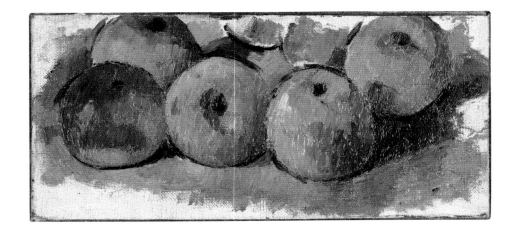

He came to link Gauguin's sense of Cézanne to a fashionable taste for German Romanticism—"whatever is simple, primitive, wild." Denis implied that this variety of romanticism was as French as it was German, at least as personified in Gauguin. Yet the German end of it had been taken too far, especially in the view of Denis writing during wartime in autumn 1914. He included his earlier self as having fallen into a certain cultural trap: "The influence of these [romantic] ideas reached its maximum in France in Gauguin's era [the 1890s]. Assuming an almost animal meaning, the notion of instinct replaced that of genius, and everything that was not rude, infantile, coarse, and even uncouth seemed to merit our disdain."[153] Through his evolving interpretation, Denis reformed Cézanne by substituting rational order for his rudeness and wildness. To a Cézanne who had lost too much of the "subject," a Cézanne whose "motif" threatened to revert to chaos, Denis restored the rule of art. He worked to eliminate Cézanne's extremes from his analysis so he could re-create him as a moderating "classical" force in culture. Cézanne would then counterbalance many of the same artists he had influenced—Expressionists and Cubists who Denis believed had become entirely subjective and abstract, losing their grip on objective nature (too German, in other words). An essay of 1916 names Matisse, Braque, and Lhote as contributing to this aesthetic decline: "By each one outdoing the next, by abuses of theory, by the lack of traditional craft, painting has evolved toward the limits of abstraction."[154] Abstraction, once Denis's interest, had become an extreme to avoid.

Premonitions of the relatively conservative position Denis would take in the 1910s appear in his brief review of an exhibition by Charles Guérin, published in 1905 while Cézanne was still living. Guérin, now largely forgotten, was among those who adopted Cézanne's mark (fig. 3.12). Denis stressed how far Guérin removed his painting from mimetic naturalism and objective observation. To us, this is surprising because the mark in Guérin's hands generated conventional representation. A contemporary critic described his still lifes as "modeled in the traditional way [but], with regard to how the paint is worked, recalling the influence of Cézanne."[155] It must have been the self-evident presence of the mark—for Denis, the preeminent cultural indicator—that placed Guérin's art within the category of abstraction. Denis wrote in conclusion: "Despite the statements of naturalists and vitalists, it's surely toward the abstraction of Beauty that all the arts are headed." The tendency toward abstraction, both intellectual and sensual, constituted a response to the loss of stimulation in the everyday environment: "Our streets are chillingly ugly, our domestic interiors banal. . . . The police suppress every form of fantasy within social life."[156] Painting's animated mark returned passion to this depressing existence. Within a few years, however, Denis was intent on reducing the range of overt signs of expression that were acceptable. Cézanne survived the cut. The crux of the defense Denis offered might seem like double-talk: Cézanne never "com-

Fig. 3.12. **Charles Guérin** (French, 1875–1939), *Two Girls on a Terrace,* 1903. Oil on canvas, 57⅞ x 51⅝ inches (147 x 131 cm). Pushkin Museum of Fine Arts, Moscow

promised [his art] with any abstraction," that is to say, any theoretical or conceptual abstraction. Yes, he had abstracted his means from his subject matter, drawing the two apart. But he never divided the means from his sensation, his contact with nature.[157]

To relieve feeling from the yoke of convention, custom, and propriety: This was the early modern artist's anti-ideological aim. Art, a vehicle of culture, would also be its counterforce. It would combat the claim that the dominant cultural forms prevailed by right because they represented the natural order. The means to expressive liberation for the individual and to cultural liberation for the society would be material as much as conceptual, an intuitive gesture in color. Resisting clichés and ill-considered beliefs, a painter could concentrate on the physical, sensory aspects of nature, the depth of emotional life, and ultimately on the material marks that would register all human feeling. Which marks were the ones to make? This was a question for social and political debate as much as for aesthetics.

Feeling

From the close of the nineteenth century and continuing throughout the twentieth, critical analysis took a phenomenological turn to make its case for the choice of Cézanne's mark. (A shorthand definition of phenomenology: the study of how situations feel.) Gauguin's thoughts on the emotional valence of color touched on a philosophical "paradox of feeling": We simultaneously perceive the sensory qualities of an object and feel an emotion, as if this internal feeling were arising because of external conditions.[158] If feeling passes, outside to inside, like a flow of energy, we can work to identify the cause and regard the feeling as its effect. But we cannot be certain that our emotion arises because we sense an external object. The object might appear as it does because we happen to feel a certain emotion. When Lhote complicated the notion of perspective by opposing the old intellectual version to the new sensory or felt version, and when Braque distinguished representing a thing from experiencing or living it (*la chose vécue*), their statements resonated with phenomenological and existentialist thinking, including Bergsonian and Nietzschean traditions.[159]

Much of Cézanne's success with critics came because they perceived his art as the effect of pressing psychological and social causes. Although many artists were fascinated by technological progress (Cézanne not among them), art often became the refuge for those dismayed by increasing industrialization, commodification, and technocracy. The British critic Clive Bell viewed the problem of visual expression much as Gauguin had: "To us it seemed, in those days [around 1903–4], that a mass of scientific irrelevancies and intellectual complications had come between the artist and his vision, and, again, between the vision and its expression. . . . Professional painters . . . had at their fingers' ends a plastic notation that corresponded with the labels by which things are intellectually recognized. They neither felt things nor expressed their feelings."[160] Can a person think in discrete categories while feeling in wholes? Or does thinking reduce feeling to a limited number of expressive signs—markers of accepted categories of feeling?

We know that Matisse prided himself on integrating his expressive faculties and feelings: "I cannot distinguish between the feeling I have of life and the manner in which I translate it."[161] Yet he did not paint in order to have an emotional life; he painted because he had feelings that merited being painted. "But if one hasn't always emotion. What then?" he was asked in 1912. "Do not paint," he replied.[162] Though neither Bell nor Matisse pushed the phenomenological account of aesthetic experience as far as Merleau-Ponty or Lacan, they did identify the core problem of their time: feeling. Asked around 1920 why he liked a drawing by Vincent van Gogh, the British painter Augustus John replied, "No drawing, but feeling."[163] The radical aesthetic solution was to eliminate science, intellectualism, and learning. In 1923, critic Gustave Kahn recalled that during the previous four decades many technically sophisticated painters had been drawn to their opposite, "charmed by the sight of a work in which feeling replaces technical skill."[164] Kahn was alluding to Henri "le Douanier" Rousseau, whose naive painting style first received notice in 1886. Its attraction was analogous to what Gauguin had seen in Cézanne two years earlier.

While Cézanne was still living, as well as long afterward, his example led critics to raise an issue their rational language was ill-suited to pursue: prelinguistic, preconceptual, primitive feelings. Twentieth-century writers tended to make a disclaimer, as here, with the opening sentences of an essay of 1934 by Barr: "Words about art [move] through the back door of the intelligence. But the front door to understanding is through experience of the work of art itself."[165] "Feelings," Delaunay wrote, "out-perform methods. Cézanne was always searching for his method."[166] Feelings "out-perform" because they are "front door" and utterly specific. Methods have a logic; this makes them too general for the absurd particularity of feeling. The material response to a feeling would have to be just as specific to the situation as the feeling. Perhaps Cézanne was seeking a method for experience itself, as opposed to a method for painting this or that. He needed a new concept and a new word for what he was already doing.

It helps to make the type of distinction that Lhote made in 1920. On the one hand, there are the identifiable, measurable properties of an object; these amount to a set of conceptual fundamentals. On the other hand, there are the immediate conditions of the interaction of an object with a human viewer, as if no concepts applied.[167] There was a difference between Cézanne's Château Noir (plate 5) as it existed as a conceptual entity and how the building presented itself in actual experience, a difference basic to phenomenology. Most likely, Cézanne preferred the land surrounding the Château Noir as a site for painting because it was wild, virgin forest, never cultivated or cut; he may have believed that its sensations matched the force of his own.[168] The question of

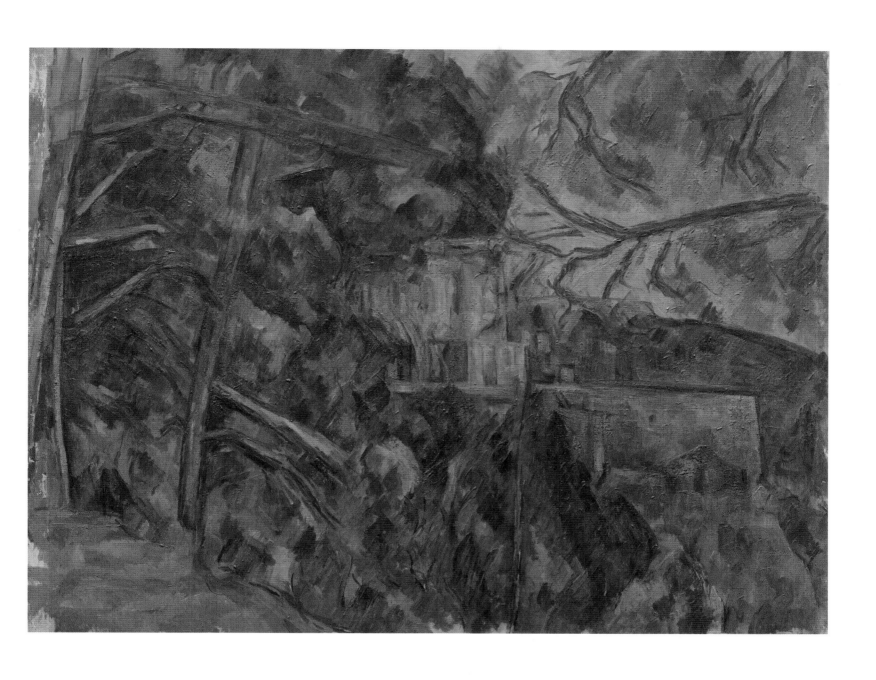

PLATE 5

Paul Cézanne

Château Noir, 1900–1904

Oil on canvas
29 x 38 inches (73.7 x 96.5 cm)
National Gallery of Art, Washington, DC. Gift of
Eugene and Agnes E. Meyer, 1958, 1958.10.1

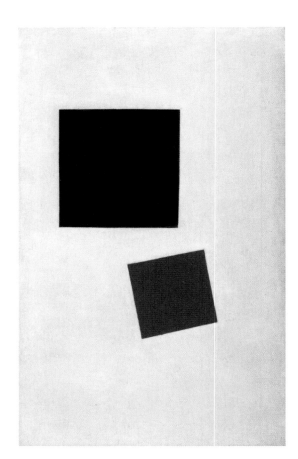

Fig. 3.13. **Kasimir Malevich** (Russian, 1878–1935), **_Pictorial Realism of a Boy with a Backpack,_** from the series _Masses of Color in the Fourth Dimension_, 1915. Oil on canvas, 28 x 17⅞ inches (71 x 44 cm). The Museum of Modern Art, New York

identifying with a natural site motivates an exchange recorded by the poet Joachim Gasquet, the son of one of Cézanne's boyhood friends. Little should be accepted verbatim, yet Gasquet's text captures issues of plausible concern to the painter. It poeticizes Cézanne's thought, which becomes phenomenological and pantheistic (and worthy of Gauguin): "In a [vision of] green my brain flows along with the sap of the tree. Moments of conscious awareness of the world live on in our paintings."[169] A more journalistic writer, Gustave Coquiot, invoked the same pantheism more succinctly: "Cézanne adds his soul to the soul of things."[170]

On his part, Lhote suggested that a thing in its measured precision and stability, _exactement_, was not the thing in its reality, _réellement._ Feeling constitutes a person's reality: "The physical object no longer matters where there is instead only a single object in view: the emotion born in the sensation [from] contact with the object, its pretext."[171] In Cézanne's art, reality seemed to pass from the objective thing—no matter what it was, just a pretext—to the subjective effect, that is, the affect, the emotional experience of the painter. Object and subject would converge in feeling. As Cézanne rendered it, the Château Noir as solid architecture lost ground to the Château Noir as feeling, which would entail a difficult act of translation: "For whoever experiences a profound emotion, the mere statement of the fact is insufficient."[172] You cannot capture a feeling by talking about it or by reducing it to conventional visual signs unless it is the feeling of talking or the feeling of signs.

Art as Itself

> Before 1915 no form, color, surface, anything, existed as itself. The main development in painting in the nineteenth century is toward the independence of these things. . . . I liked Cézanne's paintings a great deal, and still do finally. But [I had to] wonder what the forms would be like not crabbed by the figures and trees.
> —DONALD JUDD, 1974[173]

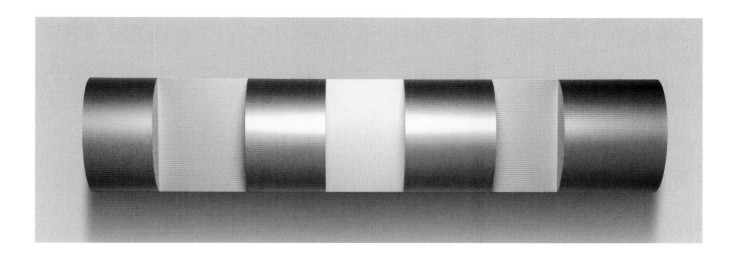

Fig. 3.14. **Donald Judd** (American, 1928–1994), ***Untitled (Yellow),*** 1974. Anodized aluminum, 25½ x 76½ x 14½ inches (64.8 x 194.3 x 36.8 cm). Philadelphia Museum of Art. Gift (by exchange) of R. Sturgis and Marion B. F. Ingersoll, 1996-69-1

Cézanne may have staked out a materialist future with his art of intensified feeling, but no understanding of present conditions controls destiny, able to predict its turns. In 1974, Donald Judd—creator of "minimalist" objects, spare yet sensually luxuriant—reviewed an exhibition of Kasimir Malevich's radical abstractions (fig. 3.13). He realized that the fact of Malevich's achievement by 1915 necessitated a reassessment of Cézanne's materiality. By comparison, Cézanne's effects no longer seemed so pure nor bore the same historical force, at least for Judd. "I liked Cézanne's paintings a great deal," he wrote, with a tone indicating that their era had passed. Their "form, color, surface" did not quite meet his criterion for valid aesthetic experience; these sensory entities were not themselves. He fantasized a remedy: no figures, no trees—a Cézanne of the pure mark. This Cézanne did not exist for Judd, though he may have existed for others—perhaps for Picasso, who only three years previously, in 1971, had rapped his knuckles against Cézanne's pictorial sea "solid as a rock," regarding it "as itself."[174] Cézanne had turned water into stone. No, he had turned blue paint into a very solid blueness. Judd, from his perspective of the 1970s, might have argued that Cézanne indeed represented blueness by means of blue but compromised the results by requiring water as an imagistic reference.

Judd held his critical view of Cézanne because he was more extreme in eliminating thematic distraction from aesthetic experience than were most who preceded him in the modernist tradition (fig. 3.14). The thinking of Braque, Giacometti, and others favored sensation over subject matter, but they would hardly dream of removing "the figures and trees" from the *Large Bathers* (see plates 66, 203). Because Cézanne's abstractions occurred in the context of representational painting, a certain pragmatic fact should be acknowledged. Every mark relates not only to the physical format and to a succession of similarly structured marks, but also to elements of the representational content, those features that Judd would have eliminated. Every representational mark has its scale, its resolution factor. When the mark is large relative to the pictorial field, the representation may seem crude and coarse, as Cézanne's did. This effect becomes all the more evident when the mark is unvaried, as opposed to being altered to suit the contours or textures of a represented object. A circular form constructed from vaguely rectilinear marks—some of Cézanne's apples, though not all—might seem serrated at its visible edge. Do we misapprehend the situation if, looking from a distance suited to the size of the picture, we see angularity where we know we should be perceiving curvature? Traditional practice ruled that paint marks should respect the scale of the image, a safeguard against perceptual ambiguity: "The touch should be broad in large works and fine in small works."[175] This correspondence would allow the materiality of the marks to recede from view without sacrificing their efficient deployment.

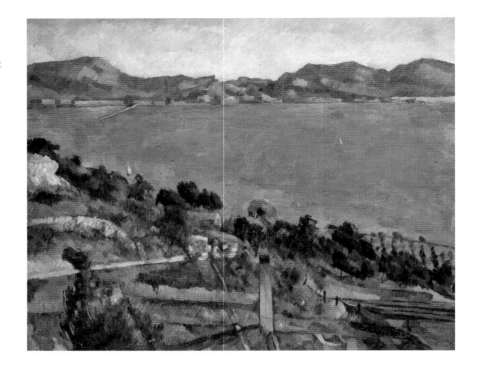

Cézanne's painting persisted in dividing medium from image. Yet, because the image often acquired the properties of the mark—a faceted and even blocky-looking apple, a fragmented sky—the effect was to challenge twentieth-century viewers to experience the two aspects as one. *This* would be a case of art "as itself"—art beyond the usual categories and words that would distinguish its separate aspects. For every viewer who saw Cézanne's repetitive marking as imposing an abstract order on pictorial naturalism, there was another who saw it as an unmediated expression of nature. The trick would be to move beyond such divisive classifications as realist representation and material abstraction. Cézanne's mark belonged to both.

My comments on the twentieth-century artists already discussed have indicated their sensitivity to the ambiguity of Cézanne, a quality we would do well to preserve. At the very least, he was lucky in having stimulated differences of opinion, assuring that he would not be reduced to a single line of dogma. Brice Marden expressed the continuing ambiguity in 1970: "There's a big difference between being realistic and depicting realistic subject matter [merely referring to the real]. . . . I think Cézanne was painting, and not painting anything, just painting."[176] "Just painting" may be another way of saying art "as itself." Marden's statement implies that Cézanne's act of abstraction (just painting) was his realism—a position similar to Ravaisou's in 1907, when he concluded that the difference between abstraction and realism may lie only in the words. On a visit to Paris in 1974, Marden confirmed his opinion; he noted the "airy weightiness" of the blue plane in Cézanne's *Gulf of Marseilles Seen from L'Estaque* (1876–79; fig. 3.15). This was much the way Ravaisou thought of Cézanne's blue, and perhaps Picasso as well, when he referred to the similar work in his collection. Marden made a note to himself to "do a big heavy sea painting."[177] With Cézanne in mind, he sketched a rectangle and bisected it horizontally to represent sea below, sky above (see fig. 18.4). He used cross-hatching to darken the two planes, investing them with his sensory energy, giving them "weightiness." Adjacent to another drawing of a similar type (from *Suicide Notes* of 1972–73), Marden wrote: "Planes made of planes, diminishing planes, molecular, Cézanne plane study."[178] It seems that he marveled at the way Cézanne's mark could mark nothing of naturalistic, thematic, or conceptual consequence—a plane constituted of other planes, an abstraction marking itself. Marden's *Grove Group* paintings, a set of large abstractions from the mid-1970s, derive

Fig. 3.16. **Brice Marden** (American, born 1938), *Grove Group IV*, 1976. Oil and wax on canvas, 72 x 108 inches (182.9 x 274.3 cm). Solomon R. Guggenheim Museum, New York. Purchased with the aid of funds from the National Endowment for the Arts; matching gift, Mr. and Mrs. Sidney Singer

in part from these musings over Cézanne, but probably more from the artist's direct experiences of nature and of the intensely tactile exercise of his own drawing. *Grove Group IV* and *Grove Group V* (fig. 3.16; see plate 198) condense Marden's sensations of water, rocky land, and atmospheric light, as well as his changing views of the planes of complex color he was slowly producing. As with Cézanne, the stable distinction between realist naturalism and formal abstraction collapses.

Sylvia Plimack Mangold, a contemporary of Marden's, has adapted aspects of Cézanne's technique as an entry into the naturalistic rendering of trees.[179] Where Judd would remove the organic model, Plimack Mangold enhances it. It was Gauguin's notion that Cézanne arrived at expressive abstraction through his naturalism: "Art is an abstraction; draw it out from nature in dreaming [or imagining] before nature, and think more of [this act of] creation than of what will result."[180] Gauguin was saying, let the materialized expression of your fantasy lead the representation where it must go. With a certain inversion of the Cézanne-Gauguin system, Plimack Mangold has come to her naturalism by handling elements of abstraction that appeared to her as she gave her dream of painting a material form. Like many artists of her midcentury generation, she was familiar with masking tape as a versatile piece of studio equipment. In abstract work, it establishes straight edges between geometric areas of color; it can also frame a space of representation within a larger surface. At some point, Plimack Mangold turned from using tape as an aid to painting, and she began painting the tape itself as the representational subject. She created illusionistic images of the tape as it would appear if it were functioning in the usual ways. We imagine being able to pull it off the painted canvas—but this is in fact the paint itself. In the context of Cézanne, the point of interest is not Plimack Mangold's skill in rendering the illusion so convincingly. Instead we wonder over the sensory, psychological moment at which a person shifts from regarding an object in terms of its use to seeing and touching it for the sake of its appearance and material qualities. *Untitled (Study for "Portrayal")* of 1979 is the type of work that resulted from Plimack Mangold's phenomenological turnabout (fig. 3.17). This not only amounts to an abstraction of the means but is also a case of naturalistic realism, tape having become the model. Paint is the model as well—a strange circumstance. *Untitled* must be a picture of paint as much as of tape, because the tape cannot be depicted without representing the paint that lies on it and the paint that lies under it. Means and end

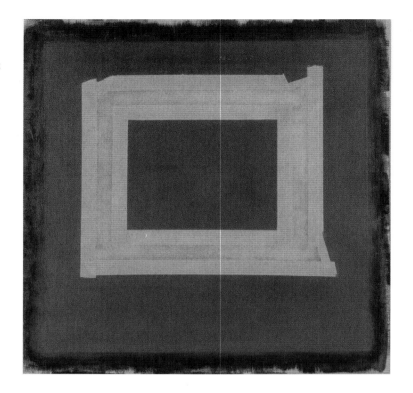

Fig. 3.17. **Sylvia Plimack Mangold** (American, born 1938), ***Untitled (Study for "Portrayal"),*** 1979. 24 x 24 inches (61 x 61 cm). The LeWitt Collection, Chester, Connecticut. Courtesy of Alexander and Bonin, New York

have converged with such severe reflexivity that looking at *Untitled* and thinking about it brings a person to a state of perceptual anxiety—like Cézanne's. Familiar concepts fail when a painting takes us this close to seeing our vision and feeling our feeling.

Plimack Mangold later painted numerous images of trees on her property, in which she maintained elements of trompe-l'oeil tape around the edges, perhaps to demonstrate that when working mimetically from nature, the constructed, abstract reality of the picture surface remains fundamental. *The Maple Tree* (1992) represents that specific subject but also some ragged, painted-over masking tape at the perimeter (fig. 3.18). This is not the only (real) abstraction that entered into this naturalistic painting. Here and there, Plimack Mangold allowed marks of a background color to project into the foreground, either by creating a chromatic opposition in the local area—an optical effect that occurs in everyday experience—or by materially covering a foreground color with the adjacent background color—a physical effect, an abstract construction. The second of the two spatial reversals results from Plimack Mangold's manipulation of her marking system and has no visual parallel in nature. This makes it all the more real: It refers to nothing outside itself. The phenomenon has to be sensed and felt for what it is. In Judd's terms, it exists as itself—a sensory incident, an accident, an experience. In the bottom left quadrant of Plimack Mangold's *Maple Tree,* a broad patch of blue sky, following the direction established by an adjacent brown branch, obliterates several other branches that as a consequence appear to pass behind it. The representational contradiction jolts the viewer, forcing spatial wanderings back to the tactile surface of the canvas, where the marks are.

This effect occurs in Cézanne. I alluded to it in passing when relating Beckmann's self-conscious painterly conceits to some of Cézanne's odd procedural tics. It appears quite prominently in *Forest,* an elaborate, multifocused landscape of 1894. Near the vertical axis, below center, Cézanne seems to have introduced a fragmented horizon, marked by clusters of sky-bright blue (fig. 3.19). It is as if an open space were glimpsed from within and beyond a dense wood, perhaps the culmination of a slight rise in the land. There, just above the horizon—if this is what it is—Cézanne sent a cascade of the light blue strokes curving downward from left to right; they violate a previously established tree by masking some of its brown presence. The same passage of blue obliterates

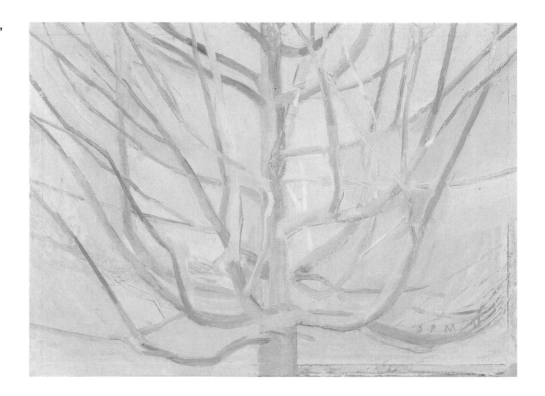

Fig. 3.18. **Sylvia Plimack Mangold, *The Maple Tree,*** 1992. Oil on linen, 15 × 20 inches (38.1 × 50.8 cm). Collection of Mr. and Mrs. Robert Ryman. Courtesy of Alexander and Bonin, New York

the remains of a different tree sketched with outlining—a phantom tree. The slanting curve of the cascade of marks echoes the curve of this missing piece of the scene. As a result, it remains as a force in the composition, but now set to a different color, a different set of strokes, and a different representational identity (sky instead of tree). Something must have happened to Cézanne's felt sensation—a kind of tychic event— for he introduced a logical fault into a well-advanced landscape. Presumably the fault was for him an aesthetic and emotional truth. This sensory reversal of fortune may correspond to his experience of abstractions, as he referred to them in 1905, those sensations that prevented him "from covering the canvas, and from pursuing the delimitation of objects."[181]

Hartley and Loran noticed how closely some of Cézanne's landscape curves matched the branches of existing trees.[182] The precise site of *Forest* is unknown, but many of its details give the impression of faithful adherence to a model in nature. Cézanne outlined specific branches with evident care, attending to their particularity; this was his custom when working at a site, unlike his creation of schematic trees for studio images of bathers (see plates 10, 70). The independent momentum of a mark-making process works against this kind of mimetic fidelity; the mark tends to develop rhythms of its own. The second outlining of a branch may be a corrective to the first, but the two together edge toward a blur when the first remains visible beside the second. Repeats of outlining accumulate in Cézanne's paintings, each stroke becoming an imperfect reflection of another. As Cézanne worked, complex linear rhythms and passages of color would emerge in local areas of the composition, not necessarily fully consistent with the larger whole. For example, just above the center point of *Forest*, a rippling starburst of foliated hues, from violet tones to greens to yellows, spreads out from a thin diagonal branch (see plate 141 and fig. 3.19). The sensory feel of this area differs dramatically from those defined by looser, less organized spreads of marks (for instance, near the top and bottom left corners). We might attribute the differences to the variety of tree (top left) and the character of a rocky ground (bottom left), but the central burst of color is itself not necessarily descriptive. It may have developed into a region of autonomous concentration—a moment apart from other moments in the painter's experience. In 1906, Cézanne remarked on how his motifs would "multiply"

from a single vantage point, new possibilities appearing with the slightest turn of his head or redirection of his line of sight.[183] At times, he had to choose between being true to what he expected of the model in nature and being true to the subjective motif, the tychic sequence of experiences he felt. The subjective motif evolves from bits of nothing, little feelings, little marks, slight variations in color falling into association. This subjectivity, a life of the emotions, is not a fantasy world. It arises from objective experience with a material base in space and time. Perhaps it only *feels* subjective, and to yield to it is to give yourself back to objectivity.

Cézanne's art remained at the center of such questions: Was his vision original and unique? Was his mark everyone's, objective and anonymous? Did his material practice transcend the dualisms with which we habitually reason? Because of the lasting significance of these issues, his historical meaning, his tychic fortune, has remained secure, even if divided. Yet his experience while living may have been a case of bad luck, for there is a good chance (curious phrase) that his art truly frustrated him. This is not a question we can decide without risky speculation. Less risky is to stress that Cézanne felt his color sensations escaping him. Fate was in control of his situation, leaving his sensations to move *him*, even as he sought to represent these abstractions with the convincing reality they had in appearance, moment by moment, mark by mark. Every sensation was valid and real—the problem was to represent these feelings. There were too many. Like a thought that seems to escape because its words are insufficient, Cézanne's picture remained unresolved because there were never enough marks.

In 1903, while Cézanne was in the thick of attempting to resolve his issues in painting, his contemporary Peirce was applying words to the problem of feeling, reasoning out what a feeling is, how we judge it, and how we act on it. Like Cézanne, he sensed that a feeling, no matter how odd, should not be dismissed as somehow unreal. What a person feels is always real. Its implications are open to question; but the feeling itself can hardly be fictive, nor can it be wrong: "A perceptual judgment can only refer to a single percept which can never re-exist; and if I judge that [an object] appears red when [after extended looking] it did not appear red, it must at least be acknowledged that it *appeared to appear* red."[184] A percept, a bit of sensory experience, "can never re-exist." At the moment of its existence, it is as it is. Cézanne differed from most other artists in the degree to which he was willing to admit this fact as the basis for his practice. There are no false moves in his paintings, only the unpredictable chances of his experience as he lived, feeling to feeling.

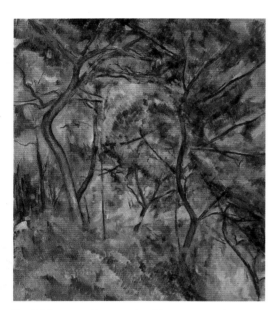

Paul Cézanne, *Forest,* 1894 (plate 141, p. 402)

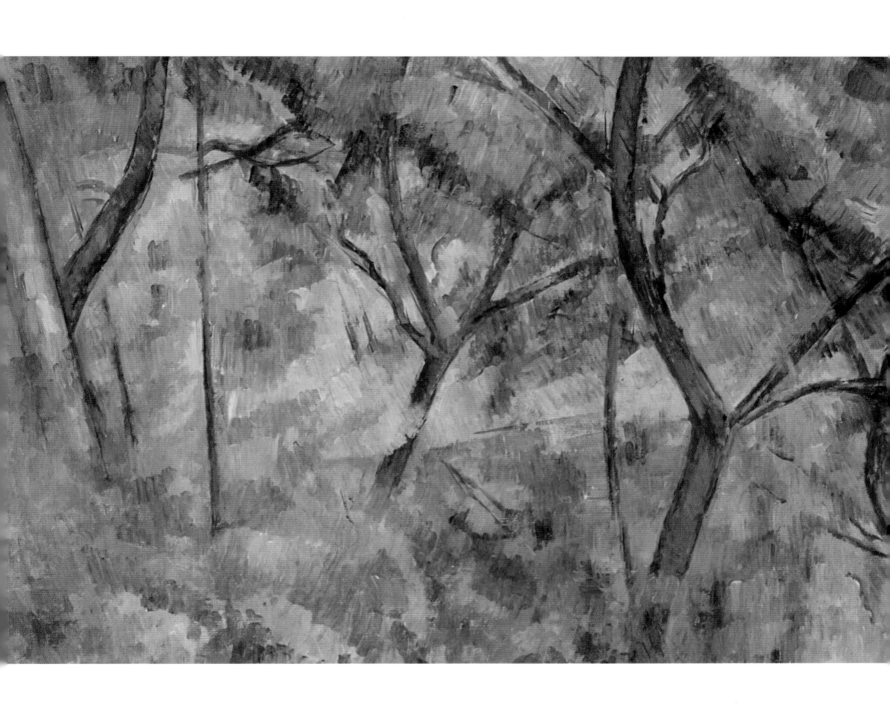

Fig. 3.19. **Paul Cézanne,** *Forest,* 1894, detail (plate 141).

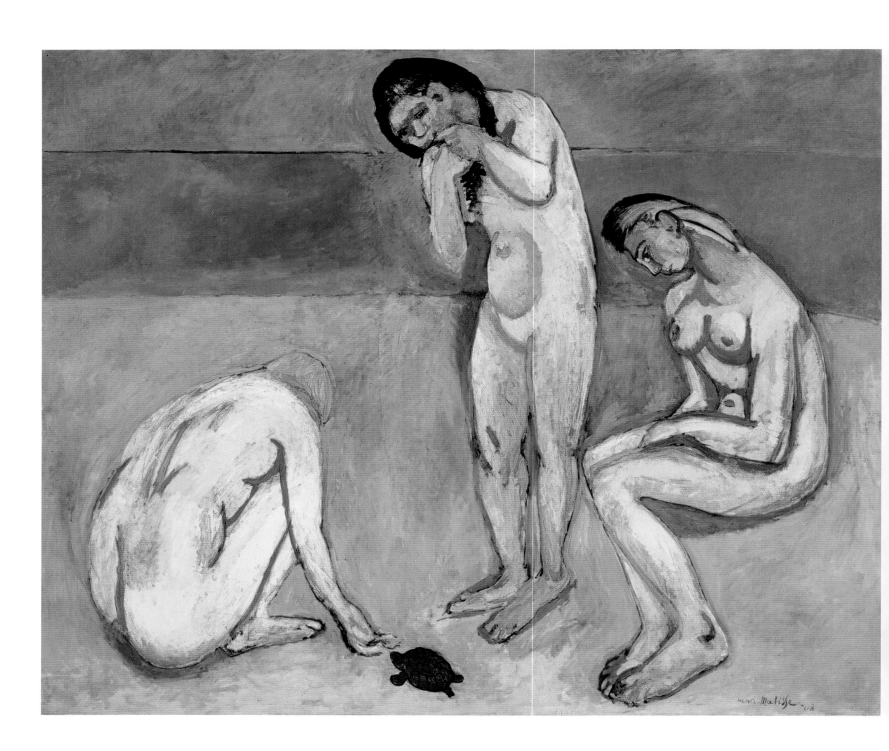

Cézanne and Matisse: From Apprenticeship to Creative Misreading

Yve-Alain Bois

PLATE 6

Henri Matisse

French, 1869–1954

***Bathers with a Turtle*, 1908**

Oil on canvas

78⅝ x 94 inches (199.7 x 238.8 cm)

Saint Louis Art Museum. Gift of Mr. and Mrs. Joseph Pulitzer, Jr., 24:1964

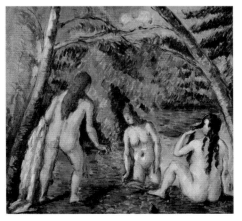

Paul Cézanne, *Three Bathers,* 1879–82 (plate 10, p. 123)

For anyone wanting to write about his art, Matisse's words can be quite daunting. They are extremely articulate, fairly consistent, and seductive. Articulateness and consistency are part of their seduction, especially for the putative writer, because they give the illusion that most of the explanatory job, and certainly the difficult part of it that deals with formal matters, has already been done. But even though Matisse said that a painter "must first cut out his tongue" and never lost an occasion to reaffirm the old modernist cliché about the separation between language and the visual arts, his words are hard to bypass—one gets trapped by them, easily persuaded to let them frame, and sometimes even conclude, the issues at stake.[1]

What Matisse had to say about Cézanne is typically articulate, consistent, and seductive, and gives the impression that he "got it" right away—that love at first sight coincided with a full grasp of what Cézanne was doing, and that this immediately filled him with a desire to partake of filiation, to be the good son. No Oedipal parricidal compulsion, but pure hero worship (he called Cézanne "a sort of good god of painting" and "the master of us all").[2] This is an illusion, compounded by the fact that most of Matisse's public statements on Cézanne came late. Cézanne's bits of theory might be as much "behind" Matisse's 1908 "Notes d'un peintre" (Notes of a painter) as his art was "behind" Matisse's 1897–1902 copy of Jean-Siméon Chardin's *The Ray,* but the name of the Aix painter appears only twice in his celebrated manifesto.[3] Except for a brief and banal mention of Cézanne in an interview with Clara T. MacChesney in 1912—"Monet is very big. Cézanne seeks more the classic"—one has to wait until 1925 to again find Cézanne's name in Matisse's public declarations, and it mostly occurs in statements from the 1940s and early 1950s.[4] That is to say, the "anxiety of influence" (to use Harold Bloom's apposite concept) had to subside fully before Matisse could feel free to say much. But, by the same token, the Cézanne that emerges in these relatively late statements is one that has been tamed, converted into a coherent entity whose contradictions tend to be underplayed.

Perhaps I should start with the issue of "influence," especially because I do not believe that such a thing exists as such, but even more importantly because it is something that seems to have obsessed Matisse. His first published statement, his interview with Guillaume Apollinaire in 1907, already points to this idée fixe: "I have never avoided the influence of others. . . . I would have considered this cowardice and a lack of sincerity toward myself. I believe that the personality of the artist develops and asserts itself through the struggles it has to go through when pitted against other personalities. If the fight is fatal and the personality succumbs, it is a matter of destiny."[5] Close to twenty years later, speaking with Jacques Guenne, Matisse recounted what he had told Apollinaire. He reissued the first part of his statement verbatim, pursued it with a paraphrase, and finally added something new: "One would have to be very foolish not to notice the direction in which others work. I am amazed that some people can be so lacking in anxiety as to imagine that they have grasped the truth of their art on the first try. I have accepted influences but I think I have always known how to dominate them."[6]

"Lacking in anxiety" Matisse certainly was not, but this is the only time, to my knowledge, that anxiety comes up in a discussion of Cézanne (and where its lack is considered as a kind of defect). In fact, Cézanne is usually presented by Matisse as a remedy to anxiety: "If you only knew the moral strength, the encouragement that his remarkable example gave me all my life!" he tells Guenne earlier in the interview. "In moments of doubt, when I was still searching for myself, frightened sometimes by my discoveries, I thought: 'If Cézanne is right, I am right.' Because I knew that Cézanne had made no mistake."[7]

No mistake, except one: Matisse liked to repeat Cézanne's dictum "Beware of the influential master!" (which he probably got from Charles Camoin) when speaking about the necessity for a young painter to "free himself from the influence of the preceding generation" (should he not be able to do this, Matisse stated, he "is bound to be sunk").[8] Yet, in one of his last published statements, just as he repeated Cézanne's warning once more, Matisse gave this "master of us all" as an example of someone who had failed on this score, albeit, of course, in order to rebound and thus possess the authority to issue the warning:

> Cézanne did not need to fear the influence of Poussin, for he was sure not to adopt the externals of Poussin; whereas when he was touched by Courbet, as were the painters of his period, his technique was too strongly affected by Courbet, and Cézanne found his expression limited by Courbet's technique. Also, after that period, all this group of painters went to the other extreme. . . . When one imitates a master, the technique of the master strangles the imitator and forms about him a barrier that paralyzes him. I could not repeat this too often.[9]

It does not take a great leap of imagination to realize that Matisse is speaking here of no other than himself—that is, Cézanne, for awhile, was his Courbet, not so much a good father as a castrating one, an overwhelming obstacle to overcome. Matisse often said, very casually, that if he never tried to meet Cézanne (unlike his friend Camoin, who gave him detailed reports of his visits to the Aix studio), it was because "an artist is wholly in his production."[10] But as Dominique Fourcade elucidates in his analysis of Matisse's claim, it would have been more truthful of him to say that he deliberately *avoided* meeting Cézanne, for he could have done so repeatedly between 1898 and 1906, each time he passed near Aix in his travels.[11] I would rather say between 1899 and 1906: Here the first date marks the moment of Matisse's discovery, his sudden revelation in

front of the small *Bathers* that he almost bought on the spot at Ambroise Vollard's (plate 10); and the second, that of *Joy of Life* (fig. 4.7), signals the point at which he no longer needed to fear Cézanne's magnetic pull because he had understood how to transform the lesson of the old painter and make it unequivocally his own.

Let us examine Matisse's initial flash of illumination. Of course he had seen works by Cézanne before, but they had seemed to him more curiosities than anything else. He told Pierre Courthion, for example, that he was lured to the first Cézanne retrospective at Vollard's in 1895 by an article in which Gustave Geffroy compared a "Bacchanal" by Cézanne (*The Feast*, R128;[12] see plate 1) to Paolo Veronese's *The Marriage at Cana*. Like many other visitors to the Vollard exhibition (not the usual laughing crowd, but "intellectuals and artists," said Matisse, who represented the journal's readership), he was struck by the "extraordinary qualities that were in these canvases, but at the same time somewhat shocked by the deformations or malformations that were unusual at the time." He added: "In some of these works, we were seeing objects that did not have the requisite form, compositions that did not correspond to the geometry of the École, though they were done in a classical spirit we simply could not detect."[13] In short, Cézanne was not yet available to him. It was only after he had learned (not too remarkably) the pictorial language of Claude Monet, listened a lot to Camille Pissarro, studied the Impressionist and Post-Impressionist works included in the bequest of Gustave Caillebotte (opened to the public in an annex of the Musée du Luxembourg from February 1897 on), been given two drawings by Vincent van Gogh, admired William Turner in London, read Paul Signac's *D'Eugène Delacroix au néo-impressionnisme* and tried to apply its principles—it was only after this series of events that Cézanne's art suddenly appeared to him as an apodictic force to be reckoned with if one wanted to do anything worthwhile in painting.

The story has been told, and commented on, many times. To quote Hilary Spurling's quick summary:

> Matisse tried and failed that spring [1899] to persuade his brother to buy van Gogh's L'Arlésienne from Vollard. . . . By the time he nerved himself to go back for the painting on his own account, the price had risen from 150 to 500 francs. . . . Matisse returned a third time in May to buy van Gogh's Les Alyscamps, but before Vollard could even fetch out the canvas, he had lost his heart at sight to another, smaller painting hanging on the wall, beside which the van Gogh looked as tame as a print.[14] The painting . . . was Cézanne's Three Bathers. . . . Before any further decision could be taken, a telegram arrived from Toulouse, where the Matisses' five-month-old son Jean was gravely ill with enteritis. They travelled down at once and remained in the south for a month and a half until the child was out of danger. Staying with his in-laws and brooding on the hopelessness of his position in Paris, Matisse watched the local boys swimming in the river Garonne and thought of the consoling bathers in Cézanne's painting, with its yellow fall of sunlight and the blue and green volumes of its riverbank.[15]

Soon, Matisse could no longer resist. Although the sum represented a considerable sacrifice for his family (Vollard was asking 1200 francs), he sent a deposit through his friend Albert Marquet and took possession of the canvas when he returned to Paris.[16]

Two details must be noticed. The first, if proven definitively, would confirm what I just wrote about Cézanne's previous unavailability to Matisse: According to both Spurling and Claudine Grammont, Matisse had already seen the small *Bathers* canvas

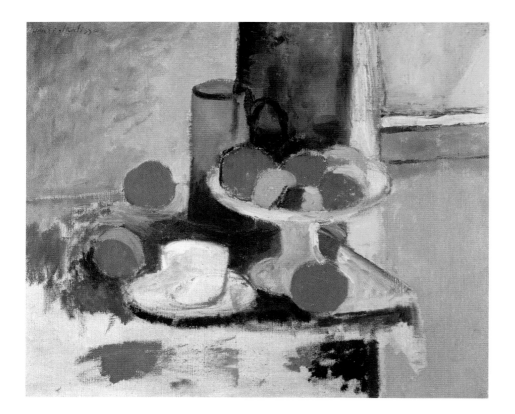

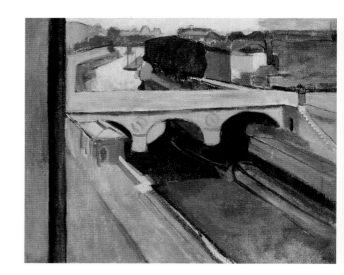

Fig. 4.1. **Henri Matisse, *Still Life with Oranges II*,** c. 1899. Oil on canvas, 18¹/₁₆ x 21⅞ inches (45.9 x 55.6 cm). Mildred Lane Kemper Art Museum, Washington University, Saint Louis. Gift of Mr. and Mrs. Sydney M. Shoenberg, Jr., 1962

Fig. 4.2. **Henri Matisse, *Pont Saint-Michel,*** c. 1900. Oil on panel, 5⅜ x 9¼ inches (13.8 x 23.4 cm). Private collection

before the epiphany (he never recalled this fact in his various retellings of his famed encounter with the painting at Vollard's).[17] The second is that it was not Vollard's famous salesmanship that finally convinced him to acquire the painting, but something he witnessed in the world at large and that functioned as a retroactive echo: "I was talking walks along the Garonne. It was the bathing period. I kept seeing my Cézanne, the colors of flesh in the greenery, the proportion of the hand of the standing woman on the left with regard to the totality of the canvas."[18] That is, even though (as we will see) Cézanne had become available to him because he needed to learn something from him in order to move on in his art, he was not yet fully aware of this. The deciding factor at the time (at least that is the way he put it retrospectively) was a resemblance he perceived between the motif of the painting and the spectacle of young soldiers frolicking in the river (for such were "the boys," Matisse told Gaston Diehl).[19] Thus, Cézanne was then still an Impressionist for Matisse, someone whose work could be summoned in one's mind by its analogy with a fleeting "moment of nature," someone whose capacity to render such a moment in paint could be emulated.

Wanting to emulate an artist one respects is not the same thing as being "influenced" by him; rather, it is to declare oneself his apprentice for a time, and for specific reasons (even if one does not yet fully know what they might be). An apprentice violin maker is not influenced by his master; he observes him and tries to replicate his work, acquiring skills that he might have to shed later on, but will be able to shed having learned exactly what the skills in question entail, what they can yield, and what crisis their lack thereof might provoke, what challenge this might induce. Between 1899 and the summer of 1904, Matisse would place himself under Cézanne's tutelage (albeit at a cautious physical remove, as we have seen) — not exclusively, to be sure. Van Gogh, Paul Gauguin, and, occasionally, Édouard Vuillard were the accompanying tutors, but Cézanne was, by and large, the reigning mentor. And as far as pupils go, Matisse did pretty well, much better than when he had attempted to convert to Signac's Neo-Impressionism, something that had happened immediately before he fell in love with Cézanne's *Bathers.* Many of his canvases of this period look unabashedly Cézannian, at least in part, from *Still Life with Oranges II* of about 1899 (fig. 4.1) and *Pont Saint-Michel*

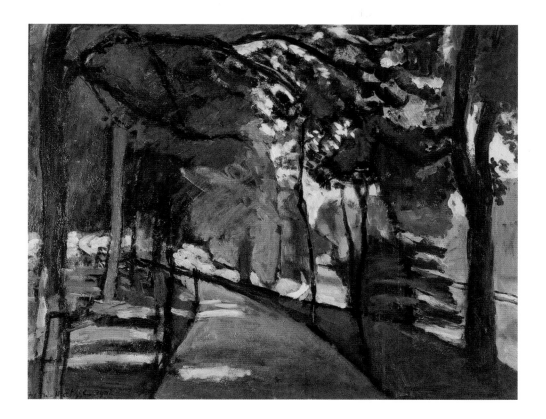

Fig. 4.3. **Henri Matisse, *Bois de Boulogne,*** 1902. Oil on canvas, 35⁹⁄₁₆ x 32¹⁄₁₆ inches (65 x 81.5 cm). Pushkin Museum of Fine Arts, Moscow

of about 1900 (fig. 4.2), with their vast unpainted areas, to the *Bois de Boulogne* of 1902 (fig. 4.3), with its strange distribution of light and dark, its "passages" that link foreground and background, and its anchoring of the oblique slope of the composition to the vertical "plumbline" (Matisse's word) of the trees near the right and left edges of the painting.[20] There are also the many still lifes with a chocolate pot painted around 1900 and, most of all, several nude figures of the same period, with their strong architecture, redoubled and independent contours, facetting of planes, bold brushwork, and implausible anatomies—see, notably, *Male Model* (Museum of Modern Art, New York), *Standing Model* (Tate Gallery, London), and *Model with Rose Slippers* (Jan Krugier Gallery, Geneva).

I could go on with the list, but Matisse's Cézannism of 1899–1904 has already been extensively and excellently studied by Jack Flam. I shall thus cut to the chase and fast-forward to early in the summer of 1904, when Matisse's virtual training in Cézanne's studio is about to end. It is then that he paints *Still Life with a Purro I* (The Phillips Collection, Washington, DC) and *Places des Lices, Saint-Tropez* (see fig. 3.5), "among Matisse's most Cézanne-like paintings," to quote Flam.[21] Among the "most Cézanne-like," no doubt, but also among the least interesting—not much more than rather uninspired imitations. Matisse the apprentice seems to have completed the Cézanne course work; at least that is the way he felt, for he promptly gave himself new assignments. His first was to get Édouard Vuillard right (his previous Vuillardises, such as *The Guitarist* of about 1902–3, were only half-successful); he very quickly passed that test with high marks when he painted the splendid *La Terrasse, Saint-Tropez* (Isabella Stewart Gardner Museum, Boston). But immediately after that, taking advantage of the proximity of Signac (and, temporarily, that of Henri Edmond Cross), he resolved to tackle again the Divisionist system that had so cruelly eluded him in 1898–99.

Matisse's second attempt at Signac's Neo-Impressionism has also been studied in depth (by Catherine Bock and, in her debt, by me).[22] I shall thus give only the conclusion of the story: It was only at the moment when Matisse understood *why* he could not become a Neo-Impressionist in earnest that he understood *how* he could benefit from what he had learned while mastering Cézanne's technique. Suddenly, he realized

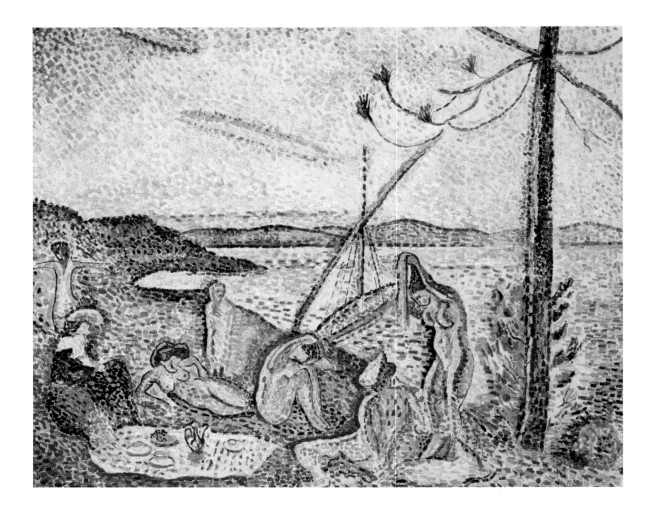

Fig. 4.4. **Henri Matisse,** *Luxe, calme et volupté,*
1904–5. Oil on canvas, 38½ x 46½ inches (98.5 x 118 cm).
Musée d'Orsay, Paris

why he had obscurely needed Cézanne as an antidote after his ill-fated first Neo-Impressionist attempt, something he could not have grasped then because he had not yet fathomed the cause of his defeat. The Cézannism of Matisse during the years 1899–1904 would have led to nowhere without the spark provided by the clash with Signac's system in 1905, for it is only *after* this spark, and in response to it, that Matisse could consciously, and purposefully, appeal to Cézanne. This time around Matisse put his finger on the cause of his failure as a Divisionist and, as an immediate consequence of this new awareness, also comprehended how he could become a true heir to Cézanne without being his imitator.

Matisse's reckoning happened in several steps:

The first has to do with his dissatisfaction with the additive procedure recommended by Signac. One studio recipe from Signac's *D'Eugène Delacroix au néo-impressionnisme* must have been particularly hard for him to follow: "Beginning with a contrast between two hues, without worrying about the surface to be covered, [the Divisionist painter] will oppose, gradate, and proportion the various elements on each side of the line of demarcation, until he comes to another contrast, the motif of a further gradation. And, moving from contrast to contrast, the canvas will be covered."[23] Matisse was explicit when he talked to Gaston Diehl about his discomfort with this piecemeal mode of production: "I just couldn't get into the swing of it. Once I had laid my dominant, I couldn't help putting on its reaction, equally intense: I would be working on a small landscape built up in dots of colors, and I just couldn't achieve a luminous harmony by following the prescribed rules. I was continually forced to start all over again."[24]

The second step occurred after Matisse had painted *Luxe, calme et volupté* (fig. 4.4), the Divisionist masterwork that he presented at the Salon des Indépendants in the spring of 1905 and that Signac liked so much that he would buy it in the fall. During the summer of 1905, Matisse mentioned his dissatisfaction with the canvas to its future owner:

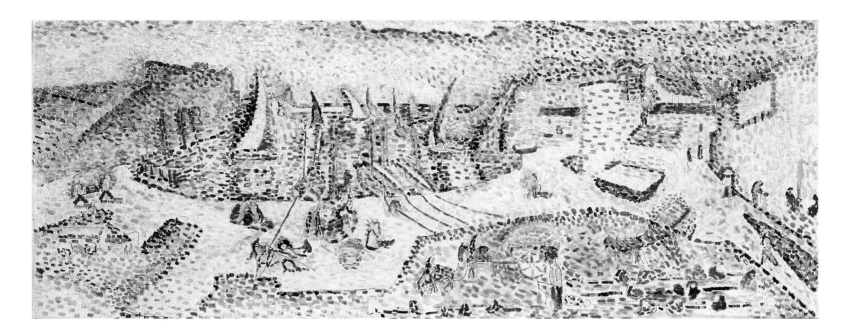

Fig. 4.5. **Henri Matisse**, ***Port d'Abaill,*** 1905. Oil on canvas, 23⅝ x 58¼ inches (60 x 148 cm). Private collection

Did you find a perfect harmony in my Bathers pictures between the ~~style~~ character of the drawing ~~of the figures~~ and the character of the painting? To me they seem totally different from one another, and even absolutely contradictory. One, the drawing ~~is~~ depends on the linear or sculptural plastique (to use Cézanne's expression as written down by Bernard) and the other, painting, depends on the colored plastique ~~which destroys it~~. The result: the painting, especially when it is divided, destroys the drawing whose eloquence comes solely from the contour. It seems to me such an obvious flaw that I am surprised that all the people interested by my picture did not mention it to me. Remember the cartoon for the picture and the canvas, and you will notice, if you have not already done so, their discordance of plastique. To color the cartoon, all that was needed was to fill its compartments with flat tones, à la Puvis for example. Conversely, I have in my series of drawings quite a few that I could realize [in the technique of] divided painting. You would be very kind if you could copy for me from L'Occident the two paragraphs by Cézanne where the two plastiques are mentioned.[25]

Signac did not answer. In a postcard he apologized for not being able to find his copy of *L'Occident* with Émile Bernard's article on Cézanne and sent a reproduction of a work by Raphael instead. But the split between his drawing and his color troubled Matisse enough for him to ask Cross a similar set of questions (or so we can gather from the older painter's response), and also send him a sketch for *Port d'Abaill,* the large Divisionist canvas on which he was then at work (fig. 4.5). Cross's critique of the latter—"it is wrong to begin with a strictly linear construction, given that our main problem is color"—extended into a critique of *Luxe, calme et volupté*: "I conceive of a painting as a harmony of hues and values; this harmony manifests itself through one or several centers linked by harmonious contrasts. . . . The number of centers varies according to the size of the canvas. In your picture *Luxe, calme et volupté,* the small figures were not conceived as centers of harmony but, it seems to me, as linear superadditions and thus they work against the harmony of the whole rather than helping it. . . . The charm of the figures is only effective from very close."[26]

The sweet Cross would soon have the courage to tell Matisse that he would never become a full-fledged Neo-Impressionist, but Matisse had probably figured this out already, especially when reading Cross's letter, for the constructive device offered by Cross still partook of the additive model dear to Signac, which had become inimical to

him. In any case, the inadequacy of Cross's solution (multiple centers of harmony) to Matisse's problem (the color-drawing split) most probably pushed him further into the arms of Cézanne. More than the "two *plastiques*" that Bernard evoked in a paraphrastic passage of his essay,[27] it would be the numerous aphorisms that immediately followed (direct quotes, those) that would henceforth resonate in Matisse's mind. Several of them stress the indissociability of drawing and color: for example, "There is no line; there is no modeling: there are only contrasts. Black and white do not provide these contrasts; the color sensations do"; or "Drawing and color are not distinct from one another; gradually as one paints, one draws. The more harmonious the colors are, the more precise the drawing will be. Form is at its fullest when color is at its richest. The secret of drawing and modeling lies in the contrasts and affinities of colors."[28]

The third step immediately followed Cross's letter and heralded the beginning of Fauvism. While Matisse was still at work on his *Port d'Abaill* (it would never fully satisfy him), he put together the various pieces of the puzzle he had been gathering. Perhaps he remembered Pissarro's admonition never to paint bit by bit, but to work on all parts of the canvas simultaneously. (No doubt the famous series of guidelines that the old painter gave to the young Louis Le Bail in 1896–97 were uttered in front of Matisse, who visited him frequently at just that time.)[29] If so, it would have helped him to link this principle of wholeness to the unity of color and drawing mentioned by Cézanne (Pissarro is just as eloquent on this point; in fact, the statements jotted down by Le Bail under Pissarro's dictation could have been penned by Cézanne). Whatever the case, it was in Collioure, during that summer (the Fauve season), that Matisse began to elaborate what I have called elsewhere an "economy of the sitting," something directly proceeding from Cézanne's method of construction by "means of relationships of forces," as Matisse would often say.[30] I apologize for quoting myself:

> Renoir used to say of Cézanne: "How does he do it? He can't put two strokes of color on a canvas without it already being very good." How does he do it? He does it by constantly thinking of his picture, in its totality, as a play of forces to be "balanced." The two brushstrokes Renoir mentions are forces opposed to each other, but also to the white of the canvas: the intensity and luminosity of the colors are the result of this internal struggle. At the end of each sitting, in its very "unfinishedness," the painting has attained a form of static equilibrium, but, based on a radical dynamism, the equilibrium is totally precarious, functioning somewhat like the force of deterrence in the arms race (the metaphor comes from Mondrian). The painter cannot leave his easel before placing the brushstroke that, whatever stage the canvas is at, will achieve this state of equilibrium. At each new sitting the painter has to begin working as if he were starting from scratch, since each new mark he makes, adding to the forces already present in the painting, implies a rupturing of the equilibrium.[31]

This totalizing procedure is particularly visible in the "unfinished" *Portrait of Madame Matisse* now in the collection of the Musée Matisse in Nice (fig. 4.6). A quick glimpse is enough to see what distinguishes its numerous unpainted areas from those found earlier in such pictures as *Still Life with Oranges II* or *Pont Saint-Michel*, mentioned above. In those, these areas were at best a stylistic ploy; now they are a consequence of a dynamic distribution of contrasting color planes that echo each other across the canvas—they partake of the picture's overall logic. (A note in passing: Matisse always revered the unpainted areas of Cézanne's canvases. One of the redeeming graces of Vollard, according to him, was to have every Cézanne painting that passed through his hands photographed: "This had considerable importance because without it others

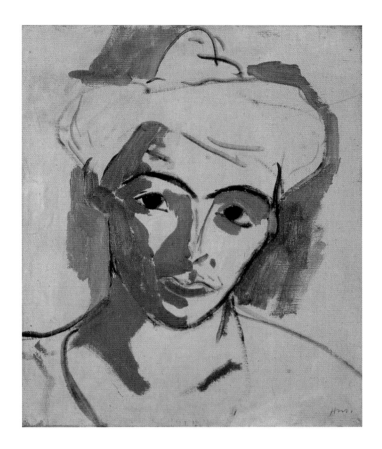

surely would have 'finished' all the Cézannes, as they used to add trees to all the Corots."[32] However, after the Fauve season at Collioure, one finds relatively few examples of large areas of unpainted canvases in Matisse's oeuvre. Moreover, he left very few paintings unfinished. He usually would go at a canvas until he had reached a "climax" [*décharge*; the sexual metaphor is Matisse's], in repeated sessions that from the early 1930s on would often begin with the full erasure of the result of the previous session.)[33]

The final step of Matisse's emancipation from Cézanne (and his definitive farewell to the status of apprentice) occurred while he was working on *Joy of Life* (fig. 4.7): It was his discovery of the equation quality = quantity, something on which Matisse commented, directly or not, in all his published essays and most of his interviews. This discovery, which stemmed from the three steps just mentioned, can be summarized by this statement of Matisse's: "One square centimeter of any blue is not as blue as a square meter of the same blue."[34] From Cézanne, he had learned that one should always conceive the painting as a whole, as a bound, energetic field of operation; that colors are the main forces playing on this field and that drawing could be produced by their relationship alone; and, even more, that there is no difference between color and drawing. During the summer of 1905, though he was still trying to complete *Port d'Abaill* in a Divisionist manner, Matisse found himself driven to augment the size of his color brushstrokes to the point where they became small color planes, after which the use of larger and larger planes of pure color came to him naturally. (He was perfectly clear about the necessity of this evolution, which he brilliantly charted on several occasions.)[35]

At that point, however, it was still only a matter of enhancing the color intensity and arresting the kind of dissipation of contour that he had come to see as a flaw in the Divisionist technique. His work on *Joy of Life* (as well as on a few woodcuts he did at the same time) allowed him to pinpoint exactly how and why color and drawing were joined: Since any single color can be modulated by a mere change of proportion, any division of a plain surface is in itself a coloristic procedure. "What counts most with colors are relationships. Thanks to them and them alone a drawing can be intensely colored without there being any need for actual color," he would declare in 1945.[36] The

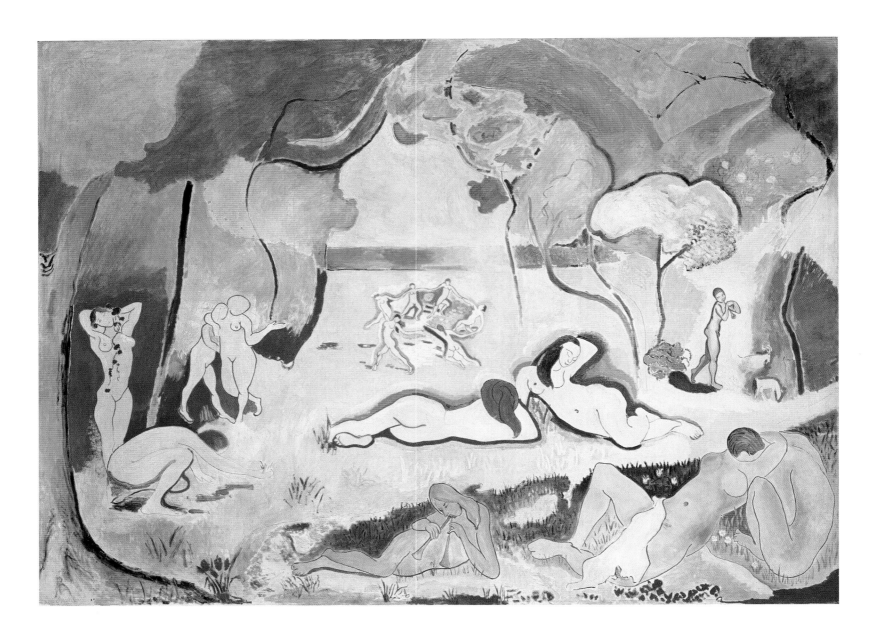

Fig. 4.7. **Henri Matisse,** *Joy of Life,* 1906. Oil on canvas, 69⅛ x 94⅞ inches (175 x 241 cm). The Barnes Foundation, Merion, Pennsylvania

link between the quality = quantity equation and the principle of the wholeness of the field is clear: Since the particular accord (and thus "mood," as Matisse would often say) struck by a painting or drawing results in large part from the differences in quantity between surfaces, it is impossible to work without immediately having to consider the totality of the surface to be covered. What is more, this equation placed scale at the center of Matisse's aesthetic, another front on which color and drawing merge. Within this logic, it is impossible to enlarge any composition or to square up any drawing. This makes any cartoon useless, and Matisse indeed abandoned this old academic practice after *Joy of Life* (with two exceptions that more than confirm the rule).[37] Finally, since modulation was now a function of surface proportion, traditional modeling would be not only redundant but hampering.

Cézanne would have been horrified in front of the large, flat planes of pure color that began to populate Matisse's canvases in 1906 (he had not been shy about condemning their occurrence in Gauguin's work). But the truth of the matter is that, unlike Gauguin's, these planes were a direct consequence of Matisse's now full grasp of Cézanne.

Let us now look back at the famous epiphany in Vollard's gallery, or rather at what Matisse said about it. Most such statements are posterior to the gift of his Cézanne *Bathers* to the Musée du Petit Palais in 1937.[38] I have already quoted the remark he made to Courthion in 1941 ("I kept seeing my Cézanne, the colors of flesh in the greenery, the proportion of the hand of the standing woman on the left with regard to the totality of

the canvas"). It is useful to complement this with a remark he made to Gaston Diehl two years later: "It was the first time that I really noticed Cézanne's power. I remember that all was hierarchized, that the hands, the trees, counted as much as the sky."[39]

In the 1954 version of his conversation with the painter, Diehl would even edit the passage to "all was *so well* hierarchized." What does Matisse mean by "hierarchy" here? And if there is hierarchy, would that not have been, on the contrary, something that repelled him? Did he not say, over and over, that in a picture "there is no principal feature"?[40] This has often been misunderstood, especially when combined with his numerous statements concerning the "decorative feeling" with which he wanted to infuse his paintings. It is best, once again, to examine this issue in light of Matisse's misgivings about Divisionism, against which Cézanne provided him with the ideal weapon. His rejection of Signac's system stemmed from at least two, apparently contradictory, factors that concern the issue of hierarchy. The first deals with color distribution: In a Divisionist picture, "Objects are differentiated only by the luminosity given them. Everything is treated in the same way."[41] Materially speaking, at least, no point is more important than the other, but the "jumpy surface" the method produces is without tension. "All the paintings of this school had the same effect," Matisse would tell Tériade in 1951, "a little pink, a little blue, a little green; a very limited palette with which I didn't feel very comfortable. Cross told me that I wouldn't stick to this theory, but without telling me why. Later I understood. My dominant colors, which were supposed to be supported by contrasts, were eaten away by these contrasts, which I made as important as the dominants."[42] The product of Signac's system is not dynamic equilibrium, but entropic implosion. The second aspect of Matisse's contention with Neo-Impressionism that is relevant here has already been alluded to briefly. It pertains to composition: Precisely because they were aware of this entropic threat, the painters of this school constantly trumped the cards. They built several "centers of harmony" (to use Cross's words) in order to prevent their work from becoming dull, but this was a mechanical device, a mere recipe that had nothing to do with one's emotion or sensation in front of the motif. The result was paratactic, a mere "juxtaposition of objects."[43] The first diagnostic can be summed up as *democratism rather than democracy*; the second as *pointless re-hierarchization*. In a real democracy, thought Matisse, everyone has a different role to play for the common good, and the same is true in painting. Thus, what he meant when speaking of the hierarchy in Cézanne's *Bathers* is that in this painting everything plays its proper part in the production of what he calls the "expression."[44]

To momentarily bring this topic to a conclusion, here is one of Matisse's rare written statements (as opposed to statements in interviews) on his departure from Neo-Impressionism (it dates from 1935). I have already quoted it in part, but it deserves to be read in full:

> In the post-Impressionist picture, the subject is thrown into relief by a contrasting series of planes which always remains secondary. For me, the subject of a picture and its background have the same value, or, to put it more clearly, there is no principal feature, only the pattern is important. The picture is formed by the combination of surfaces, differently coloured, which results in the creation of an "expression." In the same way that in a musical harmony each note is a part of the whole, so I wished each colour to have a contributory value. A picture is the co-ordination of controlled rhythms.[45]

So "all was hierarchized" in Cézanne's *Bathers*: "the hands, the trees, counted as much as the sky." Especially "the hand of the standing woman on the left," whose proportion

"with regard to the totality of the canvas" Matisse found so striking. Why would Matisse focus on this hand? Why not focus on the strange octopus-like black hair of the seated nude at right, or on the solid row of three abutting slanted columns at left, each depicting a different substance (human leg, beach towel, tree trunk)? Is it because that hand's upper edge is one of the few horizontal lines in this nearly square canvas? But nothing in particular calls attention to it, despite its being the only hand reaching out in the picture (the others are clinging to the bodies they belong to) and its position not far from the center of the canvas. One could agree that Cézanne underscored the arm of this figure by surrounding it with black, but the contrast is seriously toned down when we come close to the hand, notably by the invasion of the yellow strokes that depict the reflection of the sun-lit tree in the water.

My hypothesis (taking into account, once again, that these statements on his epiphany were uttered long after the fact) is that Matisse zeroed in on this hand precisely because it is *not* a focal point, while in any classical composition (the classicism of the École), it would have been. That is, Matisse retrospectively introjected into this bather's hand at least two things he had learned from Cézanne and applied to his own way of dealing with hands in his pictures: First, hands and the gestures they embody need not have any narrative function. Cézanne was not the first modernist painter whose multi-figure compositions, particularly those with nude figures from 1875 on, made absolutely no narrative sense (Courbet's works were already decried for the same reason), but he was certainly the most relentless practitioner, and Matisse explicitly referred to this aspect of Cézanne's work when he quoted the enigmatic gestures of the three seated nudes at the forefront of the Philadelphia Museum of Art's *Large Bathers* (plate 66) in his own *Bathers with a Turtle* of 1908 (plate 6), a very Cézannian canvas indeed.[46] Second, hands can be messy, incomplete, deformed — it matters not at all, because, thanks to the Cézannian (that is to say, energetic) mode of composition, they can be made invisible. I have devoted a long essay to Matisse's pictorial strategies of blinding his beholders, which entail, among other things, his capacity to place a highly saturated plane of color at the center of a picture without his viewers noticing its presence in the least.[47] A most telling example would be Matisse's treatment of hands (and feet, for that matter). For the most part, and throughout his long career, the hands of Matisse's painted or drawn figures tend to be anatomically incorrect, carelessly daubed as if he had run out of steam, even in the tamest works of the early Nice period. Take any hand depicted in any Matisse picture: It would often look monstrous seen in isolation — a repulsive stump. But the point is that he always got away with it. Not even his staunchest enemies seem ever to have noticed. Why would this be? The answer is: Precisely because we *never* see these abbreviated hands in isolation. And why is that? It is because Matisse prevents us from seeing *anything* in isolation in his work. Cézanne was not as casual as Matisse would be with the hands of his figures (though he comes pretty close with regard to feet), except in his bathers pictures. The picture Matisse owned is not the most telling example, but if you zero in on any of the hands it contains, you will see nothing but primitivist deformity. The hand that Matisse singled out is more "finished" than the others, but the angle it makes with the forearm is implausible, and its attachment is arthritic. "If Cézanne is right, I am right."

Matisse's statements about Cézanne, I noted above, were mostly made late in his career. But at least one dates from an earlier period during which his involvement with Cézanne was particularly intense — not only *Bathers with a Turtle* but also *Game of Bowls* and *Harmony in Red* (both at the State Hermitage Museum, St. Petersburg) and

Statuette and Vase on an Oriental Carpet (Pushkin Museum of Fine Arts, Moscow) were barely dry. The following passage from his "Notes of a Painter" (1908) follows a quick dismissal of Auguste Rodin's aggregative conception of composition as "merely a grouping of fragments":

> Look instead at one of Cézanne's pictures: all is so well arranged that no matter at what distance you stand or how many figures are represented you will always be able to distinguish each figure clearly and to know which limb belongs to which body. . . . Limbs may cross and intertwine, but in the eyes of the spectator they will nevertheless remain attached to and help to articulate the right body: all confusion has disappeared.[48]

What is fascinating with this statement is that it is patently *untrue*. I regret that I am not very cognizant of the vast trove of negative criticism that Cézanne received during his lifetime, for such knowledge would come in handy at this juncture, given that negative critics are often far more attentive than are love-struck admirers. I could easily imagine that, before the fortunes of Cézanne's art took a sharp turn toward the positive around 1900, quite a few jabs were made at the confusion concerning which limbs belong to which bodies. But these jabs, if they indeed existed, were entirely eclipsed by the lavish praise heaped on Cézanne by Émile Bernard, Maurice Denis, and their cohort, to the point that one had to wait until 1995 — one century after Cézanne's first retrospective at Vollard's — to read a discussion of the type of confusion I just mentioned. I am referring here to T. J. Clark's luminous commentary on the limbs that belong equally to two different figures at the far right of the Philadelphia *Large Bathers* (the shoulders and arms of a kneeling nude heading left are simultaneously the buttocks and legs of another one seen from the back and moving toward the right).[49] But even more important than the falsehood of Matisse's statement is the fact that this type of confusion, from which he absolved Cézanne, is also something he emulated: The single head shared by the two embracing figures at the forefront of *Joy of Life* can be read as belonging equally to one or the other.[50] Once again, "If Cézanne is right, I am right." In other words, Matisse's wrong assertion about Cézanne's unambiguity is nothing other than a denial concerning his own work.

Why such a defensive mode? The main reason, I think, lies in Cézanne's status in 1908. Although the construction of Cézanne as a "classical" artist had been in the works for a decade, it received its consecration in Denis's long essay published in *L'Occident* in September 1907, on the occasion of the retrospective of the Aix painter at the Salon d'Automne of that year.[51] Denis had been one of Matisse's most serious detractors, particularly of his *Joy of Life*. One would think that the most efficient strategy for Matisse would have been to show that Denis's take on Cézanne as the great reviver of a French tradition going back to Nicolas Poussin did not pass muster (even though it was bolstered by some of Cézanne's own statements), and that there was precious little that was "classical" in his art. But this would have meant finding himself on the same side as Cézanne's archenemies. Even if one were to say that one loved Cézanne precisely for the reasons that these idiotic critics (Camille Mauclair and so forth) hated him, and that one felt a kinship with his sincere gaucherie, the argument, precisely at the moment when Cézanne was at last canonized, would not have been well received. The amount of sophistication required to understand such an argument was simply not available even to Matisse's most sympathetic supporters at the time. So he thought tactically: He joined the chorus of admirers of Cézanne's "classicism" (and publicly stuck to this line all his life) and sought to placate Denis by presenting himself

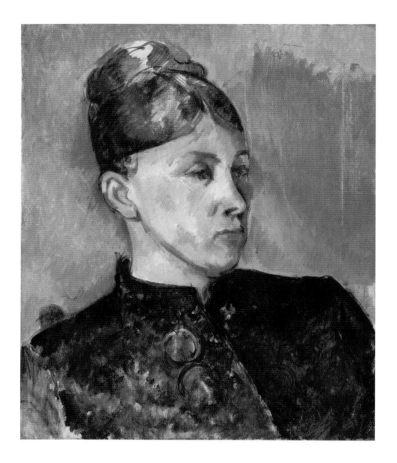 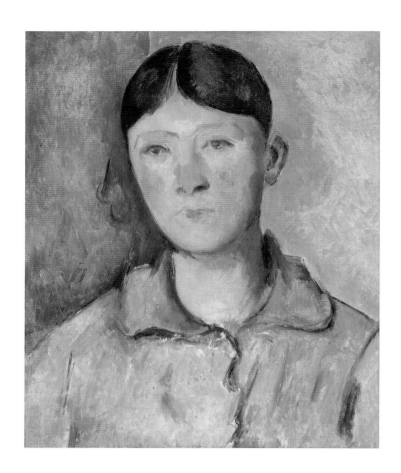

Fig. 4.8. **Paul Cézanne, *Portrait of Madame Cézanne,*** 1886–87. Oil on canvas, 18⁷/₁₆ x 15⁵/₁₆ inches (46.8 x 38.9 cm). Philadelphia Museum of Art. The Samuel S. White 3rd and Vera White Collection, 1967-30-17

Fig. 4.9. **Paul Cézanne, *Portrait of Madame Cézanne,*** 1888–90. Oil on canvas, 18⁵/₁₆ x 15⅛ inches (46.5 x 38.4 cm). Musée d'Orsay, Paris

as Cézanne's progeny. This he was, but not of Denis's Cézanne: It was Cézanne's numerous transgressions to the classical rule that gave him, in moments of doubts, the courage to go forward.

In addition to the *Bathers,* Matisse owned four other canvases by Cézanne: two portraits of Madame Cézanne, including one in the collection of the Philadelphia Museum of Art (fig. 4.8; the other is now in the collection of the Musée d'Orsay [R581], fig. 4.9); a great late landscape, *Rocks near the Caves above Château Noir* (R909); and a still life that Matisse called "my peaches" and Rewald titled *Fruit and Leaves* (R647; fig. 4.10). He also owned six watercolors, two of them painted on the versos as well (R256, R316, R323 [and its verso, R416], R334 [and its verso, R415], R340, R541). We know precisely when Matisse acquired some of these works, and this gives us some indication of the ways in which he had recourse to Cézanne.

According to Claudine Grammont, he purchased his batch of watercolors from Vollard on December 15, 1908, the month when his "Notes of a Painter" appeared (they were still not paid for in February 1913, at which date Matisse proposed to Vollard that he take a painting in exchange).[52] Getting six — or more exactly, eight — watercolors is not the same as getting just one: There is a kind of cumulative effect that was obviously sought (and quite a few visitors testified to the everlasting presence of these sheets massed on a single wall of Matisse's various apartments over the years). What is particularly intriguing is that these are all landscapes, a genre that Matisse had barely touched in 1908 and would hardly touch again until his Moroccan trip in 1912. One hypothesis for why he chose these watercolors would be that he missed painting landscapes, that he felt that the rare works he had done in this genre after the Fauve flurry of 1905 were not as bold as his recent forays into other domains — such as the "genre scene," with *Harmony in Red*, and the "nude trio," with the two versions of *Le Luxe* (plate 9) or *Bathers with a Turtle* (plate 6) — and that he pined for Cézanne's encouragement. Another conjecture would be that, with several important collectors now competing for the

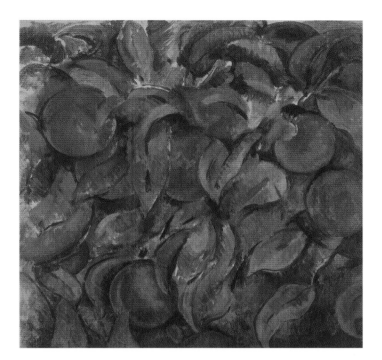

Fig. 4.10. **Paul Cézanne, _Fruit and Leaves_,** c. 1890. Oil on canvas, 11⁷⁄₁₆ x 11⁷⁄₁₆ inches (29 x 29 cm). Private collection

Fig. 4.11. **Henri Matisse, _Fruit and Leaves_,** 1914. Lithograph after Cézanne for an album published by Bernheim-Jeune, Paris. Private collection

acquisition of his paintings and a slew of commissions to fill, he could allow himself a reward for all the hard work he had been doing nonstop over the past three years. Yet another supposition, more speculative but not necessarily less persuasive, would be that Matisse needed to learn again how to bring some "air" into his painting, especially after having just painted a series of canvases that, while manifestly Cézannian, were either very tense (the prime example is _Bathers with a Turtle_) or gripped by some disquieting _horror vacui_. And if, indeed, he perceived suffocation as a looming danger, then what better medicine than a good dose of Cézanne's watercolors, all the more so because it is in these watercolors that the "economy of the sitting" to which I alluded above is most manifest? When Matisse acquired this group he was working on _Still Life with Blue Tablecloth_ (State Hermitage Museum, St. Petersburg). One can easily imagine him look- ing into ways of loosening the mesmerizing pattern provided by that blue tablecloth.

The next acquisition is more telling. On April 25, 1911, Matisse bought from the Galerie Bernheim-Jeune _Fruit and Leaves_ (fig. 4.10), a square canvas that is most unusual in Cézanne's production in that it seems to be, _stricto sensu_, an allover compo- sition.[53] I have never seen it in person, but in reproductions it looks almost like a frag- ment, something that has been cropped or could be expanded in every direction—a bit like a decorative motif for a shawl (in any case, not so very far from the "apocalyptic wall paper" Jackson Pollock would be lambasted for producing). Matisse was obviously very fond of this work, which he copied in a lithograph for an album published in 1914 by Bernheim-Jeune as a fund-raiser for Aristide Maillol's project of a monument to Cézanne.[54] The surprisingly faithful lithographic rendition—consisting merely of swirling arabesques, fruits, and leaves dancing around in full defiance of gravity—is eloquent about the reasons for Matisse's interest in this extremely atypical work (fig. 4.11). But the date of the acquisition is even more eloquent. Only two months earlier Matisse had sent to Sergei Shchukin the two still lifes he had painted in Seville (in December–January), and the anxiety that had accompanied the making of these works had probably not fully dissipated. The genesis of the two Spanish still lifes, perhaps the

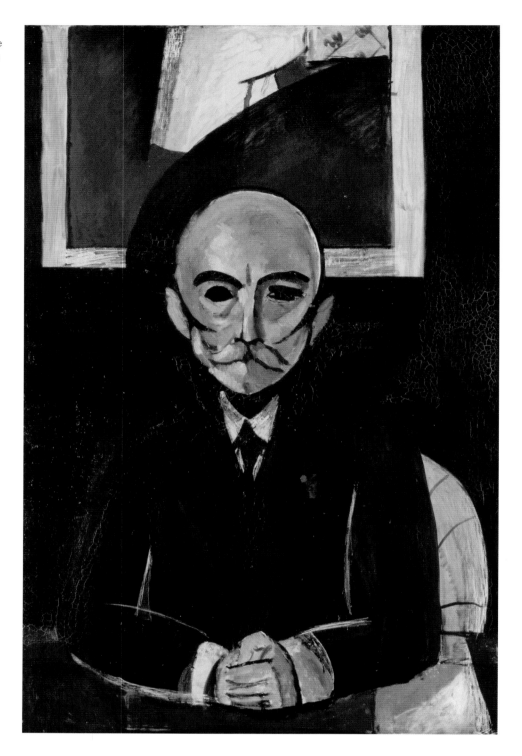

works that most closely approach the allover in this period of Matisse's career, is well
known and need not be retold here. Suffice is to say that Matisse painted them as he was
resting from the exhaustion of finishing *Dance* and *Music* for the Russian collector, and
was nursing the crushing wound caused by Shchukin's initial rejection of these major
paintings. (Shchukin had almost immediately regretted having bowed to the negative
campaign of the press against *Dance* and *Music* and sent a telegram to Matisse on his
way back to Moscow, but the unexpected — if only momentary — defection of the col-
lector's support had plunged Matisse into a deep depression.) He told Courthion that he
suffered from terrible insomnia during his sojourn in Spain (he would endure this for
more than a month) and was incapable of concentrating for more than half an hour, that
he painted the two still lifes "in a state of extreme nervosity," and that it was only once
he was back in Paris that he saw that they were "not bad."[55] My guess is that Matisse
began to gain confidence in these works (and regain confidence in himself) after he had
glimpsed Cézanne's *Fruit and Leaves* at Bernheim-Jeune (the gallery of his dealers, where
he would likely have gone immediately upon his return to Paris). Or, at any rate, that

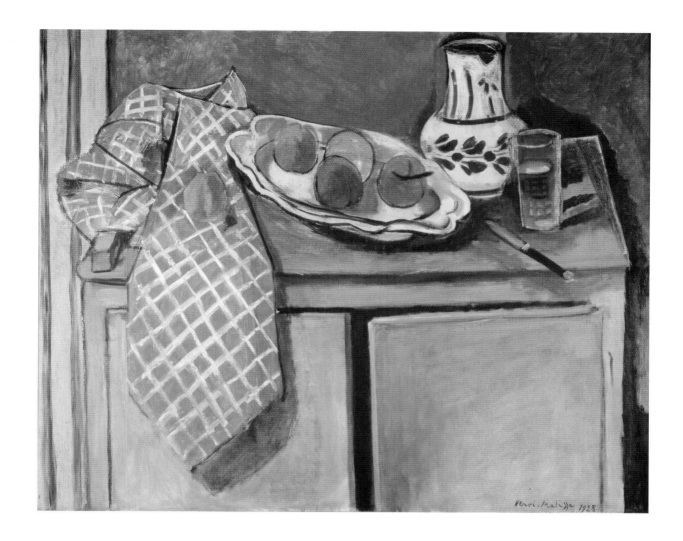

—still very fragile emotionally after the whole Shchukin crisis—he bought this canvas as a reminder that he should never lose confidence: "If Cézanne is right, I am right."

The date on which Matisse acquired his two portraits of Madame Cézanne is not entirely certain, though it seems to have been in the late 1910s—that is, precisely at the moment when he was working on a series of portraits, the most important of which were the two that he painted of the great Cézanne collector Auguste Pellerin (plate 14; fig. 4.12).[56] As for *Rocks near the Grottoes above the Château Noir,* again we do not know for sure when Matisse got it, but documents attest that on January 5, 1917, he purchased a Cézanne landscape that could very well be this one, given that no other painting in this category is listed by Venturi or by Rewald as having belonged to him.[57] If such is the case, we begin to get a sense of what, specifically, might have driven Matisse to this canvas, one of the most "abstract" of Cézanne's late paintings. He was just about to start working on *Shaft of Sunlight, Woods of Trivaux* (plate 20), a work that marks the climax of his high modernist years, immediately before his departure to Nice and his renewal with Impressionism and the much more traditional pictorial mode that this retreat elicited. He had been trying to compete with Cubism during the preceding five years, with mixed success, and throughout this difficult period he often had recourse to a Cézannian trait that, with rare exceptions (contrary to what one might assume), had not been a usual feature of his work before 1912: the prominent pentimento (the major exception, no surprise, is *Bathers with a Turtle*). His desire to exhibit temporal traces of the working process on the canvas itself was one of Matisse's ways of coping with Cubism. Cubism was commonly understood at the time as a pictorial mode that depicted objects from all sides, as if one were turning around them, and Matisse colored this cliché by adding to it a definite Bergsonian emphasis on duration.[58] The reasoning was a bit of a stretch—too "literary" for Matisse's own good—but it did yield some extraordinary

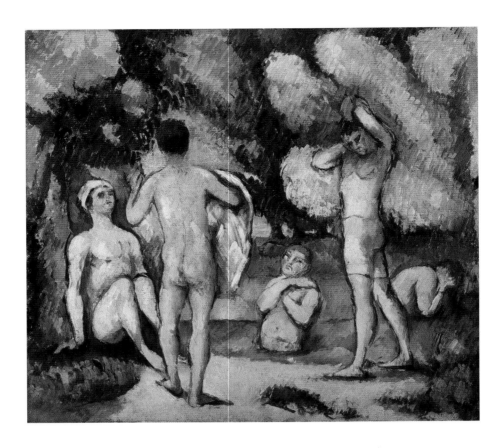

Fig. 4.14. **Paul Cézanne, *Bathers,*** c. 1880. Oil on canvas, 13⅝ x 15 inches (34.6 x 38.1 cm). Detroit Institute of Arts. Bequest of Robert H. Tannahill (70.162)

canvases: the 1914 *Mlle. Yvonne Landsberg* (plate 17), for example, or *View of Notre-Dame* from the same year (Museum of Modern Art, New York), both of which are characterized by a staccato expansion, in three successive beats, of the central figure.

My hypothesis is that Matisse had come to the conclusion that pentimenti were not adequate to the function he had devised for them, and that the function in question—inscription of process as a sign of duration—was a red herring. A new look at Cézanne, at this juncture, would have been quite helpful to him, especially as a way out of a Cubist trap of his own making. Like many late landscapes by Cézanne, *Rocks near the Grottoes above the Château Noir* is conspicuously ambiguous with regard to the spatial positioning of the various elements of its motif, particularly with regard to the opposition between plan and elevation, an opposition that Matisse had often called into question in his landscapes, to be sure, notably in *The Palm* of 1912 (National Gallery of Art) and most violently in *The Yellow Curtain* of 1915 (collection of Stephen Hahn, New York), but that he was on the verge of reaffirming with a vengeance during his Nice period. *Shaft of Sunlight, Woods of Trivaux* would be one of the last truly experimental works by Matisse until the Stéphane Mallarmé book and the Barnes *Dance* in the early 1930s. Even before he painted *Shaft of Sunlight* his faith in an avant-gardist position had begun to fade (all the Laurette portraits that preceded it were already looking back toward Renoir). The booster shot of Cézanne had come too late this time.

I do not think Matisse felt an urgent need of Cézanne in his work for a good decade after this—until he suddenly found himself totally blocked, incapable of painting. The year 1928 was a very difficult one for him, but my guess is that one of the few things that kept him going (and he produced very little that year, and even less in the following) was his turning to Cézanne for inspiration. His *Still Life on a Green Sideboard* of that year (fig. 4.13) is, among other things, an homage to the Aix painter.

There is, of course, a lot more to say on the way Matisse transformed Cézanne's art—the way he first learned it in order to understand it, and then creatively misunderstood it when the time came to use its lessons. I shall leave the provisional last words to Matisse: "Cézanne's painting jotted question marks that made me work a lot."[59]

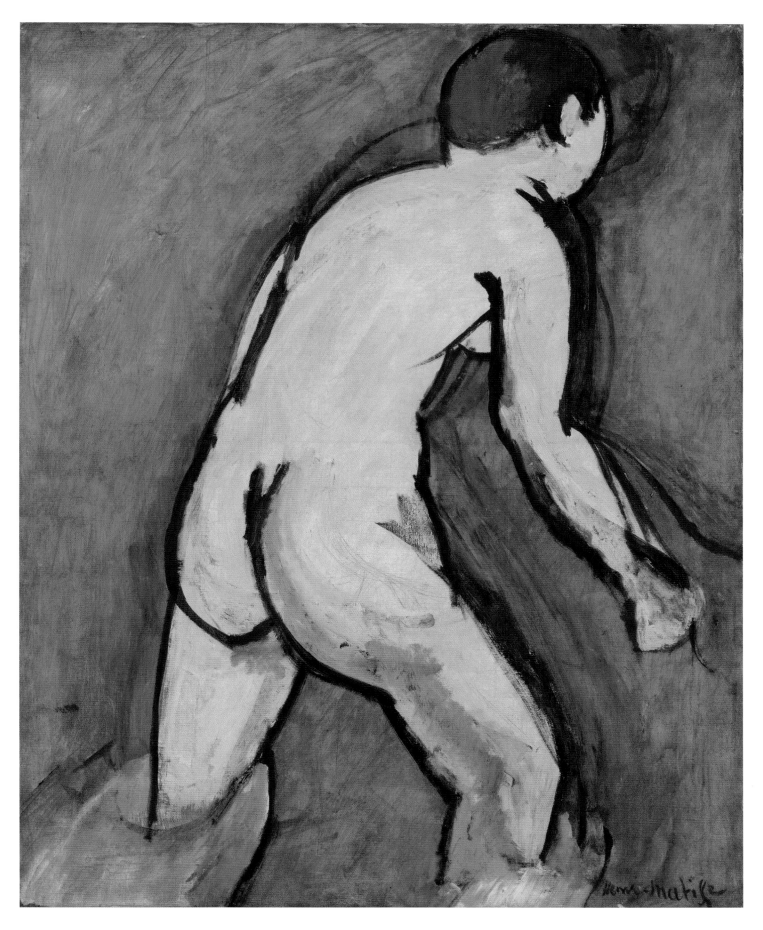

PLATE 7

Henri Matisse

Bather, 1909

Oil on canvas
36½ x 29⅛ inches (92.7 x 74 cm)
The Museum of Modern Art, New York.
Gift of Abby Aldrich Rockefeller, 1936 (17.1936)

Paul Cézanne, *Three Bathers*,
1879–82 (detail; plate 10, p. 123)

Paul Cézanne, *Bathers*, c. 1890
(detail; plate 40, p. 180)

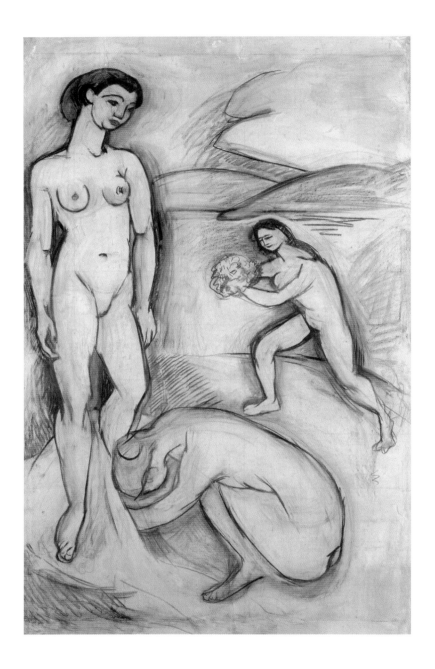

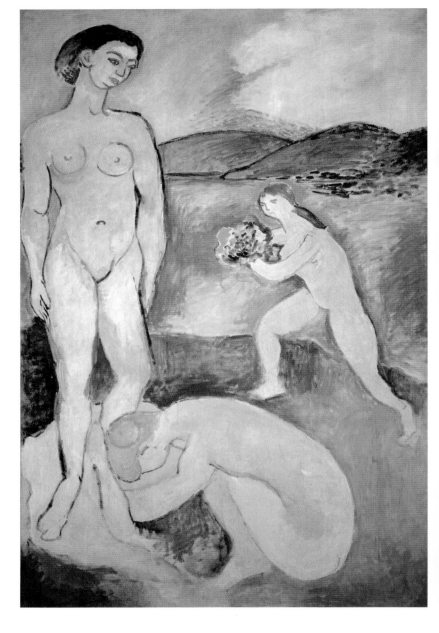

PLATE 8

Henri Matisse

Study for "Le Luxe I," 1907

Charcoal on paper

88½ x 54 inches (224.8 x 137.2 cm)

Musée National d'Art Moderne, Centre Georges
Pompidou, Paris. Gift of Mme. Marguerite Duthuit,
1975

PLATE 9

Henri Matisse

Le Luxe I, 1907

Oil on canvas

82⅝ x 54⅜ inches (210 x 138 cm)

Musée National d'Art Moderne, Centre Georges
Pompidou, Paris

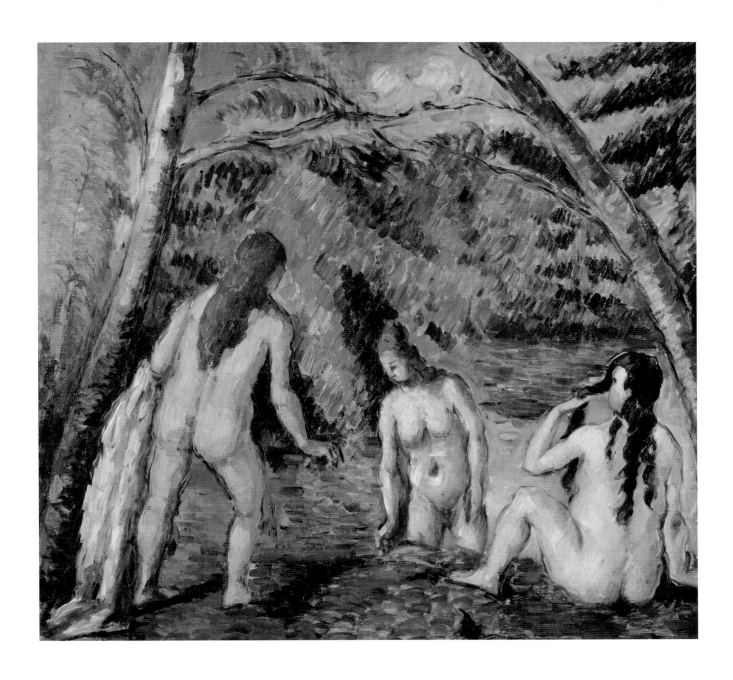

PLATE 10

Paul Cézanne

Three Bathers, 1879–82

Oil on canvas
20½ x 21⅝ inches (52.1 x 54.9 cm)
Petit Palais, Musée des Beaux-Arts de la Ville de Paris

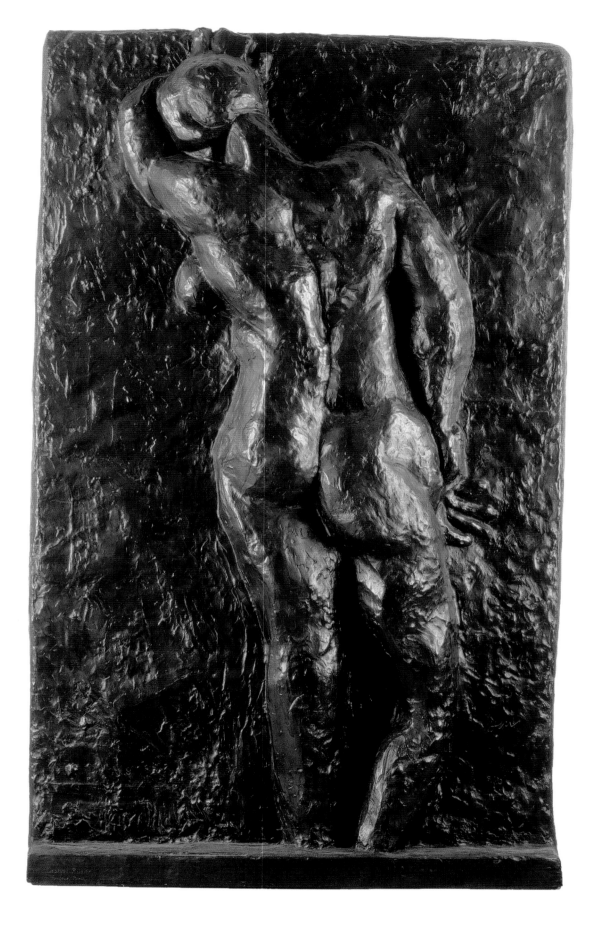

PLATE II

Henri Matisse

Back I, 1909

Bronze
74 x 44⅞ x 6½ inches (188 x 114 x 16.5 cm)
Hamburger Kunsthalle, permanent loan "Stiftung für
die Hamburger Kunstsammlungen"

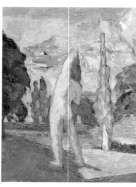

Fig. 4.15. **Paul Cézanne,** *Bathers at
Rest,* 1875–76 (detail). Oil on canvas,
overall 32¼ x 39⅞ inches (82 x 101.2 cm).
The Barnes Foundation, Merion,
Pennsylvania

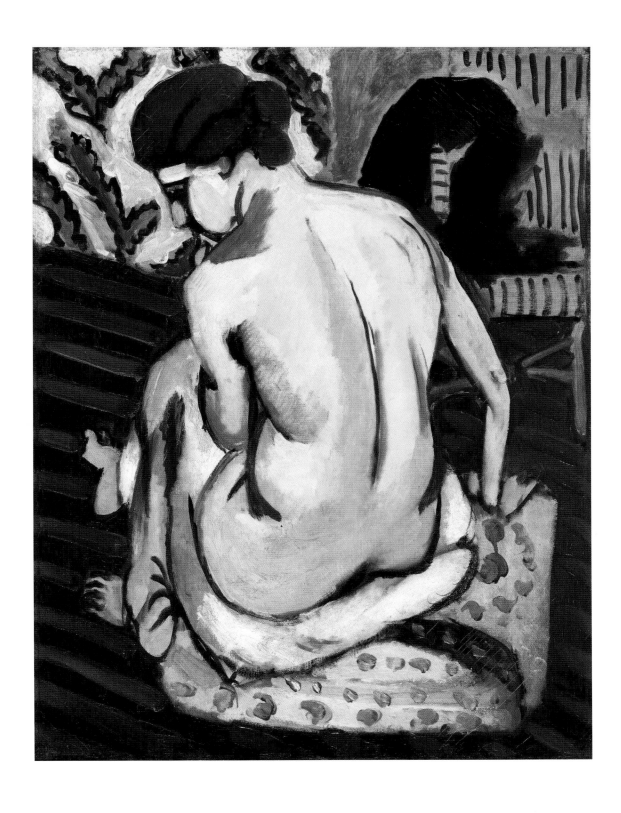

PLATE 12

Henri Matisse

Seated Nude, Back Turned, **1917**

Oil on canvas
24½ x 18½ inches (62.2 x 47 cm)
Philadelphia Museum of Art. The Samuel S. White 3rd
and Vera White Collection, 1967-30-53

Paul Cézanne, *Three Bathers*, 1879–82
(detail; plate 10, p. 123)

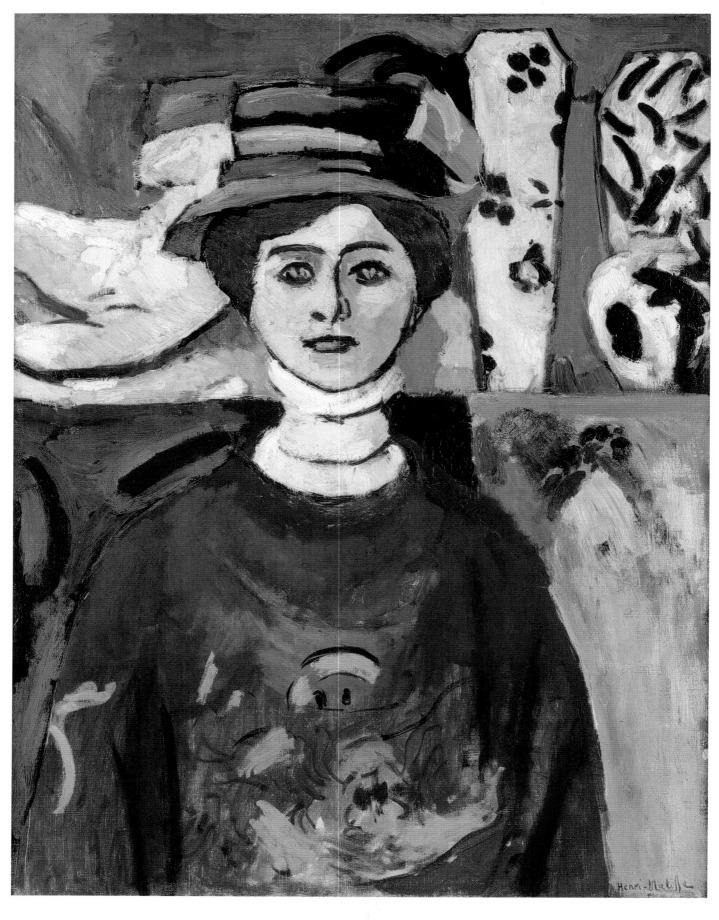

PLATE 13

Henri Matisse

The Girl with Green Eyes, 1908

Oil on canvas
26 x 20 inches (66 x 50.8 cm)
San Francisco Museum of Modern Art. Bequest of
Harriet Lane Levy

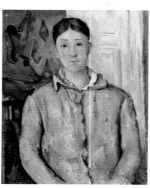

Paul Cézanne, *Madame Cézanne in
Blue*, 1888–90 (plate 111, p. 322)

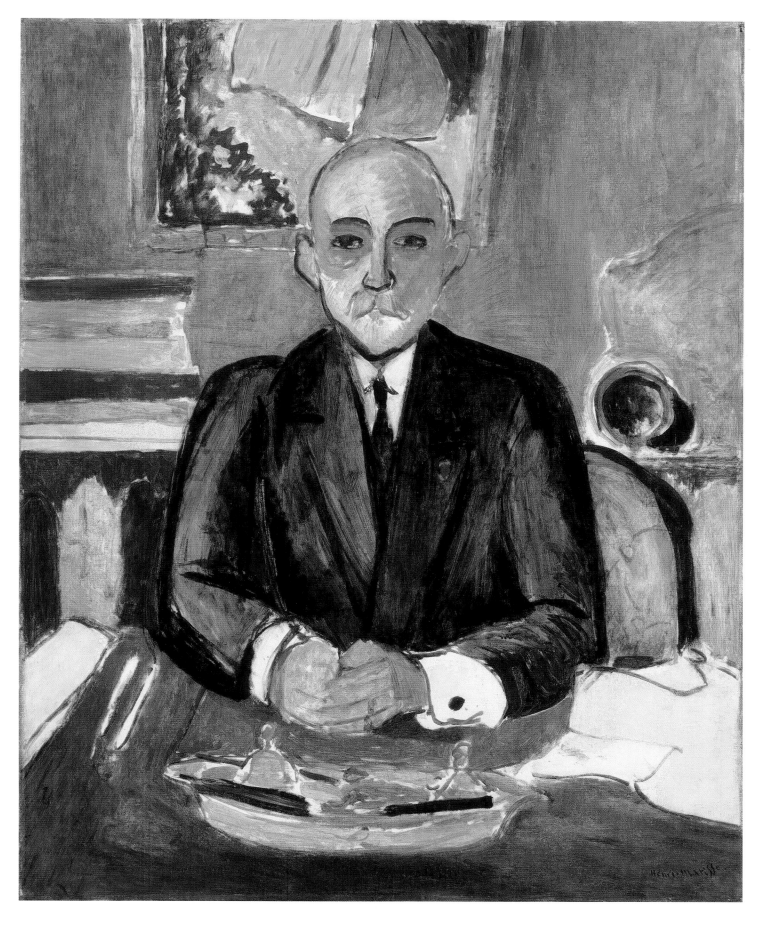

PLATE 14

Henri Matisse

Auguste Pellerin I, 1916

Oil on canvas
36⅜ x 31 inches (92.4 x 78.7 cm)
Private collection

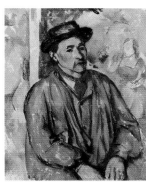

Paul Cézanne, *Man in a Blue Smock,*
1892 or 1897 (plate 62, p. 236)

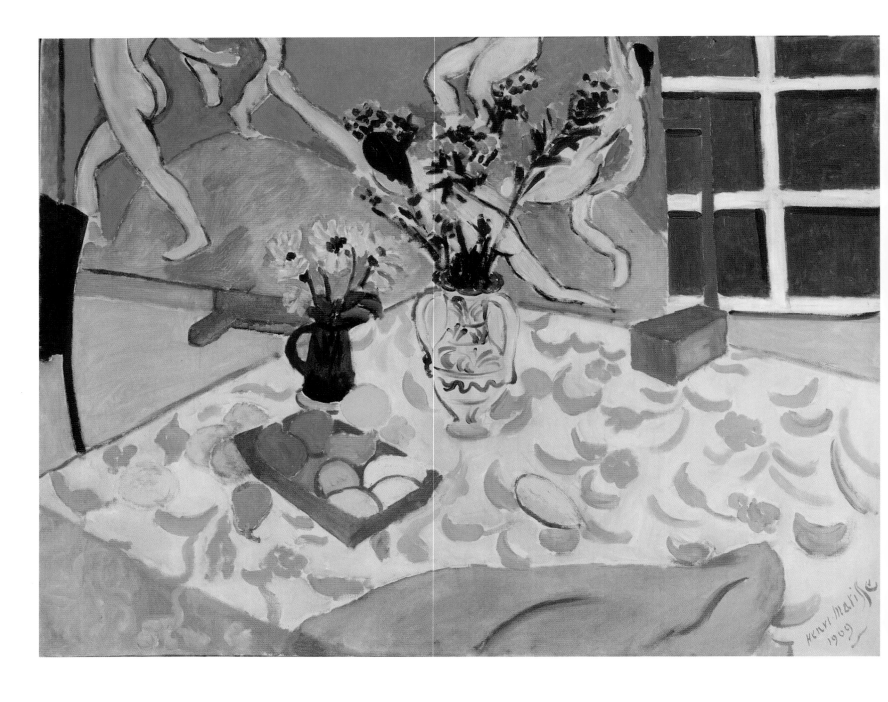

PLATE 15

Henri Matisse

Fruit, Flowers, and "The Dance,"

1909

Oil on canvas
35 x 45⅝ inches (88.9 x 115.9 cm)
State Hermitage Museum, St. Petersburg

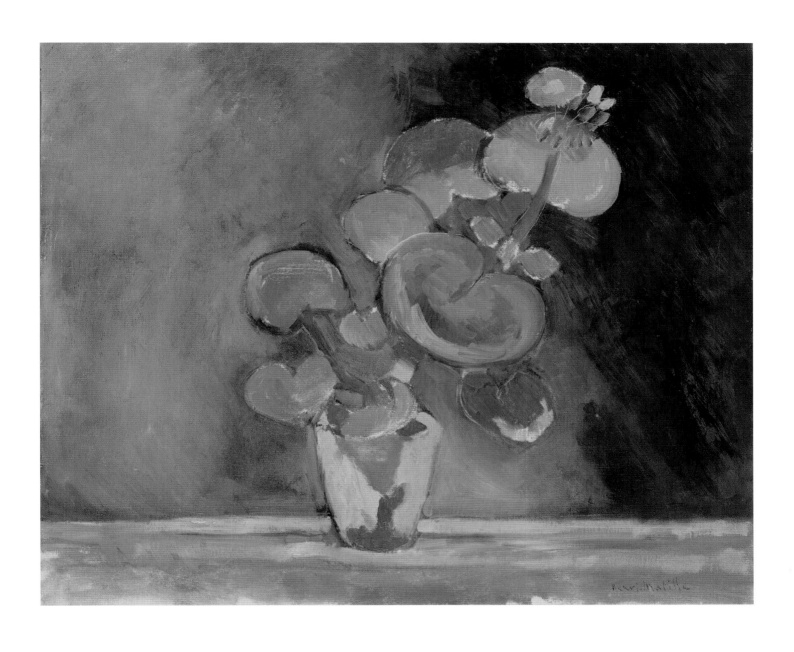

PLATE 16

Henri Matisse

The Geranium, 1910

Oil on canvas
17⅞ x 21⅝ inches (45.5 x 55 cm)
Private collection

Paul Cézanne, *Geraniums,* c. 1885
(plate 170, p. 460)

PLATE 17

Henri Matisse

Mademoiselle Yvonne Landsberg,
1914

Oil on canvas
58 x 38⅜ inches (147.3 x 97.5 cm)
Philadelphia Museum of Art. The Louise and
Walter Arensberg Collection, 1950-134-130

Paul Cézanne, *Madame
Cézanne,* c. 1886 (plate 36, p. 176)

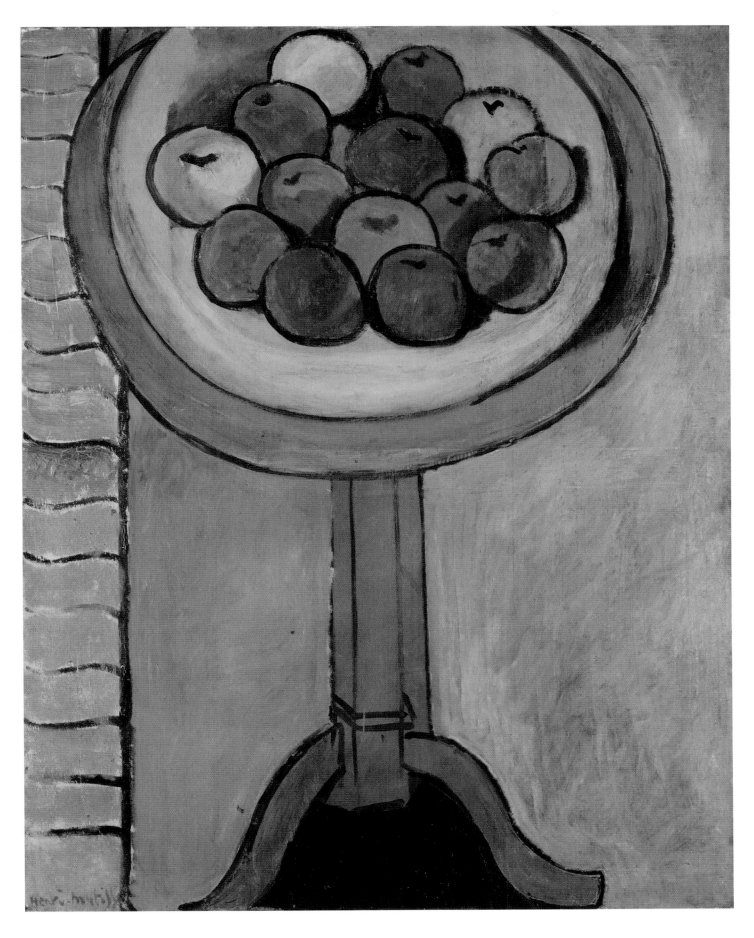

PLATE 18

Henri Matisse

Bowl of Apples on a Table, 1916

Oil on canvas
45¼ x 35¼ inches (114.9 x 89.5 cm)
Chrysler Museum of Art, Norfolk, Virginia. Gift of
Walter P. Chrysler, Jr.

Paul Cézanne, *Stoneware Jug*,
1893–94 (plate 45, p. 200)

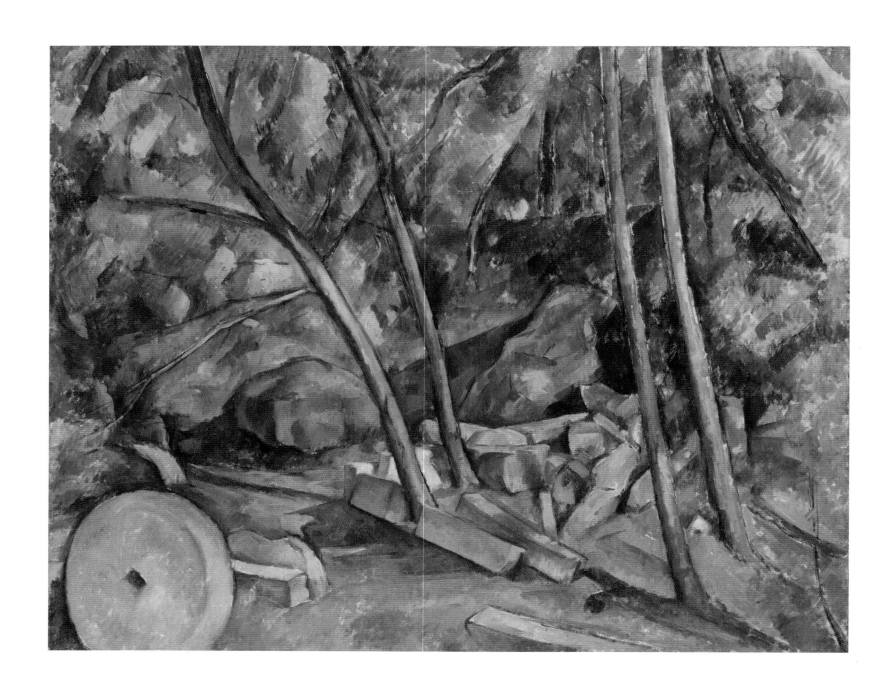

PLATE 19

Paul Cézanne

Millstone in the Park of the
Château Noir, 1898–1900

Oil on canvas
28¾ x 36⅜ inches (73 x 92.4 cm)
Philadelphia Museum of Art. The Mr. and Mrs.
Carroll S. Tyson, Jr., Collection, 1963-116-4

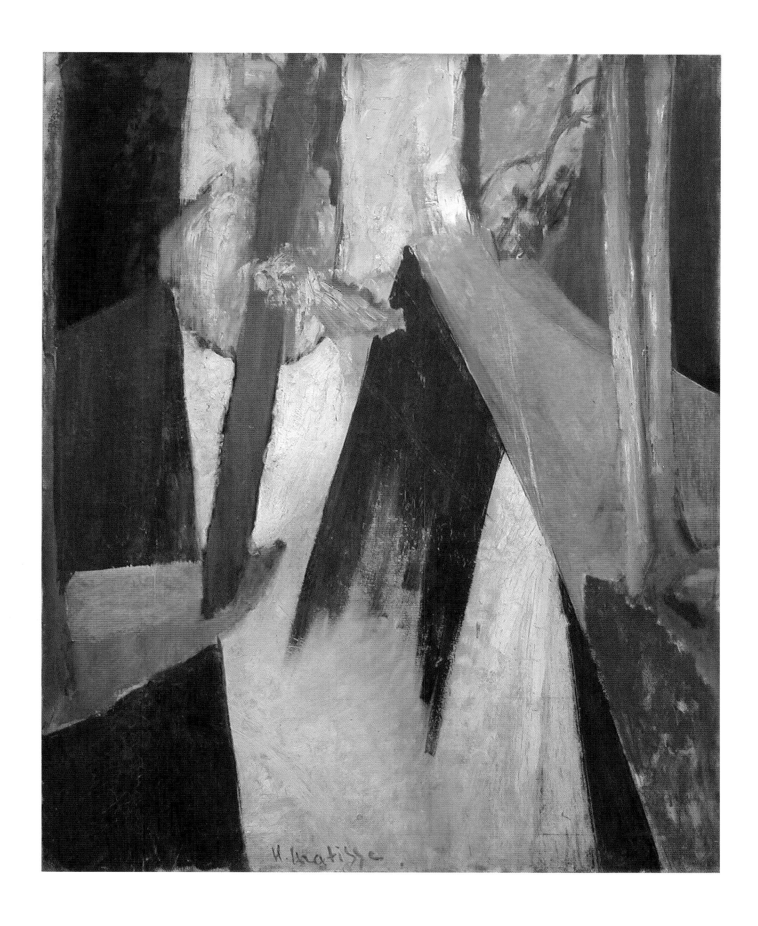

PLATE 20

Henri Matisse

Shaft of Sunlight, Woods of
Trivaux, 1917

Oil on canvas
36¼ x 28¾ inches (92.1 x 73 cm)
Private collection

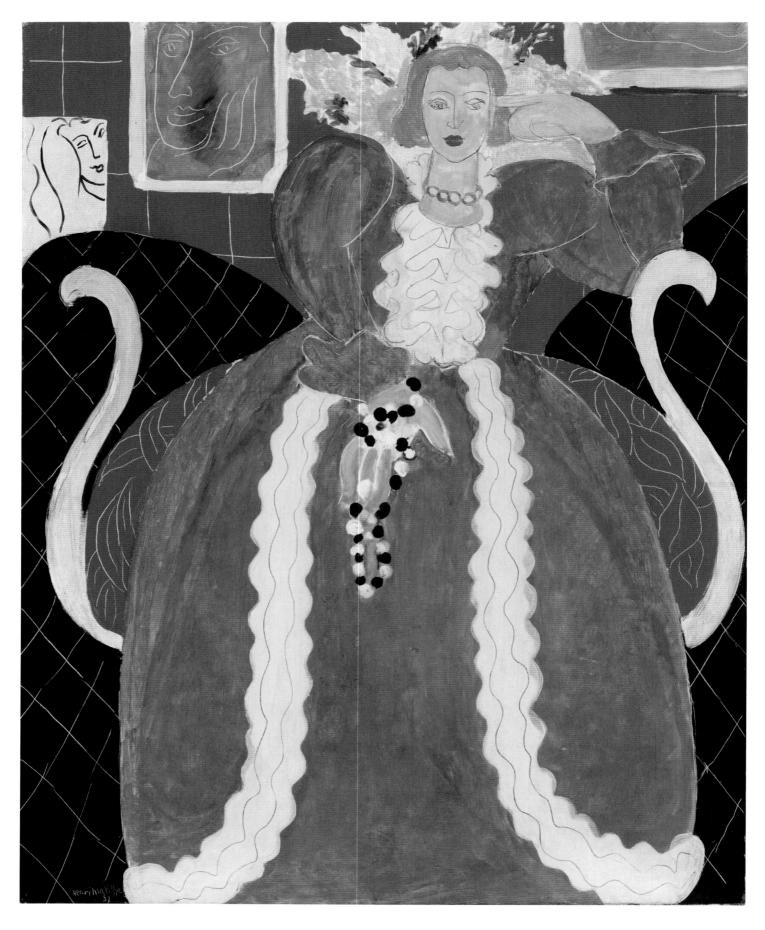

PLATE 21

Henri Matisse

Woman in Blue, 1937

Oil on canvas
36½ x 29 inches (92.7 x 73.7 cm)
Philadelphia Museum of Art. Gift of Mrs. John
Wintersteen, 1956-23-1

Paul Cézanne, *Madame Cézanne
in a Red Armchair*, c. 1877 (plate 60,
p. 234)

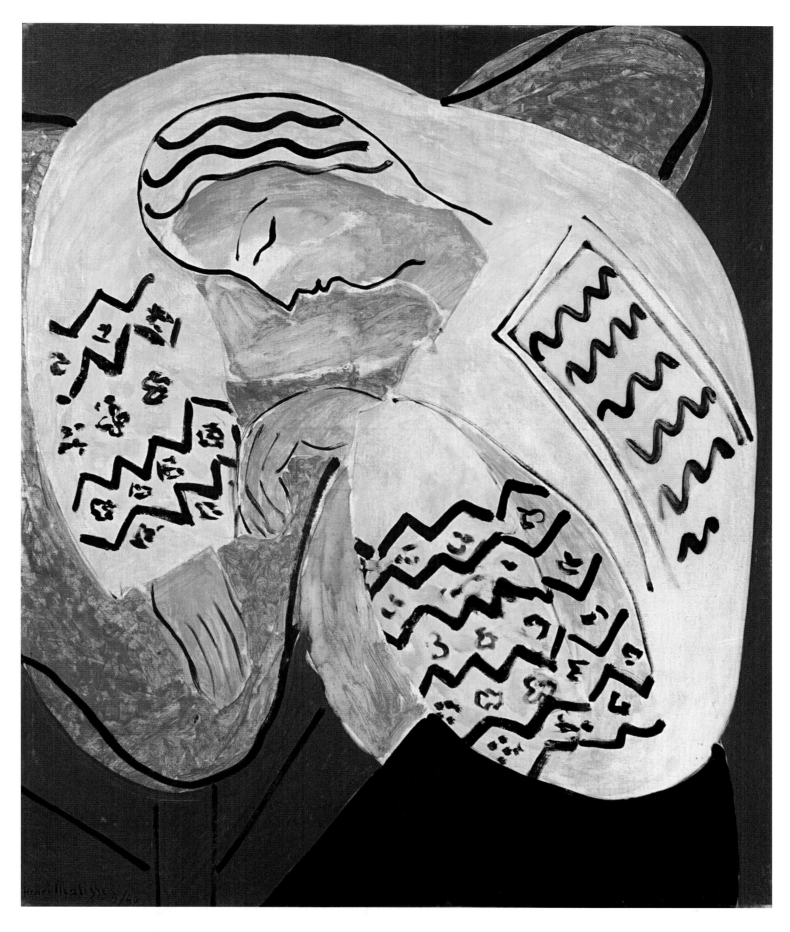

PLATE 22

Henri Matisse

The Dream, 1940

Oil on canvas
37⅞ x 25⅝ inches (81 x 65 cm)
Private collection

Fig. 4.16. **Paul Cézanne, *Young Italian Woman at a Table,*** c. 1896. Oil on canvas, 36¼ x 28¾ inches (92.1 x 73 cm). J. Paul Getty Museum, Los Angeles

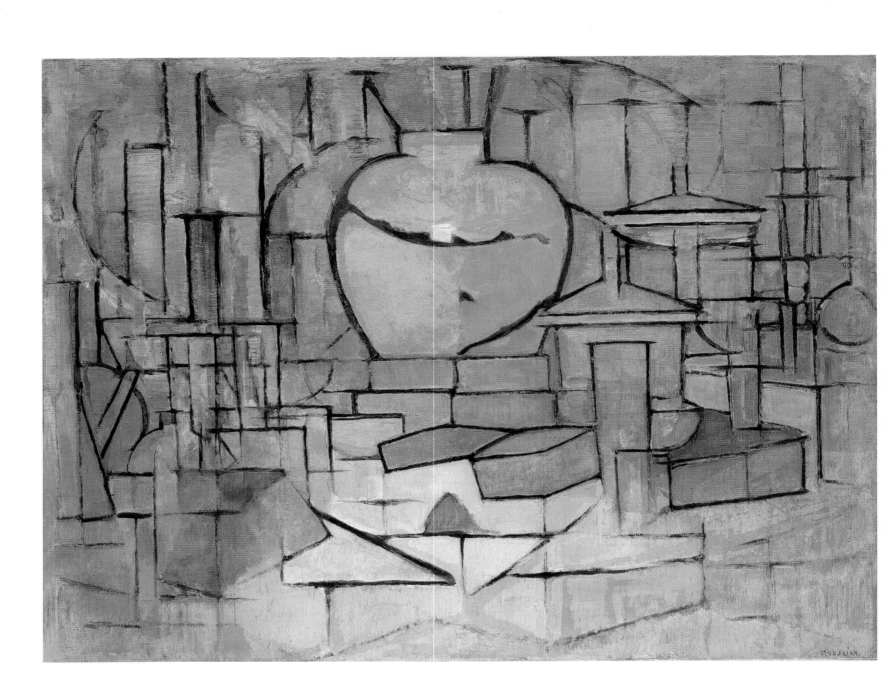

Cézanne and Mondrian: "A New Way to Express the Beauty of Nature"

Joop M. Joosten

Paul Cézanne, *Ginger Pot with Pomegranate and Pears,* 1890–93 (plate 147, p. 426)

Modern art follows ancient art in accentuating the *planarity* of natural reality, and is only a more consistent expression of the same idea: the plastic conception. After the *accentuation* of planarity there began the fragmentation of the visual corporeality of objects in the painting. (Cézanne—Kandinsky; the Cubist school—Picasso.) Here the plastic conception already becomes more plastic.

Finally, the new plastic *is the manifestation of this conception, the manifestation of the purely aesthetic idea. . . .*

Indeed, art before the new plastic determined color only *to a degree*: by intensification, by planarity, by firm stroke or surrounding line (contour). *Form* was delineated and filled in with color, or it was rendered through color (Cézanne). The value of a work of art before our time can be measured by its (relative) determination of color. In times of intense inward (or spiritual) life, color was planar and line tensed. But even in other times, when color was modeled and line capricious, art gave color its *definiteness* and line its *tension* in order to express plastically inner force.

The early modern school of painting is distinguished by strong linear expression (contour)—Van Gogh; and by planar use of color—Cézanne.
—PIET MONDRIAN, "The New Plastic in Painting" (1918)[1]

Until the modern era, the plastic means of all painting was rather the *natural appearance of objects* than *natural form and color*. Natural appearance was transformed by the prevailing sense of style but always in such a way that the natural remained recognizable. Thus we can understand the astonishment and even anger aroused in recent times when form and color began to be used autonomously and natural appearances were no longer recognizable. One was confronted with the necessity of accepting a new way of seeing. A more conscious vision, which saw form and color as means in themselves, resulted from *conscious* perception of

what was previously perceived unconsciously: that beauty in art is created not by objects of representation but by the relationships of line and color (Cézanne). Despite its greater consciousness, the new era was slow to accept this, so deeply rooted was naturalistic vision. . . .

Throughout modern painting we see a trend to the straight line and planar, primary color. Shortly before Cubism we see the broad contours emphasized as strongly as possible and the colors within them made flat and intense (Van Gogh and others). The technique of painting was correspondingly transformed: the work took on a new appearance, although the inner impulse came from the same source. Naturalistic plastic was increasingly tautened: form was tensed, color intensified. . . .

At the same time, the ideas that Cézanne had already established (that everything has a geometric basis, that painting consists solely of color oppositions, etc.) were increasingly stressed and cleared the way for Cubism.
—MONDRIAN, "The New Plastic in Painting"[2]

If the determinate demands *determination*, then the *plastic expression of relationship* in art must be carried to determination. This is achieved in painting by determining *color itself* as well as the *color planes* . . . this consists in counteracting the blending of colors by establishing boundaries either by the opposition of plane (value) or by line. *Line* is actually to be seen as the *determination of (color) planes*, and is therefore of such great significance in all painting. Nevertheless, the plastic is created by planes, and *Cézanne* could say that painting consists solely of oppositions of color.
—MONDRIAN, "The New Plastic in Painting"[3]

When I asked Mondrian what his estimate of Cézanne was, he answered: "His biggest contribution was the destruction of the old picture concept, not much else than that."
—CARL HOLTY, "Mondrian in New York: A Memoir" (1957)[4]

Cézanne

To mark the opening of the so-called Drucker Extension (now known as the South Wing; fig. 5.1) on December 3, 1909, the Rijksmuseum in Amsterdam staged a tribute to Cézanne, a museum honor that he had not previously enjoyed. In one of the downstairs galleries, which at that time still had vaulted ceilings, twelve paintings by Cézanne were displayed along with seven paintings and three drawings by Vincent van Gogh (1853–1890). To be sure, all the works—apart from the van Gogh drawings—were on loan, but nevertheless the exhibition made a significant statement about Cézanne's importance to modern art.

The construction of the museum's extension had been negotiated by businessman J. C. J. Drucker (1862–1944), son of a wealthy London financier, and his wife, M. L. Fraser, as a condition of the couple's bequest of their entire collection of works from the Hague School—the Dutch rival to French Impressionism. It was important to Drucker and his wife not only that the collection remain intact, but also that it be exhibited. To show that the offer was serious, immediately after signing the agreement they loaned part of the collection to the museum, which lost no time in fulfilling their wish, and the building's construction was soon underway. Three days before the extension's original opening date, the loan was converted to a gift, delaying the opening until December 3.

The twelve paintings by Cézanne were part of a collection of thirty paintings and one drawing by the artist that Hague collector Cornelis Hoogendijk (1866–1911) had purchased from Paris art dealer Ambroise Vollard over a period of three years at the end of the nineteenth century. As Vollard later recalled, Hoogendijk met the Paris dealer during his quest to acquire work by Théophile-Alexander Steinlen (1859–1923). By the time of Hoogendijk's death, he had collected 125 of Steinlen's drawings, as well as work by Gustave Caillebotte, Camille Corot, Honoré Daumier, Paul Gauguin, Armand Guillaumin, Claude Monet, Adolphe Monticelli, Odilon Redon, Pierre-August Renoir, Édouard Vuillard, and van Gogh. Not surprisingly, Hoogendijk also owned examples of "modern" Dutch art and a collection of sixteenth- through eighteenth-century Dutch art, in addition to his collection of "modern" French artists.

Toward the end of his life, serious illness prevented Hoogendijk from acting on his own behalf, and in 1906 his sisters loaned their brother's collection of both old and new (that is, nineteenth-century) art, including the twelve works by Cézanne and the ten by van Gogh, to the Rijksmuseum. The dream of Willem J. Steenhoff (1863–1932), director of the paintings department, and B. W. F. van Riemsdijk, Esq., the museum's director, of starting a Rijksmuseum for Modern Art thus appeared to be nearing reality. The enterprise attracted a great deal of interest, and the press, in particular, devoted substantial attention to this remarkable extension of the Rijksmuseum, especially to its opening exhibition of works by Cézanne and van Gogh.

Mondrian

> The first thing to change in my painting was the color. I forsook natural color for pure color. I had come to feel that the colors of nature cannot be reproduced on canvas. Instinctively, I felt painting had to find a new way to express the beauty of nature.
> —MONDRIAN, "Toward the True Vision of Reality" (1942)[5]

1908 This change in Mondrian's painting took place in early spring 1908. In April of that year he submitted four works to the annual exhibition held by the St. Lucas artists' society of Amsterdam at the city's Stedelijk Museum. Listed first in the catalogue is *Farm Building* (A396a/UA30), which surely was the painting illustrated a few months later in a review of Mondrian's retrospective at the Stedelijk in 1909. The work shows the farm "Duivendrecht," south of Amsterdam, which in early 1905 was the basis for

a small series of paintings, watercolors, and drawings. *Farm Building* hung, with the other works he submitted to the St. Lucas exhibition, in "a small separate gallery filled with paintings in a blue spectrum, largely by Jan Sluijters and Piet Mondrian."[6] Another reviewer noted, "P. Mondrian was also among the eccentrics, seeking in strange, unreal colors to tailor nature's forms to what he wished to express," with a reference to *Farm Building.* Later the artist himself twice referred to that "special period (in blue)" and "that blue tree period."

In the months that followed, Mondrian's work underwent a spectacular transformation, depicting a variety of both old and new subjects. The best-known works from this time are *Woods near Oele* (A591); *Mill in Sunlight* (A654); *Row of Eleven Poplars in Red, Yellow, Blue, and Green* (A558; fig. 5.3), after *Bend in the Gein with Row of Eleven Poplars IV* (A488; fig. 5.2), a painting two or three years older of the same river view; three paintings of haystacks (A655–57); *Devotion* (A642); *Dying Chrysanthemum* (A601); and the series *Dying Sunflowers* (A596–98). We cannot rule out the possibility that the exhibition held by Amsterdam art dealer C. M. van Gogh in September and October 1908, featuring Vincent van Gogh's late work from Arles, St. Remy, and Auvers, prompted Mondrian to make this radical change. He would not have missed the van Gogh exhibition, even though he left Amsterdam on September 12 to spend some four weeks in Domburg. Since the turn of the century this well-known seaside resort in Zeeland had been popular with writers and artists befriended by the painter Jan Toorop (1858–1928) and Kees Spoor (1867–1922), a violinist with the Amsterdam Concertgebouw orchestra who was well known in the Amsterdam art world for his portraits of children. Toorop and Spoor in fact were in Domburg during the weeks Mondrian spent there in autumn 1908. Mondrian's association with Spoor and his wife was particularly important for him at that time in view of their interest in theosophy — they were members of the Dutch branch of the Theosophical Society — and because of

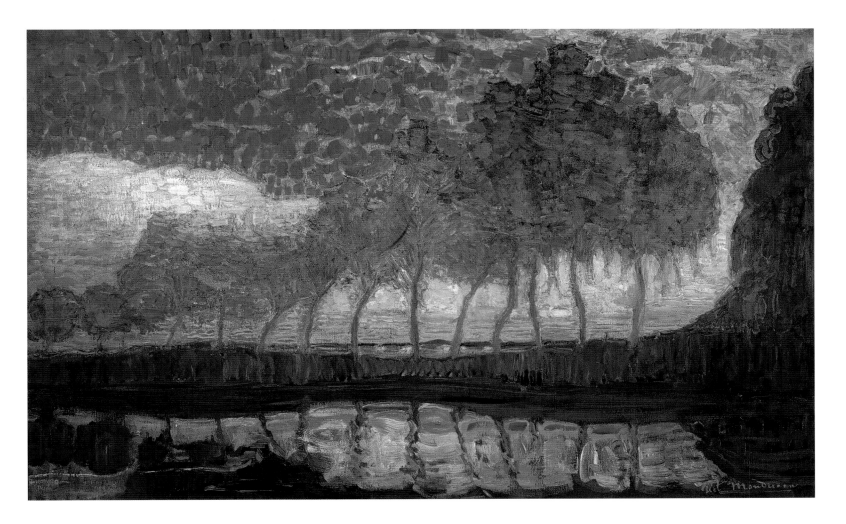

Spoor's connections with the artistic, cultural, and official circles in Amsterdam. Two paintings commemorate Mondrian's stay in Domburg: *Mill at Domburg* (A677) and *View from the Dunes with Beach and Piers* (A700), both of which can be grouped with the works listed above. Over the coming months, plans for a joint exhibition by Mondrian, Sluijters, Cornelis Spoor, and Toorop would mature.

1909 On January 6, 1909, Sluijters, Spoor, and Mondrian opened a three-man exhibition of paintings and drawings at the Stedelijk Museum, where they had been given access to the entire right half of the upper floor. As the invitation stated, the show had arisen from a desire to convey an accurate picture of each artist's development and the personal nature of his work. It was in fact a combination of three separate exhibitions that had been organized independently, and only Spoor's works were represented by a catalogue. The exhibition was reviewed extensively, however, so we are able to form a reasonable idea of the works on view within the various galleries.

Mondrian apparently divided his work among three galleries: two double galleries and a single, corner gallery. The first pair of galleries contained a series of painted studies, drawings, and sketches, starting with a still life and an urban landscape from his time at the Rijksakademie van Beeldende Kunsten; the second, corner gallery displayed a broad selection from his "blue period" and the Luminist work that followed it, including the paintings mentioned above. In the third gallery, or pair of galleries, full landscapes painted after 1900 were on view.

Toorop's failure to participate was probably related to the major retrospective of his work that opened at the Larensche Kunsthandel in Amsterdam on February 11, 1909. Prior to that, at the same time as the three-man exhibition in the Stedelijk Museum, he had exhibited eleven recent pointillist works at a group show of the Arti et Amicitiae artists' society.

It was following the exhibition at the Stedelijk Museum—when Mondrian had once again restored order to his studio, and several of his works, in the simple frames made for the three-man show, adorned the walls of his studio—that the now-famous photograph was taken of the artist sitting on a divan and reading a book (fig. 5.4). It shows a well-furnished, indeed old-fashioned, interior, with a view through to the store where he kept his paintings. This detail is worth noting because shortly thereafter, in May, Mondrian removed all the fixtures and fittings and painted the walls white and the paneling and floor pitch black. According to brief descriptions by an upstairs neighbor and a pupil, the few items of furniture he allowed to remain in his studio and his two easels were also painted white. Was it by looking at the photograph that Mondrian realized the contrast between his work and his conventional surroundings?

That same month, Mondrian became a member of the Theosophical Society, having been nominated by Spoor, among others. A month later, he traveled again to Domburg, now in the company of Spoor, remaining there until the end of October. After resting for a while, Mondrian began painting again. The sea, the beach, and the dunes drew most of his attention, though he did paint several church towers, two portraits, and two facades, all in bright colors and in the pointillist style. At the end of his stay, Mondrian belatedly responded to a two-part article by writer and critic Is. Querido in the weekly journal *De controleur*, on the artist's contribution to the three-man exhibition held the previous January. The first part of the article had been published at the end of May, and Querido had sent Mondrian the second section for his approval, most likely realizing that, in his quest to explore the background to Mondrian's work, he might have interpreted some things incorrectly. Indeed, Mondrian's response was such that Querido deemed it wise to publish the reply rather than his own text. It was to be the first time Mondrian discussed his work in public:

> I find the work of the great masters of the past very beautiful and very grand, but you will agree with me that everything done in our own time must be expressed very differently, even through a different use of technique. I believe that in our period it is definitely necessary that, as far as possible, the paint is applied in pure colors set next to each other in a pointillist or diffuse manner. This is stated strongly,

and yet it relates to the thought which is the basis of meaningful expression in form, as I see it. . . .

There are great intrinsic values or truths which remain the same throughout the ages, but form and expression are changing. . . .

It seems to me that you too recognize the important relationship between philosophy and art, and it is exactly this relationship which most painters deny. The great masters grasp it unconsciously, but I believe that a painter's conscious spiritual knowledge will have a much greater influence upon his art, and that it is merely a weakness in him—or a lack of genius—should this spiritual knowledge be harmful to his art. . . .

I do not know how I shall develop, but for the present I am continuing to work within ordinary, generally known terrain, different only because of a deep substratum, which leads those who are receptive to sense the finer regions. Therefore my work still remains totally outside the occult realm, although I try to attain occult knowledge for myself in order better to understand the nature of things.[7]

Once back in Amsterdam, Mondrian began producing a large number of drawings and watercolors of chrysanthemums and other flowers, as well as small studies, "for a living." The new home and studio he moved into in early 1908 and his trips to Domburg would have greatly burdened his meager finances. During the exhibition in January he had indeed sold a large number of works, but the three artists had been obliged to pay all the costs of the show, including rental fees for the galleries.

1910 In the new year Mondrian turned his attention to the forthcoming annual St. Lucas exhibition, which was scheduled to open on April 14. Together with a number of the paintings produced in Domburg the previous summer, he also showed two new works dating to the first few months of 1910: the largest of two dune landscapes, *Summer, Dune in Zeeland* (A708), and *Rhododendrons* (A618). Although the latter has since been lost, the existence of a preliminary study and an illustration of the painting, as well as contemporary reviews, allow us to classify it as belonging to Mondrian's pointillist works from the Domburg period. In *Summer, Dune in Zeeland,* by contrast, the artist went his own way, as he did in the smaller version, *Dunes near Domburg* (A709). Apart from the difference in size—the dimensions of the larger of the two are exceptional for a work by Mondrian—there is also a remarkable difference in painting technique. Both works were produced in a manner that Mondrian described as "diffuse," but the vertical bank of dunes in *Summer, Dune in Zeeland* is structured with a series of short, parallel brushstrokes not present in the smaller painting. Instead of using light brown, the color of the sand, Mondrian painted the dune in light blue.

Among the artists in the 1910 St. Lucas exhibition, Mondrian was the one whose work appeared to merit the most discussion, suggesting that in the view of most people he had gone too far. But the prominent critic Conrad Kikkert (1882–1965) praised Mondrian in the journal *De kunst*: "Though Mondrian was until a few years ago a pale imitation of Sluijters, he has now worked himself free, surpassing Sluijters with more mature, fuller and more splendid work. A simple dune landscape of his in the exhibition dazzles the eye at first, but later appears just right: the shimmering heat above the baking sand." Previously, Kikkert had not been so favorably disposed to Mondrian's work. His positive response at this point might have prompted the idea of setting up a society with the task, like that of the Salon d'Automne in Paris, of introducing modern artistic movements from abroad to the Netherlands at an annual exhibition.

On November 24 the Moderne Kunst Kring was established, with Toorop as chairman, Kikkert as secretary, and Mondrian and Sluijters as members. It was planned that the first exhibition would feature Fauvism, Expressionism, and Luminism, particularly the work of Henri Matisse and Kees van Dongen (1877–1968).

Soon after the St. Lucas exhibition closed, Mondrian went to Leiden to earn a living by drawing microscopically enlarged images of bacteria for an Amsterdam acquaintance, who for some years had been appointed as a professor at the University of Leiden. This work would keep Mondrian busy until around March of the following year, interrupted only by a stay in Domburg from late August to late October.

This time he traveled to Domburg by himself, with an express wish to be alone in order to follow the path upon which he had started on his previous visit. A carpenter in Domburg, who knew the summer visitors by virtue of his profession, had the following interesting recollection of Mondrian in what was for the artist a crucial period:

> Mondrian's red. On those beautiful summer evenings, when it had been a little stormy in the late afternoon, when the wind was still warm from the sun, and it was low tide, you could bet your boots you'd find Mondrian in the dunes. At his regular spot, halfway up the steep incline by Villa Carmen Sylvia. Usually with a big, pale green sketchpad on his knee. I never saw him with one of those easels, like the other painters had.
>
> He just sat there. You could just see the top of his head as you passed. He didn't stand out particularly, I always thought. He had an everyday sort of face, a bit of a coarse nose, and remarkably dark eyes. And they were piercing, believe you me. Often he just sat there looking at a book.
>
> I was never that happy to see him there. It was my spot you see. There's no better spot on the Domburg side of the dunes. It's the only place you can see both the east and west beach right beyond Hoge Hil. When it's really clear, you can see Belgium to the left, and the dunes of Schouwen to your right. You see the big black four-masters traveling up the Scheldt, the steam ships struggling against the flow in the Westkappelse Gat, and then our beach. You need only turn your head and all the beauty of Domburg passed before your eyes.
>
> That painter had discovered this too. When the sun went down, the sky lit up red in the West, big shadows passed over Hoge Hil, until just before it went dark. And something like that is beautiful in itself if you're a painter, right? The people on the beach were little dark red figures. And sometimes, if you were lucky, there might be some porpoises playing near the groynes.[8]

It was doubtless during those months that Mondrian painted *Zeeland Church Tower* (A691), which depicts the tower in Domburg at sunset, half in sunlight, half in the shadow of the houses opposite, and *The Red Mill* (A692), seen by night. Given the size of the works, we might well wonder where he painted them. Did he use the studio of his friend Jacoba van Heemskerck (1876–1923), who lived during the year in The Hague?

Later, in his third essay in *De Stijl*, Mondrian provided an important account of the position of the windmill's sails and its red color against the blue of the night sky. In Scene 4 he describes "a windmill seen at very close range, sharply silhouetted against the clear night sky; its arms, at rest, forming a cross." He continues:

Indeed, I find this windmill very beautiful. Particularly now that we are too close to it to view it in normal perspective and therefore cannot see it or draw it normally. From here it is very difficult merely to reproduce what one sees: one must dare to try a freer mode of representation. In my early work, I tried repeatedly to represent things seen from close by, precisely because of the grandeur they then assume. At that time, to return to this windmill, I was particularly struck by the cross formed by its arms, Now, however, I discern the perpendicular in everything, and the arms of the windmill are not more beautiful to me than anything else. . . .

[T]he sky is pure, but so is the mill! *Visually* it appears as merely dark and without color. But gradations of light and dark paint are inadequate to render a complete impression of the mill and the sky, as I frequently found. Light and dark may be satisfactory for a drawing but color demands much more. The blue [of the sky] calls for another *color* to oppose it. The Impressionists already exaggerated color—Neo-Impressionists and Luminists went further. To speak from my own experience, I found it satisfactory to paint the mill red against the blue. . . .

[L]et us keep in mind that aesthetic vision is something other than ordinary vision. And in general the one thing that counts in art is to reflect aesthetic *emotion*: to the extent that we feel the purity of color more intensely, we are able to express color more purely.[9]

What is remarkable about both *Zeeland Church Tower* and *The Red Mill* is the planar emphasis, which partly—perhaps entirely—determines the use of unadulterated color. In this respect, *The Red Mill* is clearly more taut and consistent than *Zeeland Church Tower*, and as a result the latter appears largely anecdotal. With *The Red Mill*, Mondrian clearly took the first step toward abstraction. It is not the mill as such that stands out, but the forms and the colors, though his use of crossed diagonal lines to structure the bank on which the mill stands is no less significant.

Toward the end of his stay in Domburg, Mondrian did after all meet Aletta de Jongh (1887–1975). His reply to a letter from her, which he had received after her departure, began: "So, did you find me so changed? Oh, but that is only on the outside: I am still the same, just a little better balanced, if I don't deceive myself. My studies of theosophy have helped in that. I know a lot about it: It really is a guide to developing your consciousness." In a postscript (her comment must have struck him profoundly), he added: "I did not find you changed, with me it's just the absence of the beard that seems strange." The reference to shaving his beard suggests that Mondrian—on rereading his letter—realized he had given away more than he intended. He may have been conscious that the time spent in isolation over the past few months, working out where and how to proceed, inevitably left its mark on his face, betraying the process of growing awareness he had undergone. Together with the ideas he had developed on evolution, stimulated in part by theosophy and occultism, this final sentence almost certainly set him thinking, prompting him to create the *Evolution Triptych* (A647), with its subtle but evocative variations between the facial expressions of the figures on the left and on the right panels, typifying the difference between the unconscious and the conscious. The central panel depicts revelation, the beginnings of awareness. With the help of theosophical and occult images and signs, he underscored the meaning of the features.

It is likely that Mondrian painted the *Evolution Triptych* when he returned to Amsterdam after his stays in Leiden and Domburg. The painting's links with *The Red Mill* are obvious.

It was during this early period of experiment that I first went to Paris. The time was around 1910 when Cubism was in its beginning. I admired Matisse, van Dongen, and the other Fauves, but I was immediately drawn to the Cubists, especially to Picasso and Léger. Of all the abstractionists (Kandinsky and the Futurists), I felt that only the Cubists had discovered the right path; and, for a time, I was much influenced by them.[10]

1911 According to his own account, Conrad Kikkert had settled in Paris by late 1910 or early 1911, staying with his childhood friend Lodewijk Schelfhout (1881–1943), who had lived there since 1903. It was probably while he was still studying, or shortly afterward, that Schelfhout had come into contact with a group of young German painters, pupils from the school of Matisse who later were regulars at the Café du Dôme. On the first Tuesday after his arrival in Paris, Schelfhout introduced Kikkert to poet and dramatist Paul Fort's "Mardi" gathering, where he met the Cubists of the Left Bank. The meeting was a revelation. If the Moderne Kunst Kring truly wanted to be modern, Kikkert realized, its first exhibition would have to include work by the French Cubists. But this would require the entire committee's approval, which meant that the members would need to see Cubism, in Paris, at the earliest opportunity. The trip did not represent a problem for Sluijters. He knew Paris and could afford the cost of the journey. But it was financially impossible for Mondrian. Nevertheless, by selling four paintings to a doctor friend, Kikkert enabled Mondrian to travel to Paris to observe the latest developments in art. He spent ten days there in May, primarily to visit the twenty-seventh annual exhibition of the Société des Artistes Indépendants. That year's exhibition was the first that allowed like-minded artists to hang their works together, and consequently it became the first great Cubist event, albeit without the presence of Braque and Picasso. Mondrian himself had been a member of the Indépendants since July 1910, and he would have been keen to see where the work he had submitted— his large dune landscape *Summer, Dune in Zeeland*—had been been hung. Apart from this exhibition, undoubtedly he also would have visited the Cubists in their studios, certainly that of Henri Le Fauconnier (1881–1946), and possibly also the studios of Fernand Léger, Georges Braque, and Pablo Picasso, or he would have seen the Cubists' works at the galleries of their art dealers Daniel-Henry Kahnweiler, Clovis Sagot, and Wilhelm Uhde. The only comment from Mondrian or information about his stay is the brief impression he wrote on a picture postcard to Steenhoff: "It's good for me to be here. Everything is so big and grand."

Back in Amsterdam, Mondrian was still faced with providing his contribution to the Moderne Kunst Kring's first exhibition. He submitted five works: *Summer, Dune in Zeeland*; *The Red Mill, Zeeland*; *Church Tower*; and *Evolution Triptych*, as well as two new works, *Dune Landscape* (B1) and *Flowers* (U1). From reviews we know that *Flowers* featured the same pronounced structure as *Dune Landscape*. Listed first in the catalogue—and thus presumably produced after *Dune Landscape*—*Flowers* was lost at some point; Mondrian may have destroyed it out of dissatisfaction with the result.

Through the application of a series of brushstrokes in *Dune Landscape*, his largest painting (52¾ x 76¾ inches [134 x 195 cm]), Mondrian achieved what he must have begun to envision in his second-largest painting, *Summer, Dune in Zeeland*. It is not surprising that the need for structure manifested itself in an image of a dune landscape, which itself has no structure or boundaries, suggesting to Mondrian, we may assume, the extraordinary sizes for these two paintings.

On October 6, 1911, Jan Toorop, chairman of the Moderne Kunst Kring, opened

Figs. 5.5–5.7. Three installation photographs of Cézanne
paintings at the Moderne Kunst Kring exhibition,
Stedelijk Museum, Amsterdam, 1911

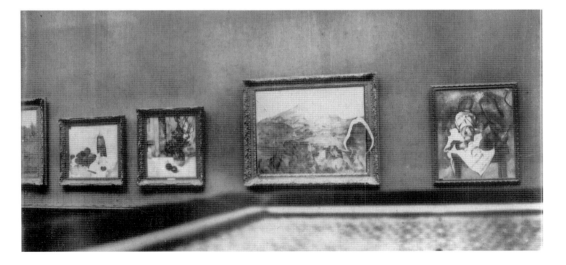

Fig. 5.8. Installation photograph of paintings by Braque
and Picasso at the Moderne Kunst Kring exhibition,
Stedelijk Museum, Amsterdam, 1911

Fig. 5.9. **Piet Mondrian, *The Gray Tree,*** 1911. Oil on canvas, 31½ x 42⅞ inches (79.7 x 109.1 cm). Haags Gemeentemuseum, The Hague

the society's first exhibition at Amsterdam's Stedelijk Museum. Kikkert had been lucky enough to secure a loan of Hoogendijk's entire Cézanne collection for the exhibition. We know from photographs (figs. 5.5–5.7) and reviews that Cézanne's self-portrait hung in the museum's gallery of honor, opposite the entrance, with all the paintings (except for the two that were not exhibited) distributed over the entire wall space, which measured about 90 feet (30 meters) in length. One can speculate as to whether Kikkert would have given Cézanne's work as much space if he had not discovered Cubism. This movement was represented by Braque, André Derain, Raoul Dufy, Le Fauconnier, Auguste Herbin, Rudolf Levy, Hermann Lismann, Picasso, Jean Puy, Schelfhout, and Maurice de Vlaminck.

In all probability, the works by Braque and Picasso hung opposite those by Cézanne, to the left or right of the entrance. Thanks to an extant photograph (fig. 5.8), we know that the exhibition included four Cubist works by Braque from 1908 and 1909, plus two earlier works, and one of Picasso's Cubist works from 1909 (the portrait of Clovis Sagot), as well as six early drawings. These works by Braque and Picasso had already been shown in Germany — in Düsseldorf, Munich, and Berlin and then again in Düsseldorf.

Mondrian's work hung in the last, corner gallery, where he had displayed his revolutionary work in January 1909.

It is likely that during the exhibition or shortly thereafter, Mondrian painted *The Gray Tree* (B4; fig. 5.9); he would have needed the whole of December to prepare for his scheduled departure for Paris in January 1912. The painting is built up of deliber-

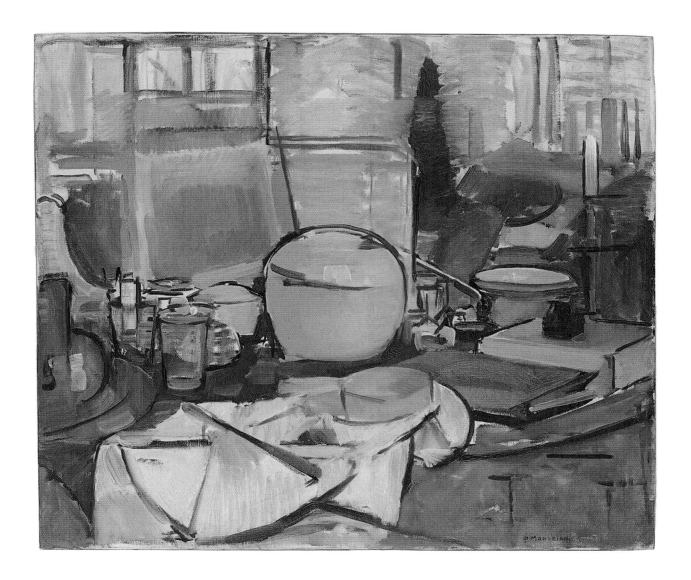

ately visible brushstrokes in light and dark gray. In the tree, as well as along the bottom line, the gray brushstrokes are in line with each other, to depict the connection between the trunk and branches and the ground, which is represented almost exclusively by horizontal brushstrokes. The space surrounding the tree and ground and between the branches of the tree is filled with brushstrokes in gray placed at an angle to the black lines of the tree.

Mondrian must have been inspired to paint like this by Cézanne's late work, such as _Pines and Rocks_, which had been featured in the Moderne Kunst Kring exhibition and by the early Cubist work of Braque and Picasso that had been included in the show. Mondrian used only gray, leaving no room for doubt that his attention was focused upon the effect of the highly structured brushstrokes.

Cézanne and Mondrian

Gradually I became aware that Cubism did not accept the logical consequences of its own discoveries; it was not developing abstraction toward its ultimate goal, the expression of pure reality. I felt that this reality can only be established through _pure plastics_. In its essential expression, pure plastics is unconditioned by subjective feeling and conception. It took me a long time to discover that particularities of form and natural color evoke subjective states of feeling, which obscure _pure reality_. The appearance of natural forms changes but reality remains constant. To create

pure reality plastically, it is necessary to reduce natural forms to the *constant elements* of form and natural color to *primary color*. The aim is not to create other particular forms and colors with all their limitations, but to work toward abolishing them in the interest of a larger unity.

—MONDRIAN, "Toward the True Vision of Reality"[11]

1912 At the time of the Moderne Kunst Kring exhibition or not long afterward, Mondrian also painted *Still Life with Gingerpot 1* (B1; fig. 5.10). At any rate, we know from his friend Albert van den Briel that Mondrian returned to him the blue glazed gingerpot and several other objects represented in the painting when he visited to say good-bye before leaving for Paris early in the new year.

Due in part to the loosely folded white tablecloth and the knife, the painting conjures associations with Cézanne's still lifes—indeed, specifically, with the still lifes from the Hoogendijk collection, including *Pitcher and Fruit on a Table* (1893–94; fig. 5.5, fourth painting from the left); *Curtain, Jug, and Compotier* (1893–94, see plate 90; see also related works by Alberto Giacometti [plate 134] and Jasper Johns [plate 175]); and *Bottle and Apples* (c. 1890; fig. 5.7, first painting from the left).

The composition of Mondrian's still life is on the whole vaguely reminiscent of the "throw a few things together" strategy that is so characteristic of Cézanne's still lifes. The difference lies in the ingredients. Virtually all the still lifes by Cézanne feature living objects, particularly fruit. Mondrian's *Still Life with Gingerpot 1* depicts only everyday items—drinking vessels, bowls, a few books, a tall candelabra, and, in the background, files, and possibly, on the left, a window—all inanimate objects, a highly unusual theme for that time. It is not known, and there is no evidence to tell us, what Mondrian intended with this painting. Is the painting part of his creative work, or was it just a potboiler, like many of his early still lifes?

In early January 1912 Mondrian moved to Paris and found accommodation in the studio building where Kikkert already lived. He probably soon began painting the highly varied series of subjects that date to this time—a portrait, a nude, trees, landscapes, and so forth—using straight, structured brushstrokes and pure colors, however muted, his aim being "to reduce natural forms to constant elements of form and natural color to primary color."

It is interesting that Mondrian, who in the summer reached the level of the work *Flowering Trees* (B20; fig. 5.11), returned to *Still Life with Gingerpot 1*, reducing the image to a composition consisting mainly of vertical and horizontal rectangular shapes: *Still Life with Gingerpot 2* (B18; plate 23). One is struck that, in the bottom half of the painting, most of the shapes are horizontal, with the color applied using vertical brushstrokes, while in the top half the reverse is true. And so the forms and colors of the "Old Plasticism" are captured in the first moves toward the rectangles and primary colors of the New Plastic Art, as in *Composition with Grid 4: Lozenge Composition* (1919; B98; plate 27) and *No. I: Opposition of Lines, Red and Yellow* (1937; B273; plate 29).

Although Mondrian was actually in search of a living reality, not the lifeless and artificial, ultimately he must have wanted to experience the impact of his efforts leading to his New Plastic Art, "the true vision of reality." *Still Life with Gingerpot 2* can be seen as a farewell to the old, naturalistic way of painting, reflected in the technique he used to paint the blue glazed gingerpot, and a foretaste of the new abstract. But there was still a long way to go before he achieved the new.

Translated from the Dutch by Sue McDonnell.

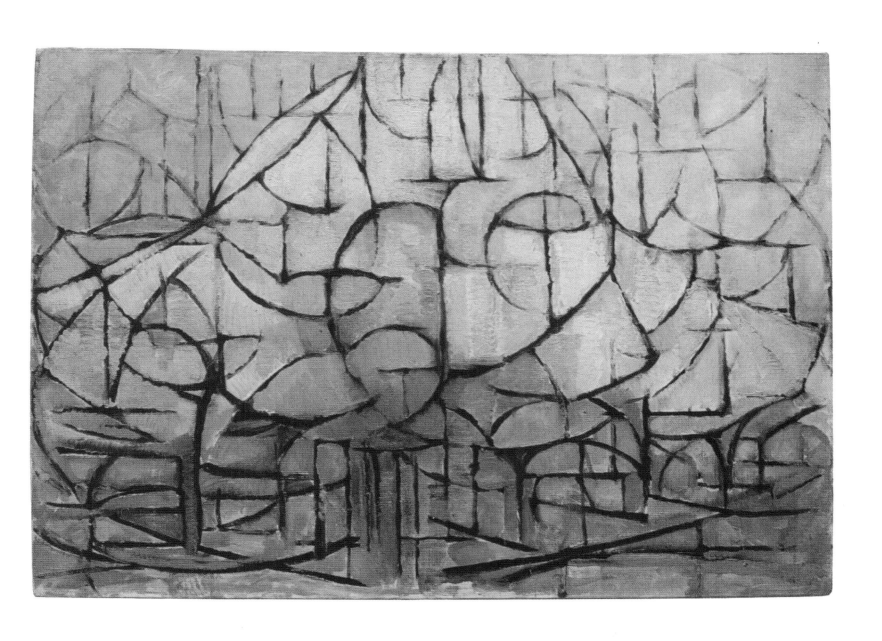

Fig. 5.11. **Piet Mondrian, _Flowering Trees_
(Bloeiende Bomen),** 1912. Oil on canvas,
23⅝ x 33½ inches (60 x 85 cm). The Judith Rothschild
Foundation, New York

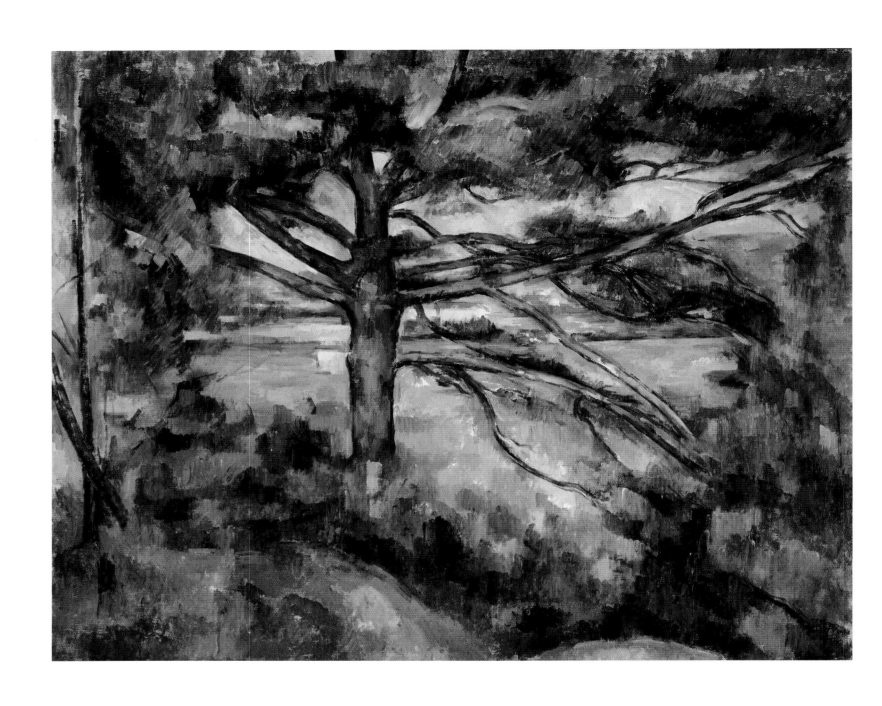

PLATE 24

Paul Cézanne

Large Pine and Red Earth, 1890–95

Oil on canvas
28⅜ x 35¹³⁄₁₆ inches (72.1 x 91 cm)
State Hermitage Museum, St. Petersburg

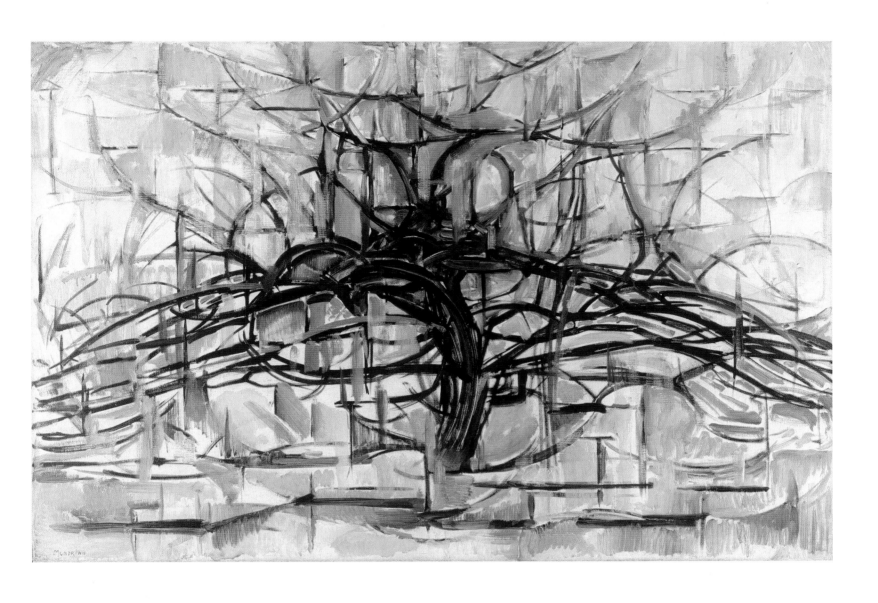

Piet Mondrian

Tree, 1912

Oil on canvas

29½ x 43⅞ inches (76.2 x 112.3 cm)

Munson-Williams-Proctor Institute, Museum of Art,

Utica, New York

PLATE 26

Paul Cézanne

Winter Landscape, Giverny, **1894**

Oil on canvas
25⅝ x 31⅞ inches (65.1 x 81 cm)
Philadelphia Museum of Art. Gift of Frank and Alice
Osborn, 1966-68-3

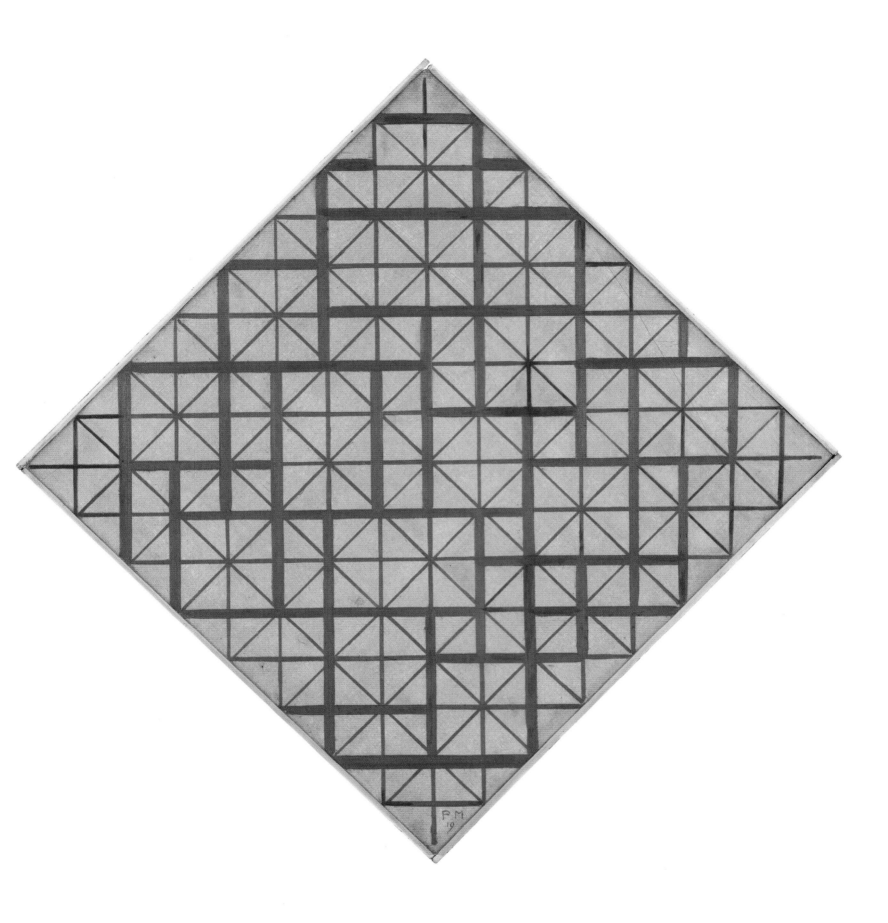

PLATE 27

Piet Mondrian

Composition with Grid 4: Lozenge Composition, 1919

Oil on canvas
Diagonal 33½ x 33¼ inches (85 x 84.5 cm);
sides 23⅝ x 23¹¹⁄₁₆ inches (60 x 60.2 cm)
Philadelphia Museum of Art. The Louise and Walter
Arensberg Collection, 1950-134-151

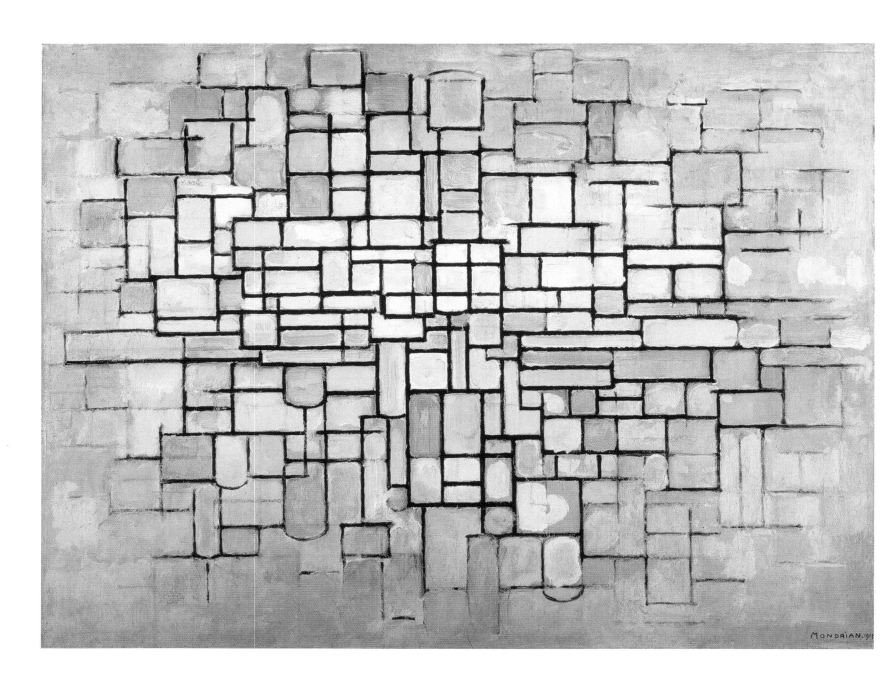

PLATE 28

Piet Mondrian

Composition No. II, 1913

Oil on canvas
34¾ x 45¼ inches (88 x 115 cm)
Kröller-Müller Museum, Otterlo, The Netherlands

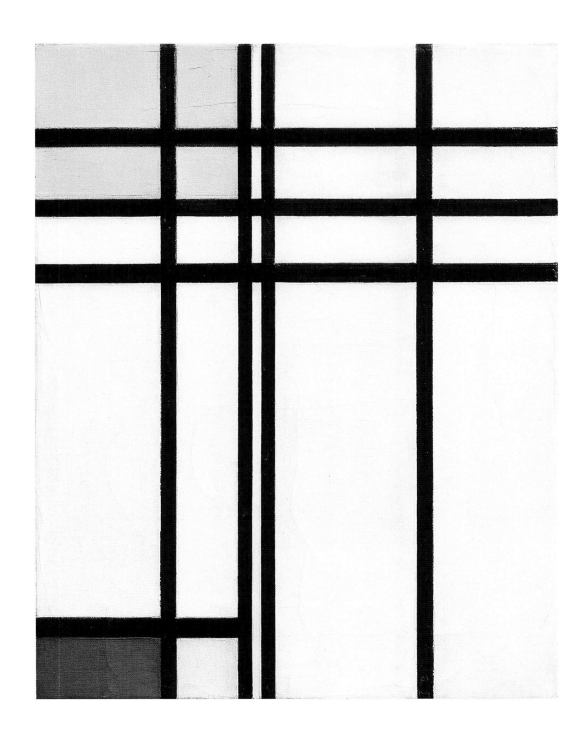

Piet Mondrian

No. I: Opposition of Lines, Red and Yellow (No. I: Opposition de lignes de rouge et jaune), 1937

Oil on canvas
17⅛ x 13¼ inches (43.5 x 33.5 cm)
Philadelphia Museum of Art. A. E. Gallatin
Collection, 1952-61-90

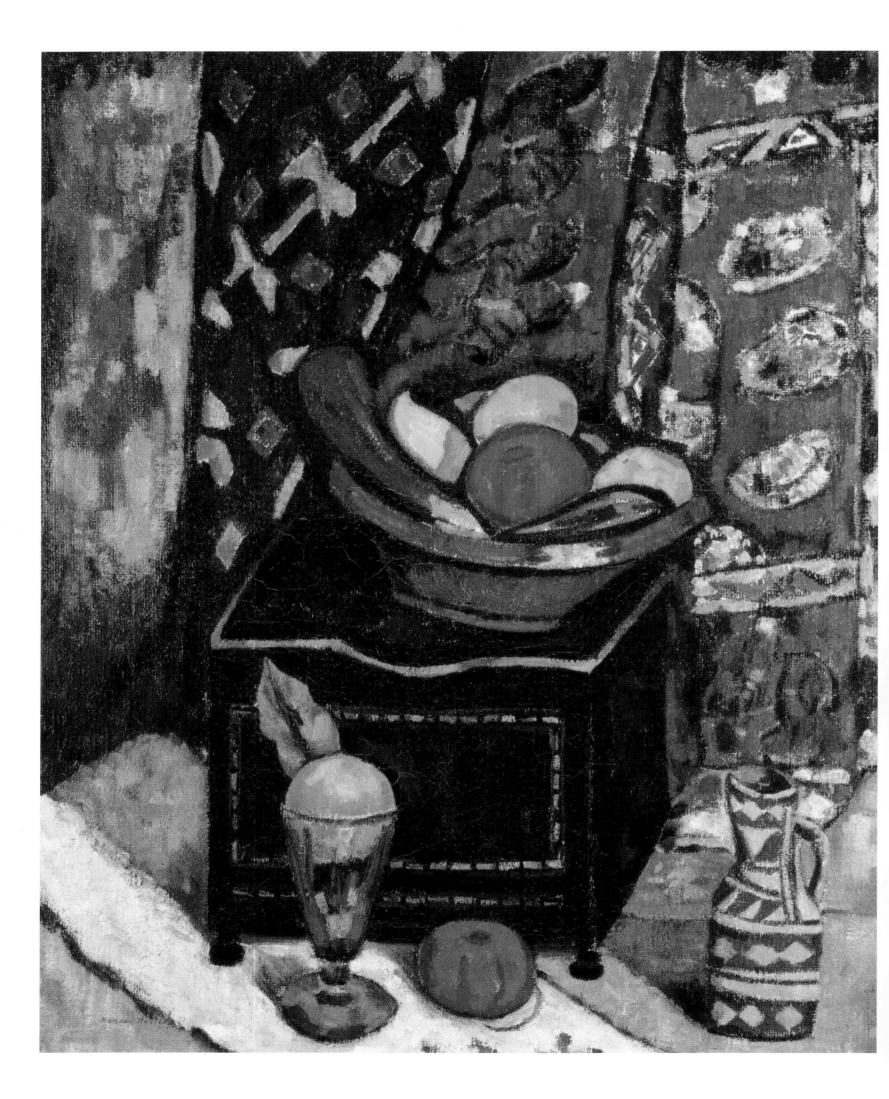

Cézanne and Hartley: On Sacred Ground

Joseph J. Rishel

Following Marsden Hartley's death in 1943, a trunk of handwritten manuscripts was placed at the Beinecke Rare Book and Research Library at Yale University by his niece, Norma Gertrude Berger.[1] Had he never painted a picture in his life, these writings, along with the voluminous collections of his poetry, essays, reviews, and general observations about art and literature published during his lifetime, would assure him a serious place in the history of American modernism. In the Yale horde are notes, written about 1933, for an autobiography entitled "Somehow a Past: Prologue to Imaginative Living." These were lovingly transcribed and edited by Susan Elizabeth Ryan and published in 1997.[2] The book stands as a winning credo, in a tone both reflective and authoritative, of Hartley's beliefs, as demonstrated by his statement about Cézanne:

> Cézanne was of Italian extraction—Cezani was the original name—something of the great tradition being brought in by atavism—and a strange new, wonderfully revealing work begun—ideas that were to make the world of painting over again and give modernism its next powerful start. There is no modern picture that has not somehow or other been built upon these new principles. The story is all clear now—the bridge from impressionism to all later modernism having been built until the invention of surrealism and calligraphy. To make a monument of an apple—that was Cézanne's accomplishment—and to show the way to colour perception invented by him. "When the colour harmonizes the design becomes precise"—"all art is based on the cone, the sphere, and the cylinder," etc.[3]

With his entry in 1909 into the Stieglitz circle[4]—that small group of artists who centered around Alfred Stieglitz's gallery at 291 Fifth Avenue in New York—Hartley was at thirty-two following a pattern of increasing sophistication and cosmopolitanism, which had already led in his Maine landscapes to his own personal and very powerful interpretations of European progressive painting (be it Post-Impressionism or Divisionism), charged by fellow American painter Albert Pinkham Ryder's visionary qualities. His artistic ambitions and curiosities were already as far-reaching as his restless, far-traveling career would document. In his painting *Maine Landscape No. 27*, from 1909

PLATE 30

Marsden Hartley

American, 1877–1943

***Still Life No. 1*, 1912**

Oil on canvas
31½ x 25⅝ inches (80 x 65.1 cm)
Columbus Museum of Art, Ohio. Gift of Ferdinand Howald

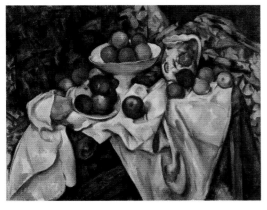

Paul Cézanne, *Apples and Oranges,* c. 1899.
Oil on canvas, 29⅛ x 36⅝ inches (74 x 93 cm).
Musée d'Orsay, Paris

Fig. 6.1. **Marsden Hartley, _Maine Landscape No. 27_,** 1909. Oil on cardboard, 12 x 12 inches (30.5 x 30.5 cm). Philadelphia Museum of Art. The Alfred Stieglitz Collection, 1949-18-6

(fig. 6.1), for example, the Divisionist technique of the Italian Giovanni Segantini (1858–1899)—which Hartley saw only through reproductions—is as potent a presence as French Post-Impressionism, just when his lifelong awareness of popular American nineteenth-century imagery was making itself known.

In company with the Stieglitz circle, Hartley was to see in 1910 two critical drawing shows at 291 Fifth Avenue, of Auguste Rodin and Henri Matisse, the latter of which pushed him into a series of essentially Fauve landscapes that summer. It also put him in contact with artists who understood the nature of his experimentations from their direct knowledge of those European impulses that were already holding such sway over Hartley, who was by then learning very fast from published images and passed-along illustrations. The New York artist Max Weber, already a figure around town in Paris (and a friend of Picasso's), had by 1907 sent back to Stieglitz large photographs of several Cézanne still lifes, which Stieglitz seems to have forwarded to Hartley in Maine in the summer of 1911.[5] That fall or early in the new year,[6] back in New York, Hartley finally, and it seems for the first time, laid eyes on a real painting by Cézanne. His memory of this experience, recalled much later in _Somehow a Past_, is worth reproducing in its entirety:

> Of course I wanted to go to Paris. I had seen some Matisse, Cézanne, and Picasso and I wanted to see more for I wanted to have an artist's education.
>
> I wanted above all to see what I could see in New York and I knew Mrs. Havemeyer had several real Cézannes. How to get there. It so happened a friend of Mrs. Havemeyer's used to come to 291, and she asked the beautiful woman to tea one Sunday and Arthur Carles was the other man besides myself. I spoke of this idea of seeing Mrs. Havemeyer's Cézannes then—and Mrs. Simpson said it would be easy as Mrs. Havemeyer was very kind. The matter was arranged for four people and I by a sad breach of etiquette was left out. The day came for the Havemeyer visit and the party went and my eyes got wet because I was not going. Carles said, "I am sure it is all right for you to go too," but I couldn't as I had not

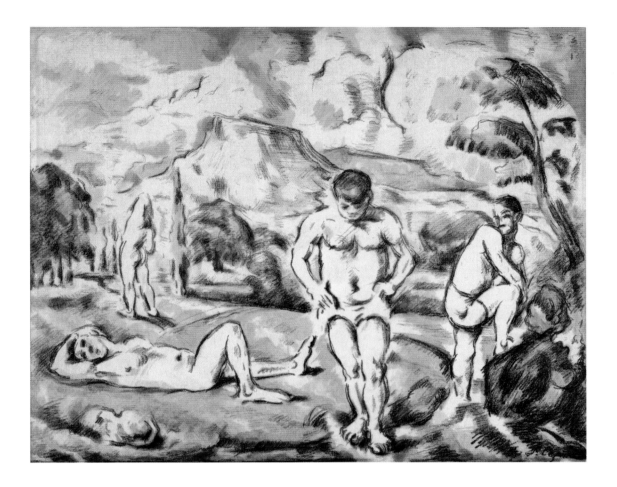

Fig. 6.2. **Paul Cézanne,** *The Bathers,* 1898. Color
lithograph, 16⅛ x 20⅝ inches (41 x 52 4 cm). Philadelphia
Museum of Art. The Louise and Walter Arensberg
Collection, 1950-134-874

been personally asked. . . . I told the story to Arthur B. Davies—and he said "O that
is easy, I know Mrs. Havemeyer and I will take you,"—and he did. We were there
alone—Mrs. Havemeyer leaving word with the butler she was sorry she couldn't be
home—but that we must enjoy ourselves just the same.

It was an amazing afternoon—one needed strength to be with all the great
pictures for everyone now knows the Havemeyer Collection in the Metropolitan
Museum. I was sorry when the collection was finally put on view not to find the
Cézannes I had remembered most of all. Perhaps these had been given to the
family and were therefore kept out. I had had my first sweep of Cézanne and of
course was all afire with the hope of getting to Paris.[7]

His guide that day, Arthur B. Davies, was of course already busily at work, in col-
laboration with the progressive critic Henry McBride (who had taken notice of Hartley
at his 1909 show at 291), on the famous Armory show of 1913, which would once and
for all force "Modern Art" into the broader American consciousness and have huge
repercussions for American art.

Ironically, while Hartley probably saw three Cézanne lithographs at the end of
1910—including *The Bather*s (fig. 6.2), which would have such a hold on him only to
surface much later—in a show at Stieglitz's gallery that included prints by Henri de
Toulouse-Lautrec, Auguste Renoir, and Édouard Manet, there is no clear evidence that
he saw Stieglitz's March 1911 show of Cézanne watercolors. He was hospitalized for five
weeks that January and may well have been shut in for much of the rest of the winter
and spring. He did revisit Cézanne with renewed curiosity and productivity that sum-
mer, when in June he returned to North Lovell, Maine, where he made a series of still
lifes of pears (fig. 6.3) in connection with Weber's black-and-white photographs of
Cézannes sent to him by Stieglitz.

The gathering at 291 of twenty watercolors chosen by Edward Steichen from the
stock of (and in collaboration with) the Galerie Bernheim-Jeune in Paris has long been

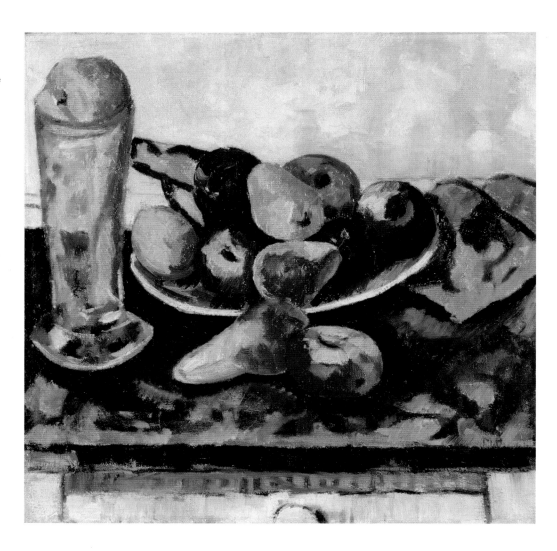

rightly seen as a new plateau of Cézanne awareness in the United States. In the introduction to the pamphlet accompanying the show, Stieglitz simply declares Cézanne the artist "whom posterity may rank as the greatest . . . of the last hundred years."[8] Viewed in hindsight, it is easy to understand how this first encounter with Cézanne through his watercolors, many of them having the unfinished, embryonic quality of the most beautiful of the artist's late works, was asking a great deal of an audience who was almost entirely innocent of direct contact with his work in any form. The refinement of Cézanne's watercolors certainly did not elude Hartley, who was later to describe them as a "peculiar psychic revelation . . . that is a purely spiritual rendering of forms in space."[9]

Following Hartley's second solo exhibition at 291 in February 1912, and in direct response to the critical success of that endeavor, Stieglitz was able to muster a fund to send him to Europe, first from the sale of one painting to Agnes Meyer and then with the support of Arthur B. Davies, who engaged the attention and finances of the collector Lillie P. Bliss. (The latter would purchase, only five years later, Cézanne's *Bather* [see plate 64], a linchpin of Cézannism in the United States and a critical point of departure for Hartley late in his own life.) Hartley's dream had come true.[10] On April 12, his second day in Europe, he wrote from Paris to his niece: "I've had a wondrous glimpse of perhaps the finest city in existence."[11] The next day, at the beginning of a loyal correspondence with his patron and friend Stieglitz, he could report: "I saw 8 Van Goghs this afternoon—several fine, one 'La Berceuse' a beauty—others—landscapes—four Cézannes at Vollard's (funny place). Tomorrow I shall go on to the Louvre—then the Salon des Indépendants."[12]

Within days Hartley had entered into a lively American community of artists and, perhaps most significant of all, was invited to a Saturday evening at 27, rue de Fleurus,

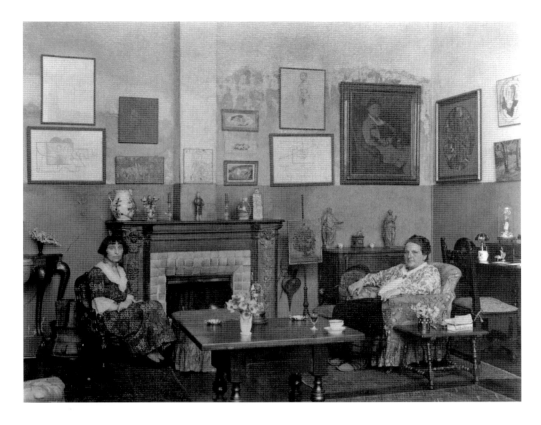

Fig. 6.4. **Man Ray** (American, 1890–1976), *Alice B. Toklas and Gertrude Stein, rue de Fleurus, Paris,* 1922. Telimage

the house of Gertrude Stein and Alice B. Toklas (fig. 6.4), a center of new art in Paris, both pictorial and literary. Gertrude seems truly to have taken Hartley's measure as a mature, focused artist and, at least for a time, encouraged him as the best of the new breed "whose work went beyond anyone else's"[13] — this in the context of the works she owned by Picasso, Cézanne, and Manet[14] (her reference must be to a drawing she bought from Hartley after he had moved to Germany). There is little doubt that Hartley got the most out of Paris in terms of both people and art (old and new). He visited Ambroise Vollard's gallery with some frequency, with all the dirty windows and hostile treatment that entailed, looking at Gauguins and Matisse bronzes as well as at Cézannes.[15] And he seems to have visited the largest collection of Cézannes ever, the apex of any encounter with the artist at that point, that of Auguste Pellerin, "who lived outside of Paris — and whose home you could then visit by card, once in the week on Wednesdays."[16]

Hartley was in Paris for the pivotal show of forty Cézanne watercolors at Bernheim-Jeune, which he reported was the artist's "finest expression as pure vision."[17] It was here, departing from the austerity and solidity he had found so deeply satisfying in his first encounters (through the Steins in particular) with Cézanne and Picasso, that he discovered a new point of departure, "registrations of pure sensation out of a peaceful state of mind," making Cézanne, in Hartley's terms, "the first cosmic painter."[18]

This shift, with his "new" Cézanne as a kind of talisman, opened him up to a quite different side of art making that would eventually lead him into the most revolutionary aspect of his own art — what became known as "intuitive abstraction" — provoked by his deep interest in Vasily Kandinsky, both as an artist and a writer, and by the painter Franz Marc, who became a friend. He made his first visit to Germany early in 1913, settling in Berlin until he was forced in 1915 by the war to return to the United States (fig. 6.5). The time in Berlin was a point of remarkable vitality and productivity. It brought him to a level of independent experimentation and originality that sets him (along with Arthur Dove) well apart from his American contemporaries. This side of Hartley's nature — subjective, drawn to the spiritual and mystic — is of course deeply linked to his early concerns with William Blake and Walt Whitman and the spiritualist

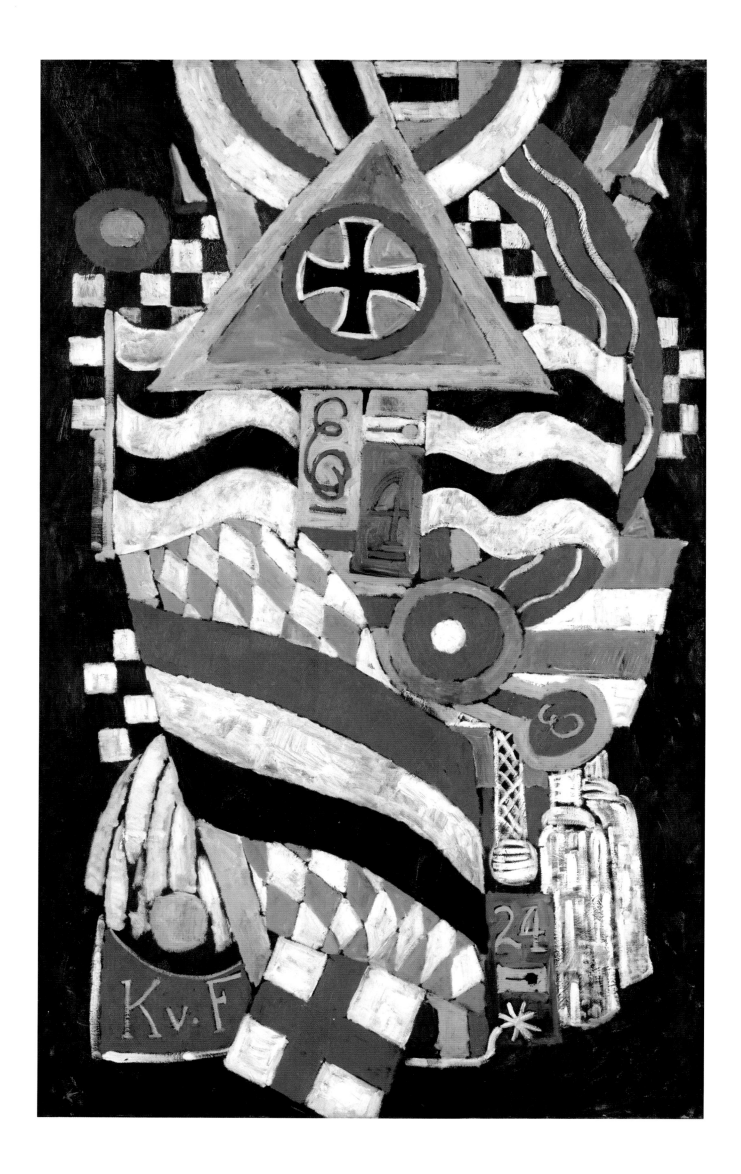

Fig. 6.6

thinking of his early life in New England, but in Berlin it triumphed anew in exuberant and unprecedented ways.

On Hartley's return to New York a more formal experimentation with objects in space set in, first in his still lifes and then, dramatically, in his landscapes, particularly thanks to the patronage of Mabel Dodge and her sponsorship of his trip to New Mexico. A more objective viewpoint (going back, in certain ways, to his notions of Cézanne on his first, pre-European encounters) emerged in paintings like the 1918 *Arroyo Hondo, Valdez* (fig. 6.6), marking a new and deepening engagement with Cézanne, ironically more through the watercolors of Mont Sainte-Victoire than through the paintings. The Southwest landscape would hold him in its spell almost more firmly than his eventual encounter with Cézanne's Provence ever would (plate 31).

Hartley did confront Cézanne in Provence head-on in a pilgrimage of sorts, which he embarked on in August 1925 with a particularly lonely and reflective sense of melancholy, unusual even for him and only alleviated by the company of his spaniel, Toy. He first set himself up in Vence (above Nice) and finally in Aix-en-Provence itself in 1926, settling in (albeit with escapes to Marseilles and jaunts up to Paris) for three years, almost the longest span he had spent anywhere up to that point in his mature life. He said at the time that he wanted to "take up where Cézanne left off."[19] For the subject at hand, the Aix visit was of course central, enhanced by the fact that in 1927 Hartley actually rented a room in the small house called the Maison Maria on the Tholonet Road that adjoins the so-called Château Noir — sacred ground and a frequent source of motifs for Cézanne (fig. 6.7). It was at this point that he looked his god straight in the face, taking the mountain of Sainte-Victoire as his own motif. All in all, it was a complex and moving transition in Hartley's career, one both loaded with and strangely empty of implications about localism and regionalism in general, particularly for the profound meaning that Cézanne held for Hartley throughout his life.

An unpublished manuscript entitled "Remembering Marsden Hartley" by the young painter and future Cézanne scholar Erle Loran (fig. 6.8) tells of Hartley's obsession. Though Loran's remembrance is tainted with the pretensions of the twenty-one-year-old painter he was when the two became friends (he was well pleased with himself, living as he was in Cézanne's studio just below Les Lauves, the favored perspective of the late Cézanne views of Mont Sainte-Victoire), he was clearly thrilled to be in the company (and fond company at that) of so famous a figure:

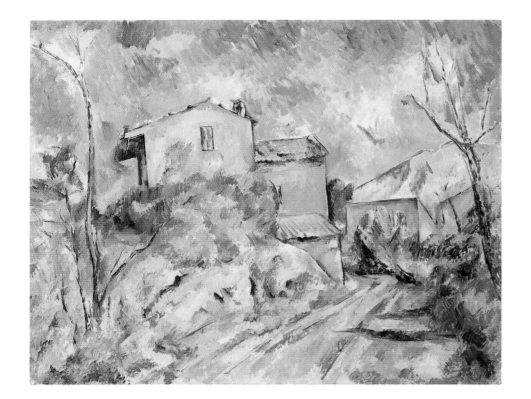

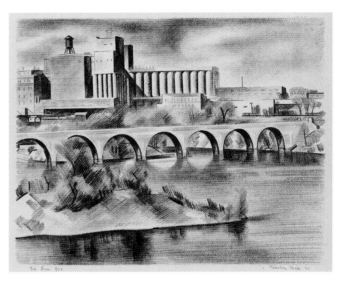

Fig. 6.7. **Paul Cézanne, *Maison Maria with a View of Château Noir,*** c. 1895. Oil on canvas, 25⅝ x 31⅞ inches (65 x 81 cm). Kimbell Art Museum, Fort Worth, Texas, 1982.05

Fig. 6.8. **Erle Loran** (American, 1905–1999), ***Pillsbury Mills,*** 1934. Lithograph on paper. Frederick R. Weisman Art Museum, University of Minnesota, Minneapolis. Gift of the Public Works Administration, 1934.44

Hartley had come to Aix because he wanted to get closer to Cézanne. I remember the great ceremony he made of finally inviting us to lunch and to show us his work. I liked it but I was surprised to see how closely he followed in Cézanne's footsteps. It seemed right for me at 21 to be a follower and student of Cézanne but I couldn't quite accept this well known, established painter doing what I was doing. For me it was study and learning but shouldn't he go beyond that? However I must admit that I have been very deeply impressed with these same paintings of the Mont Sainte Victoire whenever I have seen them in recent years and that seems to be telling me that I was wrong in 1928.[20]

Hartley finally returned to Paris in December 1927, and a month later to New York. He had an exhibition at the Arts Club of Chicago in March, and then went back to France in August. In January 1929, back again in New York, he had a show of one hundred of his Provence landscapes and Paris still lifes at Stieglitz's Intimate Gallery and, following another few months at the Maison Maria that spring, would show more works of Aix (along with paintings of Maine and New Hampshire) with Stieglitz in 1930. The ongoing drama of these works never ceases to confound, even this late in the game. In many cases it is almost as if Hartley is distancing himself from his artistic source — rethinking everything, all the way back to his early Maine and Vermont pictures, when confronting the Provençal landscapes anew. At the same time, there is a feeling of levity and of swiftness in the making that dispels false reverence (with all due respect to Loran) for his sources as a point of departure. His real pleasure was in letting all of his by now hugely informed and sophisticated artistic vocabulary play out, not to mention his own very highly wired cerebral and psychic complexity as a wandering loner.

Perhaps it is fairest to let Hartley have the last word, simply to demonstrate that, fraught as one may make his long passage in dangerously close quarters with his nearest fellow travelers, the Provençal years were for him often a quite idyllic and peaceful time — even to the point of achieving a kind of grace, apparent when he talks about his simple life with his adored dog (fig. 6.9). On the occasion of his March 1928 show at the Arts Club of Chicago, Hartley published an ode — his "confession," as he termed it in the exhibition's catalogue — entitled "The MOUNTAIN and the RECONSTRUCTION." For

all of its Whitmanesque arching, or thanks to it, the poem truly serves as Hartley's most moving and revealing statement about his relationship to Cézanne, the "sweet old man" who appeared in a vision:

> And—The MOUNTAIN—and it was
> A new Mountain to ourselves, and the dog,
> and it was a very noble one.
> Lights poured from it in the passing of the day—
> Calm fires warmed its shadows, and there was the quality
> of revelation contained in it, revelation
> for the body, the mind, and the spirit—
> and the dog, not knowing or needing to know
> of these things, was not aware of them,
> and was therefore not troubled by them.
>
> "Come, my angelic pup," I said—"come and see,
> we are going to live with this mountain, all of us,
> as long—as there is time,"
> . . .
> the sweet old man appeared in vision—
> a man who had evolved some of the clearest principles
> for himself, a new metaphysic—a new logic—
> a new, inviolable conviction, a new law for the artist
> with ambitions toward truth, a belief in real
> appearances, and a desire toward expression, without
> the HYPOCRISIES.
> . . .
> "TO ANNIHILATE MYSELF IN THE SUBJECT
> 　　—to become ONE
> with it"—this was the purpose of the sweet old man
> consumed with humility and sincerity, who wandered away
> from the scene of our infantile assertions and of our
> egotistic despairs.
> "I shall die, PAINTING"—and he died,
> PAINTING.[21]

His sense of investment with Cézanne would hold throughout the rest of his life as a landscape painter, whether painting the mountains of Garmisch-Partenkirchen in the Bavarian Alps, where he would live in the fall of 1933 (fig. 6.10),[22] or most especially Mount Katahdin in Maine, which he would visit as a sort of publicity stunt for eight days in 1939 and where his memories of Aix had a profound impact (fig. 6.11).

Hartley's return to New York in 1928, just on the brink of the Depression, was a difficult passage for him on nearly every level—spiritually, artistically, financially, and physically. His engagement with foreign sources, even one as honored as Cézanne, served him poorly in the 1930s, when a spirit of regionalism and isolationism swiftly gained momentum during dour times. In the foreword to the catalogue for his 1929 show at the Intimate Gallery, his friend the stage designer Lee Simonson applauds Hartley's ability to lose himself in his subject to the point of transference of self: "In the interval between Maine and Aix, Hartley did, like Alice through the Looking Glass, seem to disappear for a while down Kandinsky's Kaleidoscope and be lost among its

Fig. 6.9. Marsden Hartley with his dog, Toy, Aix-en-Provence, 1928. Erle Loran papers, 1913–91, Archives of American Art, Smithsonian Institution, Washington, DC

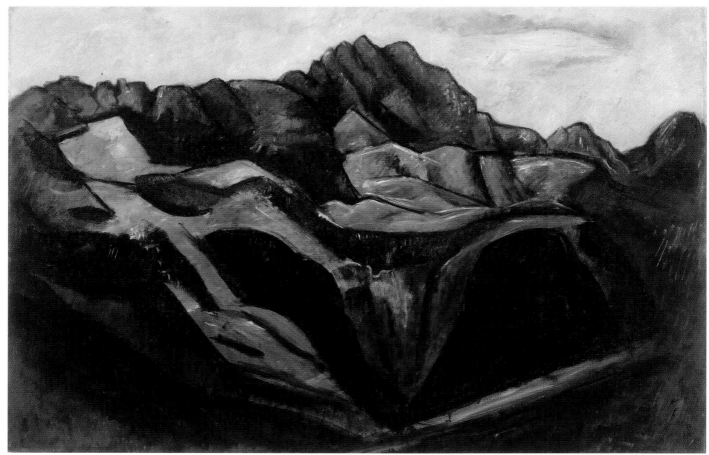

Fig. 6.10

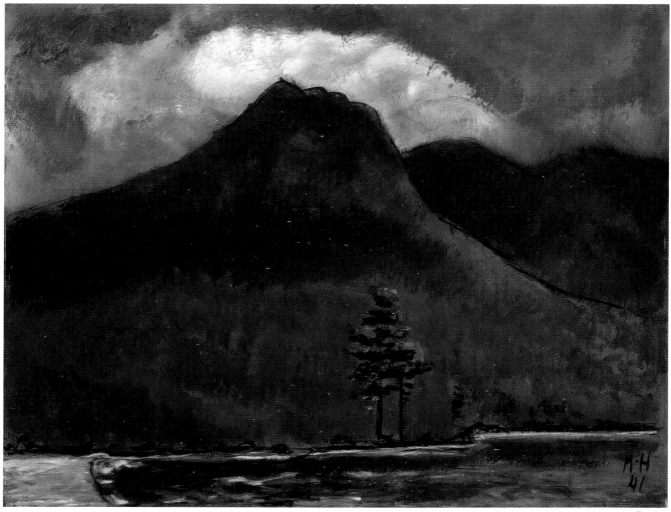

Fig. 6.11

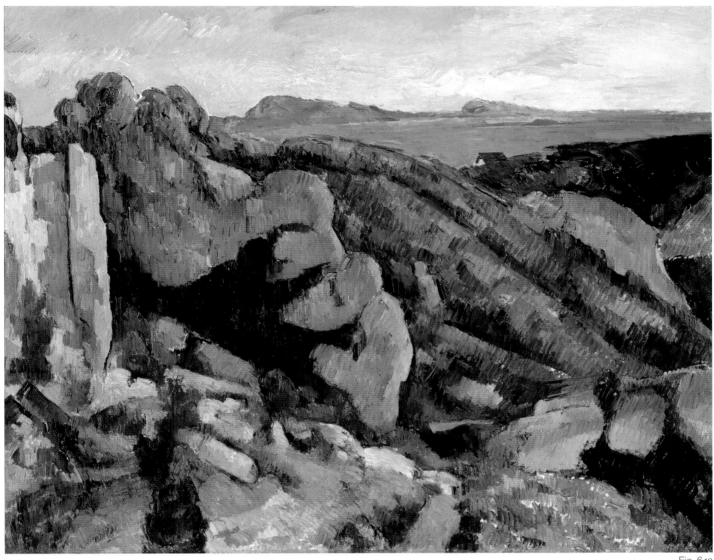

Fig. 6.12

Fig. 6.10. **Marsden Hartley, *Garmisch-Partenkirchen, No. 2,*** 1933. Oil on cardboard, 20 x 30 inches (50.8 x 76.2 cm). The Regis Collection, Minneapolis

Fig. 6.11. **Marsden Hartley, *Mount Katahdin*,** 1941. Oil on fiberboard, 22 x 28 inches (55.9 x 71.1 cm). Hirshhorn Museum and Sculpture Garden, Smithsonian Institution, Washington, DC. Gift of Joseph H. Hirshhorn, 1966.2369

Fig. 6.12. **Paul Cézanne, *Rocks at L'Estaque,*** c. 1882. Oil on canvas, 28¾ x 35¾ inches (73 x 90.8 cm). MASP, Museu de Arte de São Paulo Assis Chateaubriand, São Paulo, Brazil

Fig. 6.13. **Marsden Hartley, *Rock Doxology, Dogtown,*** 1931. Oil on academy board, 18 x 24 inches (45.7 x 61 cm). Private collection

Fig. 6.13

Fig. 6.14. **Marsden Hartley, *Fisherman's Last Supper,*** 1940–41. Oil on board, 29⅞ x 41 inches (75.9 x 104.1 cm). Collection of Roy R. Neuberger, New York

colored fragments. . . . Hartley after ten years of journeying has found his mountain again."[23] However, one Murdock Pemberton, writing in the journal *Creative Art* in 1929, found the show an affront and a rejection of American Art and accused Hartley of "intellectualiz[ing] his life to the point where he can go over to Europe and worship Cézanne at the foot of his own shrine [Mont Sainte-Victoire] and not be ashamed of it."[24]

If it seems a bit exaggerated to stress such a provincial view of the cosmopolitan Hartley, it was not unique at this retreatist moment. Perhaps it is best to balance Pemberton's earnest polemic with the judgment of the ever-grounded Georgia O'Keeffe (never fond of Hartley's work for long),[25] when she confessed many years later: "When I finally got to Cézanne's Mont Sainte Victoire in the south of France, I remember sitting there thinking 'How could they attach all those analytical remarks to anything [Cézanne] did with that little mountain?' All those words piled on top of that poor little mountain seemed too much."[26]

Hartley's appetite for fresh engagement, aesthetically and psychologically, is nowhere more evident than in a review of his evolving relationship with Cézanne. In the Aix paintings, by his own confession, he sees himself immersed in the motif itself with complete singularity. This is equally true in the series of three painting cycles he began with a view of glacier-strewn rocks (technically a moraine) in Dogtown, behind Gloucester, Massachusetts, which he first visited in 1931, his head full of Cézanne's most confrontational views of the quarry at Bibémus and the cliffs on the bay of L'Estaque (figs. 6.12, 6.13). These late paintings of Hartley's allowed him to deeply rethink the

artist in ways more charged than anything dating from the Aix period, supporting the notion of a powerful tension between Cézanne's literal motifs and the subjects back home in New England. The walls of stone at Dogtown seem just different enough from Bibémus or the cliffs of L'Estaque to allow a greater variety of explorations.

Hartley's life from this point took on a truly tragic tone, what with his failing health and perilous finances, which forced him at the depths of the Depression to destroy more than one hundred drawings and paintings to avoid storage fees—this even as he continued to exhibit (with few sales) and to experience increasing fame, which appears to have given him pleasure, however highly guarded. He lived in more-and-more isolated areas, beginning in 1935 in Nova Scotia with a Greek fishing family, the Masons, who brought him to a new level of social engagement and unguardedness—one can only say love. This time ended with the tragic drowning of two of the Mason boys in a squall in September 1936, affecting him deeply (fig. 6.14). He returned in the summer of 1937 to the coast of Maine, where he worked in season until his death in Ellsworth six years later. His level of production did not let up in any marked way during these years. If anything, his creative openness intensified as he experimented with new subjects, particularly bird and sea-life still lifes. Most remarkable is the way in which the human figure, for the first time, emerged in his work as a principle occupation, a choice that places him firmly in the context of our explorations here.

During the final decade of his life Hartley came to a new resolve with his "sweet old man" Cézanne, forming in quite remarkable ways a bond with him as a picture maker. This is pointedly evident in his figure paintings, be they of young men (not far from the heroic Teutons of his youth in Berlin), either bundled up in lumber jackets or nearly nude on the beach, or of the occasional women who sat for him. Even so, the strangeness of his multiple-figure paintings still jars, beginning with the Mason family at table (shades of Cézanne's *Card Players* [see plate 210]) and reaching its most complex expression in the *Finnish-Yankee Sauna* (plate 41)—with Cézanne's male *Bathers* (fig. 6.2) lurking only slightly beneath the surface.

More out of reach is what Cézanne meant for Hartley when he took up, with such vigor and conviction, these late figurative works. They are, of course, in their blunt homoeroticism, in the case of the male bathers or the paintings memorializing the Mason brothers, foremost the product of his own high-pitched emotions. In their intensity and outright strangeness, they go beyond and above any place he could reach with his landscapes and still lifes. They forced him to confront completely new expressive issues. Yet they seem perfectly natural in the evolution of his work, perhaps in part because of the basso continuum of Cézanne, which helped to sustain them in their progress. It is for both artists the strange muteness and distance of these players—so absolutely dumb—that in part make their paintings such comfortable companions. Single male nudes, half-length seated figures in repose, and especially the actors from the multiple versions of the *Card Players* and bather subjects occupied Cézanne all his life, while Hartley only entered this arena at the end of his remarkably open and varied career. Perhaps this is why his bored boys seem to stand so patiently in the wings, awaiting their entry.

We are brought back to a comment—particularly prescient considering his own future and the slight exposure to real works by Cézanne he had at the time—that Hartley made to Stieglitz in 1911, when he noted "how personal one can become through striving to express the impersonal."[27]

Paul Cézanne, *The Card Players*, 1890–92 (plate 210, p. 528)

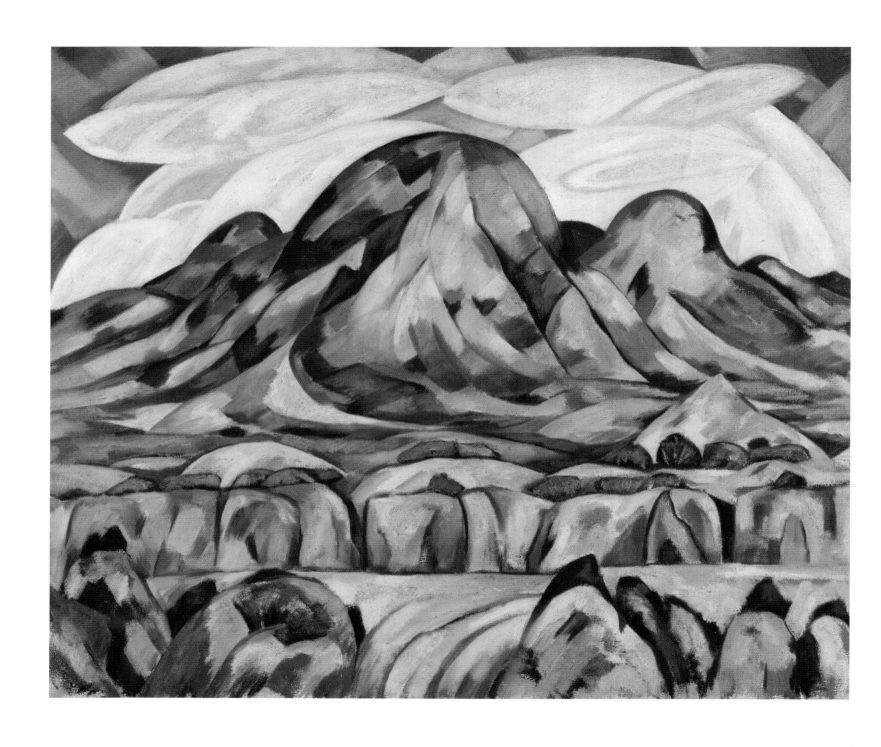

PLATE 31

Marsden Hartley

New Mexico Landscape, 1919–20

Oil on canvas
30 x 36 inches (76.2 x 91.4 cm)
Philadelphia Museum of Art. The Alfred Stieglitz
Collection, 1949-18-10

PLATE 32

Paul Cézanne
Mont Sainte-Victoire, c. 1885

Graphite and watercolor on paper
12½ x 18 inches (31.8 x 45.7 cm)
Private collection, courtesy of Babcock Galleries,
New York

PLATE 33

Marsden Hartley
Mont Sainte-Victoire, 1927

Pencil on paper
21½ x 24 inches (54.6 x 61 cm)
Babcock Galleries, New York

PLATE 34

Marsden Hartley

Château Noir with Mont Sainte-Victoire in the Background, 1925

Oil on canvas
19½ x 24 inches (49.5 x 61 cm)
Michael St. Clair Trust. Courtesy of Babcock Galleries,
New York

Paul Cézanne, *Château Noir,* 1900–1904
(plate 5, p. 93)

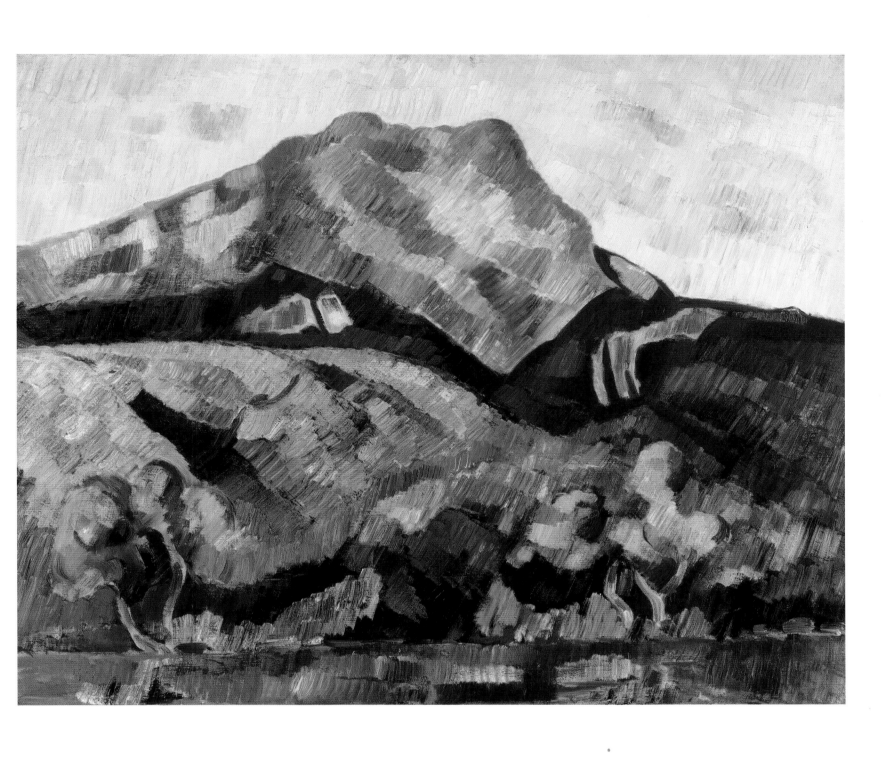

PLATE 35

Marsden Hartley
Mont Sainte-Victoire, 1927

Oil on canvas
31¾ x 39¼ inches (80.6 x 99.7 cm)
Des Moines Art Center, Iowa. Gift of Mr. and Mrs.
Fred Bohen

Paul Cézanne, *Mont Sainte-Victoire*,
1900–1902 (plate 166, p. 456)

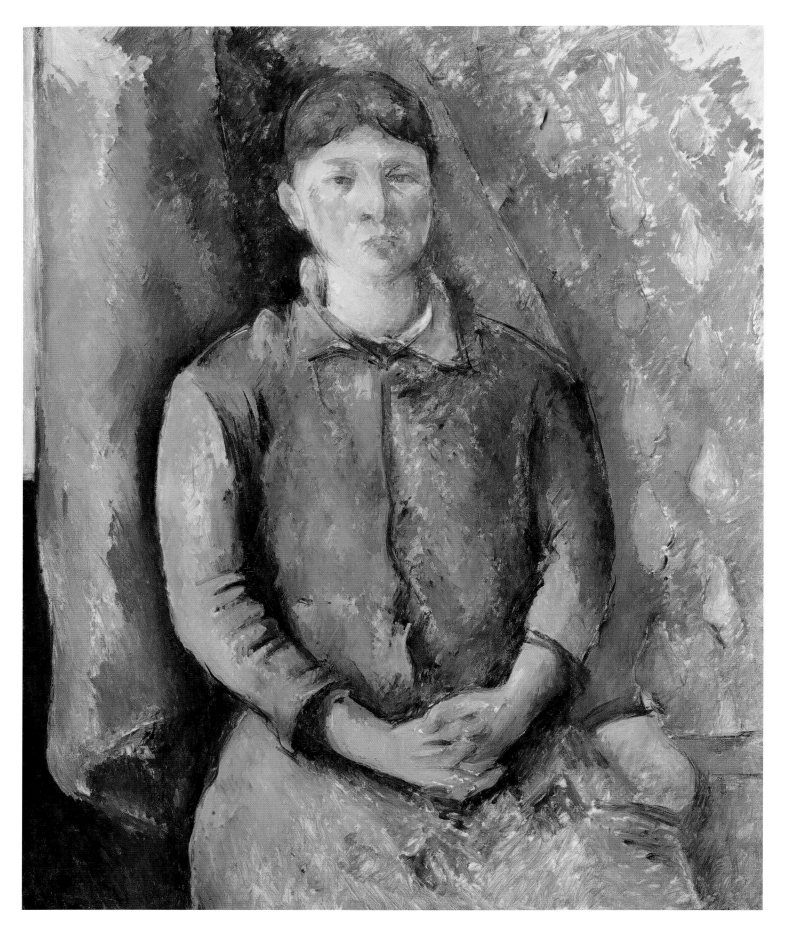

PLATE 36

Paul Cézanne

Madame Cézanne, c. 1886

Oil on canvas
49⅜ x 41½ inches (125.4 x 105.4 cm)
The Detroit Institute of Arts. Bequest of Robert H.
Tannahill (70.160)

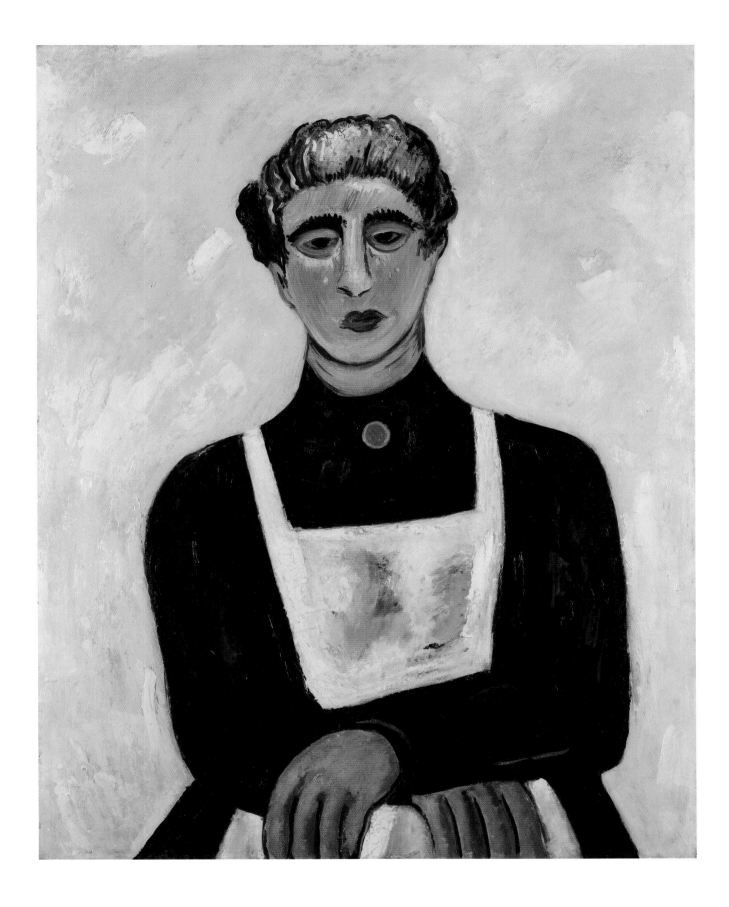

PLATE 37

Marsden Hartley

Marie Ste. Esprit, 1938–39

Oil on academy board
28 x 22 inches (71.1 x 55.9 cm)
Frederick R. Weisman Art Museum, University of
Minnesota, Minneapolis. Bequest of Hudson Walker
from the Ione and Hudson D. Walker Collection

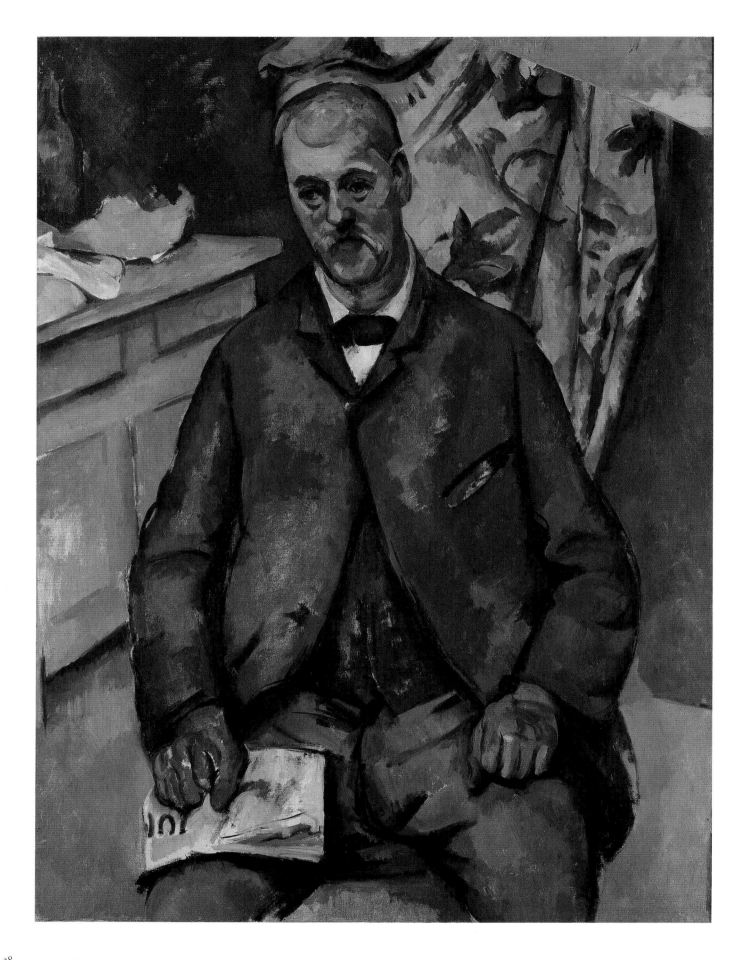

PLATE 38

Paul Cézanne

Seated Man, 1898–1900

Oil on canvas
40⅛ x 29¾ inches (102 x 75.5 cm)
The National Museum of Art, Architecture and
Design, Oslo

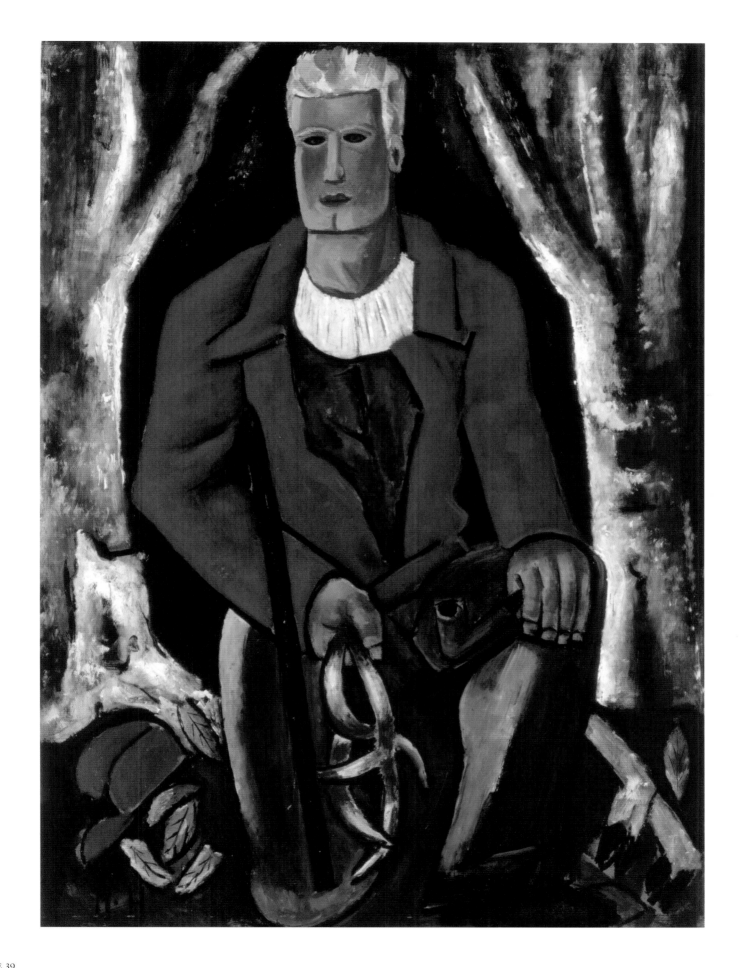

PLATE 39

Marsden Hartley

Young Hunter Hearing Call to Arms, c. 1939

Oil on masonite
41 x 30¼ inches (104.1 x 76.8 cm)
Carnegie Museum of Art, Pittsburgh. Patrons Art
Fund, 44.1.2

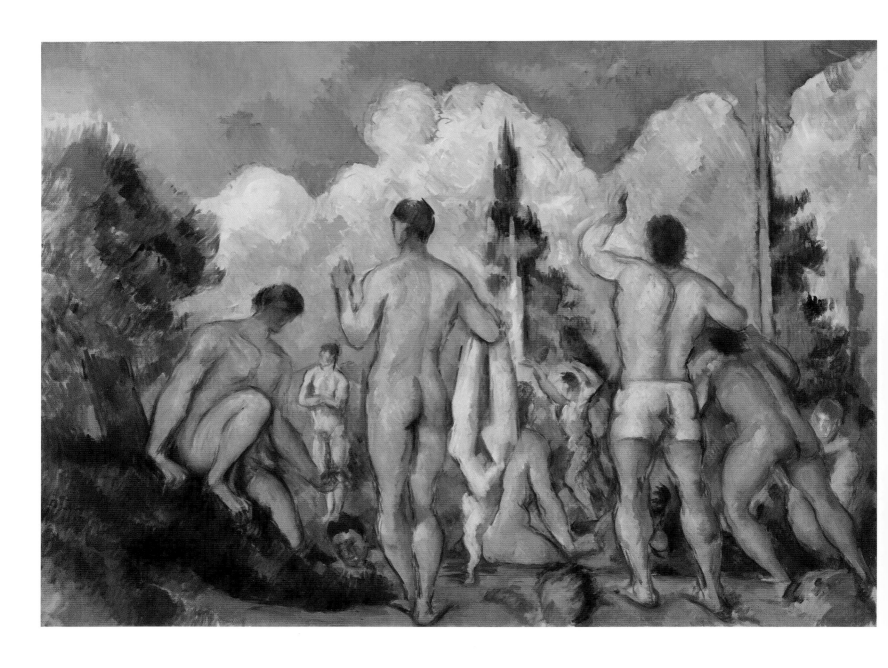

PLATE 40

Paul Cézanne

Bathers, c. 1890

Oil on canvas
23¾ x 32⁵⁄₁₆ inches (60 x 82 cm)
Musée d'Orsay, Paris. Gift of Baroness Eva Gebhard-
Gourgaud, 1965 (R.F. 1965-3)

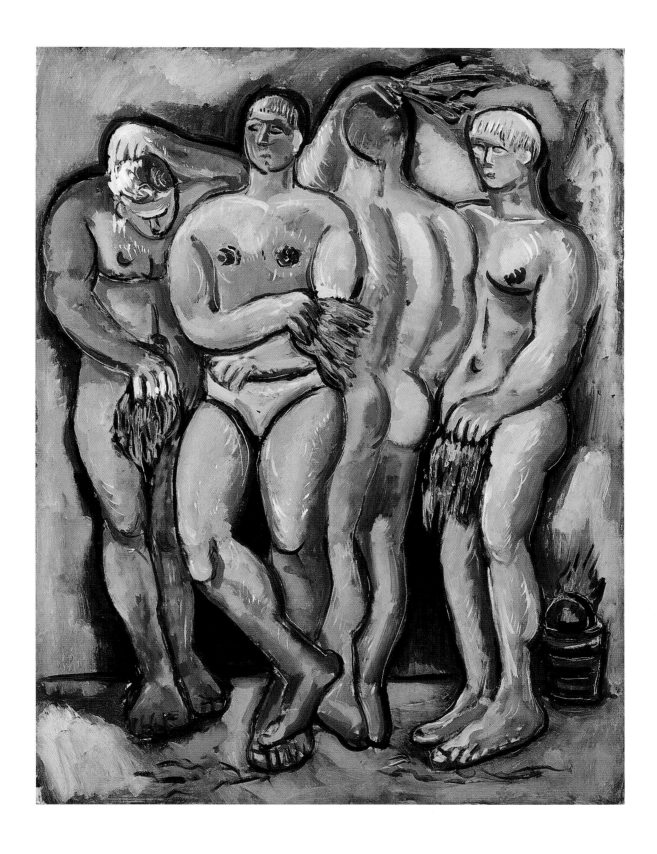

PLATE 41

Marsden Hartley

Finnish-Yankee Sauna, 1938–39

Oil on academy board
24 x 18 inches (61 x 45.7 cm)
Frederick R. Weisman Art Museum, University of
Minnesota, Minneapolis. Bequest of the Ione and
Hudson D. Walker Collection

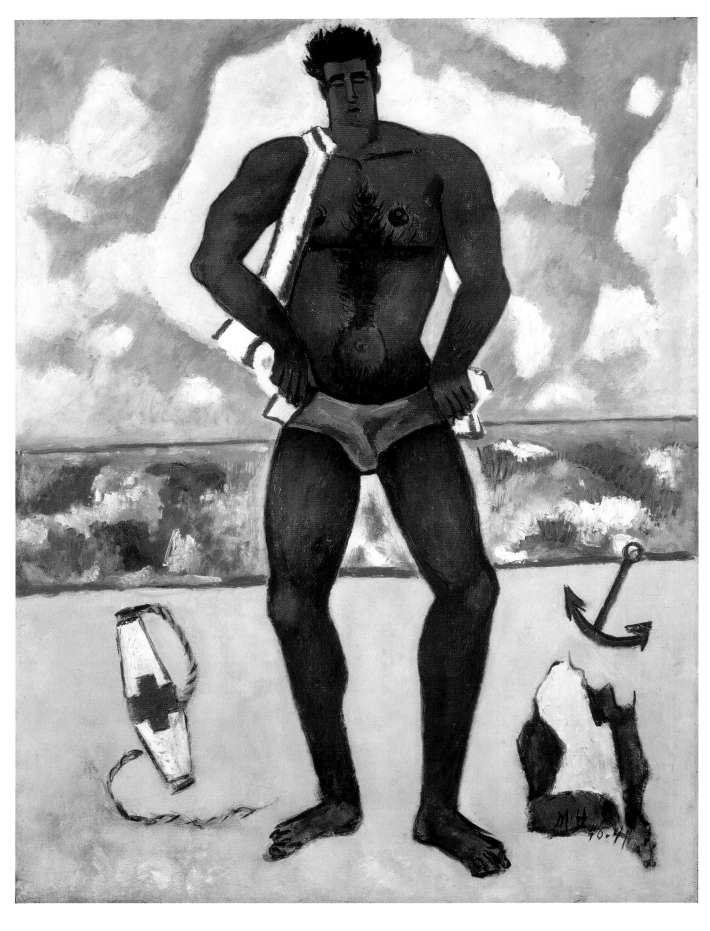

PLATE 42

Marsden Hartley

Canuck Yankee Lumberjack at Old Orchard Beach, Maine, 1940–41

Oil on fiberboard
40⅛ x 30 inches (101.9 x 76.2 cm)
Hirshhorn Museum and Sculpture Garden,
Smithsonian Institution, Washington, DC. Gift of
Joseph H. Hirshhorn, 1966

Paul Cézanne, *The Bather,*
c. 1885 (plate 64, p. 238)

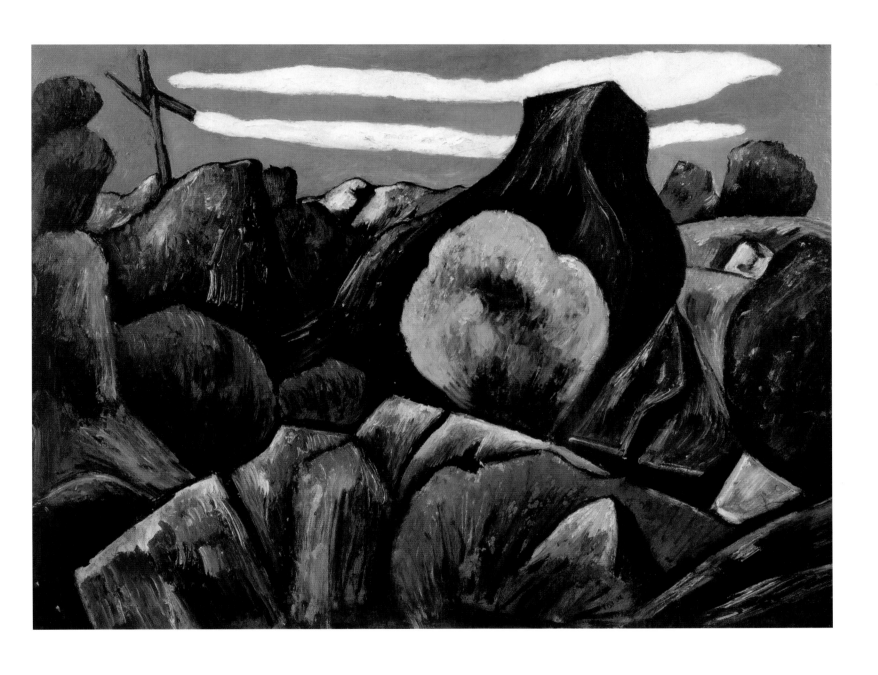

PLATE 43

Marsden Hartley

***Mountains in Stone, Dogtown*, 1931**

Oil on academy board
18 x 24 inches (45.7 x 61 cm)
Collection of James and Barbara Palmer

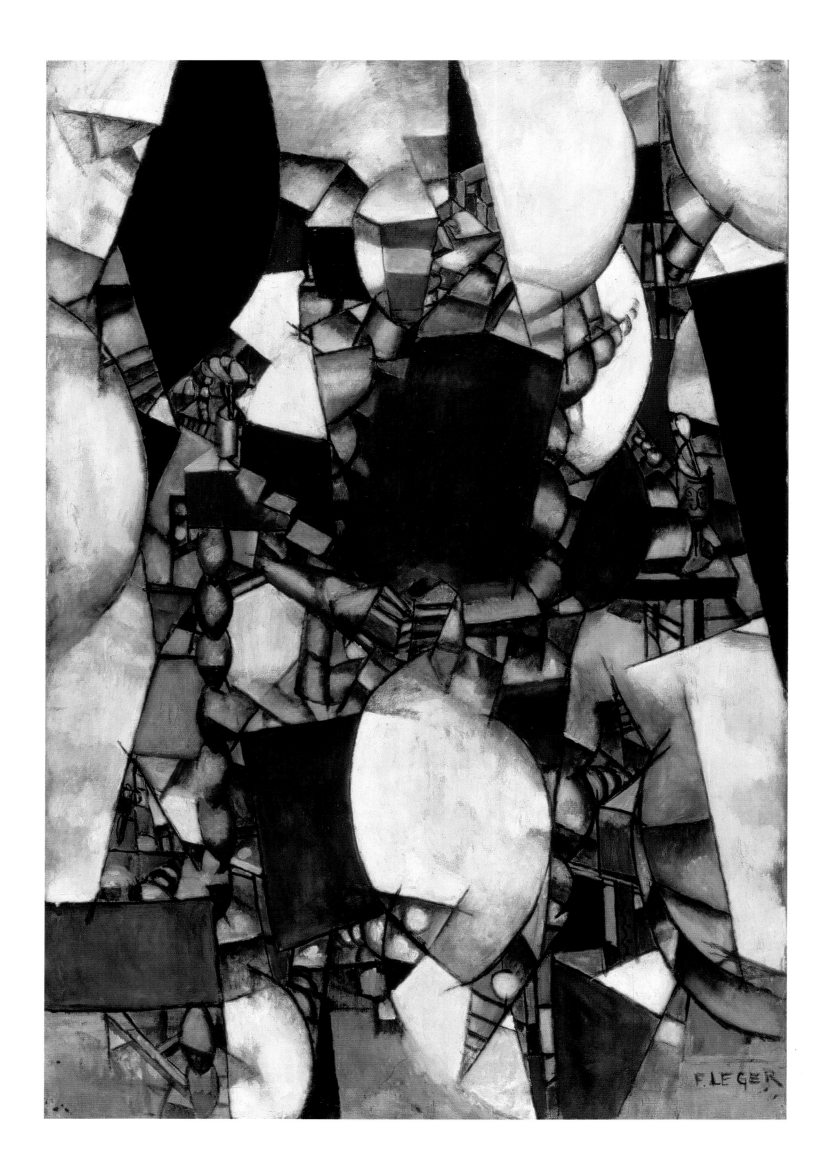

Cézanne and Léger: Realizing New Sensations

Christopher Green

Fernand Léger
French, 1881–1955

***Woman in Blue*, 1912**

Oil on canvas
76 x 51⅛ inches (193 x 129.9 cm)
Öffentliche Kunstsammlung Basel,
Kunstmuseum Basel

Paul Cézanne, *Woman with a Coffeepot*, c. 1895
(fig. 8.7, p. 212)

In 1930 the painting of the French artist Fernand Léger (1881–1955) came under the scrutiny of the German critic Carl Einstein in the periodical *Documents*. Einstein opened his piece by remarking on Léger's otherness in the context of the artists who, alongside Picasso, otherwise dominated that "undercover surrealist" publication.[1] If they were to be thought of more as "introverts," driven by their internal monsters to produce "psychograms," Léger, Einstein asserted, citing C. G. Jung, was an "extrovert," "a constructor, . . . a maker." He painted "the naked object," "raw and perfect."[2]

Four years earlier the English artist-critic Roger Fry had published a long article in the periodical *L'amour de l'art* on the works by Cézanne in the Auguste Pellerin collection, which in 1927 he expanded as his monograph *Cézanne: A Study of His Development*.[3] Fry's Cézanne is neither a painter of "psychograms," except perhaps in what is represented as his failed "romantic" early period, nor a painter of perfect objects. In common with Cézanne's own much-quoted statements, and with the image of him produced by the influential artist-critics Émile Bernard and Maurice Denis, Fry's Cézanne does not paint objects but rather his visual experience of them—his "sensation."[4] He is a "constructor" certainly, but he finds structure in painting and in nature; he is not a "maker" who imposes order on what he sees. Each painting is an open exploration. "He seems," wrote Fry, "hardly to arrive at the comprehension of his theme till the very end of the work; there is always something . . . he would grasp if he could. . . . Many modern painters have intense assurance; no one was less assured than Cézanne."[5] This image of an open, perpetually experimental, uncertain Cézanne who evades the definitive is one that continues to be reinforced in the twenty-first century by new technical research into the way his works were made.[6] If there was a definitive core to that image, it was his rootedness in Provence. Fry's *L'amour de l'art* article followed the 1920s editions of Joachim Gasquet's recollections of Cézanne, and like Gasquet he insisted on the identification of Cézanne's mature art with Provence, out of the reach of modernity, far away from Paris.[7] Carl Einstein's Léger makes finished paintings with the assurance of optimism. His extrovert Léger is the quintessential painter of modern materialism, whose base is the city.

Einstein's Léger is close to the image Léger himself projected, not only in his

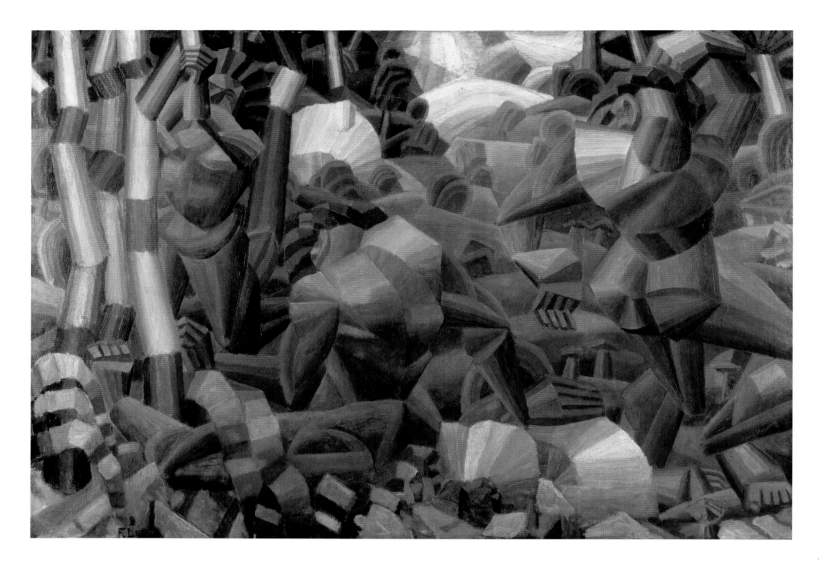

Fig. 7.1. **Fernand Léger, *Nudes in the Forest*,** 1910–11. Oil on canvas, 47¼ x 66⅞ inches (120 x 170 cm). Kröller-Müller Museum, Otterlo, The Netherlands

painting but also in his unusually articulate writings.[8] Could there be a modernist further from the Cézanne of twentieth-century myth and of current scholarship? In his discussion of Léger Einstein does not mention Cézanne, but from his very earliest published statement in 1913 onward, Léger himself repeatedly acknowledged him as one of his most valued precursors. Moreover, before the mid-1920s he thought of himself, like Cézanne, as a painter not of appearances as such but of visual experience—his "sensation" (this is something to which I shall return; it is a crucial aspect of any consideration of Léger's relationship with Cézanne). From his first mention of Cézanne, however, the story he told was not one of being dependent but of going beyond Cézanne. By 1954, the year before his death, Léger had the story pat for Dora Vallier in an interview that offered his own final verdict on his work. Yes, he said, Cézanne had been at the center of his attention early in his career, but as an "open" model from whose lesson different directions could be taken. From Cézanne, he revealed, came his drive to "swell volumes," so that his first major modernist work, *Nudes in the Forest*, shown at the Salon des Indépendants in Paris in 1911, became "a battle of volumes" (figs. 7.1, 7.2). But 1912–13 had seen his "battle to quit Cézanne," and by the time he painted *Railway Crossing* (fig. 7.3) and his major contribution to the Salon d'Automne of 1912, *Woman in Blue* (plate 44), he felt that he had "liberated" himself from Cézanne.[9] According to his one-time student Georges Bauquier, Léger used his story of dependence on and then escape from Cézanne in his teaching to encourage the acceptance of influence— "one isn't born a genius"—so long as students found their own way beyond it. "Personally, I was under the influence of Cézanne. Then, one bright day, I said, 'Zut!' It's for you to do the same and say, 'Zut to Léger,' while keeping . . . all you consider useful to the development of your own personality."[10]

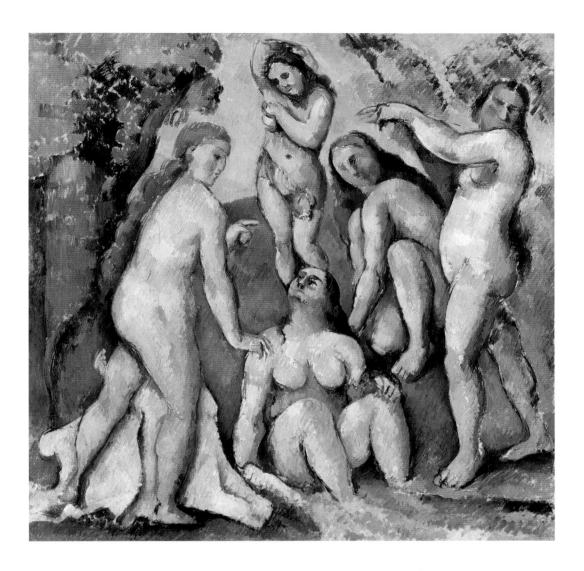

Fig. 7.2. **Paul Cézanne, *Five Bathers,*** 1885–87. Oil on canvas, 25¹³⁄₁₆ x 25¹³⁄₁₆ inches (65.6 x 65.6 cm). Kunstmuseum Basel

The questions that I take as my starting point here are: Should we accept Léger's story of escape as the whole story of his relationship with Cézanne? Does the obvious and extreme difference between the Cézanne that Bernard, Denis, and Fry tried to put into words and the Léger summed up by Carl Einstein corroborate that story? Was the impact of Cézanne on Léger ultimately shallow and short-lived? It is clear where attention has to be concentrated once these questions are posed: in the brief period of Léger's engagement with and then escape from Cézanne, which is, according to his story line, between 1910 and 1914.

Léger's choice of subject matter between 1910 and 1912 is enough to demonstrate an engagement with Cézanne that he was willing to signal so explicitly that no admirer of Cézanne at the time could have missed it. His painting *Nudes in the Forest* (fig. 7.1) was begun in 1910, the year that the Galerie Bernheim-Jeune put on one of the major Cézanne exhibitions in Paris of the early twentieth century. Both the Basel *Five Bathers* (fig. 7.2) and Matisse's *Three Bathers* were included in that show; the London and Philadelphia *Large Bathers* (see plates 66, 203) had both been shown in the Salon d'Automne Cézanne retrospective of 1907, which we know Léger saw and by which he had been immensely excited.[11] In 1913 Guillaume Apollinaire identified Léger's nudes as woodcutters wielding axes, an idea that has been reiterated ever since (their relationship with the forest is certainly violent). The long hair and pelvic region of the nude on the left, however, leave its gender at least ambiguous, and so the gender of the others too. Certainly, when the picture was shown in 1911, Cézanne's female bathers would have been an instant reference point.[12] Otherwise, in 1911 and 1912 Léger painted landscapes that set smoke forms against angular buildings much as Cézanne had set trees against Provençal buildings (fig. 7.4), and a still life whose fruit bowl threatens to tumble off its

Fig. 7.3. **Fernand Léger,** *Railway Crossing,* 1912. Oil on canvas, 36¼ x 28¾ inches (92.1 x 73 cm). Beyeler Collection, Basel

tabletop much as Cézanne's sometimes do (plates 45, 46). And he followed up *Nudes in the Forest* with his 1912 showing of *Woman in Blue*, whose female sitter is posed much as Cézanne posed his wife, for instance in the portrait that was illustrated that year in Albert Gleizes and Jean Metzinger's *Du "Cubisme"* to underline Cézanne's fundamental importance to all the Cubists, not just Léger.[13]

If his referencing of Cézanne was explicit enough, so, however, would Léger's independence have been recognized by any pre-1914 viewer as seriously responsive to Cézanne. That would have been clear enough not only in the violent clashes of *Nudes in the Forest,* but even in the painting of its "battle of volumes," for Léger built his volumes tonally, managing the transitions from dark to light systematically by means of clearly graduated values. There may not have been here the hierarchical organization of light and shadow familiar from academic chiaroscuro, but form was not constructed by color at all, as Cézanne and his apologists repeatedly asserted it should be. Moving on to *Woman in Blue*, in this canvas not only does the intrusion of arbitrary flat color planes declare almost brutally Léger's liberation from the model, and so from Cézanne's demand that "nature" should always come first, but along with nuggety passages of tonal modeling, line makes a decisive contribution, cutting and swinging across the picture surface with irresistible force. There could not be a more direct denial of Cézanne than line used with such confidence and finality; Léger's line here never betrays hesitation. Perhaps the single crucial marker in Cézanne's painting of the work as open exploration rather than definitive conclusion was the broken contour, itself

Fig. 7.4. **Fernand Léger, *Smoke over Roofs*,** 1911. Oil on canvas, 23⅝ x 36⅝ inches (60 x 93 cm). The Minneapolis Institute of Arts. Bequest of Putnam Dana McMillan

the symptom of his hesitations as he approached the edges of things in terms of color relationships; it is this broken line that acts as one marker of the exploratory openness of Braque's and Picasso's Cubism in 1910 and 1911.[14] Via Bernard's record of Cézanne's "opinions," Léger almost certainly knew that Cézanne's commitment to color led him actually to deny the very existence both of modeling and of line as viable pictorial elements: "There is no line; there is no modeling; there are only contrasts."[15]

The briefest look at these two key moments in Léger's early Cubist encounter with Cézanne inevitably lends credibility to his story of an initial commitment to Cézanne from which he was compelled, because of his very different "personality" as an artist, to escape. My contention is that a closer look at Léger's work and at his recorded statements, especially between 1912 and 1914, reveals that at a deep level the lesson of Cézanne remained profoundly important, and that this was so at least into the 1920s though not all the way to 1930, the date of Carl Einstein's assessment of Léger in *Documents*.

In May and June 1913, Léger published in the little magazine *Montjoie!* the first of two lectures he gave at a private studio art school, the Académie Wassilieff.[16] He gave the second the following year and published it in Apollinaire's influential periodical *Soirées de Paris*.[17] These two lectures have been read rightly as the verbal accompaniment to a new series of paintings that he had begun producing by May 1913. These works include still lifes, figure paintings, and landscapes (figs. 7.5–7.7), but these are clustered around a core suite of paintings, each of which Léger simply titled *Contrasts of Forms* (fig. 7.8).

The first of the Wassilieff lectures took as its central point the urgent need for painting to leave the representational job of image-making to the new media, photography and film, and to replace devotion to subject matter (Cézanne's motifs) with devotion to the painting as a "reality" in its own right (Léger called this "realism of conception" as against "visual realism"). It was by going "as far as abstraction," he told Dora Vallier, that he finally escaped Cézanne.[18] On one level, certainly, the *Contrasts of Forms* are a rejection of all the genres as Cézanne knew and painted them and so can seem to stand as a final rejection of the motif in nature: They have no recognizable

subject matter. But on another level they confirm the continuing hold on Léger of Cézanne's example.

Most obviously, the works in the series are literal applications of Cézanne's famous dictum, recorded by Émile Bernard, concerning the sphere, the cone, and the cylinder, by which, as John Rewald was the first to clarify, he meant an only-ever-partially-apprehended underlying structure in nature.[19] In the *Contrasts of Forms* suite, that structure has become explicit to the point of taking over altogether. Léger had taken, it can seem, Bernard's emphasis on the organization of "sensation" in Cézanne to a logical conclusion: the marshaling of pictorial resources has replaced altogether the gathering of colored sensations experienced in the study of nature.[20] Bernard's 1907 "Memories" of Cézanne, with its precious horde of quotations, was gratefully acknowledged in the lecture.[21]

And yet, with the *Contrasts of Forms* series, does painting take over from Léger's visual experience of the world (in Cézanne's vocabulary, his "sensation")? As I have pointed out, the *Contrasts of Forms* paintings were only one suite of works in a larger series that included all Cézanne's major genres. Léger did not stop painting fruit bowls, or buildings in landscapes, or women seated as Cézanne had so often seated his wife for her portrait. Moreover, his insistence on the term "realist" in the 1913 Wassilieff lecture was deeply significant the year following Gleizes and Metzinger's insistence on Gustave Courbet's "realism" as the ultimate precursor of Cubism.[22] It underlined Léger's commitment to painting, however far removed from legible representation, as an *equivalent* of the visual impact of things in the world. Among the quotations from Bernard's pub-

Fig. 7.6. **Fernand Léger, *Woman in an Armchair,*** 1913. Oil on canvas, 51 x 38¹³⁄₁₆ inches (129.5 x 97 cm). Beyeler Collection, Basel

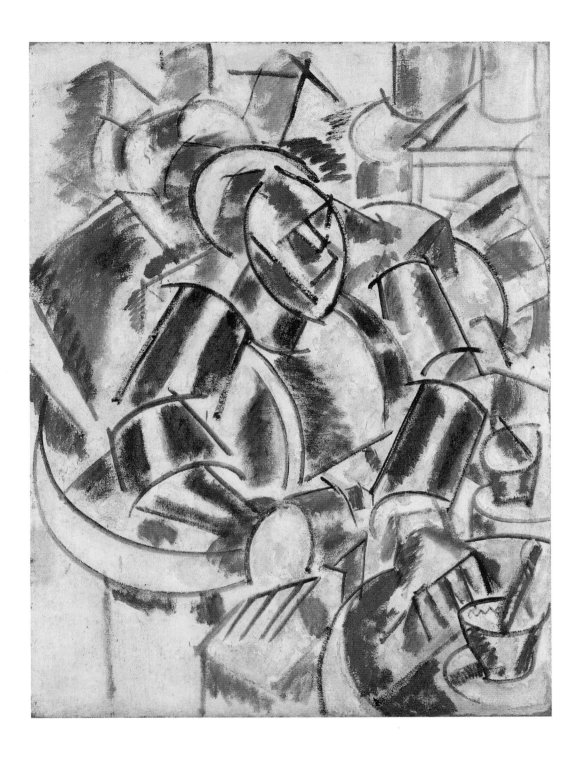

lication of Cézanne's sayings and opinions that he lifted for his lecture was one that makes absolutely clear his understanding of the separation Cézanne made between the object and his "sensation": "To paint after nature is not for an impressionist to paint the object, but to realize sensations."[23] For Léger, it gave support to his own statement at the beginning of the lecture (an axiom, he called it): "The realist value of a work is perfectly independent of all imitative quality."[24] In other words, it gave support to his separation of painting, as a "conceptual" art, from representation, but not to any claim that painting should be separated altogether from the visual experience of the world — hence his term "*realism* of conception." Indeed, it is possible to see the *Contrasts of Forms* paintings as containing within themselves all the ingredients necessary for a renewal of Cézanne's genres, not only the possible components of figures and still-life objects, but landscape too. Elsewhere I have demonstrated how Léger actually developed these works, which are more easily associated with a world of bodies and objects, from landscapes featuring trees, smoke, and bursts of sunlight.[25]

The 1914 Wassilieff lecture would leave no doubt about the importance of "sensation" — his visual experience of the world — to Léger's new work, nor about its

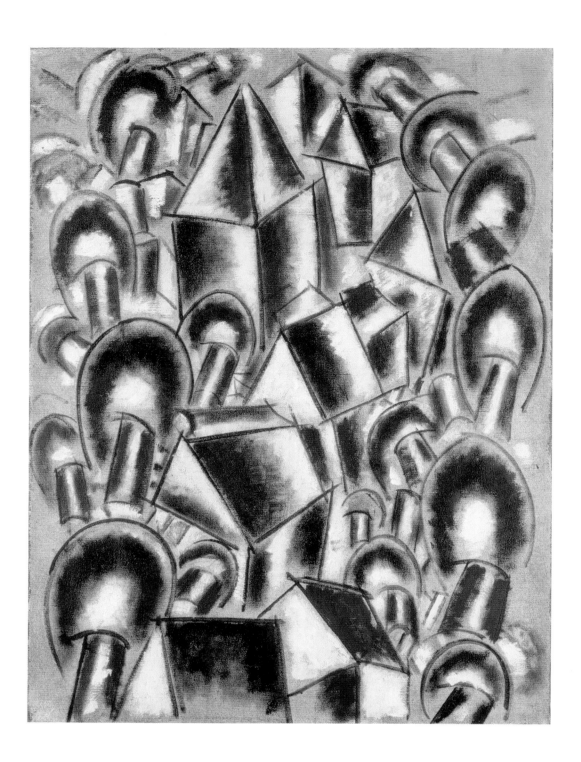

Fig. 7.7. **Fernand Léger, *Houses with Trees***, 1914.
Oil on canvas, 51⅛ x 38³⁄₁₆ inches (130 x 97 cm).
Kunstmuseum Basel. Raoul La Roche Collection

Cézannian dimension. Indeed, that second lecture of 1914 can be read perhaps more comprehensively than the first as a response to Cézanne. Before I read that lecture in these terms, however, a closer look at how Léger approached "realization" in the paintings he produced between 1912 and 1914 is necessary.

As we have seen, Léger paired *Railway Crossing* with *Woman in Blue* as a work that convinced him that he had escaped from Cézanne. But it is both one of his most overtly Cézannian paintings and a work that opens the way to his own personal future as a modernist. If "modulation," Cézanne's favored term for the pictorial organization of his colored sensations, could ever apply to a Léger, it might apply to *Railway Crossing*. Something close to Cézanne's "constructive stroke" articulates the transitions between greens, pinks, and ochers, opening the softly colored surfaces into one another across the central field of contrasts. Yet, where forms are condensed (the rhythm of curves, like smoke, on the left), tonal modeling is hinted at, and that swinging, slicing line pulls everything together as decisively as it does in *Woman in Blue*. Léger's drive to organize his means and to reach decisive conclusions is already clear. It is clearer still in the monumental, exhibition-sized *Woman in Blue*, where the opening of surfaces into

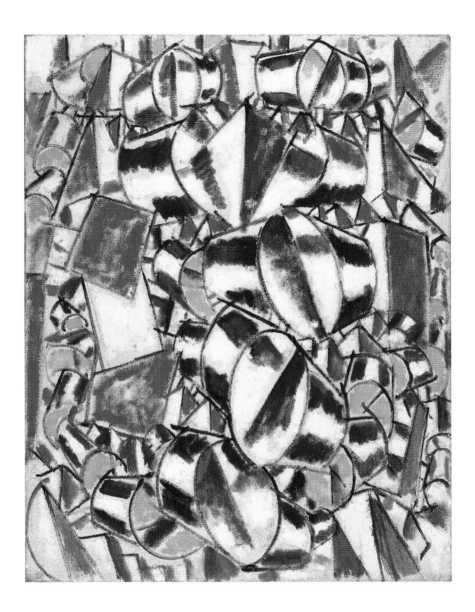

each other ("passage," in Cubist terminology) has been checked almost completely by the decisiveness with which areas are contained by line-as-contour. He has moved decisively not only toward abstraction, but away from the hesitations so often commented on in Cézanne, especially where planes and forms abut.

Something else is clearly present in *Woman in Blue* that goes with its decisiveness: the rigorous division of Léger's means and their organization in forcefully contrasted groupings. Large flat color planes break up small tonally modeled sequences of forms; black and white planes confront strong blues and reds. There is structure, there is division, and there is contrast. It is this rigorous division of means and their constructive (logical) organization as contrasting forces that become the defining characteristics of the *Contrasts of Forms* series and the suites of subject paintings that accompany them in 1913–14. The first Wassilieff lecture opposed Cézanne's insistence on color alone as the technical foundation of painting with the assertion that all of the three "great quantities" deployed in picture-making—line, form, and color—should be given equal emphasis. Only then, Léger claimed, could painting achieve the greatest possible pictorial intensity and at the same time have the technical completeness to endure, to achieve "pure classicism."[26] All the paintings produced in the period of the *Contrasts of Forms* series were put together quickly, decisively, and with the same technical priorities. Léger worked on coarse canvases, to which he had added an even coarser priming, either brown or gray. He used black to brush his lines; he activated surfaces by scrubbing on patches of white and color (unmodulated primaries and secondaries) that he was careful to keep separate from the lines; and he constructed forms (spheres, cylin-

ders, cones) by the combined shaping capacities of line, color, and black and white acting together. Straight and curved lines act against one another, as do flat saturated colors and geometric solids, and they all come together to produce still more powerful collisions: color against line, line and color against form.[27] In that way, Léger would claim in the 1914 lecture, the "great quantities" did not simply work additively, but were multiplied together.[28]

In the second Wassilieff lecture, Léger pointedly set his commitment to line against Cézanne's declared commitment to color alone, but in fact the way his paintings of 1913–14 actually work can be thought of in terms profoundly sympathetic to Cézanne, even when the discussion is kept on the level of pictorial rather than representational effect.[29] In the first place, despite his fervent protests to the contrary, Cézanne actually gave line an active role throughout his working process during the whole of his mature post-1870s period, as recent technical research has emphasized. Moreover, although Cézanne's interest was always in the relationship between line and color in handling the transitions between forms, he tended to keep them clearly separate from one another.[30] Second, and most important, Léger's actual organization of his pictorial means across the picture surface is in broad terms closely comparable with Cézanne's. Leger's paintings of 1913–14 have a large, structural aspect, which is established formally by the way Cézanne's spheres, cylinders, and cones combine, often in centrifugal rotation contained by angular, vertically oriented planes. Yet the division of line from color patch means that this structure and the solidity of the primary solids that construct it disintegrate before one's eyes into a scintillating succession of linear and chromatic collisions. An underlying structure is declared and at the same time the entire picture surface is activated, so that it becomes alive with incident.

Looked at in this way, these are paintings that invite an analysis obviously (though perhaps surprisingly) in tune with Roger Fry's analyses of post-1870s Cézanne. Here is Fry summing up his responses to a Cézanne still life from the turn of the 1870s to the 1880s; he could almost be writing about a Léger of 1913–14: "It is this infinitely changing quality of the very stuff of the painting which communicates so vivid a sense of life. In spite of the austerity of the forms, all is vibration and movement. Nothing is less schematic than these works, even when, as here, the general forms have an almost geometrical appearance."[31]

Fry's understanding of the interaction between structure and "the changing quality of the very stuff of the painting" brings back into focus both Bernard's and Léger's emphasis on the logical or "cerebral" in Cézanne and how they related it to the realization of "sensation." As Fry described it, Cézanne first reduced what he saw to "pure elements of space and volume," the elements of an "abstract world" that was "organized by the artist's sen-sual intelligence." He then brought "these abstractions . . . back into the concrete world of real things, not by giving them back their specific peculiarities, but by expressing them in an incessantly varying and shifting texture. They retain their abstract intelligibility . . . and regain that reality of actual things which is absent from all abstractions."[32]

Fry on Cézanne gives me an apt starting point for my reading of Léger's 1914 Wassilieff lecture as an extended response to Cézanne, because the way he describes the abstract and cerebral made vividly "real" by "the very stuff of the painting" comes so close to the way Léger argued in the lecture that his new abstract art of contrasts could be "realist" without simply depicting appearances. Indeed, the statement by Cézanne with which Fry opened his monograph—"Art is a harmony parallel to nature"—could be said to underpin Léger's entire argument in the 1914 lecture, even though he could not

have known it at the time.[33] One just has to rephrase it as Léger might have: The disso-
nance of art parallels the new conditions of visual experience. The 1914 lecture is Léger's
attempt to show how the "multiplicative" contrasts of his new painting (dissonance)
relate to the new, fragmentary intensity of his visual experience of things, a subjective
experience like Cézanne's experience of nature, but one transformed by the new condi-
tions of modernity. The lecture seeks to modernize Cézanne's equation between "sensa-
tion" and pictorial "realization" in terms fit for an urban society in which the very
conditions of visual experience have been fundamentally changed by new modes of
communication and transport.

The opening statement of Léger's lecture reads almost explicitly as Cézanne
brought "up-to-date": "The pictorial realizations of today are the result of the modern
mentality and are closely linked to the visual aspect of external things, which are cre-
ative and necessary for the painter."[34] It is the "modern mentality" that counts and,
though this is linked to the visual aspect of external things, that is to be differentiated
from mere appearances, just as Cézanne's "sensation" is. Léger's idea of "modern men-
tality" is summed up by the high-speed fragmentation and condensation of impressions
experienced through the window of a motorcar or a train carriage, but the example of
rupture he dwelled on — the stark yellow and red of a poster "screaming out" in the
countryside whose force "brutally" destroys any harmony that might have been found
there — is one that can be read as a direct challenge to the unspoiled "nature" of
Cézanne's Provençal landscapes.[35]

By launching his lecture thus, Léger ensured that the equivalence between what he
thought of as modern visual experience (modern sensation) and the new painting (tech-
nical realization) was clearly in mind when he expanded in detail on the "multiplicative"
organization of pictorial contrasts. The new intensity of visual experience demanded a
new intensity of pictorial realization, one that used all the three "great quantities." It was
on the basis of this equivalence that he specifically confronted and dismissed Cézanne's
negation of line.[36] Moreover, the example he finally selected by which to underline the
direct connection between dissonant, "multiplicative" painting and modern visual expe-
rience was explicitly presented as an advance beyond Cézanne. He recalled how the
experience of seeing smoke curling up between angular buildings resulted in a particularly
forceful organization of pictorial contrasts of a kind that Cézanne could only hint at in
"his landscapes where houses are clumsily crushed in the trees."[37] Cézanne, according to
Léger, could sense the need for a new kind of integrated drawing and painting leading to
the "multiplicative concept," but he could not fully grasp it. The landscapes with houses
and trees that Léger painted in 1914 (see fig. 7.7) using the "multiplicative" techniques
of the *Contrasts of Forms* series were, it is clear, a direct response to the Cézanne of, for
instance, the *Gardanne* (see plate 56) or the Château Noir landscapes of the 1880s and
the 1900s. They realized what Léger believed Cézanne's Impressionist commitment to
color at the expense of line had prevented him from achieving.

He moved on, however, to reinforce his fundamentally Cézannian separation of
"sensation" from external appearance (subject matter) by stressing that modern subject
matter was not needed. Since it was the transformation of the very experience of seeing
that mattered, the new fragmentation and condensation of vision had the power to give
pictorial force to the most banal of subjects.[38] Already in *Woman in Blue* his painting
had said as much by the way it preserved and yet simultaneously destroyed its unexcep-
tional seamstress successor to Madame Cézanne.

In the end, it was by stressing at every stage his own capacity for decisive realiza-
tion that Léger distanced himself from Cézanne. In the 1913 lecture he had talked

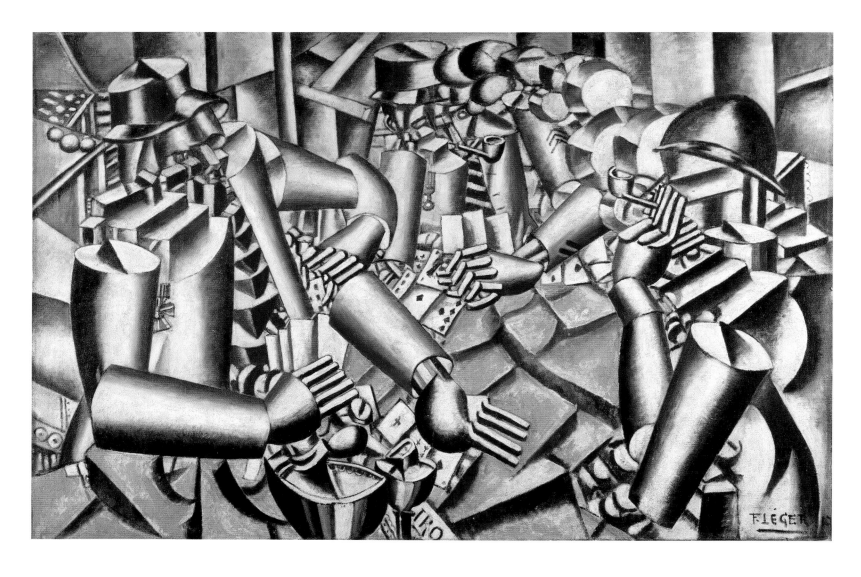

Fig. 7.9. **Fernand Léger, *The Card Game,*** 1917. Oil on canvas, 50¹³⁄₁₆ x 76 inches (129 x 193 cm). Kröller-Müller Museum, Otterlo, The Netherlands

of Cézanne in despair, crying out: "I have not been able to realize [my sensation]; I remain the primitive of the way I have discovered."³⁹ Léger had quoted him thus, of course, to throw into relief his own certainty. He ended the 1914 lecture by declaring with irrepressible confidence that he had quit the Salon des Indépendants because it was for the young, "the searchers with their worries" (the primitives of their art), not for artists (like himself) who were capable of "perfectly realized works."⁴⁰ It is, of course, significant that he titled the lecture, "Contemporary Pictorial Realizations" (Les réalisations picturales actuelles). Léger was well aware of what Picasso called Cézanne's anxiety; he would never identify with it.

Anyone familiar with the story usually told of Léger's development as a painter (by himself as well as by his commentators) will know that his experience as a soldier on the front in World War I turned him away from the banal subject to modern subjects: the city, the machine, man in a mechanizing world.⁴¹ With that turn to the modern subject came the development of a tighter, more tangible painting of things, and also a return to the tonal modeling that had been so important to *Woman in Blue*. Even his most abstract works of 1918–19, developed from the 1913 *Contrasts of Forms* paintings (fig. 7.8), were therefore more concretely related to the appearance of things, especially to machines, most obviously the big guns of the Great War. Following the logic of the "multiplicative" theory of contrasts set out in the 1914 Wassilieff lecture, this return to modeling was perhaps inevitable. If line and black and white are separated from color, the most intense contrasts will be obtained by pitching flat, saturated color against them. Modeling by color requires modulation, as Cézanne insisted. For Léger, this could only weaken the contrasts. If form was to be made more concretely tangible

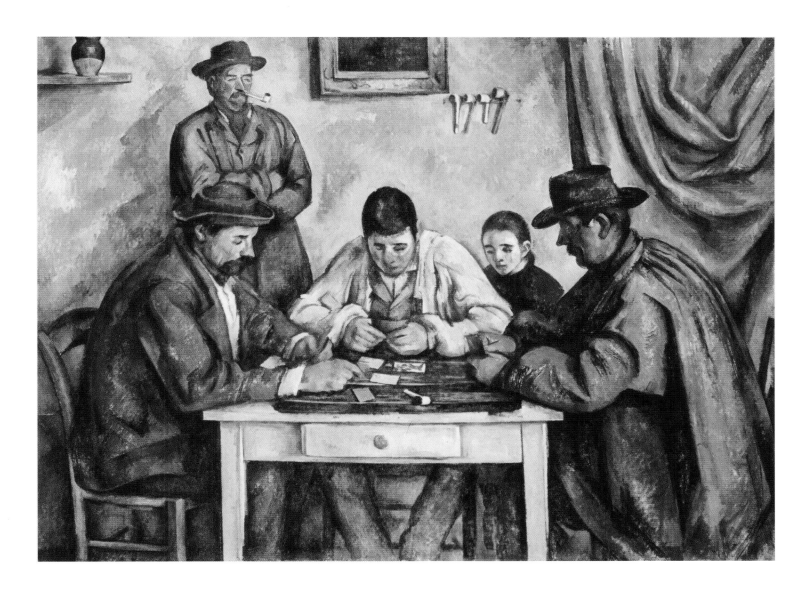

Fig. 7.10. **Paul Cézanne, *The Card Players,*** 1890–92.
Oil on canvas, 53 x 71 inches (134.6 x 180.3 cm). The
Barnes Foundation, Merion, Pennsylvania

by modeling, it had be opposed to flat color; it had to employ black with white tonally.
Léger moved a step further away from Cézanne.

Yet, Léger announced his return to modeling and his new commitment to the
modern subject with a war painting that could not have more convincingly declared
his continuing admiration of Cézanne, *The Card Game* of 1917 (fig. 7.9), which was
the centerpiece of his exhibition of February 1919 at Léonce Rosenberg's Galerie de
l'Effort Moderne that returned him to avant-garde prominence a few months after the
armistice. The painting monumentalized the soldiers with whom Léger had served by
posing them very much as Cézanne had posed his Provençal sitters in the card-player
paintings of the early 1890s (fig. 7.10), but Léger realized them entirely on the terms of
his multiplicative technique reinforced by tonal modeling, and indeed realized them
with a decisiveness that far exceeds that of the *Contrasts of Forms* paintings and their
relatives. Decisive those paintings of 1913–14 may have been, but their manifest speed
of execution gave them the appearance of openness, which can still be connected, how-
ever tenuously, to the exploratory openness so characteristic of Cézanne. Behind Léger's
Card Game there certainly lies one closely related pen-and-ink drawing that gives the
composition a clearly defined starting point.[42] The introduction of tonal modeling
closes forms, as does the clear delimitation of color surfaces. Every element of the
painting is carefully defined; it is built slowly, the result of patient preparation; nothing
is left open to change. This homage to Cézanne is, in fact, a statement of Léger's deter-
mination to achieve in a still more conclusive way what Cézanne himself knew — "the
primitive of the way I have discovered" — but had never realized. The relative complete-
ness of Cézanne's card players had been, in fact, what Léger had valued from his very

first encounter with them. Writing of the thrill the Cézanne exhibition at the Salon d'Automne of 1907 had given him, he singled out "a canvas representing two working class chaps playing cards" as one of the "stunning things" among "incomplete things." "It cries out," he wrote, "with truth and completeness."[43]

By 1919, Léger's commitment to the conclusive and the finished had led him to a thorough overhaul of his working method. He set out his new practice for his dealer Rosenberg as an important postwar development: "Above all the definitive state, you have a drawing, a watercolor, several states of different dimensions (all complete in themselves)[;] when I attack the definitive state, I am the total master of my means, I dominate them."[44] His commitment to the realization of finished works took him back to a quasi-academic practice, one that could not be further removed from the openness of Cézanne's. It did so, however, without changing the basic terms of what I have argued was a profoundly Cézannian understanding of the relationship between painting and his experience of the external world—Leger's modernized idea of "sensation"—one that separated both painting and sensation from the appearance of things, from objects as such. He continued to think in terms of a transformed way of seeing (sensation), fragmented and condensed, taking over anything it encountered, though by the early 1920s he gave geometry a more explicit and important role in that optical takeover than he had in his lecture of 1913–14.[45] When he sent a short piece on "contemporary plastic life" to the Berlin periodical *Das Kunstblatt* in 1923, he still could write of his practice as aimed at finding "the condition of organized intensity"; Émile Bernard's Cézanne organizing his sensations is still very much there in the background.[46] Moreover, those sensations in their new, modern form still produced "multiplicative" contrasts in painting, as they had in 1913–14. Léger even brought back the images of smoke over roofs and the poster in the landscape as examples of new and transforming visual experiences.

In his 1923 Berlin statement, however, are the seeds of the move that in the mid-1920s would put behind him his fundamentally Cézannian understanding of the relationship between painting and his visual experience of the modern world. He opened the piece by giving painting a new aim: "to equal and surpass in beauty the 'beautiful' industrial object."[47] At first, this can seem to be simply a reformulation in modernized terms of Cézanne's view that art should be a "harmony" parallel with nature: Art should rival the products of modernity. But Léger's focus on the object can also suggest that his careful separation, following Cézanne, of the object in the external world from his idea of "sensation" and so from painting might not hold now that he had engaged with the modern subject. The year 1923 saw him begin work with the American Dudley Murphy on his film *Ballet mécanique*, an experience that confirmed for him the conviction that manufactured objects could in themselves be responded to fundamentally just as paintings are: They themselves could be "classic." By the time Carl Einstein wrote his piece on Léger for *Documents* in 1930, the distance between Léger and Cézanne had become a gulf, because for Léger paintings had become objects to be thought of very much as objects in the modern world were; hence Carl Einstein's phrasing, so alien to any that might be applied to the work of Cézanne: He paints "the naked object," "raw and perfect."[48]

Léger's escape from Cézanne was neither as simple nor as quickly achieved as he made it seem in his 1954 interview with Dora Vallier, but by 1930 and Einstein's *Documents* article few signs of that connection remained either in his painting or his writing. It is worth concluding, however, with the point that there was one aspect of Cézanne—or at least the mythic Cézanne—with which Léger could always identify: Cézanne's own

identification with the simplest of his neighbors and those who worked for him. "Two working-class chaps," Léger called Cézanne's card players. His card players were also from "the people." *The Mechanic* of 1920 (plate 50), Léger's heroic image of the working man of industrialized society, updates Cézanne's late portraits of his peasant neighbors (see plate 62). It is significant that Léger chose not an assembly-line factory worker but a skilled man, an artisan of mechanization, the modern heir to the artisans whom the historian Jules Michelet had vaunted as the quintessential representatives of the "people."[49] He is a figure whose individual mastery of a *métier* links him, despite his modernity, to the preindustrial representatives of the "people" painted by Cézanne.

Léger liked to think of himself as a worker in his art too, or more precisely as a modern artisan; so did Cézanne. Looking back from 1919 to the prewar years, Léger wrote to his dealer Rosenberg that his paintings were put together as constructions: "I was the most conscientious of masons."[50] He would have known and valued Cézanne's opinion, recorded by Émile Bernard, that "the artist has to be a laborer in his art."[51] In 1925, indeed, Léger was willing to promote Cézanne to the status of modern technician: "A little engineer," he called him.[52]

Perhaps the ultimate demonstration of the closeness with which Léger could identify with Cézanne is the fact that he was even willing to ignore his southern, Provençal identity (so crucial to the then current art-historical image of "the Master of Aix"). In the 1920s, as a "northerner," Léger would passionately contest Léonce Rosenberg's promotion of the "Latin" south as the foundation of art in the West. He is not merely mistaken when he writes to Rosenberg that the lesson of light and color taught by the Impressionists and Cézanne is "northern."[53] He knew well enough that Cézanne came from Aix-en-Provence. This worker painter, this "little engineer," had done enough to be treated, for a moment, as a man from the north, like him.

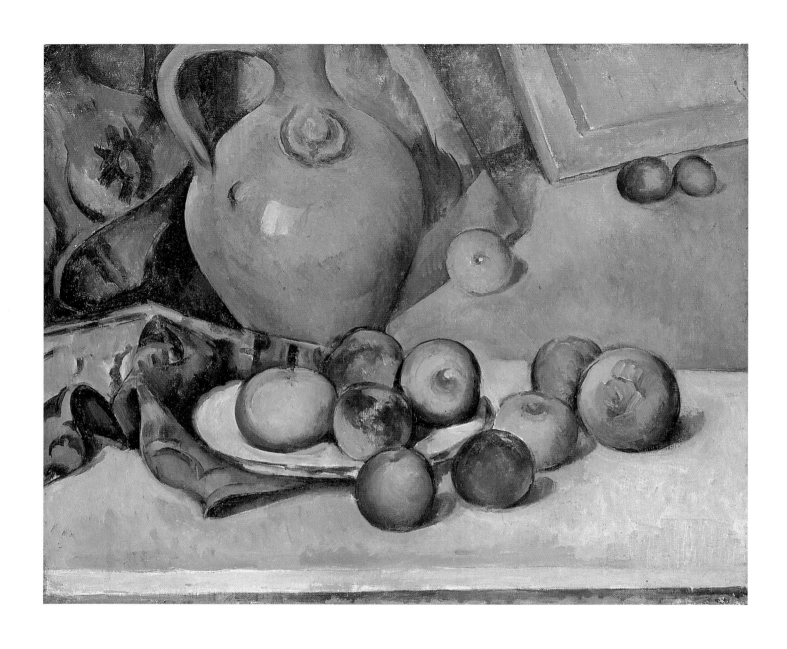

PLATE 45

Paul Cézanne

Stoneware Jug, 1893–94

Oil on canvas
15 x 18⅛ inches (38.2 x 46 cm)
Beyeler Collection, Basel

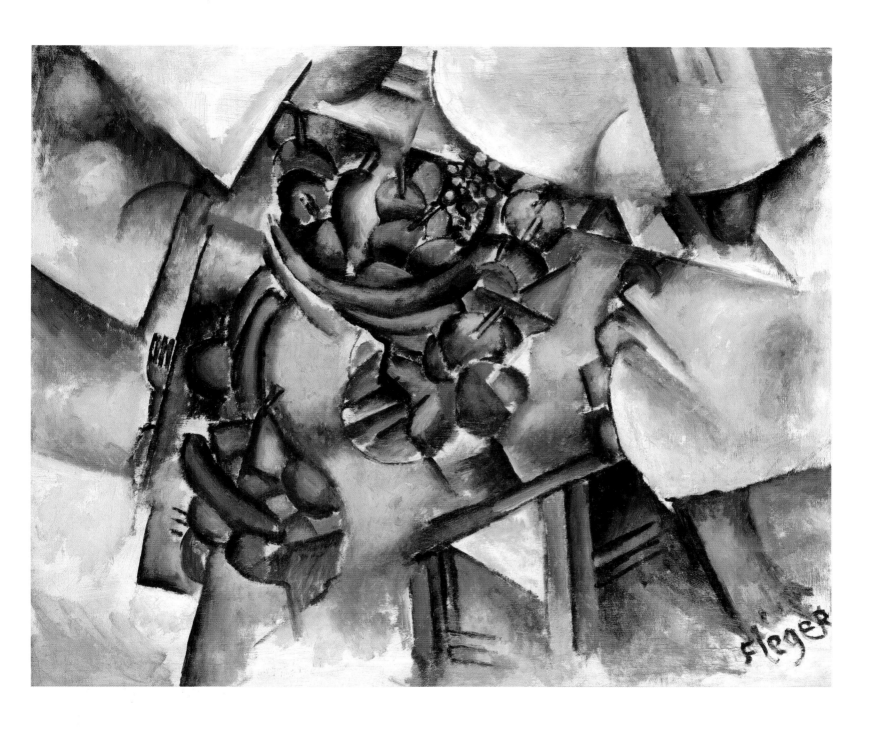

PLATE 46

Fernand Léger

Compotier on the Table, 1911

Oil on canvas
32⅜ x 38½ inches (82.2 x 97.8 cm)
The Minneapolis Institute of Arts. The William Hood
Dunwoody Fund

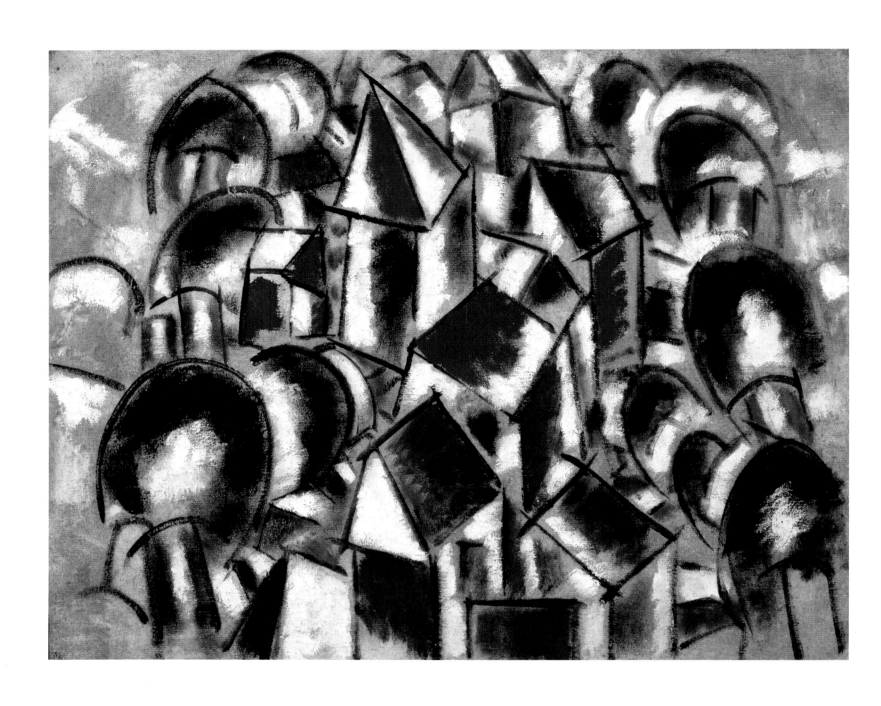

PLATE 47

Fernand Léger

Village in the Forest, 1914

Oil on burlap
29⅛ x 36⅝ inches (74 x 93 cm)
Albright-Knox Art Gallery, Buffalo, New York. Gift of
A. Conger Goodyear, 1960:4

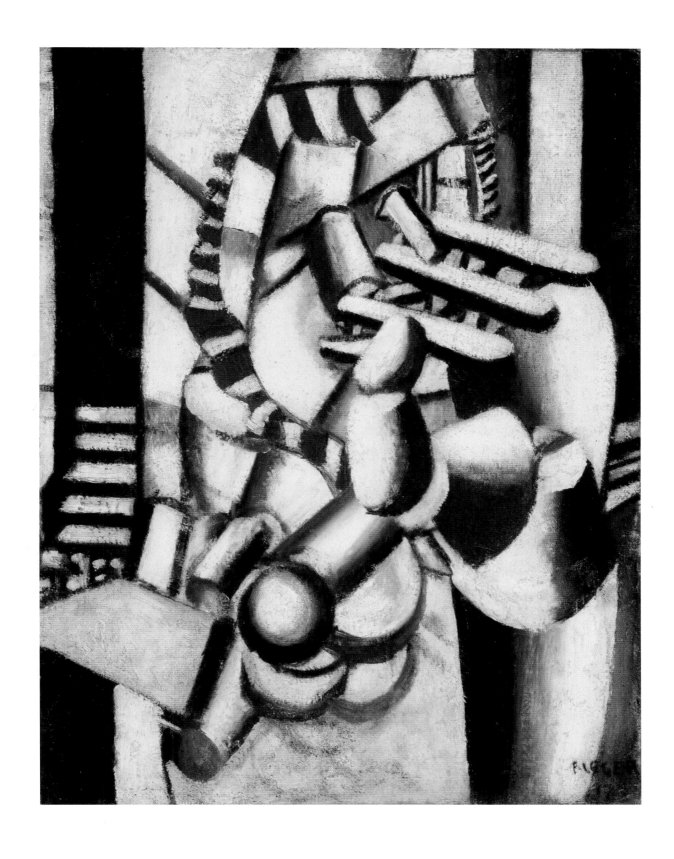

PLATE 48

Fernand Léger

The Wounded Man, 1917

Oil on canvas
24¼ x 18½ inches (61.6 x 46.7 cm)
Portland Museum of Art, Maine. Scott M. Black
Collection, 23.1997.1

Paul Cézanne, *Man in a Blue Smock*,
1892 or 1897 (plate 62, p. 236)

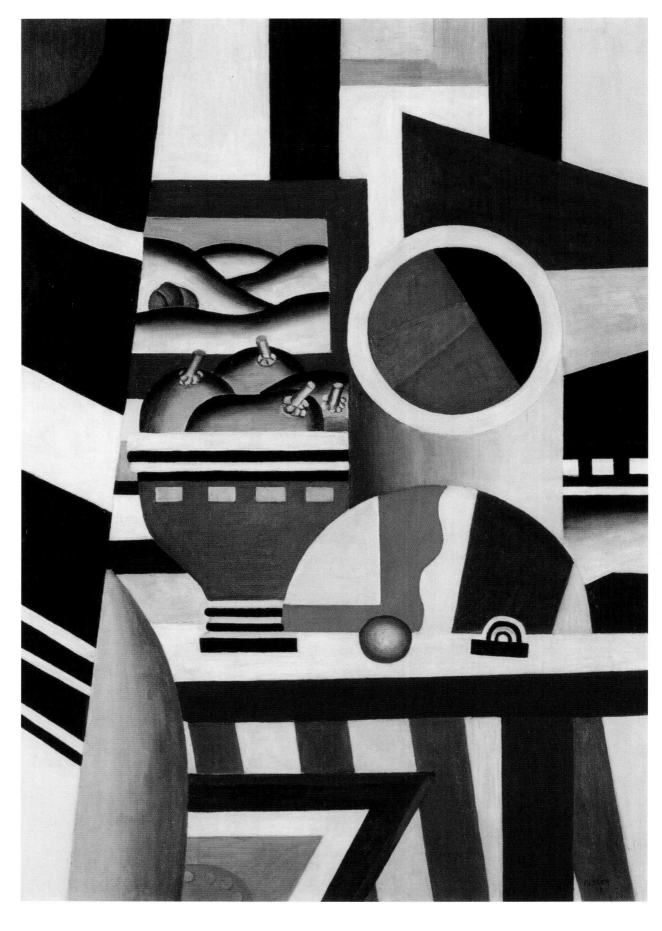

PLATE 49

Fernand Léger

Still Life with Fruit Bowl, 1923

Oil on canvas
45¹¹⁄₁₆ x 33½ inches (116 x 85.1 cm)
Musée d'Art Moderne de Lille, Villeneuve d'Ascq

Paul Cézanne, *Still Life with Fruit Dish,*
1879–80 (plate 84, p. 270)

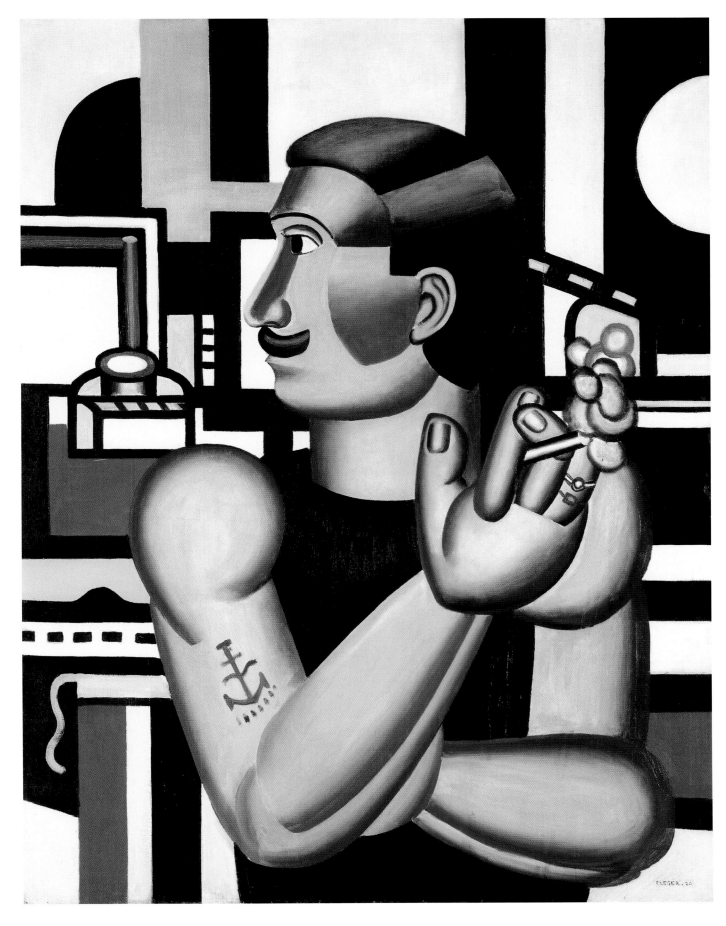

Fernand Léger

The Mechanic, 1920

Oil on canvas
45⅜ x 35 inches (116 x 88.8 cm)
National Gallery of Canada, Ottawa. Purchased 1966

Paul Cézanne, *The Smoker,* c. 1890–92
(plate 155, p. 447)

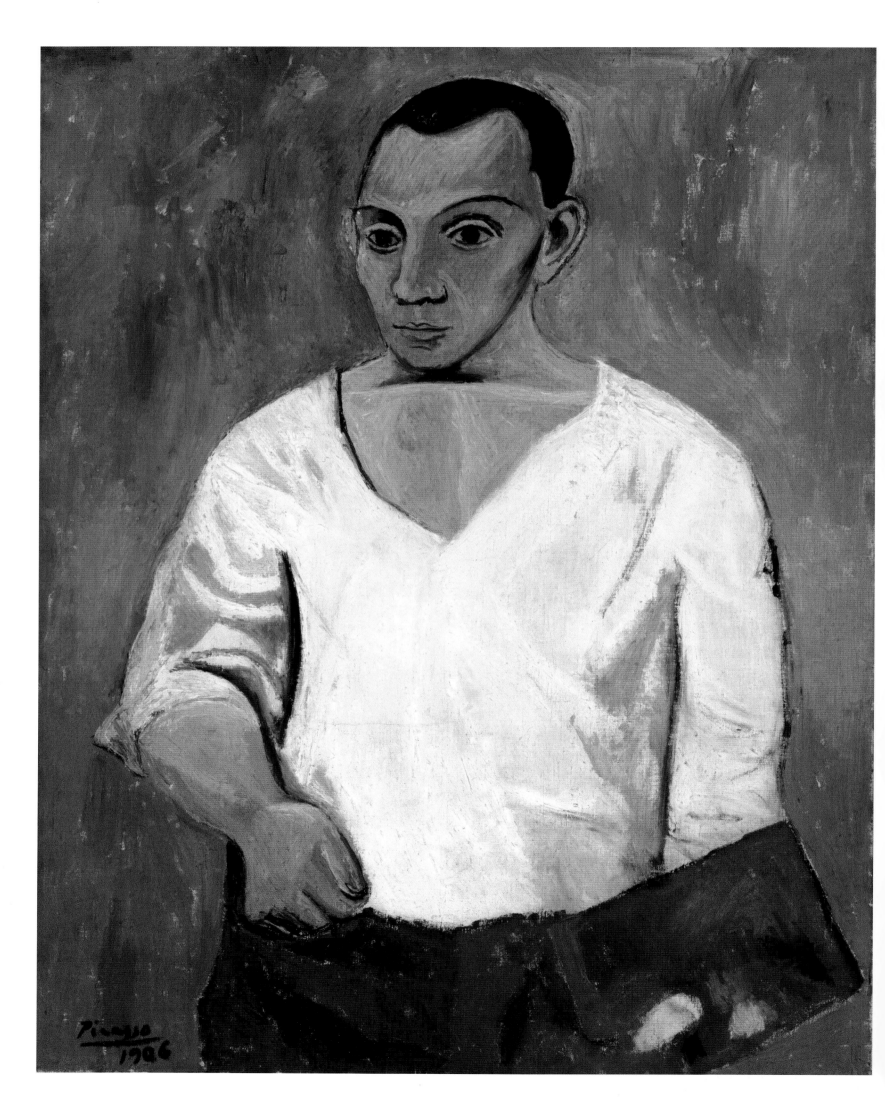

Picasso's Extreme Cézanne

John Elderfield

Pablo Picasso

Spanish, 1881–1973

***Self-Portrait*, 1906**

Oil on canvas
36¼ x 28¾ inches (92.1 x 73 cm)
Philadelphia Museum of Art. A. E. Gallatin
Collection, 1950-1-1

Paul Cézanne, *Self-Portrait with Palette,* 1885–87.
Oil on canvas, 36⅜ x 28¾ inches (92.5 x 73 cm).
Foundation E. G. Bührle Collection

A few years after Cézanne's death in 1906, a group comprised mainly of well-meaning artists and collectors set about raising funds for a monument to the great painter in his hometown of Aix-en-Provence.[1] The commission went to Aristide Maillol, who eventually produced a sculpture of a river goddess that now seems puzzlingly historicist for and serenely indifferent to its particular purpose (fig. 8.1). But this only goes to show how very changed is our understanding of Cézanne as compared to that of his earliest admirers, who celebrated his art as a novel form of classicism with a certain touch of awkwardness in it to certify artistic integrity.[2] Although Maillol himself took this general approach to the commission, he nonetheless smoothed out most of the discomfiture as well as choosing for his subject one of the few plausible poses for a reclining bather that Cézanne himself had never used. It was probably for the best that the good citizens of Aix decided to reject the monument.

Many years later, however, a sculpture was set up near Aix that may be thought to be a sort of monument to Cézanne—or at least to his influence on a most important successor. I refer to Pablo Picasso's extraordinary *Woman with a Vase* of 1933 (fig. 8.2), which, shortly after his death in 1973, was set on his grave on the slopes of Mont Sainte-Victoire, the mountain that Cézanne loved and where Picasso had owned a home. It is not known whether Picasso himself chose this memorial, but it is a very apt one for its Provençal setting.[3] He probably had been aware of Maillol's monument, for he had known this fellow Catalan artist since the turn of the century,[4] and when the city of Aix finally rejected the sculpture in 1920 Picasso was himself working in a reprised form of Maillol's pneumatically primitivized classicism, which had been influential on him back in 1906 even as he was beginning to discover Cézanne. In any event, Picasso's own monument is a testament to the qualities of inspiration that, far more important than style or method, he had recognized in Cézanne's art, among them a stubbornness and aggressiveness that were indifferent to received opinion, impatient with anything tame and nostalgic, and utterly convinced of the importance of the work at hand. Needless to say, Cézanne never used a pose like this one either, although Picasso's forbidding, prehistoric goddess does call forth something of the weirdness of the French painter's late figure compositions, and some early ones, too. But precise visual similarity is not the point. It will be the argument of what follows that Picasso saw the extremism in Cézanne's art and made it his own.

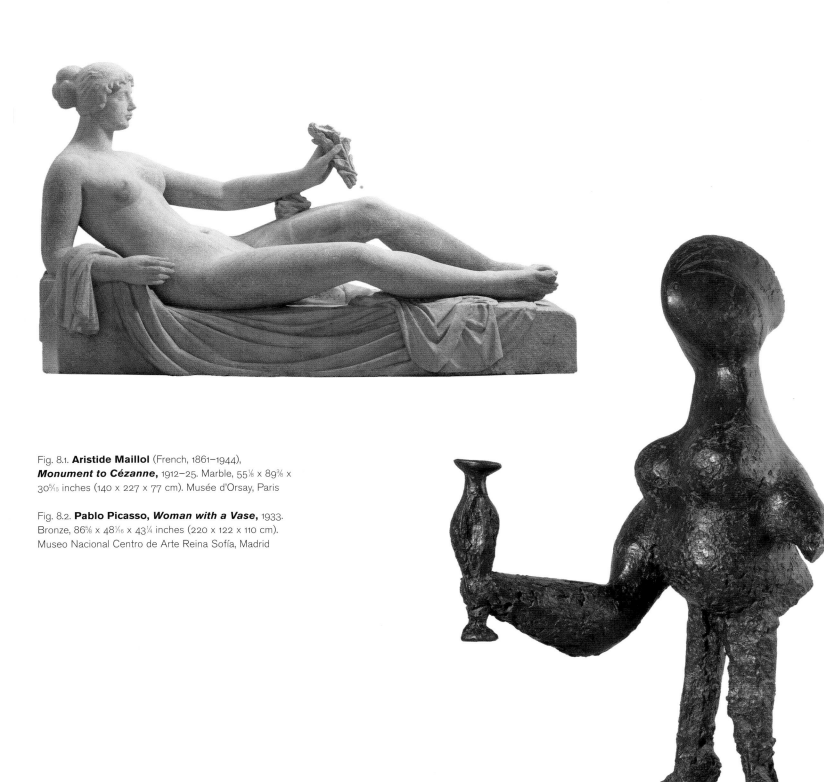

Fig. 8.1. **Aristide Maillol** (French, 1861–1944),
Monument to Cézanne, 1912–25. Marble, 55⅛ x 89⅜ x
30¾₃ inches (140 x 227 x 77 cm). Musée d'Orsay, Paris

Fig. 8.2. **Pablo Picasso, *Woman with a Vase,*** 1933.
Bronze, 86⅝ x 48¹⁄₁₆ x 43¼ inches (220 x 122 x 110 cm).
Museo Nacional Centro de Arte Reina Sofía, Madrid

His Master's Voice

"He was like our father," Picasso said. He was speaking to the photographer Brassaï on November 12, 1943, in occupied Paris, remembering the magnitude of Cézanne's importance in happier times some thirty-five years earlier. "It was he who protected us," he insisted. "He was my one and only master!"[5]

When Picasso was speaking, he and his friends badly needed protection. The last and worst period of the German occupation had arrived along with a bitter Paris winter, bringing even more food shortages and immobilizing power cuts, the RAF bombings, brutal reprisals against resisters and innocent hostages alike, and the deportation to likely death of Jews and other undesirables.[6] Christian Zervos, the author of Picasso's catalogue raisonné, was in hiding, his apartment having been taken over by Germans. The poet Max Jacob, who had been there when Picasso was discovering Cézanne, was now forced to wear a yellow star like all Jews in Paris; he would die the following year in a transit camp at Drancy on the outskirts of the city. Picasso's statement about Cézanne speaks simultaneously of the past and the present, of the past seen through the filter of the present, and this is true—is a claim of this essay—of everything that Picasso said about Cézanne.

Of course, when Picasso spoke of protection, he was referring not to physical safety but to the security of paternal guidance in matters artistic. Yet, his statements on Cézanne are more than acknowledgments of a professional debt; they are invocations of his master as a moral exemplar, as someone from whom to learn—not how to paint Cézannist pictures, but how to be an artist.

Picasso was sixty-two when he spoke to Brassaï, and no recorded statement of his on Cézanne appears to date from before he was in his mid-forties.[7] Everything was deeply retrospective. And everything—is another claim of this essay—was said in the context of broader retrospection about the past, and hence the future, of his art. Therefore, when Picasso told Brassaï that Cézanne protected "us," we need to ask who else he had in mind. Probably it was Georges Braque and Henri Matisse: the former because a room devoted to his work had been the center of attention at the 1943 Salon d'Automne, and that spring a selection of his earlier, more Cézanne-influenced Cubist paintings had been exhibited at the Galerie de France;[8] the latter because Picasso's comment echoes a remark by Matisse, who said in 1908 that Cézanne was "the father of us all."[9] Although Matisse's phrasing reflects a ubiquitous early modern manner of admiring Cézanne, an apparently universal benefactor,[10] Picasso may well have recalled these particular words because he had engaged Matisse as well as Cézanne in a recent painting about which he and Brassaï had spoken.

The photographer had told Picasso how much he admired the beautiful blouse of his 1942 *Portrait of Dora Maar* (fig. 8.3), and the artist, delighted, told him it was entirely invented: "Despite what they say of my 'facility' . . . how I sweated over this blouse."[11] His anxiety about being thought facile is very Matissean, and this blouse is, in fact, a very Matissean piece of painting. It is also a very Cézannian one—in its melancholy context it recalls the equally painful *Portrait of Madame Cézanne* of 1890–92 (fig. 8.4)[12]—while Picasso's story of sweating over the blouse recalls, and is probably adapted from, the dealer Ambroise Vollard's famous account of Cézanne abandoning his portrait after 115 sessions with the words, "I'm not discontented with the front of the shirt."[13] We might, therefore, want to consider that Picasso's remark to Brassaï about Cézanne emerged from a complex of interconnected thoughts about Braque, Matisse, facility, anxious times, and the work of painting, as well as about Cézanne as a father and protector.

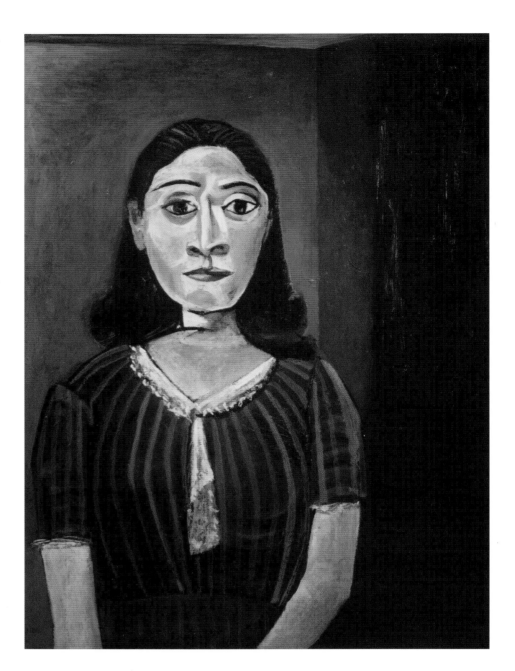

This is speculation. Nonetheless, experience of Picasso's paintings, as well as the evidence of his few statements on Cézanne, argues very strongly that his understanding and admiration of his "one and only master" is a complex matter, not to be reduced to simple statements of influence as stylistic resemblance. There were a lot of Cézannists in the early years of the twentieth century, painters influenced by Cézanne who painted like Cézanne—with hatched, thematized brushstrokes; stiff and erratic contouring; spatial compression without loss of bulk; compositions tumbling down the surface; sobriety within variety of color; and so on. Their names include Charles Camoin, Georges Braque, André Derain, Raoul Dufy, Émile-Othon Friesz, and Maurice de Vlaminck. Picasso was not one of them.

There were moments—most of them in 1909—when Picasso did try on the Cézannist uniform, but these were exceptions, and it is impossible to dismiss the thought that he set out to make parodies, as if offering his master a guest appearance in his own art, and especially so when the style was accompanied by a pastiche of a Cézannist subject: the artist's hat, Mont Sainte-Victoire, a hillside at Gardanne, a peasant from Provence.[14] There were also moments—great moments—when Picasso made sequences of works based on remembrances of specific paintings by Cézanne: Madame Cézanne wearing a red dress; a young man sitting at a table; bathers escaped from larger, multifigure compositions.[15]

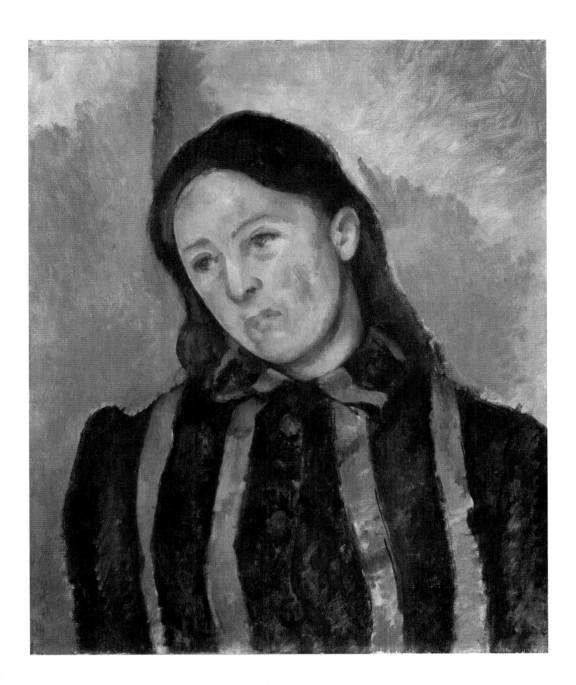

Fig. 8.4. **Paul Cézanne, *Portrait of Madame Cézanne,*** 1890–92. Oil on canvas, 24⅜ x 20⅛ inches (61.9 x 51.1 cm). Philadelphia Museum of Art. The Henry P. McIlhenny Collection in memory of Frances P. McIlhenny, 1986-26-1

Far more frequently, though, his master's voice was immingled with other voices; distinctly different statements were conflated; or Cézanne's voice was so thoroughly absorbed in Picasso's that its original accent was altered. An amusing example of the first case is how an homage to Édouard Manet's *Déjeuner sur l'herbe,* painted on February 29, 1960 (private collection), came to resemble as much the *Five Bathers* by Cézanne that Picasso had bought three years earlier (plate 70).[16] A vivid instance of the second is how Picasso's startling *Composition with Skull* of 1908 (fig. 8.5) draws upon Cézanne's spatially dislocated, beautifully delicate *Still Life with Plaster Cupid* of about 1894 (fig. 8.6) while adopting the more expressionistic treatment of his late paintings of skulls.[17] And a possible example of the third case may be discovered in a correspondence between the big, geometrically paneled door of Cézanne's *Woman with a Coffeepot* of about 1895 (fig. 8.7) and the background of Picasso's *Girl with a Mandolin* of 1910 (fig. 8.8)—an affinity that extends to their smoothly modeled cylinders, forms pleated and expanded, and faces of absorbed concentration.[18] Picasso's painting decomposes the monumentality of the Cézanne—the point here being not paraphrase but reimagination—and in doing so discovers unease, even in this famously firmly rooted work.[19]

This brings us to Picasso's most famous remark about any painter: "It's not what the artist does that counts, but what he is. . . . What forces our attention is Cézanne's anxiety—that's Cézanne's lesson."[20] The context of this 1935 remark is twofold. The first

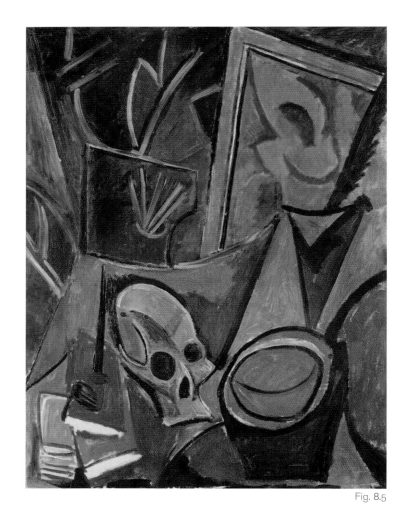

Fig. 8.5

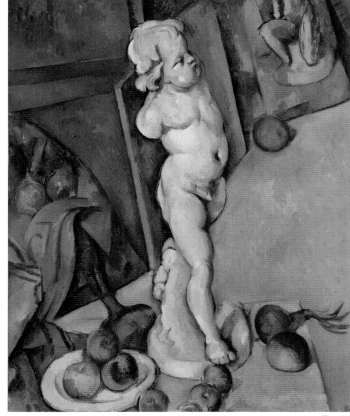

Fig. 8.6

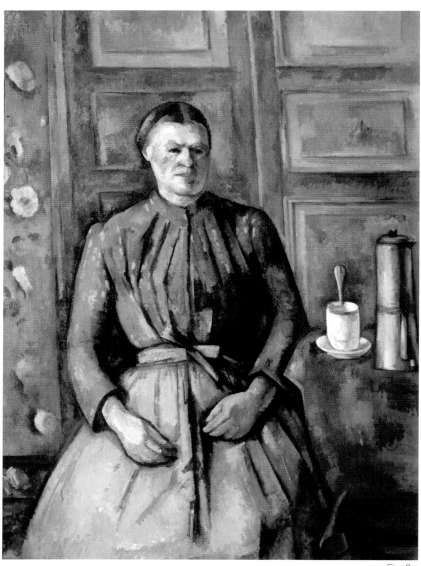

Fig. 8.7

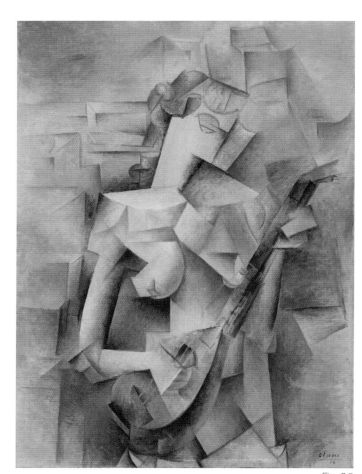

Fig. 8.8

part is Picasso's work of the preceding decade, following upon his earliest statement on
Cézanne, in 1926, on the influence of what that artist did rather than of what he was.
The second is Picasso's life, both public and personal, in the period immediately pre-
ceding the famous remark. I shall take them in that order, and the first will return us to
the years of Cézanne's initial influence on Picasso, around 1906.

Forms and the Rhythm of Colors

Picasso was notorious for not talking about his art: "The others talk; me, I work," he
said.[21] However, he broke his silence in 1923 with the first of three extended statements
about his practice;[22] its successors—those containing remarks on Cézanne—followed in
1926 and 1935.[23] The first and third statements garnered immediate attention in the art
world and gained wide currency after being reprinted in Alfred H. Barr, Jr.'s 1939 and
1946 monographs on Picasso.[24] By contrast, and for reasons that remain obscure, the
second, 1926 statement appeared originally in Russian in the Moscow journal *Ogoniok*,
and, although French and English translations were published in the Parisian journal
Formes in 1930, it nonetheless has led a shadowy existence, the passage devoted to
Cézanne entering the art-historical literature in a fragmentary and corrupted form.[25]
However, it contains not only Picasso's first recorded pronouncement on Cézanne but
also his sole testimony on what Cézanne's specifically artistic influence meant to him.

The 1923 statement, "Picasso Speaks," had begun with Picasso insisting: "To search
means nothing in painting. To find is the thing."[26] The 1926 statement, "Letter on Art,"
which borrows some sentences from its predecessor, refined the wording to the cele-
brated "I do not seek; I find," only to follow this anti-investigative boast with a string
of complaints about decorative art (the great Art Deco *Exposition internationale des arts
décoratifs et industriels modernes* had taken place the previous year) that then shifted
abruptly to speak of the omnipresent importance, precisely twenty years earlier, of
Cézanne, long known as a seeker rather than a finder.[27] This seems eccentric, to say
the least, and the way that Picasso explains Cézanne's influence is also unexpected:

> In 1906, the influence of Cézanne, that Harpignies of genius,[28] was everywhere
> pervasive. The art of composition, of the opposition of forms and of rhythms of
> colors was rapidly becoming commonplace. Two problems were confronting me. I
> understood that painting had an intrinsic value, independent of the actual represen-
> tation of objects. I asked myself if we should not represent the facts as we know
> them rather than as we see them. Given that painting has its own, independent
> beauty, one could create an abstract beauty, as long as it remained pictorial.
>
> For many years, cubism had no other aim than painting for painting's sake. It
> rejected all elements that had nothing to do with its palpable reality [*sa réalité sensible*].[29]

Leaving aside the opening, backhanded compliment—a mere landscape painter of
genius, indeed—Picasso has deeply interesting things to say about the formal aspects
of Cézanne's painting. Although he was often ready to talk about questions of pictorial
style, he nearly always refused to theorize about art;[30] this is a rare exception, and
unsurprisingly some parts of it are ambiguous. Thus, we cannot be sure whether he is
crediting Cézanne with popularizing two competing notions of pictorial composition—
one as a juxtaposition of forms, the other as a rhythmic arrangement of colors—or one
notion that combines both options. His "two problems" are clear enough, and both may
derive from statements by or on Cézanne that were accessible to him. The first, on the
independence of painting, could have come from many sources, including Cézanne's

famous definition of art, in a letter to the poet Joachim Gasquet, as "a harmony parallel to nature."[31] The second, on representing the known rather than the seen, seems to draw specifically on Cézanne's statement to the painter Émile Bernard, "Within the painter, there are two things: the eye and the brain," and Bernard's own conclusion that Cézanne's "vision was centered much more in his brain, therefore, than his eye."[32] The remark that "one could create an abstract beauty, as long as it remained pictorial" may also derive from Bernard,[33] yet it seems to allude to Cézanne's well-known antipathy to flat, poster-like painting,[34] suggesting that Picasso's opening comment did refer to two opposing compositional systems. The lead-in to his discussion of Cézanne, on the awfulness of decorative art, suggests that too. If this inference is correct, Picasso's 1926 statement is, expectedly, an affirmation of Cézanne's importance to him for juxtapositions of form rather than rhythms of color. However, Picasso's own art around 1926 proposes the contrary interpretation that he is referring to Cézanne's importance for defining the art of composition as an opposition of forms, on the one hand, and as rhythms of colors, on the other.

In his 1923 statement, Picasso had defined Cubism as "an art dealing primarily with forms" and said that it "has kept itself within the limits and limitations of painting, never pretending to go beyond it."[35] At that time, a period was coming to an end in which his art had been divided between an austere, flatly geometric Cubism and a heavily three-dimensional neoclassicism—a reprised form of the pneumatic style of 1906 on which Maillol had been influential. Since the French *forme* does not as strongly assert volumetric mass as the English *form* does, we should not be misled into thinking that it was Picasso's neoclassicism and not his Cubism of the early 1920s that dealt primarily with forms. Nonetheless, as the years elapsed, his Cubism had become less and less an art of volumetric mass and more deferential to the flatness of painting (keeping itself "within the limits and limitations of painting"); Picasso's patent desire for an outlet for the creation of volume had required a return to something akin to his pre-Cubist 1906 style. Therefore, when he wrote in 1926 that Cubism long had been about "painting for painting's sake," the implication is that this was changing; and, indeed, Picasso's divided oeuvre was about to be superceded by the most drastic revision of Cubism since the flattening introduction of collage in 1912. This newly revised Cubism would, by 1930, begin to absorb the volumetric mass that had previously required a non-Cubist style; first, however, it absorbed to its opposition of forms the rhythms of colors. Witness, for example, *The Dream* of 1932 (plate 61), whose red armchair and quatrefoil-patterned wallpaper teasingly place—with a side glance at Matisse—a sexy *femme décorative* where Cézanne's sober *femme d'intérieur* sat (plate 60). Of course, vivid color had been part of Cubism since the flat planes of collage were there to receive it; however, what began in the mid-1920s raised not only the temperature of the color but also the passion of its rhythms, even to the grotesque and fantastic.

What began—between Picasso's 1923 and 1926 statements—bears the name Surrealism, which, even more than renewed competition with Matisse, affected his revision (or, perhaps better, rediscovery) of Cubism as "a more risky, intuitive, imaginative and inspired art-form" than contemporaneous readings of it, Picasso's own included, admitted.[36] It would do the same for his interpretation of Cézanne; not only in his words—the formalism of 1926 being superceded by the anxiety of 1935—but also in his art. An especially important instance of this is the *Seated Bather* of 1930 (fig. 8.10), a figure at once decorative and uncanny, whose body is composed of volumetric forms linked in rhythmic sequences to produce a very distant remembrance of a Cézanne bather in a pose that, Elizabeth Cowling noted, Picasso's audience may have been expected to asso-

ciate with well-known works by both Matisse and Maillol.[37] It is notable, however, that intense color is sacrificed in the process. In fact, alliances of volumetric form and color rhythms were relatively rare; more frequently, a divided oeuvre was reinstated—now by medium, with sculpture becoming the bulbous province of volume (fig. 8.2), and painting, the field of rhythmic, coloristic flatness (plate 61). Picasso's 1926 statement, we remember, was ambiguous on whether Cézanne had initiated two means of composition—one, a juxtaposition of forms; the other, a rhythmic arrangement of colors—or a single system that combined both approaches. The answer was one system, as Picasso had to know. His ambiguity aligned him with Cézanne's achievement and disguised a methodological disagreement with the "seeker" Cézanne's laborious modeling of form from repetitive, rhythmic color markings; this obviously tried the "finder" Picasso's patience. And his ambiguity replayed the confusion that Cézanne's art had caused him twenty years earlier.

In 1930, the same year that Picasso painted *Seated Bather*, his "Letter on Art" of four years earlier on Cézanne's influence was published in French for the first time, in *Formes*. It appeared while the poet Louis Aragon was writing an essay titled "La peinture au défi" (The defiance of painting), which sought to sever discussion of Cubist collage from formalism, and while Picasso was working with Christian Zervos on the first volume of the catalogue raisonné of his work, devoted to the years 1895 to 1906, the latter being the very year in which "the influence of Cézanne . . . was everywhere pervading."[38]

In that first volume appears a painting of early 1906, *Boy Leading a Horse* (fig. 8.9), which is commonly understood to represent Picasso's first important engagement with Cézanne. It is the most famous of a group of paintings of shallow figural volumes that read almost as bas-relief decals pasted on the surface, some affording a greater sense of volume to the heads of figures, which, therefore, appear to float forward of their more flatly painted bodies. *Boy Leading a Horse* is among the works that attempt to overcome such awkwardness by using a stepping-forward pose to pry the body, too, off the flat surface.[39] Picasso is frequently said to have borrowed the version of the pose in this painting from Cézanne's *Bather* of about 1885 (plate 64).[40] Be that as it may, two things are certain: Picasso had not yet engaged with Cézanne's shaping of solids into rhythmic sequences across the entire pictorial surface; and his work does not display the lonely introspection without palliative and discomforting harshness of the supposed prototype. In contrast, Picasso's *Seated Bather* of 1930 (fig. 8.10), while distant from Cézanne in style and imagery, reflects long learning of his master's lessons, both pictorial and affective. I propose that Picasso first arrived at this understanding in works like *Bather* of early 1909 (fig. 8.11); therefore, before going any further, we need to turn back to the years from late 1906 into 1909—very selectively, of course—and learn how difficult it was for Picasso not only to get smart to Cézanne's lessons but actually to respond to him at all.[41]

The Discomfiture of Picasso

Boy Leading a Horse is perhaps the final masterpiece of the dreamy "bohemian nostalgia" that infiltrated Picasso's work in the winter of 1904–5,[42] and which produced masterpieces at the expense of a world-weariness that infused the painterly performance. Gertrude Stein spoke of Picasso "needing to completely empty himself of everything he had" before he entered this period, and there is a quality of voided passion as well as worldly isolation in the lethargic beauty that resulted.[43] In the summer of 1906, the dream began to dissipate, and by that autumn Picasso was awakening to the fact that his

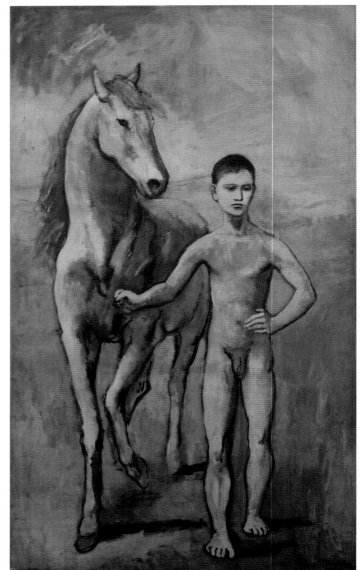

Fig. 8.9

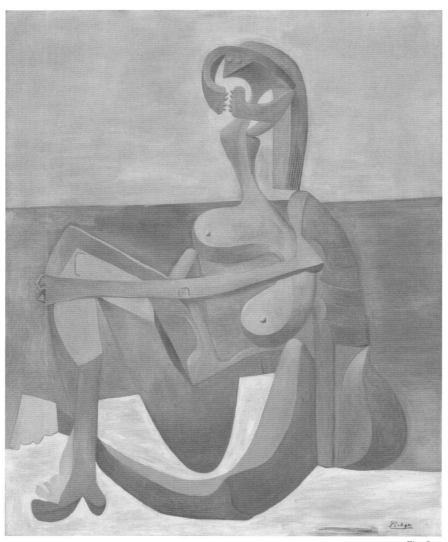

Fig. 8.10

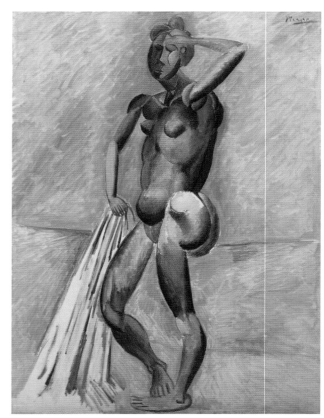

Fig. 8.11

earlier, truculent self and way of acting out his obsessions in paint should not, perhaps, have been jettisoned after all.[44] It was then that he began to discover Cézanne, and the fact that he saw an affective as well as pictorial lesson there is critical to what followed.

In the autumn of 1906, it was not always clear how the affective and pictorial parts fitted together. They fit in *Nude Combing Her Hair* (fig. 8.12): not a posture but now a torqued rhythm made with the body discovers bulk in and space around a figure truly strange enough to have stepped out of a late Cézanne Bathers.[45] More often, though, Picasso appears to have been conflicted between a desire to give way to excess and nostalgia for the retirement comforts of a Golden Age; the brilliant compromise was to maintain an aloofness in his art even as its figuration became increasingly bizarre. Those works of sandstone, pneumatic bulk painted near the end of the year, like *Two Nudes* (fig. 8.13), do come close to the more classical Cézanne of works like the *Five Bathers* of 1885–87 (fig. 8.14), yet Picasso could equally well have intuited these qualities from the work of Maillol, the very exemplar of contemporaneous taste for the *primitif classique*.[46] These works enlarge, both literally and imaginatively, Picasso's earlier engagement with depiction of increasing projective bas-relief in a manner that calls for affinity with Cézanne—yet without fully answering that call. They hesitate on the brink of surrender to the unexpected, still styling the plainspoken truth of the physical and carnal.

Very much on the brink is Picasso's famous *Self-Portrait* (plate 51), which is now habitually compared to Cézanne's own painting of that title from around 1890.[47] If the comparison holds, it is for more affective than pictorial reasons; Picasso pastes his own archaically Iberianized mask of a head onto a roughly troweled, flat body and a background reminiscent of the sort of expressionistic painting he was doing back in 1901.[48] Rather than further enlarging the bulk of his figuration, which had been steadily increasing through 1906, Picasso's self-portrait arrests that development; and far from exhibiting a classical plenitude of form associable with Cézanne, its surface is as unyielding as a cement wall. Yet, returning to his own early work, Picasso recovered just the sort of unidealized, rebellious crudeness—and imminent power—that would allow him to discover his own Cézanne: both in response to the older artist's paintings and to the interpretations of them that had been proliferating in Paris since 1904, when Cézanne's work began to be exhibited annually at the public salons.

So influential were these displays on younger painters that a hard-working critic, Louis Vauxcelles, was prompted to remark that the unjuried Salons des Indépendants, which took place in the spring, in particular those of 1904 and 1905, "could have borne as a banner . . . 'homage to Cézanne'."[49] He was thinking of Matisse and his circle, "a luxuriant generation of young painters, daring to the point of excess, honest draftsmen, powerful colorists . . . disciples of Cézanne."[50] Thus, the first, turn-of-century neoclassicist interpretation of Cézanne was superceded by the colorist interpretation of the soon-to-be Fauves.[51] That was almost how things stood when Picasso began to engage more fully with Cézanne in 1907—almost, because, according to Vauxcelles, the 1907 Salon des Indépendants showed that "the influence of Cézanne is on the wane."[52] Vauxcelles did not recognize that Matisse's *Blue Nude* and Derain's *Bathers*, both exhibited at that Salon, adumbrated a third interpretation of Cézanne.[53] But Picasso did.

Matisse and Derain had shifted their interest, with the aid of a still-tentative primitivism, from Cézanne's landscapes and still lifes to his Bathers, and Picasso followed suit, but much more aggressively. Even before the great Cézanne retrospective at the Salon d'Automne of 1907 offered him a view of the last, largest, and most radical of such compositions,[54] Picasso had intuited how their genre could open onto a personal arena of sexualized transgression. The rawness of some of Matisse's 1907 paintings must

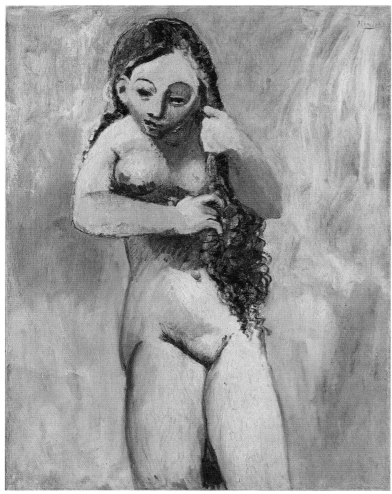

Fig. 8.12

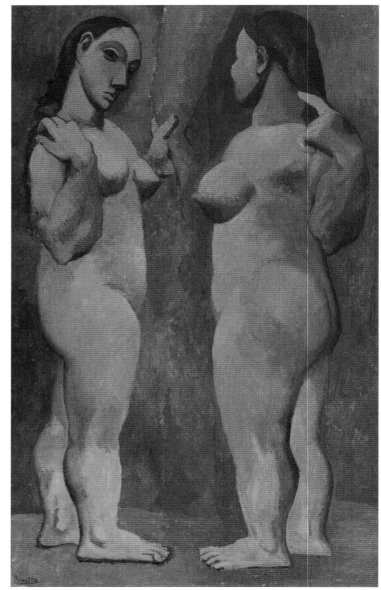

Fig. 8.13

Fig. 8.12. **Pablo Picasso, *Nude Combing Her Hair*,** 1906. Oil on canvas, 41½ x 32 inches (105.4 x 81.3 cm). The Kimbell Art Museum, Fort Worth, Texas

Fig. 8.13. **Pablo Picasso, *Two Nudes,*** 1906. Oil on canvas, 59⅝ x 36⅝ inches (151.3 x 93 cm). The Museum of Modern Art, New York. Gift of G. David Thompson in honor of Alfred H. Barr, Jr.

Fig. 8.14. **Paul Cézanne, *Five Bathers,*** 1885–87. Oil on canvas, 25¹³⁄₁₆ x 25¹³⁄₁₆ inches (65.5 x 65.5 cm). Öffentliche Kunstsammlung Basel, Kunstmuseum Basel

Fig. 8.15. **Pablo Picasso, *Les Demoiselles d'Avignon,*** 1907. Oil on canvas, 96 x 82 inches (243.9 x 233.7 cm). The Museum of Modern Art, New York. Acquired through the Lillie P. Bliss Bequest

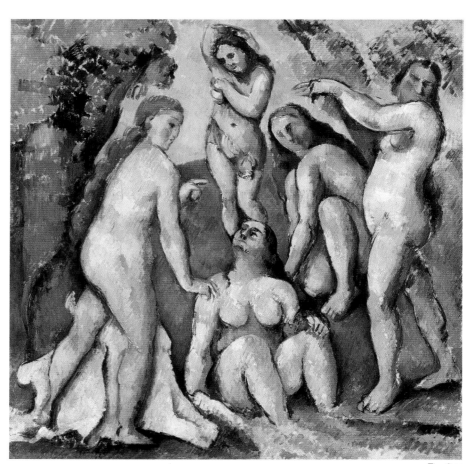

Fig. 8.14

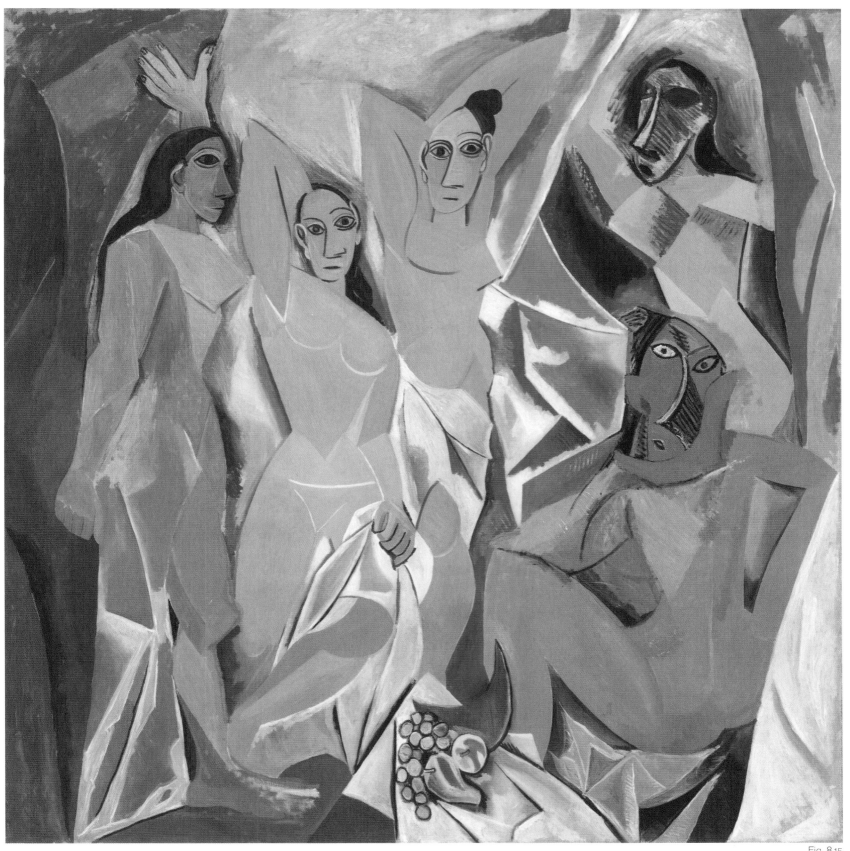

Fig. 8.15

have struck a familiar chord,[55] helping Picasso to see how something even more brute and blunt could be found in Cézanne's figural fantasies. However, what he himself discovered — with *Les Demoiselles d'Avignon* (fig. 8.15) — was, of course, utterly his own, and not only in the range of appetite that it revealed. His graft of memories of a shrill Spanish Mannerism and a newly discovered, fantasized tribalism onto the generic format of a Cézanne Bathers, without worrying about their unification, was an inflammatory mixture. Moreover, while capturing and enlarging the element of the grotesque in Cézanne's figural groupings, he also adapted their tone of melancholy introspection to his confrontational sexual display, infusing the coarse hedonism with a silent, unflinching, seemingly unending disquiet.

Picasso's *Demoiselles*, we may safely say, thus required the example of Cézanne's Bathers without being a particularly Cézannist work. Indeed, one of the few parts of it that explicitly recalls Cézanne is, curiously, the area of Picasso's most brazenly extreme makeover of the faces, in the Africanized figures at the right, which read almost as a parody of Cézanne's parallel hatched brushstrokes, fast becoming the uniform of the growing brigade of Cézannists in the Paris art world. Simultaneously, Picasso holds the influence of Cézanne at the distance of impersonation, and — deconstructing the classic, constructional stroke into resemblances of the marks of facial scarification and the chiseling on tribal masks — makes the contemporaneous works of Braque, Derain, and the other Cézannists seem cautious to the point of timidity. He also excavates the then often unnoticed element of savage linearity in Cézanne (which he drew from Pierre Puget and Eugène Delacroix, among others) as if mocking the failure of the Fauves, with one exception, to have made anything rhythmically energetic out of their revered master. However, the sheer voltage of the linear energy that crackles through this picture crumples solids and spaces alike; to make rhythms from forms seemed to require surrender of the bulk of forms. Or did it? Picasso's *Three Women* (plate 73), mainly or wholly painted in 1908,[56] is the great battleground on which the opposing imperatives were contested — which is also to say, as Leo Steinberg first argued, on which the influence of Cézanne was felt and fought.[57]

The constant element in studies for the *Three Women* is unification of the figures in pinwheel curves; Picasso appeared to have been, according to his dealer Daniel Henry Kahnweiler, "occupied only with the articulation of the color planes."[58] Pepe Karmel, to whom I owe these observations, also reports Kahnweiler's remark that Picasso "perceived the danger of lowering his art to the level of ornament," and, therefore, "resumed his quest" for "the representation of the three-dimensional."[59] (In 1926, Picasso recalled the "opposition of forms and of rhythms of colors" and the danger of ornamentation for three-dimensional representation as among the lessons he had learned from Cézanne.) That is to say, he resumed what he had been doing in the sandstone relief pictures of late 1906, only now (looking over his shoulder at Matisse) seeking to graft such bulky objective forms onto the rhythms of colors. However, what he ended up with was not a rhythm of prismatic colors but a rhythmic arrangement of juxtaposed, masonry-like forms.

A study made just before the composition was transferred to the canvas (fig. 8.16) shows long, more-or-less continuous curves that change signification along their length — connoting arm, then breast, then thigh, then leg, and so on — while remaining pretty much in plane. In other words, neither added shading nor variegated pressure modifies the line, and there are only a few overlappings to connote spatiality and volume. If the line had been thus inflected or if there had been more overlappings, the continuity of the curves would have been compromised — which is precisely what

Fig. 8.16. **Pablo Picasso,** *Three Women,* 1907–8. Charcoal on paper, 24¹³⁄₁₆ x 19⅛ inches (63 x 48.5 cm). Private collection

happened in the finished work after Picasso had implanted volume on the linear framework. As with the *Demoiselles,* he ended up accepting discontinuity—only now discontinuity bred a new, extremely robust order as the compromised curves, fragmented by the huge volumes, took on the function of spatial arabesques. The volumes, this is to say, are not simply and conventionally united by their location but by how they share in—comprise, cluster against, pull from—the life of the large, sweeping gestures that run through the composition, appearing and disappearing with indifference to separation of either spatial position or figure and ground.

Here, Cézanne's great *Five Bathers* (plate 70) probably helped, with its extraordinary compacting of volume against the surface, except that Picasso shunned its effect of bodies (with trees) having been fragmented or truncated and then reassembled to comprise new, composite figures. He sustained an interactivity of forms over the entire canvas, reminiscent as much of Cézanne's dissolution of objects in the optical field as his emphasis on the sculptural—except that the big shapes in Picasso's composition seem able to dissolve only momentarily before reforming with immense, arresting weight as somnolent figural gestures. Kathryn Tuma must be correct in viewing the big bent arms with peaked elbows, which previously appeared in the *Demoiselles,* as deriving from the *écorché* that Cézanne painted, connotative of anguish or despair.[60] If so, the *Demoiselles* may be thought troubling because it faces us with discomfort, and the *Three Women* discomforting because the painting, not merely its dreamers, is asleep to us, in troubled and troubling petrifaction.

The strongly Cézanne-influenced landscapes that Braque made in L'Estaque in the summer of 1908, which prompted the term "Cubism," also have an air of somnolence to them. Whether Picasso required knowledge of these works to complete his *Three Women* remains a subject of debate.[61] Probably so. One thing is certain: His completion

of this painting was only the end of the beginning of his struggle to make sense of Cézanne. While working on it, Picasso re-sculpted its weighty figural blocks into the rocks, trees, and Cézannian red-ocher earth of imagined landscapes—one of them specifically on the subject of somnolence—that look quarried and carved (plate 52). Remembering the rougher, most Expressionist of Cézanne's, and conceivably Braque's, L'Estaque landscapes, they describe a terrain wrenched and contorted, as if Picasso was dreaming of violence done to places that others had tended. Although he was clearly not afraid of the destructive act, the year 1909 saw him thrashing around for direction; looking enviously about him at the dissolving forms in Braque's paintings and the rhythms of colors in Matisse's; and turning to the Douanier Rousseau, even, to find another way to the opposition of forms that was for him Cézanne's main lesson. And, all the while, he was painting extraordinary pictures, not the least (though not the greatest, either) of which are the parody paintings referred to at the beginning of this essay. As Tuma and Jeffrey Weiss have shown,[62] the summer at Horta was the period of Picasso's greatest crisis. Renouncing a Cézanne mediated by Braque or Matisse, or even by his own paraphrased impersonations, Picasso began to allow forms to fracture and separate, the better to form rhythms "independent of the actual representation of objects," all the while trying to keep in control close-valued modeling, density, and volume, the better to "represent the facts as we know them rather than [or, as well] as we see them."[63]

Yet, early in 1909, even before going through the indubitable pain that summer would bring, Picasso had painted what may well be his most perfected, sublimely pessimistic picture before *Girl with a Mandolin* (fig. 8.8), its successor a year later. His *Bather* of early 1909 (fig. 8.11) battles with Braque, Matisse, and especially Cézanne as it unwraps and pulls into view both sides of a carapace body to shape an impossibly serpentine anatomy on a beach. And, to add to the strangeness, there is a distant memory of Lucas Cranach's glossy, erotic nudes in this picture of mourning and of renewal: Although detailed, nothing in it is trivial or superfluous; while grotesque and stark, everything is in harmony and forms a plenitude. Picasso remembered it twenty-one years later when, pondering Cézanne, he painted his even more pessimistic, insectival, and weirdly decorative *Seated Bather* (fig. 8.10).

The Anxiety of Cézanne

As noted earlier, when Picasso made this *Seated Bather* in 1930, he had begun to work with Zervos on the first volume of the catalogue raisonné of his work, devoted to the years 1895–1906, and was in a retrospective mood. This mood would have been deepened the following year when, responding to a major Matisse exhibition at the Galeries Georges Petit in Paris, he engaged to have such an exhibition himself at the same venue and then, in a revised version, at the Kunsthaus, Zurich.[64] The 1932 exhibition was his first full-scale retrospective, and he selected and hung it himself. That same year, the first volume of Zervos's catalogue raisonné was published.

A catalogue raisonné for a living artist—let alone for a fifty-year-old, as Picasso was then—was virtually unprecedented. By comparison, Lionello Venturi's first catalogue of Cézanne's oeuvre would not appear until four years later, in 1936, the thirtieth anniversary of the artist's death. Thinking of these two publications, it is simply impossible to imagine Cézanne collaborating in the processes of sorting and ordering in which Picasso engaged himself, which meant not only reviewing and sequencing his existing oeuvre but also committing these works to the uniformity of page after page of

sequentially numbered images of a similar size laid out in a uniform grid, without captions or dimensions.[65] The implications of mechanization and commodification, not to mention the context of visibility and exposure, would have been anathema to the intensely private Cézanne in a way that they seem not to have been to Picasso.

However, Picasso must have been tiring of the relentlessly chronological understanding of his art prompted by the catalogue raisonné, for he installed his 1932 retrospective in an utterly bizarre manner that was indifferent not only to temporal sequence but also to likenesses of subject or style. As he said to an interviewer at the time: "Someone asked me how I was going to hang my exhibition. 'Badly,' I told him." It did not matter, any more with an exhibition than with a picture, whether it was "well or badly 'arranged.' . . . What counts is the consistency in [an artist's] ideas."[66]

"Everything depends on oneself—on the fire in one's belly," he insisted. "The rest does not matter." Matisse, for example, was to be admired because his force of individual passion triumphed over canons of taste.[67] Picasso's sensitivity on this subject had been tested by an old friend, a society painter named Jacques-Émile Blanche, who had responded to the generous gesture of a private, guided tour of the exhibition by publishing a truly spiteful review: "Taste, taste, always taste," it read. "Manual dexterity, Paganini-like virtuosity. . . . He can do anything . . . succeeds at all he undertakes."[68] Especially coming from someone who, on the one hand, had visited Cézanne and, on the other, was notorious for having his palette and brushes served up on a silver salver by his valet each morning,[69] this was guaranteed to make its subject furious. However, another review, by André Lhote, had gone in the opposite direction, saying that Picasso's art reflected the "disquiet" of the age,[70] and this direction was carried to an extreme in responses to the exhibition when it appeared in Zurich.

There, the critic Gotthard Jedlicka stated that "the work of Picasso [was] the game of a demon."[71] Even more excessive was an unprecedented review by the Swiss psychoanalyst Carl Gustav Jung, which spoke of Picasso as a schizophrenic, and of his art as characterized both by "intellectual laceration . . . that is to say, psychic clefts or rents that transverse the image," and attempts to oppose disintegration, revealing his "unconscious mind's tendency to overcome the conflict of the emotions by force."[72] The jittery Zervos panicked at the attack and reprinted the greater part of Jung's article in his *Cahiers d'art*, but in small type, preceded by two pages of piqued rebuttal in very large type.[73] Picasso, however, appears not to have been bothered by Jung's article, and seemed even to be approving of it—though he was definitely disapproving of Blanche's —when he spoke to Zervos three years later about Cézanne as an anxious, tormented genius, like himself:

> I want nothing but emotion to be given off by [a painting]. . . . A painter paints to unload himself of feelings and visions. . . . Art is not the application of a canon of beauty but what the instinct and the brain can conceive beyond any canon. . . . It's not what the artist does that counts, but what he is. Cézanne would never have interested me a bit if he had lived and thought like Jacques-Émile Blanche, even if the apple he painted had been ten times as beautiful. What forces our attention is Cézanne's anxiety—that's Cézanne's lesson; the torments of van Gogh—that is the actual drama of the man. The rest is a sham.[74]

It has become commonplace to suggest that, when Picasso spoke of Cézanne's anxiety, he was thinking of the French painter's well-known concern about his difficulty in "realization," in finding exact painterly equivalents for his visual sensations, and therefore in bringing his paintings to completion. However, we need to distinguish

anxiety as a trait of character, as a consequence of a particular artistic practice, and as a manifestation in the products of that practice. It is in the last aspect that William Rubin, for example, spoke of how "Picasso became attached to precisely that 'flaw' in Cézanne's classicism which makes his art truly modern, namely his malaise—the tremor we detect behind even the most outwardly calm and apparently stable of Cézanne's compositions."[75] There is, indeed, a perceptual tremor that takes place upon especially extended viewing of many of Cézanne's paintings; the unusually large size of the patches of color that compose each discrete object creates instability in the eye's identification of the form, and hence the identity, of the object. But this was a carefully contrived effect, not a malaise, on which subject Willem de Kooning was typically astute when he said, "If one takes the idea of trembling . . . all of a sudden most art starts to tremble. . . . Cézanne was always trembling but very precisely."[76]

The record is fairly clear that Cézanne's doubt, as Maurice Merleau-Ponty famously described it,[77] was intrinsic to his practice, and that the difficulty of realization was a source of great anxiety to him, especially in his later years. But this is not the same as saying, as Picasso does, that anxiety was an overwhelming trait of Cézanne's character, even that it was a factor of immense importance to the creation of his art—an all-too-popular view of artistic motivation.[78] Still, he paints Cézanne, as Roland Penrose once portrayed Picasso, as having "always been assailed by the demons of perpetual doubt."[79]

This unassailable because unverifiable statement, hyperbolic though it must be as a lifetime status report, nonetheless does seem to fit the truly miserable position in which Picasso found himself in 1935. That year, he separated with the deepest acrimony from his wife, Olga Koklova; his mistress, Marie-Thérèse Walter, gave birth to a daughter; and there was talk of a divorce, abandoned only owing to the punitive financial consequences for the artist.[80] Picasso later called this "the worst time of my life," and he stopped painting for a year.[81]

The question is not whether Picasso's characterization of himself—and, by extension, of Cézanne—as a tormented outsider to conventional norms was shaped by this massively conflicted period of private and public disturbance. It had to be. The question, more precisely, is how true this characterization is to both artists. Did they, in fact, rate the artist's private emotions and uncertainties over conventional canons of beauty—indeed, over the display of painterly processes? Did they view the art of painting as an instrument to unburden the artist of his feelings and visions, the products of his imagination? And did they believe that it is not what the artist does that counts, but what he is? The answer, surely, is that while Cézanne, as Rainer Maria Rilke remarked, decidedly did not paint "Look at me," but rather, "Here it is,"[82] nonetheless, Picasso's excitable outburst is not so far off the mark, both for himself and for the Cézanne beneath the classicized face. In respects of background, lifestyle, and artistic practice, there could hardly be a greater contrast than between these two artists. Indeed, Braque, rather than the worldly, self-publicizing Picasso, is the true successor to Cézanne for his humbleness and reclusiveness; both believed that the artist, as an individual, must, as Cézanne put it, "remain obscure." As Cézanne added, "I thought that one could do good painting without attracting attention to one's private life."[83] And Braque, rather than Picasso—the "searcher," rather than the "finder"—inherited Cézanne's commitment to painting as a record of perceptual difficulty if not, indeed, of representational failure. All this said, however, both Cézanne and Picasso were conscious of their own importance, given to impatience and anger, disdainful of the consequences of their actions, and opportunistic in their borrowing in a way that, while admiring of those from whom they borrowed, set them outside the sequences of history as free individu-

als. And, while Cézanne's emotive core became far more deeply buried than Picasso's, this is neither to say that it burned any cooler nor that its passion, and corollary pessimism, was invisible to someone as observant as Picasso.

Indeed, the Cézanne that Picasso invoked in 1935 when he said, "A painter paints to unload himself of feelings and visions," sounds more like the fervent and troubled early Cézanne than the classic artist so favored by the formalists of early modernism. Cézanne's early works had been hardly unknown; Vollard's 1914 book on the artist reproduced a lot of them. However, it was in the 1930s, as the classicism of the previous decade faded, that this other Cézanne began to be rediscovered, unquestionably owing to the climate of Surrealism, and would become much better known in the second half of that decade.[84] It remains to be seen whether Picasso was aware of this growing trend (for example, whether he knew of Georges Rivière's *Cézanne, le peintre solitaire*, published in 1933)[85] or had intuited the early, impassioned painter through, perhaps, Cézanne's late work. Picasso's affiliation with Surrealism may have made him too prone at times to the charms of disenchantment, but it did energize him to the ominous and reopen him to the discomforting.[86] One thing is clear: His 1935 understanding of Cézanne must be reciprocal with not only his public and personal life but also the paintings and sculptures that he had been making over the last half-dozen years, works such as *Woman with a Vase* of 1933 (fig. 8.2), fully as passionate and pessimistic together as anything either early or late by Cézanne.[87] Moreover, acknowledgment of these qualities in Cézanne's and in Picasso's art was exactly contemporaneous. A striking demonstration of this, of which Picasso had to have been aware, may be found in two essays that the critic Waldemar George contributed to the April 1930 issue of *Formes*. In "The Passion of Picasso," a response to the painter's "Letter on Art" in the February issue, George insisted that Picasso was rarely a formalist, but more often "stanches our thirst for disquiet."[88] In "Cézanne 1930," illustrated by an early painting of around 1875,[89] he argued that the Cubists had misunderstood Cézanne by formalizing him and, thereby, had missed "the disquiet of Cézanne," an artist who was "prey to delirium, a 'constructive' delirium, that shows the traces of his holy madness."[90]

William Wordsworth famously wrote that although "all good poetry is the spontaneous overflow of powerful feelings: it takes its origin from emotion recollected in tranquility."[91] When Picasso remembered and spoke of Cézanne in 1935 it was in a mood not of tranquility but of anguish and insecurity that made him quick to find pure spontaneous overflow of emotion in his master's work. However, when Picasso remembered Cézanne in his art, it was a different matter. Yes, both artists worked to unburden themselves of their feelings, and judged the correctness of what they made not by any external aesthetic criteria but solely from the reactions that a canvas in process produced in them. But this closed-circuit method of working, far from being a mere outpouring of emotion, is a testing of it. Matisse, who also learned this method from Cézanne, once spoke of it as working by instinct, saying: "To give yourself completely to what you're doing while simultaneously watching yourself do it—that's the hardest of all for those who do work by instinct."[92]

Work by instinct, until recently a commonplace, was perhaps Cézanne's greatest bequest to modern art. Since Romanticism, others had worked in this way, but none so willfully, so apparently without self-consciousness, and yet with the succession of reactions to instinctual creation showing patently in, indeed, actually comprising, the picture.[93] Moreover, shaping the drive of raw emotion into a pictorial practice, Cézanne recovered for painting—as Picasso intuited—its capacity to produce a shudder of anxiety and a quiver of pleasure that can feel just the same.

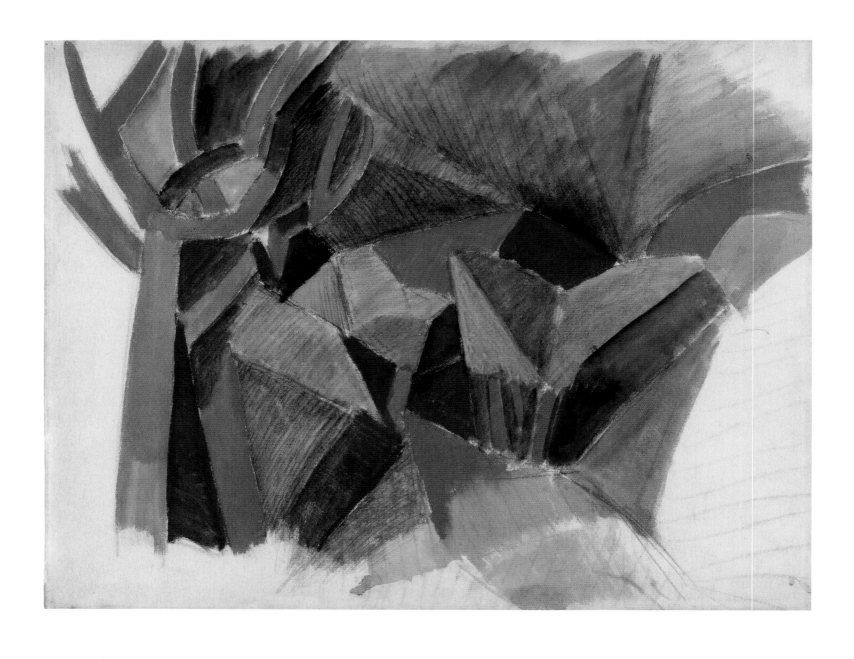

PLATE 52

Pablo Picasso

Landscape, 1907

Gouache over charcoal on thick beige paper
18¾ x 24¼ inches (47.6 x 56.5 cm)
Collection of Kate Ganz

Paul Cézanne, *Millstone in
the Park of the Château Noir*,
1898–1900 (plate 19, p. 132)

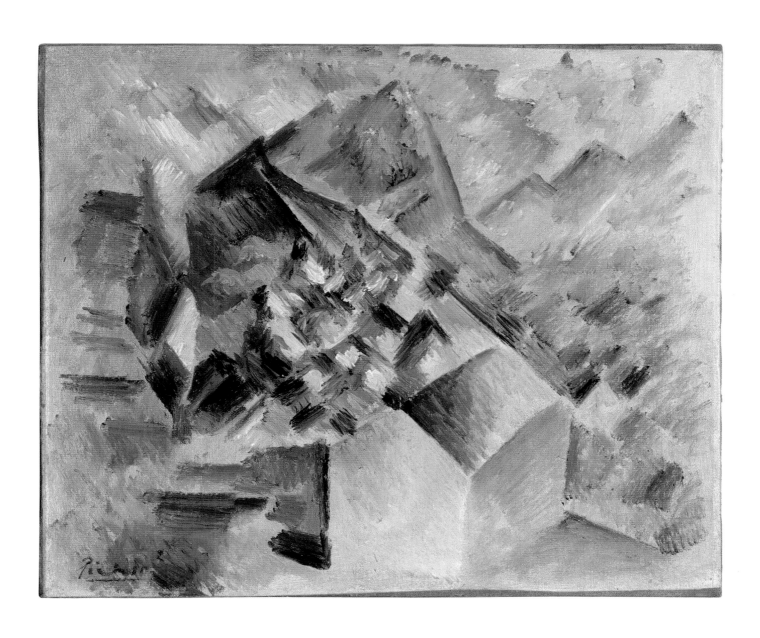

PLATE 53

Pablo Picasso

Santa Bárbara Mountain, 1909

Oil on canvas
15⅜ x 18⅝ inches (39.1 x 47.3 cm)
Private collection

PLATE 54

Paul Cézanne

***Quartier Four, Auvers-sur-Oise
(Landscape, Auvers)*, c. 1873**

Oil on canvas
18¼ x 21¾ inches (46.4 x 55.2 cm)
Philadelphia Museum of Art. The Samuel S. White 3rd
and Vera White Collection, 1967-30-16

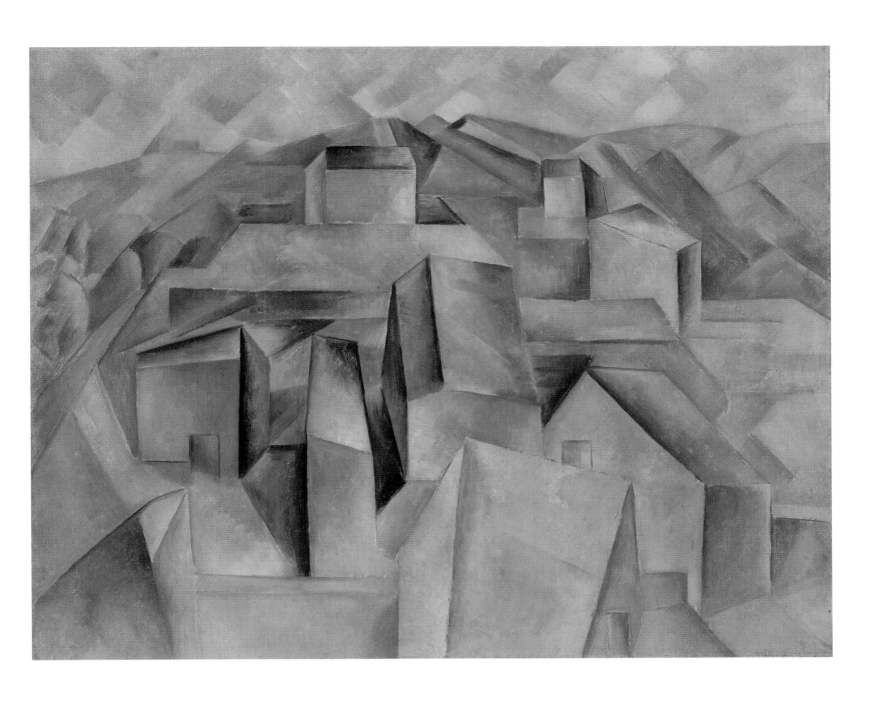

PLATE 55

Pablo Picasso

Houses on the Hill, Horta de Ebro,
1909

Oil on canvas
25⅝ x 31⅞ in. (65 x 81 cm.)
Heinz Berggruen Collection, Berlin

PLATE 56

Paul Cézanne

Gardanne, 1885–86

Oil on canvas
36¼ x 29⁹⁄₁₆ inches (92.1 x 74.5 cm)
The Brooklyn Museum. Ella C. Woodward and A. T.
White Memorial Funds

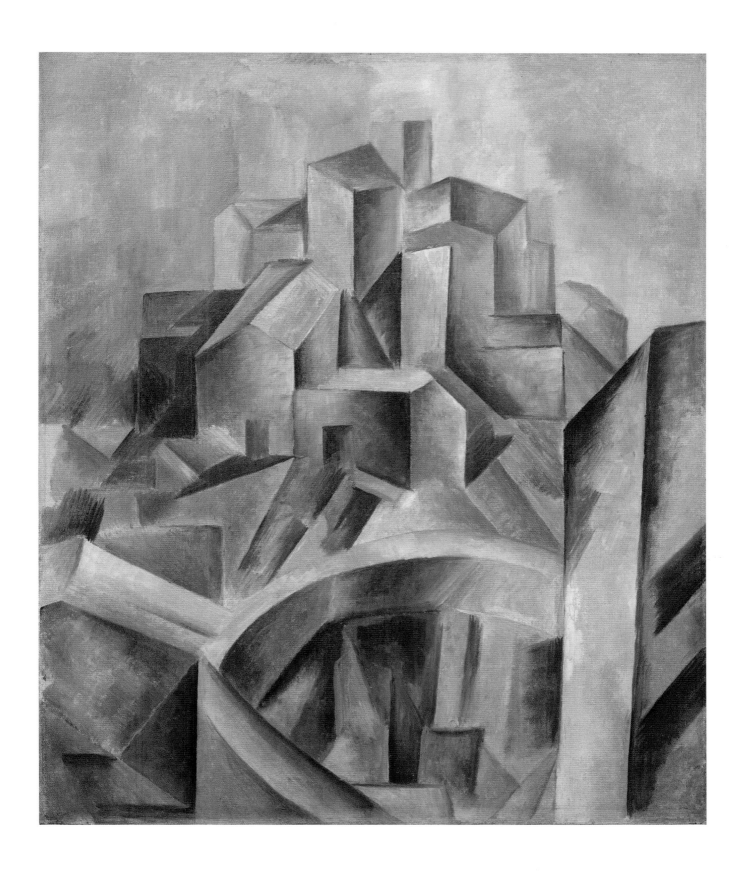

PLATE 57

Pablo Picasso

The Reservoir, Horta de Ebro, 1909

Oil on canvas
23⅝ x 19⅝ inches (60 x 49.8 cm)
The Museum of Modern Art, New York. Fractional
and promised gift of Mr. and Mrs. David Rockefeller

Paul Cézanne

*The Fishermen's Village at
L'Estaque*, c. 1870

Oil on canvas
16½ x 21¾ inches (41.9 x 55.2 cm)
Private collection

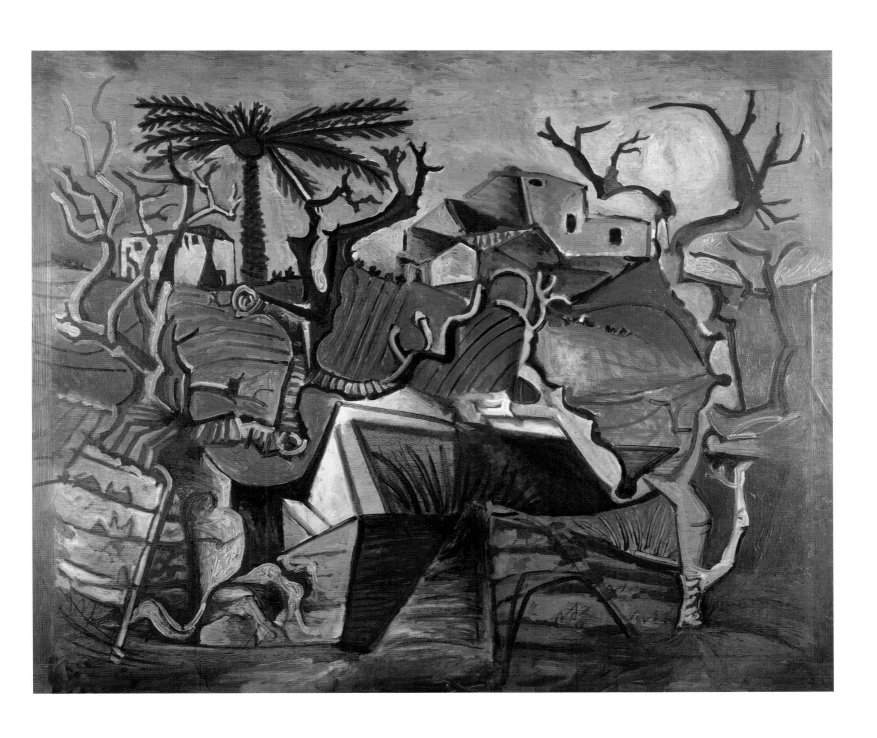

PLATE 59

Pablo Picasso

Winter Landscape, 1950

Oil on panel
40½ x 49½ inches (102.9 x 125.7 cm)
Collection of Kate Ganz

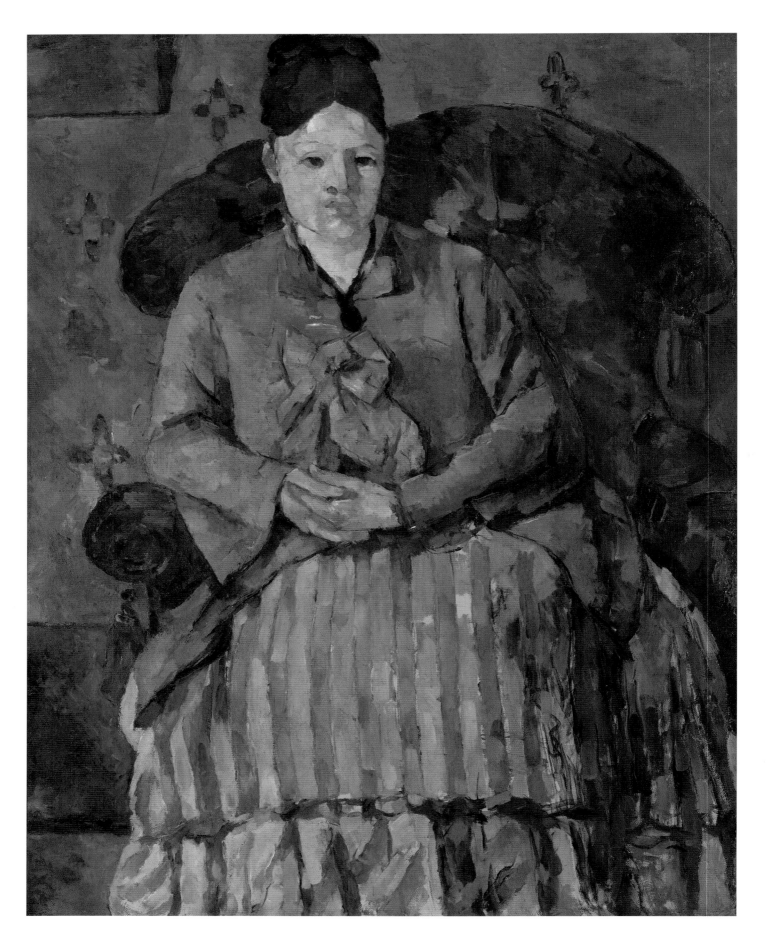

PLATE 60

Paul Cézanne

Madame Cézanne in a Red Armchair, c. 1877

Oil on canvas
28½ x 22 inches (72.4 x 55.9 cm)
Museum of Fine Arts, Boston. Bequest of Robert Treat
Paine, 2nd, 44.776

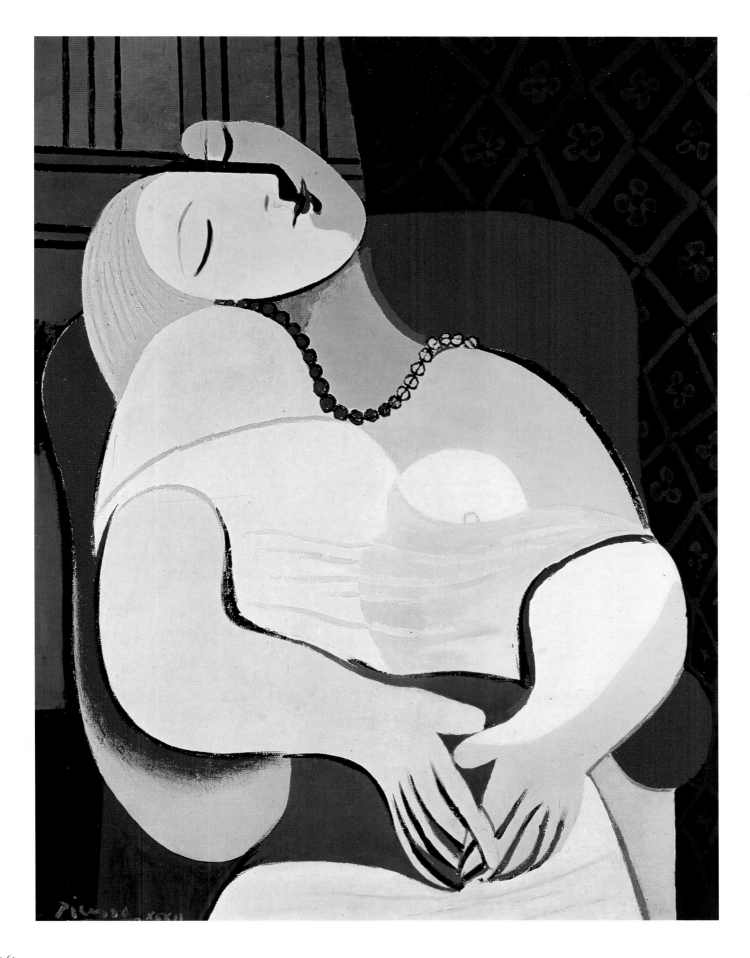

PLATE 61

Pablo Picasso

The Dream (Marie-Thérèse), 1932

Oil on canvas
51¼ x 38⅛ inches (130.2 x 96.8 cm)
From the Collection of Steve and Elaine Wynn

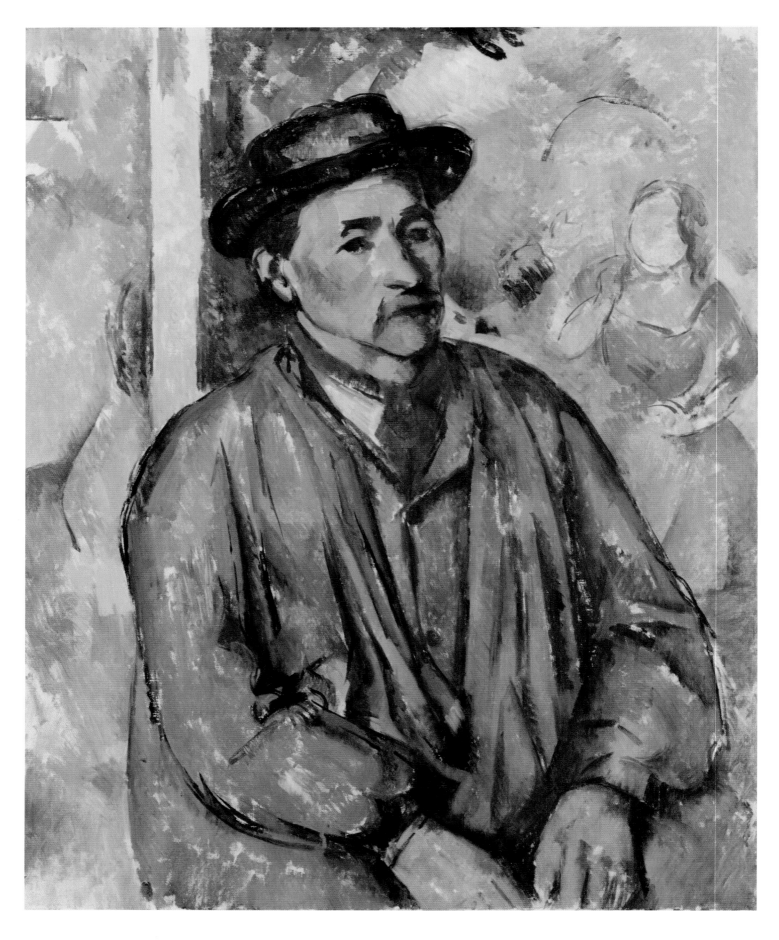

PLATE 62

Paul Cézanne

Man in a Blue Smock, 1892 or
1897

Oil on canvas
31⅞ x 25⅜ inches (81 x 65 cm)
Kimbell Art Museum, Fort Worth, Texas

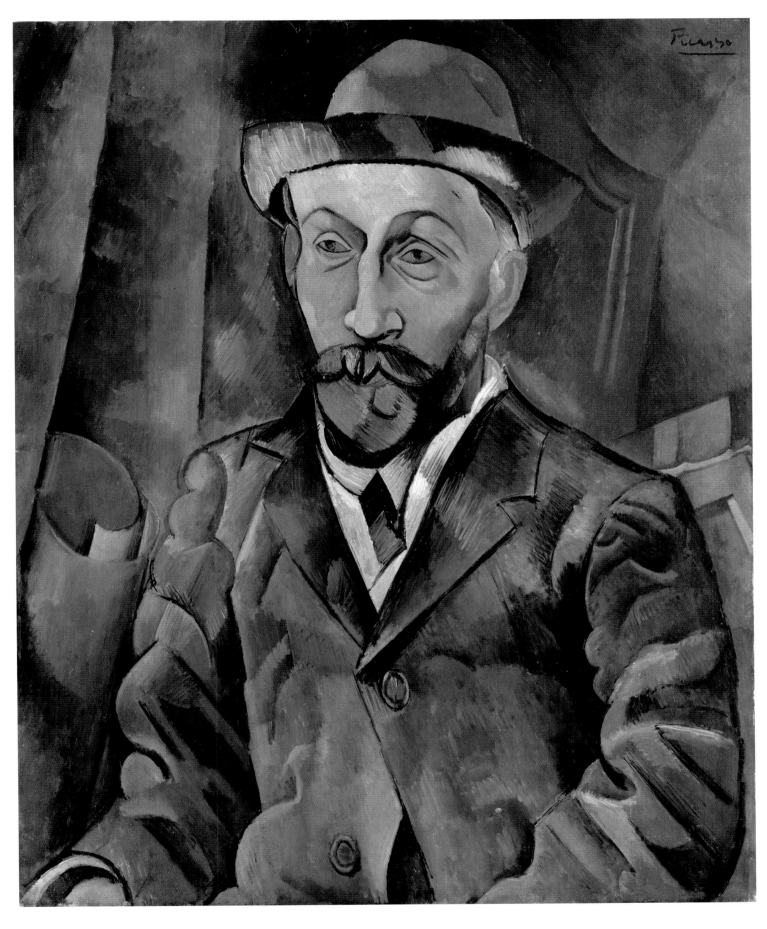

PLATE 63

Pablo Picasso

Portrait of Clovis Sagot, 1909

Oil on canvas
32¼ x 26 inches (81.9 x 66 cm)
Kunsthalle Hamburg

Paul Cézanne, *The Smoker*,
c. 1890–92 (plate 155, p. 447)

PLATE 64

Paul Cézanne

The Bather, c. 1885

Oil on canvas
50 x 38⅛ inches (127 x 96.8 cm)
The Museum of Modern Art, New York. Lillie P. Bliss
Collection, 1934 (1.1934)

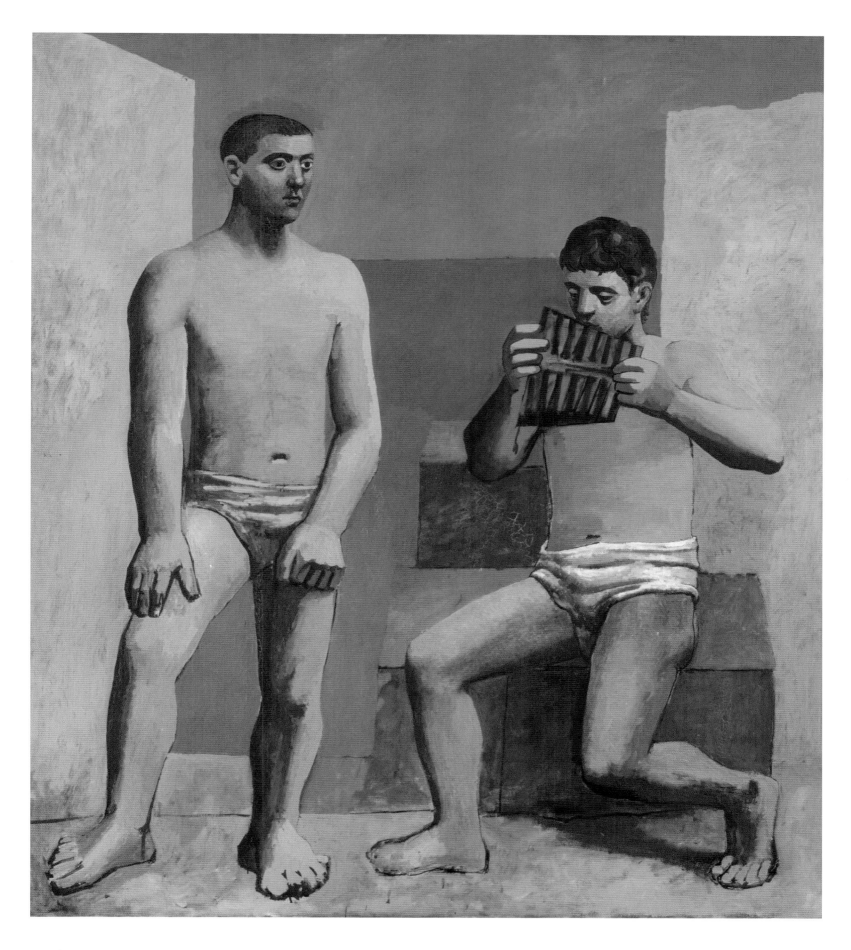

PLATE 65

Pablo Picasso

The Pipes of Pan, 1923

Oil on canvas
80¾ x 68¾ inches (205.1 x 174.6 cm)
Musée Picasso, Paris

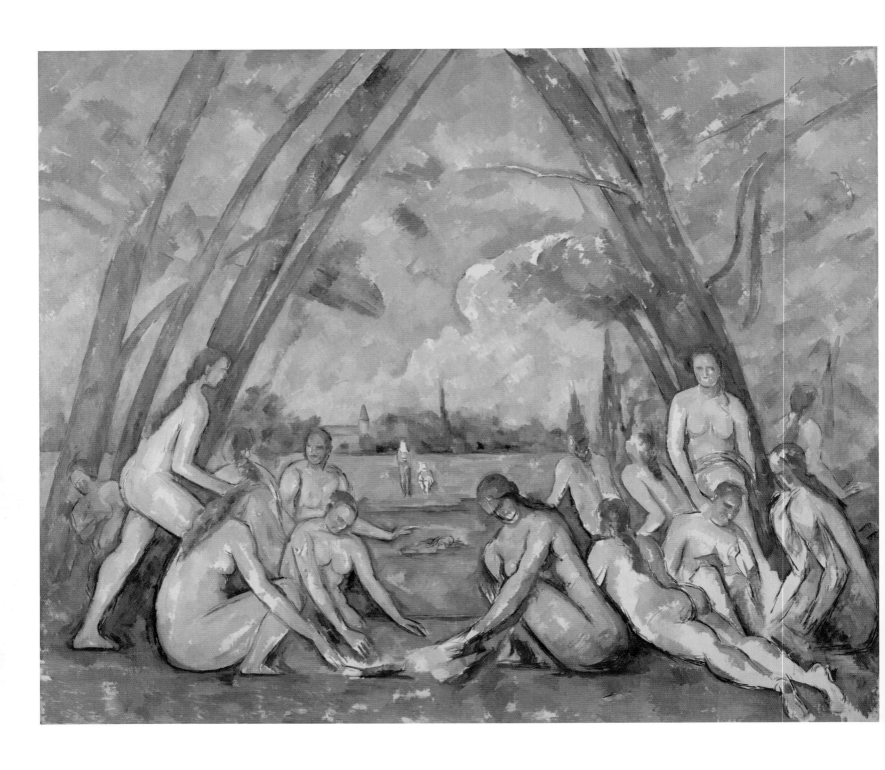

PLATE 66

Paul Cézanne

The Large Bathers, 1906

Oil on canvas
82⅞ x 98¾ inches (210.5 x 250.8 cm)
Philadelphia Museum of Art. Purchased with the W. P.
Wilstach Fund, W1937-1-1

PLATE 67

Pablo Picasso

The Bathers, 1956

Bronze
Height (largest figure) 103 inches (261.6 cm)
Kykuit, National Trust for Historic Preservation,
Nelson A. Rockefeller bequest

PLATE 68

Pablo Picasso

Seated Female Nude, 1908–9

Oil on canvas
45⅞ x 35³⁄₁₆ inches (116.5 x 89.4 cm)
Philadelphia Museum of Art. The Louise and Walter
Arensberg Collection, 1950-134-164

PLATE 69

Pablo Picasso

Nudes in a Forest, 1908

Watercolor, gouache, and graphite on wove paper
18¾ x 23¼ inches (47.6 x 59.1 cm)
Philadelphia Museum of Art. The Samuel S. White 3rd
and Vera White Collection, 1967-30-68

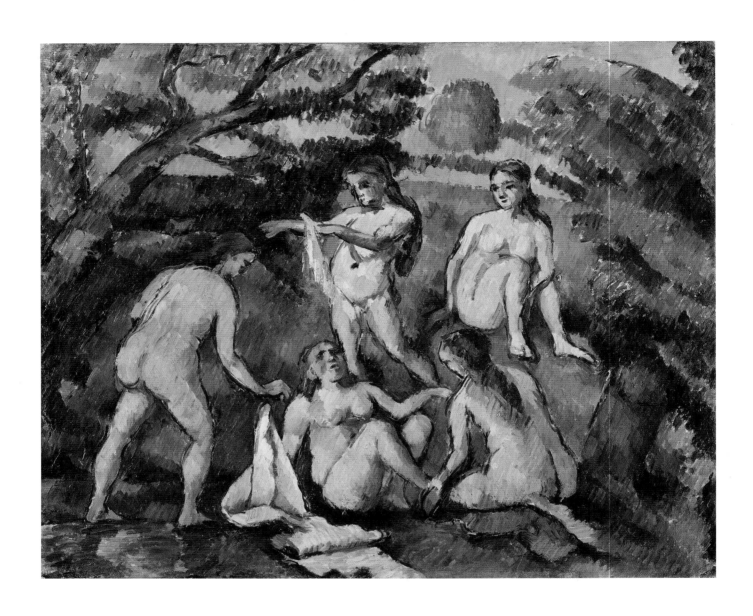

Paul Cézanne

Five Bathers, 1877–78

Oil on canvas
18¹⁄₁₆ x 21¹⁵⁄₁₆ inches (45.9 x 55.8 cm)
Musée Picasso, Paris

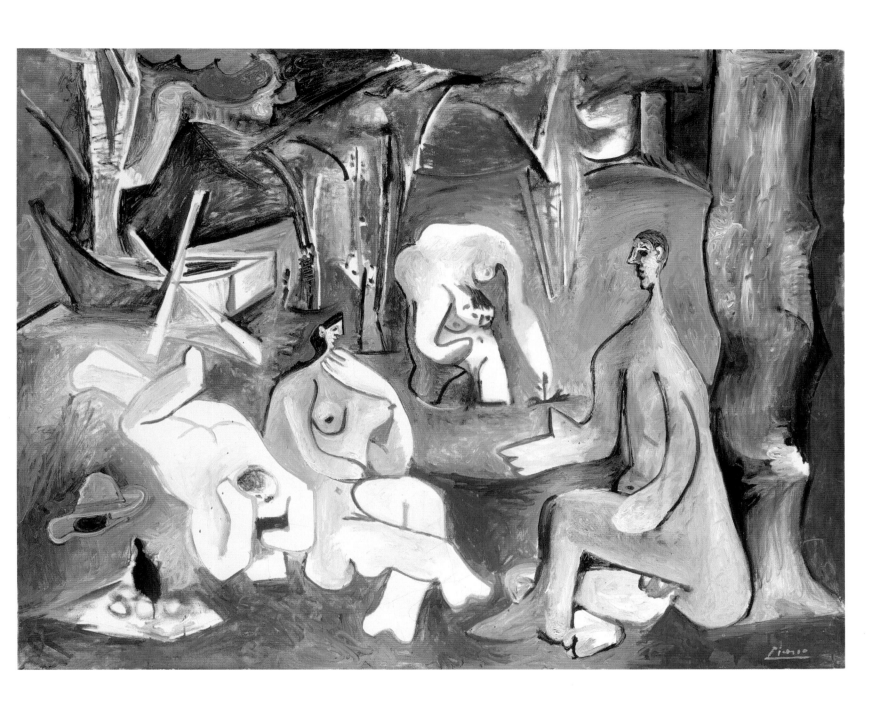

PLATE 71

Pablo Picasso

Luncheon on the Grass, 1961

Oil on canvas
45 x 57½ inches (114.3 x 146.1 cm)
Staatsgalerie Stuttgart

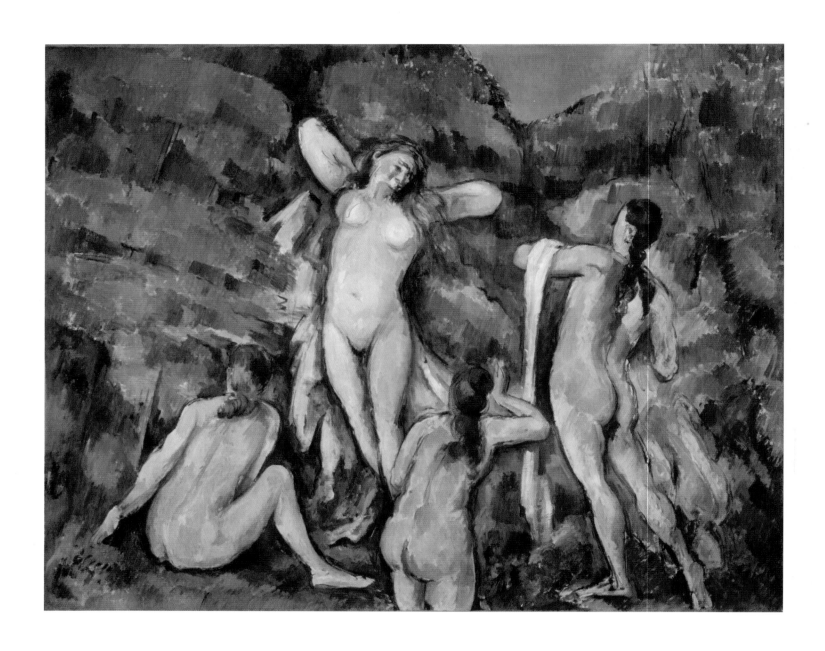

PLATE 72

Paul Cézanne

Four Bathers, 1888–90

Oil on canvas
28¾ x 36¼ inches (73 x 92.1 cm)
Ny Carlsberg Glyptotek, Copenhagen

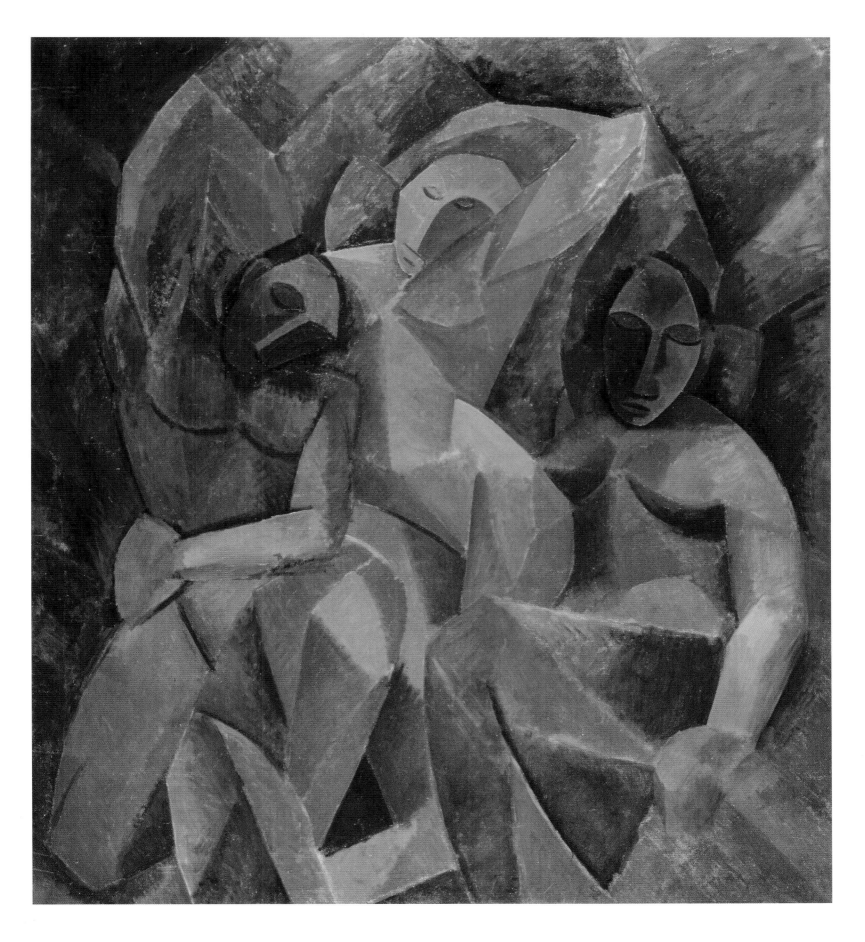

PLATE 73

Pablo Picasso

Three Women, 1908–9

Oil on canvas
78¾ x 70⅛ inches (200 x 177.8 cm)
State Hermitage Museum, St. Petersburg

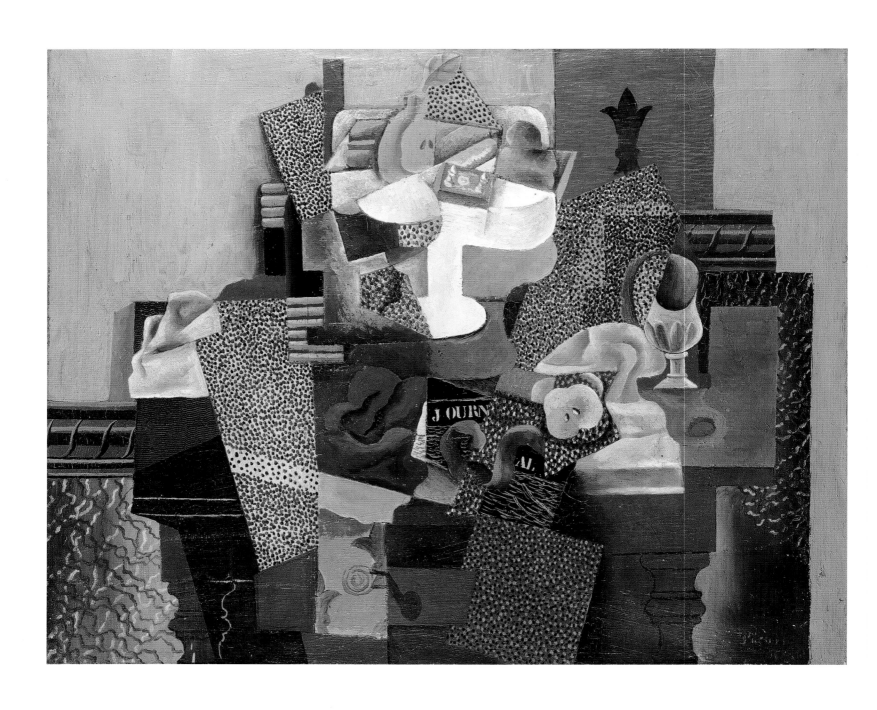

PLATE 74

Pablo Picasso

Still Life with Compote and Glass,
1914–15

Oil on canvas
25¼ x 31½ inches (64.1 x 80 cm)
Columbus Museum of Art, Ohio. Gift of Ferdinand
Howald

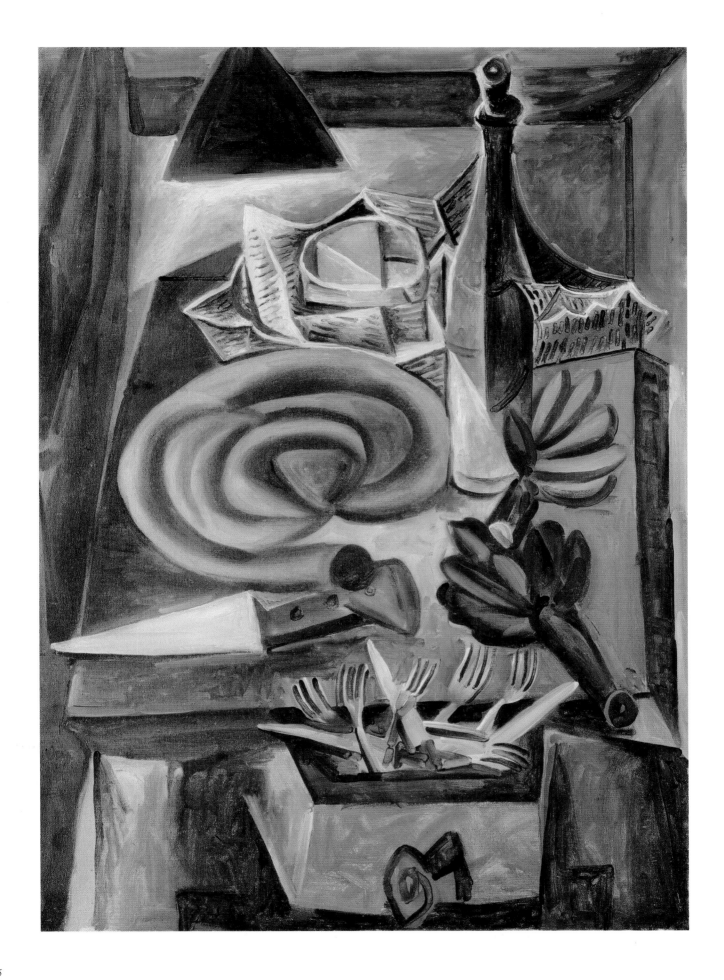

PLATE 75

Pablo Picasso

Still Life with Sausage, 1941

Oil on canvas
36½ x 25⅞ inches (92.7 x 65.7 cm)
Collection of Gail and Tony Ganz, Los Angeles

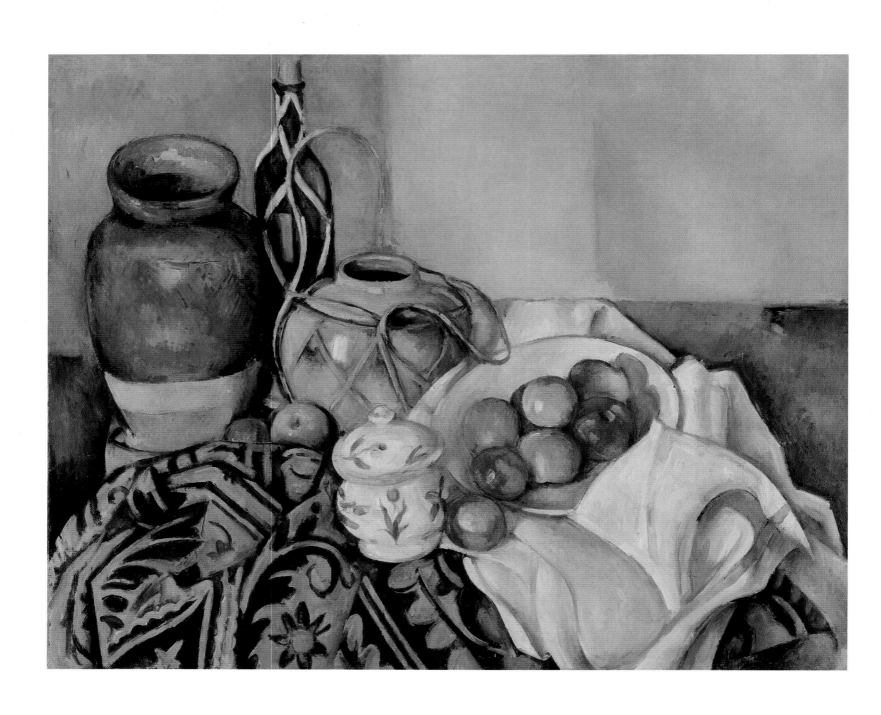

PLATE 76

Paul Cézanne

Still Life with Apples, 1893–94

Oil on canvas
25¾ x 32⅛ inches (65.5 x 81.5 cm)
J. Paul Getty Museum, Los Angeles

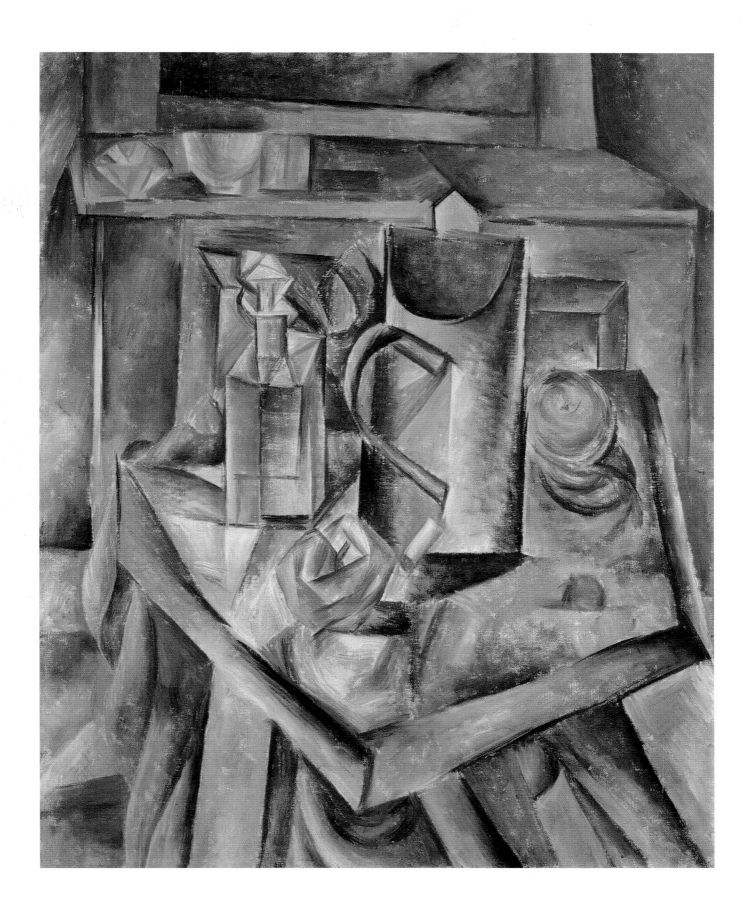

PLATE 77

Pablo Picasso

The Glass of Beer, 1909

Oil on canvas
31⅞ x 25¾ inches (81 x 65.5 cm)
Musée d'Art Moderne de Lille, Villeneuve d'Ascq.
Gift of Jean and Geneviève Masurel, inv. no. 979.4.111

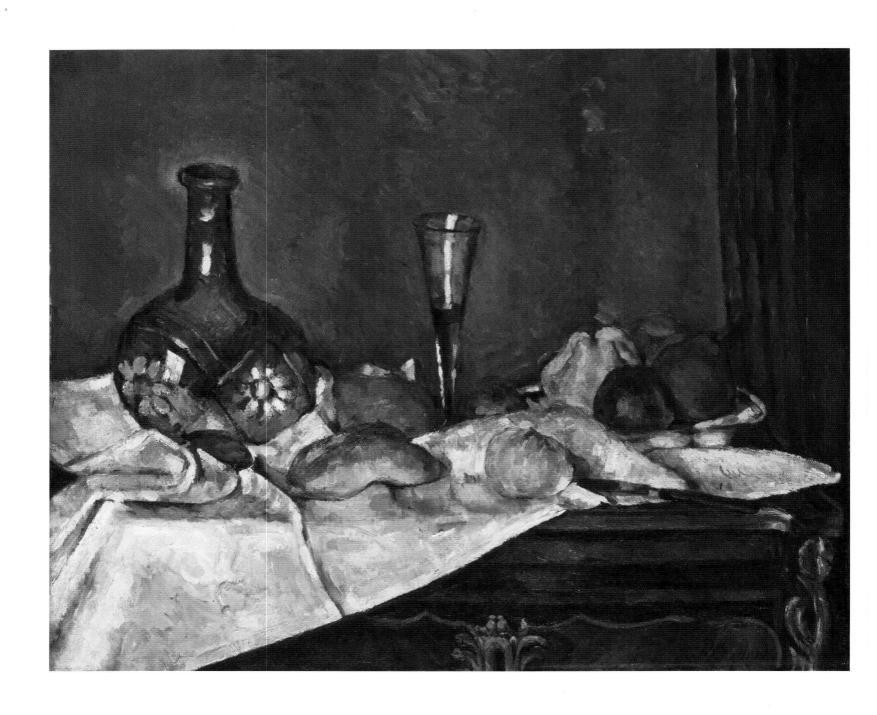

PLATE 78

Paul Cézanne

Still Life with a Dessert, 1877 or 1879

Oil on canvas
23¼ x 28¹¹⁄₁₆ inches (59.1 x 72.9 cm)
Philadelphia Museum of Art. The Mr. and Mrs.
Carroll S. Tyson, Jr., Collection, 1963-116-5

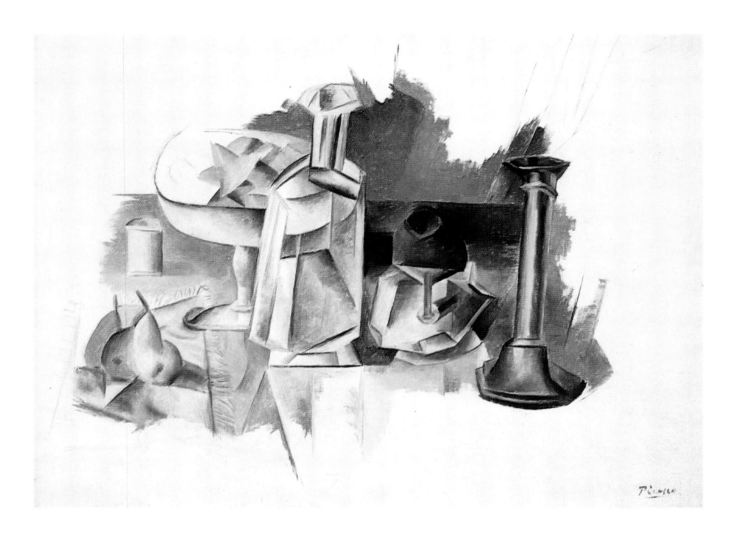

PLATE 79

Pablo Picasso

Carafe, Compote, and Candlestick, 1909

Oil on canvas
21½ x 29⁹⁄₁₆ inches (54.5 x 75 cm)
Private collection

PLATE 80

Pablo Picasso

Fruit, Walnut, and Glass, 1909

Watercolor on paper
9⅜ x 12⅜ inches (24 x 31.5 cm)
Private collection

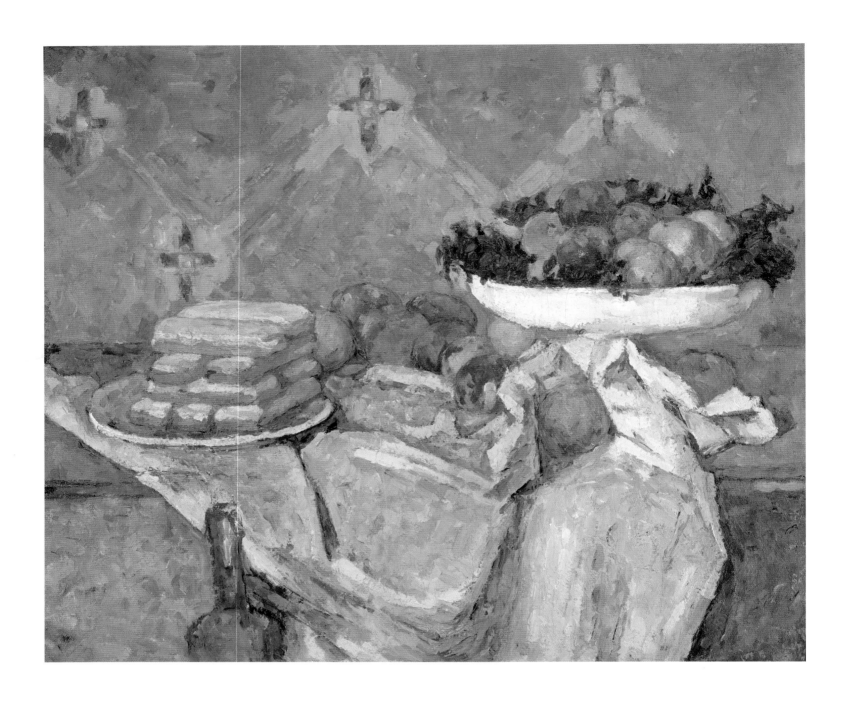

PLATE 81

Paul Cézanne

Compotier and Plate of Biscuits,
c. 1877

Oil on canvas
20¾ x 24⅜ inches (52.7 x 61.9 cm)
Private collection

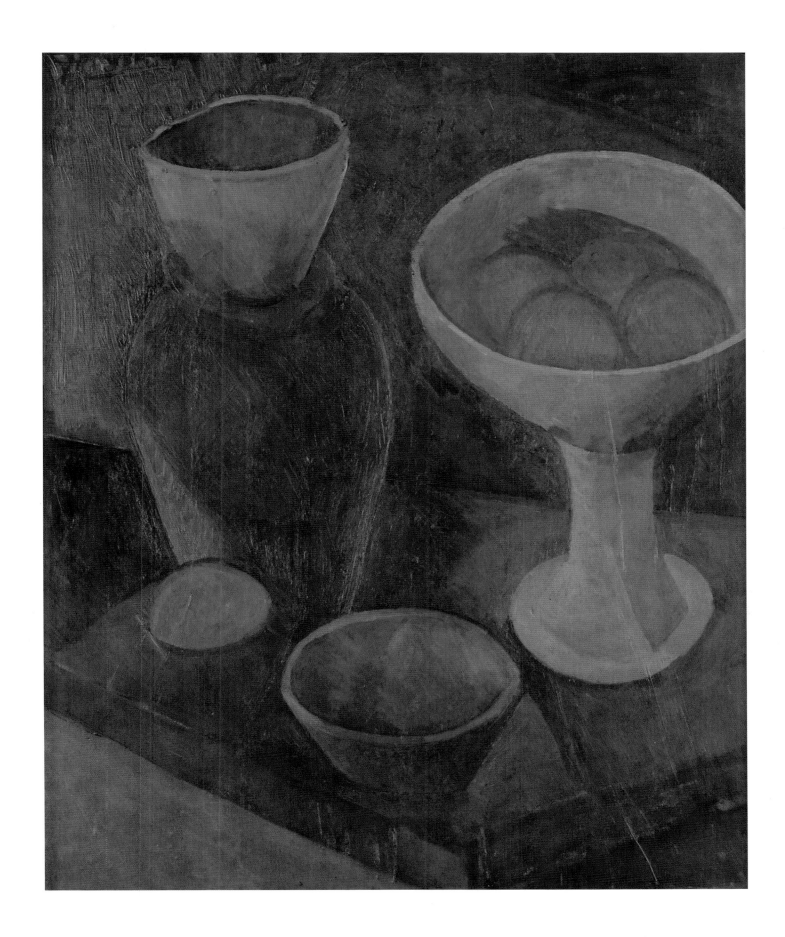

PLATE 82

Pablo Picasso

Still Life with Bowls and a Jug, 1908

Oil on canvas
32¼ x 25⅞ inches (81.9 x 65.7 cm)
Philadelphia Museum of Art. A. E. Gallatin
Collection, 1952-61-93

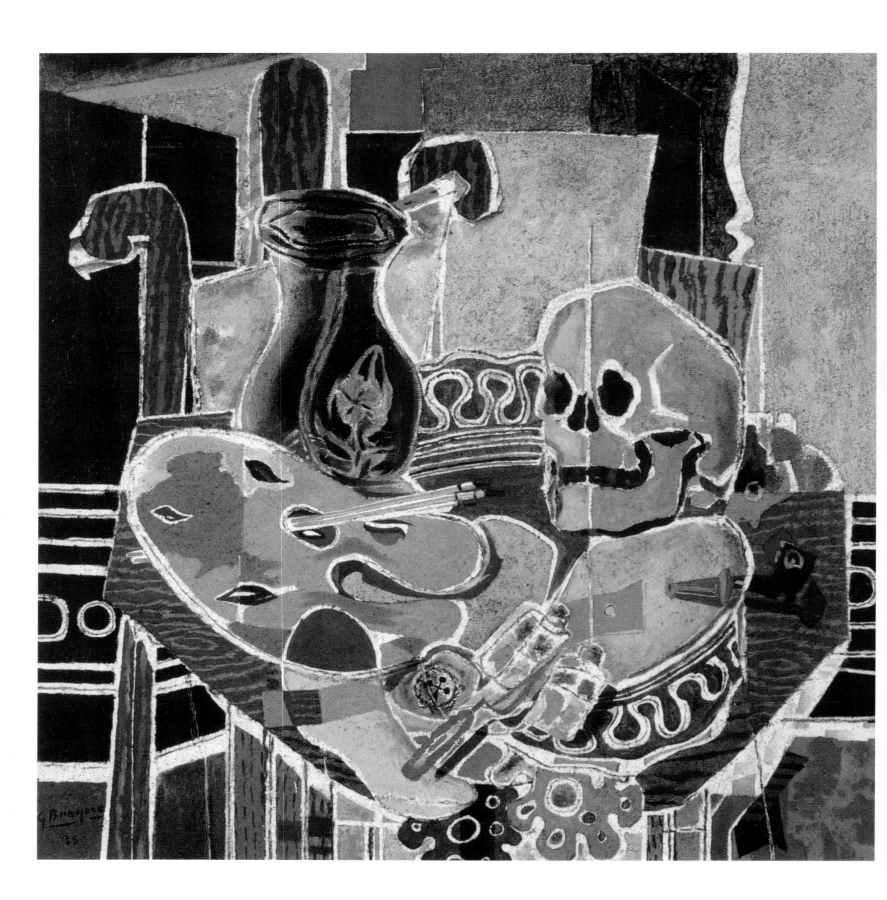

Cézanne, Braque, and Pictorial Space

John Golding

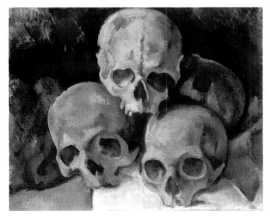

If, in the autumn of 1906, a perceptive critic had been asked to name the single most important influence on young French artists of the new century, he or she probably would have said Paul Gauguin. The artist's large memorial retrospective at the Salon d'Automne that year had generated enormous interest—partly because of the myth Gauguin had invented for himself, and subsequently acted out, of a highly sophisticated man who had retired from the civilized world to embrace a primitive existence. It also introduced the public to Gauguin's sculpture, which, unlike his paintings, had about it a "primitivizing" air and was to be important in promoting the enthusiasm for tribal art that was so important to developments in the avant-garde in subsequent years.

The same question posed a year later, however, could have elicited only one reply: Paul Cézanne. Like Gauguin, Cézanne had referred to himself as "primitive," but his primitivism was to be that of a new painterly sensibility. Gauguin's sumptuous colors and decorative arabesques could mask profundity, but the lessons he passed on to younger artists, both verbally and through his example, could also seem dangerously simplistic.[1] Cézanne, on the other hand, opened doors onto totally unimagined artistic corridors. His own memorial exhibition at the Salon d'Automne of 1907 was arguably the most decisive artistic event of the decade until the advent of Cubism a year later. Although he was born a few years earlier than the Impressionist painters with whom he is most often associated—Claude Monet, Auguste Renoir, and Alfred Sisley[2]—Cézanne was the only artist of his time who succeeded in spanning several generations to become, so to speak, an honorary twentieth-century painter. In the first two decades of the new century, hardly a significant artistic movement arose that did not feel his influence, not only in France but in Italy, Germany, the Netherlands (Mondrian studied his art in 1912–13), and Russia as well.

Georges Braque (1882–1963) entered modernism under the aegis of the Fauves, who exploded onto the Parisian scene in 1905. Gauguin's influence on the young artist was at a distance, although it encouraged him to use a much wider palette. While Gauguin's palette was exotic, in keeping with his subject matter, Braque's pictures from this period are light and airy and make much more restrained use of the primary reds, yellows, and blues that had characterized the work of André Derain and Maurice de Vlaminck, who, together with their leader, Henri Matisse, formed the nucleus of the Fauves. Gauguin's temperament, however, would have been totally foreign to Braque.

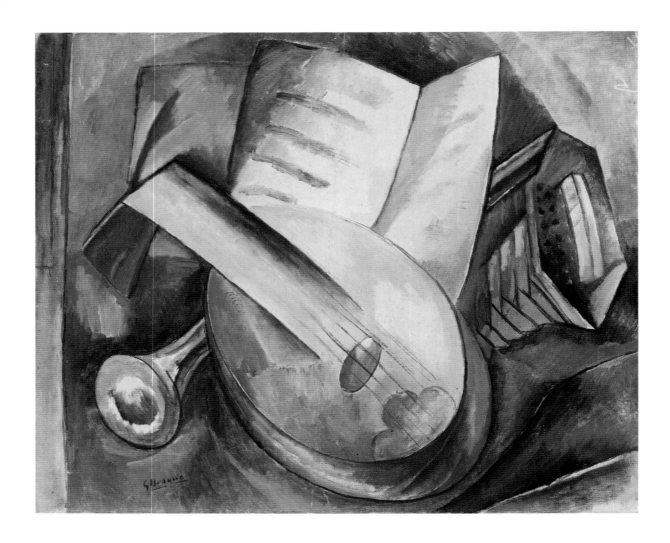

Fig. 9.1. **Georges Braque,** *Still Life with Musical Instruments,* 1908. Oil on canvas, 19¹¹⁄₁₆ x 24 inches (50 x 61 cm). Private collection

He was not a cautious artist, but he disliked extremes of all kinds, which makes his subsequent collaboration with Pablo Picasso in the creation of Cubism in 1908 doubly strange, since Picasso reveled in wild experiment and was certainly the most radical young artist of his time. After discovering Cézanne in depth at the 1907 memorial, Braque proceeded to immerse himself in the artist's work over the next two years and beyond. In this connection, it is worth mentioning that virtually every major artist who had been influenced by Gauguin, including Matisse, subsequently expressed reservations about his art, whereas those who had found shelter and inspiration under Cézanne's wing never ceased to revere him.

Braque was to become primarily a painter of still lifes—the greatest of his age, in fact—and, as time progressed, of the interiors that contained them (fig. 9.1). Paradoxically, it is through his Cézannesque landscapes that we can most easily find our way visually into the crystalline, infinitely mysterious Cubism of 1910–12, one of the movement's highest points; paradoxically because Cubism produced relatively few landscapes after the style reached its maturity. The great richness of Cézanne's achievement lies in part in the fact that he intuitively distinguished among the different genres of painting. In youth he had dealt with subjects that had literary implications, some of them disturbing and even at times violently sexual, properties that relate them to the early novels of Émile Zola, who in boyhood had become his closest companion. These Cézanne subsequently rejected in favor of exploring the gamut of multiple- and single-figure pieces, portraits, still lifes, and landscapes, becoming in the process the most formally rich and inventive painter of his age. It was because of this that his art became such a vast inspiration and cornucopia for younger artists.

Among these genres, Cézanne probably found landscape the most meaningful. He was passionately attached to the landscape of his native Provence, a passion that was

also nurtured by his early intellectual development, conditioned by a rigidly traditional French introduction into Greek and Roman literature. During his school days he had immersed himself deeply in classical literature — more so than any other artist of his generation. He was familiar with Ovid, Lucretius, Cicero, and Apuleius; but Virgil was the writer he most loved — at the age of twenty, he had translated the Eclogues into French. Gauguin, who admired Cézanne — a feeling that was most emphatically not reciprocated — refererred to him once as "a man of the South" who "spends whole days on a mountain top reading Virgil and looking at the sky."[3] Like Virgil, Cézanne believed that nature could echo the moods and experiences of human existence, and his landscapes are Virgilian in their controlled lyricism and structural discipline, their occasional feel of yearning; and even, in his last depictions of Mont Sainte-Victoire, in their evocation of nature's apocalyptic powers. Very late in life one of his closest attachments was to his aged gardener, Vallier, in whose seamed face and gnarled hands he saw the personification of Virgil's identification of man with nature.

Braque's landscapes of early 1908 marry the Fauve liberation of color to a new Cézannesque sense of structure. One of the reasons for Cézanne's enormous influence was that his pictorial procedures could be "read" in so many different ways. Braque chose to examine Cézanne's use of volumetric forms, which the younger artist then simplified in his own work. Cézanne used to affirm and then endlessly reaffirm the contours of his subjects, reinforcing their solidity by feeling his way around them with his brush until the forms, while they convey an ever-increasing three-dimensionality, nevertheless seem to flow out and fuse with the space around them. Young painters called this effect "passage," and it is this device that Braque set out to explore. Cézanne always insisted that form was at its fullest when color was at its richest, but it had cost him the work of half a lifetime before he was fully to realize his ideal; Braque and the painters of his generation could not hope to achieve it, as it were, overnight. Braque now limited his palette just as he simplified his forms. He was above all a painter of space, and he now felt that color interfered with the spatial sensations for which he was searching; he declared that color could in fact destroy these sensations.

In this regard, we should consider one of Braque's most significant maxims: "There is in nature a tactile space. I might even say a manual space. . . . This is the space that fascinated me so much. Because that is what early Cubist painting was about, a research into space."[4] At first sight some of the paintings he executed in 1908 at L'Estaque on the Mediterranean (also a haunt of Cézanne's), although they instantly announce their allegiance to his new mentor, look starkly reductive and austere (fig. 9.2). In Cézanne's landscapes of the 1870s and 1880s, he generally introduces a visual barrier at the bottom of the picture: a road or a sheet of water, for example, or a path that twists so sharply up the picture plane as to deny the eye any immediate access into depth. Once we have climbed metaphorically over these barriers, Cézanne's landscapes become places of sanctuary. The eye is led serenely upward and back through planes placed parallel to the picture surface and flowing into each other; the overhanging branches of foreground trees often mask the transitions into depth, yet again bringing the eye forward. Cézanne virtually never makes use of atmospheric perspective, of tinting and paling colors back into depth. Although Braque adopted these pictorial devices in his L'Estaque landscapes, these paintings convey none of the feeling of psychological reassurance that Cézanne's do. Rather, there is a sense of the creation of a tabula rasa, a wiping clean of the slate in order to create a totally new pictorial idiom. After this southern sojourn, Braque's landscapes executed in the north at La Roche-Guyon and Carrières Saint Denis (plate 87) show a new, even more angular fragmentation of form, and the resultant planes begin

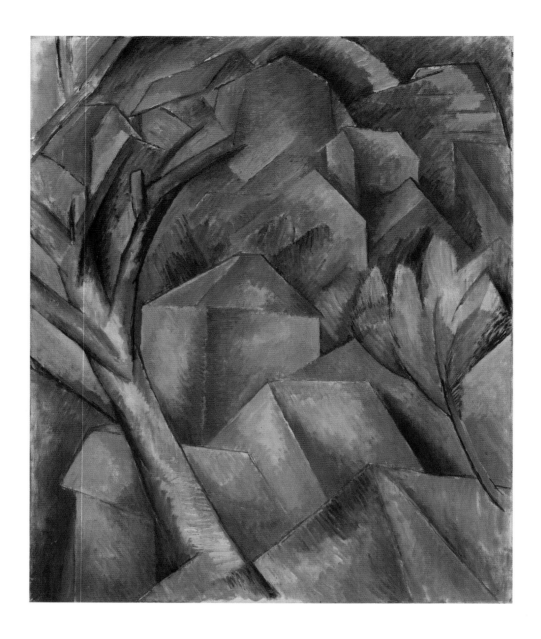

Fig. 9.2. **Georges Braque, *Houses at L'Estaque*,**
1908. Oil on canvas, 28¾ x 23½ inches (73 x 59.7 cm).
Kunstmuseum Bern. Hermann and Margrit Rupf
Foundation

to arrange themselves at times on vertical and horizontal axes and to flow into each
other by transitional, transparent passages, in anticipation of the linear grids of the high
"Analytic" or "Hermetic" Cubism of 1910–12.

Braque also approached Cézanne's work to a great extent through his fellow pio-
neer, Picasso. He had already met Picasso earlier in 1907, but that autumn, when he
visited Picasso's studio — in the celebrated "Bateux Lavoir," a complex that fell back-
ward from the artistic Montmartre quarter of Paris — in the company of Guillaume
Apollinaire, he was confronted by *Les Demoiselles d'Avignon* (see fig. 8.15). Few individ-
ual works of art have changed the face of visual history — Titian's *Assunta* and Manet's
Déjeuner sur l'Herbe (Luncheon on the Grass) come to mind — but this one did. The
sources behind this large and in some respects devastating canvas are legion, but
Cézanne's late pictures of bathers are prominent among them. Unlike his other mature
achievements, Cézanne's bathers are not rooted in perceived visual observation but are
purely works of the imagination. Braque ultimately had little interest in Cézanne's
nudes. However, under Picasso's influence he produced a large canvas entitled *La Femme*
(now lost or more probably destroyed, but known through a related sketch that is now
also lost), which shows the same naked woman in three poses, as well as another large
upright canvas of a single nude in 1908, now in the Centre Georges Pompidou in Paris,
which shows her aggressively distended, as if revolving on a pedestal rotated through
180 degrees. These works demonstrate that Braque was the very first artist to recognize
fully that Picasso had broken definitively with classical Western single-viewpoint per-

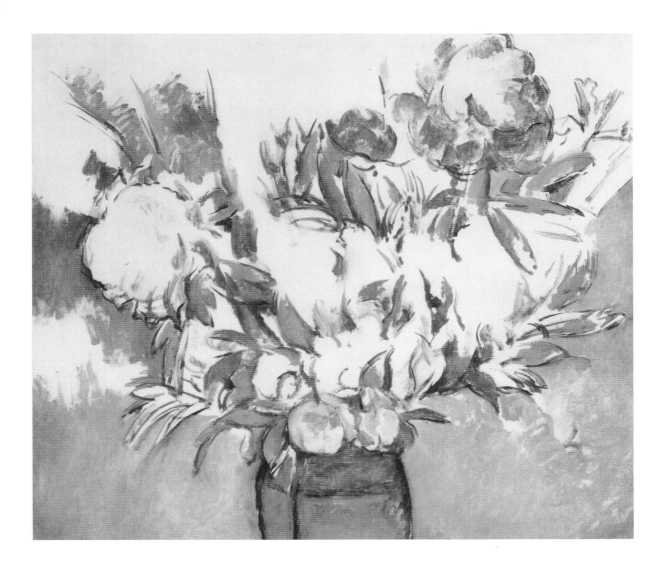

Fig. 9.3. **Paul Cézanne,** *Bouquet of Peonies in a Green Jar,* c. 1898. Oil on canvas, 22⅝ x 25¾ inches (57.5 x 65.4 cm). Private collection

spective. It was Picasso's intention to show his subjects in ever-greater volumetric plenitude; one might even suggest that in the works immediately following the *Demoiselles,* he was trying to produce sculptures on a flat surface. It was Braque's creation of a fluid Cézannesque space that allowed Picasso to do this. Between them, they had created Cubism, possibly the most truly revolutionary artistic movement since the Italian Renaissance. For the next six years the two artists were inextricably bound together — as Braque himself put it, linked like mountaineers ascending a summit.[5]

A comparison between Braque's *Rooftops at Céret,* a rare landscape of 1911 (private collection),[6] executed in a fully formulated Cubist idiom, with any one of the 1908 L'Estaque landscapes speaks for itself. In the 1911 canvas, the contours are much more broken, and the arbitrary juxtaposition of lights against darks creates an overall effect of shifting planes flowing into each other in a spatial flux and into a composition now held together by the famous Cubist linear grid. The beautiful *Table (Still Life with Fan)* of the previous year (plate 91), with its high viewpoint, lucidity of composition, and spatial innovations, reminds us that the ghost of the great master of Aix was still hovering over Braque's shoulder.

With his next major innovation, the creation of papier collé in 1912, Braque to a certain extent detached himself from his mentor, although Cézanne always remained a source of inspiration and Braque's favorite painter among his immediate antecedents. Braque never became a total recluse as Cézanne did, but in later life he turned increasingly in upon himself, and he must have admired Cézanne's single-mindedness, his

unswerving dedication to his calling. In many ways, the two men had similar temperaments. Braque owned two works by Cézanne, a watercolor and a still life, *Bouquet of Peonies in a Green Jar* (fig. 9.3). The latter was one of his most prized possessions and hung in his bedroom together with a landscape by his father, a daily reminder that he had had two paternal figures in his life. The still life was "unfinished"; Braque always rejected pictorial certainties in favor of new pictorial possibilities.

Braque's invention of papier collé, which ushered in the "Synthetic" phase of prewar Cubism, brings up the question of his somewhat unusual artistic background. He was born in 1882 in Argenteuil on the banks of the Seine, a location much loved by the Impressionists. His father and his grandfather were *peintres décorateurs*, decorators who produced those effects of illusion—false woodgraining, marbleizing, artificial moldings, and dadoes, for example—that were much in demand in French middle-class dwellings in the late nineteenth and early twentieth centuries. Braque was apprenticed first to his father and, after the family's move to Le Havre, to the firm of Rupalay et Rosney, famous for their trompe l'oeil illusions. However, after moving to Paris to be "finished" in the family business, Braque also took evening classes at the Cours Municipal of Batignolles and then at the Académie Humbert, where he met young artists such as Francis Picabia and Marie Laurencin, whose friendship encouraged him to aspire to become, for want of a better word, a "high" artist. He was at this time still a somewhat shy young man, but he was good-looking and personable and made friends easily. He loved to sing and dance, to box and fence. There was nevertheless an aspect of his character that he reserved exclusively to himself and put entirely at the service of his art. Prior to his removal to Paris he had been a Sunday painter, like his father, mostly of landscapes. He had his first modest commercial success at the Salon des Indépendants of 1907 and was subsequently picked up by the aspiring dealer Daniel-Henry Kahnweiler. Braque's first exhibition at Kahnweiler's small new gallery in November 1908 was largely responsible for earning Cubism its name.

The story of the invention of papier collé has been told often and is revealing at several levels. Braque spent the summer of 1912 in Sorgues, in the south of France, working in the company of Picasso. In the town he happened to spot a roll of imitation woodgrain wallpaper in a shop window; it cannot have failed to awaken in him memories of his own training in the trade. He waited until Picasso had returned to Paris before purchasing the illusionistic paper; he was by then used to Picasso picking up his innovations and pushing them to more extreme conclusions. He incorporated three strips of the commercial paper into a still life, *Fruit Dish and Glass* (fig. 9.4), with pencil marks to indicate where he wanted to place these readymade, flat compositional planes. The subject matter, rendered in charcoal, was then superimposed over the composition and integrated into it. In subsequent canvases, the cut-and-pasted paper was replaced by large planes derived from his original procedure and rendered in oil. Thus began the dialogue between abstraction and representation that would condition all of Braque's subsequent work throughout his long career. This dialogue also divorced him from any immediate connections to Cézanne—although, since the creation of Cubism would not have been possible without Cézanne, the master was in a sense still standing behind the works the movement produced.

Put at its simplest, Analytic Cubism was concerned with new ways of looking at the external world, while Synthetic Cubism was concerned with new ways of constructing works of art. Cézanne's interpretation of his subjects was radical in that it was so entirely unique; but he nevertheless saw himself as working in a tradition that extended from the Italian Renaissance to the Southern and Northern Baroque. It might be

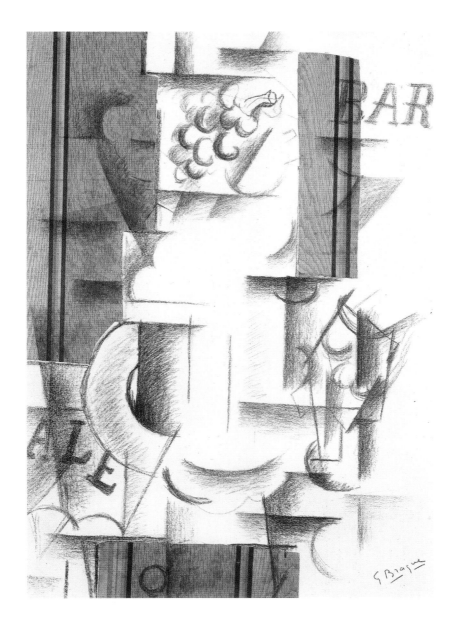

Fig. 9.4. **Georges Braque, *Fruit Dish and Glass***, 1912. Charcoal and wood-pattern paper on paper, 24⅞ × 17½ inches (62 × 44.5 cm). Private collection

possible to draw parallels between Cubism's used of bold, flat abstract forms integrated into compositions with identifiable subjects and Cézanne's striking bondings of different areas of his canvas with daring spatial inventions. His methods were somewhat unusual in that he used to work from one part of the canvas to another, leaving areas of white canvas between them. Many pictures were left in this condition, and he would almost certainly have considered them unfinished, although his eye must have told him that these compositions were satisfying nevertheless. But in his more "finished" paintings—the only ones he signed—he would unite the various components of a picture with bold compositional devices, arbitrarily introducing forms, objects such as moldings and pieces of furniture, or dramatically altering swinging draperies. However, such comparisons between these effects and the quasi-abstract compositions of Synthetic Cubism are distant ones. For some two decades Braque's work existed independently of Cézanne's example, and even after that, comparison between the two artists can be invoked only in general terms of their shared and lifelong concerns with pictorial space.

Braque's career was deeply influenced by the two world wars. He served in the first and was gravely injured leading his men in the vicious fighting for Neuville-Saint-Vaast. He was forced to undergo trepanation, and subsequently was much decorated as a hero. But Braque always had the ability to make the ordeals he faced—and these were relatively few, for he had on the whole a good and fulfilled life—somehow productive. While convalescing he clarified his ideas about painting and aesthetics in a series of aphorisms about art that were published in 1917 in the avant-garde periodical *Nord-Sud*,

Fig. 9.5. **Georges Braque, *The Table,*** 1918. Oil on canvas, 52⁵/₁₆ x 29¾ inches (132.9 x 75.6 cm). Philadelphia Museum of Art. The Louise and Walter Arensberg Collection, 1950-134-29b

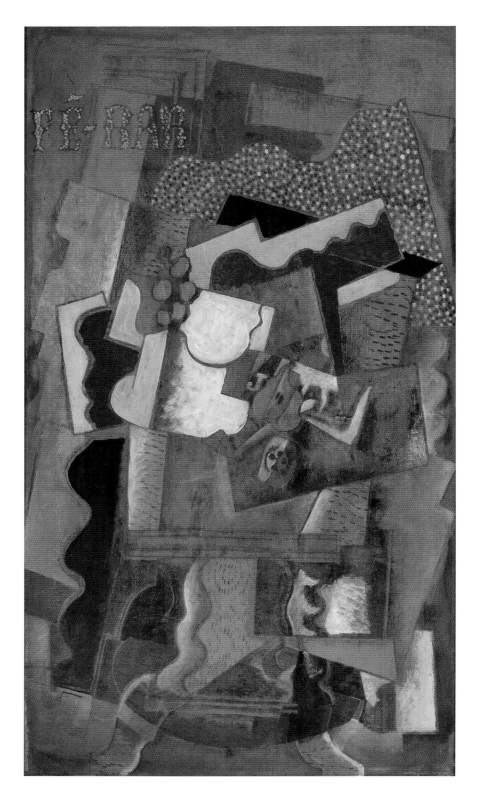

edited by his friend the poet and critic Pierre Reverdy, under the title "Pensées et réflections sur la peinture." These sayings invoke parallels with Pascal's "Pensées," and possibly with the philosophical principles of Jansenism, a seventeenth- and eighteenth-century branch of Catholic thought that stressed the unknowability of salvation while rigorously insisting on total moral rectitude. Like Cézanne, Braque had become a stoic. It was probably also during this period that Braque began to expand the depth of his reading, which would eventually lead him to Cézanne's beloved classics.

After a transitional moment in his output, Braque embarked between 1918 and 1928 on a series of paintings characterized by his use of blacks. Many of these works are upright still lifes depicting objects placed on three-legged tables called *guéridons* (fig. 9.5). It was in these works that Braque capitalized most strongly on his training as a *peintre décorateur*; the pictures are simultaneously decorative and austere, which perhaps accounts for the particular attraction they now hold for collectors and dealers. The compositional

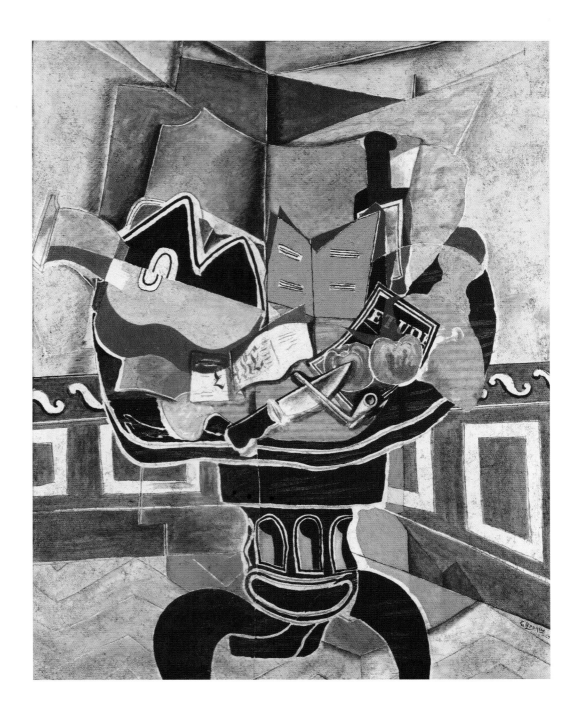

procedures are basically still those of Synthetic Cubism: large, bold, overlapping planes tip backward into a limited depth, only to be counterbalanced by others that assert the picture plane. Some of these paintings are enriched by varying marbling effects, while the pervasive blacks throw into relief the subjects played off against them; these are relieved by flashes of white and cream, which Braque referred to as "foyers d'intéret."

In 1928 Braque lightened his palette almost to blondness, introducing a new phase of spatial exploration into his work. In a key picture of 1929, *The Round Table* (fig. 9.6), the table is now placed in a corner of the room; above it we see a wedge of ceiling, below, a fragment of flooring, so that the eye cannot take in the space depicted in a single reading and is forced to read it sequentially, either up or down. The composition is governed simultaneously by an implied vertical axis, so that the subject is, as it were, cracked apart and thrust forward to our left and right. The temporal aspect of Braque's art—the fact that his paintings have to be studied over a period of time to be fully apprehended—was to become a prime concern to him. Braque had long since gained international recognition, but now he was achieving ever greater fame, something he on the whole chose to ignore.

Cézanne, on the other hand, was elderly by the time he was accorded the recognition he had long since merited. Although it came to him too late to have an impact

on his career as an artist, one senses that he too would have rejected his celebrity status. He had, however, long since won the respect and admiration of his peers, from Gauguin onward. Renoir, for example, remarked that Cézanne was incapable of putting two marks on a canvas without making a satisfactory composition. In 1882 Renoir joined Cézanne in L'Estaque, and the works he produced there show the older painter's influence in their more disciplined use of space. But Cézanne was already beginning to distance himself from his old colleagues; on one occasion, he insultingly refused to acknowledge Monet. In old age he very occcasionally received younger artists—a notable exception being Maurice Denis, a critic as well as a painter, to whom we must be grateful for passing on to us some of Cézanne's comments.

The 1930s witnessed some of the most magnificently full and decorative still lifes ever produced by Braque—or, indeed, by any artist in the twentieth century. Although no direct influence of Cézanne is evident in Braque's works from this period, their closest parallel is to be found in Cézanne's own late still lifes, which are characterized by their great arching, swinging, centrifugal rhythms. These works are among the most physical pictures ever produced by Cézanne, and we sense that they are the transcendental substitutes for all the flesh that Cézanne never touched, for all the muscle that never found contact with his own. But Braque's aesthetic concerns in the 1930s were no longer close to Cézanne's; despite its visual amplitude, Braque's art remained basically unsexual and the erotic seldom touched him. Braque was now extending his coloristic range beyond that of anything he had produced since his early Fauve period. He incorporates whole spectrums of reds, roses, and yellows, and the gamut of tonal variety in the pale fawns and up into the siennas and browns becomes ever richer.

The works of the mid-1930s are also enriched by the liberal use of curves, sometimes rendered in a linear fashion and played off against angular pictorial elements to create new and complex spatial effects, and above all the "metamorphic confusion" (the term is his own) for which Braque was now searching. Solid forms such as fruit dishes and musical instruments deliquesce, while softer objects (napkins, drapery, fruit) become hard and unyielding. He was also becoming obsessed by what he called "rhyming shapes": a pulpy mandolin echoes a curvilinear compotier, while the round fruits the latter contains and others scattered over the tabletop pick up on the sound holes of stringed instruments (figs. 9.7, 9.8). The wealth of patterns, some of them inspired by those found on Etruscan pottery, which fascinated Braque, now often reads like a secret, hieroglyphic painterly script. Braque's concerns were becoming increasingly philosophical; many of the works painted toward the end of the decade look forward to the metaphysical questions about different forms of reality that preoccupied him in his late career. These concerns would have been foreign to Cézanne, whose work embodied his personal philosophy of life but was bound up with his increasingly intense concentration on the immediacy of his physical surroundings— and, in the bathers, their transposition into idyllic metaphors for them.

Braque's iconographic path again overlaps with Cézanne's in the skull pictures he initiated during the run-up to World War II in 1937 and continued making throughout the war. These most often take the form of vanitas or memento mori, themes that had preoccupied Cézanne in his early years when his use of symbolism was traditional and overt: a skull, an open prayer book, dead flowers, a black clock devoid of hands, and so forth. As Cézanne's art matured he turned his back on all symbolic art, although sometimes one senses that an object depicted is standing in for something else—for example, the single trees in his landscapes that seem to inform the viewer of the artist's own presence. Cézanne's late skull paintings are works of great intensity, and clearly he

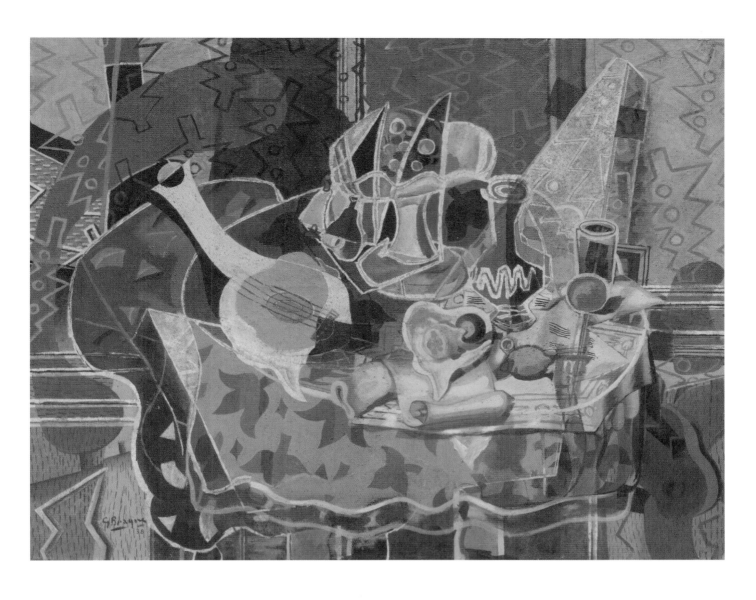

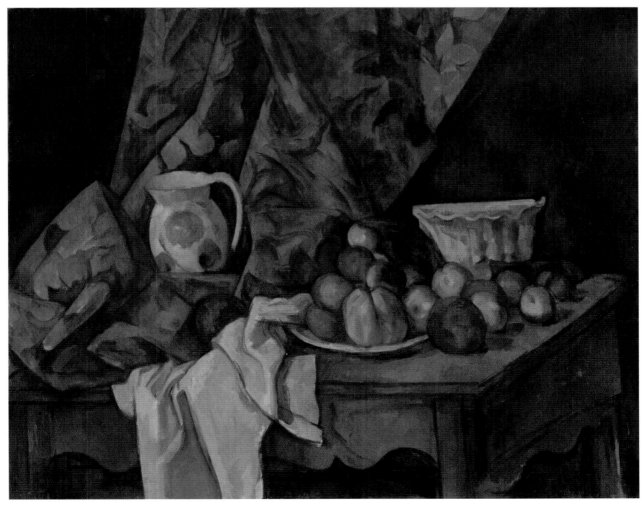

was becoming increasing aware of mortality and impending death. Most of Braque's skull pictures are relatively small in scale and are not very inventive spatially. One of the most striking and powerful exceptions is *Studio with Skull* of 1938 (plate 83). The palette of the painting is rich but somber and brooding. The skull is echoed by a palette and brushes to the left, with the implication that with death an artist's endeavors will also cease. (Braque actually stopped painting for a time out of depression at the advances being made by invading German troops.) The bands of pattern that weave through the composition, tying it together, have about them a slightly menacing quality. Interestingly, although the parallels with Cézanne are self-evident, they are most directly evinced in the photographs taken in 1938 at Cézanne's studio at Les Lauves, just outside Aix, which show the skull he owned juxtaposed with the simple, much-loved objects that appear time and again in his still lifes. To this very day, Cézanne's studio emanates an air of simplicity and total purity. Braque's own studios—one in Paris (fig. 9.9) and one at his second home in Varengeville in Normandy, built to his specifications—are considerably larger. He liked working with windows facing south, and hence in softer, more varying light than in traditional artists' studios facing a more stable, unyielding northern exposure. But they, too, stand forth as places of contemplation.

Braque's late "Ateliers" represent the very summit of his achievment. The series comprises nine paintings. The first, relatively small canvas of 1949 acts as a prologue to what ensues. The other eight are very large paintings, excecuted between 1949 and 1956, and, with the exception of a vertical canvas and a final one that is squarish, are horizontal in format. With this group of pictures Braque demonstrates more fully than ever before the "manual" space that was his goal; in fact, they introduce us to pictorial spatial sensations hitherto unknown in the history of art. *Studio V* (also known as *Studio III*; Braque often reworked his paintings over a period of years, so that it is not always possible to establish an exact sequence) is the most complex of the series (plate 89). The series as a whole is homogenous despite the distinctiveness of each canvas. These are paintings of the utmost gravity; they radiate a sense of silence and are designed for lengthy contemplation. In each work, the entire space of a large studio has been pleated up like an accordion onto the picture surface. The space, though dense, is comprehensive—it envelopes us totally and reassures us, as do so many of Cézanne's later landscapes. There is a sense that the paintings are foundries in which space is melted, folded, bent, and shaped. Because of the studio objects embedded in the dense spatial matrix —the palettes, brushes, easels, rulers, and plaster casts (and, in the case of *Studio V*, a goldfish bowl at the bottom right)—these paintings comment on the very act of painterly creation. In all but one, a mysterious gigantic bird is impaled on a canvas at the top right; sketches make it clear that this is so, and there was a large bird painting sitting in his studio. Simultaneously, these mythical creatures glide forward through the studio space; in doing so they, too, inform one of the metaphysical processes contained in a painter's working space. These pictures emobdy a lifetime's experience of a life lived for art.

Because the pleating processes in the the Atelier paintings tend to be on a vertical or tipped vertical axis, they evoke distant analogies with some of the very late landscapes of Cézanne, which show upright trunks of trees governing the composition, while between them iridescent complexes of shimmering, interacting planes evoke sensations of a fluid space in flux. But the aesthetics of the two painters were now widely divergent. Cézanne remained firmly rooted in and focused on the soil of his own beloved Provence and, particularly in the case of the landscapes and the bathers, the spiritual climate engendered by it. His culture was based on the education he had

received as a youth, which he was simultaneously relating to his surroundings; he had
been intellectually formed by his early immersion in classical literature and viewed his
landscape through it. Braque, who by his own admission had read relatively little when
young, had deepened his thought through extensive reading over the years, and by
doing so became a philosopher in paint. He had now absorbed some of the mysticism
of the East; he was familiar with the teachings of Lao Tzu, Confucius, and Milarepa.
He denied being influenced by Zen Buddhism but was well aware of it.[7] Late in life he
expressed his position thus: "I no longer believe in anything. Objects don't exist for me
except in so far as a rapport exists between them or between them and myself. When
one attains this harmony, one reaches a sort of intellectual non-existence—what I can
only describe as a state of peace—which makes everything possible and right. Life then
becomes a revelation. That is true poetry."[8] Among his very last recorded words before
his death, for which he had prepared himself with characteristic fortitude, was a request
for his palette, which he could no longer have held. For Cézanne, too, in old age the
mystery of creation, the inevitability of never being able to attain what he called the
chosen land, remained the driving force of life.

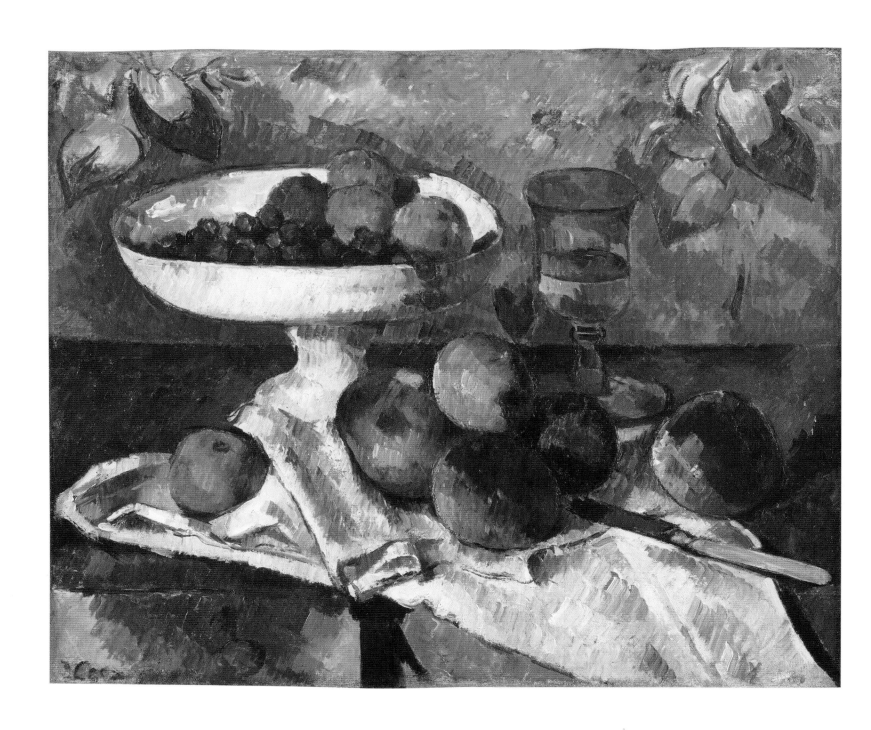

PLATE 84

Paul Cézanne

Still Life with Fruit Dish, 1879–80

Oil on canvas
18¼ x 21½ inches (46.4 x 54.6 cm)
The Museum of Modern Art, New York. Fractional
gift of Mr. and Mrs. David Rockefeller

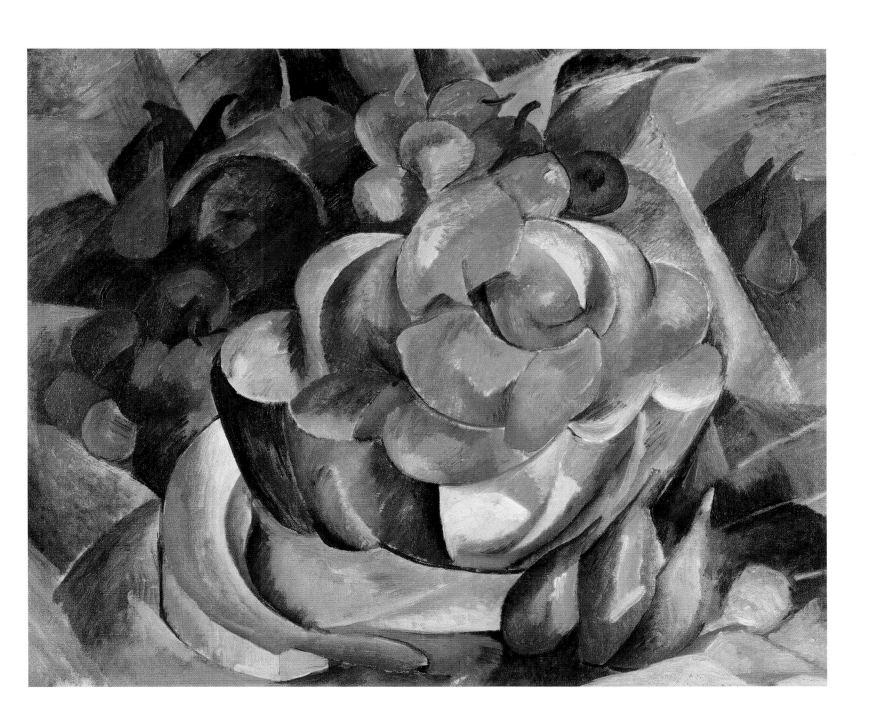

PLATE 85

Georges Braque

Fruit Dish, 1908

Oil on canvas
20⅞ x 25¼ inches (53 x 64.1 cm)
Moderna Museet, Stockholm. Donation 1966 from
Rolf de Maré

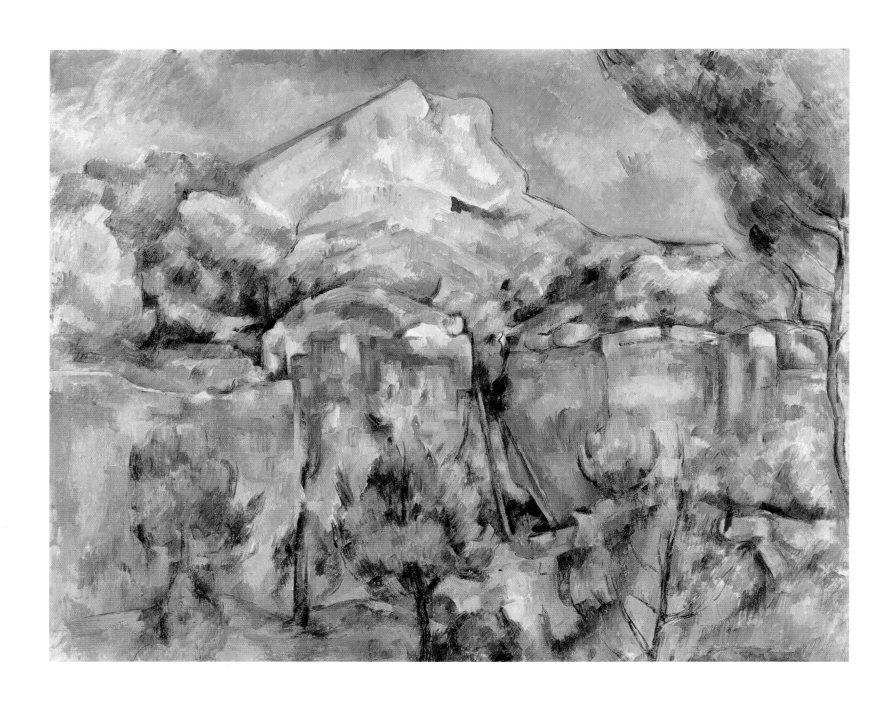

PLATE 86

Paul Cézanne

Mont Sainte-Victoire Seen from the
Bibémus Quarry, c. 1897

Oil on canvas
25⅛ x 31½ inches (63.8 x 80 cm)
The Baltimore Museum of Art. The Cone Collection,
formed by Dr. Claribel Cone and Miss Etta Cone of
Baltimore, Maryland, BMA 1950.196

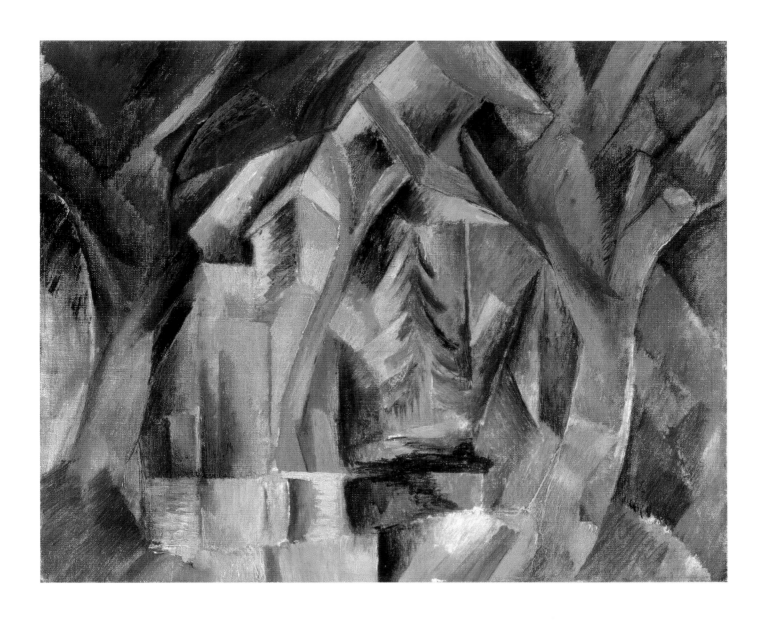

PLATE 87

Georges Braque

The Park at Carrières Saint Denis,
1909

Oil on canvas
16 x 17⅞ inches (40.6 x 45.3 cm)
Museo Thyssen-Bornemisza, Madrid

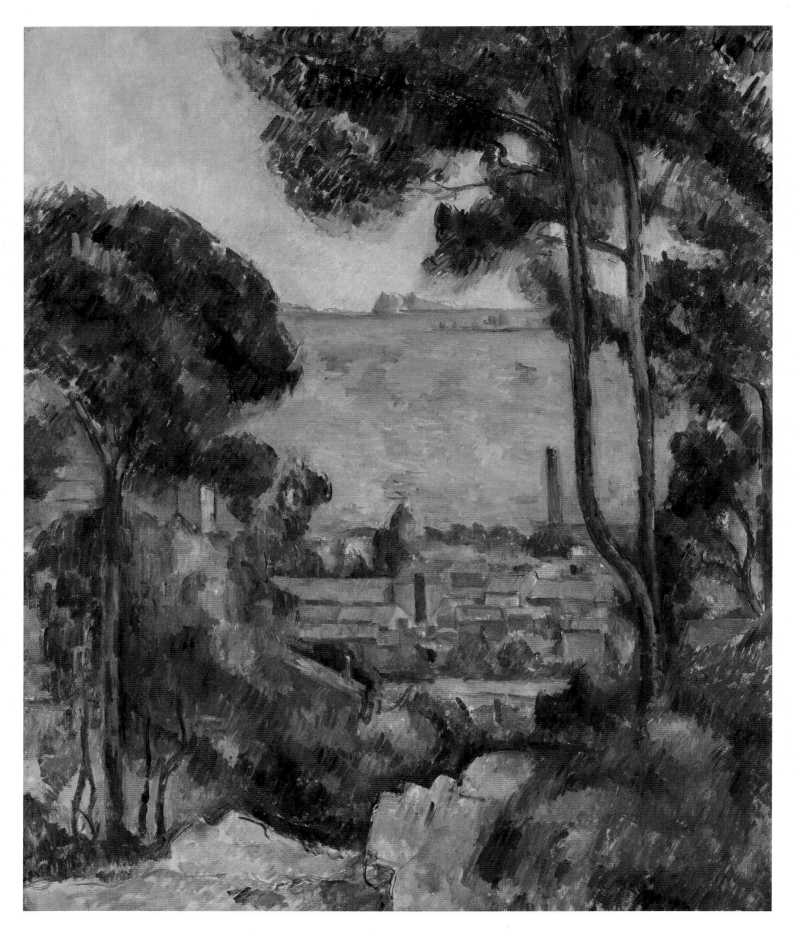

PLATE 88

Paul Cézanne

View of L'Estaque and the Château d'If, 1883–85

Oil on canvas
28 x 22¾ inches (71.1 x 57.8 cm)
Private collection, on loan to the Fitzwilliam Museum,
Cambridge

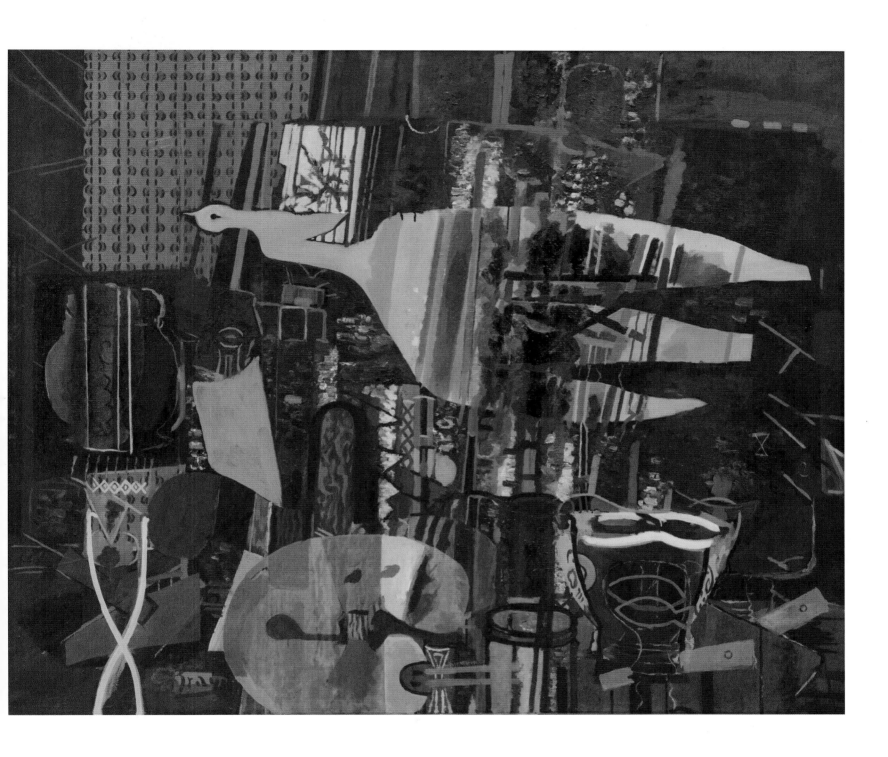

PLATE 89

Georges Braque

Studio V, 1949–50

Oil on canvas
57⅞ x 69½ inches (147 x 176.5 cm)
The Museum of Modern Art, New York. Acquired
through the Lillie P. Bliss Bequest, 2000 (123.2000)

PLATE 90

Paul Cézanne

Curtain, Jug, and Compotier,
1893–94

Oil on canvas
23¼ x 28½ inches (59.1 x 72.4 cm)
Private collection, Chicago

PLATE 91

Georges Braque

The Table (Still Life with Fan), 1910

Oil on canvas
15 x 21¾ inches (38.1 x 55.2 cm)
The Museum of Modern Art, New York. Promised
anonymous gift and bequest of Florene May
Schoenborn (by exchange), 2006 (358.2006)

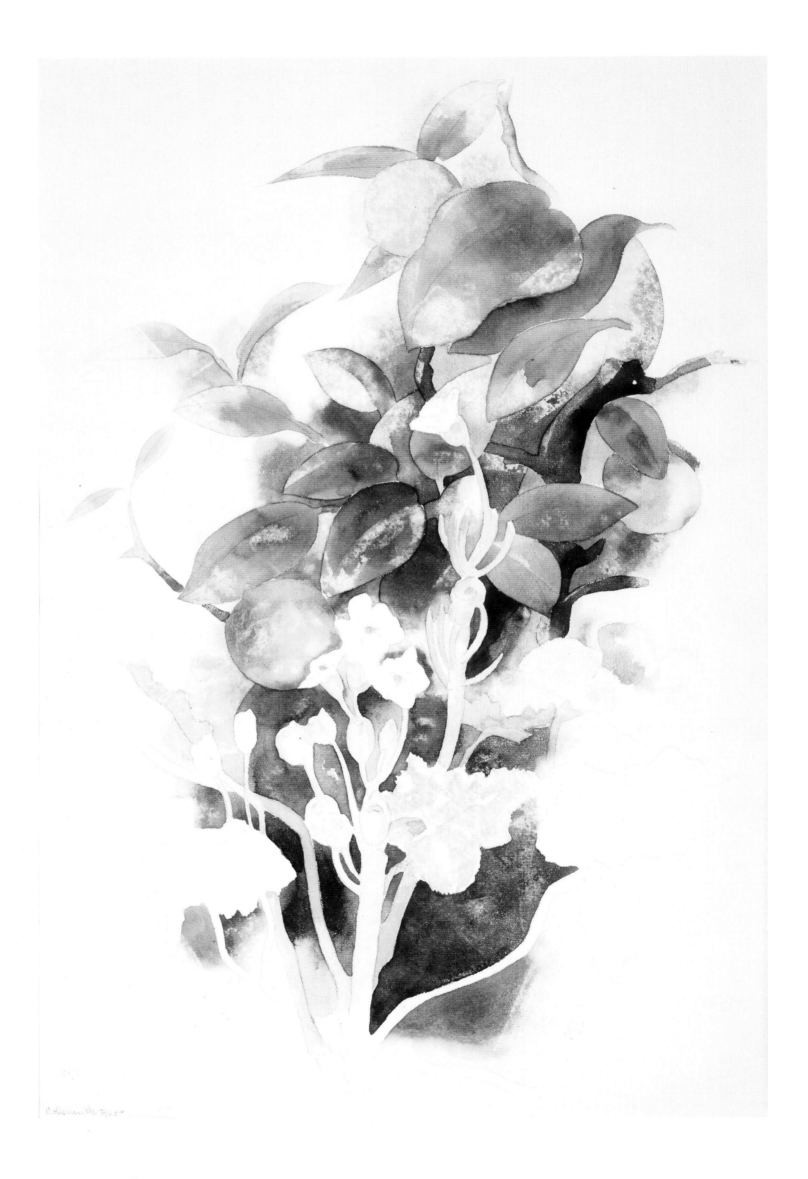

Camomile Plant

A New Tradition: Cézanne, Demuth, and the Invention of Modern Watercolor

Mark D. Mitchell

Paul Cézanne, *Rose in the Greenery*,
1895–1900 (plate 99, p. 298)

In his groundbreaking 1922 study of American watercolor, A. E. Gallatin described the beginnings of "a new tradition" initiated by Paul Cézanne and continued by John Marin and Charles Demuth (1883–1935) "in much the same spirit."[1] In Demuth's day Cézanne was routinely characterized as modernism's fountainhead, and Gallatin was quick to align the young American watercolorists with the French artist's legacy. At the height of Demuth's own career from the mid-1910s through the 1920s, he contributed to the then vibrant, ongoing artistic and critical reinterpretation of Cézanne, providing a lens through which his contemporaries, including Gallatin, would appreciate Cézanne. In Cézanne's watercolors, Demuth would find dual inspiration: stylistic innovation and tacit expressiveness. While the former is the more commonly described of their works' shared characteristics, it opened the door to the latter and to Demuth's most vital achievements in the medium.

Cézanne had indeed revolutionized the practice of watercolor, though it was widely recognized only in hindsight. By the artist's death in 1906, his ideas had been embraced and were being pushed ever outward by younger artists. Cézanne had begun the process of taking watercolor apart—as he had oil painting—admiring its formal properties and introducing the idea of facture itself as a subject of art. Demuth was among the many art students in Paris whose early careers were influenced by the moment of Cézanne's posthumous apotheosis at the Salon d'Automne in October 1907, in which watercolors featured prominently.[2] His influence on Demuth had two phases—exploration and engagement—that reflected the broader arc of Cézanne appreciation during the decades after his death.

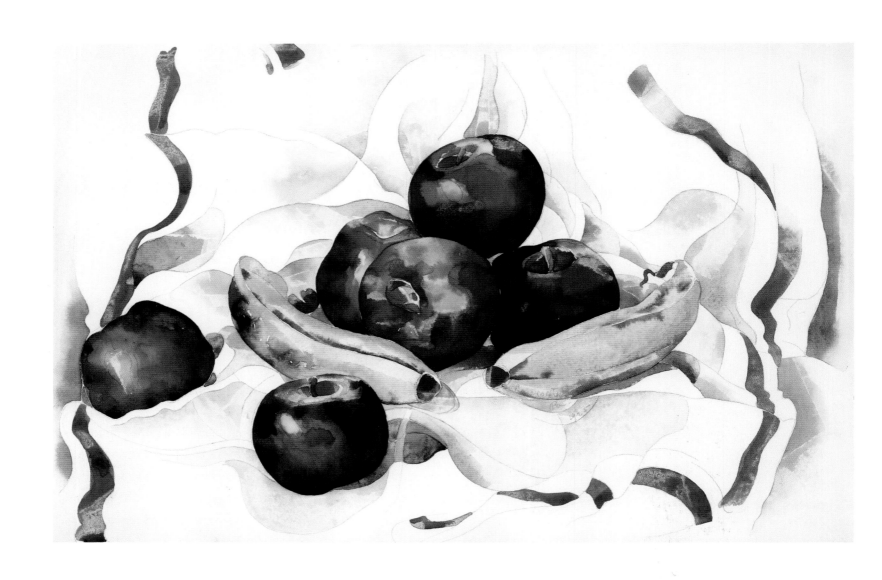

Fig. 10.1. **Charles Demuth, *Still Life with Apples and Bananas,*** 1925. Watercolor and pencil on paper, 11⅞ x 18 inches (30.2 x 45.7 cm). The Detroit Institute of Arts. Bequest of Robert H. Tannahill

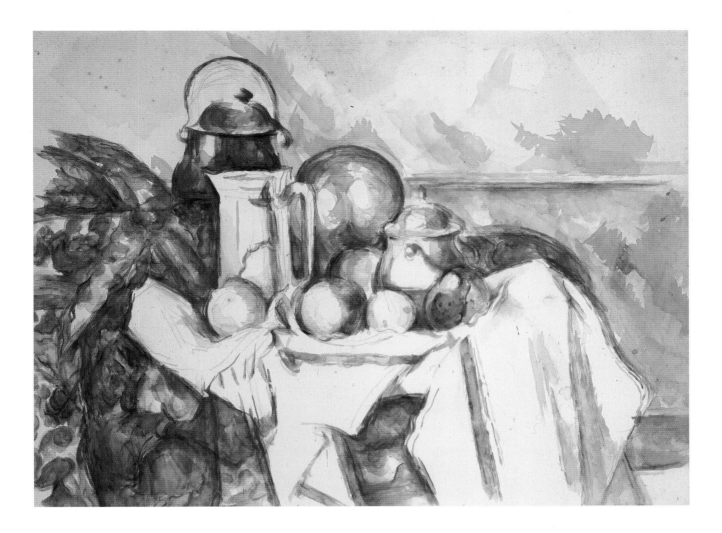

Fig. 10.2. **Paul Cézanne, *Still Life with Milk Pot, Melon, and Sugar Bowl,*** c. 1900–1906. Watercolor and graphite on white paper, 18 x 25 inches (45.7 x 63.4 cm). Edsel and Eleanor Ford House, Grosse Pointe Shores, Michigan, 1986.2

Coming to Cézanne

In Demuth's day, Cézanne's legacy was divided into the stylistic and the theoretical, framing what the Symbolist painter and theorist Maurice Denis called "the Cézanne question" in 1907. According to Denis, "The Cézanne question divides inseparably into two camps those who love painting and those who prefer to painting itself the literary and other interests accessory to it."[3] By the early 1900s, Cézanne's theories had proven as influential as his art, and a single, integrated understanding of his legacy remained elusive. Exasperated by the futility of his project, Denis proclaimed the conundrum of his study: "But how hard it is to be precise about Cézanne!"[4] In 1913, the critic Clive Bell concluded similarly that "Cézanne discovered methods and forms which have revealed a vista of possibilities to the end of which no man can see."[5] For the artists and critics of Demuth's generation, Cézanne supplied only the dangling questions of modernism, not their answers.

A comparison of Demuth's and Cézanne's finest watercolors—particularly their still lifes—accentuates the most compelling facets of both artists' work in the medium. Demuth's *Still Life with Apples and Bananas* (fig. 10.1), painted at the height of his career during the mid-1920s, is among the compositions that illustrate his closest stylistic and intellectual engagement with Cézanne, notably his late tabletop still lifes such as *Still Life with Milk Pot, Melon, and Sugar Bowl* (fig. 10.2). The similarity of the tablecloths suggests a direct quotation on Demuth's part, and in both works the whiteness of the cloth draws attention to the paper and to the artists' evocation of texture and form though the absence of pigment. In Cézanne's watercolor, the cloth structures the larger composition, with its rectilinear lines ordering his subject. For Demuth, the impeccable cloth both gently defines space with its light pencil contours and bright red ribbons of patterning, and frames the brightly colored fruit. Demuth at once amplifies

Cézanne's approach and concentrates the viewer's attention while enhancing the forms'
suppleness through calligraphic line, limpid color, and fluid brushwork. Demuth not
only elaborated on his related interest in how we look at art, feel its expressive convic-
tion, and appreciate its illusionism, but also openly confessed his stylistic debt, a rare
moment of sincere emulation in an age that championed unfettered originality. The
watercolors Demuth produced during his mature career often feel like meditations on
Cézanne, just as Cézanne's watercolors offer manifold and varied meditations on the
formal properties of art and observation.

Watercolor was an ideal medium in which to pursue Cézanne's legacy. Unbound
by the same expectations as oil in terms of finish and technique, watercolor permitted
greater latitude for innovation and experimentation. It had long been a medium of
choice for study, as artists worked out their ideas in anticipation of a more finished
composition in oil. Artists such as Cézanne and Auguste Rodin expanded on water-
color's unexplored potential, extending the immediacy and spontaneity that emerged
from Impressionism and adding to them an emphasis on form and structure. Modern-
ism had become a hydra during the first decade of the new century, however, as new
schools and styles emerged almost simultaneously. Artists claiming Cézanne's mantle
worked in an array of styles, many of which Demuth sampled for some period of time,
resulting in what his biographer Emily Farnham characterized as "his early amorphous,
formative style."[6] His consistent use of watercolor offers a unifying aspect to his early
career and brought him quickly under the influence of Cézanne, whose leadership as a
watercolorist was undisputed.

Demuth's move to Cézanne came during the mid-1910s and had been long in
the making. His experiences as a student at Philadelphia's Drexel Institute (1901–5)
and Pennsylvania Academy of the Fine Arts (1905–11), studying with Thomas Anshutz,
William Merritt Chase, Henry McCarter, and Hugh Breckenridge, introduced him
to Impressionist and Post-Impressionist aesthetics. Grounded in a range of styles and
academic training, Demuth enjoyed a thorough preparation that complemented the
cosmopolitan demeanor for which he was known. During an extended sojourn in
Paris in 1912–14, Demuth met Marsden Hartley, Marcel Duchamp, Gertrude Stein (a
fellow Pennsylvanian), and many others who brought him to keener awareness of con-
temporary developments. This was a new world for the young man from Lancaster,
Pennsylvania, and yet he took to it with poise and grace that endeared him to a broad
array of artists, collectors, patrons, and intellectuals and granted him ready entrée to
the avant-garde salons. Duchamp later recalled that Demuth was "one of the few artists
whom all other artists liked as a real friend, a rare case indeed."[7] On the surface, at
least, Demuth's sociability during the 1910s resembled Cézanne's isolation hardly at all.

Despite his easy sociability, Demuth was a perpetual outsider, a trait that may
have led him to identify personally with Cézanne. Lame since childhood, Demuth
walked with a cane, and he was diagnosed with diabetes in 1919. Although he was an
early beneficiary of the introduction of insulin, the young artist spent much of his
adult life coping with the illness. Demuth was also gay, which distanced him from
mainstream American society and socially acceptable intimacy. Although the artist was
fairly discreet about his sexuality, most of his friends and colleagues knew. Doubly
stigmatized as sickly and homosexual in an age that championed virile masculinity,
Demuth compensated by establishing a highly refined, distinguished persona with
which he deflected scrutiny. Demuth and Cézanne both stood outside of the main-
stream and lived outside of the urban artistic centers. Demuth chose to reside with his
mother in their family home in Lancaster, and Cézanne preferred the southern French

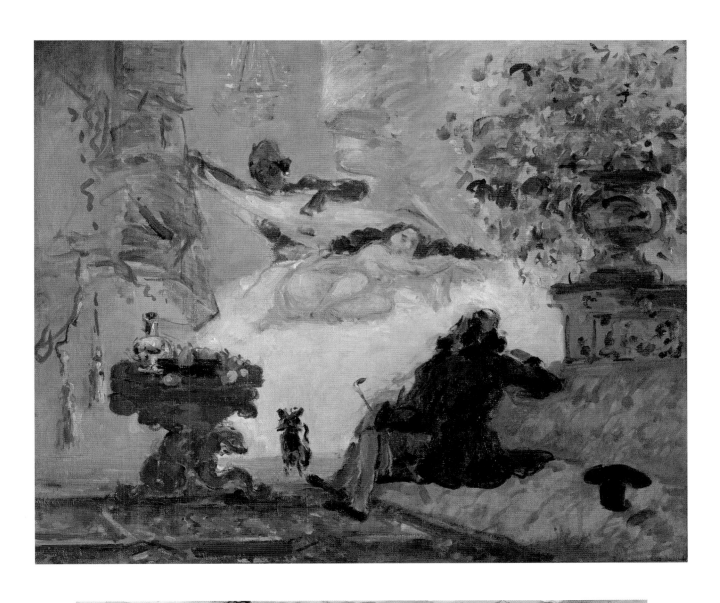

Fig. 10.5. **John Marin** (American, 1870–1953), *Tyrol at Kufstein,* 1910. Watercolor on paper, 15¼ x 18¼ inches (38.7 x 46.4 cm). The Metropolitan Museum of Art, New York. Alfred Stieglitz Collection, 49.70.106

community of Aix-en-Provence to the social life of Paris. Both men cultivated the role of detached observers, apart from society at large.

Demuth's early engagements with Cézanne were sporadic and varied, enmeshed in a broader exploration of style and meaning. Like Cézanne's, Demuth's early works often display striking passion and displacement of feeling into art. Demuth occasionally contended with Cézanne directly, adapting entire compositions from the French artist's early career. A substantive series of literary illustrations that Demuth created during the 1910s that are often counted among his greatest accomplishments at times also directly emulate well-known early Cézannes, including *A Modern Olympia* (fig. 10.3) and *Eternal Feminine* (c. 1877; now in the J. Paul Getty Museum, Los Angeles). In modified versions of Cézanne's works, Demuth borrowed their compositions, spirit, and dramatic impact and then transposed them onto literary sources that often date to Cézanne's own era and circle, including Émile Zola's novel *Nana* (1880). Demuth's *Count Muffat Discovers Nana with the Marquess de Chouard* (fig. 10.4) and *Nana and Her Men* (1916; now in the Barnes Foundation, Merion, Pennsylvania) are his versions, respectively, of the above-mentioned Cézannes, using heavy pencil lines and lurid color to enhance the emotional intensity of the scenes. These illustrations were part of a larger series, and Cézanne was only one of several sources to whom Demuth looked for inspiration.[8] Nevertheless, as part of Demuth's evolving interaction with Cézanne, they mark a key engagement of both substance and style. The scenes that Demuth chose to borrow at this point in his career are powerful, symbolic works, not at all the cool, studied experiments to which he would later turn for inspiration. Like Cézanne, Demuth worked through an overtly passionate vein in his work before turning inward.

In his memorial to Demuth, Marsden Hartley later remembered his friend as a man of the 1890s: "I always felt that Charles's special personal tone had been formed with this period."[9] Curator James Thrall Soby, in one of the most insightful studies of Demuth's work, further observed that "time and again in viewing Demuth's figure pieces a *fin de siècle* reminiscence suggests itself."[10] As Demuth traversed this phase of

Victorian retrospection, he examined the late nineteenth century's precedents and preoccupations, melding literary and artistic movements—Cézanne and Zola, Henri Toulouse-Lautrec and Henry James—into a dynamic form of reading as interpretation rather than illustration. The illustrations offer a suggestive corollary to the active looking as a means of artistic practice extolled by Cézanne. To Hartley's eye, "the transition from the earlier, superiorly illustrative subjects [in Demuth's work] to the later, cubistically evolved realistic pictures, is all one thing, and there is, therefore, a natural sequence in his product."[11]

In the salons, studios, and cafés that Demuth frequented in Paris and New York, he joined the artistic and literary intelligentsia of his day. At the apartments of the Steins in Paris and Walter and Louise Arensberg in New York, Demuth would have enjoyed extended exposure to the art and legacy of Cézanne. He also encountered Cézanne at Alfred Stieglitz's gallery, 291, which held monographic exhibitions of Cézanne's watercolors in 1911 and 1914, even as new publications and favorable criticism of the artist's work expanded awareness of his accomplishments among American audiences. Cézanne's inclusion in exhibitions and major collections to which Demuth had access offered regular reminders of the esteemed position Cézanne held in the eyes of his contemporaries.

Among the first works that Demuth exhibited upon his return to the United States in 1914 was a series of watercolors of the sand dunes of Provincetown, Massachusetts, where he spent that summer. In this series, which includes *Mt. Gilboa #5* (plate 93), the artist displays a layered awareness of Cézanne as well as Cézanne's influence on another of Demuth's early heroes, John Marin, in works such as *Tyrol at Kufstein* (fig. 10.5). While Demuth's proximate debt to Marin is demonstrated by his acidic palette and dynamic brushwork, *Mt. Gilboa #5* equally looks back to the monumentality of form and underlying geometric structure in nature that had distinguished Cézanne's depictions of his beloved Mont Sainte-Victoire. Demuth likely knew a comparable watercolor (fig. 10.6) from his visits to the apartment of Gertrude and Leo Stein

Fig. 10.7. **Charles Demuth, *Bermuda Landscape #2*,** 1917. Watercolor and graphite on wove paper, 10 x 14 inches (25.4 x 35.6 cm). The Barnes Collection, Merion, Pennsylvania

in Paris during his first sojourn in Paris in 1907–8.[12] Demuth's emphasis on the contour of the soaring peak, transparent washes, structured brushstrokes, and faceting of the mountainside demonstrate a debt to Cézanne, perhaps more even than to Marin.

Denis's account of the Cézanne question helps to resolve the seemingly disparate alliance of Marin and Demuth in Gallatin's vision of watercolor's "new tradition." Writing at roughly the midpoint of Demuth's career, Gallatin was biased toward the artist's beginnings, which Marin had greatly influenced.[13] Demuth had struggled with his early debt to Marin as he sought his own place in the art market during the early 1910s. In 1914, when he first approached Alfred Stieglitz in hopes of representation at 291, Demuth was reportedly rebuffed because his work was so close to Marin's, a view shared by critic Henry McBride in that same year.[14] Demuth would instead be represented by the gallery of Charles Daniel, perhaps Stieglitz's closest competitor in New York, with almost yearly solo exhibitions between 1914 and 1923.[15] Demuth's early stylistic affinity to Marin relegated him to the borders of the Stieglitz circle for much of his career.[16]

By early 1917, however, Demuth had set a new artistic course. During a month and a half spent with Hartley in Bermuda, Demuth developed a Cubist-inspired vocabulary of line and form that established his mature aesthetic in a series of watercolors, including his *Bermuda Landscape #2* (fig. 10.7), that he later described as "maybe the best of any of my 'times.'"[17] The sloping countryside, waterfront towns, intense sunlight, and brightly colored architecture of Bermuda echoed the subjects that Cézanne had explored from his home in Aix-en-Provence, and the French painter's influence is apparent in Demuth's Bermuda scenes. In *Bermuda* (plate 94), for example, Demuth explored the strict geometries of the island's low houses below a framing arc of tree limbs in view of a distant mountain peak that is immediately reminiscent of Cézanne's series showing Mont Sainte-Victoire in the distance (fig. 10.8). The intercombination of natural and man-made forms was a recurring theme in Demuth's Bermuda watercolors, but here it is shown in a more schematic, proto-Cubist style that is unusual for the

Fig. 10.8. **Paul Cézanne, *Mont Sainte-Victoire*,** c. 1883–87. Watercolor over graphite, heightened with white gouache, on buff wove paper; 13¹⁵⁄₁₆ x 21⅛ inches (35.4 x 53.7 cm). The Art Institute of Chicago. Gift of Marshall Field, IV. 1964.199

series and suggests a starting point for his explorations. Reminiscent of Georges Braque's early experiments of 1907–9 (see fig. 9.2) with their wan palette, framing trees, and climbing tiles of architectural forms, Demuth's *Bermuda* illustrates the continued vitality of Cézanne's influence, even as it suggests a way forward for Demuth.

When juxtaposed with his other Bermuda landscapes, such as *Trees and Barns: Bermuda* (plate 96) and *Red-Roofed Houses* (plate 98), the pale washes and strict geometries of *Bermuda* suggest a somewhat different project. *Bermuda* is a rare crossover between the more abstracted, fragmentary views identified with Demuth's later Precisionist scenes and the lush sensuality of his flower and vegetable watercolor still lifes. The difference in palette, design, and feeling is dramatic. The keynote red of *Red-Roofed Houses* sustains a vivid accent of color and emotion in the midst of a more subdued landscape, whereas *Bermuda* offers a more prominent sense of compositional experimentation, constructing forms and patterns rather than detailing a view that he observed. Demuth's artistic project diverged in these Bermuda landscapes, but both paths—the expressive and the formal—pursued aspects of Cézanne's complex legacy.

The concepts that Demuth explored in Bermuda are apparent among Cézanne's watercolor landscapes shown at the Montross Gallery in New York in 1916, which likely provided a catalyst for Demuth's change in style. Cézanne's *House among the Trees* (plate 95) and *Landscape with House and Roof* (plate 97), for example, both incorporate the element of contrast between natural and architectural forms, though in a far less saturated palette than in Demuth's work. Color is nevertheless a significant dimension in both, particularly contributing to the bucolic sensibility of *House among the Trees.* The two watercolors contrast well, one dominated by tree trunks, the other by roof forms. A related balance is evident between Demuth's *Trees and Barns* and *Red-Roofed Houses.* The radiating trunk in the foreground of *Trees and Barns* extends throughout the composition, gracefully unifying its otherwise disparate planes. The knot of trees in Cézanne's *House among the Trees,* though less mannered, functions similarly. In *Bermuda,* Demuth joined Cézanne's project, adding blotting, pooling, and gridding to

Fig. 10.9. **Charles Demuth,** ***Bermuda: Rooftops through Trees,*** 1917. Watercolor with graphite under-drawing on wove paper, 10 x 14 inches (25.4 x 35.6 cm). The Barnes Foundation, Merion, Pennsylvania

the technical repertoire that Cézanne used to modulate and explore watercolor's intrinsic properties of fluidity and transparency.

The connections between these works were observed by Demuth's contemporaries. Philadelphia-area collector Albert Barnes, with whom Demuth had a supportive relationship, installed Demuth's *Bermuda: Rooftops through Trees* (fig. 10.9) along with Cézanne's *Trees* (fig. 10.10) in his private gallery, creating a direct dialogue of which Demuth himself may have been aware, if not an advocate.[18] The sinuous embrace of branches across Demuth's composition relates to his *Trees and Barns* but here is even more expansive, echoing both the overarch of limbs in *Bermuda* as well as an underarch similar to that found in *Trees and Barns,* between which roof structures are visible. In Cézanne's *Trees* the trunks and limbs have a degree of curvature and movement that is unusual for the artist but makes an insightful comparison in which Demuth's work was read back into conversation with Cézanne.

Context is significant here. Demuth introduced his watercolor landscapes of Bermuda into a heated atmosphere of admiration for Cézanne and ambivalence toward his successors, most notably Picasso and Braque. Barnes, Demuth's patron, sparked debate by criticizing the Cubists for hollow repetition, "dissecting out the pattern" from Cézanne to "reduce his design to a skeleton that never takes on the flesh and blood of a living body."[19] The bulk of Demuth's watercolors from this series favor the vivid palette and compositional complexity of *Trees and Barns,* which reaches back to Cézanne more directly than his more conceptual, abstracted *Bermuda.* In a letter to Barnes, Demuth admired Cézanne's landscapes for capturing "the excitement of the out doors," an intensity more readily observed in Demuth's own work than in Cézanne's.[20] Seven years later, in 1924, when Stieglitz at last agreed to represent Demuth, the artist gave him a similar watercolor, *Bermuda No. 1, Tree and Houses* (1917; The Metropolitan Museum of Art, New York). Coming years after the work was created, the gift suggests a memento of the transition that established Demuth's mature vision and eventually brought him fully into Stieglitz's circle.

Fig. 10.10. **Paul Cézanne, _Trees_,** c. 1900. Graphite and watercolor on white paper, 12 x 18½ inches (30.5 x 47 cm). The Barnes Foundation, Merion, Pennsylvania

Framing Cézanne

Beginning with the Bermuda landscapes and other works from 1916–17, Cézanne became "unquestionably" Demuth's foremost inspiration.[21] For the young Demuth, that shift represented a return to fundamentals, demonstrating that Cubism, which had come to the fore since Cézanne's death and in his footsteps, "could speak in whispers with extraordinary wit and delicacy."[22] Like art historians and critics of his day, Demuth perceived modernism's progress in evolutionary terms and wanted to prevent, as he put it, his "'wheels' [from] going around backwards."[23] In his reinvigoration of Cézanne, Demuth could claim a shared source with his contemporaries even as he charted a different aesthetic course toward poignant sensuality—a mode all his own. His new style coincided with his discovery by the critics and their favorable appreciation of his work.

Demuth's creative encounter with Cézanne would reach a new level in his still lifes beginning in the later 1910s. Just as Demuth had found harmony with Cézanne's Aix-en-Provence in the landscapes of Bermuda and Provincetown, so too he was able to domesticate French still life to his own surroundings "in the province"—_en Provence_—as he liked to refer to Lancaster.[24] In a series of watercolors of flowers, fruits, and vegetables begun in 1917 and continuing until 1933—the full span of his mature career—Demuth experimented with a wide range of formal properties, including positive and negative space, pattern, color, line, and symmetry, as well as more subjective themes such as feeling and sensual allusion. In still life, Demuth found a genre that offered endless variety, and one which he could invest with a unique degree of expression. The sensitivity of Demuth's light, fluid pencil contours in concert with his evocative, often intense palette led Soby to the eloquent characterization of Demuth's innate understanding of "the exact strength of fragility."[25]

During this transition, Demuth also embarked on a series of watercolors depicting vaudeville and circus subjects that provide a bridge to his signature still lifes. These

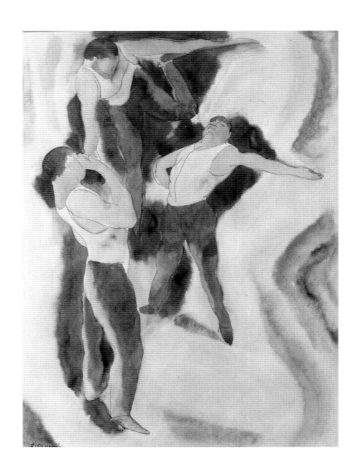

Fig. 10.11. **Charles Demuth, *In Vaudeville,*** c. 1916.
Watercolor and graphite on thin off-white wove paper,
10⅞ x 8⁷⁄₁₆ inches (27.7 x 21.4 cm). Harvard University Art
Museums. Fogg Art Museum. Gift of Mrs. Burton
Tremaine, Jr., 1949.10

works balance the expressiveness of his literary illustrations with the experiments
in form and composition that became his primary emphasis. In works such as *In
Vaudeville* (fig. 10.11), his acrobats, musicians, dancers, and gymnasts contort and bal-
ance a languid mannerism against abstract, spotlit backdrops.[26] As Cézanne did in his
career-long Bathers series, Demuth explored the human body as a source of inspiration,
one that resonated with his formal experiments in both still life and landscape. For
both artists, the structure and complexity of the human body offered limitless variation
and expressive potential; in Demuth's case, this exploration was balanced with a vibrant
palette to emphasize abstract structure. Demuth, however, would render overt the pre-
viously tacit parallels among the genres that recurred in both artists' work.

In 1922, writing about Cézanne's legacy, critic Clive Bell employed an apt simile:
"A work of art is like a rose. A rose is not beautiful because it is like something else.
Neither is a work of art. Roses and works of art are beautiful in themselves."[27] Cézanne's
and Demuth's roses bear out Bell's description, confounding the flowers' celebrated
beauty in order to call attention to their medium, rather than to their subject. Cézanne's
Rose in the Greenery (plate 99) and Demuth's *Orange Tree and Primrose* (plate 92) both
create a centralized vignette, building the secondary foliage and its cast shadows as a
silhouetted backdrop for a rose drained of color. Roses' romantic symbolism, rich color,
and elegant form render them almost banal, so well known are their received meanings.
Cézanne and Demuth contradict the viewer's expectations by inverting positive and
negative, subject and backdrop, creating their roses in silhouette and using the pattern
of background leaves as the subject of their compositions. Cézanne's foliage takes a
further step toward abstraction with its individual, diaphanous brushstrokes faceting
the background foliage beyond the description of separate leaves. Cézanne's rose has
only a hint of color and the lightest description of petals in otherwise undefined space.
If not for the tendril of the rose's stem and paralleling verticals emerging in the back-
ground to organize and orient the composition, it would consist almost exclusively of
abstract brushwork.

Fig. 10.12. **Paul Cézanne, *Apples and Pears*,** c. 1882–85. Watercolor and graphite on white paper, 9⅞ x 12⅝ inches (25.1 x 32.1 cm). Collection of Mrs. Alexander M. Lewyt, New York

Demuth's *Orange Tree and Primrose*—a subject he likely borrowed from his mother's garden—compares closely to Cézanne's *Rose.* He silhouettes a rose with an orange tree, and similarly inverts positive and negative. In Demuth's composition, however, detailed naturalism remains integral. His drawing is crisp, controlled, and defining. The leaves of Demuth's orange tree are modulated in color and modeled in structure, like the round form of the orange on the left. Demuth has taken Cézanne's experiment and given it a more finished form. He endows it with a sense of authority and control well beyond what Cézanne initiated, elevating Cézanne's aesthetic and essentially codifying his informality. Six years after *Orange Tree,* Demuth offered an even fuller conception in his *Roses* (plate 100), in which the flowers' saturated color and dynamic forms are juxtaposed with an unpainted flower at the lower right, present only in contour. Demuth adopts Cézanne's play and formalizes it within a naturalistic framework of sensual realism. By Demuth's time, critics and collectors—if not the general public—had learned to appreciate Cézanne's attention to the process of art itself, enabling Demuth to move beyond their shared experimental technique more deeply into its expressive potential.

Certainly, both artists were interested in the essential. Demuth's *Three Red Apples* (plate 102) reduces forms to their basic elements. Cézanne's *Oranges on a Plate* (plate 101) likewise records the balance among geometric shapes. In Cézanne's *Apples and Pears* (fig. 10.12), by contrast, contours are heavily worked and seemingly agitated, generalizing the fruits' shapes in search of their interactions, rather than their individuality. Cézanne's brushwork and application of color to his fruit are idiosyncratic—the highlights bleach entirely, while the shadows are more saturated, rather than darker. There is a deliberate maladroitness to Cézanne's *Apples and Pears,* showing process, whereas Demuth's *Three Red Apples* is flawless, like a textbook lesson in the stages of constructing a form, building from contour to broad surface treatment to a complete form that includes the apples' stems. By the later 1920s, Demuth was a conceptualist illustrating the mechanics of art, rather than a pioneer struggling to make sense of his medium.

Studies of Demuth's life and art generally mention Cézanne's influence only in passing, though always with emphasis on its importance. Close stylistic affinity is observed in the unfinished quality of both artists' compositions, the transparency of their washes, the lyricism of their palettes, and the use of untouched expanses of paper as a foil for their attention to surface.[28] Beyond similarities in style, however, Cézanne also offered Demuth a medium for sensuality, a subtle subtext of both men's work that was regularly overlooked during Demuth's era. Cézanne's brand of modernism was characterized as classical by critics of Demuth's generation, particularly Walter Pach. Similarly, Cézanne's interests in structure, geometry, and form led critics such as Willard Huntington Wright to admire the stoicism of his work as "without adjectives, adverbs or participles," a prevailing impression that few contradicted.[29] Demuth's art too was described by contemporaries as cool and distant, even scientific, but his saturated palette and sinuous contours tell a different story. Writing in 1932, the art historian Alfred Vance Churchill was among the few who clarified the meaning of Cézanne's famed "petite sensation," often mistakenly cited as the basis of the artist's coolness, as "the exact opposite of what it says. 'Little' here stands for great, or deep."[30]

Demuth's exceptional control of his medium perplexed and unsettled the artist's critics, as well as his friends. Whereas Georgia O'Keeffe, who claimed Demuth among her closest artist friends, sought the passionate core behind the seemingly cool objectivity on the surface of Demuth's works, McBride, at the other end of the spectrum, pondered the artist's intensity that to him suggested "an inward rage."[31] Critic Carl Van Vechten agreed with McBride: "How beautiful and how terrible the flowers: daisies with cabalistic secrets, cyclamens rosy with vice, orchids wet with the mystery of the Rosicrucians!"[32] The paucity of Demuth's own words about his art only enhanced his mystery. The allusion and innuendo in Cézanne's work became more pronounced in Demuth's as his degree of finish submerged questions of formal experimentation in favor of symbolic suggestion. The veiled symbolism of Demuth's flowers, so eloquent in their sensuality yet incomplete in meaning, transcended Cézanne's example, but also revised it and drew attention to subject matter in Cézanne's own work where critics otherwise focused primarily on technique.

In 1929, the same year in which he painted the *Three Apples,* Demuth created his exceptional *Green Pears* (plate 104), which sheds as much light on Cézanne as it does on Demuth himself. The seven pears can only be said to recline like human figures, their mannerist contours appealing to the viewer's sense of touch. The completeness, even perfection, of the pears' conception is impressive, as is the porcelain surface of the overturned bowl on and against which they lean. As with many of his later still lifes, the hardness of Demuth's pears and bowl was the basis on which he was endowed by critics with the "classical" rubric often associated with Cézanne. Gallatin himself characterized Demuth's fruits and vegetables as "very cool" and lacking the "passion which Cézanne put into an apple. . . . This is not voluptuous fruit: it comes from a country whose *vin du paye* [sic] is iced water."[33]

Pears were a recurring theme in Cézanne's art, and Demuth's *Green Pears* owes much to the example of Cézanne's *Still Life with Three Pears* (plate 105) and *Three Pears* (plate 103). The plate in the latter, although not overturned, plays a related organizing role, with the pears radiating outward from it. The bowl in Demuth's composition appears to repel the pears, rather than embrace them as in Cézanne's work. Nevertheless, it offers a central element that defines their space and interaction. Cézanne's *Still Life with Three Pears* is a more essentialized rendering, akin to Demuth's *Three Red Apples,* but the curious asymmetry of their upright pose contrasts with the fully supine

Three Pears. The integration of formal experiment with sensual bodily allusion closely aligns their work in this genre.

Contemporary critics seemed split in their awareness of the subtext of deep feeling and tactile sensuality in both artists' works. It awaited the insight of art historian Meyer Schapiro in 1968 to reveal irreversibly the "emotional ground" of Cézanne's still lifes as well as "the association here of fruit and nudity."[34] In a rare, undated moment of candor that was never published, Demuth substantiated the relationship between "forms and body forms" in art as those "which always seem about to become completely recognizible [*sic*] but which gain an intensity by not; formes [*sic*] which always seem about to become sexed but continue to dally."[35] In a related spirit, he wrote to Stieglitz in 1923 about an eggplant in one of his watercolors, likely similar to the one in *Eggplant and Green Pepper* (plate 106), as "a heart; — maybe mine."[36] Demuth set the stage for Schapiro's reading of Cézanne's art in which "fruit is a natural analogue of ripe human beauty."[37]

Cézanne offered Demuth a poetic structure to explore and elaborate, which he did with particular success in the genre of still life. In his memorial to Demuth, Marsden Hartley noted what he called Demuth's "spiraling imagination." Although the observation could be construed as criticism, Hartley's remark conveys instead his awareness of Demuth's deep probing of a subject's potential over time within a given set of formal constraints. Perhaps better than any other artist of the period, Demuth understood not only Cézanne's stylistic project in watercolor, but also his expressive one. Demuth had traveled a road similar to Cézanne's, from the ardent, sometimes violent narrative scenes he created early in his career to cooler abstractions from nature in landscape and still life. At the end of his life, Demuth's passion reemerged in a series of highly erotic watercolors. The work between these two passionate phases was created by the same artist, and to view his landscapes and still lifes without appreciating their expressive allusion neglects the source of their "exact strength" as well as a critical dimension of Cézanne's "new tradition."

How can we make sense of such an eclectic, contrarian artist as Demuth? The answer may lie in part in the depth of his relationship with Cézanne. The ambivalence about debt has challenged writers on Demuth since his death, as when the well-intentioned James W. Lane observed defensively: "From Cézanne he may have learned his method of building up the tone on the surfaces of fruit, but he was not Cézannesque, for his things are finished and elegant, they have more *hauteur* than Cézanne's, and in the design there is more rhythm."[38] Demuth would have been less apologetic. He owed much to Cézanne, but he also looked deeply into Cézanne's work, picking up themes and styles that his contemporaries had not yet observed, or at least had not addressed. He thereby obeyed his own dictum: "Paintings must be looked at and looked at—they, I think, the good ones, like it."[39]

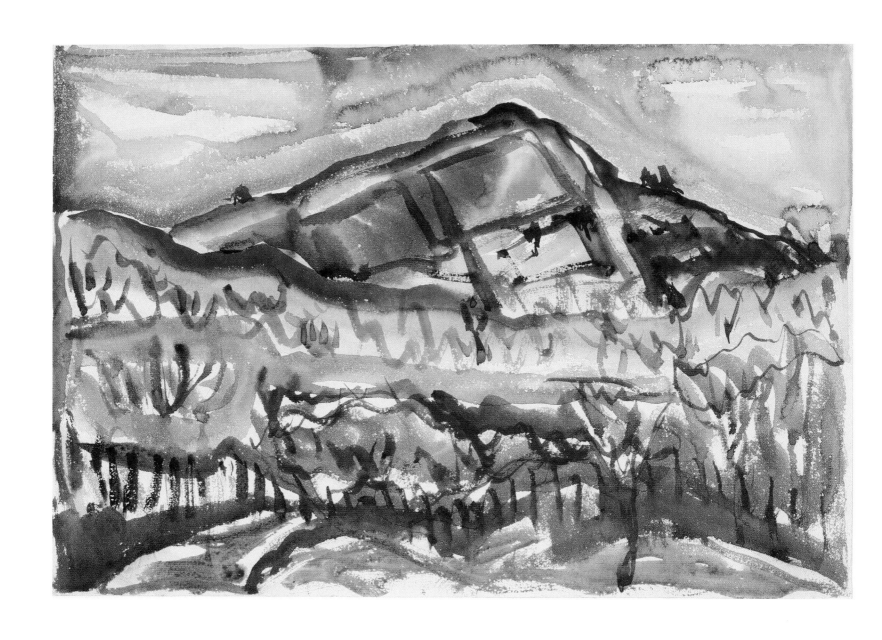

PLATE 93

Charles Demuth

Mt. Gilboa #5, c. 1914–15

Pencil and watercolor on paper
10 x 14 inches (25.4 x 35.5 cm)
Hirshhorn Museum and Sculpture Garden.
Smithsonian Institution, Washington, DC. Gift of
Joseph H. Hirshhorn, 1966, 66.1318

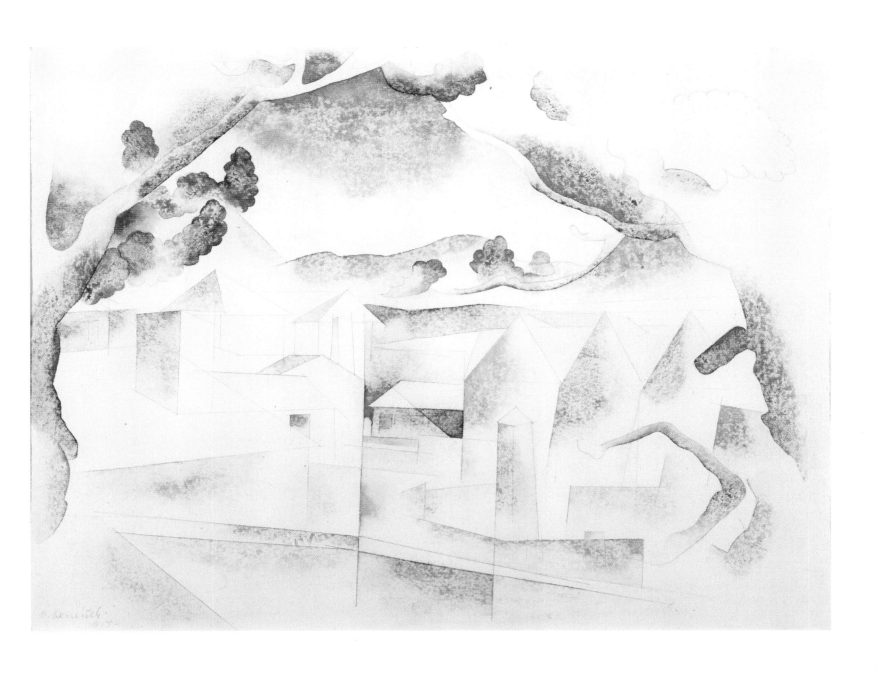

Charles Demuth

Bermuda, 1917

Watercolor and graphite on off-white wove paper
10 x 14 inches (25.4 x 35.6 cm)
Philadelphia Museum of Art. The Louise and Walter
Arensberg Collection, 1950-134-44

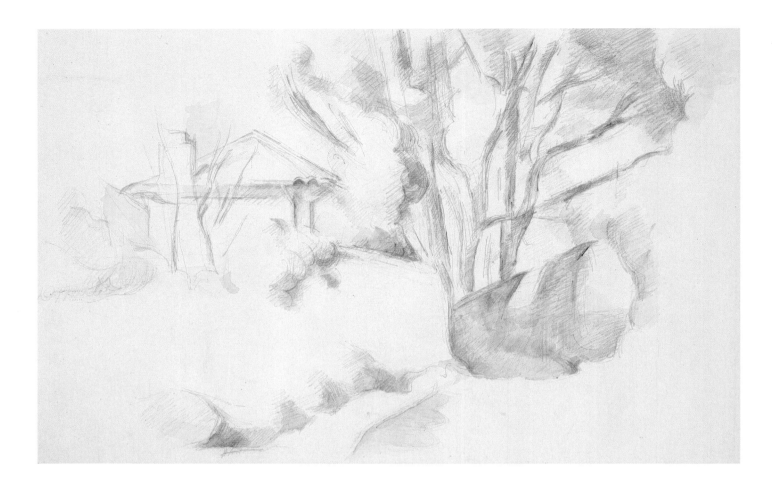

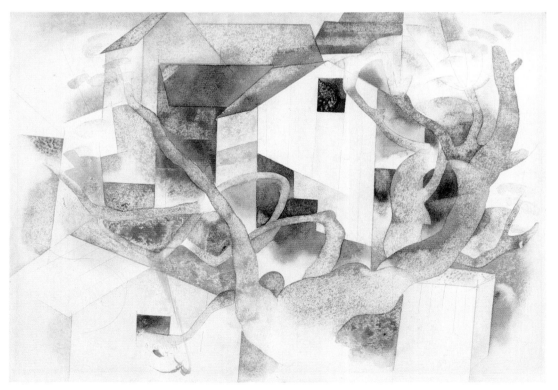

PLATE 95

Paul Cézanne

House among the Trees, c. 1890–95

Pencil and watercolor on white paper
12⅞ x 19¾ inches (32.7 x 50.2 cm)
Private collection, Germany

PLATE 96

Charles Demuth

Trees and Barns: Bermuda, 1917

Watercolor over pencil on paper
9½ x 13½ inches (24.1 x 34.3 cm)
Williams College Museum of Art, Williamstown,
Massachusetts. Bequest of Susan W. Street, 57.8

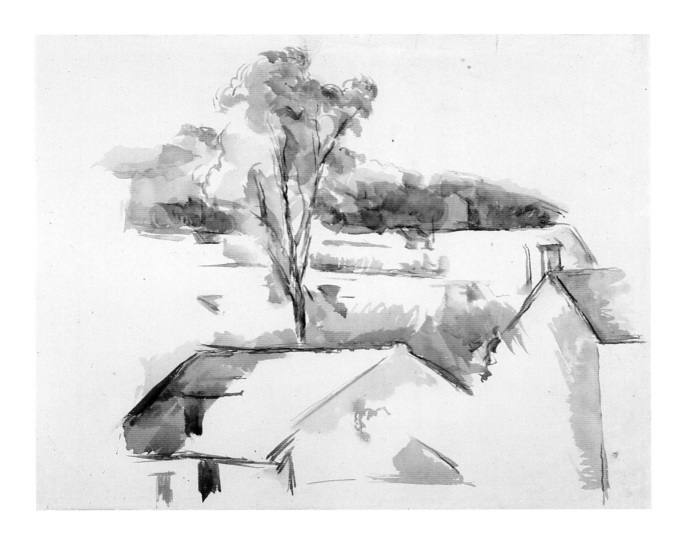

PLATE 97

Paul Cézanne

Landscape with House and Roof, 1882–83

Pencil and watercolor on white paper
15¾ x 17⅞ inches (32.5 x 40 cm)
Museum Boijmans Van Beuningen, Rotterdam.
Koenigs Collection, inv. no. F II 213 (PK)

PLATE 98

Charles Demuth

Red-Roofed Houses, 1917

Watercolor and pencil on thick off-white wove paper
9¾ x 14 inches (24.8 x 35.6 inches)
Philadelphia Museum of Art. The Samuel S. White 3rd
and Vera White Collection, 1967-30-25

PLATE 99

Paul Cézanne

Rose in the Greenery, 1895–1900

Pencil and watercolor on white paper
18¾ x 12¼ inches (47.6 x 31.1 cm)
Collection of Judy and Michael Steinhardt, New York

PLATE 100

Charles Demuth

Roses, 1926

Watercolor over graphite on paper
11½ x 16¾ inches (29.2 x 42.5 cm)
Museum of Fine Arts, Boston. Bequest of John T.
Spaulding, 48.766

PLATE 101

Paul Cézanne

Oranges on a Plate, c. 1900

Watercolor and graphite on paper
11⅝ x 17⅞ inches (29.5 x 45.4 cm)
Philadelphia Museum of Art. The Mr. and Mrs.
Carroll S. Tyson, Jr., Collection, 1963-116-20

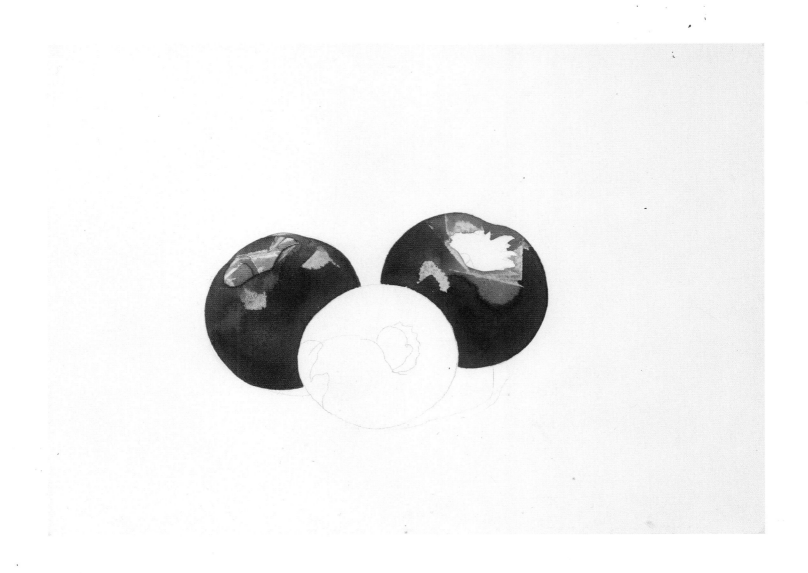

PLATE 102

Charles Demuth

Three Red Apples, c. 1929

Watercolor and pencil on paper
10 x 14 inches (25.4 x 35.6 cm)
Debra Force Fine Art, New York

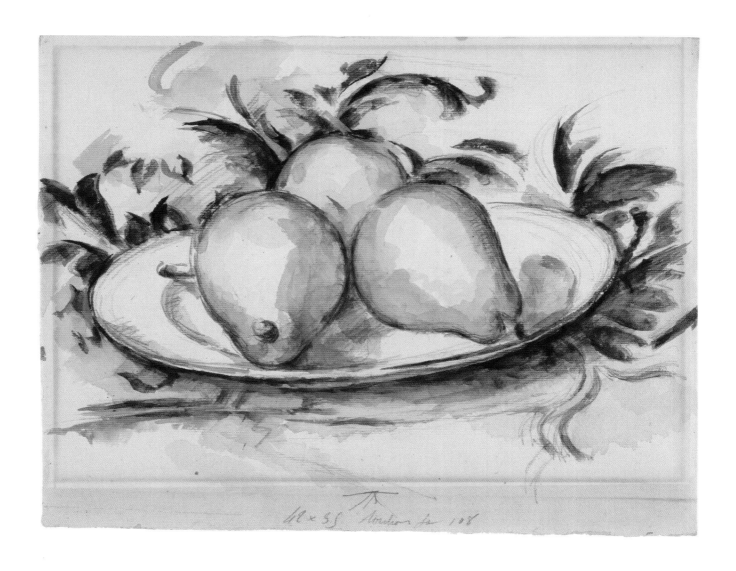

PLATE 103

Paul Cézanne

Three Pears, c. 1888–90

Watercolor, gouache, and graphite on
cream laid paper
9⁹⁄₁₆ x 12¼ inches (24.2 x 31 cm)
The Henry and Rose Pearlman Foundation; on long-
term loan to the Princeton University Art Museum

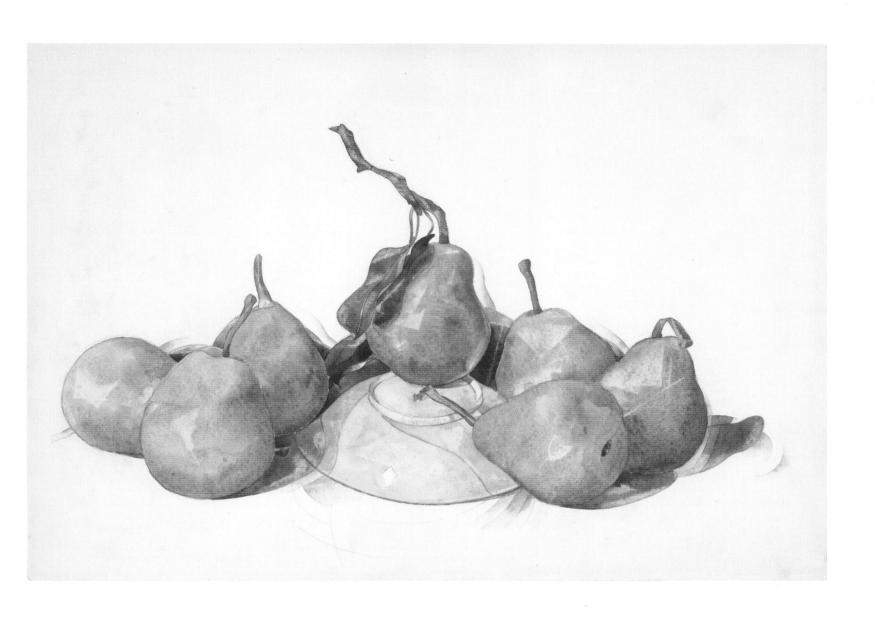

Charles Demuth

Green Pears, 1929

Watercolor over graphite on paper
13⅞ x 19⅞ inches (35.2 x 50.5 cm)
Yale University Art Gallery, New Haven, Connecticut.
Philip L. Goodwin, B.A. 1907, Collection, Gift of
James L. Goodwin, B.A. 1905, Henry Sage Goodwin,
B.A. 1927, and Richmond L. Brown, B.A. 1907

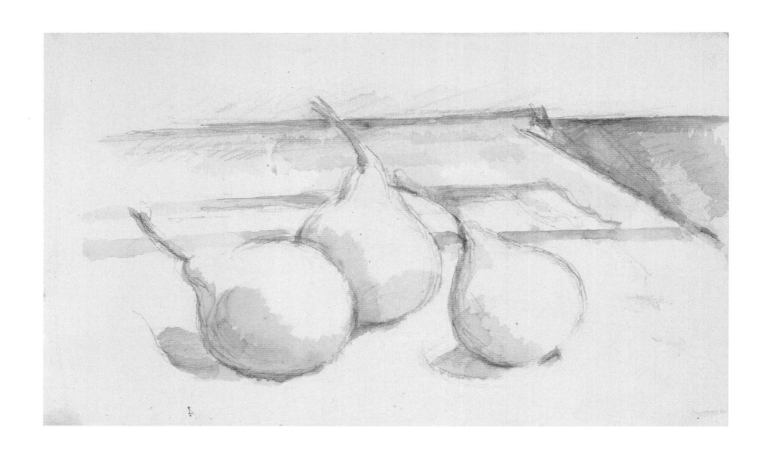

PLATE 105

Paul Cézanne

***Still Life with Three Pears*, 1880–82**

Pencil and watercolor on paper
5 x 8¼ inches (12.6 x 20.8 cm)
Museum Boijmans Van Beuningen, Rotterdam.
Koenigs Collection, inv. no. F II 210 (PK)

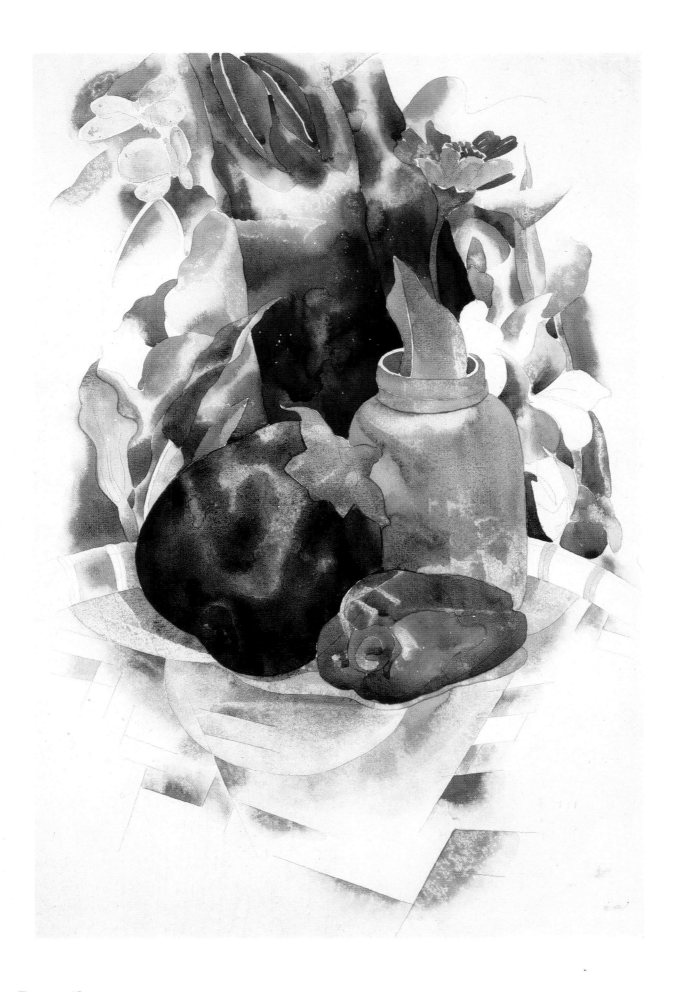

PLATE 106

Charles Demuth

Eggplant and Green Pepper, 1925

Watercolor and pencil on paper
18 x 11¹⁵⁄₁₆ inches (45.7 x 30.3 cm)
Saint Louis Art Museum. Eliza McMillan Trust

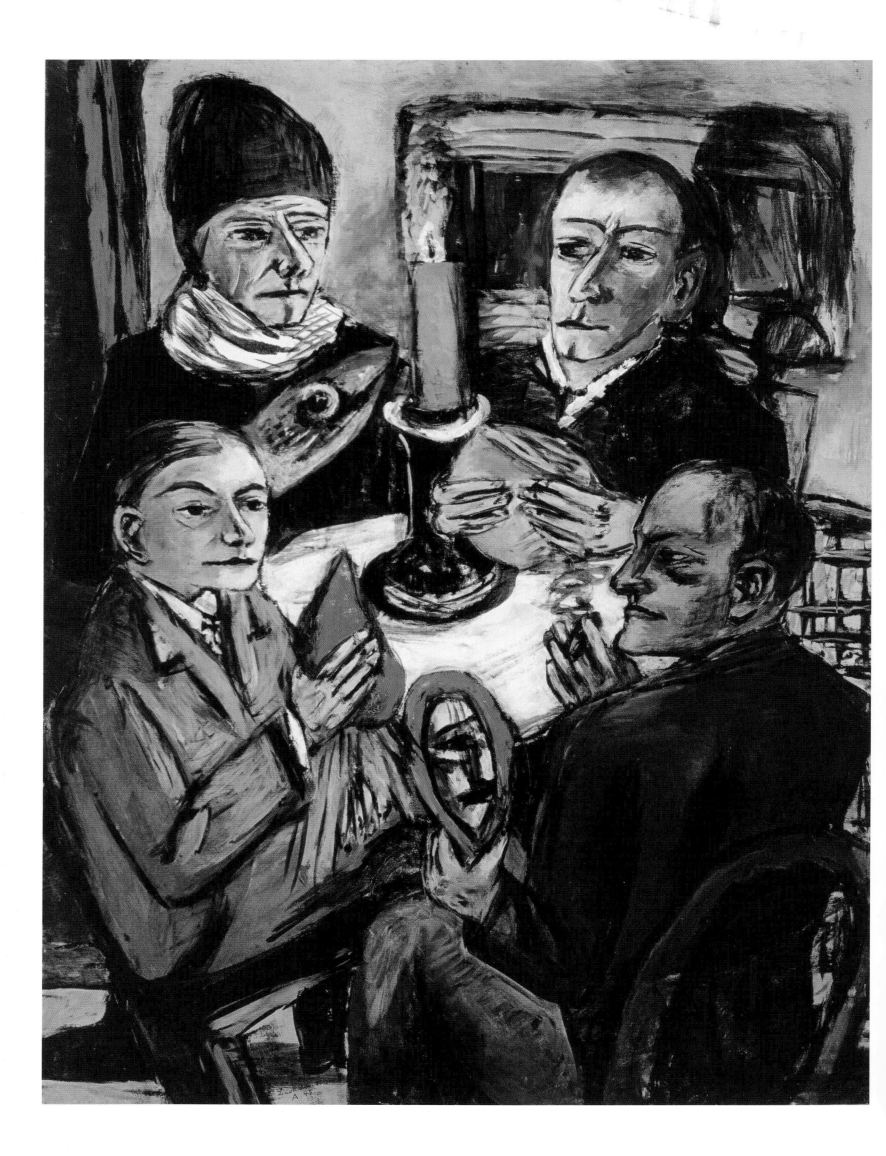

Cézanne and Beckmann: "A Powerful New Pictorial Architecture"

Anabelle Kienle

I must refer you to Cézanne again and again.
—MAX BECKMANN (1948)

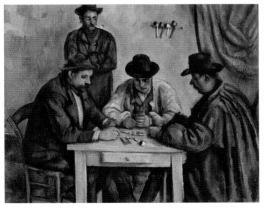

Paul Cézanne, *The Card Players*, 1890–92
(plate 210, p. 528)

In early 1948, in response to an invitation from Stephens College in Columbia, Missouri, the German painter Max Beckmann (1884–1950) wrote a lecture titled "Letters to a Woman Painter." Beckmann, who then held a senior teaching position at Washington University in nearby Saint Louis, sat in the audience at the women's college while his wife Mathilde, nicknamed "Quappi," delivered the lecture in English. It was so well received that the artist was subsequently asked to present it at other colleges and art schools across the country.[1] This event came at a pivotal moment in Beckmann's career: After being defamed by the National Socialists as a "degenerate artist" in 1933 and spending a decade in exile in Amsterdam, he found himself back in the spotlight.[2] With his first U.S. retrospective on the horizon at the City Art Museum of Saint Louis,[3] Beckmann wanted to establish himself in America among other leading international artists, notably Henri Matisse and Pablo Picasso, whose New World success Beckmann coveted.

"Letters to a Woman Painter" was Beckmann's strategic response to this new terrain, in which he sought to present himself as a worldly and connected figure. His imaginary addressee, a naive young woman who seeks the mature artist's counsel, becomes a Rilkean foil to whom he can expound his artistic credo. In the first two letters, Beckmann reflects upon the necessity of delving deeply into the nature of things to arrive at what he calls a "higher reality," which can only be achieved by showing "the deepest respect for what the eye sees and for its representation on the area of the picture in height, width and depth."[4] In the second letter, he goes on to

discuss one of the principal dangers of painting, that of unreasonable absorption, which any artist might feel compelled to "plunge headlong into," when what is called for is a state of "disciplined intoxication."[5] Both comments resonate with Beckmann's image of Cézanne, who repeatedly said that he only painted what the eye saw, and who had abandoned the subjective fantasies of his youth in favor of a more disciplined approach.

While the first two letters reflect Beckmann's personal vision, the third addresses his artistic heroes — a line of masters that culminates in Cézanne, who for Beckmann represented an exemplary synthesis of objectivity and absorption, analysis and intuition, structure and sensuousness. He opens the final lesson by saying, "I must refer you to Cézanne again and again,"[6] and the French painter was a constant point of reference for Beckmann throughout his career. In the early years, Beckmann made frequent mention of Cézanne in diary entries, letters, and public statements. Later, as his intellectual and artistic engagement with Cézanne's work became subtler and more refined, his appreciation continued to grow and influence his own art.

As with any ambitious artist, Beckmann wanted to be seen in a lineage of great painters, and for him Cézanne had achieved things that every notable painter had to countenance: artistic objectivity, discipline, vital engagement with subject, and an honest, unmediated technique. While these qualities linked Cézanne with the old masters, he had also left the new generation with a legacy, indicating a way forward that Beckmann felt destined to continue. Beckmann's artistic pantheon was extensive — Vincent van Gogh, for example, was another fixed star in his artistic universe — but Cézanne figures at the forefront. As Beckmann put it, Cézanne had

> succeeded in creating an exalted Courbet, a mysterious Pissarro, and finally a powerful new pictorial architecture in which he really became the last old master, or I might better say he became the first "new master" who stands synonymous with Piero della Francesca, Uccello, Grünewald, Orcagna, Titian, El Greco, Goya, and van Gogh. Or, looking at quite a different side, take the old magicians. Hieronymus Bosch, Rembrandt, and as a fantastic blossom from dry old England, William Blake, and you have quite a nice group of friends who can accompany you on your thorny way, the way of escape from the human passion into the fantasy palace of art.[7]

Here Beckmann traces a distilled trajectory of Cézanne's development: the early figurative paintings are Courbet with exaltation; the early landscapes add an essential dimension to the lessons of Pissarro; and with the "powerful new pictorial architecture" he developed later in his career Cézanne surpasses the Impressionists, breaking free of the traditional distinctions within painting through controlled synthesis of design, color, and painterly expression. Beckmann's aim was to carry on this succession, through the gateway Cézanne had opened for the new generation.

Beckmann's admiration for Cézanne can be traced to the fall of 1903, when the nineteen-year-old graduate from the Weimar art academy decided to study in Paris. In October Beckmann moved to the French capital and rented a studio in the rue Notre-Dame-des-Champs. He later wrote to the German art critic Julius Meier-Graefe, "As early as 1903, Cézanne was my greatest love and still is when I think of French art."[8] Until then, Beckmann had known Cézanne's work only from reproductions; in Paris, he had the opportunity to see the actual paintings. At that time, to see Cézanne's work one had to visit commercial galleries, since the reclusive artist — though widely admired among the Parisian avant-garde — was not prominently represented in public institutions. In one of his diary entries Beckmann jotted down the address of the art dealer

Durand-Ruel et Fils, whom he noted as "the owner" of "Mannet [*sic*], Renoir Cézanne Sisley etc."[9] In February 1904, Cézanne's work was shown at the Galerie des Collectionneurs in Paris.[10] In April of that year, upon returning to Germany, Beckmann had the opportunity to see the second Cézanne exhibition at the Kunstsalon Paul Cassirer in Berlin.[11] In the fall of 1906, after marrying his great love, fellow Weimar student Minna Tube, Beckmann returned to Paris on his honeymoon, and together the couple visited several collectors and galleries that Meier-Graefe had recommended prior to their departure from Berlin. Minna later recalled a meeting with Cézanne's dealer, Ambroise Vollard, who welcomed them into his apartment and, in response to Beckmann's evident enthusiasm for Cézanne's work, presented the young painter with "a large beautiful photograph of Cézanne."[12]

Cézanne's early influence on Beckmann is immediately apparent in a small series of landscapes from 1905, in which he tried to emulate the French painter's constructivism. Beckmann's unusual mosaic of color patches and tightly woven brushstrokes shows that he had studied Cézanne's work carefully, and his painting *Old Botanical Garden* (fig. 11.1) has been justly compared to the latter's *Tree-Lined Path, Avenue at Chantilly* of 1888 (fig. 11.2).[13] Beckmann's landscape offers deliberately varied and constructed foliage and a concealed, nestled house in the center of the composition, but somehow falls short of Cézanne's analytical breakdown of pictorial space.

It should come as no surprise that Beckmann, like many young painters of his generation, selected Cézanne as an exemplum in the first years of the twentieth century. During these pivotal and, for Beckmann, formative years, Europe witnessed the emergence of a new avant-garde. In 1907, the year in which Picasso — three years Beckmann's senior — created his groundbreaking canvas *Les Demoiselles d'Avignon* (see fig. 8.15), Meier-Graefe challenged the German painter to come into his own with the thrilling yet daunting statement, "All eyes are upon you."[14] Cézanne became a guiding figure for Beckmann, but for other reasons than for most of his contemporaries. In his opinion, Cézanne's objectives were a world apart from the aims of Franz Marc and his Expressionist colleagues, the Fauves, or the Cubists. Beckmann's viewpoint is well documented in his dispute with Marc, a member of the Munich-based Blaue Reiter group, who in 1912 published a glowing endorsement of all abstract tendencies in art. The twenty-eight-year-old Beckmann did not share Marc's opinion and wrote a detailed response in which he labeled the new tendencies "feeble and overly aesthetic."[15] But what incensed Beckmann was Marc's attempt to lay claim to Cézanne as the father of the "new art." For Beckmann, it was not Cézanne who was responsible for starting this trend, but Paul Gauguin, whom he accused of merely "assembling a momentarily diverting décor out of Cézanne and tropical-island motifs."[16] By criticizing the primitivism of Gauguin, Beckmann sought to defend and reclaim Cézanne for his own work and goals:

> I myself revere Cézanne as a genius. In his paintings he succeeded in finding a new manner in which to express that mysterious perception of the world that had inspired Signorelli, Tintoretto, El Greco, Goya, Géricault, and Delacroix before him.
>
> If he succeeded in this, he did so only through his efforts to adapt his coloristic visions to artistic objectivity and to the sense of space, those two basic principles of visual art. Only thus was he able to preserve his good paintings from an arts and crafts flatness. His weaker things are not much different from a tasteful wallpaper or tapestry; but his good pictures are magnificent in their greater objectivity and in the resulting spatial depth; they embody eternal human values, yet they are emblematic of the place and time in which he lived.[17]

Fig. 11.1. **Max Beckmann, *Old Botanical Garden*,** 1905. Oil on canvas, 37 x 23⅝ inches (94 x 60 cm). Buchheim Museum, Bernried

In sharp contrast to contemporary artistic trends, Beckmann applauded Cézanne as a role model for the spatial depth, solidity, volume, and structure of his work. In his exchange with Marc, Beckmann not only indicated the importance of Cézanne for his own practice, he also criticized the "new" artists for misunderstanding the French painter's legacy.

In 1914, Beckmann renewed his attack, this time emphasizing Cézanne's early achievements to highlight the artist's concern for plasticity—in contrast with the abstraction of his later work, which the avant-garde had misperceived as simple spatial flattening:

> In my opinion there are two tendencies in art. One, which at this moment is in the ascendancy again, is a flat and stylized decorative art. The other is an art with deep spatial effects. It is Byzantine art and Giotto versus Rembrandt, Tintoretto, Goya, Courbet, and the early Cézanne. The former wants the whole effect on the surface and is consequently abstract and decorative, while the latter wants to get as close to life as possible using spatial and sculptural qualities. Sculptural mass and deep space in painting need not by any means be naturalistic in effect. It depends upon the vigor of presentation and the personal style.
>
> Rembrandt, Goya, and the young Cézanne strove for important sculptural effects without succumbing to the danger of naturalism in the least.

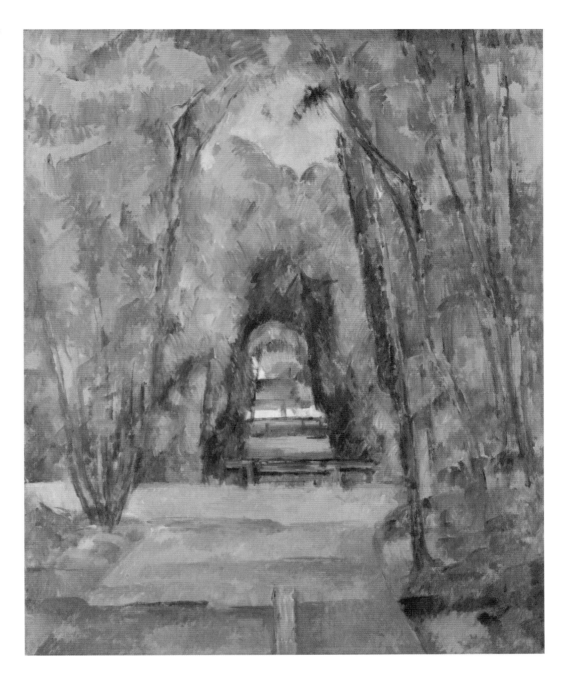

... But I am of the opinion that not one of the French followers of Cézanne has vindicated the principle of two-dimensionality that followed the inspired clumsiness of the late Cézanne, the holy simplicity of Giotto, and the religious folk cultures of Egypt and Byzantium.[18]

At the time of this writing, Beckmann had had the opportunity to study more of Cézanne's work. In 1912, the Munich publisher Reinhard Piper sent the artist reproductions of works by Cézanne and van Gogh.[19] Later that year, the collection of the industrialist Gottlieb Friedrich Reber, which included seven Cézannes, was presented at the Kunstsalon Paul Cassirer, just prior to Beckmann's first major exhibition in Berlin, which opened in January 1913 at the same gallery.[20] In March and April 1913, Beckmann also must have visited the Berlin Secession, where Cézanne was represented with seven paintings.[21] His comments were therefore based on a growing familiarity with the artist's work. Over the next twenty years, Beckmann would encounter more of Cézanne's oeuvre in exhibitions in Berlin, Frankfurt, and Paris. He also had an ongoing discussion of the master's work with his friend Meier-Graefe, who had steered the young artist toward Cézanne during his first visit to Paris. In 1919, Beckmann congratulated Meier-Graefe on his book *Cézanne und sein Kreis* [Cézanne and his circle], calling it "a beautiful, serious study."[22]

Fig. 11.3. **Max Beckmann, *Battle of the Amazons,*** 1911. Oil on canvas, 98¹³⁄₁₆ x 86⅝ inches (250 x 220 cm). The Robert Gore Rifkind Collection, Beverly Hills, California

Fig. 11.4. **Max Beckmann, *Temptation. Triptych (Temptation of St. Anthony),*** 1936–37. Oil on canvas; 78¾ x 66¹⁵⁄₁₆ inches (200 x 170 cm), side paintings 84¹³⁄₁₆ x 39⅜ inches (215.5 x 100 cm) each. Pinakothek der Moderne, Bayerische Staatsgemäldesammlungen, Munich

Fig. 11.5. **Paul Cézanne, *The Temptation of St. Anthony,*** 1867–1870. Oil on canvas, 22⁷⁄₁₆ x 29¹⁵⁄₁₆ inches (57 x 76 cm). Foundation E. G. Bührle Collection, Zurich

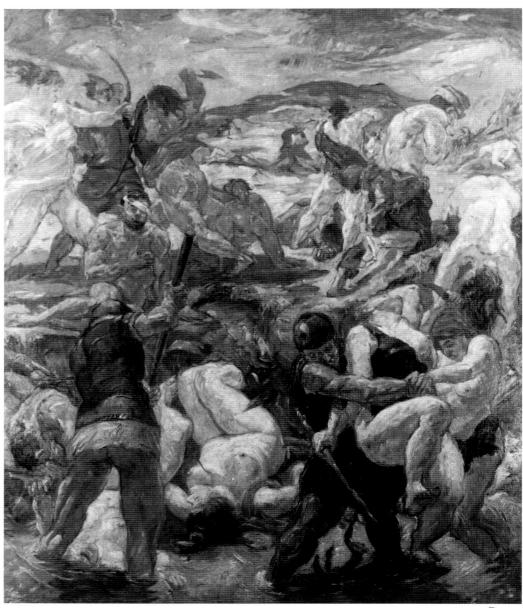

Fig. 11.3

Over the decades, Beckmann's appreciation for Cézanne not only deepened, it also evolved along with his rising level of maturity as a painter. In his early twenties, as an emerging artist with figurative inclinations, Beckmann had been particularly drawn to Cézanne's emotionally charged images of the late 1860s and early 1870s.[23] In 1905, he had discussed with a fellow student from the Weimar academy his fascination with Cézanne, calling him "deeper, more dramatic, more nervous and much more tragic than Van Gogh. . . . While Cézanne rules nature and is able to express his deepest emotions in an onion and I can remember landscapes he has painted which are like a living drama. In my opinion, he has found the finest and the most discreet way ever to express the soul through painting."[24] Beckmann marveled at Cézanne's ability to create emotionally charged subject matter while focusing on the most humble of objects. Based on his description, Beckmann may have had in mind early landscapes such as *Melting Snow at L'Estaque* of 1870–71 (now in a private collection) and *Pastoral (Idyll)* of 1870 (now in the Musée d'Orsay, Paris).[25] But he would also have been intrigued by Cézanne's reworkings of brutal episodes from stereotypical classical figurative themes, such as *The Abduction* of 1867 (see fig. 14.1) or *The Murder* of about 1870 (see fig. 14.3). Beckmann's large canvases, such as *Scene from the Destruction of Messina* of 1909 (now in the Saint Louis Art Museum) and *Battle of the Amazons* of 1911 (fig. 11.3), resonate with Cézanne's early scenes of violence, in which struggle is evoked not only by the subject matter but also by the nature of the agitated brushstrokes.

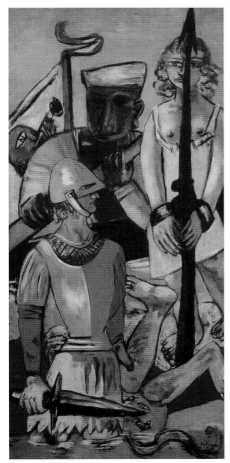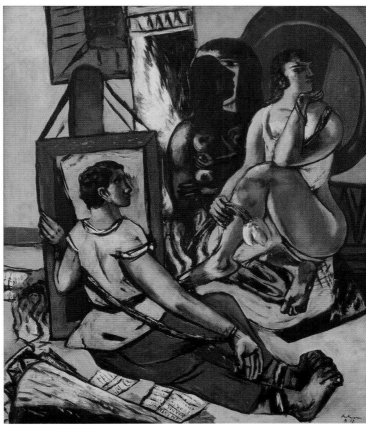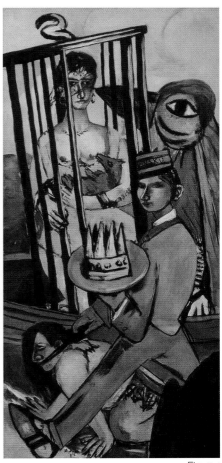

Fig. 11.4

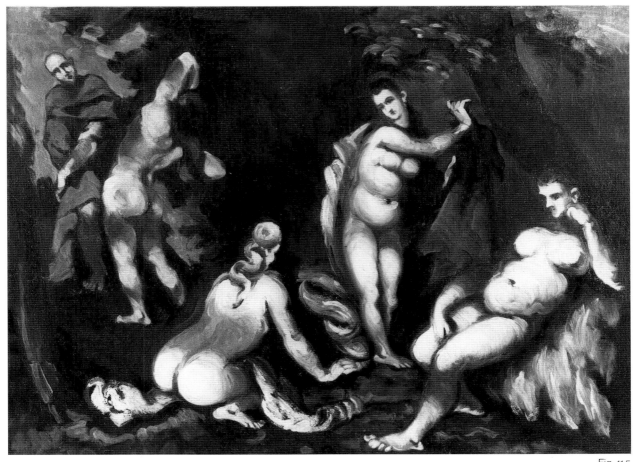

Fig. 11.5

Beckmann's feeling of kinship with the master continued into his mature years. One of his major works, *Temptation* of 1936–37 (fig. 11.4)—the first triptych in an important series of seven that he would produce in the 1930s and 1940s—recalls something of the emotionally charged scenes painted in his youth. The painting was inspired by Gustave Flaubert's "The Temptation of St. Anthony," which Beckmann had read repeatedly, filling his copy of the book with annotations.[26] Beckmann also knew of at least two of Cézanne's adaptations of the theme—a canvas from 1867–70 (fig. 11.5) and another from about 1875–77 (now in the Musée d'Orsay, Paris)—from reproductions. Like Cézanne, he chose to not depict the gruesome scenes of terror and debauchery to which other artists were attracted;[27] in very different ways, both painters instead emphasized the sexual element of the Temptation in order to draw attention to the constant challenge of struggling with desire. In Beckmann's triptych the St. Anthony figure is a painter, his hands and feet bound in chains, who is transfixed by a redheaded woman, his version of the eternal feminine, a more modern yet more ancient Olympia. Seated next to a mysterious figure, an ur-goddess with multiple breasts, she is the archetype of feminine beauty.[28] The engaged detachment, the "artistic objectivity" that Beckmann so valued in Cézanne, is part of the subject matter of at least the central panel. While the young painter appears to be deeply mesmerized, he also shows determination to fulfill his calling by keeping a firm grip on the frame of his canvas. As with Cézanne, the theme of temptation and the need to find balance in resisting or surrendering to it, was of particular interest to Beckmann and resonated both with his artistic practice and with his personal life, as this passage from his "Letters to a Woman Painter" indicates:

> Certainly art is also an intoxication. Yet it is a disciplined intoxication. . . . If you devote yourself to the ascetic life, if you renounce all worldly pleasures, all human things, you may, I suppose, attain a certain concentration: but for the same reason you may also dry up! Art, love, and passion are very closely related because everything revolves more or less around knowledge and the enjoyment of beauty in one form or another.[29]

Another theme that aligns Beckmann with Cézanne is his series of portraits of his closest relations. Most prominent among these is his second wife, Quappi, who is featured in seventeen paintings and numerous drawings. While this number cannot compare with Cézanne's forty paintings of his longtime companion Hortense Fiquet, each portrait pays homage to the beloved woman who accompanied Beckmann from Frankfurt to Berlin, into exile in Amsterdam, and on his last adventure to the United States. In the summer of 1925 he wrote to her, then his fiancée: "If you read about Cécanne [*sic*], I know that you think of me."[30] The thought of his lover reading about his favorite painter (the book he references is probably Meier-Graefe's *Cézanne und sein Kreis*) delighted Beckmann, who was then experiencing the happiest and most carefree time of his life and was evidently keen to share his enthusiasm for Cézanne, almost to the point of indoctrination. By educating herself about Cézanne, Quappi would be better able to understand and share in Beckmann's artistic pursuits.

For his 1944 portrait *Quappi in Blue and Gray* (plate 112), Beckmann might have had in mind Cézanne's *Madame Cézanne in Blue* of 1888–90 (plate 111), which he likely saw in 1927 at the Galerie Thannhauser in Berlin. Like Cézanne, Beckmann capitalized on the color that lends the portrait its name, but he displays a more assertive handling of the brush than his predecessor. Quappi's slender frame is rendered with fluid yet light, feathery brushstrokes. Beckmann succeeded in making this portrait entirely his

Fig. 11.6. **Max Beckmann, *Portrait of Minna Beckmann-Tube,*** 1930. Oil on canvas, 63³⁄₁₆ x 32⅞ inches (160.5 x 83.5 cm). Pfalzgalerie Kaiserslautern

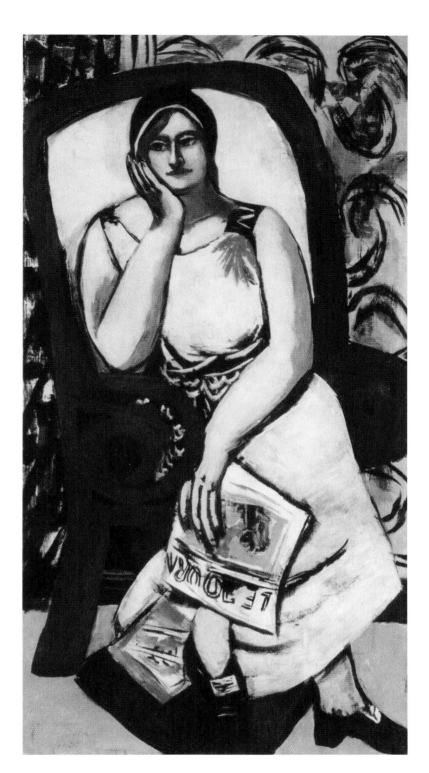

own with his interpretation of the color blue, a luminous shade echoed by the iris to the right and offset by a gray background.

Cézanne's influence can also be seen in a portrait Beckmann made of his ex-wife Minna in 1930 (fig. 11.6), after he was already married to Quappi. The painter then maintained a studio in Paris, where he portrayed Minna during one of her visits to the French capital.[31] In a playful reference to Cézanne's *The Artist's Father, Reading "L'Événement"* of 1866, Beckmann depicted Minna in a fauteuil, with a copy of the newspaper *Le Figaro* on her lap. Minna's soft, pensive gaze differs from the attentive expression of Cézanne's father, who is actually engaged in reading the paper. In her posture, Minna's portrait can more pointedly be seen as a contemporary version of pictures such as Cézanne's *Hortense Fiquet in a Striped Skirt* of 1877–78 (Museum of Fine Arts, Boston), in which she is depicted on a red, overstuffed armchair against the background of cobalt blue medallions. For Minna's portrait, Beckmann chose a sleek chair with wooden curves that mold to her figure and are complemented by the blue tapestry

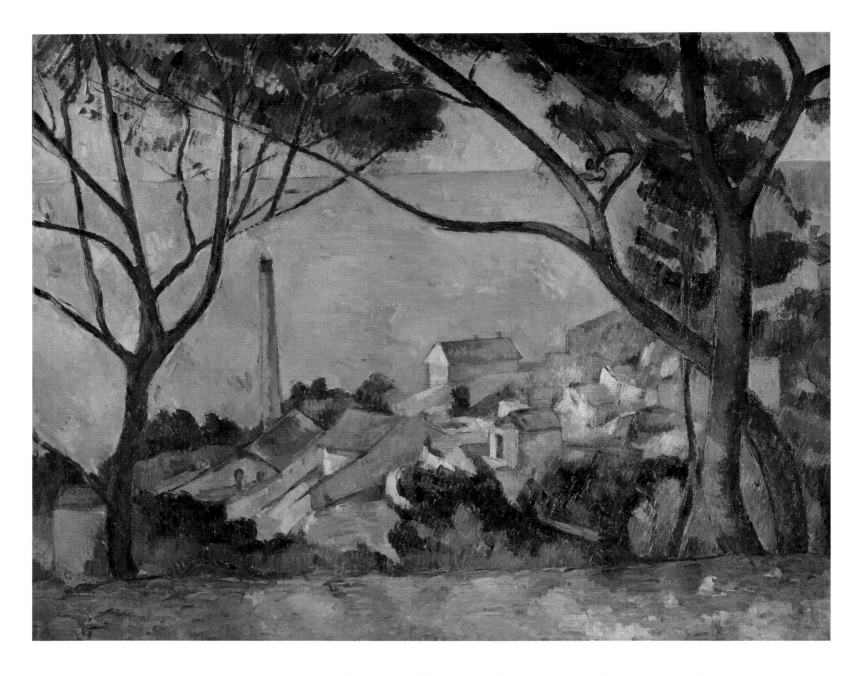

Fig. 11.7. **Paul Cézanne, *The Sea at L'Estaque,***
1878–79. Oil on canvas, 28¾ x 36⅜ inches (73 x 92 cm).
Musée Picasso, Paris, R.F. 1973-59

with black swirls. With its fluid brushwork and distinctive use of black, Minna's portrait is also a response to the work of Beckmann's contemporaries in Paris, especially to Picasso's *Olga in an Armchair* of 1917 (Musée Picasso, Paris) and *Woman Reading* of 1920 (Musée de Grenoble).[32] Beckmann's painting could just as easily be coupled with Matisse's portraits of his wife Amélie, such as *Mme Matisse: Madras Rouge* of 1907 (Barnes Foundation, Merion, Pennsylvania), and is therefore the German artist's fusion of the influence of Cézanne and that of his Parisian colleagues, who like him were looking to Cézanne for inspiration.

Beckmann's career-long use of Cézanne as a benchmark to assess his own progress as an artist is especially true in the genre of landscape. Although landscape was not Beckmann's principal arena, it was a recurrent and absorbing component of his work. The keen observation of nature was a key element to his artistic practice, as this passage from "Letters to a Woman Painter" illustrates:

> Don't forget nature, through which Cézanne, as he said, wanted to achieve the classical. Take long walks and take them often, and try your utmost to avoid the stultifying motor car, which robs you of your vision, just as the movies do, or the numerous motley newspapers. Learn the forms of nature by heart so you can use them like the musical notes of a composition. That's what these forms are for. Nature is a wonderful chaos to be put into order and completed.[33]

Wherever Beckmann lived or worked, he went on extensive walks. One of his favorite vacation destinations was the Côte d'Azur. He was aware, of course, that Cézanne used to work in L'Estaque, a small fishing village just outside Marseilles. In the early 1930s the German artist traveled to Cap Martin, Nice, Marseilles, and Saint-Cyr-sur Mer; in 1938 and 1939, he went to Bandol and again to Cap Martin. Unlike Cézanne, Beckmann did not like to work outdoors, preferring instead to reconstruct scenes, largely from memory, back in his studio. Cézanne's presence can be felt in many of these works almost as an indirect mediation. Beckmann's *Seascape with Agaves and Old Castle* of 1939 (plate 108), for example, uses the same compositional feature as Cézanne's *The Gulf of Marseilles Seen from L'Estaque* of about 1885 (see plate 164), letting the coastline cut diagonally through the picture plane, thus framing the large blue expanse of sea. One is reminded of another of Cézanne's compositional devices, demonstrated in *The Sea at L'Estaque* of 1878–79 (fig. 11.7), where trees in the foreground obstruct the view of the blue sea. Beckmann's choice of tonal combinations is similar to Cézanne's, perhaps due to the bright light of the Midi, about which Cézanne once wrote: "The sun here is so tremendous that it seems to me as if the objects were silhouetted, not only white and black, but in blue, red, brown and violet. I may be mistaken, but this seems to me to be the opposite of modelling."[34] When facing the same challenge, Beckmann found a different solution in paint: Whereas Cézanne rendered his view of L'Estaque in structured planes, Beckmann's forms have an inherent organic shape. His sturdy, expressive palm trees and agaves can bestow these scenes with a primeval atmosphere.

Beckmann did not share in the obsessive quest to return to the same site again and again, as Cézanne did with his series of images of Mont Sainte-Victoire. Beckmann instead stored his images in memory to return to them at another moment, sometimes aided by photographs or postcards. Upon returning from the south of France in 1938, Beckmann wrote to his friend Stephan Lackner: "Cap Martin has done me incredibly well and colored all my nerves and ideas anew. I've come to realize many new things and it will take me twenty years to realize them all."[35] Indeed, during his Amsterdam exile Beckmann repeatedly recalled images from the south in his paintings. And as late as 1947, almost twenty years after his last sojourn, he re-created the feel of a hot summer night on a terrace in *Landscape with Three Palm Trees (Beaulieau)* (Krannert Art Museum, Champaign, Illinois).

During one of the most difficult and yet most productive periods of his life, Beckmann turned once more to Cézanne for encouragement. In his painting *Artists with Vegetables (Four Men around a Table)* of 1943 (plate 107), the artist depicted himself in the company of his closest acquaintances and fellow exiles in Amsterdam, a gathering that never occurred as such in real life.[36] The theme of four men seated around a table immersed in common activity echoes Cézanne's compositions such as *The Card Players* of 1890–92 (see plate 210), which Beckmann could have seen as early as 1927 at the Galerie Thannhauser in Berlin.[37] The severe situation in which Beckmann and his friends find themselves is suggested by the confined space—a dark room, illuminated only by candlelight. Instead of engaging in a game of cards, each member of the group is depicted with his much-needed ration of food: a loaf of bread, a turnip, and so on. Using Cézanne's example, Beckmann found a way to construe an image that dealt with his identity as an émigré artist.

Only weeks before the Netherlands was freed from Nazi occupation in May 1945, Beckmann was in his Amsterdam studio finishing *Still Life with Three Skulls* (plate 113) —a painting that resonates with Cézanne's renderings of the same subject matter, such

as his *Pyramid of Skulls* of about 1898 (plate 114). Instead of treating the motif in the *vanitas* tradition, Beckmann followed Cézanne's example and adapted the theme to his own visual language. Beckmann's skulls confront the viewer much like Cézanne's powerful pyramid of skulls with their gaping voids. But contrary to Cézanne, he was not interested in a calm contemplation of death; instead, his skulls tumble across a cluttered table and develop a life of their own, their bony, distorted features giving the impression that they are roaring with laughter. Painting near the end of World War II, Beckmann goes beyond his predecessor, filling his picture with a biting sarcasm and irony that evoke a macabre, carnivalesque atmosphere. In his diary, Beckmann wrote: "Skulls really finished. Quite a funny painting—just as everything else is totally funny and becomes more and more ghostly."[38] This image lends itself more to Picasso's much earlier response to Cézanne, his 1908 *Composition with Skull* (see fig. 8.5). Here, the artist conceived similar arrangement of objects in disarray around a skull, which is prominently placed next to a toppling stack of books. Beckmann's image recalls the vivid colors and animated composition of Picasso's much earlier composition. When working on his *Still Life with Three Skulls,* Beckmann's health was deteriorating and he battled occasional bouts of depression. In this critical moment of his life, while clearly attracted to Cézanne's meditation on death, Beckmann could not stop the horror and grimness of the situation from spilling over in a terrible mockery of life.

Years later, while living in New York from 1949 until his death in 1950, Beckmann made repeated visits to the Metropolitan Museum of Art, which showcased several works by Cézanne. Among the paintings in the museum collection were four landscapes and one still life: *View of the Domaine Saint-Joseph,* late 1880s (see fig. 15.1); *Mont Sainte-Victoire and the Viaduct of the Arc River Valley,* 1882–85 (see plate 199); *Rocks in the Forest,* 1890s; and *Still Life with Jar, Cup, and Apples,* c. 1877. On a cold January day in 1949, Beckmann recorded the enthusiastic response "always beautiful Cézanne's [*sic*]" in his diary.[39] All throughout his life, he never lost sight of Cézanne, finding in him a companion in his lifelong quest to "get hold of the magic of reality and to transfer this reality into painting—to make the invisible visible through reality."[40]

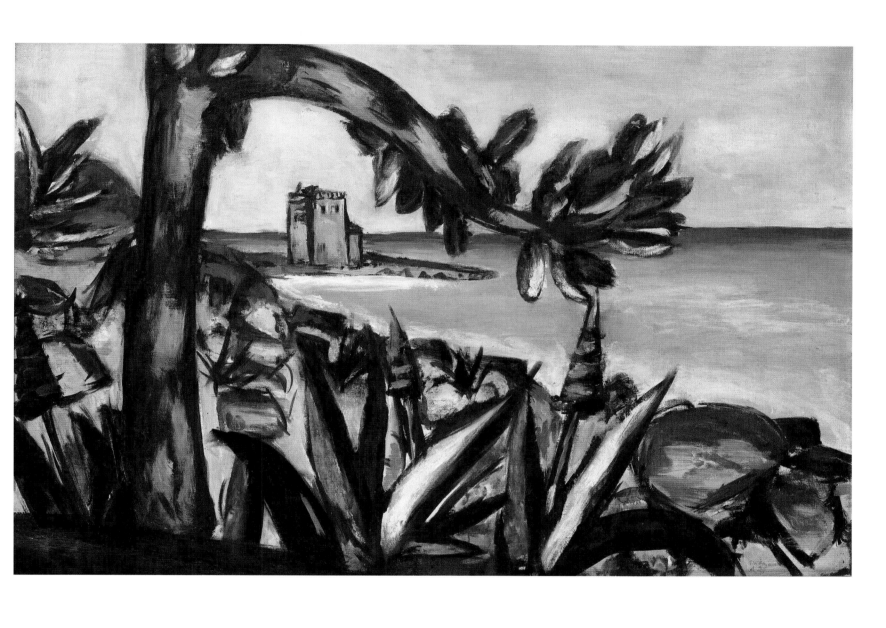

PLATE 108

Max Beckmann

Seascape with Agaves and Old Castle, 1939

Oil on canvas
23⅝ x 35⅝ inches (60 x 90.5 cm)
Staatliche Museen zu Berlin, Nationalgalerie,
inv. no. B29

**Paul Cézanne, *The Gulf of
Marseille Seen from L'Estaque*,**
c. 1885 (plate 164, p. 454)

PLATE 109

Paul Cézanne

*View of the Bay of Marseilles with
the Village of Saint-Henri, c. 1883*

Oil on canvas
25¹⁵⁄₁₆ x 32 inches (65.9 x 81.3 cm)
Philadelphia Museum of Art. The Mr. and Mrs.
Carroll S. Tyson, Jr., Collection, 1963-116-3

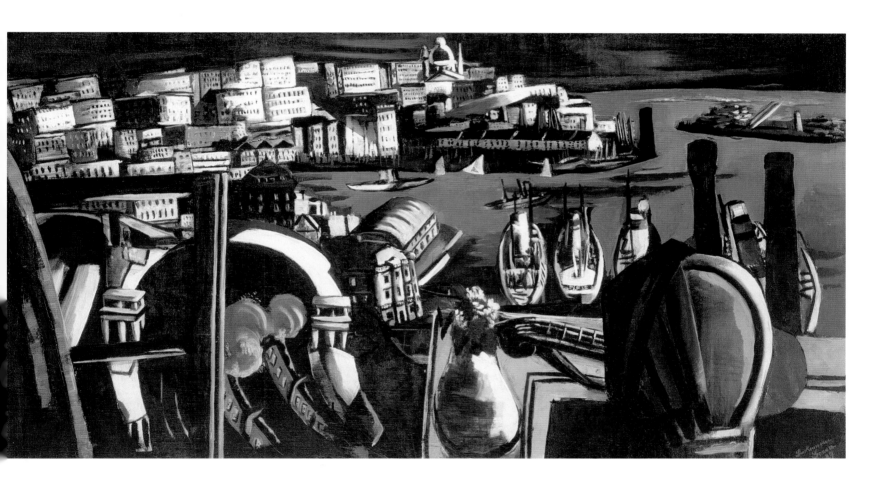

PLATE 110

Max Beckmann

The Harbor of Genoa, 1927

Oil on canvas
35⅝ x 66¾ inches (90.5 x 169.5 cm)
Saint Louis Art Museum. Bequest of Morton D. May

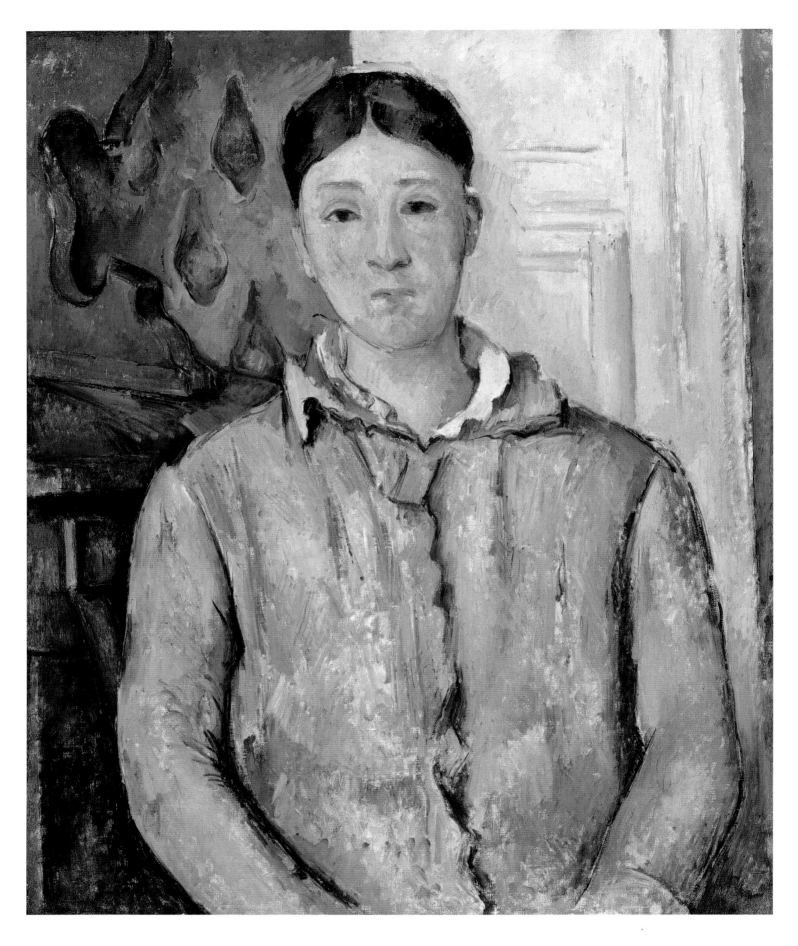

PLATE III

Paul Cézanne

Madame Cézanne in Blue,
1888–90

Oil on canvas
29³⁄₁₆ x 24 inches (74.1 x 61 cm)
The Museum of Fine Arts, Houston. The Robert Lee
Blaffer Memorial Collection, gift of Sarah Campbell
Blaffer

PLATE 112

Max Beckmann

Quappi in Blue and Gray, 1944

Oil on canvas
38¹³⁄₁₆ x 30⁵⁄₁₆ inches (99 x 77 cm)
Museum Kunst Palast, Düsseldorf

PLATE 113

Max Beckmann

Still Life with Three Skulls, 1945

Oil on canvas
21¾ x 35¼ inches (55.2 x 89.5 cm)
Museum of Fine Arts, Boston. Gift of Mrs. Culver
Orswell, 67.984

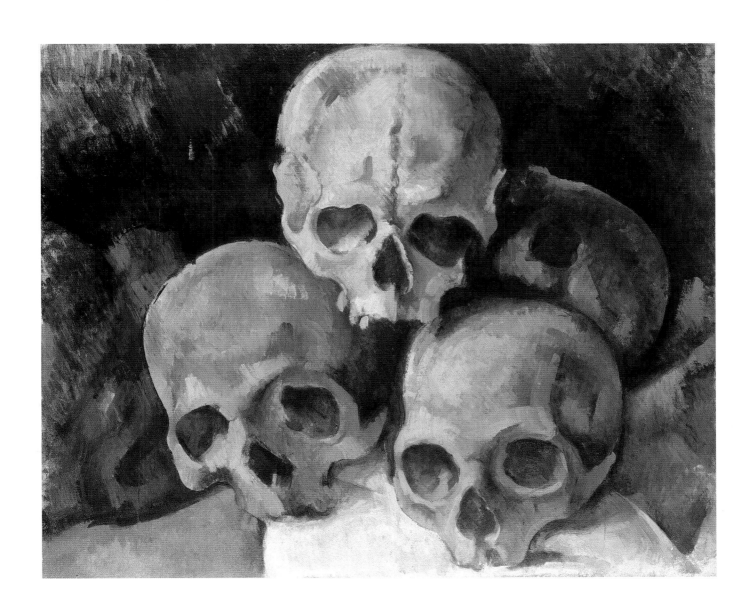

Paul Cézanne

Pyramid of Skulls, c. 1898

Oil on canvas
15⅜ x 18⅜ inches (39.1 x 46.7 cm)
Private collection

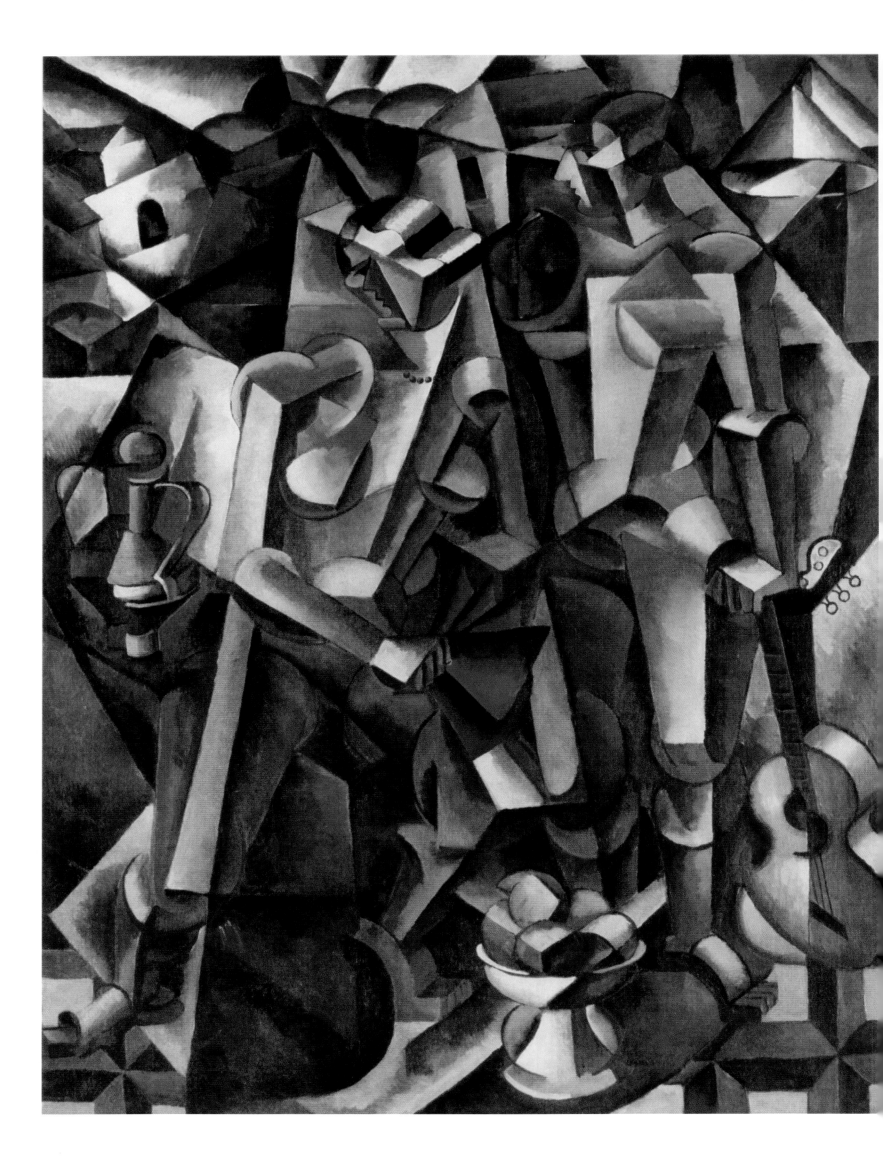

Liubov Popova: From Cézanne to Utopia

Albert Kostenevich

Viewed side by side, the abstract creations of the Russian artist Liubov Popova (1889–1924) do not appear to have anything in common with the works of Paul Cézanne, whose art never abandoned its representational quality. To establish that a link exists, however, it is necessary only to consider what brought Popova to her "architectonics" and "spatial force constructions," as she called her abstract paintings.

Having rejected the traditions of the Renaissance, often in favor of a kind of artistic nihilism (a word, if not a concept, that was a Russian invention), young Russian artists in the 1910s sought to base their art on the most contemporary foundations possible, and therefore, above all, they turned to Cézanne. Some were drawn to Cézanne's expressiveness, closely tied to materiality, others to his fixation with order and discipline of form. Cézanne's oft-repeated refrain to "deal with nature through the cylinder, the sphere, and the cone" was quickly seized upon, including in the studio of Vladimir Tatlin (1885–1956), where in 1913 Popova, recently returned to Moscow from France, was working alongside Robert Falk (1886–1958),[1] Aleksei Grishchenko (1883–1977), and Aleksandr Vesnin (1883–1959). Later, in the 1920s, Popova became closely associated with the Constructivists, a group of artists whose abstraction was rooted largely in French Cubism, which itself drew heavily from Cézanne. Thus, Popova shared her creative starting point with almost all avant-garde artists in early-twentieth-century Russia: Paul Cézanne.

In 1907, when the French artist's posthumous retrospective at the Salon d'Automne in Paris was attracting the attention of everyone interested in the latest artistic developments, the eighteen-year-old Popova, born forty years after Cézanne and just starting out as an artist, would have known nothing of him. She came from a wealthy merchant's family; family members were prominent in Moscow trade, particularly the owners of two firms dealing in tea and cloth (dubbed by visiting German businessmen "Thee-Popoff und Tuch-Popoff"). As a child, Liubov, granddaughter of the famous cloth maker, was educated at home by a French governess and visiting tutors, including a drawing master; later she attended high school.

After graduation, Popova started a two-year "general education" course, similar to a university course in philology, under a man called Alferov. Popova did not complete

the program, however, for by then she had begun to work in the studio of Stanislav Zhukovsky (1873–1944). A student of the artists Valentin Serov (1865–1911) and Isaak Levitan (1860–1900), from whom he learned a refined lyricism and sure grasp of color, Zhukovsky was one of the finest Russian Impressionists, and in 1907 he founded the school that Popova would join. Zhukovsky's landscapes and interiors, portraying the vanishing charm of country estates, would not have held much attraction for Popova—such nostalgia for the nobility would have been quite alien to the merchant's daughter, educated in what was then a liberal spirit. Her painting was to take a markedly different direction, and in 1908 she left Zhukovsky's tutelage, moving to the school of Russian painter and writer Konstantin Yuon (1875–1958). There Popova met fellow artists Vesnin, Vera Mukhina, and Liudmila Prudkovskaia (sister of the Russian painter Nadezhda Udaltsova [1886–1961]), who would form the nucleus of a group of friends that would lead the inquisitive young Popova to the brink of more experimental art.

Zhukovsky and Yuon were particularly skilled in observing and capturing the nuances of color in the changing light of different times of day or year. Both teachers contributed to the development of Popova's talent for color, although their Impressionist leanings, allied to the somewhat theatrical effects of Art Nouveau, were not greatly admired by their more radical young charges; Impressionism never grew into an influential movement in Russia. Doubtless this was due in part to its late arrival; moreover, the Russian Impressionists for a long time retained what Chekhov called a certain "Levitanism" tinged with melancholy: landscape remained their principal subject; they were too preoccupied with conveying mood and unwilling to reject literary elements in their work.

Popova's early works, of which few have survived, comprise nude studies and landscape sketches made between 1910 and 1912 that demonstrate a certain academic manner. Although raw, they are reminiscent of Cézanne in their attempt to construct the picture around consolidated blocks of color reduced to a common denominator, while retaining a sense of three-dimensionality. It would be wrong, however, to say that Popova borrowed directly from Cézanne. Rather, she drew vicariously on the experience of artists she admired, many of whom had absorbed Cézanne's tenets. Popova's *Trees* of 1912 (fig. 12.1), for example, reveals a familiarity with the landscapes of Piotr Konchalovsky (1876–1956) and Ilya Mashkov (1881–1944) from the early period of the Jack of Diamonds group of avant-garde Russian painters, who were active in Moscow from 1910 to 1917. The first Jack of Diamonds exhibition took place from December 1910 through January 1911; Popova could hardly have missed it, for all of Moscow was talking about the "Jacks." Exactly which works were shown at the group's first exhibition is unknown, but checklists from the subsequent exhibitions in 1912 and 1913 reveal the kinds of paintings that united these artists. While the group's figural compositions and still lifes suggest a primitivist orientation, their landscapes are notable for a predominant Cézannism. There is little doubt that the thick foliage of Popova's *Trees* was influenced by Jack of Diamonds pictures such as Konchalovsky's *Bridge* or Mashkov's *Cityscape*, both of 1911 (State Russian Museum, St. Petersburg), which were shown at the group's second exhibition in 1912.

By this period Popova was also fascinated with the work of artist Mikhail Vrubel (1856–1910), for what may have been personal reasons. She was drawn not only to the "Symbolist mysticism" of his art, but also to the tragedy of his private life. Ivan Aksionov (1884–1935), the poet and theoretician of Constructivism in theater, who knew Popova well, called the period of 1911 to 1912 "extremely painful" for her, saying

Fig. 12.1. **Liubov Popova, *Trees,*** 1912. Oil on canvas, 23⅞ x 18¾ inches (60.6 x 47.6 cm). Private collection, Moscow

it nearly cost her life.[2] Aksionov did not go into detail, but clearly there was a critical moment, and it seems likely that Popova was drawn to Vrubel by thoughts of life and death and of the tragic fate of this artist, who was stricken by incurable mental illness. Although melancholy and mysticism color the few surviving examples of Popova's poetry, written between 1907 and 1911, her sketches and studies demonstrate another influence: the magnetism of the creative precedents that she was beginning to discover in Cézanne's work.

Vrubel and Cézanne, who knew nothing of each other, followed quite different artistic paths. In his mature art, Cézanne avoided explicitly literary compositions such as Vrubel's *Seated Demon* of 1890 (State Tretyakov Gallery, Moscow), but an assessment of the structure, drawing, and powerful brushstrokes in this work, devoid of anything small-scale, shows that the techniques of these two artists are entirely comparable. Vrubel's *Savva Mamontov* of 1897 (State Tretyakov Gallery, Moscow) and Cézanne's *Ambroise Vollard* of 1899 (Petit Palais, Paris), for example, are similar in composition: Both canvases depict a middle-aged man sitting with his legs crossed in an armchair, centered in the composition by his white shirtfront. In the summer of 1904, Vrubel, then seriously ill, stood in front of his painting and wrote: "I used to feel like running away with my tail between my legs when faced with the perfection of [Valentin] Serov's and [Anders] Zorn's portraits . . . but now I see that Zorn falls some way short of my

portrait, while Serov had not the sureness of technique: His drawing and tone are quite correct, but neither has any sense of outburst [*aufshwung*], of rapture."[3] Popova would not have read Vrubel's letters, but she would have appreciated the energy of his painting, recognizing in it the same internal strength that later drew her to Cézanne. Cézanne's portrait of Vollard may have required 115 sittings, but however much the artist worked on it, the painting lost none of its sonority and vitality. Cézanne groped his way forward, but he never lost the gift of *aufshwung* so valued by Vrubel.

When the collector Sergei Diaghilev organized an exhibition of Russian art at the 1906 Salon d'Automne in the Grand Palais in Paris, he was determined that a separate hall be dedicated to Vrubel. The artist Sergei Sudeikin (1882–1946) later recalled, "The Vrubel Room was in the middle, and when we entered this enormous room, we felt as if captivated and tormented by the languid beating of the wings of a new art, born out of Vrubel's suffering. . . . In the Vrubel Room, which was completely empty, [Mikhail] Larionov and I kept on meeting a thickset man, like a young Serov, who would stand for hours in front of Vrubel's works. It was Picasso."[4]

A year later, in 1907, Cézanne's posthumous retrospective was held, also in the Grand Palais. By then Cézanne was known around the world, although not yet in Russia, even by the country's boldest young artists. Mikhail Larionov (1881–1964), the ringleader, first became familiar with Cézanne's work in 1908 at the first *Salon of the Golden Fleece*, an exhibition of French and Russian artists that included three Cézannes.[5] He later encountered the artist's work in the collections of Sergei Shchukin (1854–1936) and Ivan Morozov (1871–1921). Although there is no documentary evidence, it is unlikely that Popova would have missed the *Golden Fleece* exhibition, which was the most important art event in Moscow at the time.

At the beginning of the twentieth century, critical opinion of Cézanne in Russia was limited. Some critics, like Aleksandr Benois, refused to see any merit in Cézanne's work. Igor Grabar was more farsighted, however, and in September 1905 he wrote to Benois:

> You lump Rops, Redon and Cézanne together with Gauguin, Moreau and van Gogh, without paying any attention to detail. . . . Some of [Cézanne's] things are excellent; certainly they are coarse, if you must, in the ordinary sense, but I insist that they are still excellent. . . . Do not think that Maurice Denis is a charlatan when he says that Cézanne is *le plus grand maître de notre temps*. I am deliberately concentrating on these questions because they are important, and I'm sure you'll agree it is essential we understand each other before we begin our work together. I think that this is the only point on which we disagree; indeed not so much about Cézanne— of whom, as you can see, I hardly have the highest opinion—as Gauguin and especially Van Gogh.[6]

The mention of Denis, whom Benois admired greatly, would have been persuasive, but Benois was not prepared to revise his opinion immediately, preferring instead to maintain his distance from the "mini-redons" and "mini-cézannes," as he called their Russian imitators.

Younger and bolder critics soon emerged in Russia who had more appreciation for Cézanne's achievements. Iakov Tugendkhold's 1911 book, *Frantsuzskoe iskusstvo i ego predstaviteli* [French art and its representatives], was familiar to everyone involved in the Russian avant-garde. Even independent collectors like Shchukin deferred to it. Popova also read it, and there can be little doubt that much of what Tugendkhold wrote matched her own thoughts. For example, Tugendkhold wrote:

Cézanne said it was necessary to be a laborer in one's art—*il faut être ouvrier dans son art*—that you must learn your artistic technique from youth, and know how to use coarse, raw materials. These words were characteristic, for Cézanne did not thrash about searching for technique, like van Gogh, but at an early stage, almost from childhood, seemed to "know" it. He was master of his material, knew how to bring a medium under his control, and like a fourteenth-century craftsman was brought up with his craft. It is difficult to imagine anything further from the shallow trickery and fashion of the salon than this art, which is coarse and weighty, corporeal and naive, emanating not from the tips of virtuosic fingers but from the fertile depths of the soul. Cézanne does not paint, but carves out his canvas with great strokes from right to left.[7]

Although this description of Cézanne's technique is somewhat hyperbolic, it undoubtedly made an impression on Tugendkhold's contemporaries who were part of or sympathetic to the avant-garde, and who would have found resonance in pronouncements such as the following: "The striving for architectural composition is the border that delineates Cézanne from the Impressionists: for what was a *sketch* for them is for him a *picture*. They were able only to register their impressions, while he was able to organize them."[8]

Cézannism spread like wildfire in Moscow—faster, indeed, than anywhere else in Europe. Kazimir Malevich (1878–1935), Aleksei Morgunov (1884–1935), and Tatlin, the leaders of the circle to which Popova belonged, however, had already moved beyond Cézannism, though without losing any interest in Cézanne's art. In the fall of 1912 Popova frequented Shchukin's collection, which was open to the public on Sundays. At that time works by Picasso were being added to those by Impressionists and Cézanne, and Popova realized that Picasso's work was a natural successor to, and a radical reworking of, Cézanne's.

In Tatlin's Moscow studio, known as "The Tower," Popova worked alongside Viktor Bart (1887–1954), Ilya Zdanevich (1894–1975), and Udaltsova. Regular gatherings in various places, which would include Popova's apartment, were characteristic of Russian artistic life, particularly in Moscow. The artists would meet to work and discuss art, creating one style after another as they plunged into an intensive pursuit of the entirely new. Recent experiments with Fauvism and primitivism were replaced by something different—part Cubism, part Futurism—that began to appeal more and more to Larionov's followers. Everything that had been so important at the start of the Jack of Diamonds—city folklore, street signs, trays, *lubok* (folk prints)—soon lost attraction for the artists surrounding Tatlin, including Popova. She decided to find out more about Parisian art, a few examples of which had reached Moscow, and in November 1913 she set off for France. Her journey led not to the École des Beaux-Arts, from which women were still barred, but to the Académie de la Palette in Montparnasse, where Cubism's leading lights, Jean Metzinger (1883–1956) and Henri Le Fauconnier (1881–1946), were teachers. (Six months later, when Popova returned to Moscow, Tatlin mischievously suggested that she teach him Cubism for twenty rubles a lesson.)

Popova's past experiences had prepared her for the simplifications and generalizations of Cubism, and later for her sudden propulsion toward the forefront of contemporary art. Her admiration for Giotto's frescoes, which she encountered during a trip to Italy in 1910, was significant, as was her profound interest in icon painting that had arisen during trips throughout Russia between 1910 and 1912. Her two trips to Paris (the second in 1914) were also extremely influential. Most important, perhaps, were her

regular meetings with like-minded artists in Moscow: in Tatlin's studio in the autumn of 1913; in her own studio on Novinsky Boulevard in the winter of 1914–15 (the so-called "weekly art gatherings"); and in Udaltsova's apartment in the winter of 1916–17, where visitors included Aleksandr Arkhipenko, Aleksandra Ekster, Ivan Kliun, Olga Rozanova, and Malevich. Popova also participated in several exhibitions during this time, including the Jack of Diamonds exhibition in Moscow in 1914; *Tramvai V: Pervaia futuristicheskaia vystavka kartin* [Tram V: The first Futurist exhibition of paintings] and *Posledniaia futuristicheskaia vystavka kartin: 0.10* [The last Futurist exhibition of paintings: 0.10], both in Petrograd in 1915; and *Magazin* [The shop] in Moscow in 1916.

For her debut at the Jack of Diamonds exhibition in March 1914, Popova chose *Composition with Figures* (plate 115), a work she had completed some months before. More than simply a product of her lessons at La Palette in Paris, this painting signified a revision of the techniques of restrained Cézannism that Le Fauconnier had instilled in her.[9] The influence of Le Fauconnier's *L'Abondance* of 1910–11 (Gemeentemuseum, The Hague) can be seen in Popova's *Composition*. An enormous picture, clearly indebted to Cézanne's paintings of bathers, *L'Abondance* quickly attracted attention in Paris and abroad, since Vasily Kandinsky and Franz Marc were swift to reproduce it in *Der Blaue Reiter* almanac of 1912. To Popova, Le Fauconnier's modern allegory of abundance opened up a new artistic language, although she was bolder than her teacher, moving further toward Cubism and Futurism. In the restless dynamics of these two styles the young artist seemed to hear the true music of modernity, although she felt it essential to introduce harmony or, at least, the foundations of a solid structure. Her tuning fork, therefore, was Cézanne.

The pyramidal structure of *Composition with Figures* is reminiscent of Cézanne's *Mardi Gras* of about 1890 (Pushkin Museum of Fine Arts, Moscow). Popova would have seen this painting at Shchukin's gallery three or four years earlier, although at the time she was not mature enough as an artist to engage in dialogue with this iconic work of modern art.[10] It was not until after her time in Paris that Cézanne's work became the catalyst for Popova's art. In a number of details—a guitar, a tin jug, an architectural grille—*Composition with Figures* recalls other works by Cézanne. The middle foreground shows a bowl of Cézannesque red and green apples, which have undergone a Cubist reincarnation, turned into mechanical ingots, thus integrating them with the machinelike figures in the work. Overall, Popova's "variation on Cézanne" stands as homage to Cubo-Futurist Urbanism, although in the background there remains a small and not immediately obvious detail, likewise reworked in a Cubist manner: a small, white church, emblematic of Russia.

The prismatic refractions in Popova's art of 1913 to 1915, a period when she made significant strides in technique and began to carve out her own path, reflect her Cubist and Futurist inclinations almost in equal measure. The title of *Man + Air + Space* of 1913 (State Russian Museum, St. Petersburg) is echoed in Italian artist Umberto Boccioni's *Cavallo + cavalliere + caseggiato* of 1914 (Galleria Nazionale d'Arte Moderna, Rome), although Popova's title lacks the elegance and play of sound and rhythm of the Italian. In Russia, however, Futurism was somewhat of a hybrid and thus was known as Cubo-Futurism. The "Amazons of the avant-garde,"[11] most obviously Natalia Goncharova (1881–1962), Olga Rozanova (1886–1918), and Popova, deliberately borrowed from the Italian Futurists, as if they wanted to expose the internal dynamism that drove their compositions. For Popova this was not demonstrated so much by linear movement; rather, following Boccioni, she made use of the spiral (see, for example, *Portrait of a Lady [Plastic Drawing]* of 1915 [plate 119]), a form that would take on new significance in abstract art between 1918 and 1920.

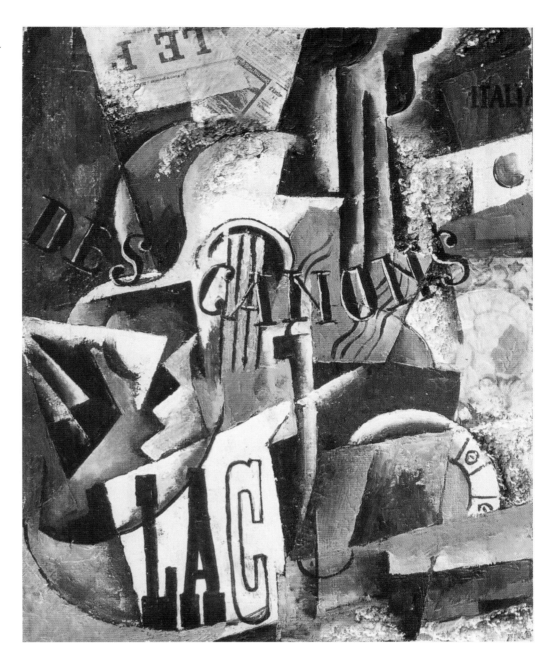

Whereas Russian poets called themselves Futurists, the artists were described more accurately as Cubists. Picasso remained their lodestar. On the mount of her *Italian Still Life* of 1914 (fig. 12.2), Popova wrote, "dedicated to the Italian Futurists," but the painting itself immediately recalls the most recent additions to Shchukin's collection: Picasso's *Guitar and Violin* and *Musical Instruments,* both of 1912 (State Hermitage Museum, St. Petersburg). The repeated circular outlines of the guitar, the sound hole, the strings, and even the addition of substances alien to oil painting—in this case, plaster—originate from Picasso's works. His still life *Table in a Café* of 1912 (State Hermitage Museum, St. Petersburg) presaged the inclusion of snippets of advertising slogans, as well as the decorator's technique of using a comb to reproduce the texture of wood.

Picasso's influence can also be seen in Popova's *Cubist Construction,* also known as *Portrait of a Philosopher,* of 1915 (plate 122). The painting, a portrait of the artist's brother, transforms physical details into an imagined relationship between conventional symbols and planes. Popova was drawing less on the works of Cézanne, with their philosophically musing smokers (well represented in the collections of Shchukin and Morozov), than on Picasso, whose *Portrait of Vollard* of 1910 (Pushkin Museum of Fine Arts, Moscow) was brought to Moscow by Morozov in 1913. Popova was strongly attracted to the extraordinary faceting of forms and light in Picasso's painting, and the dynamic transposition of details in space—for example, in the movement of the

subject's arms. It has long been clear that in the 1910s Moscow's young artists understood Cézanne in large part through "translation" by Picasso.[12]

In the mid-1910s, as shown in *Birsk* of 1916 (plate 123), Popova fell in love with the most primitive Cubist motif, the cubic house. Cubism had begun with Georges Braque's houses and continued with the buildings in Picasso's *Brick Factory in Tortosa (Factory at Horta de Ebro)* of 1909 (State Hermitage Museum, St. Petersburg). During the same period Popova turned to the motifs of the guitar and violin—anthropomorphic symbols of femininity, replete with allusion, with which Picasso also liked to play. Here, too, were pendulums and clock faces, Popova's contribution to the Cubist lexicon—symbols not of Picasso's bohemian youth, but of everyday Russian mercantile experience.

All pictures contain elements of the artist's personality, and in this sense all paintings are self-portraits. Photographs of Popova show a woman who stares almost like the dreamy, modest heroine of a Turgenev novel. But her Cubist self-portraits, like that of 1915 (private collection, United States), show something quite different: a woman of forceful character, without a hint of maidenly languor or the familiar charms of feminine self-embellishment.[13] All that is left of the artist's expressive eyes is a single pupil. It looks like a target, or the cross-section of a tree trunk, while the heavy outline of the jowly face with its prominent chin echoes the equally simplified contours of the rest of the picture, culminating in a quite pitiless and unflattering character portrait. "For all her femininity," recalled Vera Mukhina, who knew Popova well from their time together at Yuon's studio and later traveled with her to Italy, "there was a remarkable astringency in her perception of life and art."[14]

Everything that Popova did combined thoroughness with levity and a thirst for new impressions, a "hunt for a change of place." Her youthful interests moved from Gauguin to van Gogh to Cézanne, and she loved to travel. She may even have made fun of her fickleness: for who but the artist herself is referred to in her Cubist variations on the theme of travelers (fig. 12.3)? Little can be identified specifically in the dynamic kaleidoscope of these works: the outline of a hat, without which in those days a lady would never have gone out; letters spelling out *shliap*, a truncated form of *shliapa* (hat) (the word *shliap* does not exist in the Russian language and resembles more closely the onomatopoeic squelch of a quick walk in filthy weather); the inscription *zhurnaly* (magazines), for no journey would be complete without them; and the clothes that appear to be made up of white and black squares reminiscent of paving stones. All of this is subjugated to a different geometry altogether, to a kind of striding cone, a generalized symbol for a moving female figure in a long dress, the traveler herself. How else can we interpret the figure but as a moment of ironic self-reference?

The places Popova visited almost never were reflected in her art, with the exception of the sketches of Birsk, a town in the Bashkiria region that she visited in the fall of 1916. These landscapes provide a generalized image of an extinct settlement, inimical to all biological life, and the complete antithesis of the garden cities of the future, which Soviet propaganda would later portray through the efforts of Popova's Constructivist friends. There is only one example of a garden in her work, in a sketch for the scenery of a production of *Romeo and Juliet* that was never staged; the garden is the fantastic creation of a machine. The adoption of clean, extremely simplified forms and equally clean, primary colors in Popova's Cubist works took place at such a rate that by 1916 she was creating abstract compositions that defied figural description. There is the faintest echo of a guitar motif in her *Painterly Architectonics with Three Bands* of 1916 (private collection, Moscow); the bands are a kind of oblique reference to strings, but they have suddenly become markedly massive, turning into a dynamic

Fig. 12.3. **Liubov Popova, *Traveling Woman*,** 1915. Oil on canvas, 52 x 41½ inches (132.1 x 105.4 cm). Norton Simon Museum, Pasadena, California

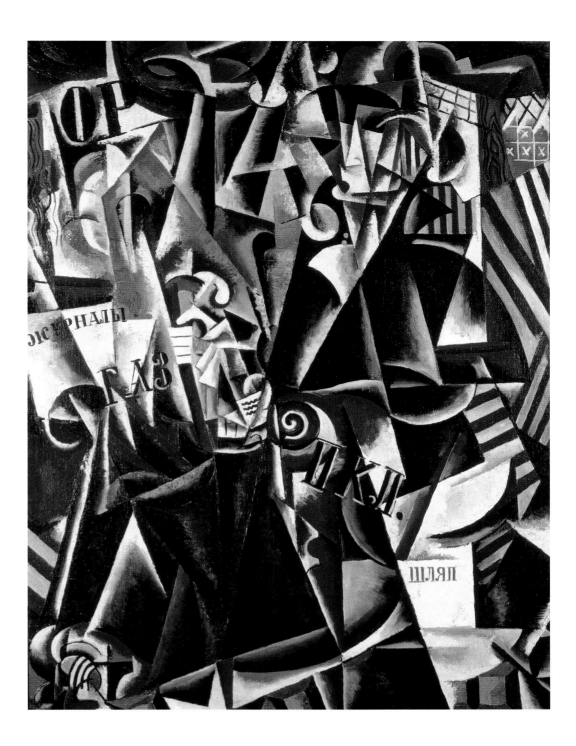

element without which the picture would not be nearly so energetic. In *Painterly Architectonics: Black, Red, and Gray* of 1916 (fig. 12.4), everything is reduced to an entirely autonomous interplay between three forms—two triangles and a truncated trapezoid—that are delineated by three powerful cords of color.

The dynamics of Popova's mature—in other words, entirely abstract—art from 1916 to 1921 would have been unthinkable without Cubism, itself a development of the techniques of Cézanne. Nevertheless, Popova's experiments with Cubism lasted for a relatively short period. Her creative evolution may be explained as "from Cézanne through Cubism to Suprematism," a variation on the title of Malevich's 1915 publication, *Ot kubizma i futurizma k suprematizmu* [From Cubism and Futurism to Suprematism]. Popova used the term *Suprematism*, coined by Malevich, deliberately, and her membership in the Supremus group from 1916 to 1917, alongside Arkhipenko, Kliun, Malevich, Rozanova, and Udaltsova, was no accident. Nevertheless, compared with the other Supremus artists, Popova's Suprematism was her own.

In 1917, with the advent of the Russian Revolution, all artists in Russia found themselves in extremely difficult circumstances, from political, practical, and aesthetic

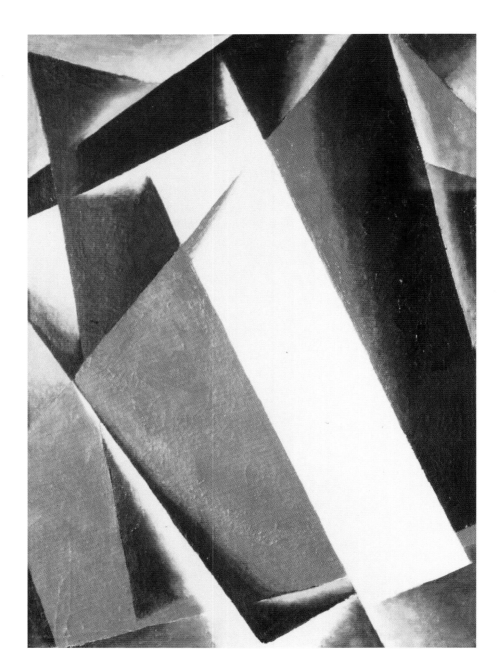

points of view. Popova, like many artists, engaged in what was most important for the Bolsheviks, in particular, agitational posters and street decorations. Before the October Revolution, under the Provisional Government, Popova had taken part in the decoration of the Moscow Council Building for the May Day celebrations of 1917. Within a year, she and Aleksandr Vesnin were engaged in the same activity to mark the same date, but under Soviet rule. Despite the political cataclysms of the period, Popova's creative evolution proceeded immanently, and her abstract compositions of 1917–18 were further developments on what had been defined in 1916. Her determined search for principles of plasticity through the positioning of colored planes in the space of the painting continued and, indeed, broadened, as she strove for overarching principles in the plastic arts.

Difficult times descended, however, and for various reasons Popova's work underwent interruptions and then stopped altogether. In March 1918 she got married, and in November she gave birth to a son. The following summer the young family moved to Rostov-on-Don in the south of Russia, where it was easier to survive during the struggles and privations of the Civil War. A typhoid epidemic broke out in Rostov, however; in August of 1919, Popova's husband died, and then her life hung in the balance as she contracted first abdominal and then murine typhus. Popova survived, but her heart was seriously weakened. No works from 1919 survive; it seems unlikely that there ever were

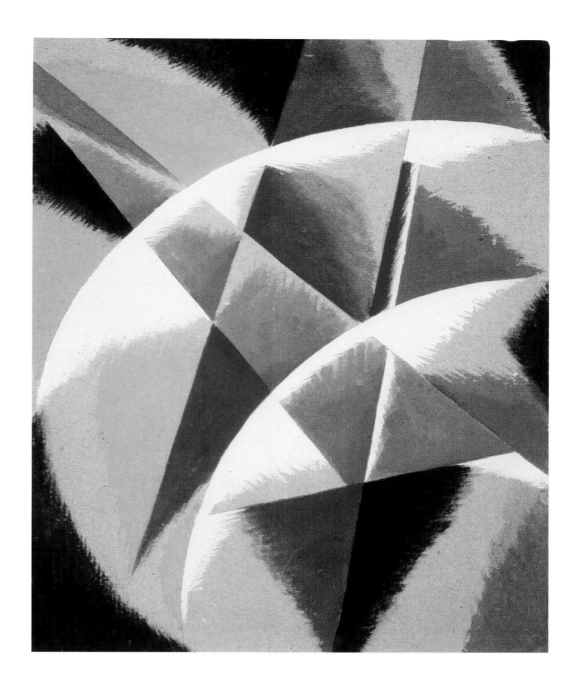

Fig. 12.5. **Liubov Popova, *Spatial Force Construction,*** 1921. Oil and metal dust on plywood. 27½ x 20¼ inches (69.9 x 51.4 cm). State Tretyakov Gallery, Moscow

any. In November she returned to Moscow with her son, where she accepted an invitation to participate in the exhibition *Non-Objective Art and Suprematism.*

Popova plunged herself into her art once more, and along with other avant-garde artists she sought out, in her words, "work formulae" applicable to all art.[15] These instructional formulae were, in one way or another, born out of Constructivism, and Cézanne's words *construction d'après nature* (construction according to nature) served as their creative starting point. Popova became involved in the short-lived organization of the Museum of Painting, for which she wrote the following "explanation of work" in December 1922:

> From the analysis of the volume and space of objects (cubism) to the *organization of elements*, not as a means of expression, but as formations in themselves (whether of color and plane, volume and space or other material constructions). The meaning of each of the elements (line, plane, volume, color, material) that constitute the means of representation is defined by the concrete work in the given material, which determines the function of the object itself (whether it is utilitarian or abstract). Apart from directly mechanical-visual work, a construction serves an ideological purpose, since in its forms it is a reflection of its time, and by revealing the principle of organization the construction replaces aesthetic criteria with this principle.[16]

Popova was one of the first to incorporate these ideas into art (fig. 12.5) prior to the establishment in 1921 of the Constructivists, a group of artists and architects who strove to apply the language of abstract art to social purposes. The Constructivists, whom Popova never joined, were immediate and sincere in their support of the Communist regime, which in the early days looked favorably on their work and did not try to repress it. They occupied prominent positions in Soviet art institutions, including the Vkhutemas (Higher State Art and Technical Workshops) and Inkhuk (Institute of Artistic Culture), which were established in 1920. Inkhuk was established to engage in "the study of basic elements of art" as conceived by Kandinsky, the school's first chairman, who was soon removed by the Working Group for Objective Analysis, headed by Aleksandr Rodchenko (1891–1956) and made up of future Constructivists, Objectivists, and architects who had taught at Vkhutemas. Inkhuk brought together most of the leftist artists in Moscow, Popova among them.

At this stage architecture was the most important discipline, both for the ruling powers and for everyone involved in the creation of cultural values. A country torn apart by wars and strife needed buildings as never before. Constructivism, understood as the most practical and effective style for resolving both construction and aesthetic problems, became the banner of the age. Many believe that Constructivist buildings represent the most valuable contribution of the Soviet era to world culture. In everything, the Constructivists were at the service of an all-powerful collectivism, "the masses"; they aimed to unify norms of living for the working classes and destroy "outdated" concepts such as the family. They designed not just houses, but "housing communes," with highly functional and entirely depersonalized blocks, such as carbon-copy living spaces with tiny six-foot-high bedrooms, larger communal dining rooms (living spaces were not intended for eating in), or other communal spaces for regulated relaxation.

On closer inspection, even the earliest architectural plans, however much they may have dazzled the enthusiasts of the post-revolutionary way of life, turned out to be chimeras of Thomas More and promised nothing but misery to anyone disinclined to submit to such ruthless standardization. The famous Narkomfin (Ministry of Finance) Building constructed in Moscow at the end of the 1920s has, like the majority of the Constructivists' creations, been falling down for a number of years. For all its expert supervisors, it was erected without skill and using low-quality materials. Moreover, notwithstanding the much-trumpeted early Soviet propaganda that accompanied residential constructions, it was built to house not the proletariat, but the newly appointed bureaucracy. Like the other artists in her circle, however, Popova shared this belief in a utopia and was quite ready to close her eyes to the temporary inconveniences invested economically or ideologically in architecture. This does not place her pictures, in functional and aesthetic terms, on the same level as the buildings of the Constructivists, for these structures remained, in philosophical terms, pseudo-artistic justifications for non-freedom. Painting, which left utilitarianism to one side, remained for Popova a surge for freedom, even if her arsenal of creative techniques was severely reduced.

The majority of leftist artists, even those who were not Constructivists, actively pursued the geometrism that seized not just architecture, but also a significant part of all graphic art. Although a pastiche of an ancient Egyptian mastaba, Lenin's mausoleum, designed by Aleksei Shchusev (1873–1949), was not without a certain romantic aura and conveyed a dynamic thrust toward the sky—and thus, presumably, the future. In the mid-1920s, soon after the first wooden incarnation of the tomb had been banged together, a dish (now in the Alberto Sandretti Collection, Milan), an example of so-

Fig. 12.6. **Liubov Popova**, sketch for set design for Vsevolod Meyerhold's production of *The Magnanimous Cuckold* by the Belgian playwright Fernand Crommelynk, 1922. Watercolor, gouache, collage on paper; 19⅝ x 27⅛ inches (49.8 x 68.9 cm). State Tretyakov Gallery, Moscow

called propaganda porcelain, appeared featuring the design of the mausoleum not within a circle, but within a five-pointed star—the most important Soviet symbol—with the star's points linked to the circumference of the dish.

Such primitive symbolism would be surprising from an artist of Popova's caliber, but she was unable and unwilling to let the movement pass her by. Like her contemporaries, she saw her creative duty as the elaboration of a revolutionary culture, although not in a strictly political sense so much as in the rejection of outdated modes of creative expression. Her mature works, which date to the first five years of Soviet rule, have much in common with numerous manifestations of an art at the mercy of extremely simplified, often even aggressive, geometry. In the consciousness of the artistic avant-garde this was the creative paradigm of revolutionary activity.

In Moscow, Popova tried her hand at design for theater (fig. 12.6), and in 1922 she joined the faculty at Vkhutemas, where she was given the title "professor of color." The appointment was entirely appropriate, for in the field of color she was the most gifted of the "Amazons of the avant-garde," including Ekster and Goncharova. Few details of her teaching are known, however, and one must wonder how, beyond preparing students to avoid coloristic solecisms, the mastery of color can be taught.

Popova also worked in the Production Department at Vkhutemas, where Vesnin taught architecture, Rodchenko metalworking, and Popova and Varvara Stepanova textiles. Here it was necessary to follow the slogan "Art into Production," an idea that, in 1923, held total sway. The previous year had seen an important shift in the activities of Inkhuk in the direction of production art, of which Popova had been a part. As a contemporary chronicler of the institute wrote: "24 November 1922 was a remarkable day, a *Serment du Jeu de Paume.*" This was the day when "twenty-five progressive artists of the left under the pressure of revolutionary conditions of modernity rejected pure forms of art, recognized self-sufficient easel-painting as irrelevant, and their activities

Fig. 12.7. **Liubov Popova, *Work Uniform Design for Actor #3,*** 1921. Pasted paper, ink, gouache, collage on cardboard; 13½ x 9⅝ inches (34.3 x 24.4 cm). Private collection, Moscow

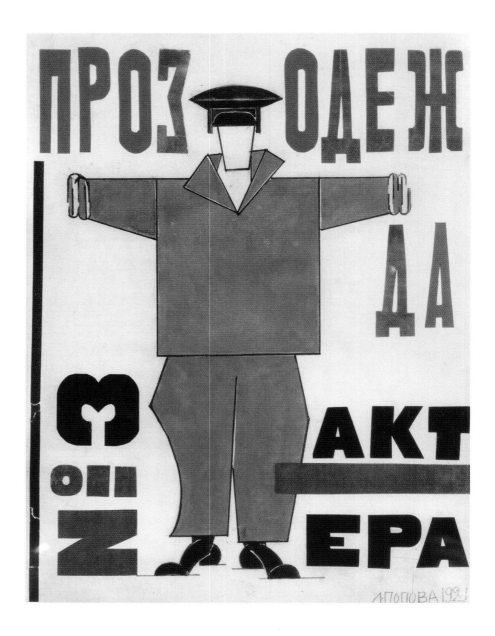

as pure artists pointless. The new craftsman has *hoisted the banner of production.* The artists were Rodchenko, Lavinsky, Popova, Vesnin, and others."[17]

Only a small number of artists, however, ultimately were able to work in production, among them Tatlin and Popova herself, whose designs for fabric make a strong impression to this day. Her fabric prints have nothing to do with utopia or Cézanne, but they are remarkable for their invention and immutability of design. In 1925 Tugendkhold recalled, "Popova used to say that no single artistic success gave her deeper satisfaction than to see a peasant woman or worker buying a piece of her material to make a dress. And it is quite true that last spring the whole of Moscow was wearing material designed by Popova, without knowing it, with patterns that were bright, sharp, and full of movement, like the artist herself."[18]

Popova's costume sketches were similar to her fabric designs; it is no accident that contemporaries referred to her as an "artist-designer." The sketches in the series *Prozodezhda for an Actor* of 1921 (fig. 12.7) are among her most expressive works. *Prozodezhda,* a word little understood today, is marked as a new entry and defined in the standard four-volume *Tolkovyi slovar russkogo iazyka* [Dictionary of the Russian language] of 1935–40 as "clothing issued by an enterprise to workers on production sites to protect their usual clothes from dirt and the workers themselves from injury."[19] In the decade and a half since Popova's series appeared, the meaning of *prozodezhda* had changed into something closer to "overalls." For Popova, however, it meant something rather different: clothing that met the requirements of the revolutionary era and the

new reality, highly democratic and simple, but at the same time ceremonial. A verse in Vladimir Mayakovsky's *Bedbug* of 1928 provides a distorted reflection of the reality with which Popova and her friends at Inkhuk and Vkhutemas were struggling, as they created decorative attire for the post-revolutionary period:

> They descended on ZAKS by the tramway
> To see the red wedding take place,
> The groom all in new prozodezhda,
> His union card stuck from his pocket.[20]

The crowd descends on ZAKS, the institution for the "registration of acts of civil status," including marriage, by the most modern means available, the electric tram, to celebrate the wedding of progressive workers, who are wearing the requisite clothing. The action of Mayakovsky's play appears to be heading into the future, but in fact the subject of this "fairy comedy," as the play was known, was the present, when the smoke of optimistic utopias had dissipated.

Popova's costumes are an extremely interesting document of the age and not without artistic merit. The wide, applied pockets seem to be designed so that something emblematic might protrude from them, such as a union card, a highly important social symbol. The outline of the suit echoes the generalizations of early Cubism—and consequently, strange as it may seem, Cézanne.

The early 1920s were a time of great hope in Russia: With the end of the Civil War and the implementation of the New Economic Policy, it seemed that life was moving toward a more normal course. By the end of the decade, however, the climate had cooled sharply. Had Popova lived until then, it seems unlikely that she would have wanted to invest her energy in the latest fads in textile design or models for women's dresses, on which she worked for much of the winter and spring of 1924. At that time she was teaching "The Material Decoration of Stage Productions" at Proletkult (proletarian culture), an organization that was deeply involved in the promulgation of clichés in honor of the dictatorship of the proletariat. It seems more likely that after her "production" phase she would have returned to painting, though probably without her belief in utopia. She was not, however, fated to live that long. On May 23, 1924, her five-year-old son died from scarlet fever, and two days later she followed him.

Translated from the Russian by Frank Althouse.

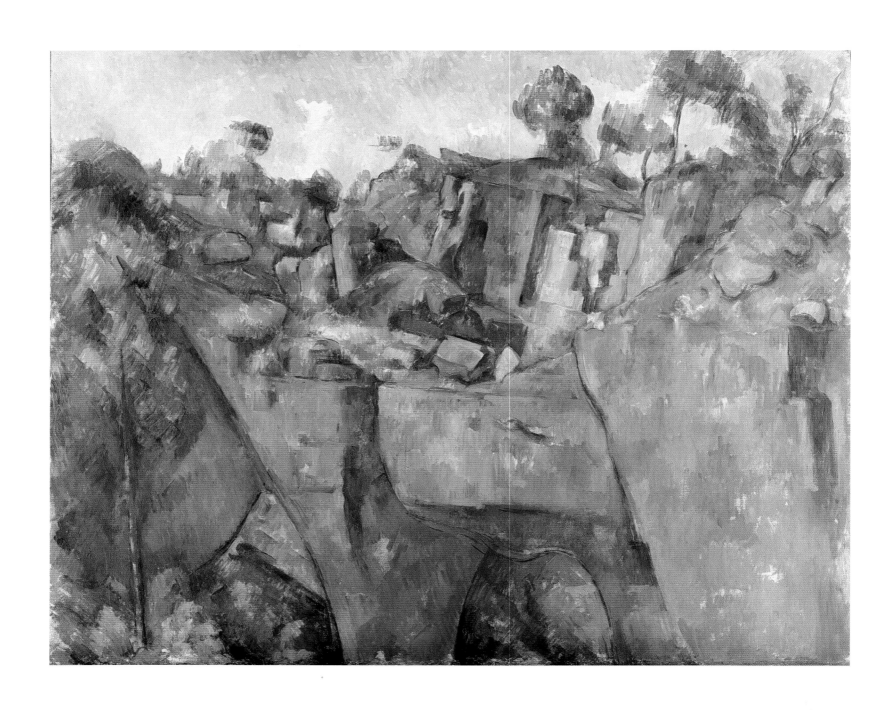

PLATE 116

Paul Cézanne

Bibémus Quarry, c. 1895

Oil on canvas
25⅝ x 31⅞ inches (65.1 x 81 cm)
Museum Folkwang, Essen

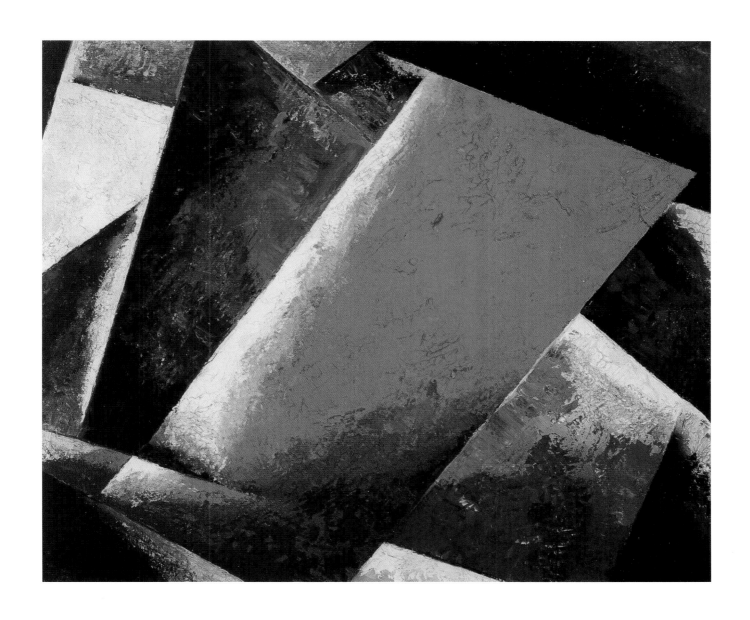

PLATE 117

Liubov Popova

Pictorial Architecture, 1918

Oil on canvas
10⅞ x 13½ inches (27.6 x 34.2 cm)
Courtesy of Ivor Braka Limited

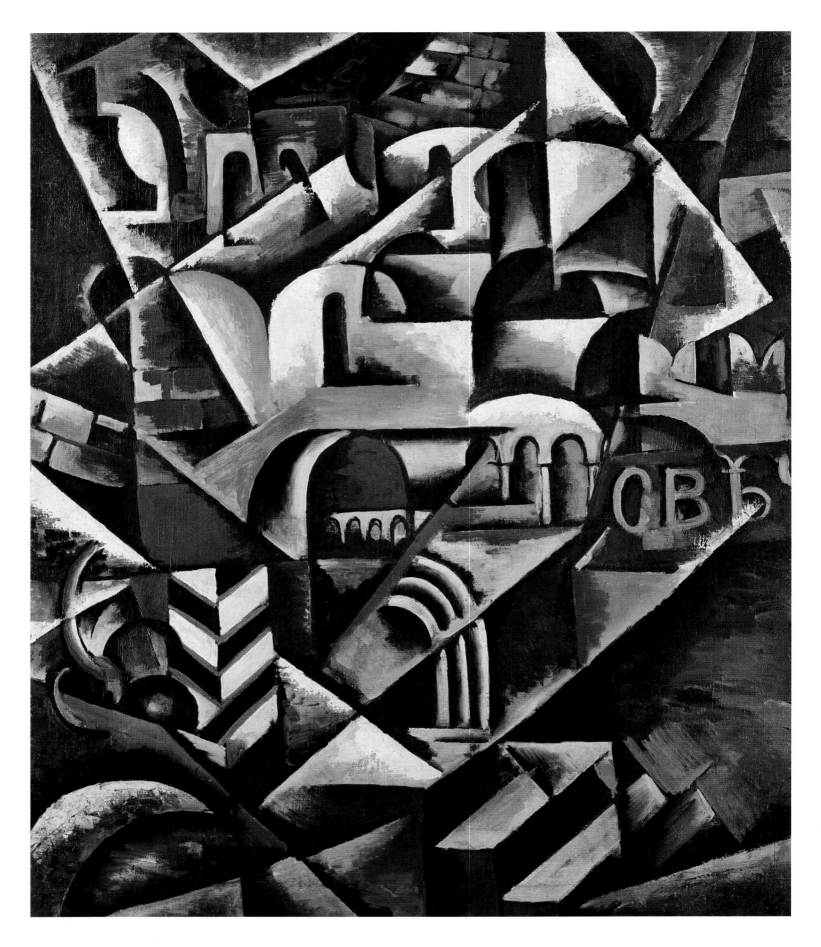

PLATE 118

Liubov Popova

Cubist Urban Landscape, 1914

Oil on canvas
40¹⁵⁄₁₆ x 34¹⁄₁₆ inches (104 x 86.5 cm)
Private collection

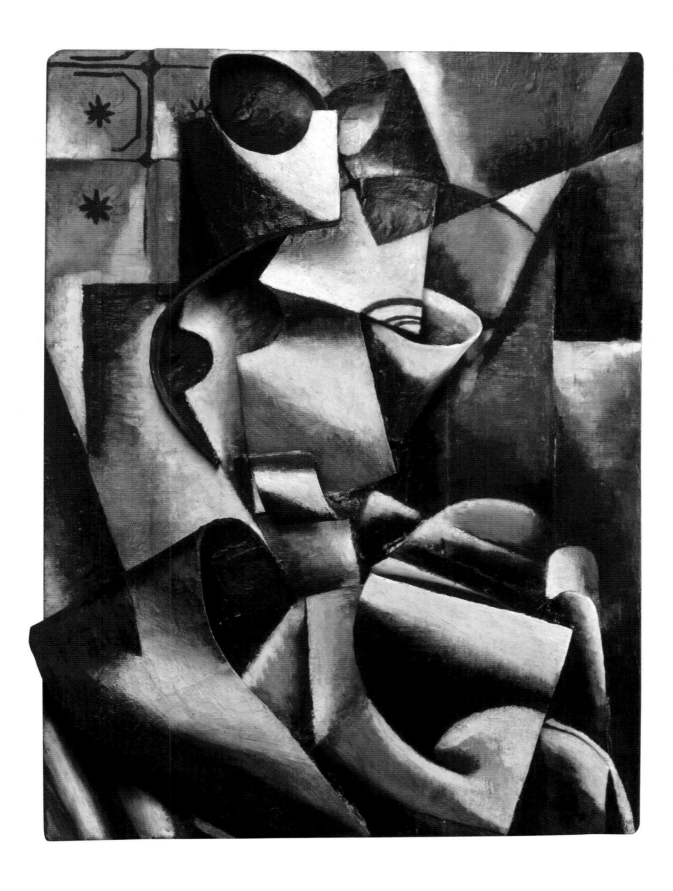

PLATE 119

Liubov Popova

Portrait of a Lady (Plastic Drawing), 1915

Oil on paper and cardboard on wood
26⅛ x 19⅛ inches (66.3 x 48.5 cm)
Museum Ludwig, Cologne

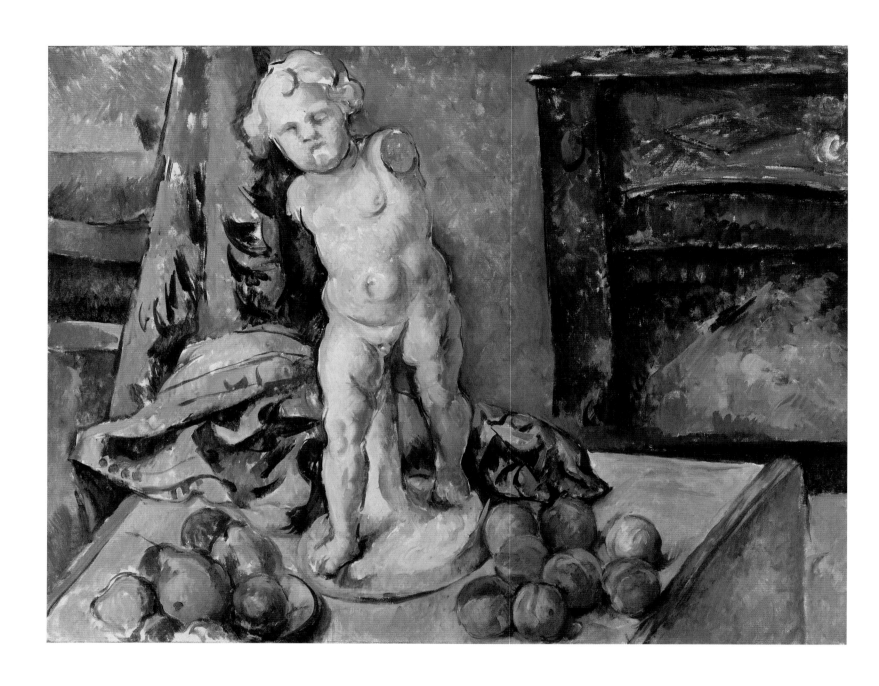

PLATE 120

Paul Cézanne

Still Life with Plaster Cupid, 1894–95

Oil on canvas
24¹³⁄₁₆ x 31⅞ inches (63.1 x 81 cm)
Nationalmuseum, Stockholm

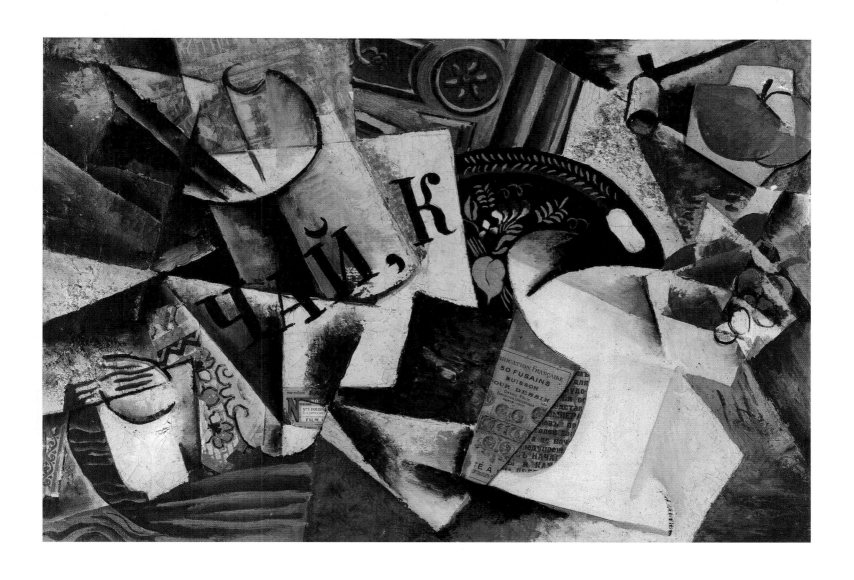

PLATE 121

Liubov Popova

Still Life with Tray, 1915

Collage and oil on canvas
15¾ x 22⅞ inches (40 x 58 cm)
Private collection

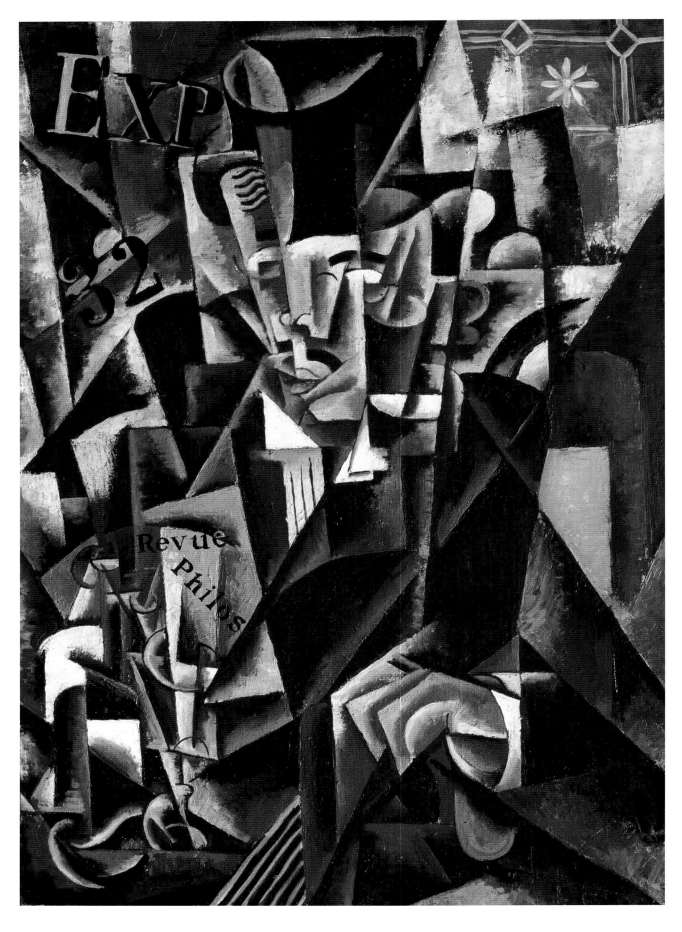

PLATE 122

Liubov Popova

Cubist Construction (Portrait of a Philosopher), 1915

Oil on canvas
35 x 24¾ inches (88.9 x 62.9 cm)
State Russian Museum, St. Petersburg

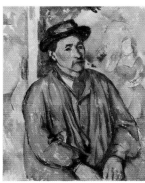

Paul Cézanne, *Man in a Blue Smock,* 1892 or 1897
(plate 62, p. 236)

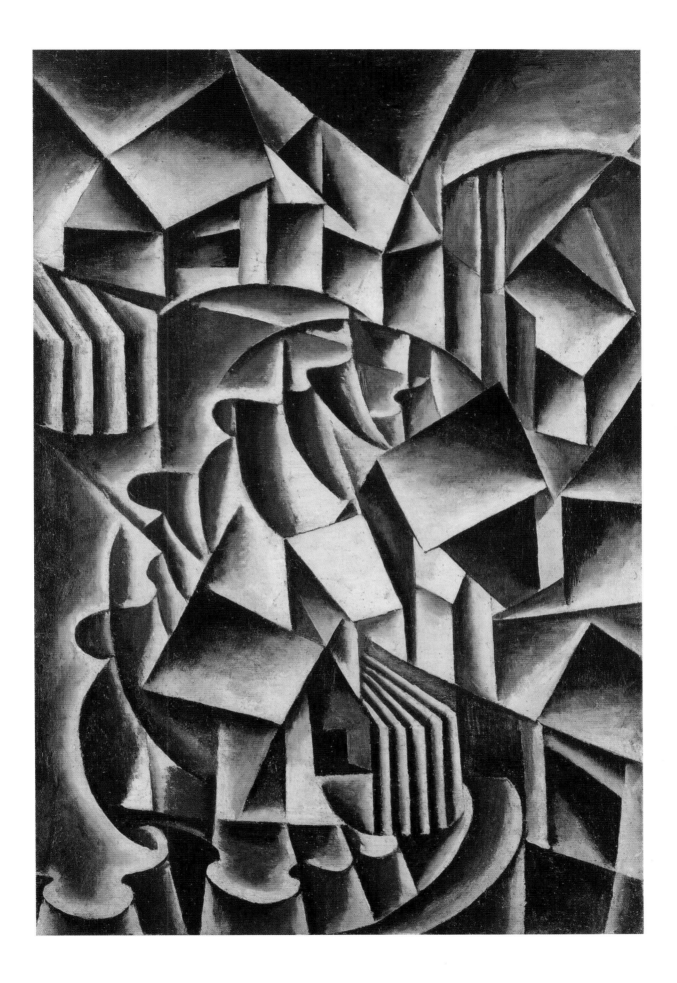

PLATE 123

Liubov Popova

Birsk, 1916

Oil on canvas
41⅜ x 27⅜ inches (105.1 x 69.5 cm)
Solomon R. Guggenheim Museum, New York. Gift of
George Costakis

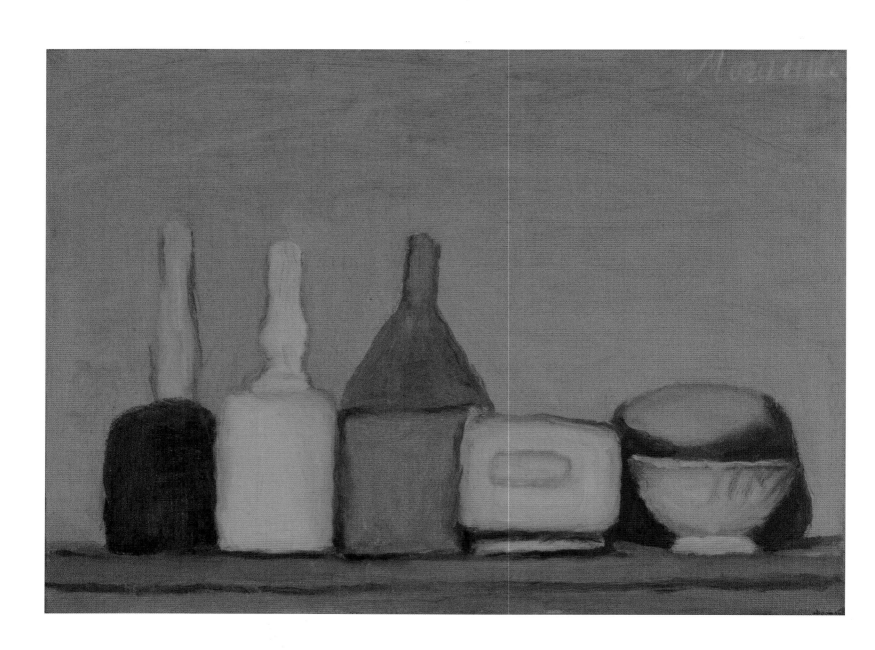

For the Love, and Fear, of Painting: Cézanne, Morandi, and Italian Modernism

Jennie Hirsh

> Paul Cézanne represents a unifying desire in modern painting.
> —ARDENGO SOFFICI (1908)[1]

> Among the ancient painters, the Tuscans are those who interest me most: Giotto and Masaccio above all. I believe that, of the moderns, Corot, Courbet, Fattori, and Cézanne are the most legitimate heirs of the glorious Italian tradition. Among the painters of today who have been most useful to my formation, I recall Carlo Carrà and Ardengo Soffici; their work and their writings have, in my view, had a beneficial influence on the state of Italian art today.
> —GIORGIO MORANDI (1928)[2]

For Italian artists working in the first half of the twentieth century, French modernism represented a double-edged sword. On the one hand, the French tradition served as a model for Italian artists eager to appear not only sophisticated and cosmopolitan but also distinct from their Renaissance and Baroque predecessors. On the other hand, French modernism, like the Italian past, cast a shadow of doubt on the possibility of native originality and creativity in Italy, precipitating an artistic crisis that went hand in hand with the intensely nationalistic atmosphere of the Fascist *ventennio*, the twenty-year period stretching from 1922 to 1943.

Nevertheless, long before the rise of Fascism, Italians had looked to the French for modern strategies, and following Italian reunification in 1861, there had certainly been cross-pollination between the group of Italian artists known as the Macchiaioli, who were opposed to formal academic training, and the like-minded French Impressionists.[3] In the first half of the twentieth century, artists in Italy were eager to look at artistic

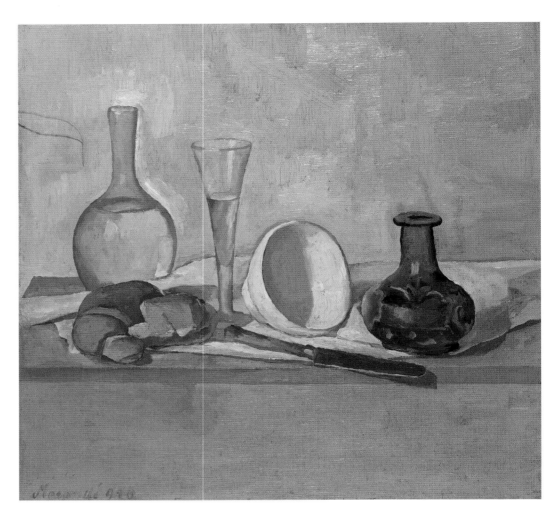

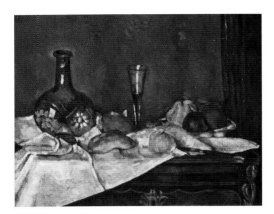

Paul Cézanne, *Still Life with a Dessert,* 1877 or 1879 (plate 78, p. 252)

Fig. 13.1. **Giorgio Morandi, *Still Life,*** 1920. Oil on canvas, 19½ x 20½ inches (49.5 x 52.1 cm). Kunstsammlung Nordrhein-Westfalen, Düsseldorf

developments in France, where modernism was advancing at the fastest rate.[4] Needless to say, Cézanne's art and critical reception would play a central role in the evolution of Italy's own brand of modernism, and in the first decade of the twentieth century, several Italian artists and critics began to describe and debate the relative merits of his work in newspapers, magazines, and exhibition catalogues, typically underscoring him as distinct from the Impressionists as well as the Post-Impressionists.[5] In artistic terms, perhaps no artist more successfully, and with such poignancy, absorbed and renegotiated the pictorial lessons of Cézanne than did Giorgio Morandi (fig. 13.1; see plate 78).[6] Best known for his soft, subtle, and sophisticated paintings and etchings that span a six-decade career, the Bolognese painter played a pivotal role in the Italian artistic reception of Cézanne. In particular, one can trace the influence of Cézanne in Morandi's still-life and landscape paintings (plates 125, 126), though the degree to which he relied on and renegotiated the French painter's work changed over time.[7] Morandi's oeuvre represents not only a formal response to Cézanne but also a hushed yet audible voice within a larger critical conversation regarding the French master and his impact on Italian modernists—including Umberto Boccioni, Carlo Carrà, Giorgio de Chirico, and especially the painter, critic, and writer Ardengo Soffici. Cézanne's critical fortune in Italy was informed by great admiration as well as measured trepidation, an attitude symptomatic of what may have been the greatest fear of Italian artists: complete loss of the self (that is, Italy) within an image of the other (within this context, France), a phobia understandable in light of the catastrophic losses suffered by Italy, even as a victor, in World War I.[8]

Morandi Meets Cézanne

Morandi traveled outside Italy only once in his life, unlike his countrymen who made regular and prolonged trips to France and other destinations abroad. Understanding Morandi's study of Cézanne's formal and thematic lessons therefore requires acknowledgment that his contact with Cézanne was heavily mediated through both visual and critical lenses. Morandi first encountered Cézanne's paintings in the final chapter of Vittorio Pica's monograph *Gl'impressionisti francesi*, published in 1908.[9] Pica described Cézanne as the quintessential outsider artist, claiming for him "a separate place" (*un posto a parte*), not only outside the mainstream academic art world but also apart from the cohesive group of Impressionists working in a mode distinct from that espoused by the academy.[10] For Pica, Cézanne was linked to the extended French tradition that moves from Eugène Delacroix through Gustave Courbet and Édouard Manet. But more importantly, Pica claimed that the artist from Provence was ultimately defined by his unique, "harsh" style.[11] Beyond providing a general description of Cézanne as an artistic revolutionary, Pica's book triggered two significant events. First, the volume occasioned Morandi's initial encounter with reproductions of eight of Cézanne's works, though they were notably drained of the chromatic splendor that, for those who saw the paintings firsthand, constituted one of their most striking features.[12] Thus, Morandi's initial sensory experience of Cézanne was compromised, leaving him with only a sense of the master's geometry and plasticity, aspects of Cézanne underscored by Soffici's textual accounts, which likewise lacked discussion of Cézanne's color. Second, the book exposed Morandi to the broader Italian reception of French modernism through Soffici's extended critical discussion of French Impressionism, a series of articles generated in response to the lack of emphasis on French modernism at the 1908 Venice Biennale, which coincided with the publication of Pica's monograph.[13]

Pica provided the initial Italian recognition of Cézanne as an important offshoot from the larger story of the reception of French Impressionism. But Soffici, who lived from 1900 to 1907 in Paris and was the Italian artist perhaps most influential on Morandi, would become Cézanne's strongest champion in Italy in the decades that followed.[14] In order to bring Cézanne into an art history that would attend to the needs of budding Italian artists, Soffici made two notable claims. He "naturalized" Cézanne, establishing an Italian identity for the French painter—a "Giotto reborn" and a reincarnation of the Christian mystic Iacopone da Todi (1228–1306)—who now appeared as a displaced Italian genius in order to dispel rejections of him on xenophobic grounds.[15] Further, Soffici argued that proper appreciation of Cézanne required an acute Italian sensibility. Claiming that no one in France "understood or would ever *truly* understand Cézanne," Soffici declared that an Italian sensibility was required because Cézanne's art was "made to fill up our souls, an Italy reborn."[16] It was Italy, argued Soffici, that made the French painter "see how one can deduce a free, fertile, sincere and marvelously modern [form of] painting from the masterpieces of the antique masters of the Trecento and the Quattrocento."[17] Early on, these passages firmly established Soffici's attitude toward Cézanne, and they also formed the basis for all his writing that followed. Moreover, and perhaps most importantly, Soffici reminded his readers that Cézanne "left Paris and the bohemian life . . . and he exiled himself to Aix-en-Provence," biographical facts that mirrored Soffici's own retreat from Parisian life.[18]

Without moving too far afield from this essay's focus on Morandi's relationship to Cézanne, it is important to note that Soffici's embrace of the figure of the artist who rejected urban culture recurred in his 1912 monograph on Arthur Rimbaud and in his

portrayal of Lemmonio Boreo, the semi-autobiographical character whose name was also the title of his novel published in 1911.[19] Soffici's emphasis on Cézanne's withdrawal would not go unnoticed by Morandi, who, as we shall see, in the interwar period cultivated a similar myth — that of a solitary, apolitical outsider, a characterization of his career that, as has been shown by more recent accounts, was inaccurate.

Indeed, at the forefront of Italian journalistic interest in French art, Soffici's writings served as an essential *vade mecum*, a handbook or manual, for the young Morandi, who not only was distanced from modern art, both inside and outside the Accademia di Belle Arti in Bologna, where he spent six long years from 1907 to 1913, but also was crushed by the weight of traditional Bolognese painting.[20] Soffici's writings offered a light at the end of a dark academic tunnel.[21] The Florentine avant-garde magazine *La voce* proved to be a significant venue for Soffici's criticism, publishing numerous articles and editorials on Impressionism as well as reproductions of Cézanne's works.[22] *La voce* also noted the publication of a monograph on Cézanne by the German art historian Julius Meier-Graefe.[23] Along with his adoption of Soffici's views on modern French art, during this period Morandi acquired a second education, in early Italian art. Traveling to Florence to see works by Trecento and Quattrocento painters, Morandi discovered historical figures more to his liking than those he had encountered while at the Accademia.[24] And as Janet Abramowicz has astutely observed, "Cézanne's paintings demonstrated the importance of form and structure rather than the subject matter itself. . . . Thus, when [Morandi] looked for the first time at Giotto, Piero and Alberti, it was with eyes that had already understood Cézanne and Rousseau."[25]

With his interest thus piqued by Soffici's enthusiasm for Cézanne, the young Morandi was primed to see his first modern French paintings at the *Prima Mostra dell'impressionismo*. The exhibition was curated by Soffici in 1910 at the Lyceum Club in Florence and included four paintings by Cézanne, as well as works by Edgar Degas, Claude Monet, and others, along with sculptures by Italian artist Medardo Rosso, then resident in Paris.[26] A few years later, following Morandi's departure from the Accademia in 1913, the artist attended the 1914 *Secessione* show in Rome, where he would have seen thirteen watercolors by Cézanne.[27] The two exhibitions surely enhanced Morandi's earlier, less immediate contact with Cézanne in print, which had deprived him of the paintings' salient formal features — size, scale, color, and facture. Although pictorial evidence of Cézanne's influence would not fully emerge in Morandi's aesthetic discourse until the late 1910s, it is important to recognize that Cézanne's innovations paved the way for Morandi as he embarked on his modernist journey, first experimenting with a Cubo-Futurist aesthetic.[28]

Morandi Goes Modernist:
Cubism, Futurism, and the *Trofeini*

In 1914, Morandi painted *Still Life with a Silver Plate*, whose nearly monochromatic, gray surface with tonal variations is echoed in a series of planes organized vertically in the upper portion of the canvas and horizontally in the lower (fig. 13.2).[29] Soft white borders outline a plate that sits before a trademark Cézannian champagne flute, a thin vase, and the apertures of a clock — whose contours recall the bodies of ancient Cycladic statues — while sooty black patches define the barely intelligible shapes of the objects collected. Morandi's objects rest just at the surface of the painting, rather than receding within the pictorial space; they are softened and more focused versions of the violins and tabletop objects that had interested Pablo Picasso and Georges Braque in their ana-

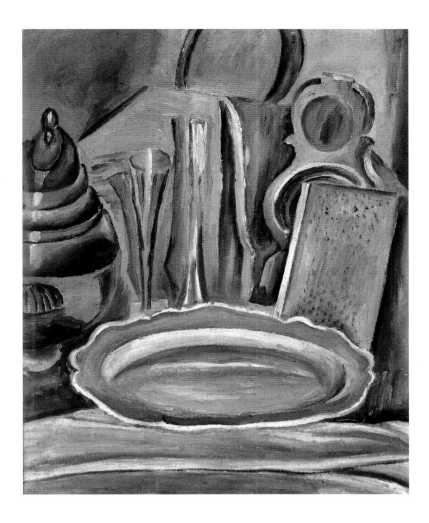

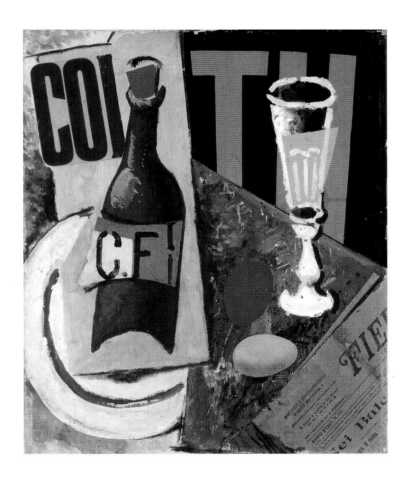

Fig. 13.2. **Giorgio Morandi,** *Still Life with a Silver Plate,* 1914. Oil on canvas, 26⅜ x 21⅝ inches (67 x 55 cm). Private collection

Fig. 13.3. **Ardengo Soffici** (Italian, 1879–1964), *Still Life with Red Egg,* 1914. Oil, tempera, and collage on canvas; 18⅛ x 15 inches (46 x 38 cm). Museo di Arte Moderna e Contemporanea di Trento e Roverto

lytic Cubist canvases, which Morandi would have read about in *La voce*.[30] In addition, his contact with the Futurists during this period would have exposed him to a number of their canvases, whose style also mimicked the French Cubist idiom, although Morandi resisted the Futurists' preferred subjects of war, urban life, and technology.[31] It was the formal strategies of both Cubism and Futurism that influenced his initial processing of a Cézannian vocabulary.

Morandi likely took his cue to experiment with Cubo-Futurist pictorial strategies from Soffici, who, despite having long praised Cézanne in his prose, went through his own period of artistic experimentation, employing a visual vocabulary that illustrates his attempt to naturalize French Cubism, too, as Italian by incorporating traces of Italian *realia*, or real-life objects. Although Soffici had initially resisted Italian Futurism for its rejection of tradition, in the mid-1910s he fused elements of Parisian Cubism and Milanese Futurism with traces of Tuscan life to produce a series of collages now known as *trofeini*, or "little trophies," inspired by rural folk and sign art as well as by the art of Henri "le Douanier" Rousseau.[32] Soffici's *Still Life with Red Egg* (1914), for example, combines linguistic signs (floating letters), a scrap of the Florentine daily newspaper *Fieramosca*, and still-life objects—in the form of flattened eggs, a champagne flute heavily outlined in white, and a ceramic platter tucked beneath a mysteriously labeled wine bottle (fig. 13.3). But ultimately Soffici could not embrace Cubism as a model for Italian art, not only because of its turn toward primitivism, but also because Picasso continued to fashion himself a bohemian artist, even after attaining commercial success. Soffici's move back to Tuscany following his own seven-year sojourn in Paris entailed a return to the stability of classical pictorial values and native-Italian traditions, both of which were incompatible with the ethos and inspiration of Picasso's bohemianism. Moreover, in establishing his own brand of *toscanità*, or Tuscanness, that would celebrate the wild nature of the countryside peppered with its typical *case coloniche* (country

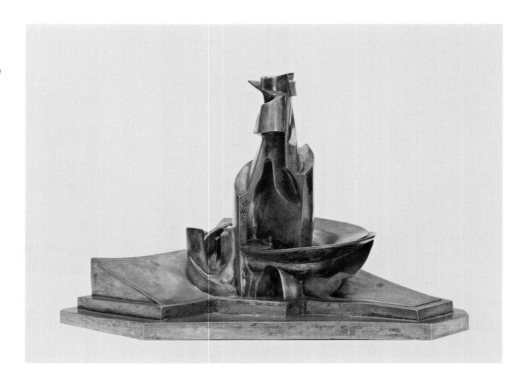

Fig. 13.4. **Umberto Boccioni** (Italian, 1882–1916), ***Development of a Bottle in Space,*** 1912 (cast 1931). Silvered bronze, 15 × 23¾ × 12⅞ inches (38.1 × 60.3 × 32.7 cm). The Museum of Modern Art, New York. Aristide Maillol Fund

houses), Soffici wanted to promote and practice a pictorial rhetoric replete with native Italian references rather than the African signs Picasso employed.

For Morandi, the formal lessons of Futurism and Cubism would not endure. While his canvases from this period make only cursory gestures toward the worlds of Picasso and the Futurist Filippo Tommaso Marinetti, Morandi was in direct contact with prominent figures of the movement, including Carrà and Boccioni, through exhibitions and Futurist events known as *serate*, or evenings. The always polemical Soffici, whose ideas found wide circulation through his journalism as well as, to a lesser extent, his art, did not function in a vacuum. Though he was certainly at the forefront of Italian Cézannophilia, in the 1910s Soffici circulated within larger artistic circles, including those of the Futurists, making regular contact with peers such as Carrà.[33] By the end of World War I, these two artist-critics had become close associates, and their artistic and critical paths would continue to cross through exhibitions, articles, and monographs during the first half of the twentieth century.[34]

From the time of the publication of Futurism's "Founding Manifesto" in 1909, Futurists had rejected the importance of earlier Italian artistic achievements, because "for too long has Italy been a dealer in second-hand clothes"; such a rejection of the past would have included Trecento and Quattrocento artists as well.[35] But perhaps what most clearly separated Soffici and, by extension, Morandi from the Futurists was the group's rejection of Cézanne. In his essay "Futurist Painting and Sculpture," published in 1914, Boccioni explained that Impressionism's inevitable culmination was Picasso, who "developed as far as possible the artistic values initiated by Cézanne," but destroyed the active impulse within objects, not to mention their "sense of volume . . . one of the principal aims of Cézanne."[36] Committed to taking the viewer inside objects and spectacles to render motion and the experience of a modern metropolis, the Futurists, Boccioni declared, would "put the spectator in the centre of the picture."[37] Furthermore, lamenting Cézanne's "search for volume and immobility, weight, tone, etc.," the Futurist asserted that "Cézanne's teachings are entirely Old Italian."[38] For Boccioni, this heritage was wholly incompatible with Futurism's platform, since "*modern Italians have no past.*"[39] Clarifying the new artistic strategy, he maintained that for the Futurists, "unlike Cézanne[,] . . . the boundaries of the object tend to retreat toward a periphery (the environment) of which we are the centre."[40]

Peeling away the layers of a *Bottle in Space* (1912) is Boccioni's attempt at just such a breakdown of the boundary of a static object, unleashing before and around us its kinetic energy and motion (fig. 13.4). Boccioni was interested in the still life, but he did not want it to be so still. In designing a strategy to merge art and life, his aims were more than aesthetic; the Futurists sought to infuse their art with politics and to use war as a form of cultural hygiene that was potentially regenerative.[41] While Morandi's digestion of Soffici's Cézanne, just barely perceptible in his *Still Life with a Silver Plate* (see fig. 13.2), would eventually draw the viewer back in time (through Piero della Francesca, Giotto, and even Jean-Siméon Chardin), Boccioni's aesthetic strategy would keep the viewer in the present moment and, more importantly, mimic the experience of motion. Ultimately, Cézanne allowed modern Italian (that is, non-Futurist) artists and critics to re-theorize representation on a chronological matrix: Both strategies impart a temporal element to representation, but each does so in a different manner. Cézanne's representational gesture toward the past thus became a means of imparting a diachronic aspect to the canvas, while Futurism aimed to remain in and active within the present. Boccioni's full-blown negation of Cézanne in 1914 coincided with Morandi's increasingly visible aesthetic adoption of him, representing for Morandi a critical step in his structuring of objects that constituted his own *rappel à l'order*, or "call to order."

Revisiting Cézanne—The *Valori plastici* Years

Just after World War I, Morandi became more actively engaged with several artists, including Carrà and de Chirico, through his association with the journal *Valori plastici* (Plastic Values), published in Rome by Mario Broglio from 1918 to 1921.[42] The magazine's articles and artistic reproductions celebrated a new form of modernism grounded in the weighty volumes and plasticity of the Italian Primitives, Giotto, and the early Quattrocento.[43] Although the magazine focused on a return to the classical in Italian art, its pages contained both the essays and the art of international avant-garde figures such as Jean Cocteau, Theo van Doesberg, Juan Gris, Picasso, and Braque. *Valori plastici* not only endorsed a general artistic commitment to solid, plastic values couched in nearly religious terms, but also reproduced a number of Morandi's metaphysical paintings, which reflected the visionary, dreamlike works of *pittura metafisica*, as defined by de Chirico and Carrà.[44] *Valori plastici*'s publication of works by Morandi and Soffici solidified the pictorial and philosophical connections between the two artists, though, as we shall see, in the 1920s Morandi would shift his allegiance from the metaphysical school to Soffici's brand of Tuscan realism.

In the pages of *Valori plastici*, de Chirico and his brother Alberto Savinio, both proponents of metaphysical painting, rallied for a return to classical values in modern artistic practice. But key for an understanding of Morandi's art is the criticism of Carrà, who explained that metaphysical qualities could be combined with realist aesthetic strategies (in line with Soffici's Tuscan realism), as evidenced by the experiences of the French artists, Cézanne included, who had turned to Italy for inspiration.[45] From 1918 onward, Morandi inaugurated a new phase of artistic practice with a metaphysical quality, revisiting the still lifes by Cézanne that he had first seen in Pica's *Gl'impressionisti francesi* (figs. 13.5, 13.6).[46] Painting a variation on a Cézannian theme, in a still life of 1920 Morandi replaces Cézanne's autumnal colors, which range from soft browns and greens to yellows and oranges, with his own more restrained chromatic vocabulary. Morandi methodically limits his composition to golden and cream hues that delicately explore the weight and volume of his objects through varied tonal expression, recalibrating

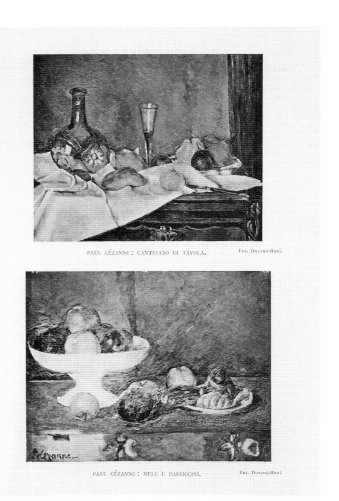

PAUL CÉZANNE: CANTUCCIO DI TAVOLA.　　Fot. Durand-Ruel.

PAUL CÉZANNE: MELE E PASTICCINI.　　Fot. Durand-Ruel.

Figs. 13.5 and 13.6. Vittorio Pica, *Gl'impressionisti francesi* (Bergamo, Italy: Istituto italiano d'arte grafiche, 1908), title page and p. 196.

Cézanne's *Still Life with a Dessert* (see plate 78) in an image that no longer uses color and contrast to model the complicated surfaces and shapes of its objects. Comparing Morandi's painting to his Cézannian antecedent calls attention to the Italian artist's erasure of Cézanne's ornamental details. And yet Morandi's inclusion of a single, more elaborate object, rendered in a cobalt blue whose coolness complements the warmth of the rest of the image, perhaps acknowledges his predecessor's earlier aesthetic choices in terms of color and motif. Moreover, Morandi produces a subtle chromatic affinity between a squat blue vase and a taller glass carafe that, though transparent, retains a barely detectable quality of color, resulting in an oil painting that approximates Cézanne's sketches in watercolor (plate 129; fig. 13.7).[47] In Morandi's image, the simplicity and faint variations that differentiate figure from ground allow the identity of each object to emerge only when the viewer pauses long enough to establish where a croissant ends and a tabletop begins. Building on recognizable Cézannian signs—champagne flute, resting knife, carafe, and fabric—Morandi's simplicity replaces Cézanne's potentially distracting elements (carved decorations, colorful fruit), essentially purifying the French master's "harsh" manner (as defined by Pica) with an arguably more clarified and controlled vision. Morandi's still and composed images bridle the more manic energy of Cézanne, as Morandi cools down the French master, who back in 1908 was described by Soffici as "crazy and primitive."[48] Fully assimilating Cézanne within his own aesthetic rhetoric, Morandi takes control of the spectral residue of Cézanne that sits within his ordered canvases.

It is essential to recall that Morandi initially experienced Cézanne's colorful works of art as black-and-white reproductions, in Pica's book and in the issues of *La voce*, images that emphasized Cézanne's volumes in the absence of his rich chromatic choices. Two paintings by Morandi produced around the same time as *Still Life* of 1920 underscore the importance of Morandi's chromatic adjustments to Cézanne's color. Fulfilling

Fig. 13.7. **Paul Cézanne, *Carafe and Knife*,** c. 1882. Watercolor and graphite on paper, 8¼ x 10¾ inches (21 x 27.3 cm). Philadelphia Museum of Art. A. E. Gallatin Collection, 1952-61-11

Fig. 13.8. **Giorgio Morandi, *Still Life*,** 1919. Oil on canvas, 17¾ x 23¼ inches (45 x 59 cm). Private collection

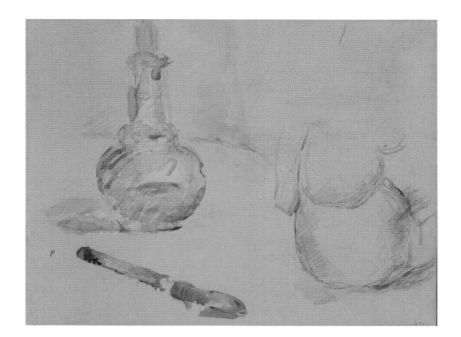

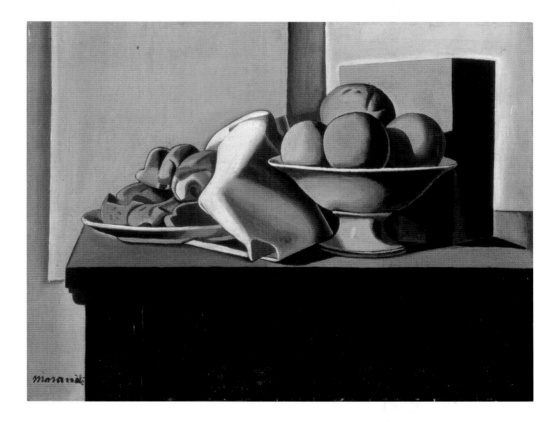

de Chirico's goals, as stated in the pages of *Valori plastici*, to "return to the craft" of painting, Morandi focuses on the solid bodies of modern, everyday objects to more clearly articulate the plasticity and volume central to the aesthetic strategies of Soffici's beloved Tuscan Primitives.[49] Toward that end, a still life of 1919 is rendered in Morandi's muted taupes, grays, and tans, echoing the frescoes of Piero, Uccello, and Masaccio (fig. 13.8).[50] The somber gray walls of this interior view with a still life mimic the soft gray frescoed surfaces of the Tuscan masters, especially those of Piero, while the heavy wooden table introduces the weight of furniture and walls seen in Quattrocento compositions.[51] At the front of the table of objects—a plate of pastries, a folded cloth napkin, a block—is a footed compote filled with oranges that announces Cézanne's presence, fusing the French master with the eerie weight of objects generated by the earlier Italians. In this metaphysical image, the somber colors not only refer to paintings of another, less stable moment but also literally color the "moods" of the weighty inanimate objects, here reclaimed as fully Italian.

Morandi's *Amphora (Still Life with Round Table)* of 1920 (fig. 13.9) refers directly to Cézanne's *Apples and Pastries* (1877), which was also reproduced in Pica's 1908 volume (see fig. 13.6).[52] Whereas the energy of Cézanne's painting stems from the dynamic contrasts between its colorfields—its bright green background, gesso-like white compote, crisp red and yellow apples, and warm pastries—Morandi's less colorful image reduces the number of objects in the composition while simultaneously altering the density of those objects by substituting chromatic synonyms for Cézanne's more highly contrasted color choices. In *Amphora*, Morandi negotiates pictorial privilege with Cézanne, elevating the latter's trademark fruit compote to a blocky pedestal, but pushing it to the background of a composition in which the Italian painter's own chosen vessels begin to take over. In this sense, Morandi perhaps envisioned an Oedipal relationship between himself and Cézanne, honoring and yet displacing his revered (if imaginary) teacher. *Amphora*'s three containers leave the compote's watchful eye behind and assert their own priorities: their peculiar weightiness, their chromatic harmony, their immobility. Even the ball—reminiscent of de Chirico's choices for his trademark oneiric, the theaters of modernity—fails to roll off its inexplicably tilted surface. But ultimately, Morandi's translation reduces and eliminates details that, once gone, allow his emerging concerns to come into focus. All of these elements pit the painting's own flat surface even further against the fantasy of one-point perspective that had already begun to disappear from Cézanne's composition. And in ironing out some of Cézanne's details, Morandi opens up space in the canvas for his own "metaphysical" gestures, which impart a magical glow to (and release from within) his beloved vessels. Morandi's critique of Cézanne is both an act of homage and a delicately designed dismissal—it is his love, and fear, of the French master. The year 1919 coincided with Italy's acknowledgment of her bitter losses in World War I and the onset of consequential nationalism, and the date clarifies what was at stake for painters like Morandi in their need to celebrate and indeed protect their Italianness. Thus his conquest and control of Cézanne mark an artistic victory with political valence.

The muted finish of these paintings imitates the matte, almost mute surfaces of the frescoes of Giotto, Masaccio, and Piero that had so thrilled Morandi on his visit to Tuscany nearly a decade earlier. Morandi would later mention his attachment to Tuscan art and artists in his "Autobiografia" of 1928: "Of the cities visited in order to study my art, the one that attracted me the most is Florence, where I find the greatest [artists] and where I count my friends to whom a certain spiritual affinity attaches me."[53] While Soffici had already staked a claim for Cézanne's Italian origins, Morandi intensified the Frenchman's Italianness by sealing his own Cézanne-inflected paintings with what read aesthetically as an Italian finish. Morandi balanced his investment in Cézanne with a healthy measure of de Chirico's urge to return to the craft, in this instance to embrace the physicality of painting in a gesture enlisting a "call to order" that would fulfill Soffici's desire for Italian ruralism, which in turn would eventually illustrate a regionally inflected form of Fascist modernism.

In considering the role of Cézanne in Morandi's oeuvre, we should consider other instances of Italian critical writing on the French painter published during the first decades of the twentieth century. In 1919, Carrà had thrown his hat into the ring, writing an essay on Cézanne for the journal *La ronda* (published in Rome from 1919 to 1923), which, like *Valori plastici*, sought to restore order through a more classically inflected aesthetic.[54] Following Soffici's lead, Carrà emphasized Cézanne's preference for a reclusive rural life over the urban activity and concerns of Paris.[55] But perhaps most strikingly, Carrà challenged Soffici's alignment of Cézanne with a specifically Tuscan

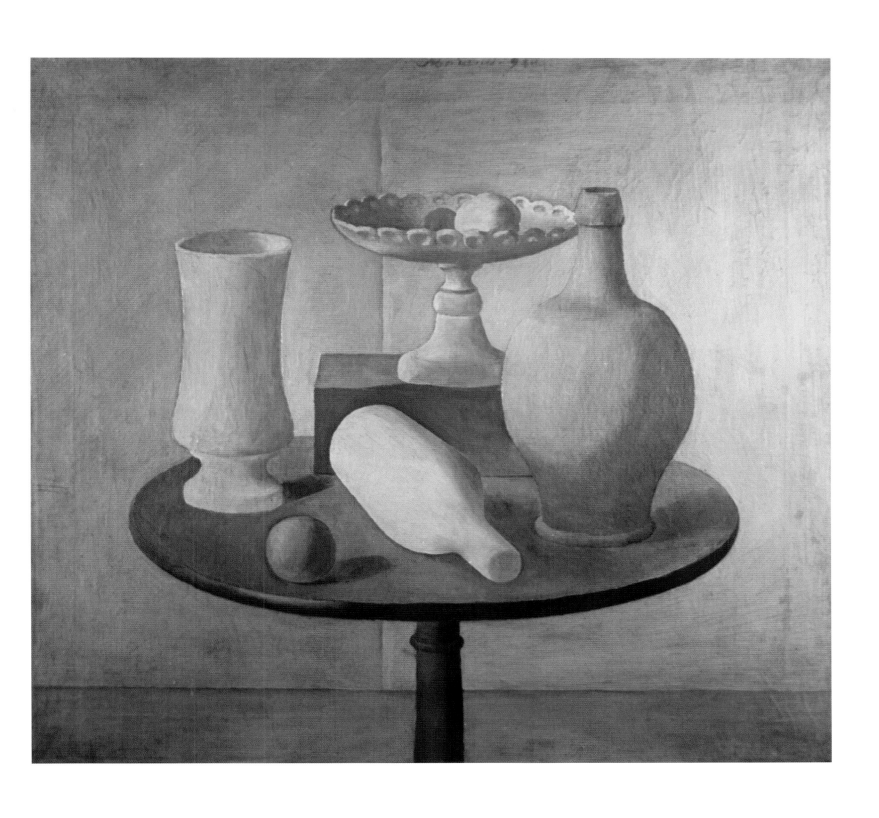

Fig. 13.9. **Giorgio Morandi, *Amphora (Still Life with Round Table)*,** 1920. Oil on canvas, 23⅝ x 26 inches (60 x 66 cm). Pinacoteca di Brera, Milan. Collezione Lamberto Vitali

sensibility. In fact, he claimed, "the most intimate and perfect value that connects him directly with tradition, and here I mean our, Italian [tradition] . . . is that he resolves the plastic problem in the manner of the Venetians, that is to say, more so in [terms of] color-tone than in the linear manner that comes from Giotto and Masaccio."[56] Carrà's argument must not be taken lightly; he singularly associated Cézanne's use of color with a strain of Italian artistic talent entirely different from that identified by Soffici.[57] Rather than seeing only weight and mass, Carrà returns our eye to the facture of pictorial surface itself, reminding us of what de Chirico would elsewhere (and later, much more intensely) call the "return to the craft."[58]

In the midst of the activity of the *Valori plastici* years, the Venice Biennale of 1920 included an installation with twenty-eight works by Cézanne, drawn from the Loeser and Fabbri collections in Florence.[59] And although Morandi had seen French paintings as early as 1910—works by Renoir were exhibited at the Biennale—it was not until 1920 that he saw a large-scale Cézanne installation at the same venue.[60] Whereas Renoir's paintings seem to have had little impact on Morandi, the exhibition of Cézanne likely affected the ways in which both Morandi and his peers approached Cézanne, especially for those artists who had seen only a handful of his canvases at Soffici's 1910 exhibition in Florence. The comprehensive 1920 installation exposed Morandi and his fellow artists to a much wider range of Cézanne's works, and ensured that they saw striking examples of his portraits (including a self-portrait of 1898), landscapes, and still lifes. Moreover, the seemingly endless critical response to the installation surely motivated artists to visit the show.[61] But while many Italian critics writing in response to the 1920 Biennale acknowledged that Cézanne's aesthetic strategy revolutionized the field of painting, most critics nervously cited his rupture with tradition and the resulting deformations of the objects in his images, prefiguring what many right-wing commentators would later say about Morandi at the very end of the Fascist regime.[62] The *Valori plastici* years were rich with still-life examples of the Bolognese artist's elaboration and renegotiation of Cézanne's pictorial forms and contents, as Morandi experimented with an Italianized version of Cézanne's canvases. But Morandi virtually abandoned landscape from just before the end of World War I until about 1925, the moment when he would return to the genre in which he could then most comfortably embrace Cézanne's example.

The Morandi Myth under (and after) Fascism

The artists associated with *Valori plastici* eventually followed their own paths, and the journal ceased publication in 1922, the very same year that witnessed the Fascist March on Rome. Distancing himself from the *Valori plastici* group, Morandi eased away from the more solid forms of his metaphysical production and joined the Strapaese, or "Supercountry," movement, a natural move that continued his ongoing association with Soffici, who was thoroughly committed to fine-tuning a rural aesthetic.[63] Morandi's retreat from *Valori plastici* was likely symptomatic of his loss of interest in a dying enterprise; moreover, his metaphysical painting and that of de Chirico were no longer compatible, as de Chirico became increasingly intent on forging a modernism wholly concerned with looking to the Italian past vis-à-vis the classical and the Baroque, rather than to more modern, and indeed foreign, influences.[64] Eager to forge a modern identity linked to his own Bolognese background, Morandi saw in Strapaese an appropriate venue for cultivating a new artistic identity. The movement played a role within the larger goals of the regime to create a rural Tuscan and Emilian

identity under Fascism in line with the regime's various incentive programs for those living outside urban centers.[65] Morandi solidified his commitment to and importance for the group through his associations with two magazines, Mino Maccari's *Il selvaggio* (1924–43) and Leo Longanesi's *L'italiano* (1926–42), the two publications whose pages outlined, illustrated, and celebrated the Strapaese movement.[66] Ruralism, or the "real Italy," became a fitting solution for Soffici (and indeed Morandi), who sought to coordinate their pictorial values with a regional aesthetic, that is, a vernacular version of modernism—and here Morandi could continue to draw on Cézanne—capable of fulfilling the nationalist goals of the regime.[67]

Morandi's relationship to Cézanne suggests that the Bolognese painter was, at least in part, a ventriloquist, both in word and image, as he channeled Soffici's verbal and pictorial discourses through his own work. In 1928 Morandi published his "Auto-biografia" in the Bolognese journal *L'assalto*, enumerating, as cited at the opening of this essay, Soffici's artistic pantheon nearly verbatim, adding only Soffici himself to the roster. Elsewhere in the article, Morandi acknowledges the support of the Fascist regime as fundamental to his artistic career, and provides a laundry list of those artists, past and present, whose work has influenced him. He begins with the "Tuscans . . . Giotto and Masaccio above all" and then declares "Corot, Courbet, Fattori, and Cézanne . . . the most legitimate heirs of the glorious Italian tradition." Before closing, Morandi praises Carrà and Soffici, acknowledging their art and criticism as important not only for him personally but for the "state of Italian art today."[68] Morandi's reference to Fascism in this context reads as a pro forma set of remarks that frame a basic art-historical canon, one based on Soffici's own, and one that Morandi still found valid, even after twenty years. The generic tone and lack of personal detail in Morandi's "Autobiografia" stand out, especially since this was the only piece of writing he published in his lifetime.

In fact, as art historian Emily Braun has pointed out, it was as *strapaesisti* that "Soffici and Carrà recultivated their origins in the bucolic pleasure of the countryside, rendering the local landscape and peasantry with a nostalgic and sentimental vision."[69] Central to an understanding of the reception and perception of Morandi's works is a text on Morandi published in 1932 by Soffici in *L'italiano*. In this essay, Soffici squarely and definitively created a nationalist reading of Morandi as the ultimate Italian painter, whose images represent a genuine Italian vision articulated through a vernacular vocabulary.[70] Soffici triumphantly proclaims that "Giorgio Morandi has resolved the problem of a modern and, at the same time, a legitimate and Italian style in painting."[71] Morandi's *Still Life* of 1932 offers a collection of containers—bottles, vases, a pitcher, and a cup—whose bodies begin to dissolve into not only one another but the soft, taupe background before which they stand (fig. 13.10).[72] His contours illustrate the tension at the heart of representation's deceit, exposing the artificiality of pictorial marks that refuse to hide their manufacture. Comfortably proclaimed as the practitioner of a "legitimate and Italian" style, Morandi feels free to dilute the stonelike weight and stature of the tabletop—which softly echoes Piero's slabs—an element of his compositions that had been more pronounced in his metaphysical meditations a decade earlier. Morandi's thick brushstrokes and more somber palette, replete with purplish, deep browns, push Cézanne further back in time, establishing firmly Morandi's mastery of the French master himself.[73]

These accolades are significant with regard to Morandi's renewed interest in landscape painting in the mid-1920s, just as he strengthened his bonds with the other members of the Strapaese movement. Painted from within an Italian context that was

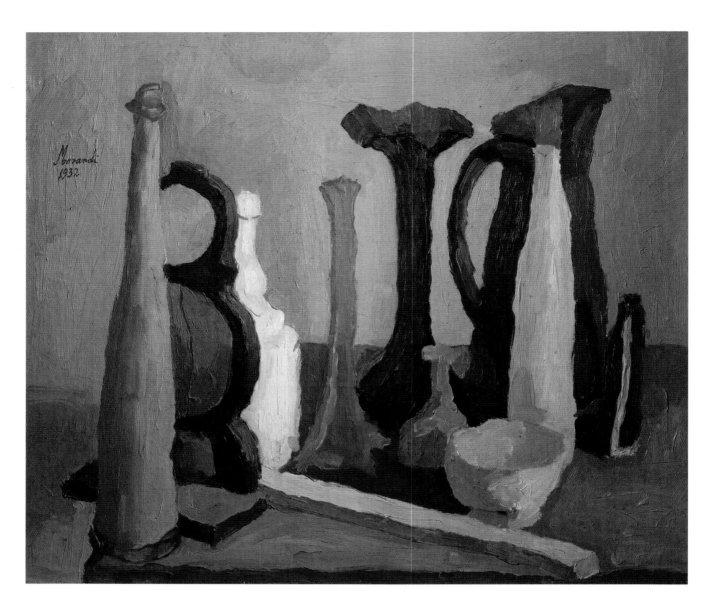

Fig. 13.10. **Giorgio Morandi, *Still Life,*** 1932. Oil on canvas, 24½ x 28⅜ inches (62.2 x 72 cm). Galleria Comunale d'Arte Moderna, Rome (on deposit at the Galleria Nazionale d'Arte Moderna, Rome)

committed to illustrating its nationalistic agenda precisely through its attachment to the land, Morandi's landscapes from this period, though formally indebted to Cézanne (and hence expressive of an ongoing admiration for the French artist) belie a much more personal political cause. Morandi's *Landscape* of 1935–36 establishes new, Italian roots for Cézanne's tree trunks and mossy green foliage (fig. 13.11).[74] The tall and thin trees of Grizzana frame and sit before Morandi's familiar hills in an image that reincarnates but re-envisions Cézanne's trademark Mont Sainte-Victoire. By the mid-1930s, Morandi was an accepted and established painter, with exhibitions and sales of his canvases, and thus unafraid to paint landscapes that admit their Cézannian ancestry. Morandi's images successfully negotiate an image for Fascist ruralism that is at once native Italian and a restoration of Cézanne's own Italian influences.

In order to appreciate fully the presence of Cézannophilia in modern, and especially Fascist, Italy, we should remember that Cézanne's pictorial lineage in Italy can be traced in the art produced not only by Morandi but by other artists working under Fascism. Most notable, perhaps, is the work of Mario Sironi, who came closest to fulfilling the role of Mussolini's "court artist."[75] It is perhaps Sironi who best replicated what Pica had referred to as the "harsh" quality of Cézanne's volumes, evident in *Still Life with Blue Cup* of 1924 (fig. 13.12). Recalling Morandi's *Still Life* of 1920 (see fig. 13.1), we might wonder if Sironi's painting nods directly to still lifes by Cézanne (fig. 13.13) or if, instead, his relationship to Cézanne was mediated by contact with his fellow Italian. A comparison of the works by Sironi and Morandi suggests that the relationship between the two artists was in fact triangulated by the presence of Cézanne.

Fig. 13.11. **Giorgio Morandi,** *Landscape,* 1935–36. Oil on canvas, 23¾ x 28 inches (60.3 x 71.1 cm). Museo Morandi, Bologna

Sironi's tenebristic palette and brushwork are far less restrained than those of Morandi, and return us to Cézanne's energetic, plastic volumes, whose contrasts impart gravity to the canvas. Morandi's seemingly weightless containers, as time goes on, more and more convey an appearance of floating on, or even dissolving into, the canvas, while Sironi's water pitcher, blue cup, and wine bottle roughly cut into the picture plane and stand in high relief against a flatter backdrop, whose densely shaded areas stage a competition between abstract and figurative painting that is visceral as a result of Sironi's thick brushstrokes. And yet the presence of the blue cup, an amalgamation of Morandi's white cup and small blue vase, hints that Sironi's still life was inflected by both Cézanne and Morandi.[76] Cézanne's "harsh" figures provide a different set of possibilities for Sironi, whose own aestheticization of politics involved a stark form of modern mythmaking that meshed well formally with Cézanne's figurative strategies.

Carrà's *Still Life with Pears and Coffeepot* (1933) testifies to the ongoing shadow of Cézanne and suggests yet another three-sided artistic relationship in which Morandi's engagement with the still-life genre subtly figures (fig. 13.14). Carrà works with a muted but self-conscious palette, though he incorporates more shades than Morandi, perhaps putting into practice his earlier claim, of 1919, regarding Cézanne's study of Venetian color. Carrà's palpable brushwork imbues the painting with romantic energy that makes the image scintillate in a way Morandi's more controlled compositions never sought to. The diagonally oriented knife seems to underscore the act of the painter reworking his medium on the palette, and so it is both an indexical and iconic sign, reminding us of Carrà's craft. Where Morandi had dissolved the strict three-dimensionality of his

Fig. 13.12. **Mario Sironi** (Italian, 1885–1961), ***Still Life with Blue Cup,*** 1924. Oil on canvas, 19½ x 23⅜ inches (49.5 x 59.5 cm). Museo di Arte Moderna e Contemporanea di Trento e Rovereto

Fig. 13.13. **Paul Cézanne,** ***Still Life,*** 1871. Oil on canvas, 23⅜ x 31¹³⁄₁₆ inches (59.4 x 80.8 cm). Nationalgalerie Berlin

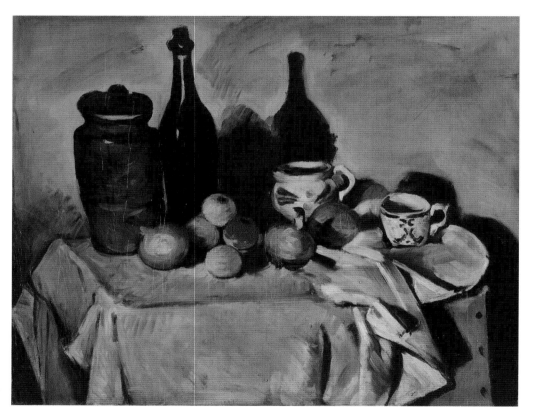

canvases by disrupting their perspective through his use of line and tone, Carrà here dissolves the sharp edges of his objects, which blend into one another as figure and ground melt softly together. The blurring of boundaries seen in Carrà's composition reflects the blurring of boundaries encountered when mapping out his artistic influences, as the presence of Cézanne, again, seems inextricably linked to an awareness of Morandi.

Artists such as Sironi, Carrà, and numerous others comfortably borrowed from Cézanne's pictorial contributions, including Novecento artists motivated by a postwar "call to order" and the Scuola Romana, which similarly embraced a return to classicism. But de Chirico had become an increasingly polemical and indeed defensive figure once the Surrealists had condemned him to an early critical death in the mid-1920s and the Fascist regime seemed to gloss over him, and he protested vehemently against Cézanne and all of his followers. In his most vicious attack in this vein, de Chirico complained

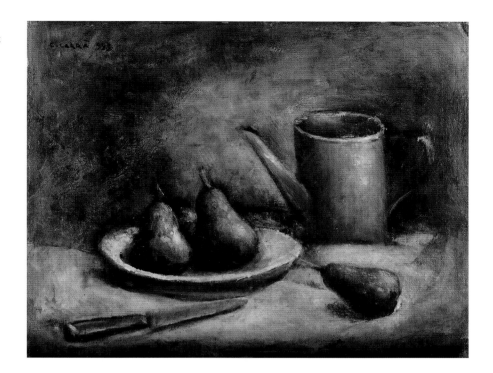

Fig. 13.14. **Carlo Carrà** (Italian, 1881–1966), *Still Life with Pears and Coffeepot,* 1933. Oil on canvas, 13¾ x 17¾ inches (35 x 45 cm). Private collection

that "whenever intellectuals talk about contemporary painting, they must constantly discuss Cézanne," whose only appeal, he argued, was that he was easy to copy.[77] De Chirico placed his rejection of Cézanne firmly within the context of his countrymen's admiration; he specifically resented the beatification of Cézanne alongside Giotto, Masaccio, and Piero, and launched an assault that named the French painter but implied hostility toward his Italian advocates, including Soffici and Morandi. De Chirico's dismissal of Cézanne was perhaps not surprising, given his German, rather than French, academic training, which had led him to admire the melancholic works of Symbolist artists, including Arnold Böcklin and Max Klinger.[78] Moreover, the highly acerbic tone of de Chirico's outburst may more closely reflect the state of art, at least his own, under Fascism than any actual investment in anti-Cézanne sentiments.[79] His virulent invective against Cézanne (and followers) thus may reflect de Chirico's frustration that the regime had chosen not to promote and celebrate him and his work.

In 1938, Italy's adoption of laws to prevent racial intermixing coincided with the tightening of the conservative critical noose around modernist artistic strategies, and criticism of Morandi's aesthetic intensified as the taste of Italian Fascists grew increasingly traditionalist. Morandi had participated in the first three Roman Quadriennali, in 1931, 1935, and 1939, where the venue featured a solo retrospective of fifty-five works. But despite Morandi's role as a card-carrying Fascist and key member of Strapaese, staunch right-wing critics like Carlo Belli and Roberto Farinacci deemed Morandi's work insufficiently Fascist in iconographic terms; some critics called it "hermetic" and "decadent." Lacking a link to the imperial campaign such as that offered by the first-prize–winning, overtly political, and classically inflected paintings of Bruno Saetti (1902–1984), Morandi was awarded second place for his 1939 contribution.[80] It may be that Morandi's Italianization of Cézanne failed to hide his source satisfactorily, and perhaps conservative critics rejected the foreign influence on his work. Morandi's paintings could not be seen as classical and did not include easily recognizable Fascist subject matter. Other naturalized brands of modernism, as seen, for example, in Giuseppe Terragni's absorption of Le Corbusier in buildings like the *Casa del fascio* in Como (1933–36), met similar fates. Whereas in the early years of Fascism, the regime exhibited a pluralistic attitude toward art, supporting and celebrating all styles, following passage of the racial laws in 1938, critics felt empowered to reject all sorts of modern forms, and

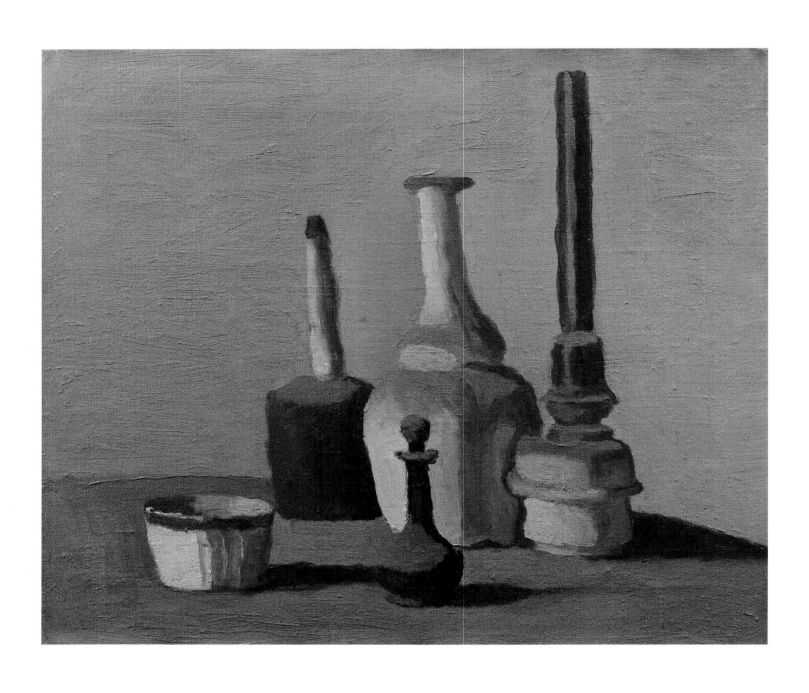

Fig. 13.15. **Giorgio Morandi,** *Still Life,* 1941. Oil on canvas, 15¾ x 18½ inches (40 x 47 cm). Private collection

especially abstraction, equating them with foreign and especially Bolshevik and Jewish influences, and their antimodernist diatribes became particularly harsh.[81] A. F. Della Porta wrote one editorial in which he illustrated both "the great masters of the past [who] exalted the [Italian] race" and likewise works by "certain modernists whose work it is clear denigrated the race"; among his collage illustrating the latter group, he included a reproduction of Morandi's painting of a female figure entitled *Fragment* of 1914.[82] The evaporation of artistic liberalism problematized critical readings of Morandi's images, since his modernism no longer satisfied the strict requirements for an imperial, and indeed xenophobic, iconography.

As discussed above, Cézanne had rejected Parisian bohemia for a more solitary and autonomous existence in Provence, a fact that encouraged Soffici's narcissistic identification with the French artist.[83] Likewise, Morandi, for whom postwar art criticism would cultivate a similar myth, had embraced the image of the reclusive, self-contained artist with no social or political ties.[84] But under Fascism, Morandi (following in the footsteps of Soffici) represented a different strain of artist—one socially engaged and aligned with the regime's own promotion of art and culture outside urban centers. Since Morandi's support for Fascism had been less staunch than Soffici's, it would be easier for him to salvage his career than it was for Soffici.[85] Whereas Italian conservative critics had previously adopted Nazi Germany's notion of degenerate art as anything "modernist" in form, by 1939 art historian and critic Cesare Brandi had instigated formalist readings of Morandi's work (the artist himself indicated his preference for a formalist approach to interpretation of his paintings). Over time, both Brandi's writings and the reiteration of his ideas by other critics would strip away the artist's complicated history within the Fascist regime.[86] The words of Morandi's fellow Fascists, such as Maccari and Longanesi, fell into silence, as did basic historical facts.[87] Brandi's formalist readings of Morandi's works stripped them of the political—that is, Fascist—context in which they had been painted and received. Such accounts ignored basic historical facts, such as Morandi's having been appointed at the Accademia in Bologna "per chiara fama" (for outstanding achievement) in 1930 thanks to his associations with the Fascist regime. But Brandi's readings of Morandi also solidified judgments about the artist's persona that had been established by Maccari and Longanesi.[88]

Brandi initiated a critical period that would define the majority of Morandi's postwar reception, and indeed his professional success as pure and protected from political contamination. Images such as *Still Life* of 1941 would emerge after the war as formal exercises in which the painter's rearrangement of familiar objects would obscure the darker history (both Morandi's and Italy's, writ large) during which they were painted (fig. 13.15).[89] Abramowicz notes that this painting was part of a series in which Morandi "gave new life to a silent world and injected new tonalities, atmosphere, and mood" in his paintings.[90] Morandi's abandonment of his late-1930s terra cotta palette for a more clarified, enlightened one perhaps reflects his gradual withdrawal from the limelight of the art world under Fascism. While the initial years of the Fascist regime were host to his professional crisis as a painter of still lifes and landscapes at odds with imperial goals and themes, the early 1940s might be seen as a moment of newly discovered independence, a time when Morandi could return, vis-à-vis his plastic containers, to the protection of his beloved Cézanne, whose influence surfaces in the small blue-capped bottle and the heavy bottom of the larger bottle with a pale, elongated white neck. Morandi continues his one-sided conversation with Cézanne through thickly painted, white impasto passages in the spiraling bottles that vibrate as they melt into the willfully rendered monochromatic background and muddy table, both of which resist depth in the

extreme. Morandi's formal exercise of painting irregular shadows of objects that bleed onto and over the objects themselves leaves conveniently little room for the political discourse percolating below and around them.

In some ways, Soffici, Carrà, and Morandi gained similar benefits from Cézanne—in each case, the artist found respite from the notion of modern art as bohemian. Soffici was able to emulate Cézanne's withdrawal from the bohemian Parisian art world by his own call for a return to Italian ruralism, avoiding contemporary xenophobia by importing Cézanne under an Italian flag. Carrà situated himself at a crossroads between the staunch metaphysical bylaws of de Chirico (and those of Savinio, to a certain extent) and Soffici's nostalgia for the Italian past. And although Soffici's art criticism mapped a path for Morandi and others, Morandi's work, more than that of anyone else, illustrates the pictorial legacy of Cézanne in modern Italy. The artist from Provence allowed Morandi to make his way, psychologically, out of an academic environment that he perceived to be oppressive, and onto a path of more liberated artistic expression that he would continue to explore in both his still-life and landscape paintings as his career evolved from the 1910s to the 1960s (plates 127, 128).[91] Cézanne allowed Morandi to develop into an artist, at once modern and Italian.

Fear of Painting

By way of conclusion, consider a final image, one embodying the pictorial, psychological, and political issues at the heart of the relationship between Cézanne and Morandi. On the table in a 1942 still life by the Scuola Romana painter Francesco Trombadori, a curious red magazine cover is caught between a book decorated with a somber self-portrait of Cézanne and a blue-and-white Dutch porcelain platter, which also holds in place a folder of drawings (fig. 13.16).[92] Like a bright red stop sign, the magazine arrests the viewer and demands that he or she read its bold, stenciled white letters: "Paura della Pittura," or "Fear of Painting," the subtitle often used to identify this peculiar canvas. Completing the composition are ears of corn and eggplants linked to Trombadori's Sicilian heritage, black-and-white photographs of Sicilian landscapes, and an open package of Macedonia-brand cigarettes, all objects that allude to this image's absent painter.[93] Nestled behind these objects, a simple white amphora, reminiscent of the pristine vessels of Morandi's still-life paintings, quietly presides. Perhaps enacting the "fear of painting" referenced by the journal's cover, three canvases are turned away from the viewer to rest against the back wall of the painting. The nearly monochromatic, soft beige tones in the top half of the composition subtly echo the trademark palette of Morandi, who, together with Cézanne, was acknowledged by Trombadori as a central source of inspiration.[94] Trombadori's image indeed confirms the complicated history at work between Cézanne, Morandi, and Italian perceptions of ruralism.

In early 1942, Sicilian-born painter Renato Guttuso (1912–1987) served as guest editor for an issue of Curzio Malaparte's cultural magazine *Prospettive* focused on the theme "paura della pittura."[95] In short, the contents of this issue can be broken down into two basic categories: first, editorials by contemporary painters on the fraught state of Italian painting, especially in terms of figurative representation; and second, French art criticism and original documents related to Cézanne and Picasso, who by 1942 were accepted by most Italian painters as having, for better or worse, inaugurated the most radical formal strategies of modern painting.[96] Effectively comprising the transcript of an artistic as well as a political debate, the essays in this issue of *Prospettive* located Cézanne at the heart of a growing representational crisis erupting in the world of mod-

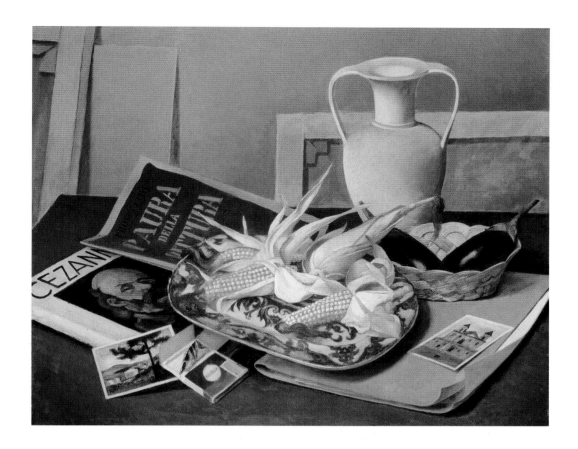

Fig. 13.16. **Francesco Trombadori** (Italian, 1886–1961), **_Still Life (Fear of Painting)_**, 1942. Oil on canvas, 25⅝ x 31½ inches (65 x 80 cm). Private collection

ern Italian painting. Casting signs of Italian identity with a testament to worries regarding the authority of French painting, Trombadori's still life provides a pictorial analog for the "anxiety of influence" faced by modern Italian painters such as Morandi in the first half of the twentieth century.[97] Within Trombadori's painting, Cézanne and Morandi are revealed as central players in this psychological drama, one already elucidated in Morandi's own paintings. And the seemingly empty vessels of Morandi's paintings ultimately contain the paradoxical francophilia and francophobia of his fellow Italian artists, who absorbed (or rejected) the Italian (especially Soffici's) historical and critical response to Cézanne that had inspired Morandi. Perhaps not as innocuous as purely formalist readings would suggest, Morandi's containers were brimming with the tension at work in his, and indeed all of Italy's, connection to Cézanne. Morandi's extended commitment to Cézanne suggests that his love exceeded his fear of the French painter, even if at times he overwrote Cézanne with the same brushstrokes that invoked him. Inevitably, these very artists emulated Morandi's complex relation to Cézanne, a connection informed always by adoration as well as resistance. Ultimately, the persistence of formalist criticism over more nuanced readings of Morandi—those that take full stock of his reception—have removed the unsavory taint of Fascism from his elegant and austere canvases. And for this reason, Morandi's utterly personal, and yet stubbornly antiseptic, visions have continued to provide an intimate space for late twentieth- and early twenty-first-century artists to explore their own pictorial possibilities.

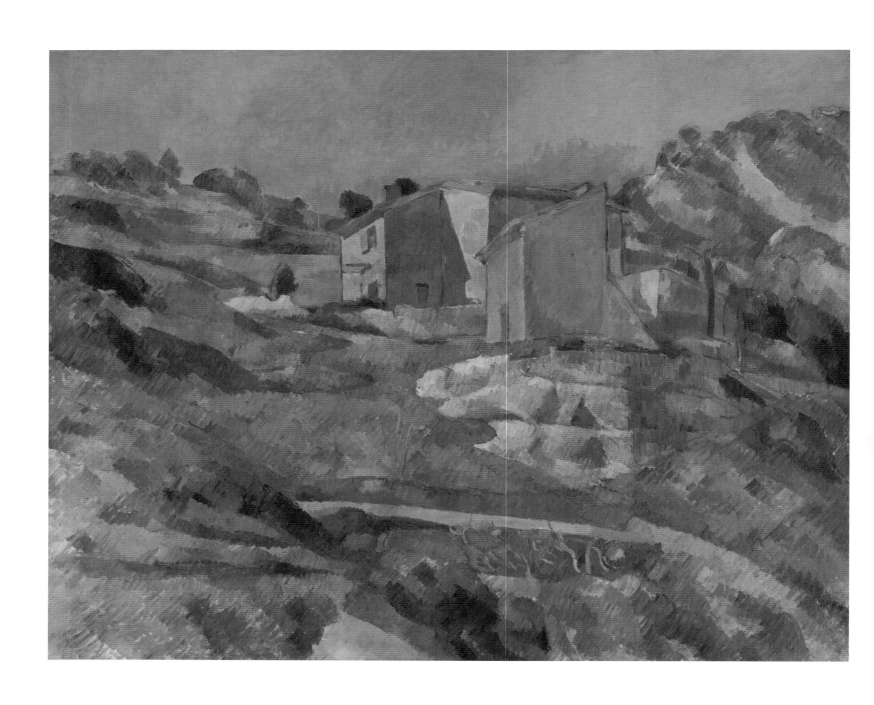

PLATE 125

Paul Cézanne

Houses in Provence: The Riaux
Valley near L'Estaque, c. 1883

Oil on canvas
25⅝ x 32 inches (65.1 x 81.3 cm)
National Gallery of Art, Washington, DC. Collection
of Mr. and Mrs. Paul Mellon, 1973.68.1

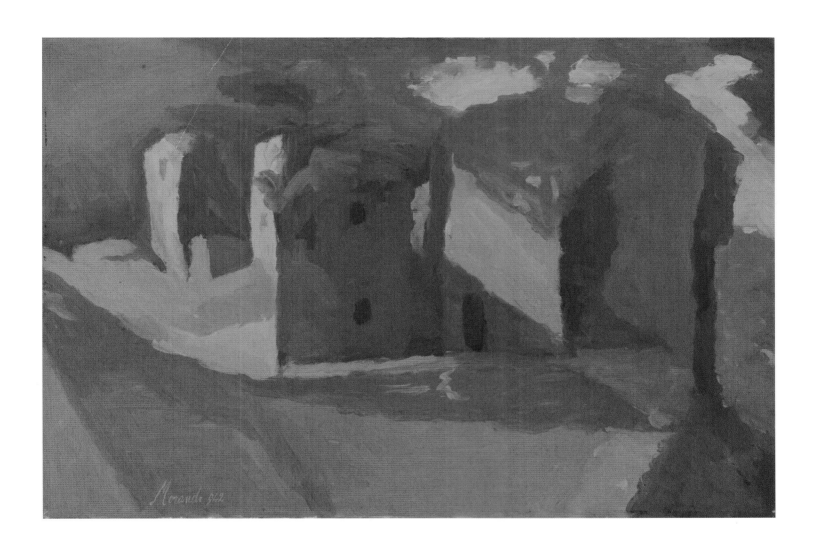

PLATE 126

Giorgio Morandi

Landscape, 1942

Oil on canvas
14⅛ x 20⅝ inches (35.8 x 52.5 cm)
Pinacoteca Provinciale, Bari. Collezione Grieco

PLATE 127

Paul Cézanne

Maisonnettes, 1880–85

Oil on canvas
12⅞ x 19¹¹⁄₁₆ inches (32.7 x 49.9 cm)
Smith College Museum of Art, Northampton, MA.
Bequest of Charles C. Cunningham in memory of
Eleanor Lamont Cunningham

PLATE 128

Giorgio Morandi

Cortile di via Fondazza, 1954

Oil on canvas
18⅞ x 19⅝ inches (47.9 x 49.8 cm)
Private collection

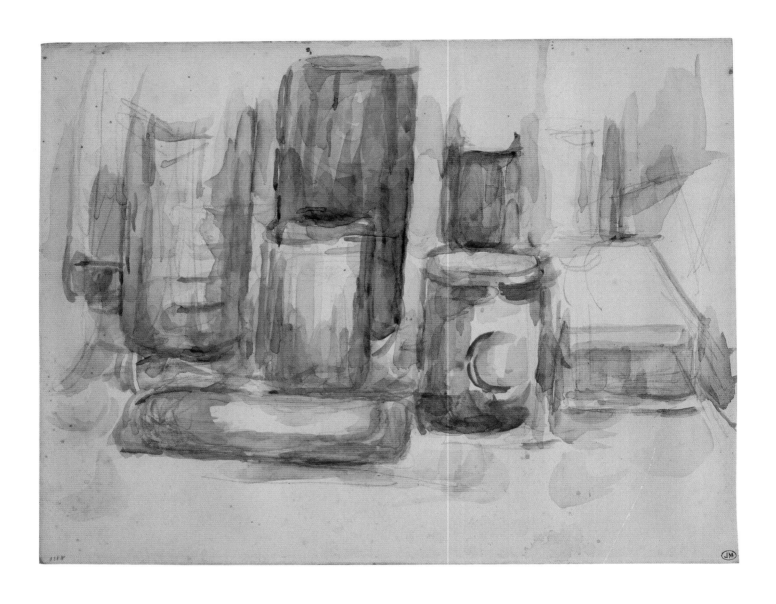

PLATE 129

Paul Cézanne

Kitchen Table: Pots and Bottles, 1902–6

Oil on canvas
8⅜ x 10¾ inches (21.3 x 27.3 cm)
Musée du Louvre, Paris

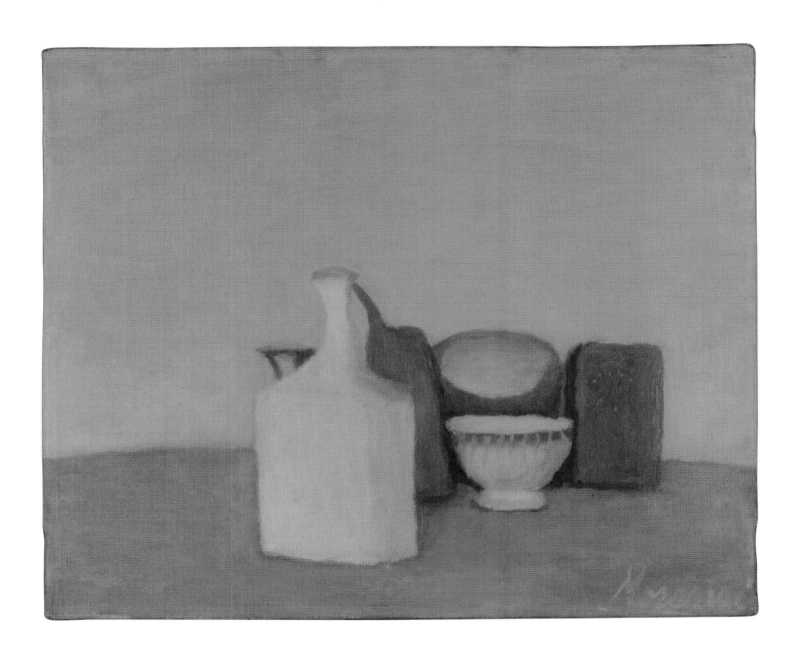

PLATE 130

Giorgio Morandi

Still Life, 1946

Oil on canvas
14¹⁵⁄₁₆ x 18⅛ inches (38 x 46 cm)
The Cartin Collection

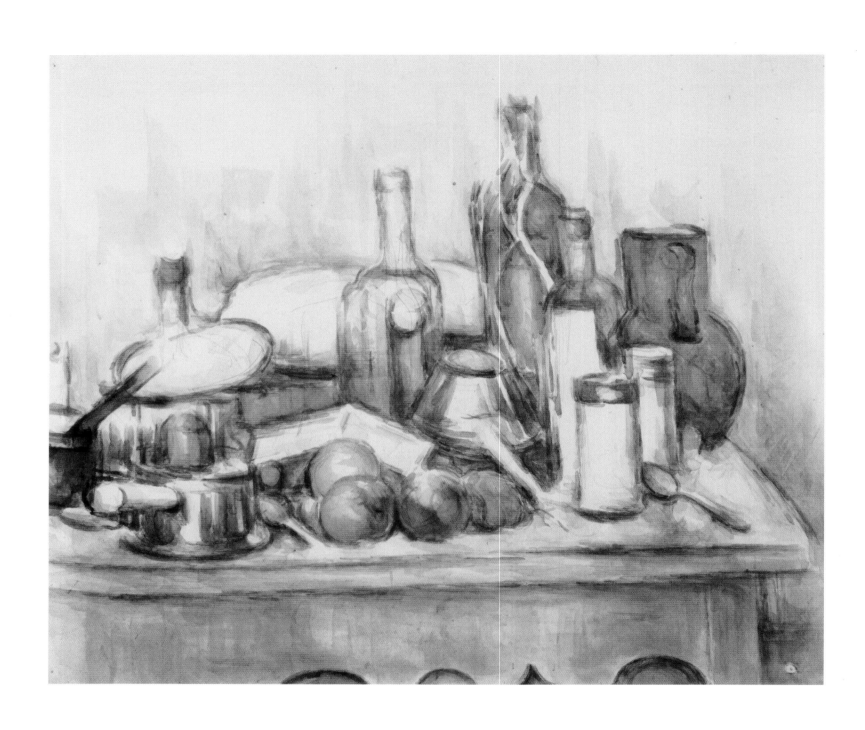

PLATE 131

Paul Cézanne

Bottles, Pots, Spirit Stove, and Apples, 1900–1906

Pencil and watercolor on white paper
18½ x 22 inches (47 x 55.9 cm)
Private collection, Washington, DC

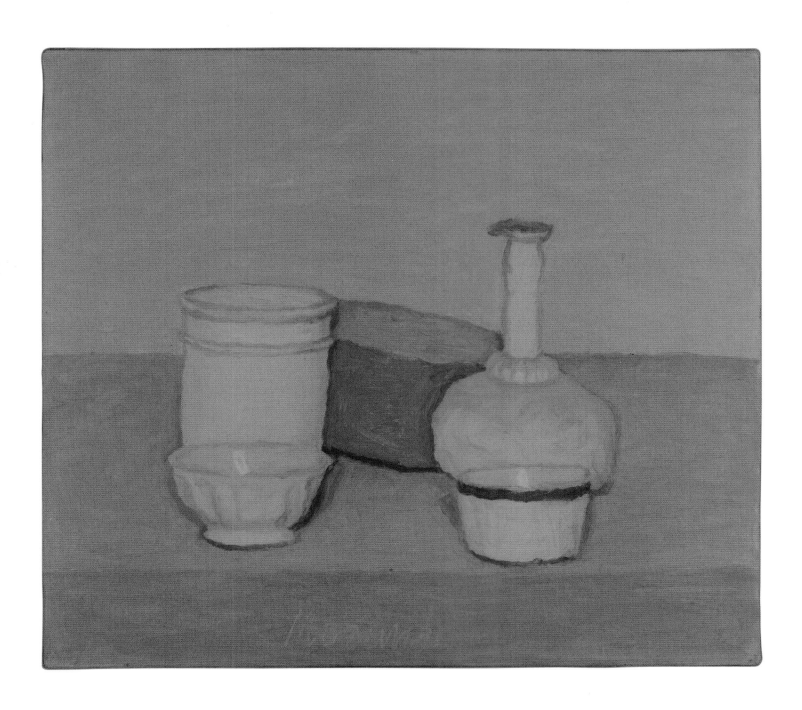

PLATE 132

Giorgio Morandi

Still Life, 1952

Oil on canvas
14³⁄₁₆ x 15¹¹⁄₁₆ inches (36 x 39.8 cm)
The Cartin Collection

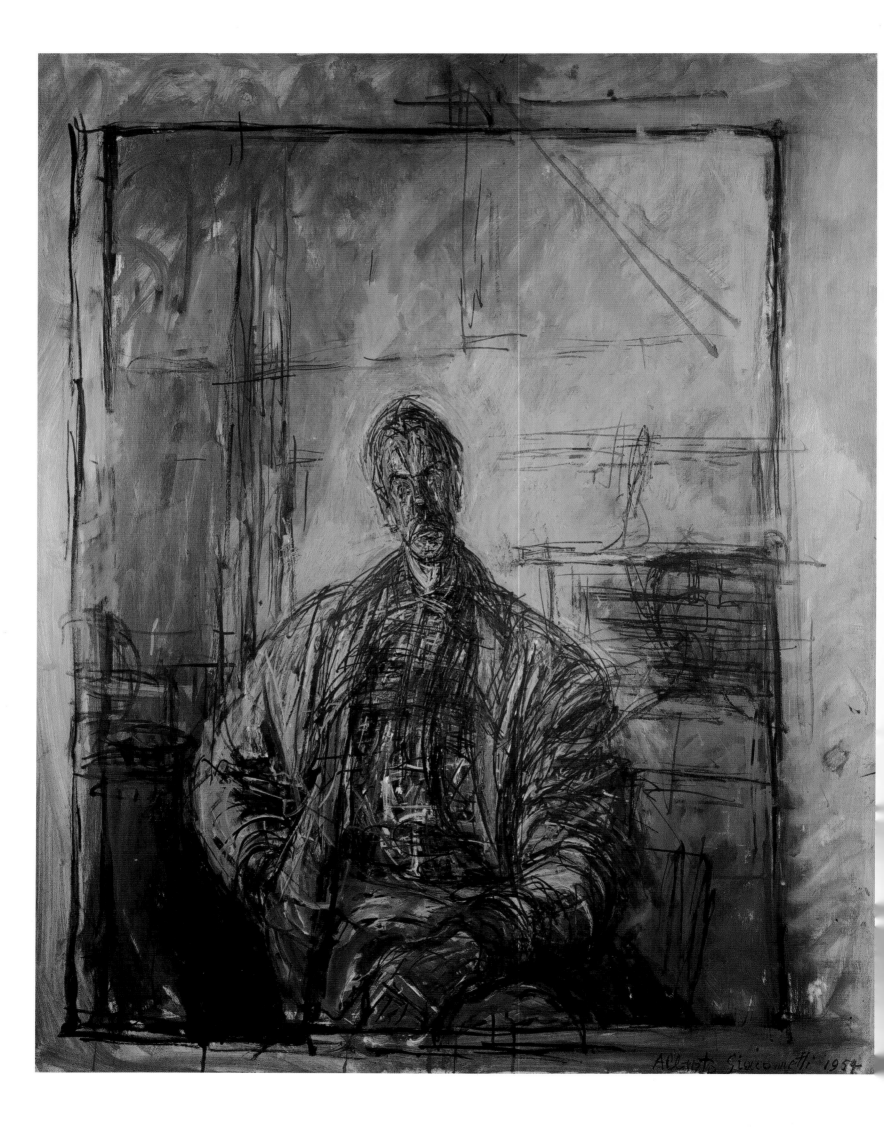

Cézanne and Giacometti: An Odd Couple

Carolyn Lanchner

"He needed one hundred working sessions for a still life, one hundred and fifty sittings for a portrait. What we call his work was, for him, only an essay, an approach to painting." This is the first sentence in Maurice Merleau-Ponty's *Cézanne's Doubt*, published in Paris in 1945.[1] Alberto Giacometti (1901–1966), who knew Merleau-Ponty and had spent the years of World War II in Geneva "meditating on Cézanne's ambitions and achievements,"[2] would certainly have read this essay. As instantly as Cézanne had once recognized himself in Honoré de Balzac's description of the mad painter Frenhofer, Giacometti would have seen himself in Merleau-Ponty's account of Cézanne.[3]

In 1965, struggling with a portrait of James Lord, he veered from invoking the old painter's ghost—"If only Cézanne were here, he would set everything right with two brush strokes"[4]—to remembering the master's own bedeviled skirmishes with the fatalities of portraiture. At Lord's observation that Cézanne had "painted some pretty good ones," Giacometti responded: "But he never finished them. . . . After Vollard had posed a hundred times the most Cézanne could say was that the shirt front wasn't too bad. . . . Cézanne never really finished anything. He went as far as he could, then abandoned the job. That's the terrible thing: the more one works on a picture, the more impossible it becomes to finish it."[5] Before consigning Cézanne to his own quagmire of the *non finibile*, Giacometti tossed off the names of a couple of artists who had avoided it— indeed had finished some portraits: Jean-Auguste-Dominique Ingres, who made "substitutes for photographs," and Pablo Picasso, who was either "vulgar" or making "caricatures" of Vincent van Gogh.[6]

Giacometti's apparently cavalier dismissal of such formidable artists as Ingres and Picasso arose from his perception—close to a moral judgment—that each was too at ease with his own virtuosity. In a more tolerant spirit, Rainer Maria Rilke, in the middle of writing a book on Auguste Rodin, was surprised to discern a similar disposition in his subject. In a letter to his wife of June 28, 1907, he wrote: "I'm beginning to understand that many [of my] perceptions . . . may possibly be a response to the standards Rodin taught us to apply. . . . Rodin does not 'think about' his work but remains within it: within the attainable—that is just what we felt made him so exceptional, this humble,

patient path he trod through the real: and I have not yet found another faith to replace this one. In art, you can only stay within the 'well done.'"[7] Rilke, who was some months away from the "strange and fortuitous insights"[8] that would come to him from that autumn's Cézanne retrospective at the Grand Palais in Paris, probably did not know how closely his appraisal of Rodin echoed Cézanne's summary judgment of the sculptor as "a wonderful stonecutter whose every figure succeeded but who lacked an idea, a faith."[9]

Cézanne and Giacometti were plagued by a faith obsessively invested in an endeavor each felt to be beyond his grasp. Cézanne spent the majority of his life trying "to realize my sensations," and Giacometti lived in the perpetual attempt "to render my vision." In these formulations—translations notwithstanding—"realize" and "render," "sensation" and "vision," are interchangeable. The verbs—meaning, respectively, "to make real" and "to cause to be"—are clearly equivalent. The nouns, signifiers of personal sensibility, are elastic and more capacious. In overarching terms, the reality both artists sought would unite perception and apperception, would capture in material form the ever-shifting moment when the act of seeing fuses optical and mental events, or, to borrow from Merleau-Ponty, would crystallize "*l'indivision* of the sensing and the sensed."[10]

Each artist had an early period in which he shifted the locus of sensation and vision from everyday sensory perception to the imaginary, and neither Cézanne's ubiquitous bathers nor most of Giacometti's standing figures were based on live models. For the most part, however, each artist was engaged in a maneuver to "trap,"[11] as Giacometti said, the totality of experience of a physical thing. For Giacometti, that thing was usually a person, but he too tried his hand at apples, trees, and mountains. Their shared ambition was aptly expressed by Cézanne: "All that we see gets dispersed, goes away. Nature is always the same, but nothing remains of it, of what appears to us. Our art has to give the feel of its duration, together with the facts, the appearance of all its changes. It has to make us sense it as eternal."[12] Other great artists have had comparable ambitions, but the two addressed here shared a rare obstinacy in their unrelenting attempts to trap the quickness of life in the materials of art.

The strong temperamental link that stretches between these artists—one born in the first half of the nineteenth century, the other at the beginning of the twentieth; one a painter, the other more sculptor than painter—is far less manifest in their styles than in the solutions each found to corresponding artistic dilemmas. In the very beginning, the older artist had problems unknown to the younger. Cézanne's father, Louis-Auguste, was a banker in Aix-en-Provence who was obdurately opposed to his son's passionate desire to become an artist, once telling him that "with genius one dies and with money one lives."[13] Eventually, he gave in and grudgingly allowed his son to give up a career in law and undertake some distinctly unpromising beginnings as an artist. By contrast, Giacometti's father, Giovanni, was a well-known painter who named his first-born Alberto, after Dürer, and his second Diego, after Velázquez. The boy's godfather was the painter Cuno Amiet, and his youngest brother's, Ferdinand Hodler. Growing up in the remote valley of the Bregaglia in Italian-speaking Switzerland, Alberto was surrounded by art and artists. To become one himself was as natural as breathing the air of his village or playing in his father's studio. In his parents' home, his later crisis of confidence was unimaginable. He later recalled: "I was terribly conceited when I was ten. I admired myself, felt I could do everything with this wonderful weapon, drawing." By the age of fourteen, he "had the feeling that there was no obstruction at all between seeing and doing. I dominated my vision, it was paradise."[14] Short-lived as it turned out to be, Giacometti's "paradise" was never accorded to Cézanne. He had little of the facility and elegance innately possessed by the young Giacometti. Rather, as

David Sylvester observed, his was a "desperate struggle to win the adroitness of his maturity," whereas Giacometti "seemed to be struggling for most of his life to deny the adroitness he began with. Cézanne couldn't help finding art difficult; Giacometti could have found it easy had he not seen how difficult it could be made to be."[15] During his first years in Paris, between 1922 and 1925, the experience of drawing from life in the studio of French sculptor Émile-Antoine Bourdelle definitively opened Giacometti's eyes to the intractable difficulties of seizing living reality. He explained, "The distance between one side of a nose and the other is like the Sahara, boundless, nothing fixed, everything dissolves." Frustrated beyond endurance, and as "a last resort,"[16] he began to work from imagination. For the next ten years his Surrealist-influenced sculptures— "objects of symbolic function," as Salvador Dalí christened them—converted interior experience into exterior form.

However far-fetched it might seem, Giacometti's play with Surrealism was not so distant from the visionary excursions of the young Cézanne. Had a time machine allowed the nineteenth-century painter to see one of Giacometti's Surrealist sculptures, he might well have supposed it to be a relic of an alien culture. Nonetheless, despite completely opposing modes of presentation, many of Cézanne's paintings of the mid-1860s and sporadically to the end of the next decade might be aligned with Giacometti's as "objects of symbolic function." Whether working in oil on canvas or in freestanding three-dimensional materials, each artist was engaged in staging his private obsessions with violence and death and with the power of woman to arouse fear and desire. Curiously—or perhaps not—Jacques Dupin's elliptically poetic profile of the "classic" Giacometti woman of the post–World War II period, embodied in bronze and thread-thin, not only describes her avatars in his work of the early 1930s, but also her predecessors in Cézanne's paintings from around the time of the Franco-Prussian War of 1870–71. She is "the woman one strangles in dreams, and the same one feared when she passes in the street. The same and the other, and the only." She is also "the fascination she incites, the desire for devouring passion and transgression she arouses."[17]

Among the odd couples joined by Dupin's words are Cézanne's *The Abduction* of 1867 (fig. 14.1) and Giacometti's *Man and Woman* of 1928–29 (fig. 14.2). Incompatible appearances aside, the two are alike in presenting a scene of violent yet equivocal encounter. And both reflect in spirit, if not in detail, the sort of nightmarish fantasies to which their authors were prone. In a poem of Cézanne's, the narrator dreamed that he was alone in a threatening forest when suddenly he was face to face with the most beautiful woman he had ever seen. Throwing himself before her, he "kissed her palpitating bosom," but "at that instant, the chill of death seized" him, and "the woman in [his] arms who had been so pink and rosy suddenly disappeared and turned into a pale cadaver."[18] A childhood fantasy still vivid in the mind of the adult Giacometti surpasses Cézanne's dream for sheer grisly detail. He would put himself to sleep nightly by pretending to be in a thick forest before a remote castle. There, after killing two men "who put up no defence . . . [,] I would rape two women—after ripping off their clothes— one aged thirty-two, all in black, with a face like alabaster, then her daughter, who was veiled in white. The whole forest would resound with their cries and moans. I'd kill them too, but very slowly . . . often beside a pool of stagnant green water."[19]

A direct kinship may exist between *The Abduction* and Cézanne's poem, but the painting itself is unclear about the survival of the victim or even whether she is the prey of the "tawny Hercules" lugging her about.[20] Has he in fact ravished her, or is he, as has been argued, rescuing her?[21] Only obliquely tied to Giacometti's savage childhood lullaby, *Man and Woman* is also equivocal about its subject. An assault is clearly under

Fig. 14.1. **Paul Cézanne, *The Abduction,*** 1867. Oil on canvas, 35¼ x 45¾ inches (89.5 x 116.2 cm). The Provost and Fellows of King's College, Cambridge. Keynes Collection

Fig. 14.2. **Alberto Giacometti, *Man and Woman (The Couple),*** 1928–29. Bronze, 15¾ x 15¾ x 6½ inches (40 x 40 x 16.5 cm). Musée National d'Art Moderne, Centre Georges Pompidou, Paris

Fig. 14.3. **Paul Cézanne, *The Murder*,** c. 1868. Oil on canvas, 25¾ x 31¹⁵⁄₁₆ inches (65.4 x 81.2 cm). Walker Art Gallery, Liverpool. Board of Trustees of the National Museums and Galleries on Merseyside

Fig. 14.4. **Alberto Giacometti, *Woman with Her Throat Cut*,** 1932 (cast 1949). Bronze, 8 x 34½ x 25 inches (20.3 x 87.6 x 63.5 cm). The Museum of Modern Art, New York

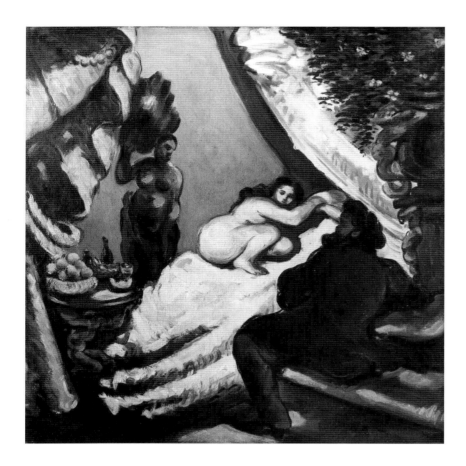

way, but to what result? The phallus of the male figure aimed at the female's vulva is equally a dagger—on its unresolved identity turns the question of the production of life or death. The woman's posture might be provocative come-on or helpless recoil, while her mouth-like vulva "is going halfway to receiving the spike."[22] Action appears suspended between the man's fear of his own aggression and the possibility of castration.

Ambiguous results are not at issue in Cézanne's *The Murder* (fig. 14.3) of about 1868 and Giacometti's *Woman with Her Throat Cut* of 1932 (fig. 14.4). In the former, the knife of the avenging male assassin furiously descends on the prostrate woman, punishing her for an unknown transgression; in the latter, a woman, represented by a jumble of imaginatively contrived body parts and splayed legs, lies raped and murdered on the floor. But even in death, the woman is not without menace—by Giacometti's preference she clutches in her leaflike hand the phallic pod movably attached to the arm bent over her head. In addition to the souvenir she holds, the fanged shapes of her rib cage impersonate the feared *vagina dentata* of male obsession.

The third in this abbreviated compendium of like/unalike duos, Cézanne's *A Modern Olympia* of about 1870 (fig. 14.5) and Giacometti's *Suspended Ball* of 1930 (fig. 14.6), is the least obvious pairing thematically but the only one that displays any compositional parallel. The action in both works is presented as though on a stage. In the painting, heavy curtains are drawn back to reveal the painter-voyeur gazing intently at a naked courtesan, whose plump body is curled into an elliptical fetal position. In the sculpture, a metal cage frames a libidinally charged abstract tableau. Dalí described it as "a wooden ball, stamped with a feminine groove . . . suspended by a violin string over a crescent the wedge of which barely grazes the cavity. The spectator finds himself instinctively compelled to slide the ball up and down the ridge, but the length of string does not allow a full contact between the two."[23] In its most obvious interpretation, the ball symbolizes the female and the phallic crescent the male. And, as Dalí notes, it is a tease; it creates an expectation—a sublimated erotic fantasy—that it then thwarts. *A Modern Olympia* seems to enact a not dissimilar gap between desire and fulfillment—

Fig. 14.7. **Alberto Giacometti, *The Cage (Woman and Head)*,** 1950. Bronze with reddish brown patina, figures painted; 70⅟₁₆ x 15⁵⁄₁₆ x 15³⁄₁₆ inches (178 x 39.5 x 38.5 cm). Alberto Giacometti-Stiftung, Zurich

and, it should be noted, is not without a similar hint of parody. The dark, brooding man, his entire attention concentrated on the rosy rounds of flesh before him—Cézanne's picture of himself—seems fixed in place, unable to move, as though the narrow area between him and the woman were unbridgeable. Where the theme of yearning and frustration would overtly reemerge in Giacometti's works of the early 1950s such as *The Cage* (fig. 14.7), beginning about 1872 Cézanne was able to "check the very real burden of his fantasy"[24] through an intense concentration on the actual.

Giacometti remembered his own decade-long retreat from the actual as "rather a happy time," yet he knew all along that "whatever I did, whatever I wanted, one day I would have to sit down on a stool in front of a model and try and copy what I saw."[25]

That day came in late 1934, when difficulties Giacometti was having with a sculpture in progress made him feel a need to "understand the construction of a head." What he thought might be a fortnight's work turned into an exhausting five-year marathon of sculptural experimentation.

Most of Giacometti's sculptures from this period bear little resemblance to those of his maturity, whereas a few canvases he produced in Stampa, Switzerland, in 1937, notably a portrait of his mother and a large still-life of a single apple on a sideboard, closely anticipate the work to come. Giacometti's long-avowed debt to Cézanne is nowhere more apparent than in these first articulations of what would become his signature painting style. In each he responded to the older artist's technique with a sculptor's eye. The field of perceptual vibrations Cézanne typically set up with flecks of color is retained in Giacometti's canvases by a network of lines of energy and contrasts of light and dark largely devoid of mass. And, as in Cézanne, traces of rapid execution combine with an obviously sustained effort.

Not long before painting *The Artist's Mother* (plate 136) and *Still Life with Apple* (plate 134), Giacometti had his interest in Cézanne rekindled by a comprehensive retrospective of the master's work held at the Musée de l'Orangerie in Paris in the summer of 1936. Among the works he would have seen was *Woman with a Coffeepot* (see fig. 8.7), a painting whose subject Lionello Venturi compared to "a grandiose force of nature. She is firmly rooted like a powerful tower."[26] Whether in deliberate reference or not, so too is Giacometti's mother. Structured pyramidally against a geometric configuration of panelling, both women sit rock-solid in their invisible chairs; the head of each tilts slightly to the left, the part in her hair defining the spine of the picture. Yet the would-be stability of each figure is compromised in multiple ways—in the Cézanne most obviously by its denials of rational structure, in the Giacometti by the unsettling visibility of space figured in shifting swaths of ocher brushstrokes to the left and in thinner veils of beige and brown to the right. The handling of the face in each painting presents other ambiguities. In the Cézanne, as Robert Rosenblum observed, it is the surprising way the shadowed plane on the right "begins, as we study it, to shift forward and backward."[27] In the Giacometti, it is the framework of nervous black lines that impart an almost skeletal fixity to Annetta Giacometti's features while suggesting their imminent dissolution. If *Woman with a Coffeepot* from Cézanne's late great period takes a somewhat more magisterial approach to imposing order on the fluid, shifting perception of things seen, Giacometti's portrait is a masterful beginning to a new way of working. In likely acknowledgment of the importance of the Master of Aix to his development, Giacometti made a drawing in which he juxtaposed a copy of a Cézanne self-portrait with another of an Egyptian sculpture in a headdress remarkably like the stiffly contoured hair he gave to his mother in her 1937 portrait (fig. 14.8).

Although Giacometti's portrait of his mother and its companion still life are equally indebted to Cézanne, the latter, whose subject existed only through Giacometti's organizing choices, allowed him more compositional freedom. Given the almost metonymic equivalence of "Cézanne" and "apple," the reference is unequivocal, even if a single small apple stands in for Cézanne's often complex arrangements. Initially, Giacometti was not bent on such a sparse composition: "On my mother's sideboard there were the makings of a fine still-life, a bowl, some plates, some flowers and three apples. But it was as impossible to paint it as to sculpt a head from life, so I took away the bowl, the plates, and the flowers. But have you ever tried to see three apples simultaneously at a distance of three meters? So I took away two of them. And I had to diminish the third."[28] He later explained, "There was more than enough to do with one."[29]

Having reduced the complexity of his motif, Giacometti does not seem to have altered his distance from it. Conspicuous in its isolation and centrality, the tightly modeled apple seems a golden knot of energy in the luminous expanse of his mother's kitchen, its diminutive presence rather like that of an acquaintance seen from a distance—the artist's obsessive sculptural motif of the time. Like Cézanne, Giacometti was a strategist of sight, and here he chose to reverse and translate his predecessor's procedures. Where Cézanne almost always presented his apples in a space whose inconsistencies of perspective rehearse the optically fluctuating sensations of seeing, Giacometti displayed this apple in a wide-angled, virtually camera-true view that dramatizes the act of seeing. And, if the sense of life's fugitive stability conjured by Cézanne through touch-by-touch patches of nuanced color could not be directly adapted to Giacometti's essentially monochrome palette, he maintained its effects by other means. The firm structures of the sideboard and paneling seem ready to shift and reform under the pressures of directionally changing brushstrokes—some intensely vigorous, some wispy, erased ghosts of their first appearances. The largely ocher coloring—layered and thick in one area, thinly painted in another—gives way here and there to lambent striations of violet, pale orange, and gold as though the very atmosphere of Annetta Giacometti's kitchen might exchange its humdrum domesticity for a numinous grace. Along these lines, Meyer Schapiro reported: "I judge from conversation of Alberto Giacometti, who painted apples all his life[,] that he regarded the choice of still-life object as an essential value. . . . In certain of his . . . paintings the apple has the air of a personal manifesto or demonstration—perhaps inspired by understanding of Cézanne's concern—as if he wished to assert dramatically, against the current indifference to the meaning of the still-life object, his own profound interest in the apple's solitary presence as a type of being."[30]

Lest any doubt remain about the importance of Cézanne to this still life, Giacometti's treatment of the right drawer pull should dispel it. In this regard, Cézanne's analysis of looking is relevant: "The eye becomes concentric . . . I mean to say that in an orange, an apple, a *boule* or a head, there is a culminating point and this point is always—in spite of the formidable effect of the light and shadow and the sensations of color—the point that is nearest the eye."[31] Giacometti chose to privilege the "culminating point" of the drawer pull over that of the apple, in effect encouraging his viewer's eye to move diagonally left from gleaming knob to the more discreetly glowing apple. This decision derived primarily from the demands of the composition, but it must also have been a declaration of kinship with Cézanne, who frequently included an almost identical knob on a table in his canvases, from still lifes to depictions of cardplayers. Indeed, this modest object seems to echo in various guises across the decades—one reverberation may be found in Jasper Johns's laconically mysterious *Drawer* of 1957 (see plate 175).

Johns's interest in Cézanne more demonstrably intersects with Giacometti's in a small painting of about 1883 in his collection. The picture, *Bather with Outstretched Arms* (see plate 191), is one of several variants of the central figure in Cézanne's *Bathers at Rest* of 1875–76 (fig. 14.9), of which Giacometti had made a rapid sketch with ballpoint pen, probably sometime in the latter half of the 1940s (fig. 14.10).[32] Long before the acquisition of his bather, Johns had been drawn to its famous counterpart, *The Bather* (see plate 64), in the collection of the Museum of Modern Art, New York. He found in it "a synaesthetic quality that gives it great sensuality—it makes looking equivalent to touching."[33] For a variety of reasons, Johns was unable to realize his intent to copy the picture.[34] Although Giacometti seems to have had no similar inclination, the first of the filament-thin figures he introduced after World War II is invested with a strong conceptual filiation to Cézanne's solitary male bather. *Walking Man* of 1947 (fig. 14.11) was described as moving "forward tentatively as if making a first ever attempt at walking,"[35] while Cézanne's *Bather with Outstretched Arms* appeared to another observer as a "sleepwalker absorbed in his dream."[36] Both works have been interpreted as self-images: Giacometti's as the artist alone, "always searching, striving to move forward";[37] Cézanne's as "a projection of Cézanne himself, . . . of his own solitary condition."[38] Each figure is monumental: the painting is "like a colossal statue,"[39] isolated in an anonymous landscape; the sculpture is a frail figure surrounded by the ambient currents of actual space. Both enact roles in the "age-old tradition of imaging man and woman as symbolic representations of the elemental."[40]

Although Cézanne rarely depicted a single male bather, assemblies of nude bathers were a constant in his work. Alternating between segregated groups of male and female figures, they display Cézanne's close familiarity with the nudes of Michelangelo, Puget, Poussin, Rubens, and others. Transposed and redesigned, they become Cézanne's properties—their bodies, especially those of the women, at a considerable remove from any normative ideal. Oddly lumpy creatures, Cézanne's female bathers participate in enigmatic Arcadian reunions of their author's invention, related only by a "strange, warped distance"[41] to pastorals of the past. Musing on Cézanne's peculiar bathers, Lawrence Gowing was prompted to observe: "Cézanne must have understood that he was by nature a subject painter as his contemporaries were not."[42] Long after the last of Cézanne's bathers had appeared, Giacometti formulated the following equation: "In every work of art the subject is primordial, whether the artist knows it or not. The measure of the formal qualities is only a sign of the measure of the artist's obsession with his subject; the form is always in proportion to the obsession."[43] This maxim provides some understanding of the internal pressures that must have possessed Cézanne

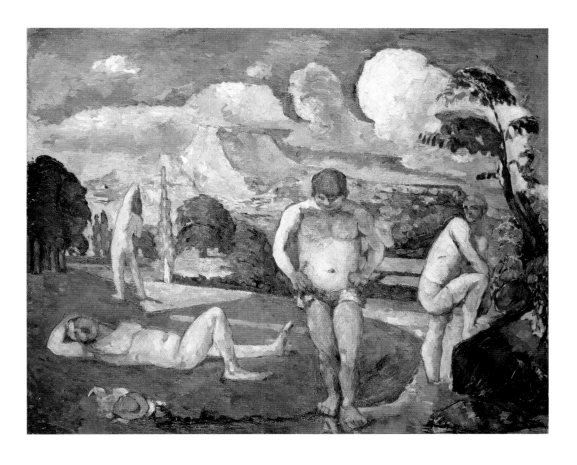

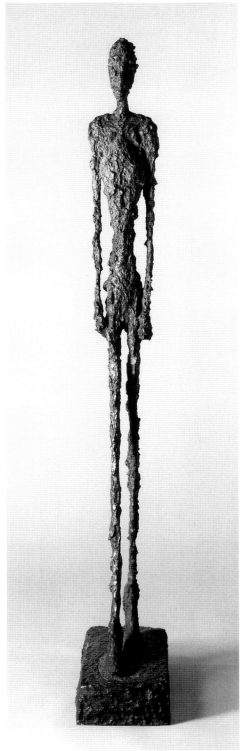

Fig. 14.9. **Paul Cézanne, *Bathers at Rest,*** 1875–76. Oil on canvas, 32¼ x 39⅞ inches (82 x 102.2 cm). The Barnes Foundation, Merion, Pennsylvania

Fig. 14.10. **Alberto Giacometti, *After Cézanne: Bathers,*** late 1940s. Pen and ink on paper, 7¼ x 7⁷⁄₁₆ inches (18.4 x 19 cm). Collection Fondation Alberto et Annette Giacometti, Paris

Fig. 14.11. **Alberto Giacometti, *Walking Man,*** 1947. Bronze, 66¹⁵⁄₁₆ x 9¹⁄₁₆ x 20⅞ inches (170 x 23 x 53 cm). Alberto Giacometti-Stiftung, Zurich

and drove him to create a pictorial world so powerful it fundamentally affected many of the greatest artists to come after him.

Unlike Picasso, Matisse, and others who included multiple and famous reverberations of Cézanne's bathers in their art, Giacometti made no sculpture or painting that directly derives from them. But even as his *Walking Man* relates to Cézanne's male bather, so do the other figures in what Lucian Freud dubbed his "whole new tribe of people"[44] connect singly and collectively to the unclothed, often meditative celebrants in Cézanne's woodlands. This "new tribe," which Giacometti began making in the late 1940s and continued until the end of his life, is dominated by elongated, impossibly slender representations of standing women and walking men whose kneaded, gouged, palpably animated surfaces were first modeled in clay or plaster and then cast in bronze (see fig. 14.11). Materially and visually they are the opposite of Cézanne's bathers, and yet they have much in common. Neither type issued from direct contemplation of a model—Cézanne used much earlier academy sketches, whereas Giacometti depended on contemporary drawings and paintings. More to the point, their contrasting, equally peculiar anatomic distortions embody not imperfect memory but the emotions and private mythologies of their creators. The convergences between them, although even less visibly apparent than those between Giacometti's Surrealist objects and Cézanne's early, moodily erotic paintings, are nonetheless discernable. Basically, and to borrow from the vernacular, each artist was burdened by a fairly hardcore, fetishist "them and us" mentality: woman was forever the unfathomable other.

Cézanne's male bathers tend to be active, vertically disposed, athletic figures often invested with autobiographical reference, while his female bathers are more passive, lounging, engaged in enigmatic play that vaguely implies a narrative structure. The stylization of Giacometti's men and women endows them with equal physical presence, but he devised their affective impact quite differently. Where the males—always allusively a self-image—stride forward purposefully, if not with entire confidence, the females remain static, rigidly frontal, their arms glued to their sides. While the heads of the men are alive with wary attention, those of the women are impassive, almost expressionless.

The parallel treatment of the sexes in Cézanne's paintings and Giacometti's sculptures could not easily carry over to their dispositions on canvas and in real space. Aside from the sexual ambiguity of some of Cézanne's figures, the genders rarely mingle in his bather paintings. Intending his solitary figures of men and women to be free-standing, iconic representations of gender, Giacometti sometimes placed them in proximity as a means of emphasizing their innate apartness. For a brief period in the late 1940s and early 1950s, he converted these impermanent arrangements to sculptural stability in a few pieces where diminutive versions of his tall figures meet on tabletop platforms. For the most part men are with men and women with women, but even when the sexes meet, the dynamics exemplified are largely those of the sterile urban encounter. Nonetheless, two pieces of 1950, *The Forest* (fig. 14.12) and *The Glade*, invite comparison with Cézanne. Where his bather compositions have been seen as "compacted mergings of figures and landscape,"[45] Giacometti found the nine figures in one sculpture like a glade, and the seven in the other like "a forest corner seen during my childhood where trees with their naked and slender trunks . . . had always appeared to me like personages immobilized in the course of their wanderings."[46] *The Forest's* congregation of seven small, expressionless figures is watched, as are the impassive participants in Cézanne's monumental *The Large Bathers* in Philadelphia (see plate 66). Allowing for the perceptual disparities between two- and three-dimensional space, the sculpture's watcher and the painting's watcher have comparably commanding views of the scene

Fig. 14.12. **Alberto Giacometti, *The Forest,*** 1950 (cast 2007). Bronze, 22⁷⁄₁₆ x 24 x 19½ inches (57 x 61 x 49.5 cm). The Metropolitan Museum of Art, New York

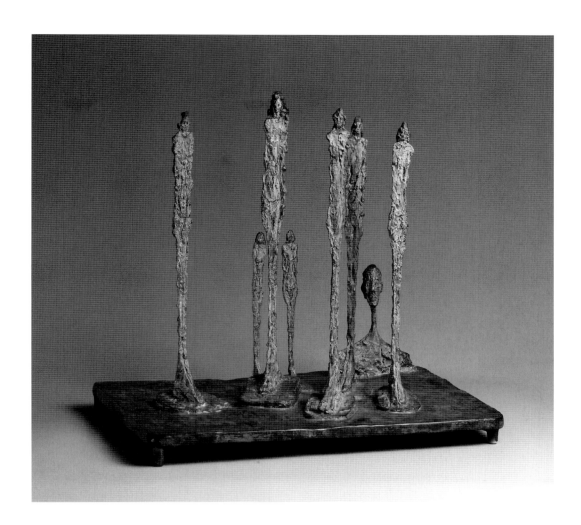

before them. The identities of the two align less clearly. That Giacometti supposed himself to be the watchman is not generally disputed. Cézanne quite often introduced himself into semi-narrative pictures, and it is possible he did so again, placing himself at the distant center of this, his last and largest painting on a theme that had haunted him for years. Whatever their identities, however, both observers clearly represent consciousness itself.

Another link between Cézanne's bathers and Giacometti's tribal types are qualities—mostly unspecified—that consistently provoke critical comments about the sense of ritual and mystery inhabiting them. Rosenblum speaks of Cézanne's bathers as "reverberating with echoes . . . as if the myths of Diana or Venus were distant elusive presences."[47] Dupin saw Giacometti's women as possessed of "the appearance of divinities. They seem in the service of a primitive cult . . . a gathering of sacred figures."[48] Very late in life Cézanne described art as "simply the means of making the public feel what we feel ourselves."[49] On that score, some forty-five years later, Giacometti had a relevant conversation with his friend Jean Genet, telling him: "When I'm walking in the street and see a prostitute completely dressed, I see a prostitute. When she's in a room naked in front of me, I see a goddess." When Genet replied, "For me a naked woman is a naked woman. That makes no impression on me. But in your statues I see the Goddess," Giacometti asked: "Do you think I've succeeded in showing them like I see them?"[50] Had Cézanne been present, he might, with some adjustments for variant mythologies, have posed the same question about his bathers. To stretch credulity further, Giacometti might have responded that the large bather compositions reminded him of "Roman tympanums and French cathedrals . . . more true to life" than any nudes of the Renaissance.[51]

During the early post–World War II years, when Giacometti was introducing his new tribe to a mostly startled art world, he threw himself into drawing with markedly

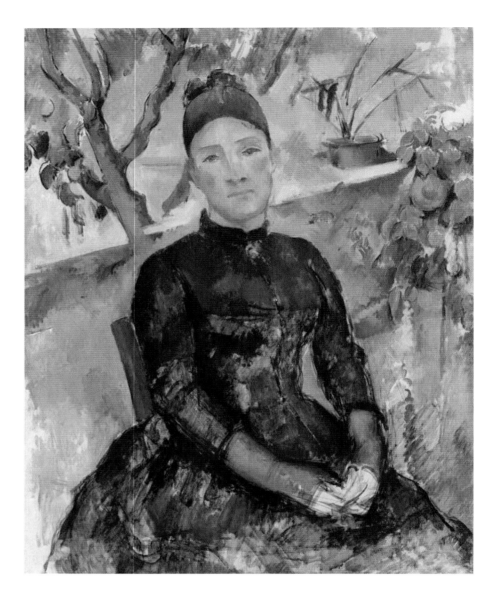

Fig. 14.13. **Alberto Giacometti, *After Cézanne: Portrait of Madame Cézanne in the Conservatory,*** n.d. Blue ballpoint pen on paper, 19⁹⁄₁₆ x 12¹³⁄₁₆ inches (49.9 x 32.6 cm). Collection Fondation Alberto et Annette Giacometti, Paris

Fig. 14.14. **Paul Cézanne, *Madame Cézanne in the Conservatory,*** 1891. Oil on canvas, 36¼ x 28¾ inches (92.1 x 73 cm). The Metropolitan Museum of Art, New York. Bequest of Stephen C. Clark, 1960

increased fervor. As it had been for Cézanne, drawing was fundamental to all his endeavors, and like his predecessor he was a dedicated copier of works by the old masters. A sheet, sketched with the newly available ballpoint pen, showing his mentor's *Madame Cézanne in the Conservatory* most likely dates from around this time (figs. 14.13, 14.14). Schematic as is the painting itself, not to mention the rapidly executed drawing, the deliberate inconsistencies between the model and Giacometti's copy define systematic differences in the artistic personalities of their makers. In Giacometti's proportionately rearranged figure, the head is considerably smaller, the body larger and longer, and the distance from the top of her head to the framing edge is increased. These revisions lead the eye of the observer to the head of Mme Cézanne and to her own eyes. Given that Giacometti was working, not from a living subject, but almost undoubtedly from a reproduction of Cézanne's canvas, the eyes of his sitter lack the intensity of those he painted from life; nonetheless, the model's impassive stare is transformed to a gaze of increased expressive confrontation.

Giacometti's alterations of the Cézanne portrait probably came about around the time painting began to rival sculpture for his attention. From approximately 1950 on, he consistently switched back and forth between the two activities. Painting from life during daylight and sculpting at night, he found one mode to complement the other—his afternoon encounters with a living subject rescuing him in his evening attempts to finish a sculpture. Ever since his youthful indecision about whether to become a painter or a sculptor, Giacometti had a pronounced tendency to force the conventions of one practice into the other. This two-way traffic is nowhere more evident than in the works

made from approximately 1950 until his death in 1966. Two 1954 portraits of his brother, one on canvas, *Diego in a Plaid Shirt* (plate 133), and one in bronze, *Diego in a Sweater* (plate 138), exemplify this symbiotic relationship and connect to Giacometti's revisions of Cézanne's portrait.

In *Diego in a Plaid Shirt*, the relation of narrow head to disproportionately volumetric body accentuates the nearness of the body while simultaneously promoting a sense of the head in perspectival retreat. Thus centered and defined in an expansive pictorial space, Diego's head and eyes compel a triadic encounter of gaze running from Giacometti to sitter to viewer. Transferred to sculpture and exaggerated, the picture's dynamics hold; in real space, and proportionately enlarged, Diego's massive body is the optical, recessively directional foil to a diminutive head whose eyes engage the viewer even more forcefully than in the painting.

Other than subject and pose, the painted and sculpted Diegos seem to have little in common with Cézanne's *Seated Man* of 1898–1900 (see plate 38). Nonetheless, through different means the expressive effects of the three are close. Each is a monumental, deeply sympathetic presentation of a man without worldly pretensions. Where Giacometti uses the figure's pyramidal mass as a path to visual encounter, Cézanne complements its tapering bulk with the sitter's near oversized head, and, although surely posed, his gentle face seems only momentarily turned away from the painter's. A strong sense of the figure as being in time, rather than preserved outside it, comes across in all three works and results from parallel, if differing, strategies. In the Cézanne, formless flecks of white scattered over the sitter's blue suit together with abrupt tonal gradations and low-keyed shifts in hue suggest changing trajectories of light. In the Giacometti canvas, nervous, gesturally free lines accomplish a similar effect, while the sculpture's mercilessly worked surface attempts to counter the permanence of the material itself. Both canvas and sculpture, in what had long been a device derived from Cézanne, refuse their figures any fixed delineation of contour. In the two canvases, both figures assertively conform to the horizontal plane of the canvas. In the Cézanne, however, nothing else seems stable; the floor tilts forward in unbalanced juxtaposition with the reddish-brown wall, and the "blond wood sideboard . . . seems about to float away."[52] While Gacometti sometimes borrowed from Cézanne's formidable repertoire of perspectival dislocations, he often preferred, as here, to replicate their effects through a palpable representation of space. If *Diego in a Plaid Shirt* is presented almost naturalistically, the shallow illusionist depth from which he emerges has a life of its own, its vaporous substance given in semitransparent, texturally shifting veils of gray, brown, and rose. Everywhere volume and space seem porous, merging in the table edge over Diego's left shoulder and fleetingly interacting in the solid forms of his body. The invisibly anchored folds of heavy drapery forming an aureole around Cézanne's sitter's head are matched in the drift of luminous, roseate space surrounding Diego's.

The artist's empathy with his model so clearly present in Cézanne's *Seated Man* and Giacometti's evocations of Diego was not limited to portraiture. Schapiro's association of the apples of Giacometti with the apples of Cézanne might well have extended to their shared identification of the tree's "solitary presence as a type of being."[53] Both artists had loved trees since their earliest days and regarded them very like companions. Different as they are, Cézanne's *Large Pine and Red Earth* of 1890–95 (see plate 162) and Giacometti's *Landscape at Stampa* (plate 142) are alike in their treatment of the tree as living presence and consoling emblem of nature's endurance. Cézanne's majestic pine presiding over a view of the Bellevue valley as seen from his sister's house is handled with a respect and devotion that make it a pictorial expression of his words, "It's

a living being . . . I love it like an old colleague."[54] Giacometti's trees seen from the studio window of his mother's house in Stampa are smaller, feistier specimens of the tree world. And, in further contrast to Cézanne's magisterial pine, they consist of spiky, linear brushstrokes applied with a speed to match the winter wind roiling their resistant branches.

The imposing stability of the Cézanne is largely due to its considered geometric composition, whereas the not dissimilar structuring of the Giacometti seems to arise from some ad hoc skirmishing. For example, in the former, the upright brushstrokes in the diagonal of foliage descending from left to right reinforce the tree's calm verticality; in the latter, the rightward tilt of wind-driven small trees and bushes looks as though it might unsettle the central tree were it not shored up by the dark horizontal band running across the picture's bottom edge.

Although the kinship each felt toward his landscape subject was similarly intense, Giacometti's sculptural impulse kept the greater part of his energies concentrated on the human model. Above all, his admiration for Cézanne was centered in his portraiture. Taking *The Boy in a Red Vest* of 1890–95 as an example,[55] Giacometti explained to a friend that its exaggerated "Byzantine" elongations were to his eyes "more true than any other [post-Renaissance] painting."[56] This was his highest praise; "Art," Giacometti said, "interests me greatly but truth interests me infinitely more."[57] Parallel to this is a critic's observation that Cézanne's work could be described as "a painted epistemological critique."[58] And corollary to both is Giacometti's: "Have you noticed that, the more true a work, the more style it has?"[59] Inevitably, the path to truth led both artists— each by way of his individual formulations of what Giacometti sometimes called the "science of sight"—to style, the sole means that might render vision and realize sensation. And the tool, however honed, always seemed not quite up to the task. In his final decade, Cézanne told Vollard: "Unfortunately, the realization of my sensations is always a very painful process. . . . I can't seem to express the intensity which beats in upon my senses."[60] About a year before he died in January 1966, Giacometti once more explained to James Lord that Cézanne's discovery of the impossibility of copying nature only meant that "one must try all the same. . . . Try—like Cézanne—to translate one's sensation."[61] On another occasion, he described his efforts: "I have to make a little hole in nature, and pass through it. Yes, I've made a little hole, but it's too small to pass through."[62] For all their self-defined "impossible projects" and all their lamenting— even, in some ways, boasting—of failure, both artists found an optimistic edge to their endeavors. Giacometti once summed up his efforts in semiarithmetical terms: "All I can do will only ever be a faint image of what I see and success will always be less than my failure or perhaps equal to the failure." Days past his sixty-sixth birthday in 1905, Cézanne wrote: "My age and my health will never allow me to realize the dream of art I've pursued my whole life. But I will always be grateful to the public . . . who— through my hesitant efforts—have intuited what I wanted to attempt in order to renew my art. In my opinion one doesn't replace the past, one only adds a new link to it."[63] Thus, while seeing himself as a traditional artist, Cézanne vested all his energies in those "hesitant efforts" that would shift painting away from an ideal of finish toward the inscription of the unfinishable, ever-insurmountable gap between aspiration and attainment. Giacometti's claim apart, Cézanne hardly "discovered" the ancient antagonism between art and nature, but he was—almost despite himself—a pioneer in making the gaps between them felt. In the tension between the ephemeral and the eternal lie the power and drama of Cézanne's art. And of Giacometti's.

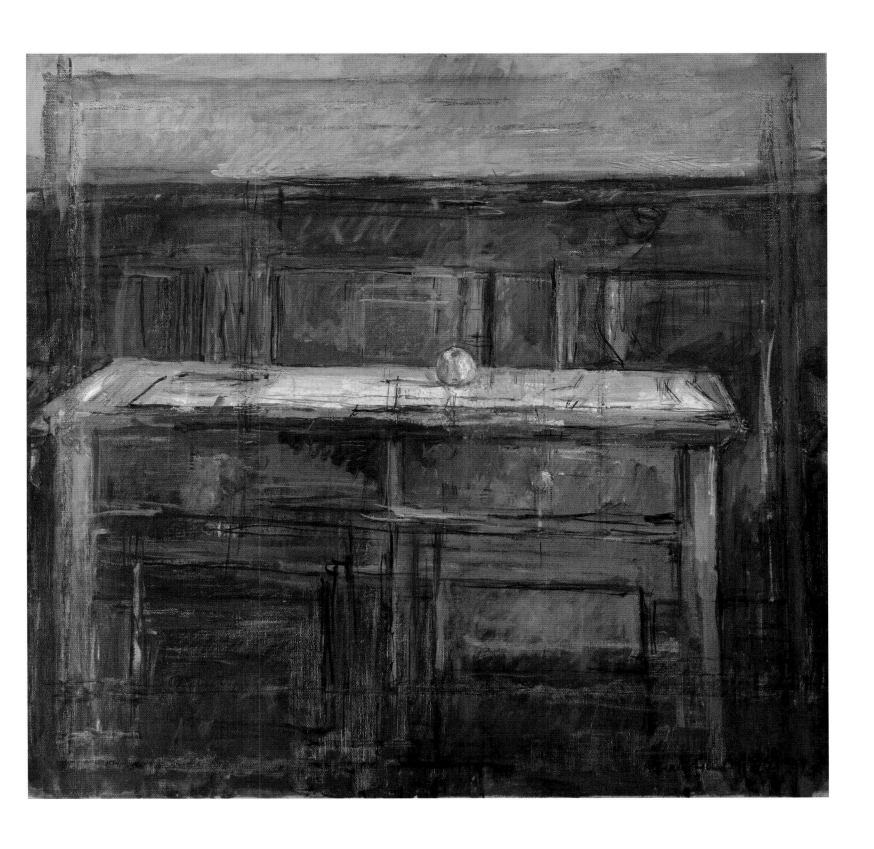

PLATE 134

Alberto Giacometti

Still Life with Apple, 1937

Oil on canvas
28¼ x 29½ inches (71.8 x 74.9 cm)
The Metropolitan Museum of Art, New York. The
Pierre and Maria-Gaetana Matisse Collection, 2002
(2002.456.3)

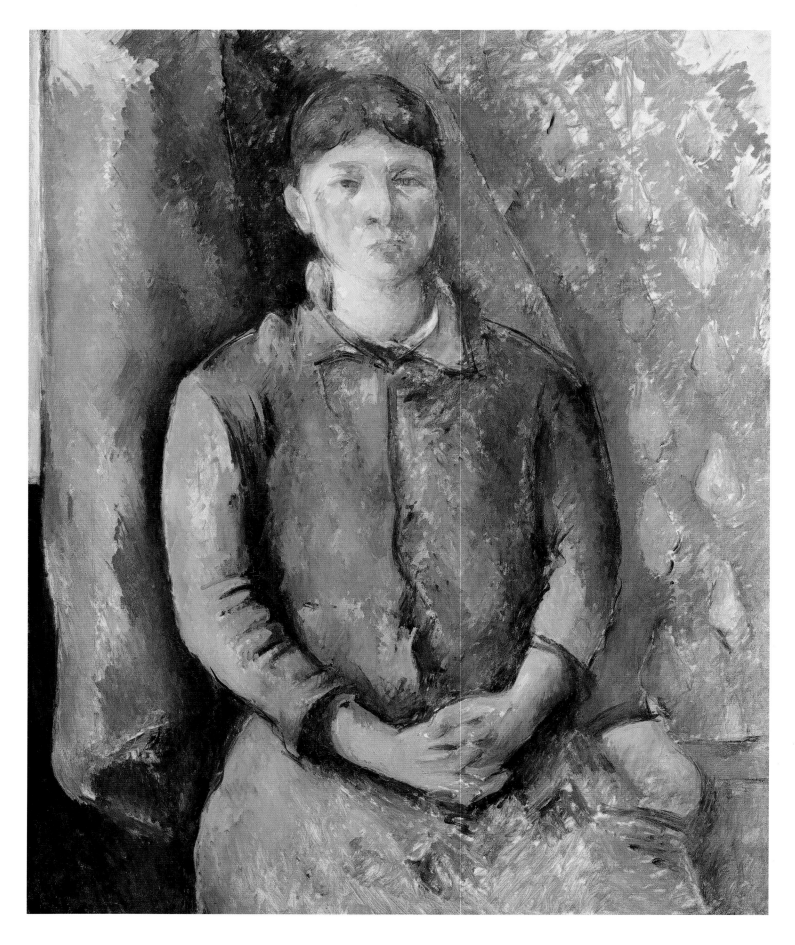

PLATE 135

Paul Cézanne

Madame Cézanne, c. 1886

Oil on canvas
49⅜ x 41½ inches (125.4 x 105.4 cm)
The Detroit Institute of Arts. Bequest of Robert H.
Tannahill (70.160)

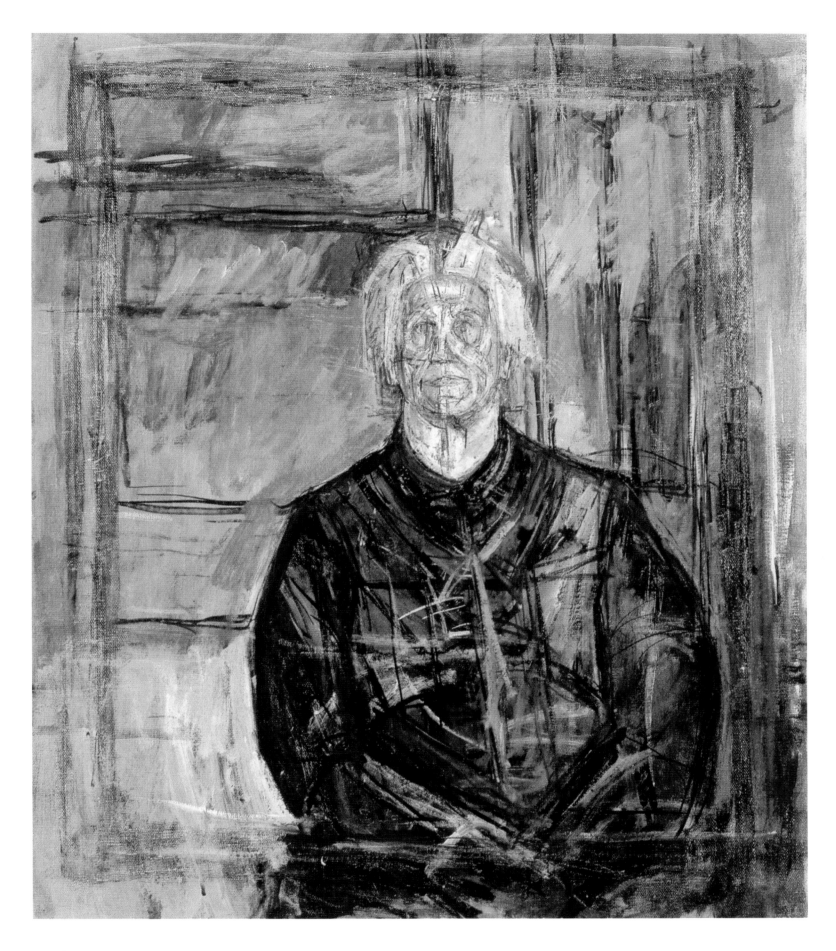

PLATE 136

Alberto Giacometti

The Artist's Mother, 1937

Oil on canvas
24 x 19¾ inches (61 x 50.2 cm)
Private collection

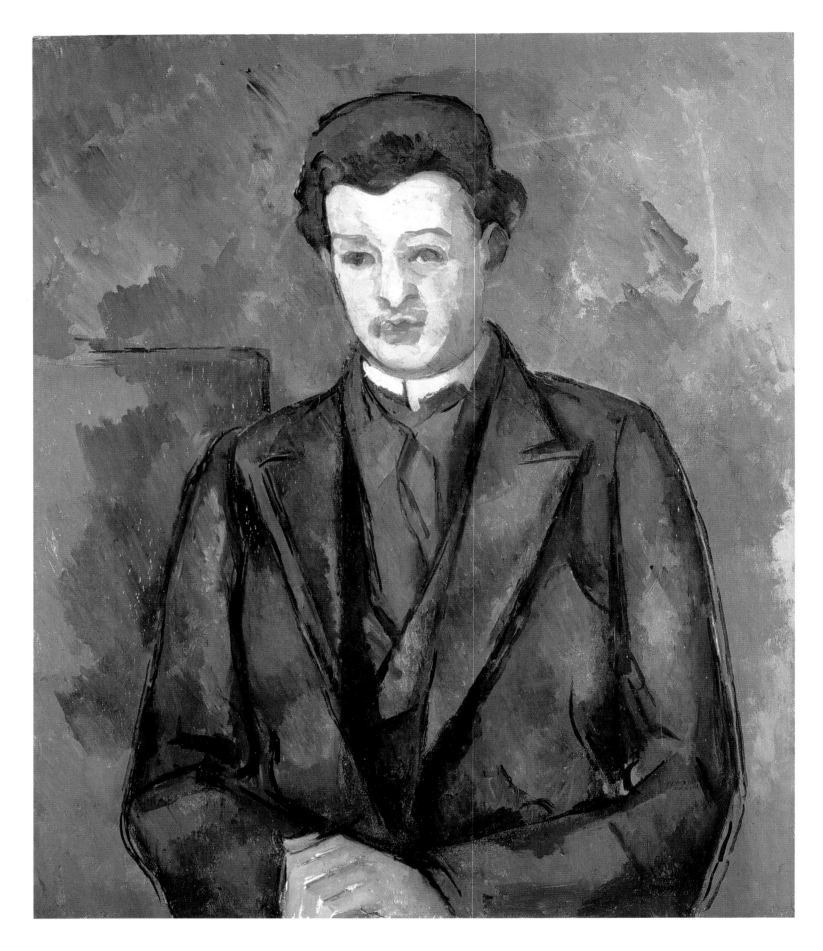

PLATE 137

Paul Cézanne

Portrait of the Painter Alfred Hauge, 1899

Oil on canvas
28¼ x 23¾ inches (71.8 x 60.3 cm)
Norton Museum of Art, West Palm Beach, Florida

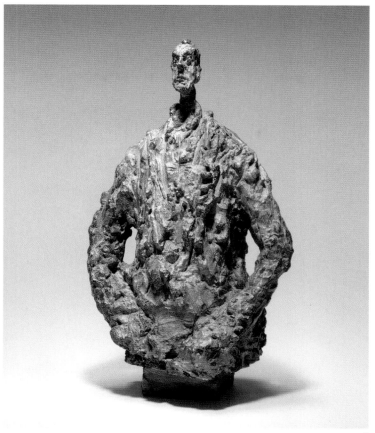

PLATE 138

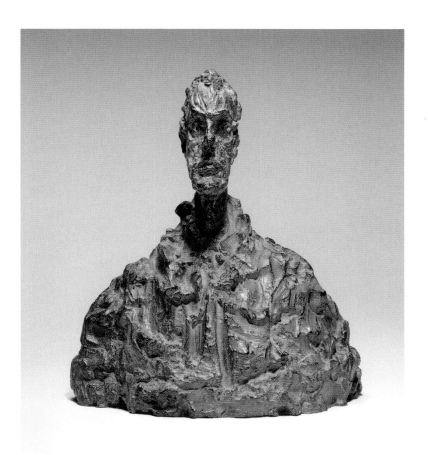

PLATE 139

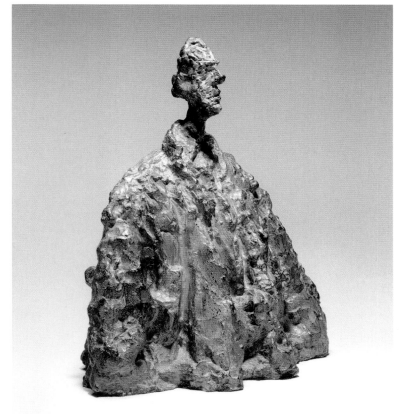

PLATE 140

PLATE 138

Alberto Giacometti
Diego in a Sweater, 1954

Painted bronze
19 x 10¾ x 8¼ inches (48.3 x 27.3 x 21 cm)
Raymond and Patsy Nasher Collection, Dallas

PLATE 139

Alberto Giacometti
Bust of Diego, 1954

Painted bronze
15⅛ x 13¼ x 8¼ inches (39.4 x 33.7 x 21 cm)
Raymond and Patsy Nasher Collection, Dallas

PLATE 140

Alberto Giacometti
Diego in a Cloak, 1954

Painted bronze
15⅜ x 13½ x 8¾ inches (39.1 x 34.3 x 22.2 cm)
Raymond and Patsy Nasher Collection, Dallas

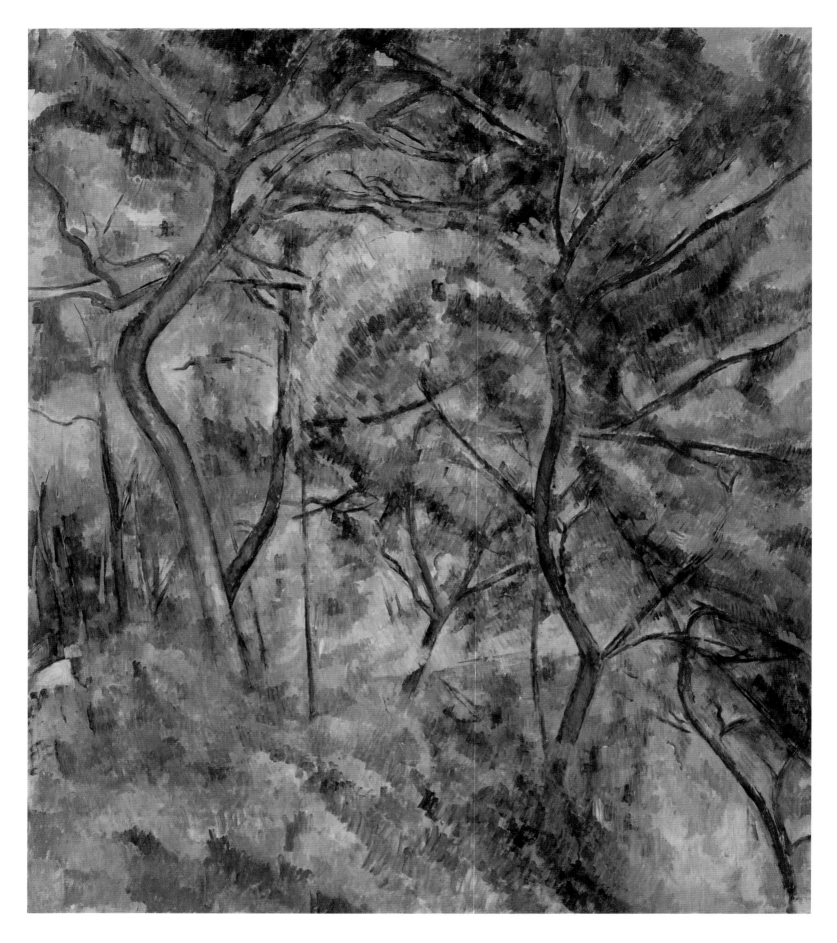

PLATE 141

Paul Cézanne

Forest, 1894

Oil on canvas
45¹³⁄₁₆ x 32 inches (116.4 x 81.3 cm)
Los Angeles County Museum of Art. Wallis
Foundation Fund in memory of Hal B. Wallis,
1992.161.1

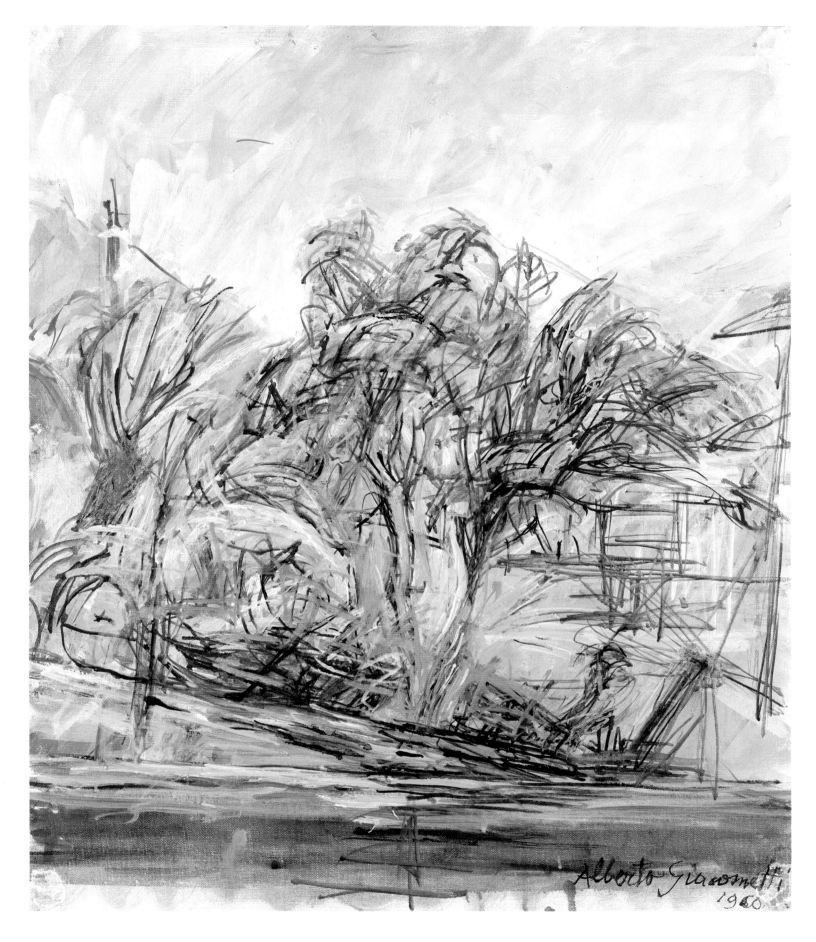

PLATE 142

Alberto Giacometti

Landscape at Stampa, 1960

Oil on canvas
21¾ x 18¼ inches (55.2 x 46.4 cm)
Private collection

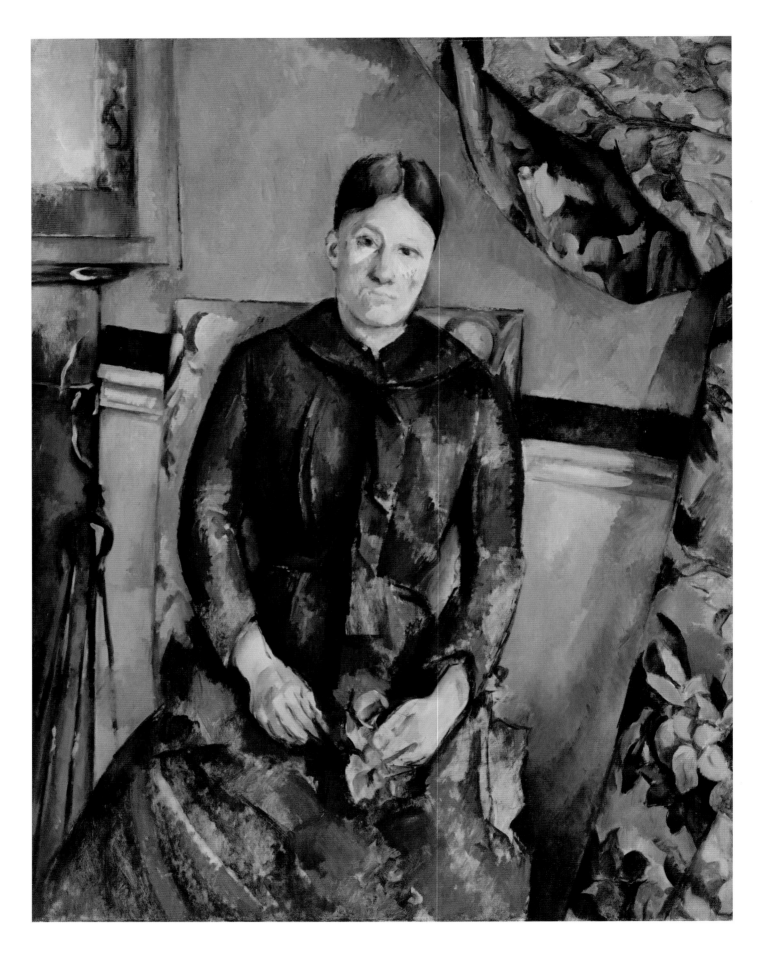

PLATE 143

Paul Cézanne

Madame Cézanne in a Yellow Chair, 1893–95

Oil on canvas
45⅞ x 35¼ inches (116.5 x 89.5 cm)
The Metropolitan Museum of Art, New York.
The Mr. and Mrs. Henry Ittleson, Jr., Purchase Fund,
1962 (62.45)

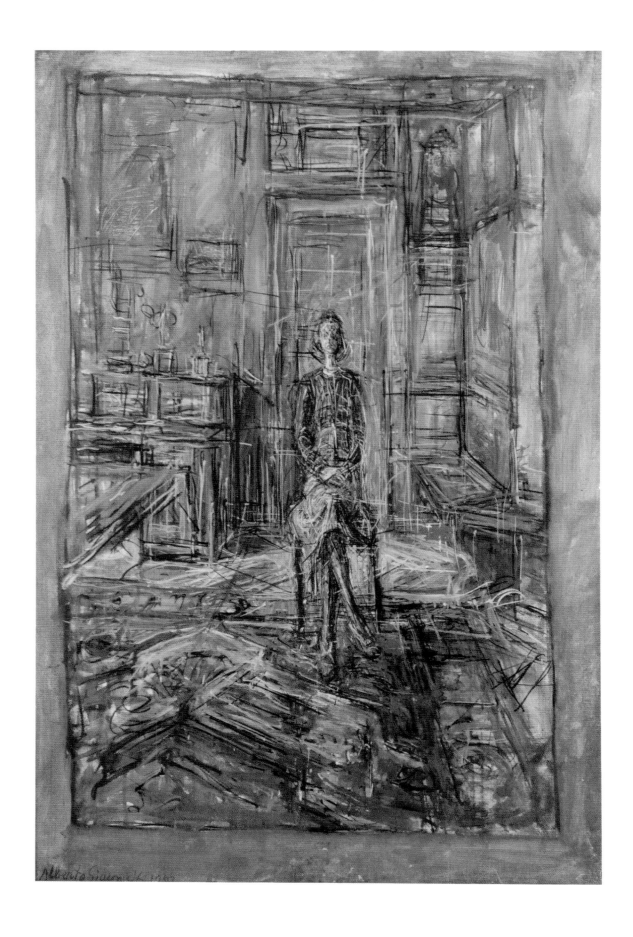

PLATE 144

Alberto Giacometti

*Seated Woman (Annette at
Stampa)*, 1949

Oil on canvas
34⅝ x 23⅜ inches (87.9 x 59.4 cm)
Morton G. Neumann Family Collection, Chicago

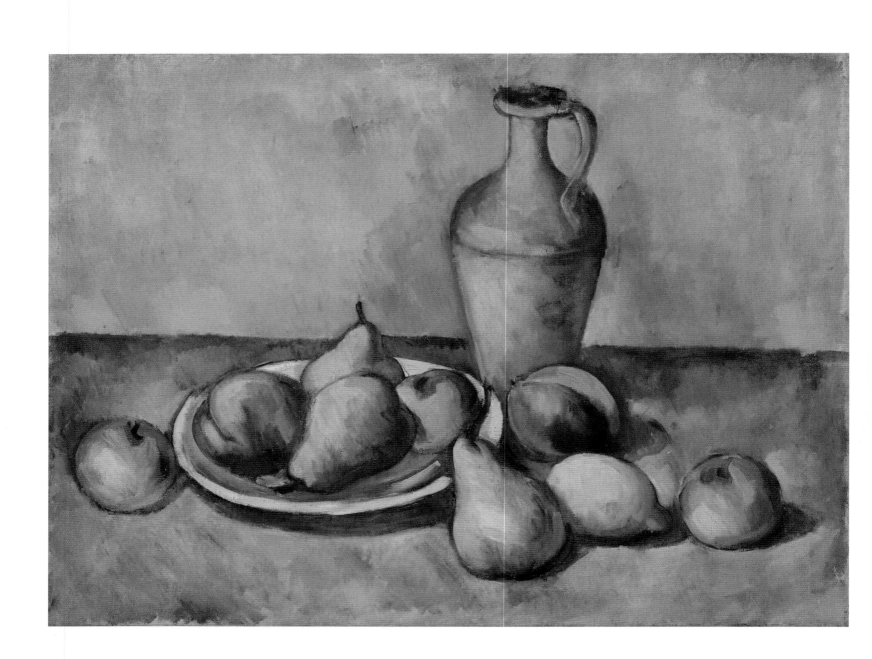

Learning from "Papa Cézanne": Arshile Gorky and the (Self-)Invention of the Modern Artist

Michael R. Taylor

The early work of Arshile Gorky (1904–1948) can be characterized as a succession of dialogues with artists, both living and dead, whose paintings he sought to emulate and ultimately to transcend. The dominant figure among the modern masters in Gorky's pantheon was Paul Cézanne, whose paintings exerted a powerful influence on the Armenian-born artist in the 1920s, before giving way in the following decade to the work of Pablo Picasso, Fernand Léger, and Joan Miró. However, the impact of Cézanne can still be felt in many of Gorky's greatest paintings of the 1940s, such as *Dark Green Painting* (plate 152), where the veils of evanescent color and all-over composition of biomorphic forms suggest an underlying structure strongly reminiscent of the French painter's landscape compositions or tabletop still lifes. In *Crooked Run* of 1944 (plate 151), for example, the freely improvised forms of fruits, vegetables, plants, and flowers are clearly discernible in an upturned tabletop arrangement that owes a profound debt to Cézanne's still lifes.

Gorky's paintings of the 1920s and early 1930s frequently invoke Cézanne's work, not through slavish imitation or parody, as his detractors have often claimed, but rather through a process of direct observation akin to the teaching methods of the nineteenth-century Académie des Beaux-Arts in Paris, where students learned the lessons of the old masters by faithfully copying paintings in museums or plaster casts in the classroom.[1] Gorky's own sporadic attempts to study art always ended prematurely—despite enrolling in numerous art schools in Boston and New York, he rarely completed more than a semester and in many cases dropped out after the first week—so he did not benefit from the kind of formal training that his close friend Willem de Kooning received at the Academie van Beeldende Kunsten en Technische Wetenschappen in Rotterdam. However, as the Dutch artist ruefully admitted, "I had more legitimate schooling in

Holland but the things I was supposed to know he knew much better. He had an uncanny instinct for all art."[2]

Gorky was "a great connoisseur of painting" whose formidable knowledge was largely self-taught, based upon his patient and sustained study of the history of art through reproductions in magazines and books and repeated trips to museums and galleries in New York and other East Coast cities, where he voraciously absorbed the techniques of the painters he discovered there.[3] The art historian Meyer Schapiro remembered frequently bumping into Gorky in museums and galleries in New York, where he would be "fixed in rapt contemplation of pictures with that grave, searching look that was one of the beauties of his face. As some poets are great readers, Gorky — especially among painters — was a fervent scrutinizer of paintings."[4] It was this passionate study and emulation of the art of the past that gave Gorky his encyclopedic understanding of the history of Western painting from Uccello to Cézanne, which far surpassed that of his better-educated peers in the fledgling American avant-garde.

Gorky's long hours of study fed his burning ambition to become a great artist, but with no instructor on hand to guide him he had no option but to choose a suitable role model on which to base his artistic persona. He aptly chose Paul Cézanne, whose own work had been informed by years of untutored study at the Louvre and other museums in Paris and his native Provence. Given Cézanne's heroic life story as an essentially self-taught artist who triumphed over adversity after years of personal struggle and critical neglect, the stubborn, brooding, temperamental French painter was the perfect father figure for Gorky to emulate during his first years as an artist.[5] Indeed, almost an entire generation of American artists who came of age during the 1920s and 1930s, many of whom were uprooted immigrants like Gorky, felt a powerful personal identification with Cézanne, whose impenetrable personality and indefatigable commitment to the pursuit of his personal vision mirrored their own efforts to develop an authentically American style of painting. However, what sets Gorky's work apart from that of Cézanne-inspired contemporaries such as Max Weber, Charles Demuth, and Marsden Hartley is the degree to which he assimilated the French artist's subject matter and distinctive painting style. An accomplished autodidact, Gorky reworked some of Cézanne's best-known paintings in order to perceive and understand his forebear's working methods and incorporate them into his own art.

Another self-taught American cultural luminary of this period, Ernest Hemingway, underwent a similarly slow yet deliberate acculturating process that also led him to the work of the French master. While in Paris in the early 1920s, Hemingway made almost daily visits to see the Cézanne paintings in the Musée du Luxembourg, the Louvre, and the apartment of Gertrude and Leo Stein.[6] The writer found another important source of information in Sylvia Beach's Paris bookstore, Shakespeare and Company, from which he borrowed Ambroise Vollard's standard biography of Cézanne.[7] In a statement that could easily have described Gorky's early years in New York, Hemingway later recalled: "I learned to write by looking at paintings in the Luxembourg Museum in Paris. . . . I never went past high school. When you've got a hungry gut and the museum is free, you go to the museum."[8] In *A Moveable Feast*, an autobiographical account of his early years in Paris, Hemingway remembered how he first learned to write "true sentences" by creating written equivalents of the French artist's paintings: "I was learning something from the painting of Cézanne that made writing simple true sentences far from enough to make the stories have the dimensions that I was trying to put into them. I was learning very much from him but I was not articulate enough to explain it to anyone. Besides it was a secret."[9]

Hemingway often alluded to Cézanne's paintings, most famously in a nine-page stream-of-consciousness monologue that was omitted from his short story "Big Two-Hearted River" when it was first published in *This Quarter* in May 1925. In the deleted section, Hemingway's fictional alter ego, Nick Adams, contemplates his literary future during a fishing expedition whose unspoken goal is to help him recover from the traumatic experiences he endured in World War I: "He wanted to write like Cézanne painted. Cézanne started with all the tricks. Then he broke the whole thing down and built the real thing. It was hell to do. He was the greatest. The greatest for always. It wasn't a cult. He, Nick, wanted to write about country so it would be there like Cézanne had done it in painting. You had to do it from inside yourself. There wasn't any trick. Nobody had ever written about country like that."[10] Hemingway's descriptions of the river and the surrounding countryside use short, declarative sentences to approximate the closely woven, parallel brushstrokes that Cézanne used in his paintings to break up the Provençal landscape into building blocks of discrete, mostly nonoverlapping painted marks, which he stitched together to create a multifaceted patchwork of shifting color covering virtually the entire surface of the canvas.[11]

As Jill Anderson Kyle has argued, a number of pioneering American modernists in the early decades of the twentieth century were attentive to Cézanne's work, which offered new possibilities of expression through purely formal means: "By virtue of being progressive and not seeking literary, dramatic, or associative content in painting, these Americans were drawn to the pictorial architecture (or type of structure for a composition) and the formal coherency in Cézanne's pictures, to his skill in constructing forms with convincing solidity and in organizing the internal relations that made them parts of a unified design."[12] Hemingway's approach to Cézanne closely resembled Gorky's in that both men perceived the underlying geometric structure of the French artist's work, as seen in the American writer's assertion that Cézanne "broke the whole thing down and built the real thing." This statement relates both to Cézanne's architectonic treatment of form and his stripping down and eventual elimination of everything that was not absolutely essential to the overall composition, a strategy that Hemingway would employ in his own carefully structured novels and short stories.

Like Hemingway, Gorky internalized Cézanne's techniques and imagery and distilled them into his own artistic practice. He was less interested than Hemingway in Cézanne's so-called constructive stroke, preferring instead to investigate the spatial inconsistencies found in the French artist's works. Gorky's paintings of the mid-to-late 1920s are filled with visual paradoxes that stress the artificial nature of the art of painting itself, as seen in *Pears, Peaches, and Pitcher* (plate 145), in which the still-life elements appear to float in a shallow, ambiguous space. In this work, the extreme tilting of the table surface toward the picture plane thrusts the objects into an almost frontal confrontation with the viewer, who perceives the upturned plate, pitcher, pears, peaches, apples, and lemon simultaneously, yet seemingly from multiple viewpoints. Gorky's dedication to the idea of being a revolutionary in art through the independent study and emulation of Cézanne echoes the latter's own admiration for Eugène Delacroix, particularly during his formative period in the late 1860s and early 1870s, when Cézanne executed several copies and variations of works by the great romantic artist.[13] Indeed, Gorky's lifelong admiration for Cézanne may have been enhanced by his identification with the self-taught artist and artistic appropriator who early in his career heeded Delacroix's advice to copy works in Paris museums as a means of study.[14]

It is surely no coincidence that Gorky and Hemingway both studied Cézanne's work at a time when they were relatively marginal, isolated figures. The phenomenon

of autodidacticism was one of the defining hallmarks of the interwar period, as young artists and writers from divergent social and economic backgrounds sought access to high culture. In the aftermath of World War I, high culture, which encompasses the visual and literary arts, was no longer seen as a tomb guarded by a privileged elite, but rather as a sanctuary or temple accessible to the initiated few, regardless of their social status or educational background.[15] The position of an autodidact like Gorky can be seen as that of an outsider who must find his or her own route to culture, most often through public institutions such as the Metropolitan Museum of Art, which offered free admission and warmth from inclement weather. Museums thus nurtured the burning ambition of interwar autodidacts, allowing them to carry out their own program of cultural education, and there can be little doubt that these hallowed art institutions provided an artistic stimulus that encouraged Hemingway, Gorky, and others toward greater formal experimentation in their own work.

As Rosemary Chapman has argued, the phenomenon of autodidacticism between the two world wars "cannot be seen independently of the class bias both of the provision of education and of subsequent access to culture."[16] As an alienated outsider, Gorky's thirst for knowledge and desire for culture was no doubt hindered by his precarious financial situation, as well as his status as a newly arrived immigrant. Like the "Self-Taught Man" (l'Autodidacte) in Jean-Paul Sartre's 1938 novel *La Nausée* (Nausea), aspiring artists and writers such as Gorky and Hemingway would have been excluded by social and economic factors from the fee-paying educational establishment, leaving them with no option but to achieve their educational and ontological aims through bookstores, public museums, and municipal libraries, all of which offered free but unstructured alternatives to the academic rigors of the university or fine arts academy. However, the standardized organization of these institutions presented a serious barrier to the interwar autodidact, who was forced to browse or wander at random through the maze of books or works of art on display. The simple alphabetical classification system employed by public libraries, for example, prevents Sartre's Self-Taught Man from choosing books by theme or subject. Like Gorky, he has little educational experience to guide him in his choice of authors or titles, and instead he employs an accumulative approach to knowledge and culture, assigning himself the task of reading all the books on the library's shelves in alphabetical order. Unfortunately, this systematic attempt to devour all the books from A to Z provides him with a limited understanding of the history of ideas.[17]

As a primarily self-taught artist, Gorky's learning process was similar to that of Sartre's existential antihero, although his innate talent, iron will, and obstinate determination to succeed were far removed from the Self-Taught Man's plodding, mediocre mind, which could only comprehend the world through systems of classification and naming. Like Sartre's character, Gorky may have viewed books and works of art as objects of devotion that allowed him to avoid the realization of his own loneliness and psychological vulnerability. However, his indefatigable passion for and intuitive understanding of painting—what de Kooning called Gorky's built-in "Geiger counter of art"—helped him to navigate his way through the accumulated knowledge of the history of art and culture in an engaged and critical manner, as evidenced by his choice of the rebellious Cézanne as his intellectual and artistic role model.[18]

Gorky's obsession with Cézanne coincided with his move from Boston to New York in 1924. This was a time of self-invention for Gorky: He adopted the persona of the neglected artistic genius who suffers for his art, and numerous friends and colleagues later recalled that he played this bohemian role to perfection and became for

them the living embodiment of the melancholy yet rebellious painter of modern life. Discarding his earlier interest in French Impressionism and the bravura brushwork of John Singer Sargent's Gilded Age portraits, to which he had been introduced by his mentor in Boston, Douglas John Connah, Gorky found new inspiration in New York in the life and work of Cézanne, which better suited his notion of bohemian radicalism.[19] Working that year as an instructor at the New School of Design, located on Broadway at Fifty-second Street, Gorky instilled in his students a passion for drawing and painting, and he complemented his classroom sessions with visits to the Metropolitan Museum of Art, where he lectured on the techniques of the old masters, as well as modern artists such as Cézanne and Auguste Rodin. Mark Rothko, who was a student of Gorky's, recalled that the artist conducted the class with an air of authority and held his students to very high standards. Although Rothko later complained that Gorky "was overcharged with supervision," he was deeply impressed by the artist's dramatic and intense obsession with painting, as well as his copies after Frans Hals and other old masters, which Gorky would bring into the classroom to demonstrate how one learned from re-creating the art of the past.[20]

In the fall of 1925 Gorky enrolled as a fine arts student at the Grand Central School of Art, located on the top floor of the Grand Central Terminal Building on Forty-second Street.[21] Opened in 1924, the school offered a thorough training in the craftsmanship of art, especially drawing from life, which undoubtedly appealed to Gorky, who had developed an uncompromising belief that a strong command of drawing was essential to great art. Gorky was no ordinary student; he had by this time acquired an exhaustive knowledge of art history and intuitively sensed the direction that modern art should take, especially after his recent exposure to Cézanne's painting at the Metropolitan Museum of Art. The talented young artist so greatly impressed the school's director, Edmund W. Graecen, and his fellow teachers that he was soon appointed as an instructor of the sketch class, and the following academic year he was hired as a full-time member of the faculty.

The school's annual report for 1926–27 noted that this new faculty member (then spelling his name "Arshele") was born in Nizhin Novgorod, the medieval cultural center of Russia, where he had studied at the School of Nizhin Novgorod, followed by additional training at the Académie Julian in Paris under Albert Paul Laurens and classwork in Boston and New York. There was an added notation that he had been "represented in many exhibitions."[22] Much of this biographical information was pure fantasy on Gorky's part, since we now know that the artist was born Vosdanig Manoog Adoian around 1904 in an Armenian village on the eastern border of Ottoman Turkey and never visited Paris, much less studied there.[23] Despite its numerous inaccuracies, Gorky's fabricated résumé contained enough half-truths to go unchallenged, and it no doubt added to the mystique surrounding him at the school. Standing around six feet four inches tall, with a handsome face, jet-black hair, dark, pensive eyes, a well-groomed mustache, and a heavy foreign accent, Gorky must have been a striking figure to his students and fellow faculty members, to whom he projected the powerful image of the romantic artist. Another factor that must have convinced Graecen to hire Gorky was his passionate advocacy for modern art, especially since the vast majority of other faculty members were still painting in the outmoded styles of William Merritt Chase, J. Alden Weir, Thomas Dewing, and other American Impressionists.[24]

In an interview in the *New York Evening Post* published in September 1926, shortly after his appointment at the Grand Central School, Gorky expressed his newfound reverence for Cézanne as a rule-breaker who had challenged tradition and reformulated

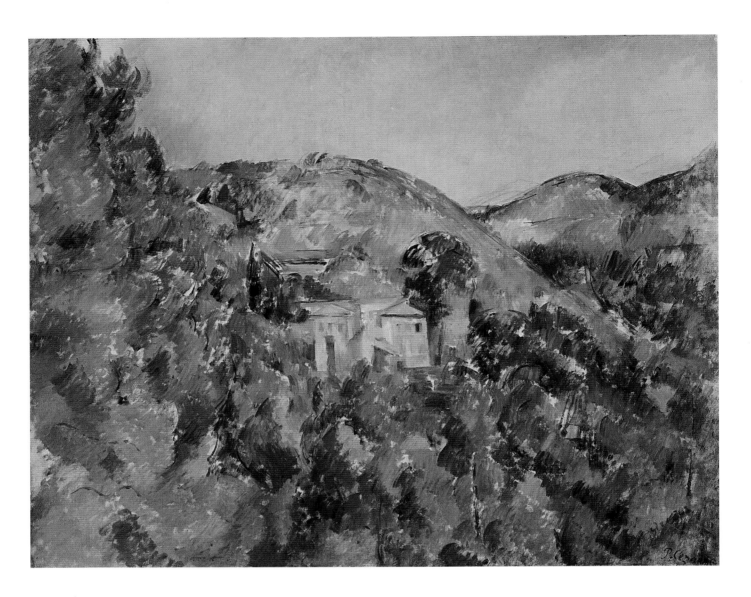

Fig. 15.1. **Paul Cézanne, *View of the Domaine Saint-Joseph,*** late 1880s. Oil on canvas, 25⅝ x 32 inches (65.1 x 81.3 cm). The Metropolitan Museum of Art, Catharine Lorillard Wolfe Collection, Wolfe Fund, 1913 (13.66)

the art of painting: "Cézanne is the greatest artist, shall I say, that has lived. The old masters were bound by convention and rule to painting certain things—saints, the Madonna, the crucifixion. Modern art has gone ahead widely and developed as it never had a chance to in the hands of the old masters."[25] This statement coincided with the artist's earliest efforts to come to terms with the radical nature of Cézanne's paintings through an intense, self-imposed apprenticeship that took place between 1926 and 1928, although its effects were long-lasting, as Gorky later suggested in his famous declaration to the art dealer Julien Levy: "I was *with* Cézanne for a long time . . . and then naturally I was *with* Picasso."[26]

As part of this apprenticeship, Gorky sought out books and magazine articles on Cézanne at public libraries and specialty bookstores such as Erhard Weyhe's gallery and bookstore at 794 Lexington Avenue, which also sold Gorky's work intermittently.[27] Despite his limited means, the artist acquired a formidable collection of books, magazines, and reproductions of modern paintings, and by the late 1920s his personal library contained some of the most important early critical studies on Cézanne,[28] including his well-thumbed 1922 edition of Julius Meier-Graefe's *Cézanne und sein Kreis* (Cézanne and His Circle), which Gorky almost certainly acquired through Weyhe.[29] According to Arthur Revington, who studied with the artist at the Grand Central School in 1927, Gorky used these books as teaching tools to introduce his pupils to Cézanne and modern art.[30]

Most importantly, Gorky seized every opportunity to observe the French artist's work in person. The Metropolitan Museum of Art had purchased Cézanne's *View of the Domaine Saint-Joseph* (fig. 15.1) from Ambroise Vollard during the 1913 Armory Show for the staggering sum of $6,700.[31] Given Gorky's penchant for re-creating masterworks

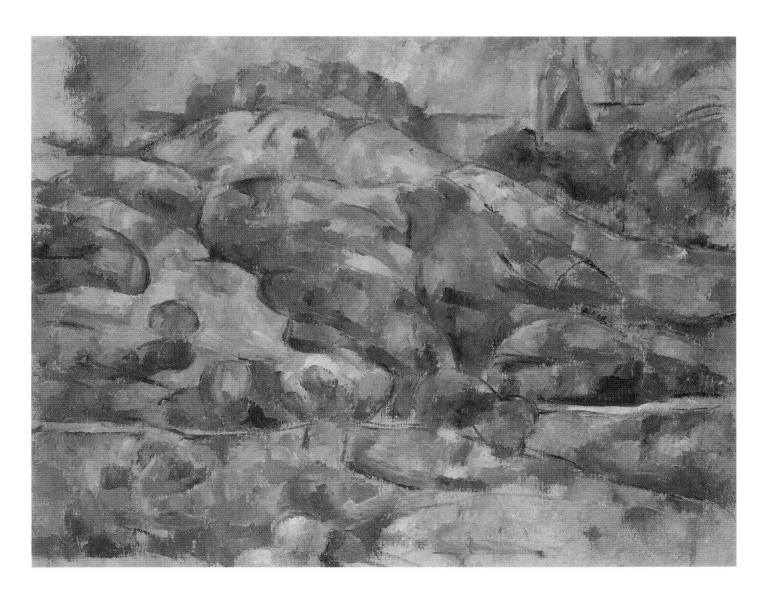

Fig. 15.2. **Arshile Gorky, *Landscape,*** c. 1927–28.
Oil on canvas, 30 x 38 inches (76.2 x 96.5 cm). Private
collection

from the Metropolitan's collection, it should come as no surprise that the artist made
his own version of this painting (fig. 15.2) of the steep rolling hills of the Colline
des Pauvres (Hill of the Poor), near Aix-en-Provence, which fill almost two-thirds of
Cézanne's canvas. Gorky clearly studied this painting intently, as its cool chromatic
range of greens, blues, ochers, orange, and violet can be felt in other works he made
during the same period, which also utilize Cézanne's technique of letting isolated areas
of bare canvas show through as a means of permeating his trees and foliage with light
and air, thus animating the entire composition.

Another Cézanne painting that Gorky must have studied closely in New York in
the mid-to-late 1920s was *Gardanne* of 1885–86 (see plate 56), which the Brooklyn
Museum acquired in 1923. Cézanne's vertiginous scene depicts the small town perched
on the rocky Captivel Hill, some seven miles southeast of Aix. The steeply sloping town
is dominated by the bell tower of an eleventh-century church that is surrounded by
red-roofed houses. These houses, as well as those found in other Cézanne paintings of
the 1880s (see plates 125, 149), reappear in Gorky's paintings of Staten Island (plate 150),
which feature blocky, rectilinear buildings with red and orange rooftops, interspersed
with loosely brushed trees and blue-green foliage. These works also reference the spare
composition of *Gardanne*, which is constructed in thinly painted, interwoven patches
of red and green, with large sections of the cream-white canvas left unpainted, thus
imbuing the verdant landscape surrounding the hilltop village with an atmosphere of
airiness and weightlessness.

Gorky was also exposed to two Cézanne watercolors, *Carafe and Knife* of about
1882 (see fig. 13.7) and *The Balcony* of about 1900 (see plate 4), when they were included

in the inaugural exhibition of the A. E. Gallatin Gallery of Living Art at New York University, which opened to the public on December 12, 1927. Gorky was a frequent visitor to the gallery, which was free to the public and conveniently located on Washington Square in Greenwich Village, just a stone's throw from the second-floor studio at 47A Washington Square South, on the corner of Sullivan Street, where he moved around 1927 (fig. 15.3).[32] It was probably at about this time that he executed *Study after an Antique Sculpture* (fig. 15.4), a stunning watercolor of a marble Aphrodite that was on loan to the Metropolitan Museum of Art, which is thought to be a sensitive Roman copy of the famous Greek original of the late fifth century B.C. (fig. 15.5).[33] Although headless, armless, and discolored by fire, the statue is notable for the transparency of the sleeveless chiton worn by the goddess, which is fastened on the left shoulder so that the left breast is bare, and it may have been the challenge of re-creating this diaphanous garment that inspired the artist to make his own rendition in watercolor. Gorky was also aware of Cézanne's long interest in copying after plaster casts and sculpture, such as the *Venus de Milo* in the Louvre, and his own watercolor may have been prompted by the French artist's numerous drawings and paintings featuring the swelling forms and curvaceous contours of a standing Cupid, formerly attributed to the seventeenth-century Provençal sculptor Pierre Puget, of which Cézanne owned a plaster replica (see plate 120).[34] This may explain why Gorky reversed the sculpture in his watercolor, although more likely he was working from a reproduction that flopped the image.

In this previously unpublished work, Gorky's assiduous study of Cézanne's watercolor techniques is evident in the thinly washed contours of the figure, which are heightened through a nimbus of vivid blues and greens that imbue the sculpture with a crystalline intensity, as well as the provocative use of the untouched buff paper for

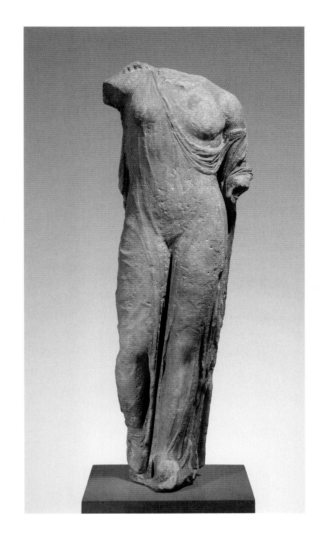

Fig. 15.4. **Arshile Gorky, *Study after an Antique Sculpture,*** c. 1926–29. Charcoal and watercolor on paper, 22 x 15¼ inches (55.9 x 38.7 cm). The Metropolitan Museum of Art. Purchase, Gift of Sam A. Lewisohn, by exchange, 2005.232

Fig. 15.5. ***Marble Statue of Aphrodite, the so-called Venus Genetrix,*** Roman, Imperial period, 1st–2nd century A.D. Copy of a Greek bronze statue of the late 5th century B.C. attributed to Kallimachos. Marble, height 59½ inches (151.1 cm). The Metropolitan Museum of Art, Purchase, 1932 (32.11.3)

the color of the marble. The animated quality of the sculpture is enhanced by the multiple lines that delineate its forms and add a sense of vibratory movement, while the unworked areas of the sheet further adumbrate the draped classical figure with an unexpectedly airy translucence. The loose and spontaneous application of transparent planes of glowing, prismatic color suggests that Gorky had recently seen Cézanne's watercolors at the Gallery of Living Art, since reproductions of the time would not have conveyed the exuberance and energy of a work like *The Balcony.*

In his catalogue raisonné of Gorky's paintings, Jim M. Jordan has proposed *Still Life with Wine, Bread, and Eggs* of about 1926–27 (fig. 15.6) as the artist's earliest surviving study after Cézanne, citing as its source the French painter's *Still Life with Bread and Eggs* of 1865 (fig. 15.7), which Gorky could only have known through reproduction.[35] Although the configuration of Cézanne's still life is quite different from that of Gorky's painting, they have several key ingredients in common—namely, a French baguette, a transparent wine glass, a pair of eggs, and a bone-handled knife placed at an oblique angle. Gorky appears to have painted the work swiftly, in a single session, in an attempt to replicate the emotional intensity of the French artist's early works, in which the paint was often applied vigorously with a palette knife. Just as in Cézanne's still life, where the objects can be seen from multiple viewpoints, Gorky's painting features a tabletop that has been similarly tilted upward toward the viewer, so that each element can be seen from above. Making his own variation on a Cézanne still life thus allowed the young artist-teacher to grapple with the formal innovations of his chosen mentor, whose work had to be experienced through the act of re-creation.

It was Gorky's firsthand experience of working through the formal complexities of Cézanne's paintings—and fully grasping how they balance on a knife-edge between art and artifice, and between sculpted space and ineluctable flatness—that gave him the

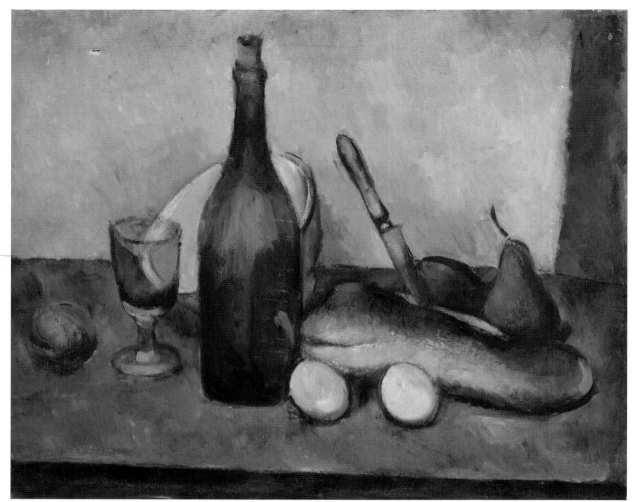

Fig. 15.6

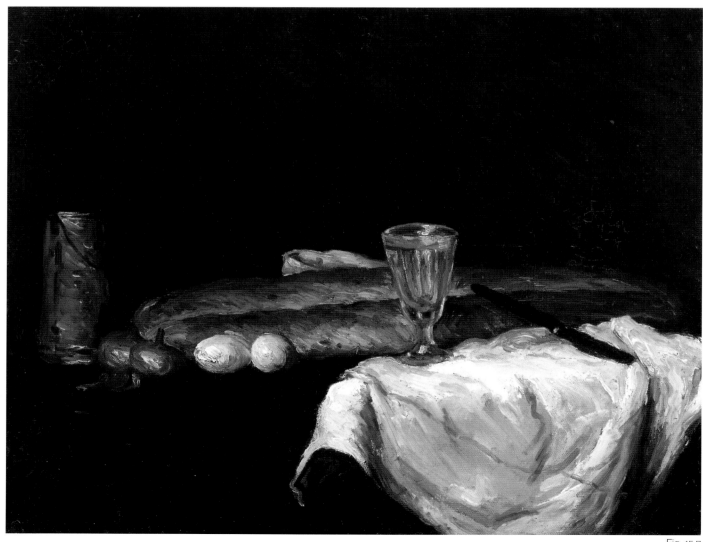

Fig. 15.7

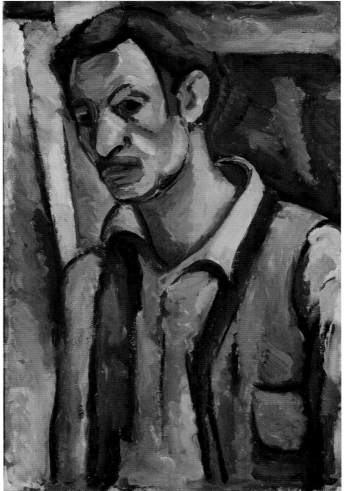

Fig. 15.8

confidence to pursue his career as a modern artist. This accomplished early still life was quickly followed by a dynamic series of self-portraits, landscapes, and still lifes in which the unrepentant autodidact demonstrated his knowledge and understanding of Cézanne's work in all genres. In the self-portraits we see Gorky take on the chiseled, rustic features and recalcitrant personality of the artist that he would affectionately call "Papa Cézanne."[36] Gorky went to great lengths to model himself on the French master, and his decision to grow a beard in the late 1920s may have been a conscious attempt to adopt Cézanne's physiognomy and rustic identity.

Gorky's self-fashioning after the solitary, reclusive genius of Aix-en-Provence can be seen again in a self-portrait of around 1928, in which the artist depicts himself in sober workman's clothes, with an open collar and unbuttoned vest that suggest the bohemian artist hard at work (fig. 15.8). In this painting Gorky utilized many of the hallmarks of Cézanne's style and palette, but he also made significant departures from the self-portraits by the French artist on which it is based. For example, Gorky's smoldering, self-searching gaze lends the image an aura of sadness that is absent from Cézanne's self-portraits, which display instead the stoic calm and steely resolve of an artist who is assured of his place in history.

Cézanne's paintings of mountains and forests also informed the landscapes that Gorky made during the 1920s, in which the lush countryside is rendered in a loose patchwork of greens, blues, oranges, and yellows. Applied with feathery, directional brushstrokes, this warm palette conjures up the sun-drenched landscape surrounding Aix-en-Provence, despite the fact that Gorky had never set foot on the baked earth of southern France. However, his fertile imagination allowed him to see Cézanne's countryside in the most mundane of places, such as Staten Island, where he would often visit a sweetheart named Nancy in the second half of the 1920s, before her father broke off

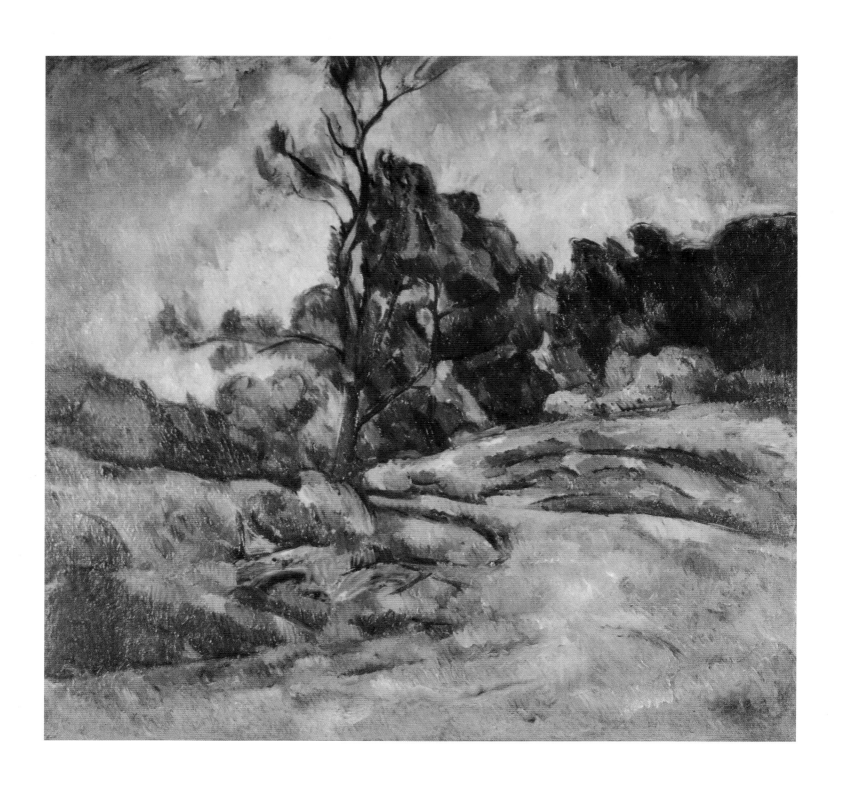

Fig. 15.9. **Arshile Gorky, _Landscape, Staten Island,_**
1927–28. Oil on canvas, 32⅛ x 34 inches (81.6 x 86.4 cm).
Collection of Richard Estes, New York

the relationship.[37] Like Henri Rousseau's invented jungle scenes, Gorky's Cézanne-inspired landscapes were figments of his imagination, but no less convincing and heart-felt for that. Although frequently dismissed as mere pastiches of the French master's work, these early paintings always bear the hallmarks of Gorky's distinctive vision and must be seen as original works of art in their own right.

Elaine de Kooning vividly remembered Gorky's early passion for Cézanne, which led him to paint outdoors in Central Park and Staten Island: "Gorky's first love was Cézanne, and often through the years he would set up his easel in Central Park and, after frightening away intrusive onlookers with a fierce scowl, make little landscapes that demonstrate, in the softly clumped brushstrokes and hacked-out edges, a profound understanding of that Master."[38] *Landscape, Staten Island* (fig. 15.9) is a good example of his attempt to re-create the vibrant coloring and vigorous execution of one of Cézanne's greatest landscape paintings, the *Turn in the Road* of around 1881 (see plate 206), which he would have studied intently through black-and-white reproductions before working out-of-doors. Once he returned to his studio, he would compare his finished painting with the original to see how successfully he had imitated Cézanne's structural balance and perspectival recession. There is even a sense of competitive rivalry in these works; Gorky was always investigating how old Raphael, Ingres, and Cézanne were when they made certain pictures in the hope that his own precocity as an artist would match and even surpass their early achievements.[39]

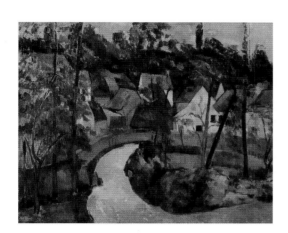

Paul Cézanne, *Turn in the Road*,
c. 1881 (plate 206, p. 524)

This interest in competing and identifying with his artist-heroes may also inform Gorky's *Self-Portrait at the Age of Nine* (fig. 15.10), which recasts Cézanne's celebrated *Louis Guillaume* of about 1882 (fig. 15.11), a work that Gorky almost certainly saw in January 1928 in the *Loan Exhibition of Paintings by Paul Cézanne* at the Wildenstein Galleries in New York. It is inconceivable that Gorky would have missed this exhibition of twenty-four Cézanne paintings, which included works from public and private collections in the United States, as well as a choice selection of paintings from the famed collection of Egisto Fabbri that were consigned by the French dealer Paul Rosenberg, who at that time operated the modern art wing of the Wildenstein Galleries. Given the historical importance of this exhibition, which followed closely on the heels of the publication in the previous year of Roger Fry's *Cézanne: A Study of His Development* and the English translation of Julius Meier-Graefe's 1922 monograph, it is perhaps no coincidence that 1928 marks the high point of the artist's engagement with the Master of Aix.[40] Although Gorky had been studying a small number of the French artist's works at the Metropolitan Museum of Art, the Brooklyn Museum, the Gallery of Living Art, and possibly the Barnes Foundation in Merion, Pennsylvania, the sudden and prolonged exposure to more than twenty of Cézanne's greatest works would leave an indelible mark on his subsequent work.

In her preface to the Wildenstein catalogue, Maud Dale, the wife of the prominent banker and art collector Chester Dale, who had recently purchased *Louis Guillaume* and lent it to the Wildenstein exhibition, emphasized Cézanne's heroic development and his status as an alienated outsider, praising his "unusual tenacity and faculty for application in the long solitary evolution of his genius."[41] The previous year, the Chicago art critic C. J. Bulliet had likewise underlined Cézanne's morbidly sensitive nature, which led him to desert Paris and "become a hermit of his native Aix, where he worked out, in agony, his art salvation."[42] These accounts closely resemble the drama inherent in Gorky's genesis as a self-taught artist with a tormented imagination. As an impoverished Armenian immigrant, Gorky no doubt would have recognized his own plight as a talented yet hitherto unrecognized artist in these descriptions of Cézanne's

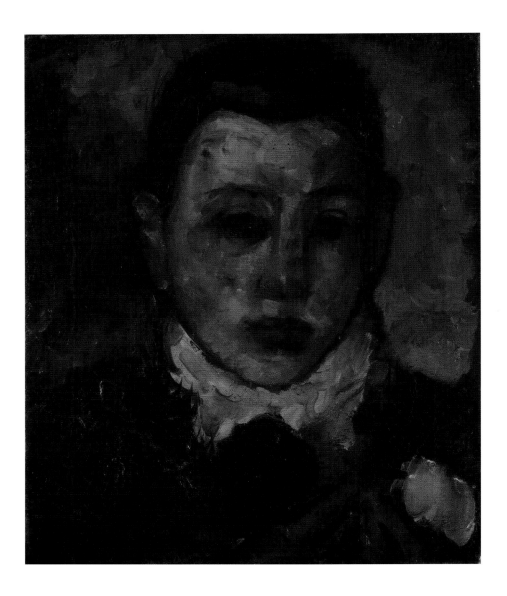

Fig. 15.10. **Arshile Gorky,** *Self-Portrait at the Age of Nine,* 1928. Oil on canvas, 12¼ x 10¼ inches (31.1 x 26 cm). The Metropolitan Museum of Art, Gift of Leon Constantiner, 2002 (2002.145)

personal suffering, and would have taken solace in Dale's conclusion that "only within himself was he to find the answer to the problems that tormented him and solitude became an absolute necessity, his long life a search that never ended until his death."[43]

Cézanne's *Louis Guillaume* was one of the great highlights of the Wildenstein exhibition and was repeatedly singled out for praise in reviews of the show. Although Gorky would have been aware of Cézanne's portrait of the pursed-lipped youth through black-and-white reproductions in his possession, his *Self-Portrait at the Age of Nine* unmistakably displays a keen knowledge of the original painting, thus suggesting that it was painted in 1928.[44] The knotted neckerchief in Cézanne's picture, for example, which looks uniformly white in reproduction, actually contains a chromatic range of green, blue, and purple highlights, which Gorky deploys to great effect in his own version. Similarly, the skin tones of the boy's face in Cézanne's painting are deftly accentuated with flashes of green and purple that would have been lost in black and white, yet are repeated in exaggerated form in Gorky's portrait of himself as a wistful young boy, whose ruddy complexion is exacerbated by flecks and patches of red paint, especially in the nose and forehead.

In his re-creation of Cézanne's portrait of the son of Antoine Guillaume, a shoemaker and friend of the artist who lived next door to him in Paris, Gorky casts himself in the role of the melancholic youth. With the chair back and floral patterned wallpaper of the original painting eliminated, the young Gorky inhabits almost the entire

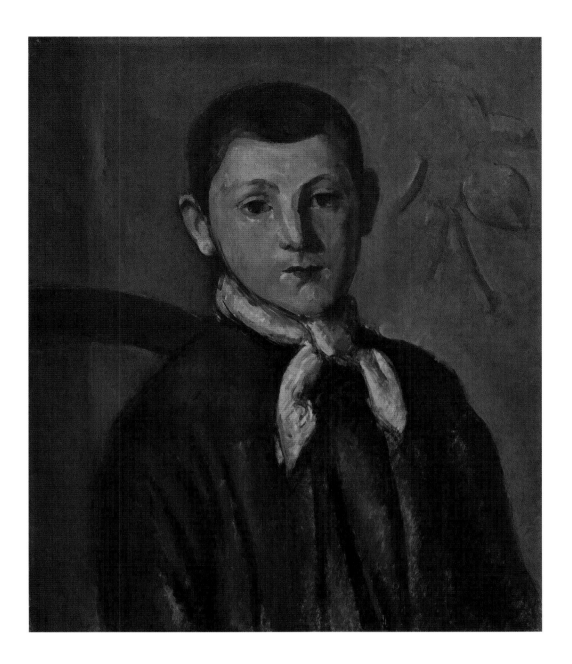

canvas, thus focusing our attention on his sad, introspective gaze and anguished appearance. Gorky may also have had in mind a physiognomic resemblance between his young self and the French artist's portraits of his own son, Paul, in which the young boy is similarly constructed through a set of interlocking ellipses, as seen in the oval shape of his head and the arcs of his hairline, eyebrows, and ears. Given its formal similarities with Cézanne's close-up compositions of his beloved son, Gorky's *Self-Portrait at the Age of Nine* takes on unexpected meanings, as the artist constructs for himself a new identity not just as a disciple of Cézanne but also as his son and heir. Taking this argument one step further, Hayden Herrera has suggested that Gorky may have reinvented his own Armenian childhood in terms of what he might have imagined Cézanne himself to have looked like as a child growing up in the south of France: "Gorky's portrait is a sort of cry for foredestined genius: into this sad, knowing youth, Gorky has projected all his own retrospective longing for his Armenian childhood, and possibly — since this child is both Gorky and Cézanne — his ambition for his own future as a proven master and Cézanne's equal."[45]

Having rejected his own father for failing to support his family during the tragic genocide and mass displacement of Armenians during World War I, when Gorky witnessed firsthand the systematic ethnic cleansing of the minority Armenians by Turkish troops, as well as the tragic early death of his mother from starvation after the harrowing forced journey from their homeland to Soviet Armenia, Gorky may have invented a

Fig. 15.12. Cover of Roger Fry's *Cézanne: A Study of His Development* (London: Hogarth Press, 1927)

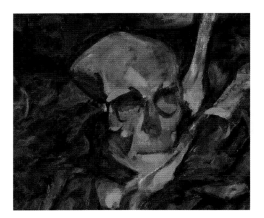

Arshile Gorky, *Still Life with Skull*, c. 1927–28 (detail; plate 146, p. 425)

private fantasy in which his true father was Paul Cézanne, thus making him the rightful heir to the French artist's modernist legacy. In this scenario "Papa Cézanne" becomes the father who does not fail or abandon him—in other words, a truer father than his own, as well as a fiercely determined personality who could guide and protect him during the long years of his self-imposed artistic apprenticeship.

Still Life with Skull (plate 146), arguably the most important painting that Gorky completed in the late 1920s, evokes the grave mood of Cézanne's fatalistic still lifes featuring skulls and other *memento mori* symbols. The painting was based on the cover illustration for Roger Fry's 1927 book on Cézanne (fig. 15.12), drawn by the author himself, which imaginatively re-creates one of Cézanne's still-life paintings, in which a human skull is surrounded by a composition of pears and apples on a plate that sits on a partially draped tabletop.[46] The skull's bulging, spherical form and hollow, deep-set eye sockets create a series of visual rhymes with the fruit and plate, much like the rhythms of line, shape, and color found in many of the French artist's still lifes. Gorky's painting places this skull on a chair, nestled within a piece of heavy drapery that is densely painted with agitated brushstrokes. Accompanying the skull on the ruglike fabric, which is rendered in sienna brown and deep viridian green with touches of purple throughout, are two large bones, whose round joints echo the curvilinear shapes of the fruit in Fry's drawing after Cézanne. In *Still Life with Skull*, Gorky's own imaginative re-creation of Cézanne's work thus surpasses the English critic's cover design in its formal complexity and daring innovation.

Gorky's inclusion of brightly patterned fabric in *Still Life with Skull* suggests that he was aware of Cézanne's exploration of this funereal motif in paintings and works on paper, which frequently include Oriental carpets or rugs. Enthroned within the folds of these richly colored textiles, Cézanne's skulls take on the deathly pallor of bleached

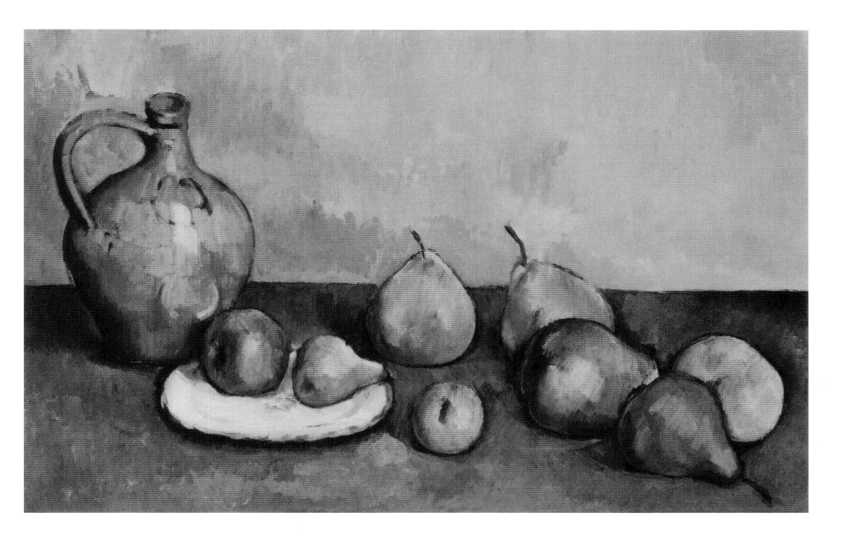

Fig. 15.13. **Paul Cézanne,** *Jug and Fruit*, 1893–94.
Oil on canvas, 17 x 24¾ inches (43.2 x 62.8 cm). Private
collection

bone, which is enhanced by their juxtaposition with the opulent colors and sharp
creases of the heavily brocaded drapery. Yet the warm brown and yellow ocher tonalities
of the human bones and cranium in Gorky's painting create a morbid atmosphere that
goes beyond the tradition of *memento mori* invoked by Cézanne in his own still life
paintings with skulls (see plate 114). While a solitary skull or group of skulls could be
placed within the conventions of Dutch and Flemish *vanitas* still lifes as references to
the transience of human existence, Gorky's macabre addition of human remains, possi-
bly a thigh bone and a femur, and a mummified head suggest that he may have used
this iconography of death and decay specifically to address the horrors he witnessed
during the Armenian genocide. This reading is supported by Gorky's placement of a
stack of canvas stretchers against the wall to the right of the chair holding the skull,
with a table or shelf on the left-hand side, and the suggestion of other paintings behind
the chair itself. These stretchers and items of furniture clearly identify the site as the
artist's studio and reinforce the notion that this work represents a personal statement
on his own brush with death during the ethnic cleansing that took place in Turkish
Armenia during the First World War, and its haunting aftermath for its survivors.

Pears, Peaches, and Pitcher (plate 145) is another example of Gorky's increasingly
adept crystallizations of Cézanne's structural principles. This spare composition from
the late 1920s is loosely based upon the French artist's *Jug and Fruit* of 1893–94 (fig.
15.13), although Gorky` has deviated from his source in a manner that suggests a grow-
ing confidence in his own ability to add a personal flavor to these works. He has
replaced the jug with an earthenware pitcher and moved this object to the right to cre-
ate a pared-down composition that is even more somber and severe than Cézanne's
original.[47] The work demonstrates the basic lessons that Gorky learned from the French
artist's still lifes, giving as much vitality to the space in and around the pitcher, plate,

and fruit as to the objects themselves, and making the shape and shadow of each object appear to lie side-by-side in a shallow, sketchily defined abstract space, rendered in vigorous, directional brushstrokes, redolent of a tabletop set against a blank wall, although the upper edge of the table is undefined and inconsistent. This pictorial device, which Cézanne used to manipulate the spatial ambiguity of his paintings and address the flatness of the picture plane, had thus been fully grasped by Gorky, suggesting that his apprenticeship to the French artist was coming to an end by the late 1920s, at which point his focus shifted to the pictorial complexities of Cubism, which would preoccupy him for more than a decade.

As this examination of Gorky's borrowings and departures from Cézanne's work has shown, the artist's experimental reinterpretations of the mid-to-late 1920s can no longer be dismissed as derivative copies or pastiches of Cézanne's work, since this view serves only to impoverish Gorky's art and fails to grasp the radical nature of his self-imposed discipleship. Gorky instead emerges from this account as a quintessential self-taught artist of the interwar years, who rejects originality in favor of a steadfast allegiance to another artist's vision as a means of self-creation.[48] Gorky's Cézanne-inspired paintings do not embrace mainstream modern art's cult of innovation, but instead emphasize his strangeness and difference as a dislocated, decentered subject, following his early experiences as a genocide survivor and an immigrant. Clearly the artist found similar qualities in Cézanne's uncompromising artistic vision and truculent personality, which alienated his contemporaries, yet won him the lasting respect of those artists, like Gorky, who followed in his footsteps.

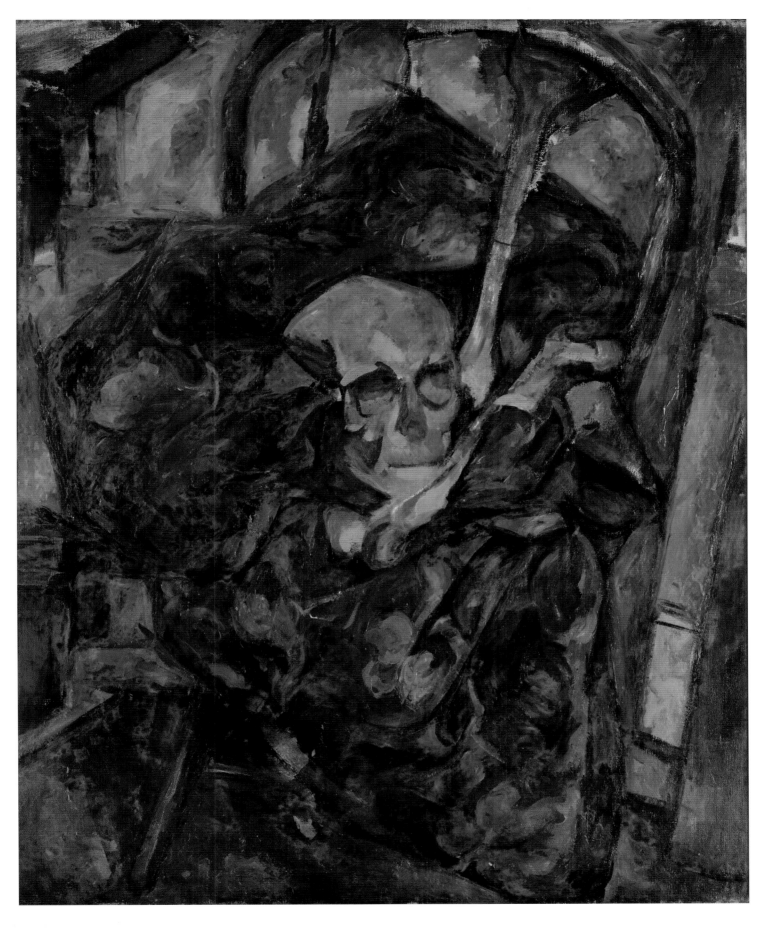

PLATE 146

Arshile Gorky

Still Life with Skull, c. 1927–28

Oil on canvas
33 x 26¼ inches (83.8 x 66.7 cm)
Private collection

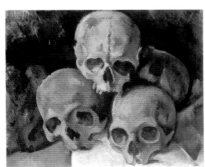

Paul Cézanne, *Pyramid of Skulls,*
c. 1898 (plate 114, p. 325)

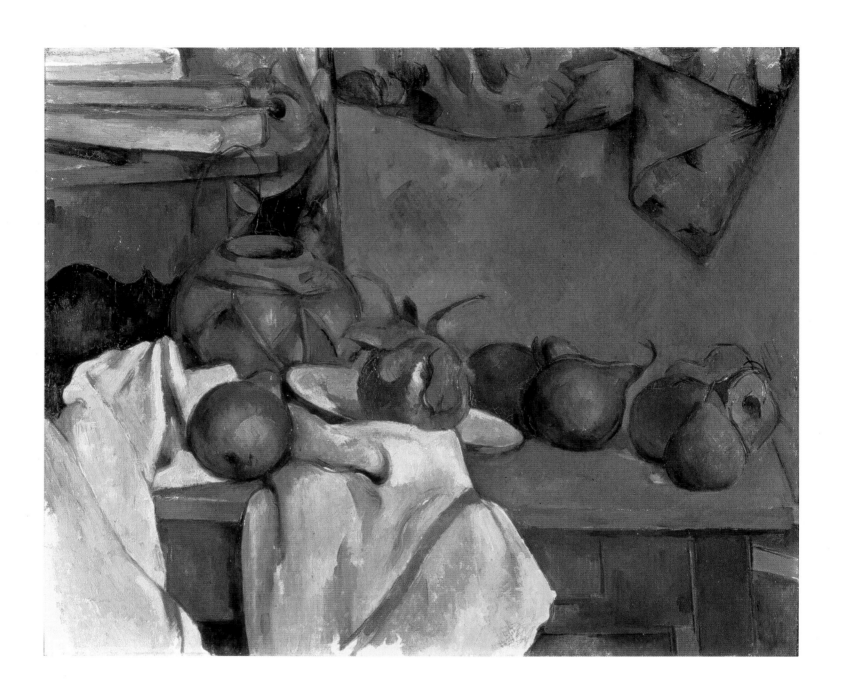

PLATE 147

Paul Cézanne

**Ginger Pot with Pomegranate and
Pears, 1890–93**

Oil on canvas
18¼ x 21⅞ inches (46.4 x 55.6 cm)
The Phillips Collection, Washington, DC. Gift of
Gifford Phillips in memory of his father, James
Laughlin Phillips

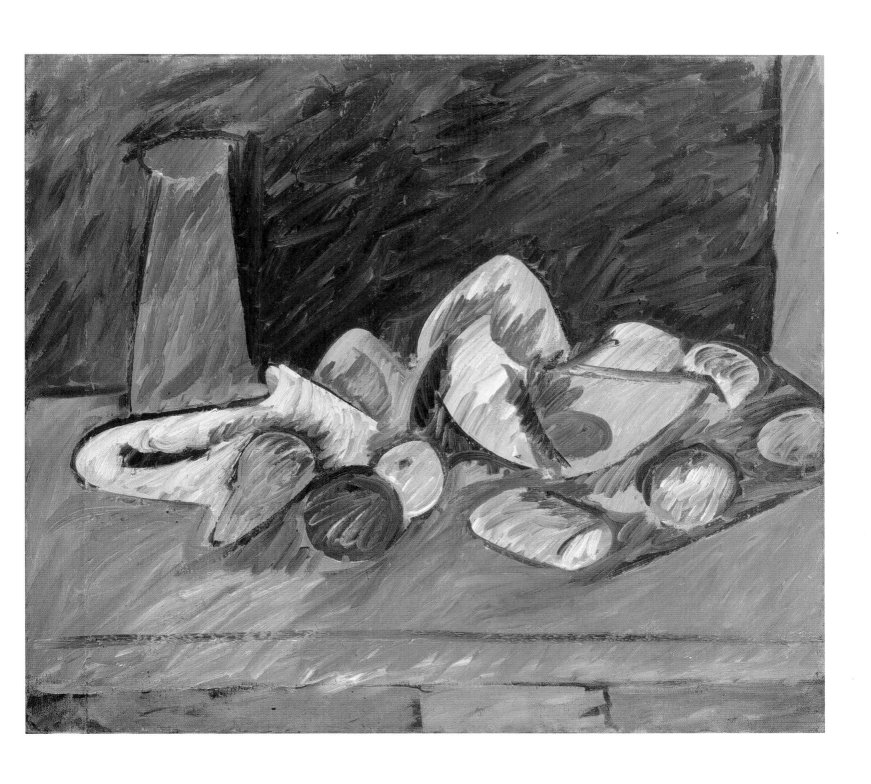

PLATE 148

Arshile Gorky

Still Life, c. 1928

Oil on canvas
23 x 26 inches (58.4 x 66 cm)
Private collection

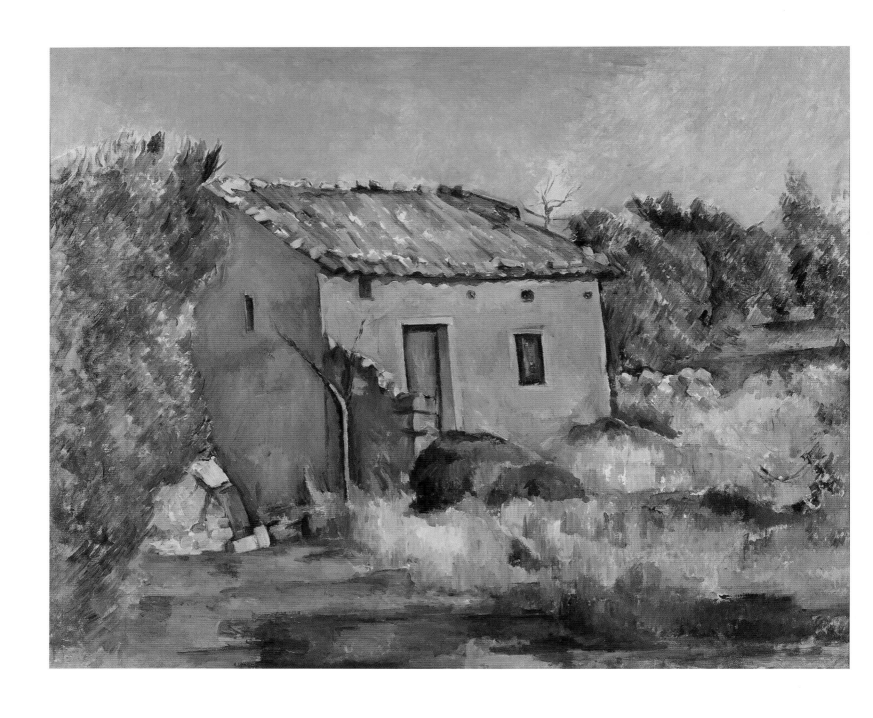

PLATE 149

Paul Cézanne

Abandoned House near Aix-en-Provence, 1885–87

Oil on canvas
25⅝ x 32½ inches (65 x 82.5 cm)
Dallas Museum of Art. The Wendy and Emery Reves
Collection

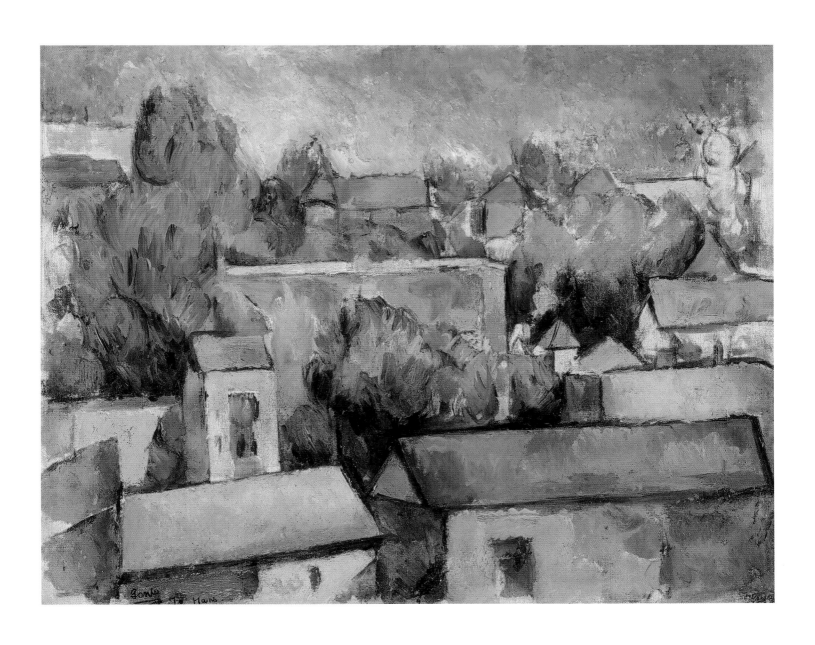

PLATE 150

Arshile Gorky

Staten Island, 1927

Oil on canvas
16 x 20 inches (40.6 x 50.8 cm)
Private collection

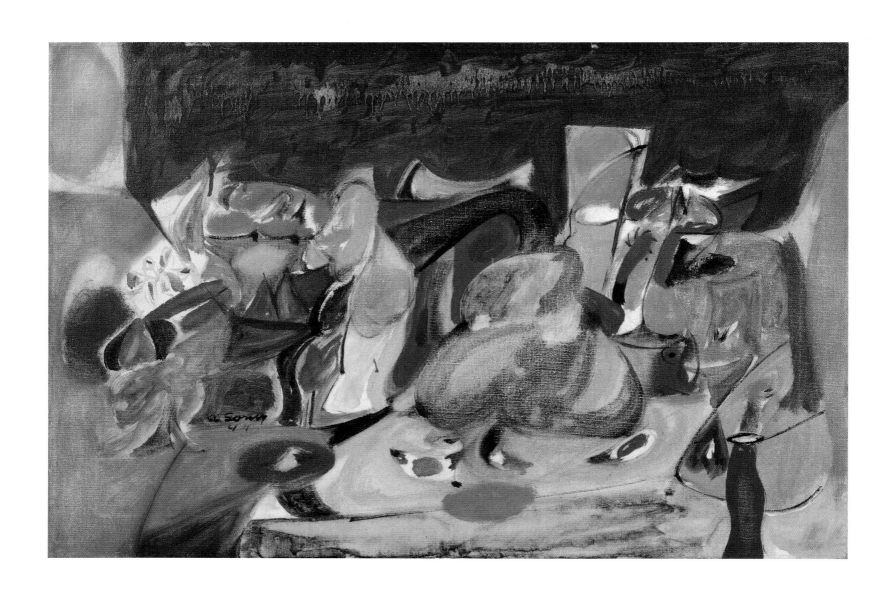

PLATE 151

Arshile Gorky

Crooked Run, 1944

Oil on canvas
19 x 28 inches (48.3 x 71.1 cm)
Private collection

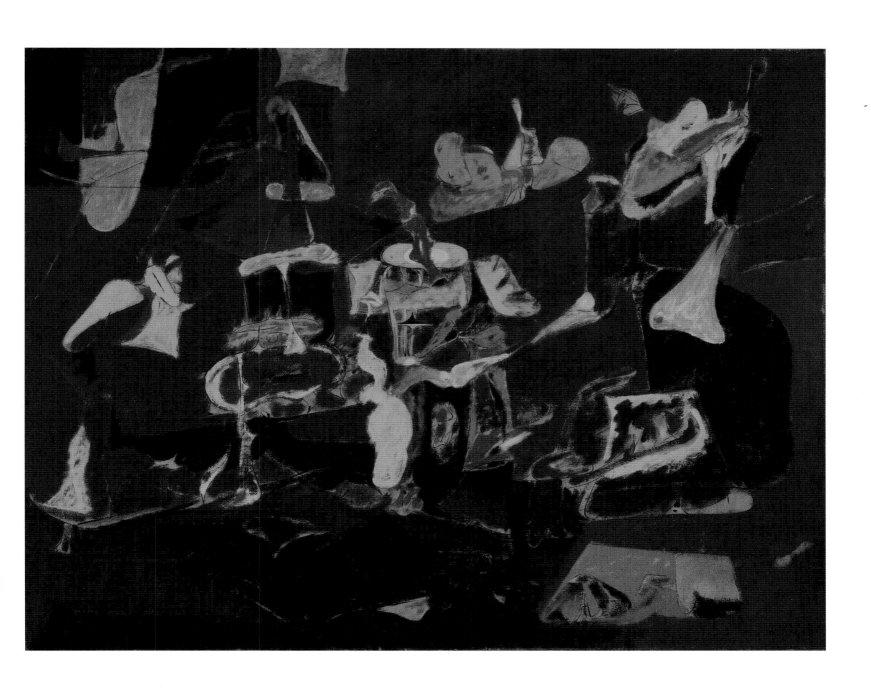

PLATE 152

Arshile Gorky

Dark Green Painting, c. 1948

Oil on canvas
43⅞ x 55⅞ inches (111.4 x 141.9 cm)
Philadelphia Museum of Art. Gift (by exchange) of
Mr. and Mrs. Rodolphe Meyer de Schauensee and
R. Sturgis and Marion B. F. Ingersoll, 1995-54-1

Cézanne and Kelly: Painting Form through Color

Katherine Sachs

> He treats [color] in a way no one has treated color before, using it solely for the creation of objects. The color is wholly used up in becoming things.
> —RAINER MARIA RILKE, in a letter to his wife, October 12, 1907[1]

The above quotation about Paul Cézanne, which Rilke made after visiting the artist's retrospective at the 1907 Salon d'Automne in Paris, could equally be applied to the American artist Ellsworth Kelly. These two painters share a common belief in the transformational power of art. Inspired by nature, they go beyond their original "sensation"—to use Cézanne's word—to create works that transcend time and place. Their art is deeply personal, reflective of their unique feelings, and expressed in a form that is consistent with their own influences and vision.

Kelly's introduction to Cézanne came early in his life, and its impact has been so strong that although it sometimes lay dormant for decades, it would be released when life circumstances triggered its appearance. Born in 1923 in Newburgh, New York, a town along the Hudson River about sixty miles north of New York City, Kelly traces his fascination with Cézanne to his teen years, when the family lived in New Jersey: "When I was young, around fifteen or sixteen, my mother got me a book of masterpieces from the beginning of painting—from Giotto to Grant Wood. This was around 1938. My favorite painting was the chestnut trees of Cézanne . . . the black branches against the sky. I took it out and put it up."[2]

The book was *World Famous Paintings*, edited by Rockwell Kent, and the picture that Kelly describes is Cézanne's *Chestnut Trees at the Jas de Bouffan* of about 1885–86 (plate 156). In this composition, the black branches that reach upward and disappear into the sky partially obscure the triangular Mont Sainte-Victoire and the varied rectangular buildings of the Jas de Bouffan, the Cézanne family's estate. Just below these forms, a horizontal wall bisects the picture plane. The painting sets up a tension between foreground and background, surface and depth, positive and negative space, all of which Kelly would go on to explore in a variety of ways in his own work.

PLATE 153

Ellsworth Kelly

American, born 1923

***Train Landscape*, 1952–53**

Oil on canvas (three joined panels)
44 x 44 inches (111.8 x 111.8 cm)
Collection of the artist. On loan to the Art Institute of Chicago

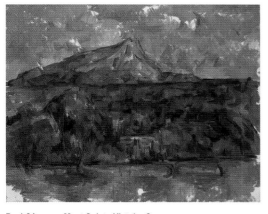

Paul Cézanne, *Mont Sainte-Victoire Seen from Les Lauves,* 1902–6 (plate 186, p. 480)

Fig. 16.1. **Ellsworth Kelly, *La Combe, I,*** 1950. Oil on canvas, 38 x 63½ inches (96.5 x 161.3 cm). Whitney Museum of American Art, New York

In an uncanny coincidence, the description that accompanies Cézanne's picture in the Kent book could also describe the essence of Kelly's art to the present day:

> Cézanne spent the last two decades of his life . . . in a painstaking and perseverant effort to solve the problems of painting form through color. . . . [Cézanne] wanted to reduce form to simple and clear existence through the architectural use of color. He broke up the surface of his pictures into separate independent areas of color which, in total effect, build up to an appearance of solidity.[3]

In retrospect, it is amazing how this one painting holds a key to Kelly's art. Living with this image on his wall instilled in the young artist a vast resource for the future, a reservoir from which he would continue to draw. Color and form and their role in the construction of a painting became the central elements of his work. Kelly recently revealed that Cézanne's *Chestnut Trees* was, in fact, the stimulus for a series of works he produced in 1950–51, in which the subject was the shadows cast across a staircase by a railing (fig. 16.1). He added: "Even now I can return to that original fascination. It's very close to drawing, and it's lively and somehow I feel that it does have a strong influence in the way I look at nature."[4]

Kelly's art, like Cézanne's, is a direct consequence of the powerful effect of looking intensely at and into nature and isolating that response. As Kelly puts it: "The most pleasurable thing in the world for me is to *see something* and then translate how I see it."[5] What catches his eye—be it a shape, a shadow, or a fragment—is "extracted" from reality and transformed by virtue of its independence into a new reality of pure color and form.[6] Those forms come to life at the moment right before recognition sets in, and their power arises from the artist's ability to harness the energy of their initial impact, giving his immediate sensations their own physicality. In this he echoes Cézanne. "The essential aim of Cézanne," according to Hans Sedlmayr, "is to represent

Fig. 16.2. **Ellsworth Kelly, *Spectrum Colors Arranged by Chance II,*** 1951. Cut-and-pasted color-coated paper and pencil on four sheets of paper, 38¼ x 38¼ inches (97.2 x 97.2 cm). Museum of Modern Art, New York. Purchased with funds given by Jo Carole and Ronald S. Lauder

what 'pure' vision can discover in the visible world, vision, that is to say, that has been cleansed of all intellectual and emotional adulteration. . . . [H]e confines us wholly to the experience of the eye."[7] Cézanne's paintings were realized after very long bouts of looking, and their strength lies in the fact that the familiarity of the image is overtaken by the creative process. Each artist in his own way begins with an intense response to nature that then becomes *form*-alized through color. This relationship of color and form, as well as the manner in which these artists have realized their isolated perceptions of visual stimuli, link these two major figures nearly a century apart.

At the end of the war Kelly moved to Boston and enrolled at the School of the Museum of Fine Arts. "The whole group of European painters excited me at the time," he later recalled. These included Max Beckmann, Pablo Picasso, Henri Matisse, Jean Arp, Pierre Bonnard, and Fernand Léger, with Picasso and Beckmann the most important for Kelly.[11] Kelly remembers very well when Beckmann visited the Boston museum school in 1948 with his wife, Quappi, who read to the students a translation of the

Robert Storr has noted that "to see as Kelly sees is to perfect the art of noticing."[8] Kelly's keen sense of looking started early. As a young boy he took up bird-watching, an activity that is by its very nature — seeking out colors and shapes partially obscured by thick foliage — training for intense concentration and focus. In the context of Kelly's work, this could be characterized as an early exercise in seeing the positive in the negative. Kelly's artistic explorations also began at an early age. Encouraged by a sixth-grade teacher, he painted throughout his school years. In the early 1940s, he moved to Brooklyn and studied applied art at the Pratt Institute. In 1943 he was inducted into the U.S. Army and served in a camouflage unit, which by definition was involved in using shape and color to "construct and deconstruct" an image.[9] Of this time, Kelly recalls, "Everybody was sketching all the time, and it was while I was in the outfit in France that I decided to become a painter."[10]

Fig. 16.3. **Ellsworth Kelly,** ***Blue Panel I,*** 1977. Oil on canvas, 104 x 80 inches (264.2 x 203.2 cm). Whitney Museum of American Art, New York. Fiftieth Anniversary gift of the Gilman Foundation, Inc., and Agnes Gund, 1979

artist's "Letters to a Woman Painter."[12] The German painter's lecture included extensive remarks on Cézanne. "Don't forget nature," Beckmann had written, "through which Cézanne . . . wanted to achieve the classical. . . . Learn the forms of nature by heart so that you can use them like the musical notes of a composition. That's what these forms are for."[13] These remarks obviously had an impact on the young Kelly, whose work since has ranged, to continue Beckmann's musical metaphor, from the symphonic compositions of his early multi-paneled paintings created by chance (fig. 16.2) to the pure tonalities of his resonantly colored single panels (fig. 16.3).

Later that year Kelly embarked for Paris to continue his studies under the GI Bill. It was his second time in the French capital; he had been there for a few weeks in 1944. Paris was an inspiration to Kelly, who was then barely twenty-five. He explored the museums and met many of the major artists living in Paris, including Arp and his wife, Sophie Tauber-Arp, as well as Constantin Brancusi, Alexander Calder, and Alberto Giacometti. He applied to the École des Beaux Arts and was accepted. He became fascinated with the architecture of Paris and soon began to realize "that figurative painting no longer interested me."

> Looking for a different way to continue . . . I studied art of the Mediterranean and the East. . . . I traveled to . . . Romanesque sites. . . . The forms found in the vaulting of a cathedral or a splatter of tar on a road seemed more valid and instructive. . . . I continued to explore the object quality of things seen . . . a kilometer marker . . . a window frame.[14]

I [also] began to draw from plant life and found the flat leaf forms were easier to do than thighs and breasts. I wanted to flatten. The plant drawings from that time until now have always been linear. They are exact observations of the form of the leaf or flower or fruit seen. Nothing is changed or added — no shading, no surface marking. They are not an approximation of the things seen, nor are they a personal expression or an abstraction. They are an impersonal observation of the form.[15]

This "impersonal observation" led Kelly to a moment of revelation that set his future course. "Art seemed to me like something of the past. I wanted to get onto something new. I was searching for another way to compose a picture."[16] For Kelly, this meant that "instead of making a picture that was an interpretation of a thing seen, or a picture of invented content, I found an object and 'presented' it as itself alone."[17] He created his first such "object," *Window, Museum of Modern Art, Paris*, the following year, in 1949 (fig. 16.4).

After constructing "Window," . . . I realized that from then on painting as I had known it was finished for me. The new works were to be painting/objects, unsigned, anonymous. Everywhere I looked, everything I saw became something to be made, and it had to be exactly as it was, with nothing added. It was a new freedom: there was no longer the need to compose. The subject was there already made, and I could take from everything. It all belonged to me.[18]

This breakthrough allowed Kelly to forge his own path into the future. He viewed this radical realization not as a break with the past, but rather as an extension of the project begun by Cézanne and others in the previous century. "Wherever we look in the world, objects are layered, jumbled together, spread out before us," he wrote in 1990. "The Impressionists, Georges Seurat, and Paul Cézanne were among the first artists to try to come to terms with this visual chaos. Cézanne tackled and conceptualized the three-dimensional world in terms of its underlying structures and our uncertain relationships to it."[19] Kelly's solution to the chaos before him was to simplify his vision and in his own unique way to isolate the object of his sensation, whether it was a leaf, a kilometer marker, or a window. Form in its almost pure sense emerged as a major force in his work. This impulse also found an early expression in his plant drawings. Kelly sees these drawings as "a bridge to the way of seeing that brought about the paintings in 1949 that are the basis for all my later work."[20] A series of three drawings (plates 157–59) made at the Bois de Boulogne in 1950 shows very clearly how Kelly's progressively sharp focus worked to simplify the shape of the tree trunks he saw there.

By 1950 Kelly not only had found himself as an artist, he also had discovered the essence of Paul Cézanne. Madeleine Grynsztejn notes that Kelly, like Cézanne, "was most inspired not by a particular art movement, mentor, or theoretical framework, but by his own dedication to a concentrated mode of seeing."[21] For both of these painters, what was of utmost importance was a new reality, inspired by something or someone real, which then took on a life and meaning all its own. Kelly's initial inspiration is arrived at objectively and then reinvigorated by his deeply felt commitment to its new realization, whereas Cézanne's was very personal and totally subjective. This is evident in Kelly's *Study for "White Plaque": Bridge Arch and Reflection* (fig. 16.6), a collage he made in 1951, inspired by the arches of a bridge he saw from the park behind Notre Dame on the Île de la Cité across from the Île Saint-Louis (fig. 16.5).[22] Here the artist brings objects into immediate view by redefining the space between the image and the viewer, much as Cézanne did in *The Pont de Maincy* of 1879–80 (plate 160). In both of these works, the artist transformed the shape of the arch from an architectural element

Fig. 16.4. **Ellsworth Kelly, *Window, Museum of Modern Art, Paris,*** 1949. Oil on wood and canvas, 50½ x 19½ x ¾ inches (128.3 x 49.5 x 1.9 cm). Collection of the artist

Fig. 16.5. **Ellsworth Kelly, *Pont Marie, Île Saint-Louis, Paris,*** 1950. Silver gelatin print, 8 x 10 inches (20.3 x 25.4 cm). Collection of the artist

Fig. 16.6. **Ellsworth Kelly, *Study for "White Plaque": Bridge Arch and Reflection,*** 1951. Collage on paper, 20¼ x 14¼ inches (51.4 x 36.2 cm). The Museum of Mocern Art, New York. Gift of the artist in honor of Mr. and Mrs. Joseph Pulitzer, Jr.

to a painting by flattening out the natural curve and bringing it forward to the picture plane. But Kelly went even further—he isolated it. The fragment became the whole. Cézanne keeps the viewer on the surface through his intense manipulation of the painted elements—the reflections of light on the water, the distorted torque of the arch, and the heavily painted gray bridge whose highlights and tactile surface belie its implied perspective and diagonal movement into the space of the painting. The tree that intersects the bridge fights this illusion and keeps everything on the frontal plane. For Kelly, this process of seeing and abstracting is what gives the image its integrity: "Making art has first of all to do with honesty. My first lesson was to see objectively, to erase all 'meaning' of the thing seen. Then only, could the real meaning of it be understood and felt."[23] A similar sentiment was expressed by Cézanne in a letter to Émile Bernard of May 26, 1904: "Get to the heart of what is before you and continue to express yourself as logically as possible."[24]

Kelly is keenly aware that this process of abstraction is inherent in the very nature of painting. "I see fragments," the artist told Paul Taylor in 1992. "I take things seen in perspective and bring them back to a plane . . . which is what painting has always been about."[25] At other times, he has said, "My painting is a fragment of the visual world with the third dimension removed,"[26] and that he sees "the history of abstraction [as] the artist's struggle to free form from depiction and materiality."[27] Cézanne, of course,

played a pivotal role in the unfolding of this history, pointing the way for many artists who followed.

The French painter's interest in maintaining the integrity of the two-dimensional picture plane while expressing his "sensation" before nature sets up a tension between the figure and the ground that would be reinterpreted by many artists, including Kelly, in the twentieth century. Cézanne's flattening of the space in painting, virtually fusing foreground and background, motivated Kelly to explore the figure/ground relationship in many variations. In the 1950s Kelly was beginning to formulate his own artistic vision, based on the independence of color, the importance of the relationship between color and form, the directness of the image, and the dynamic relationship of figure and ground. For Kelly, this has meant that the "form of painting is the content," or, as he also puts it: "In my painting, the painting is the subject rather than the subject, the painting."[28]

For both of these artists, the painted image is one inspired by nature and shaped by their desire to create a painting that is intrinsically honest to its own physicality and place in the world. Their desire to depict reality without destroying the painting's own reality creates a tension that gives their work its dynamic presence. Composition and color are the tools they employ to keep us literally on the edge of their invention.

In his efforts to record his sensations, Cézanne looked very hard at the motif before him, trying to capture everything he saw. In *Large Pine and Red Earth* (plate 162), painted from 1890 to 1895, the house and property of his sister and brother-in-law lie beyond the scrim of luminous brushstrokes, but it is difficult to see through the active surface of the painting. The tree trunk and its branches seem weightless amid this torrent of activity, as if the wind has just arisen and set the pixelated leaves into a swirling frenzy that drives them to the edges of the canvas.

Ironically, Cézanne's intense focus led him to pay more attention to the surface.[29] As Kelly notes: "Cézanne [is] about the surface—with Cézanne's work you want to go up and look at how he did it—the layering of the colors."[30] The faceted brushstrokes that emphasize the surface while also creating the illusion of depth are the same brushstrokes that break down the surface and then build it back up, giving the painting and the image a vibrant presence. As Clement Greenberg noted of Cézanne's work in 1951: "The facet-planes jump forward from the images they define, to become more conspicuously elements of the abstract surface pattern; distinct and more summarily applied, the dabs of painting stand out in Cubist fashion, dilating and their edges trembling."[31]

Kelly saw a similarity between the fragmentation of those strokes and his own "chance" paintings of the early 1950s (see fig. 16.2). His painting *Meschers* (plate 163), made in 1951, depicts the sky and water as seen through pine trees near the town of that name, on the banks of the Gironde River. The painting is based on a smaller collage he made by cutting a drawing into twenty-five squares and rearranging the pieces by chance.[32] Kelly recalls, "When I painted this picture, when I did the collage, I walked through a pine forest to the beach and it looked just like that. And I said, it's the sky and the pine trees."[33] What in Cézanne's painting is shimmering light becomes in Kelly's solid and abstract. Despite the extreme abstraction of Kelly's picture, it is easy to feel the light coming through the trees, hitting the water and reflecting back on the leaves. One leaf—in the middle vertical row, about one-third down from the top—is quite recognizable.[34]

In 1954, Kelly returned to New York and began to paint curving shapes on rectangular surfaces, as in *Bay* (fig. 16.7). Just as Cézanne had collapsed foreground and background, Kelly was now putting a figure on a ground but playing with it in such a way that the viewer could not be sure which was which. The resulting dynamic tension of

the painting is also enhanced by Kelly's denial of the natural property of the various colors themselves, for he neutralizes the intrinsic quality of some colors to push forward and others to push back,[35] thus keeping us focused on the activity on the picture plane, an ingenious solution to the problem of creating an image while simultaneously preserving the integrity of the painting. In this series of works, he plays with the illusion of foreground and background, not because he is exploring the idea of depth, but because he always wants to keep foremost in his vision the notion that the painting is a field that should not be destroyed but rather bolstered by the back-and-forth movement of the shapes it contains.

Kelly takes the push-pull of figure versus ground in many directions beyond those explored by Cézanne. Sometimes this battle is fought on the surface of the painting, as in *Bay*. Sometimes it takes place between the panels in the relief constructions; in the spaces between the panels in the multipaneled paintings; or between the painting and the wall behind it, in the single-paneled pictures (see fig. 16.3). For much of Kelly's work, the figure is the painting and the ground is the wall. The dynamic set up between panels, and between the painting and the wall, gives these works an object-like physicality usually associated with sculpture.[36]

Kelly's interest in the idea of the picture as an object[37] has led him to blur the distinction between painting and sculpture. In many paintings from the Paris period, such as *Meschers* (plate 163) or *Spectrum Colors Arranged by Chance II* (see fig. 16.2), Kelly employed the element of chance to give the works the same variety and vibrancy he saw in Cézanne's paintings.[38] The abstract forms of the earlier paintings reappear in *Sculpture for a Large Wall* of 1957, one of Kelly's largest works.[39] The flickering of the radiant aluminum shapes can be seen as a sculptural interpretation of Cézanne's brushwork. As in a Cézanne painting, these various shapes and colors work together to create form and activate the surface.

In a group of paintings from the late 1960s and early 1970s, of which *Red Green* (fig. 16.8) is an example, Kelly's interest in perspective found another resonance with the work of Cézanne, as Kelly set up a visual struggle between surface and depth that elicits a sense of imbalance in the viewer. The diagonal lines of *Red Green* recede into space, and yet the vibrancy and physical immediacy of the colored panels keep our eye focused on the surface of the picture. "It has a vanishing point. . . . I don't want it to be an obvious perspective painting, and I think that in those pictures . . . there is a slight mystery that you can or can't see. . . . It has a linear idea of space, but it's up front, it's flat and I denied it in some way."[40] The feeling of disequilibrium that is so evident in these Kelly paintings is also true of many of Cézanne's still lifes. In his *Stoneware Jug* of 1893–94, Cézanne (see plate 45) used the diagonal to create an illusion of depth, but—as in Kelly's *Red Green*—that sense of depth is denied by the vibrancy of the surface of the painting. The tension also comes from Cézanne's having created a space that cannot possibly exist in the real world. He took the gravity out of the picture, making an oxymoron of the term "still life." The contradictory reality of trying to preserve the surface and create the illusion of depth gives Cézanne's work its potency. We are kept off balance yet fascinated by the stability/instability of what we see on the canvas. This is true for the Kelly painting also, and yet both paintings hold together not in spite of, but because of all the interior tensions that work with and against each other to achieve balance.

Kelly's work is often a reinterpretation or recapturing of an idea or image from a past encounter. Reappearing and totally reconceived, the inspiration for these works is not always obvious. Whether it is an image from a postcard, a photograph, or a painting, certain shapes trigger associations with things already seen, banked, but not yet

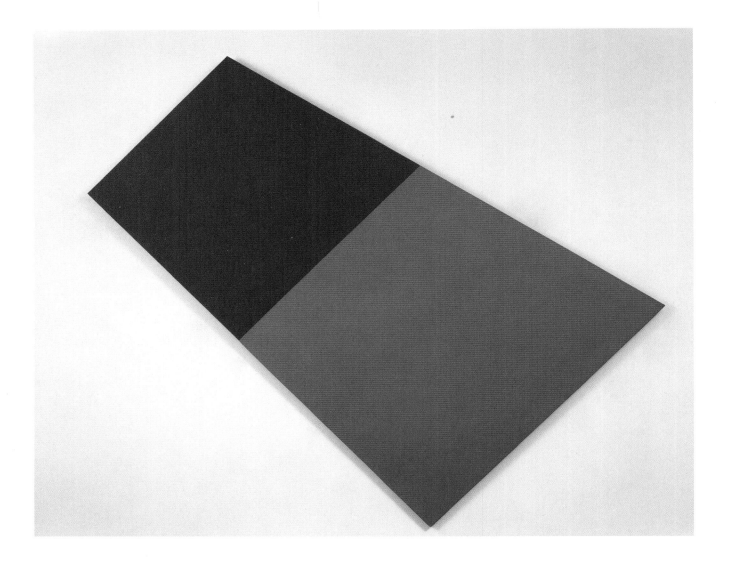

Fig. 16.8. **Ellsworth Kelly,** *Red Green,* 1968. Oil on canvas, two joined panels; 112 x 130 inches (284.5 x 330.2 cm). Collection of Mr. and Mrs. Donald Fisher, San Francisco

mined for their pictorial potential. Kelly has said, "My paintings are about the memory of things."[41] The intensity of his vision becomes magnified by memory and gives his work a depth of meaning beyond its simplified format. Such is the case for *Lake II* (plate 165) and its predecessors, *Study for "Lake"* and *Lake I* (figs. 16.9, 16.10). Of these images, Kelly recalled:

> There was a L'Estaque painting [at the Metropolitan Museum of Art] by Cézanne [plate 164], sixty to seventy-five percent of it was water. Water is a blue shape. I was reminded of the bay in that painting when I saw a lake from the top of a hill, and I made a sketch of it [fig. 16.10]. The painting [fig. 16.9] was done in 1982. Now I realize the things I was attracted to when I was very young have resulted in other things. It was an indirect influence. Every time I would go the Met I would touch base with that picture, the shape of the bay, blue water against green landscape. "This is the painting I really like best in the whole museum." And I said: "Why is it that way?" You see, I guess it's because of the blue, the dominance of the blue.[42]

Kelly's three echoes of the Metropolitan Museum's *L'Estaque* were realized over a period of thirty-two years, from 1970 to 2002. His first response to Cézanne's *L'Estaque,* however, was his *North River* of 1959 (fig. 16.11). Overwhelmingly blue against a white background, *North River* sets up a figure/ground dynamic that is totally in sync with other Kelly paintings of the late 1950s and yet very different from the 2002 *Lake II*— showing that memory is often tempered by context. The latter work resonantly epitomizes Kelly's confluence of shape and color to maximum effect and brilliantly illustrates his belief that "fragmentation and the focus on a single form have been two solutions in my own work for emptying shape of representational content and projecting it into a

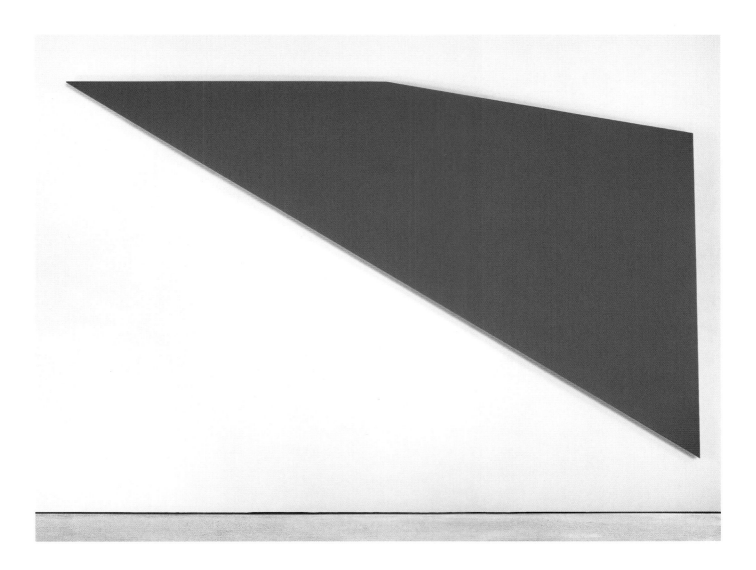

Fig. 16.9. **Ellsworth Kelly,** ***Lake I,*** 1982. Oil on canvas,
93 x 148 inches (236.2 x 375.9 cm). Private collection

Fig. 16.10. **Ellsworth Kelly,** ***Study for "Lake,"*** 1970.
Pencil on paper, 11⅞ x 17⅞ inches (30.2 x 45.4 cm).
Collection of the artist

new space."[43] For Cézanne, color defined form; Kelly takes it one step further — in his
work, color *is* form. As in *White Plaque: Bridge Arch and Reflection* of 1951–55 (fig. 16.12),
in *Lake II* Kelly has made the fragment a whole. Here, color is an active ingredient,
helping to realize the image and taking it beyond the wall. As the artist said, "I want the
painting shape and color to come into the room, not be a painting, but a presence."[44]

Capturing the image through color was important for Cézanne and Kelly. We
can see how each artist responded to the color sensations before him by comparing
Cézanne's *Mont Sainte-Victoire Seen from Les Lauves* of 1902–6 (see plate 186) with
Kelly's *Train Landscape* of 1952–53 (plate 153). Cézanne saw the complexities of the

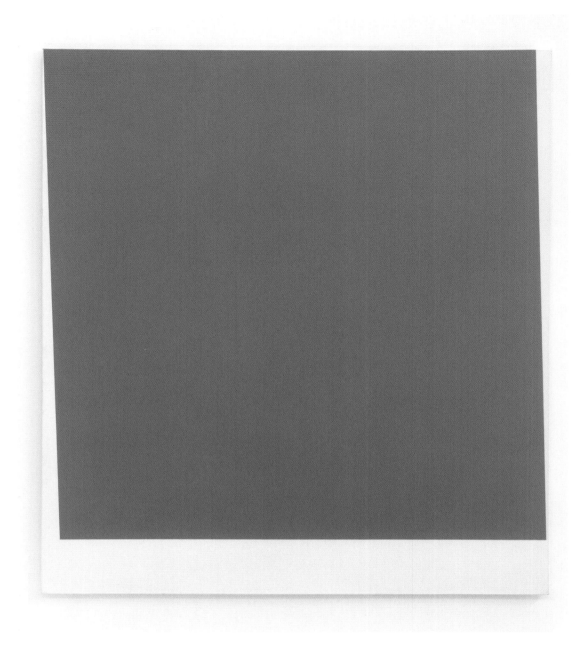

Fig. 16.11. **Ellsworth Kelly, *North River,*** 1959. Oil on canvas, 78 x 70 inches (198.1 x 177.8 cm). Collection of the artist

landscape and endeavored to capture every component without giving in to pictorial illusion, which for him would have denied the picture its legitimacy. In this version of *Mont Sainte-Victoire*, foreground, middle ground, and background become three color bands that collapse into each other, squeezing out the space and unifying the painting. Kelly's *Train Landscape*—so named because it was conceived during a train ride from Paris to Zurich—exhibits a very similar dynamic. Kelly abstracted the image he saw through the window of the train as it passed through fields of lettuce and rapes (mustard). The painting also has three horizontal bands of color, but in Kelly's painting they are more removed from reality.[45] Kelly has taken the essence of his experience and expressed it through a powerful palette. Compositionally the painting resembles a landscape, but that reality is blurred by the speed of the train. What remain, and what we experience, are Kelly's vibrant color sensations. Cézanne's image is also perceived over a great distance without creating a sense of depth. He piles his sensations one on top of the other to give the mountain an even more affecting majesty.

In 2000 Kelly visited Aix and made his own expansive drawing of Mont Sainte-Victoire (plate 167). "We were driving up from Nice and I looked over and I saw this whole range . . . and I thought I had to do the whole thing. . . . It was exciting to see the mountain."[46] In Kelly's drawing, the ten miles separating the artist from the mountain disappear. Whereas Cézanne's mountain (plate 166) is loftier, reaching up beyond

Fig. 16.12. **Ellsworth Kelly, *White Plaque: Bridge Arch and Reflection,*** 1951–55. Oil on wood, two panels separated by a wood strip; 64 x 48 x ½ inches (162.6 x 121.9 x 1.3 cm). The Museum of Modern Art, New York. Promised gift of Emily Rauh Pulitzer; Vincent D'Aquila and Harry Soviak Bequest Fund, and Enid A. Haupt Fund

the plain below, Kelly has drawn an elegant line that lies gracefully and softly on the surface, leading our eye across the breadth of the range. Although almost one hundred years separate the two works, they are very close in spirit, both capturing a mighty mountain with a very light touch.

Cézanne's search for the underlying structure in nature gives his paintings a presence and magnitude that would take him far beyond the Impressionists and into a new world born of different expectations and a new understanding of the intrinsic makeup of the natural world, one in which reality lies beyond our perception. The fact that his work could transcend the resulting shift in emphasis from looking to feeling and from representing to thinking explains his universal and continuing appeal. Kelly started with a similar notion — to find the enduring form in nature — and has refined it, isolated it, and given it life in color and form. Art that maintains its impact over time is not of a certain moment, but is ever-changing in a way that allows us to see the present from a new perspective and the past with greater insight. Henry Geldzahler wrote the following about Ellsworth Kelly: "Through his work he continues to lift us above the tumult and thunder of contemporary life, to seek with him a peace and stillness, where we can once again experience the natural world, freshly re-seen"[47] These words, to end where we began, could also describe Paul Cézanne.

Ellsworth Kelly

Larry, 1947

Oil on paper
23¾ x 18¾ inches (60.3 x 47.6 cm)
Collection of the artist

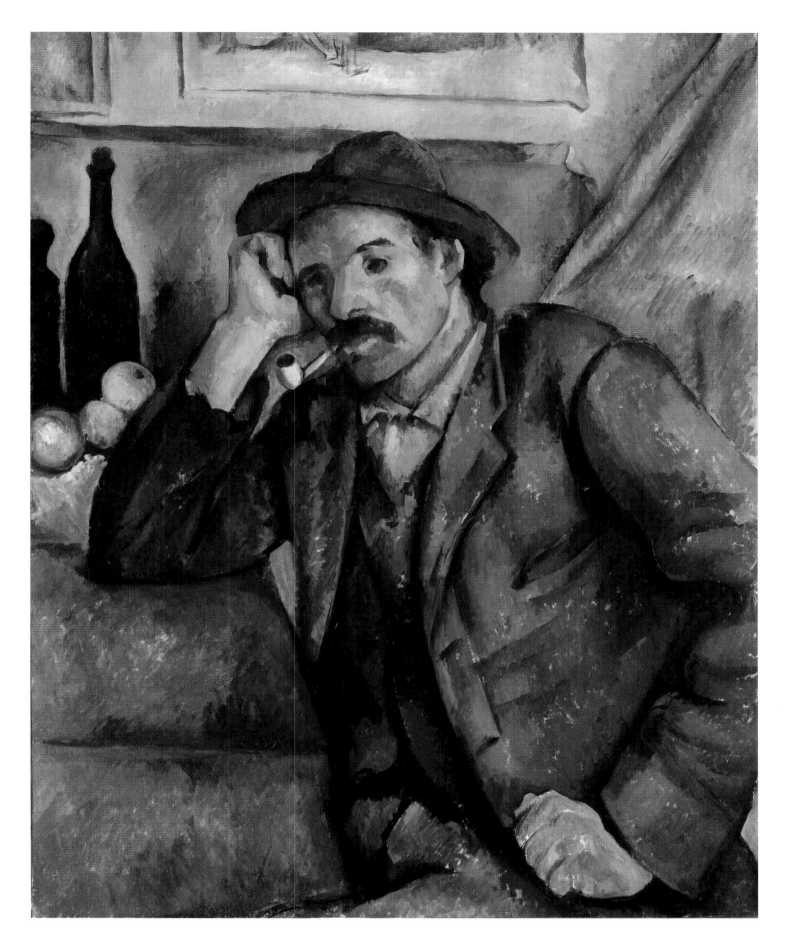

PLATE 155

Paul Cézanne

The Smoker, c. 1890–92

Oil on canvas
36½ x 29 inches (92.7 x 73.7 cm)
State Hermitage Museum, St. Petersburg

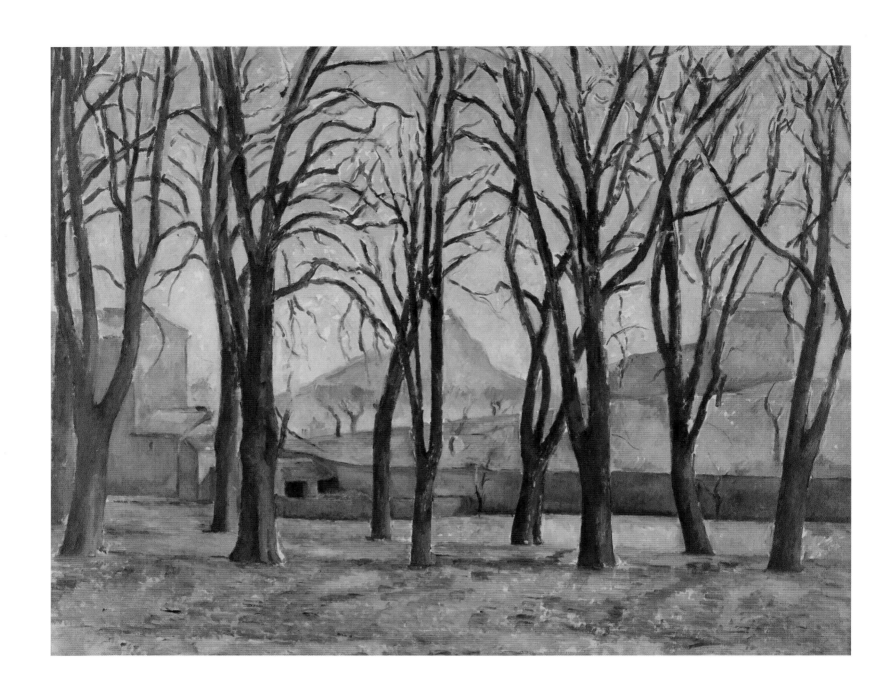

PLATE 156

Paul Cézanne

Chestnut Trees at the Jas de Bouffan, c. 1885–86

Oil on canvas
28 x 35½ inches (71.1 x 90.2 cm)
The Minneapolis Institute of Arts. The William Hood
Dunwoody Fund

PLATE 157

PLATE 158

PLATE 159

PLATE 157

Ellsworth Kelly

Three Trees (1), 1950

Pencil on paper
17½ x 12½ inches (44.5 x 31.8 cm)
Collection of the artist

PLATE 158

Ellsworth Kelly

Three Trees (2), 1950

Pencil on paper
17½ x 12½ inches (44.5 x 31.8 cm)
Collection of the artist

PLATE 159

Ellsworth Kelly

Three Trees (3), 1950

Pencil and ink on paper
17⅝ x 12½ inches (44.8 x 31.8 cm)
Collection of the artist

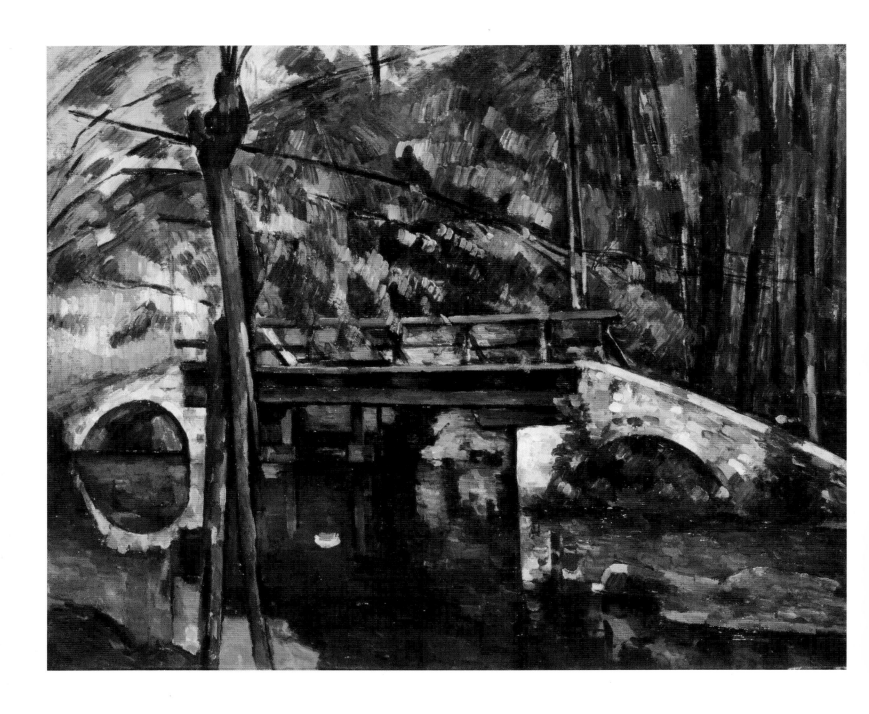

PLATE 160

Paul Cézanne

The Pont de Maincy, c. 1879

Oil on canvas
23 x 28⁷⁄₁₆ inches (58.5 x 72.5 cm)
Musée d'Orsay, Paris (R.F. 1955-20)

PLATE 161

Ellsworth Kelly

Untitled, 1987

Bronze
104 x 79 x ¾ inches (264.2 x 200.7 x 1.9 cm)
Collection of the artist

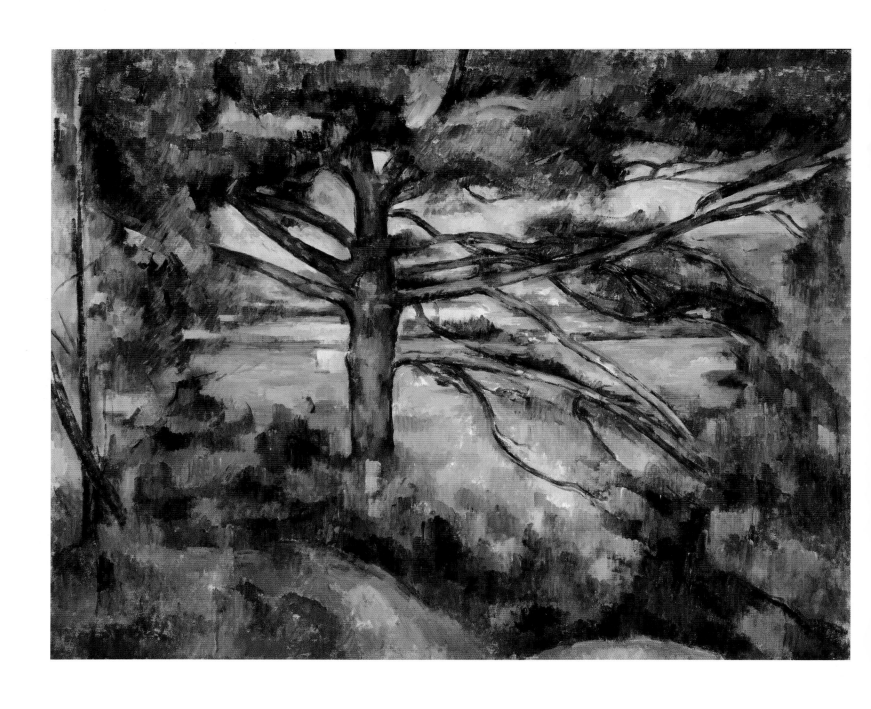

PLATE 162

Paul Cézanne

Large Pine and Red Earth, 1890–95

Oil on canvas
28⅜ x 35¹³⁄₁₆ inches (72.1 x 91 cm)
State Hermitage Museum, St. Petersburg

PLATE 163

Ellsworth Kelly

Meschers, 1951

Oil on canvas
59 x 59 inches (149.9 x 149.9 cm)
Private collection

PLATE 164

Paul Cézanne

***The Gulf of Marseille Seen from
L'Estaque*, c. 1885**

Oil on canvas
28¾ x 39½ inches (73 x 100.3 cm)
The Metropolitan Museum of Art, New York. H. O.
Havemeyer Collection, Bequest of Mrs. H. O.
Havemeyer, 1929 (29.100.67)

PLATE 165

Ellsworth Kelly

Lake II, 2002

Oil on canvas
95 x 149⅜ inches (241.3 x 379.4 cm)
Beyeler Collection, Basel

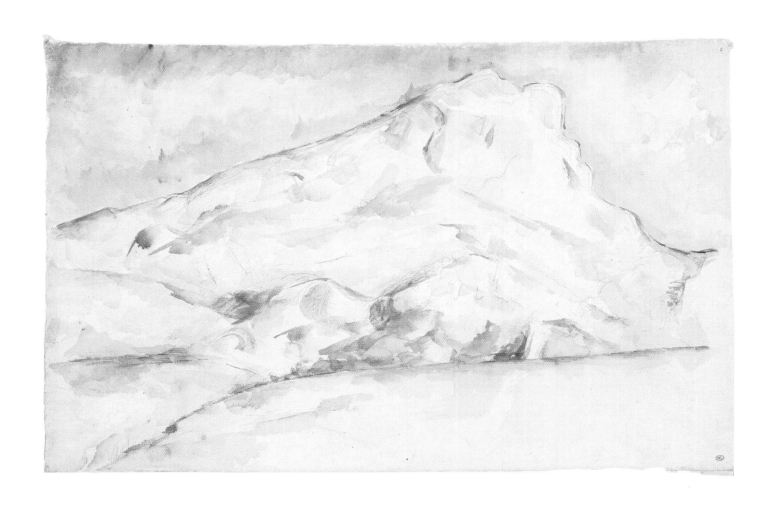

PLATE 166

Paul Cézanne

Mont Sainte-Victoire, 1900–1902

Graphite, gouache, and watercolor on paper
12¼ x 18¾ inches (31.1 x 47.6 cm)
Musée du Louvre, Paris

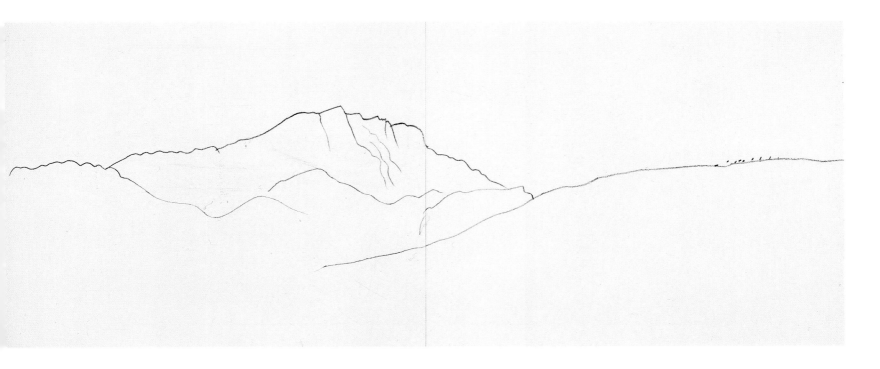

PLATE 167

Ellsworth Kelly

Mont Sainte-Victoire from
Beaurecueil, 2000

Pencil on paper, two sheets
14½ x 35¾ inches (36.5 x 90.2 cm)
Collection of the artist

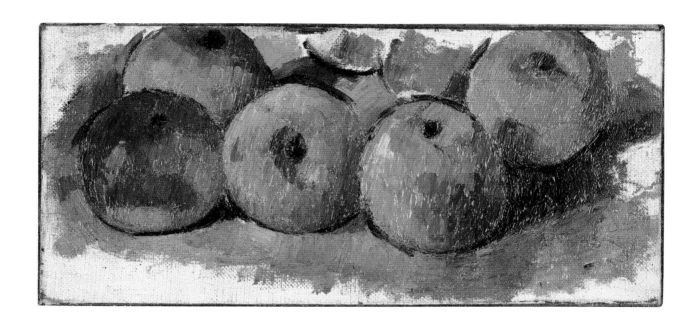

PLATE 168

Paul Cézanne

Five Apples, 1877–78

Oil on canvas
4¾ x 10 inches (12.1 x 25.4 cm)
Collection of Mr. and Mrs. Eugene V. Thaw

PLATE 169

Ellsworth Kelly

Apples, 1949

Watercolor and pencil on paper
24¾ x 19⅜ inches (62.9 x 49.2 cm)
Collection of the artist

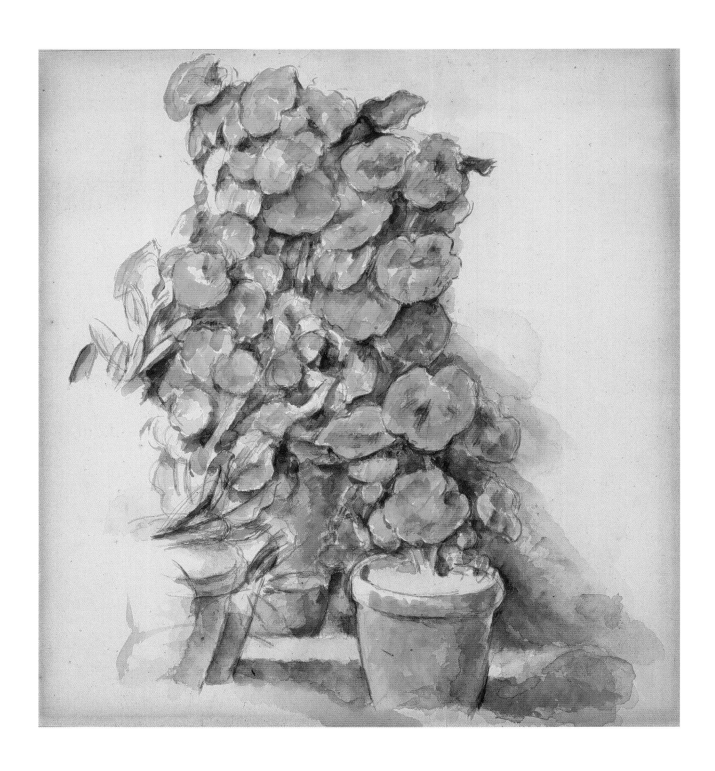

Paul Cézanne

Geraniums, 1888–90

Watercolor over graphite on laid paper
12 x 11¼ inches (30.5 x 28.5 cm)
National Gallery of Art, Washington, DC. Collection
of Mr. and Mrs. Paul Mellon, 1995.47.25

PLATE 171

PLATE 172

PLATE 173

PLATE 171

Ellsworth Kelly

Geranium, 2002

Pencil on paper
17 x 14 inches (43.2 x 35.6 cm)
Private collection

PLATE 172

Ellsworth Kelly

Geranium, 2002

Pencil on paper
17 x 14 inches (43.2 x 35.6 cm)
Private collection

PLATE 173

Ellsworth Kelly

Geranium, 2002

Pencil on paper
17 x 14 inches (43.2 x 35.6 cm)
Collection of the artist

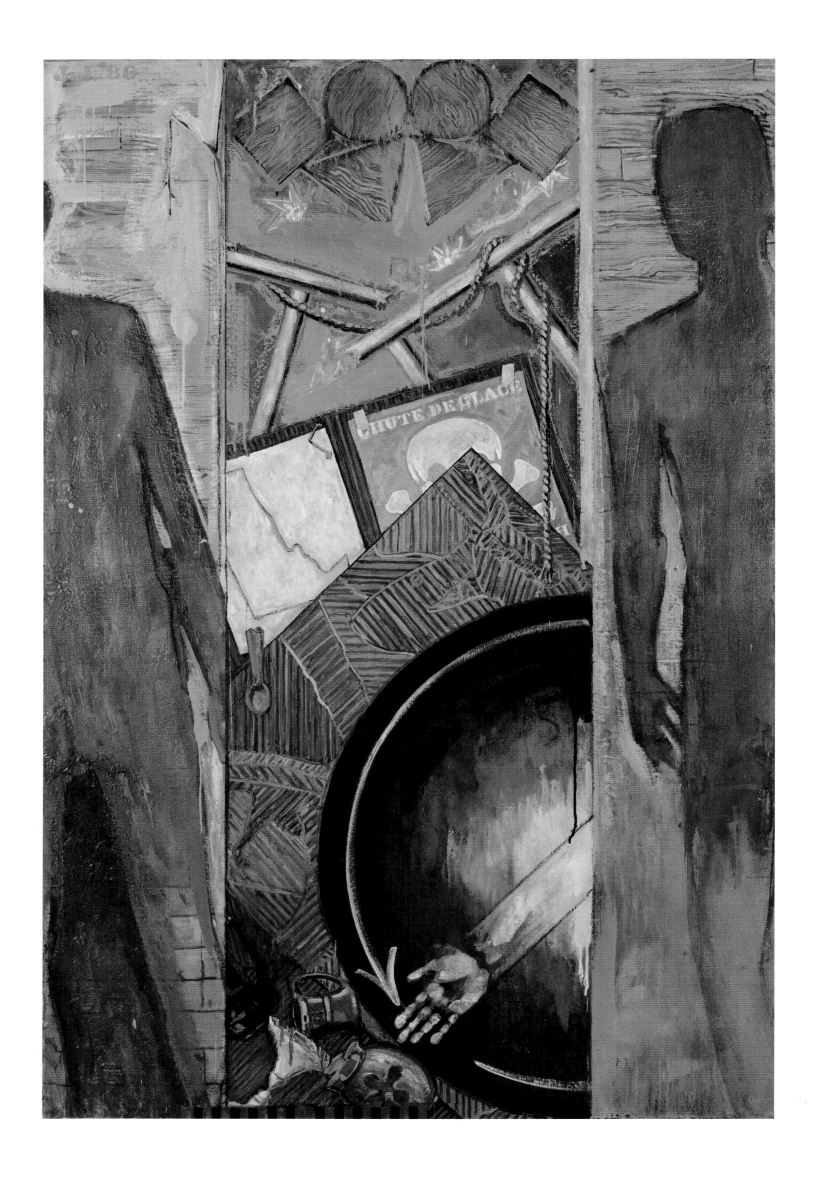

Cézanne and Johns: "At Every Point in Nature There Is Something to See"

Roberta Bernstein

In 1970 during a visit to the Barnes Foundation in Merion, Pennsylvania, Jasper Johns (American, born 1930) told me that *Boy with Skull* (c. 1895; fig. 17.1) was one of his favorite paintings by Paul Cézanne.[1] According to Joachim Gasquet, Cézanne's first biographer, the painting was favored by Cézanne as well, and one of the few he would mention after it was finished.[2] The painting shows a melancholy young man who has turned away from his studies, lost in thought. We may imagine that he contemplates his own mortality, symbolized by the skull weighing down the open pages of a book on the tabletop. We know that during his own youth Cézanne was often plagued by a fear of death, influenced by the Romantic literature that was central in shaping his artistic direction. Johns did not comment on the subject matter of Cézanne's painting as he looked at it. Instead, gesturing as I have seen him do many times in front of his own works, he raised and bent his right arm to follow the diagonal running from the fold in the hanging cloth, along the boy's head and shoulders, and across the top of the chair. He then turned his arm to align it vertically with the back of the chair and then, again, to follow the horizontals of the seat and trousers. As I watched Johns respond to the picture, I sensed that he was not ignoring the painting's expressive content, but rather responding to the way the content was intrinsically connected to the picture's composition. This aspect of Cézanne's art — the unity of meaning and structure — is at the core of the longstanding, ongoing creative dialogue Johns has held with Cézanne's work.

Johns shows great interest in seeing Cézanne's art in person, whenever the occasion presents itself. Over the past few decades he has built an impressive collection that allows him to engage with it directly on a daily basis.[3] On display in Johns's living room is a small painting by Cézanne, titled *Bather with Outstretched Arms* (1883; plate 191), whose presence is more powerful than its dimensions of thirteen by nine and a half inches would suggest. The figure stands alone by the water, feet firmly planted on the ground, with arms extended, one pointing skyward, the other toward the shore.

PLATE 174

Jasper Johns

American, born 1930

***Fall*, 1986**

Encaustic on canvas
75 x 50 inches (190.5 x 127 cm)
Collection of the artist, on loan to the Philadelphia Museum of Art

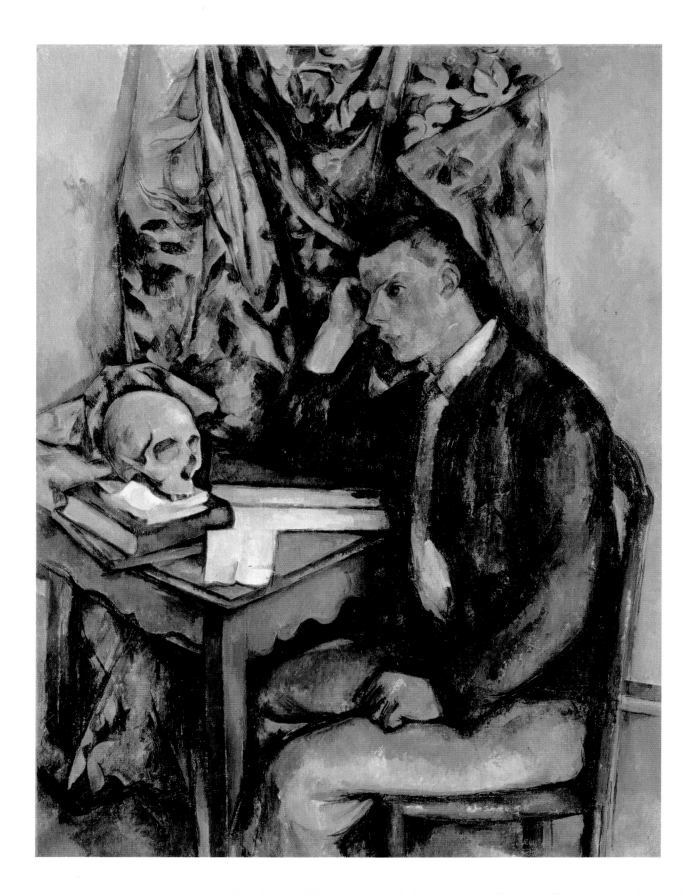

Fig. 17.1. **Paul Cézanne, *Boy with Skull*,** c. 1895. Oil on canvas, 50 x 37¼ inches (127 x 94.6 cm). The Barnes Foundation, Merion, Pennsylvania

Theodore Reff has interpreted this enigmatic figure as "less a bather than a sleepwalker absorbed in his dream."[4] It is likely that the figure held particular significance for Cézanne, because he did more versions of it than any other, and it is the only bather that always appears alone. As a result Reff considers the bather with outstretched arms to be "a projection of Cézanne himself, an image of his own solitary condition."[5] The pride of place this image holds in Johns's home suggests that he may identify with this figure as Reff proposes Cézanne did.

In 1988, the year Johns received the prestigious Golden Lion award at the Venice Biennale, he told an Italian interviewer that "Cézanne has always been his point of reference, and that, since his youth, he has studied Cézanne's pictures with more attention

than those of any other artist."[6] But of all the old and modern masters Johns has admired and appropriated — among them Leonardo da Vinci, Matthias Grünewald, Marcel Duchamp, Réne Magritte, and Pablo Picasso — why has Cézanne remained his primary point of reference? Seeing Johns's paintings in tandem with Cézanne's helps us understand the many facets of Cézanne's art that Johns has responded to over the past six decades. Johns's first exposure to a comprehensive selection of Cézanne's work was a major exhibition at the Metropolitan Museum of Art in 1952, which he later remembered as "a beautiful, big show."[7] Johns saw the exhibition on one of his occasional trips to New York while he was still in the army, stationed in his home state of South Carolina. He had yet to meet Robert Rauschenberg and John Cage, who were to be among his most important early influences, and he was still nearly three years away from painting his signature work, *Flag*, of 1954–55. Johns's first solo exhibition in 1958, at the Leo Castelli gallery, revealed an astonishing body of work that was heralded as marking a new direction in art. His blatantly representational paintings of flags, targets, numbers, and other familiar objects and signs, rendered in a sensuous but depersonalized manner, appeared to reject the self-emotive features of Abstract Expressionism, the style dominating the international art scene at the time.

During the late 1950s and 1960s Johns's art was most often compared to Duchamp's. If Johns's art was tied to Cézanne's at all, it was because of the similarities between their brushstrokes and their use of a limited array of familiar motifs. Cézanne's nearly obsessive repetitions of motifs in still lifes, landscapes, and figural scenes provided a significant precedent for Johns's own strategy to "take an object/do something to it/do something else to it."[8] For both artists repetition of a given subject allowed for refining, elaborating, and stretching its artistic possibilities — and revealing the infinite variety inherent in the process of perception. Their fundamental similarity of approach may be seen by comparing any given grouping of like motifs by each artist, such as Cézanne's views of Mont Sainte-Victoire and Johns's Maps (plates 182–87). Each artist used familiar subjects as the starting point for examining the process of perception, with all its attendant uncertainties and ambiguities. Cézanne's subject was the landscape of Aix-en-Provence that he had known since childhood and painted over and over again, varying elements, sometimes only slightly, in his ongoing search to "realize" his motif more perfectly. Johns used one of his "things the mind already knows" as the basis for his own kind of landscape motif, drawn from the realm of common cultural artifacts. Each version uses the same preformed, enduring design of the map of the United States. Yet each Map has details that distinguish it, ranging from the lettering used as labels, to the medium, color, brushwork, and scale. The artists' similar use of brushstrokes is evident when examining their works side by side: For both Cézanne and Johns brushstrokes exist on the surface as independent elements that construct, activate, and unify the picture space. For Cézanne each stroke simultaneously constructs forms in space and affirms the canvas surface. For Johns the surface is a given, and any suggestion of spatial layering is countered by the use of flat objects and signs. For the two artists the lively paint handling and rich array of spectral colors are features that draw viewers in and sustain intensive and prolonged scrutiny. This is true even in their monochromatic works — Cézanne's blues and Johns's grays — where additional colors emerge.

One of the most influential aspects of Cézanne's art is the way it reveals visual perception as a process that occurs over time and from various viewpoints. In 1952 Meyer Schapiro wrote that Cézanne created a world "put together piecemeal from successive perceptions, rather than offered complete to the eye in one coordinating glance as in the ready-made geometrical perspective of Renaissance art."[9] Johns referred to this

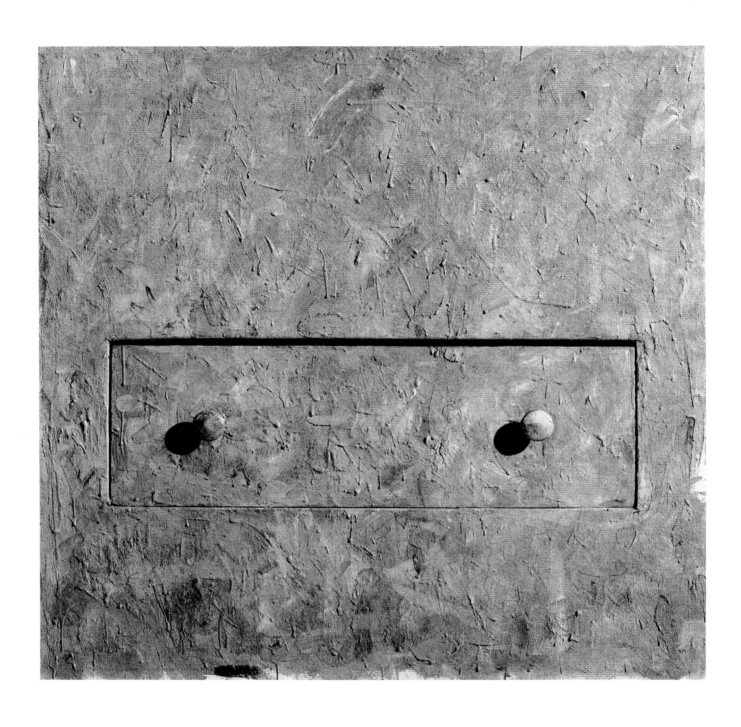

Jasper Johns

Drawer, 1957

Encaustic on canvas with objects
30½ x 30½ inches (77.5 x 77.5 cm)
Rose Art Museum, Brandeis University, Waltham,
Massachusetts. Gevirtz-Mnuchin Purchase Fund

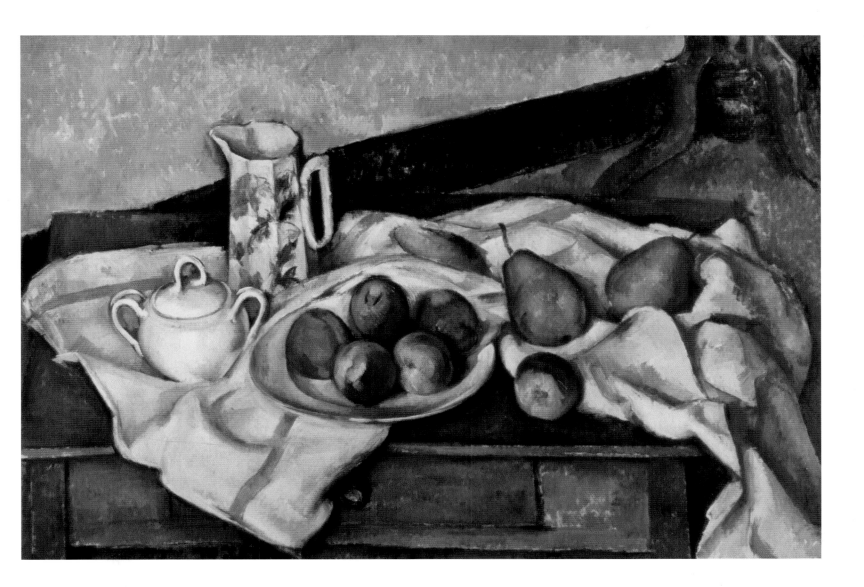

Fig. 17.2. **Paul Cézanne, *Still Life,*** c. 1890. Oil on canvas, 24 x 35½ inches (61 x 90.2 cm). Pushkin Museum of Fine Arts, Moscow

Cézanne-inspired idea as "the rotating point of view" in a statement from 1959, where he also articulated a key idea about his own work (one that Cézanne might have made about his): "At every point in nature there is something to see. My work contains similar possibilities for the changing focus of the eye."[10] Johns has affirmed the continued importance of this concept in other statements and interviews. When asked about the mood he wished to convey in his paintings, Johns replied, "My preference would be the mood of keeping your eyes open and looking, without any focusing, without any constricted viewpoint."[11] Cézanne looked to nature to record how the eye sees and the mind understands the world. Johns, who uses preformed images, relies on his experience of looking to bring the dynamics of vision that he so admires in Cézanne's art into his own.

In his early works Johns zeroed in on the issue of the integrity of the picture plane and the nature of the art object. These have remained ongoing preoccupations in his art, ones he surely recognizes as central to Cézanne's as well. The two artists address the paradox inherent in representing the world on the flat surface of the canvas. Johns paints a flag and wants you to see it as both a flag and a painting and, thereby, something indefinably in between. Cézanne wanted viewers to see his apples in a similar way. Johns's *Drawer* (1957; plate 175) suggests that what is *in* a picture must be as real as the painting itself. The work alludes to table drawers used in still lifes to mediate between the space of the observer and the fictional depicted space in the canvas. In Cézanne's still lifes, drawers function as one of many elements contributing to the tension between surface and depth (fig. 17.2; see also plate 90). The prominent table drawer in Cézanne's *The Card Players* (1890–92; see plate 210) is a particularly relevant

precedent for Johns's painting because its centered prominence within the composition calls attention to the flatness of the picture plane.[12]

Even when there appear to be no obvious motifs in common, one can see things in each artist's work that help us better understand both. In *Painting with Two Balls* (1960; plate 188), Johns reveals the painting's three-dimensional construction by prying apart the canvas to reveal the wall on which it hangs. In *Apples and Biscuits* (1885–90; plate 189), Cézanne orchestrates the three planes—the commode's front panel with its protruding hardware, the surface on which the still-life objects rest, and the wall behind it—to suggest rectangular layers of equal size, arranged one atop the other like Johns's canvas panels in *Painting with Two Balls*. The weighty forms of Cézanne's apples serve a function similar to Johns's wooden spheres by carving out and anchoring space within the painting. In later work, when Johns incorporates a shallow illusionist space, he continues to address the reality of the picture plane in ways that recall Cézanne's works. *In the Studio* (1982; plate 192) shows a blank canvas leaning against a studio wall and drawings attached with trompe l'oeil nails. Sculptural objects—a wax arm suspended from a hook and a hinged wooden slat—contradict the illusionism of the depicted objects by projecting into the space in front of the canvas. In Cézanne's *Still Life with Plaster Cupid* (1894–95; see plate 120), the tilt of the tabletop and floor toward the picture plane, the use of pictures within pictures, and the contrast of sculpture and painting are among the elements that add to the complexity of how we read the levels of illusion and reality.

The human figure is another area of interest shared by Cézanne and Johns. Scholars initially saw the figure as a secondary element for both artists, but it is now understood to be integral and closely entwined with the rest of their work. Cézanne and Johns embed within their figures psychological, emotional, and erotic content, often around themes of mortality. Following in the tradition of the disjointed anatomy of Cézanne's Bathers and their twentieth-century progeny, particularly the Cubists and Surrealists, Johns's figures are almost always in the form of fragments. In keeping with his anti-illusionist position, however, Johns's images are not representations but rather are always taken directly from the body itself as imprints, casts, shadows, tracings, or photographs. Many of Johns's figure fragments or traces of figures suggest a connection with Cézanne's solitary male Bathers through their similar projection of emotional vulnerability and psychological tension. But like Cézanne's figures, they elicit various interpretations, whether seen as universal types or as projections of the artist himself. Schapiro, who was one of the first to bring a psychoanalytical approach to understanding Cézanne's works, wrote that in *The Bather* (c. 1885; fig. 17.3) there is "a complex quality of feeling, not easy to describe." It is a figure, he went on to say, that projects "the drama of the self, the antagonism of the passions and the contemplative mind, of activity and the isolated passive self."[13] Johns named Cézanne's *Bather* among the works of modern art that have been most important to him, and described the painting as having "a synesthetic quality that gives it great sensuality—it makes looking equivalent to touching."[14]

Johns also has said that in the 1960s he thought of copying *The Bather* in gray, but could not find a satisfactory way to do it, since he did not want to work directly from the painting in the Museum of Modern Art, nor could he find a reproduction large enough to realize his idea.[15] Instead, Johns may have been inspired by Cézanne's painting to conceive his own expressive figures, most notably that of the diver.[16] In the painting and the drawing of that title from 1962, Johns used footprints and handprints to indicate a figure making a swan dive off a diving board. The diver may also be

understood metaphorically as taking a plunge into unknown waters—or a suicidal leap—contributing to the mood of emotional turmoil that surfaces in Johns's art during this period. The diver's extended arms echo those of Cézanne's *Bather with Outstretched Arms*, whose enigmatic gesture has led to interpreting the figure as preparing to dive into the water or as deeply absorbed in a private erotic fantasy.[17] The "outstretched arm" is found in several of Johns's works that immediately follow *Diver*, most notably *Periscope (Hart Crane)* and *Land's End*, both from 1963, and is taken up again as a recurring motif in later works.

In each of the four paintings in his series of the Seasons (1985–86; *Spring*, plate 190; *Summer*, fig. 17.4; and *Fall*, plate 174), a large gray figure traced from a template of the artist's shadow appears in different locations. The shadow may stand for "everyman" in general, or the artist in particular, as he weathers the inevitable changes of the seasons and the cycle of life. While not the copy that Johns once thought he would make of Cézanne's *Bather*, the gray shadow alludes to that figure's continued importance as a touchstone in his art. The "outstretched arm" adjacent to the shadow appears to trace a circular path and, like the hand of a clock, marks the passage of time from spring to winter and childhood to old age. Johns appropriated details for the Seasons from Pablo Picasso's *Minotaur Moving His House* of 1936 and *The Shadow* of 1953, autobiographical images that deal with transitions in the artist's life. In Johns's paintings direct references abound to the works of other artistic predecessors as well, most obviously Leonardo and Duchamp. Cézanne's presence throughout the series is less overt, but in some ways more profound than that represented by directly appropriated imagery. All four Seasons paintings resonate with the contemplative atmosphere and psychic unease of Cézanne's solitary male bathers. In addition, Johns has said that the geometric figures, standing for the fundamental building blocks of artistic structure and originally inspired by a Japanese brush painting, reminded him of Cézanne's advice to "treat nature by the cylinder, the sphere, the cone."[18]

While Cézanne's single male Bathers are frequently alluded to in Johns's art, explicit references have only occurred in his tracings of Cézanne's groups of female Bathers. His first was a tracing made in 1977 of *The Large Bathers* (1894–1905; see plate 203). Johns had seen the painting that year in an exhibition of Cézanne's late work at the Museum of Modern Art, and he traced the image from a postcard, possibly in response to the thick outlining Cézanne used in his composition. This was the first tracing Johns made from another artist's work, a process he would come to use extensively in the 1980s and 1990s as a means to incorporate images from art history into his own work. In 1989 Johns had traveled to see the first comprehensive exhibition of Cézanne's Bathers, held at the Kunstmuseum in Basel. This exhibition provided the opportunity to study Cézanne's use and transformation of the motifs of the Bathers over the length of his career. By then Johns had already started collecting Cézanne's works, two of which were included in that show (plate 191; fig. 17.5). In 1994 Johns made six large tracings after another of Cézanne's three monumental late Bathers (fig. 17.6). He traced the images in ink on plastic from a poster for an exhibition of French paintings from the Barnes Foundation that he had seen in 1993 at the National Gallery of Art in Washington, DC.

By the time Johns made the *Tracings after Cézanne* (plates 176–81; fig. 17.7), he had traced works by Duchamp, Hans Holbein, and most extensively Grünewald, to examine how "forms can shift their meaning" in new contexts.[19] Explaining why he traced details of reproductions from Grünewald's Isenheim Altarpiece, Johns said, "I felt there was some aspect that seemed to be 'underneath' the meaning—you could call it composition—and I wanted to trace this, and get rid of the subject matter, and find

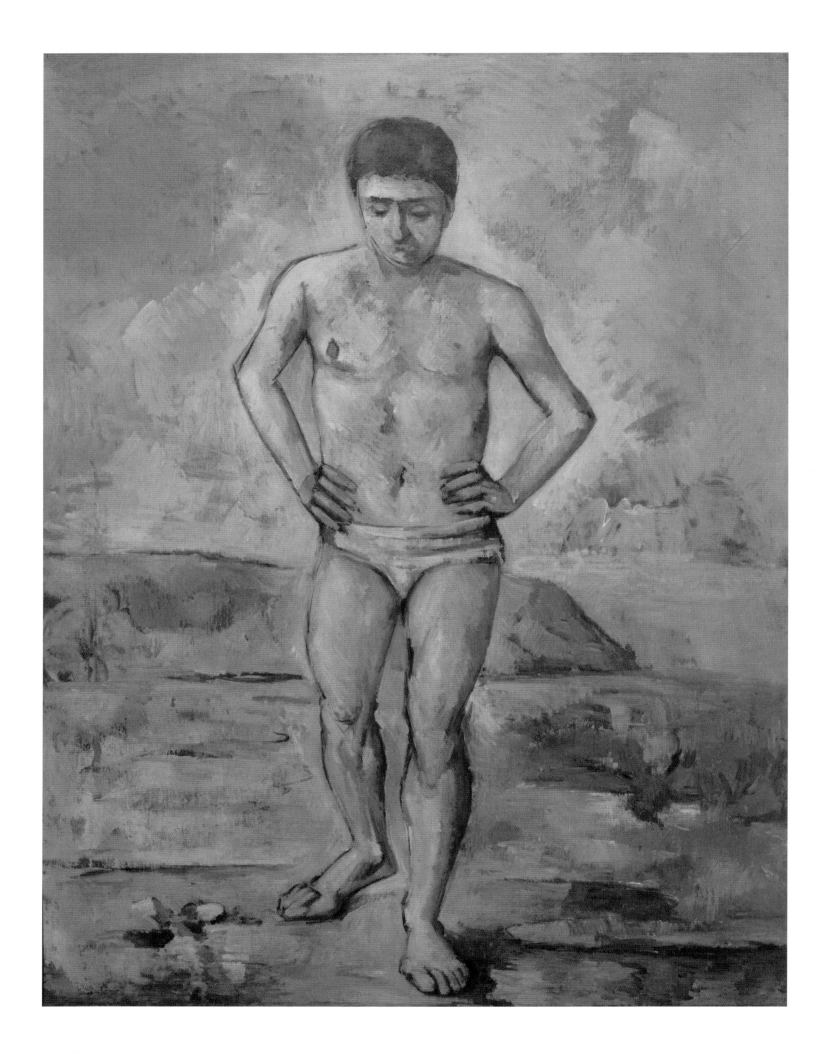

Fig 17.3. **Paul Cézanne**, *The Bather*, c. 1885. Oil on canvas, 50 x 38⅛ inches (127 x 96.8 cm). The Museum of Modern Art, New York. Lillie P. Bliss Collection, 1934

Fig. 17.4. **Jasper Johns**, *Summer*, 1985. Oil on canvas, 75 x 50 inches (190.5 x 127 cm). The Museum of Modern Art, New York

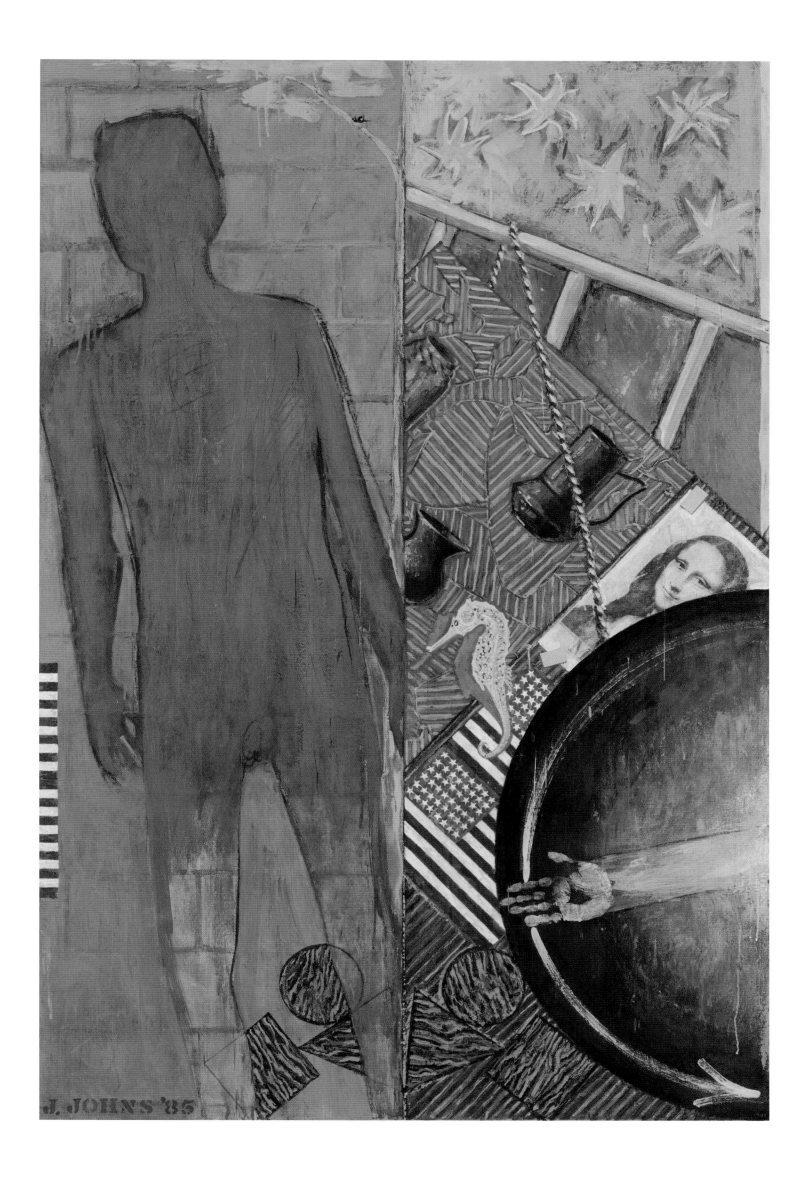

J. JOHNS '85

Fig. 17.5

Fig. 17.5. **Paul Cézanne, *Two Studies of Bathers*,** c. 1877–80. Graphite and ink on paper, 4¾ x 7¹¹⁄₁₆ inches (12.1 x 19.55 cm). Collection of Jasper Johns

Fig. 17.6. **Paul Cézanne, *Large Bathers*,** c. 1895–1906. Oil on canvas, 52⅛ x 81½ inches (132.4 x 207 cm). The Barnes Foundation, Merion, Pennsylvania

Fig. 17.7. **Jasper Johns, *Tracing*,** 1977. Ink on plastic, 10⅞ x 13 inches (27.6 x 33 cm). Collection of David and Lindsay Shapiro, Riverdale, New York

out what it was."[20] In his six Cézanne tracings, however, this process is used in such a way that, even in the most abstract of them, the subject matter remains obvious and central. Johns has said that in the course of tracing Cézanne's painting, he began to see the figure leaning against a tree as "dreaming" and "fantasizing" the other Bathers.[21] As he traced the image he transformed this sexually ambiguous female nude into a sexually aroused male. Around the same time Johns made his *Tracings*, art historian T. J. Clark independently interpreted the Barnes painting in similar terms. In his 1995 article, "Freud's Cézanne," Clark examined the painting as "a staging of some ultimate sexual material" and called the "insecurely sexed" Bather leaning against the tree a "dreaming figure."[22] By the time Clark revised the article for publication in a book, a few years later, he had seen Johns's *Tracings after Cézanne* and acknowledged that Johns had "noticed the line of shadowy blue going up from the crotch, and made it unmistakably a penis."[23] Like Clark's, Johns's creative rereading of Cézanne's picture suggests that the "dreaming" figure is a projection of the artist, set apart from the group and absorbed in erotic fantasy.

For Mary Louise Krumrine, curator of the 1989 Bathers exhibition at the Museum of Fine Arts Basel, the primary issue in all of Cézanne's final Large Bathers is "the sexual identity of the artist, of both the male and female characteristics in his nature."[24] Whether such thoughts were consciously or unconsciously in Cézanne's mind as he worked on these pictures, or what Johns's thoughts were in tracing them, we can only speculate. Both Cézanne and Johns maintain a personal reserve, even while dealing with the emotively charged topics of sexuality and death. Both artists first want to engage us in the structure and surface of their compositions, and from these elements to elicit responses that remain as dynamic and uncertain as the process of perception itself.

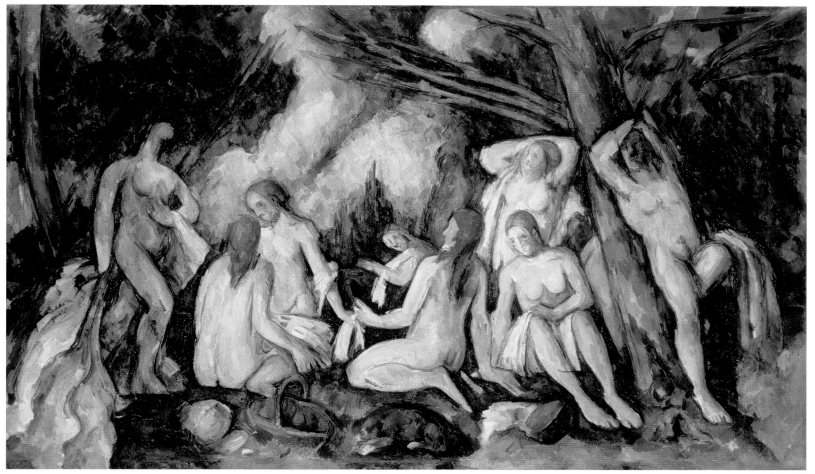

Fig. 17.6

Fig. 17.7

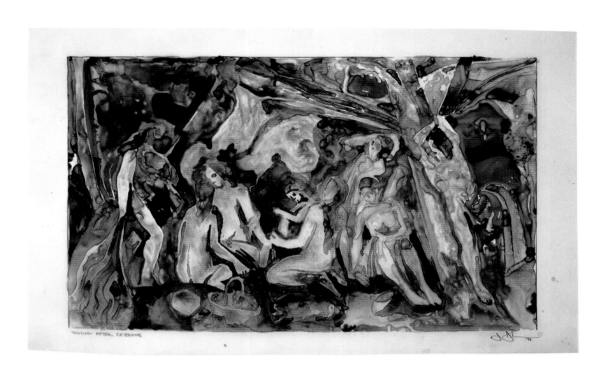

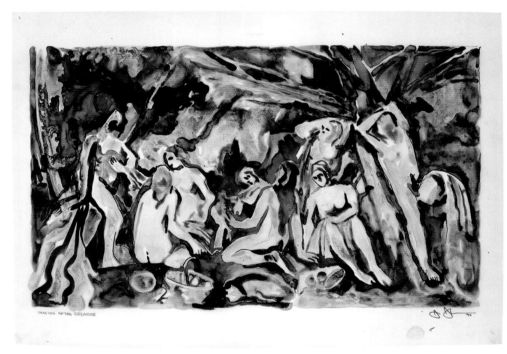

PLATE 176

Jasper Johns

Tracing after Cézanne, 1994

Ink on plastic
18¾ x 30⅜ inches (47.6 x 77.2 cm)
Collection of the artist

PLATE 177

Jasper Johns

Tracing after Cézanne, 1994

Ink on plastic
20¹⁄₁₆ x 28 inches (51 x 71.1 cm)
Collection of the artist

PLATE 178

Jasper Johns

Tracing after Cézanne, 1994

Ink on plastic
18⅛ x 28⅜ inches (46 x 72.1 cm)
Collection of the artist

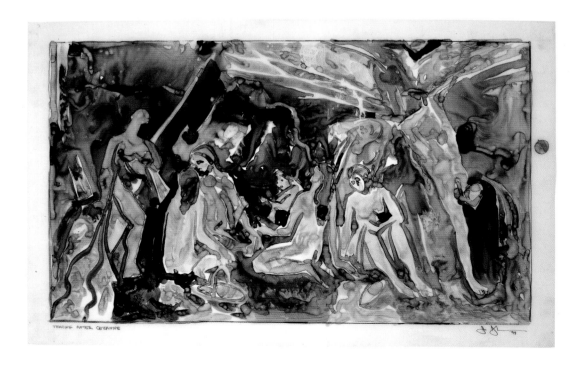

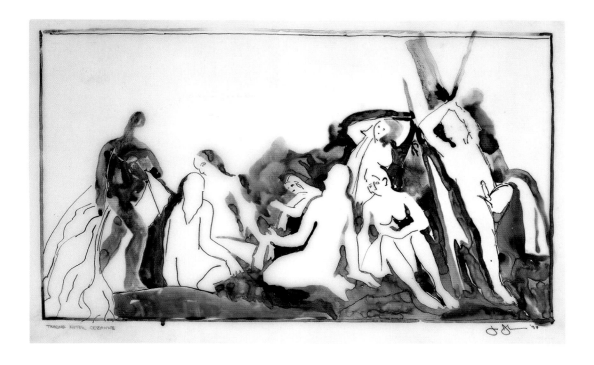

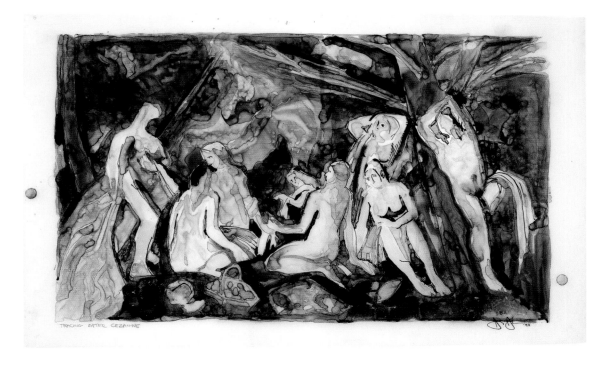

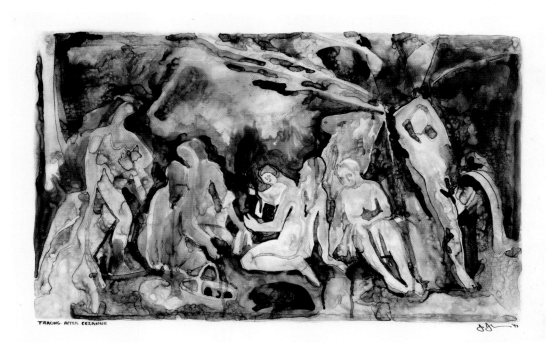

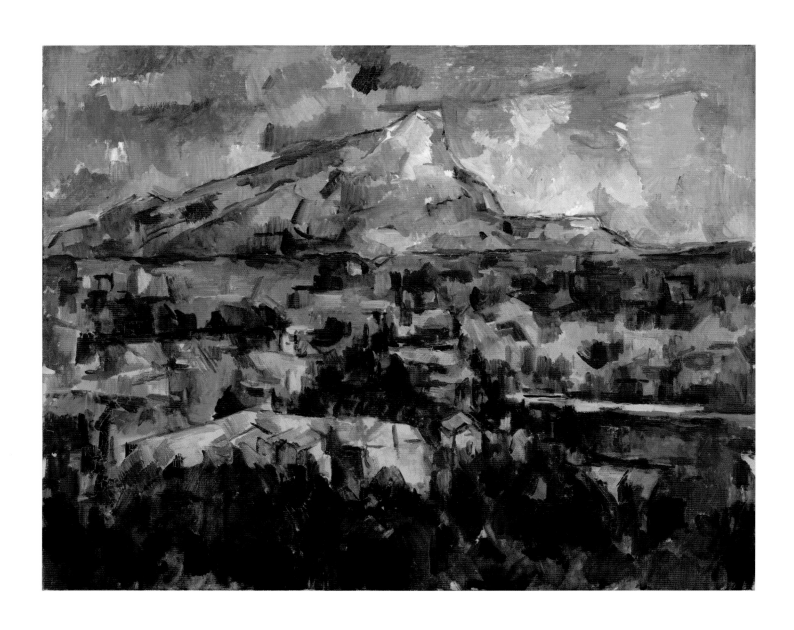

PLATE 182

Paul Cézanne

Mont Sainte-Victoire, 1902–4

Oil on canvas
27½ x 35¼ inches (69.9 x 89.5 cm)
Philadelphia Museum of Art. The George W. Elkins
Collection, E1936-1-1

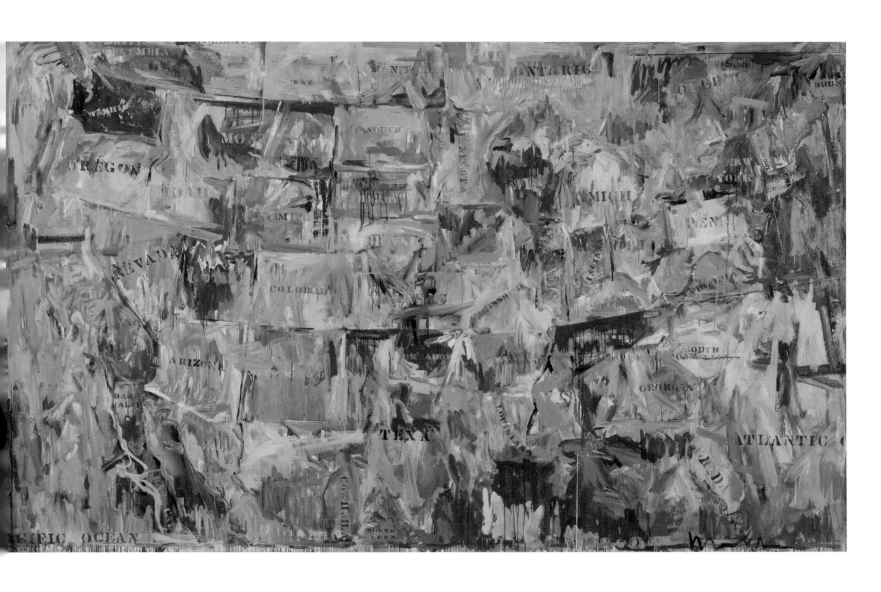

PLATE 183

Jasper Johns

Map, 1961

Oil on canvas
78 x 123⅛ inches (198.1 x 312.7 cm)
The Museum of Modern Art, New York. Gift of Mr.
and Mrs. Robert C. Scull

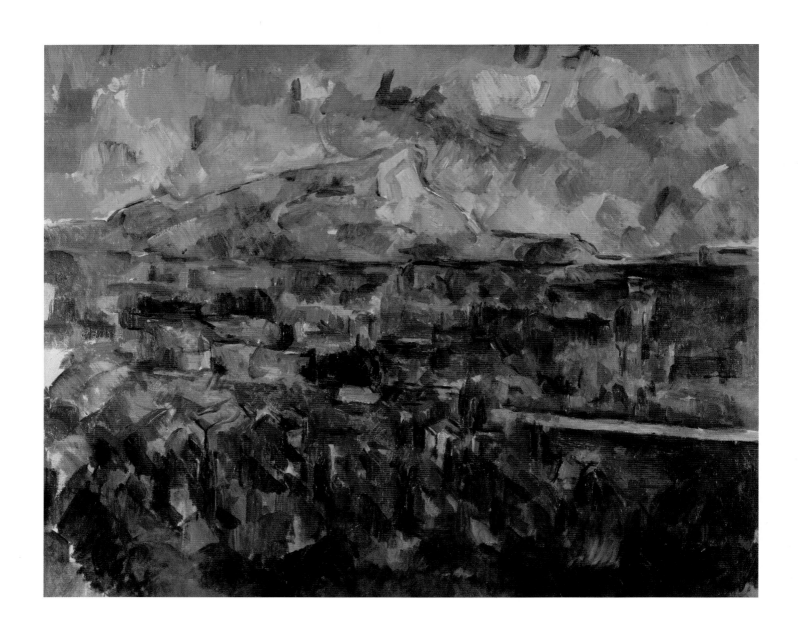

PLATE 184

Paul Cézanne

Mont Sainte-Victoire Seen from Les Lauves, 1902–6

Oil on canvas
25½ x 32 inches (64.8 x 81.3 cm)
Private collection

PLATE 185

Jasper Johns

Map, 1963

Encaustic and collage on canvas
60 x 93 inches (152.4 x 236.2 cm)
Private collection

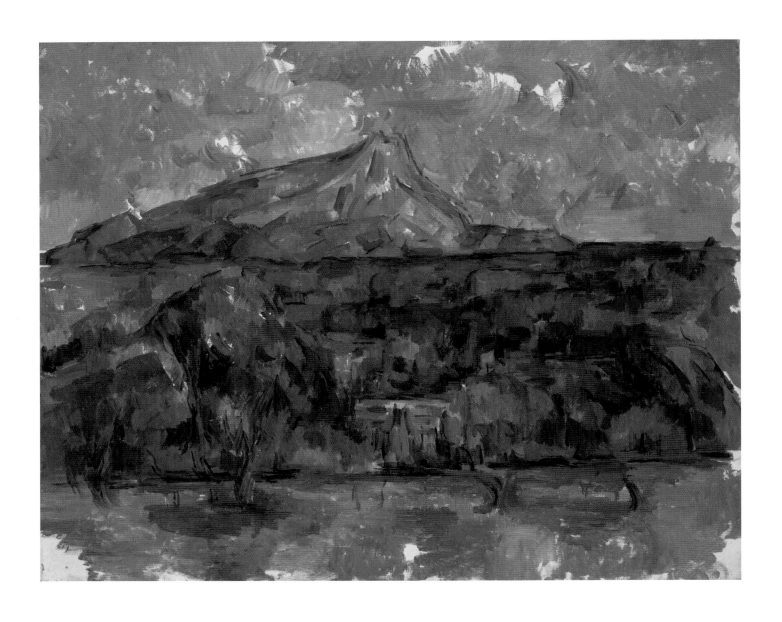

PLATE 186

Paul Cézanne

Mont Sainte-Victoire Seen from Les Lauves, **1902–6**

Oil on canvas
25⅛ x 32⅛ inches (63.8 x 81.6 cm)
The Nelson-Atkins Museum of Art, Kansas City.
Purchase Nelson Trust, 38-6

PLATE 187

Jasper Johns

Map, 1962

Encaustic and collage on canvas
60 x 93 inches (152.4 x 236.2 cm)
The Museum of Contemporary Art, Los Angeles. Gift
of Marcia Simon Weisman

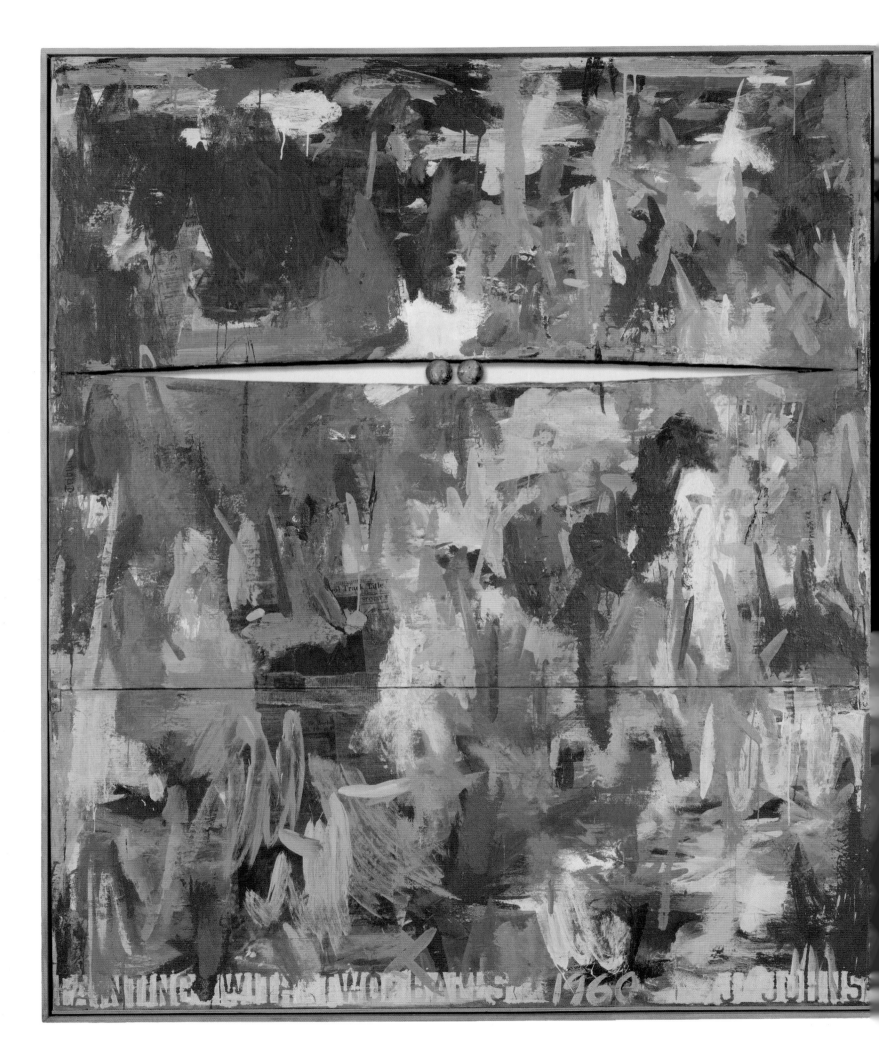

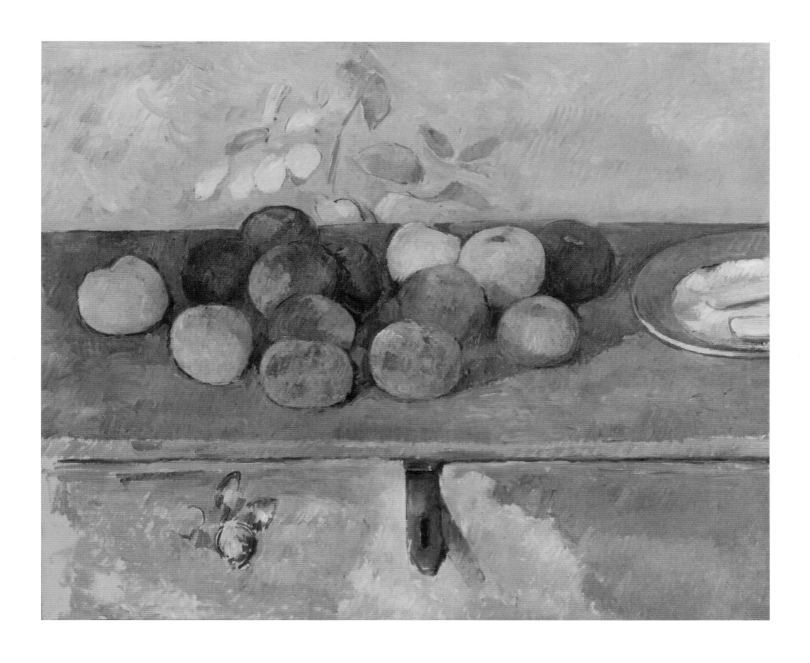

PLATE 188

Jasper Johns

Painting with Two Balls, **1960**

Encaustic and collage on canvas with objects
66 x 54 inches (167.6 x 137.2 cm)
Collection of the artist, on loan to the Philadelphia
Museum of Art

PLATE 189

Paul Cézanne

Apples and Biscuits, **1885–90**

Oil on canvas
18⅛ x 21⅝ inches (46 x 54.9 cm)
Musée National de l'Orangerie, Paris. Jean Walter and
Paul Guillaume Collection (R.F. 1960-11)

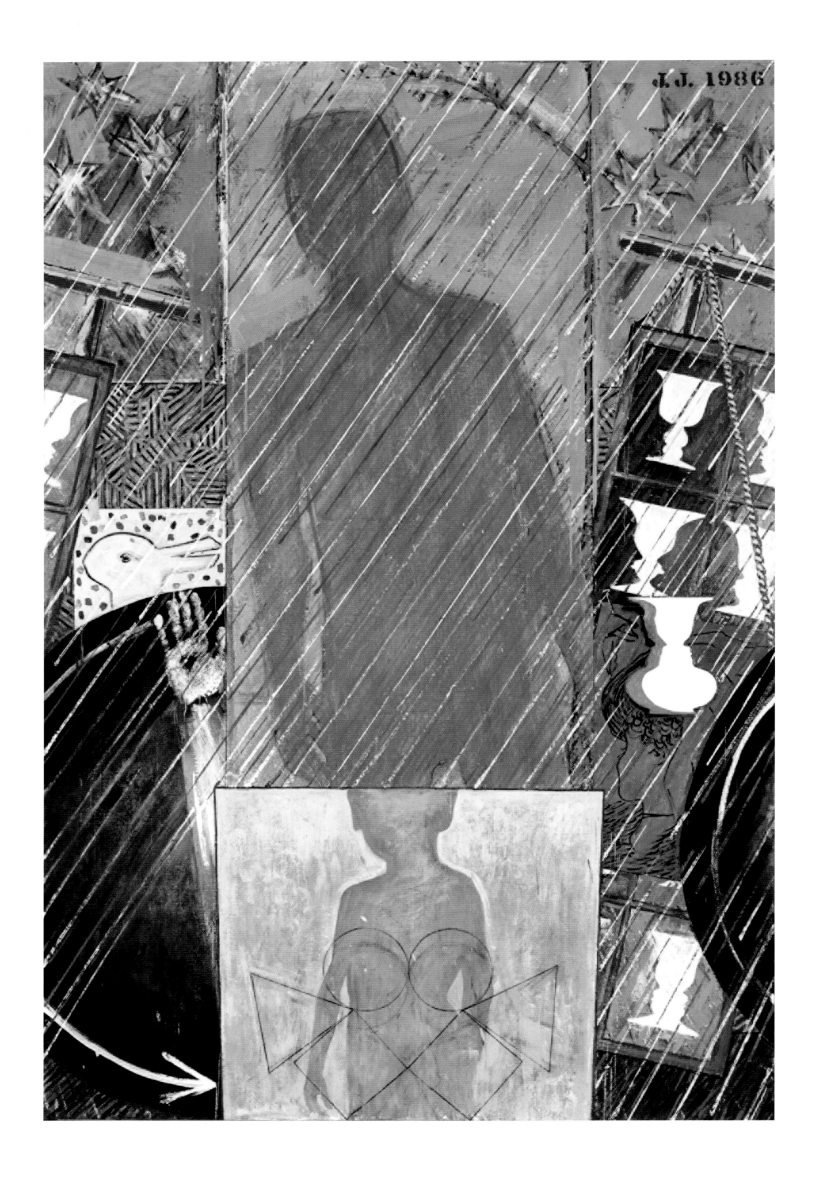

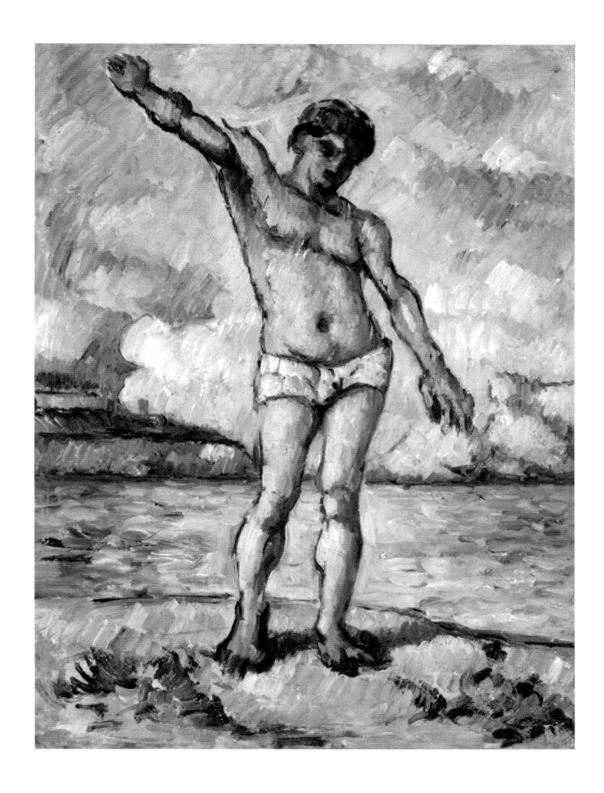

PLATE 190

Jasper Johns

Spring, 1986

Encaustic on canvas
75 x 50 inches (190.5 x 127 cm)
Collection of Mr. Robert Meyerhoff, Phoenix,
Maryland

PLATE 191

Paul Cézanne

Bather with Outstretched Arms, 1883

Oil on canvas
13 x 9⁷⁄₁₆ inches (33 x 24 cm)
Collection of Jasper Johns

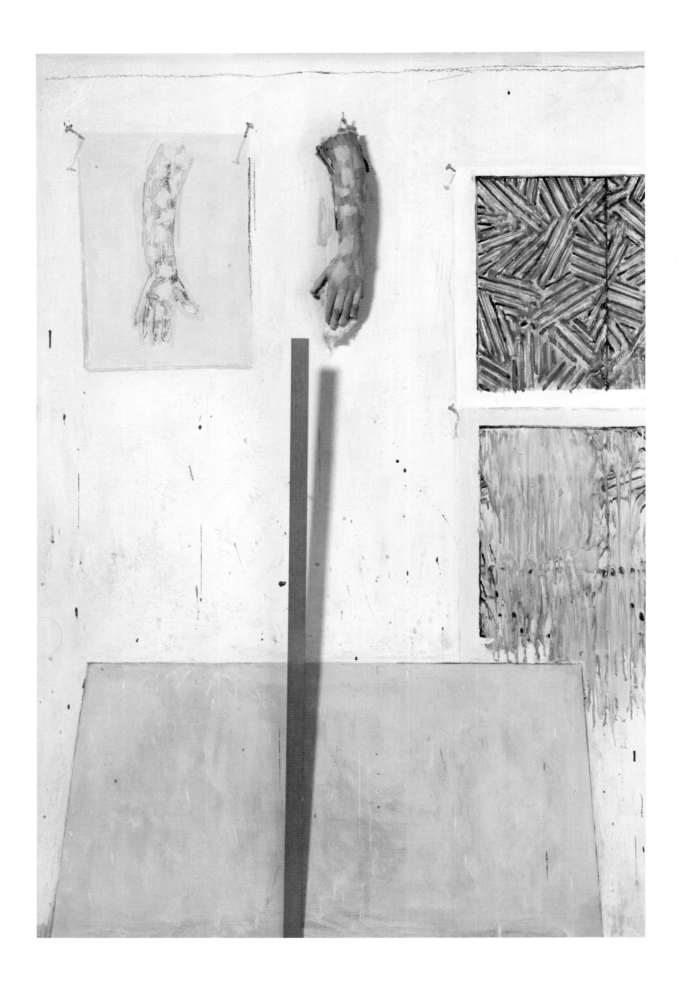

PLATE 192

Jasper Johns

In the Studio, 1982

Encaustic and collage on canvas with objects
72 x 48 inches (182.9 x 121.9 cm)
Collection of the artist, on loan to the Philadelphia
Museum of Art

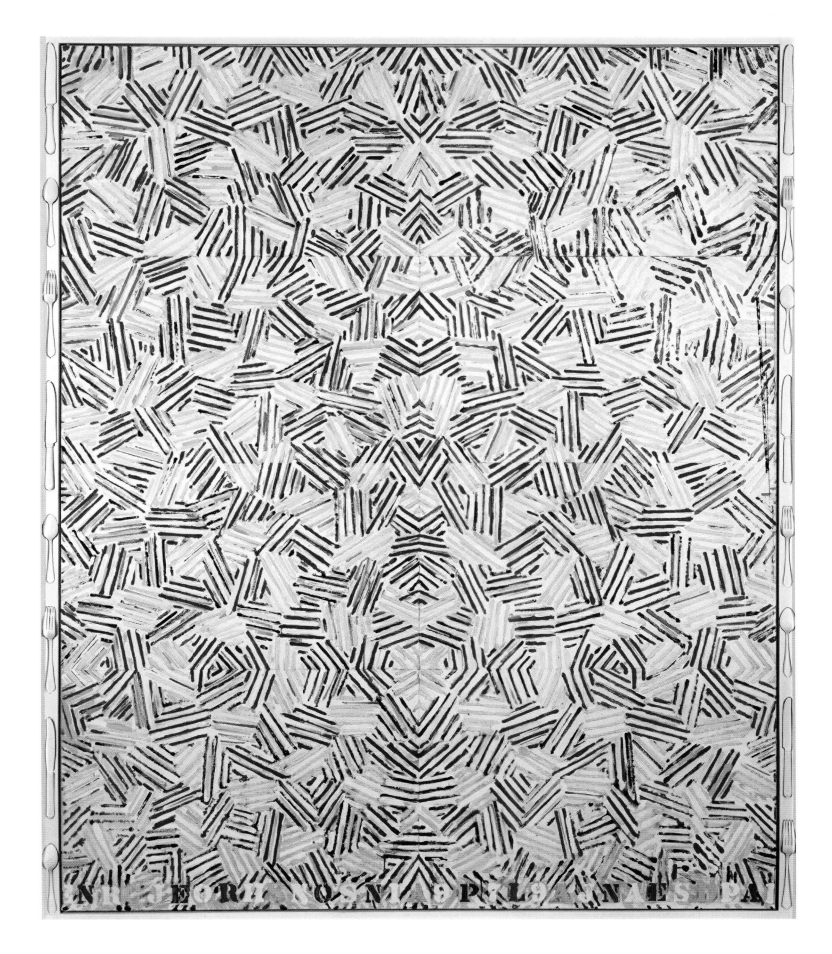

PLATE 193

Jasper Johns

Dancers on a Plane, 1979

Oil on canvas with objects
77⅞ x 64 inches (197.8 x 162.6)
Collection of the artist

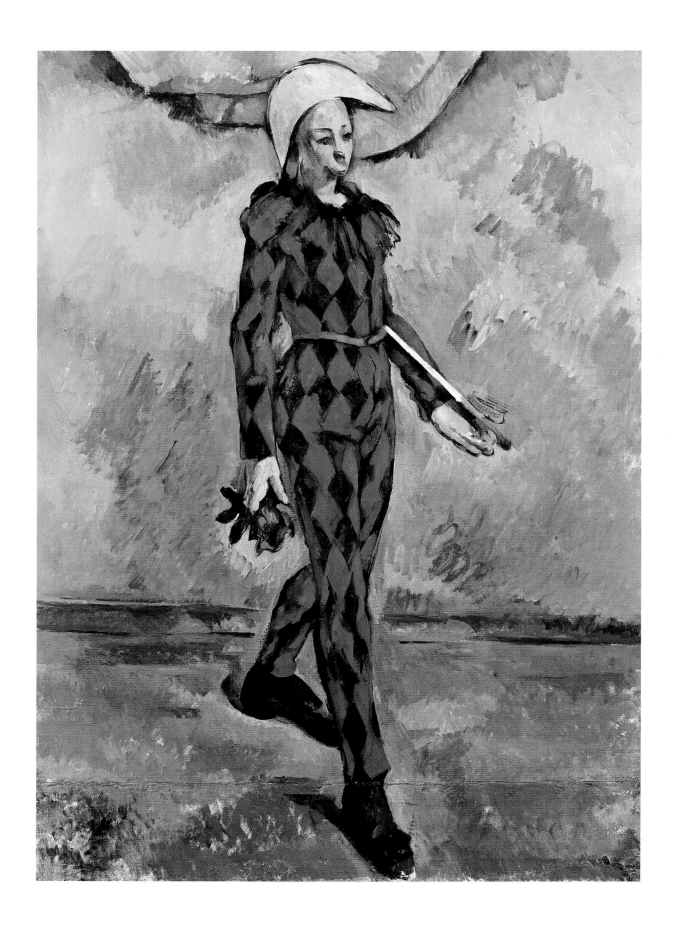

PLATE 194

Paul Cézanne

Harlequin, 1888–90

Oil on canvas
24⁷⁄₁₆ x 18⅛ inches (62 x 46 cm)
Private collection

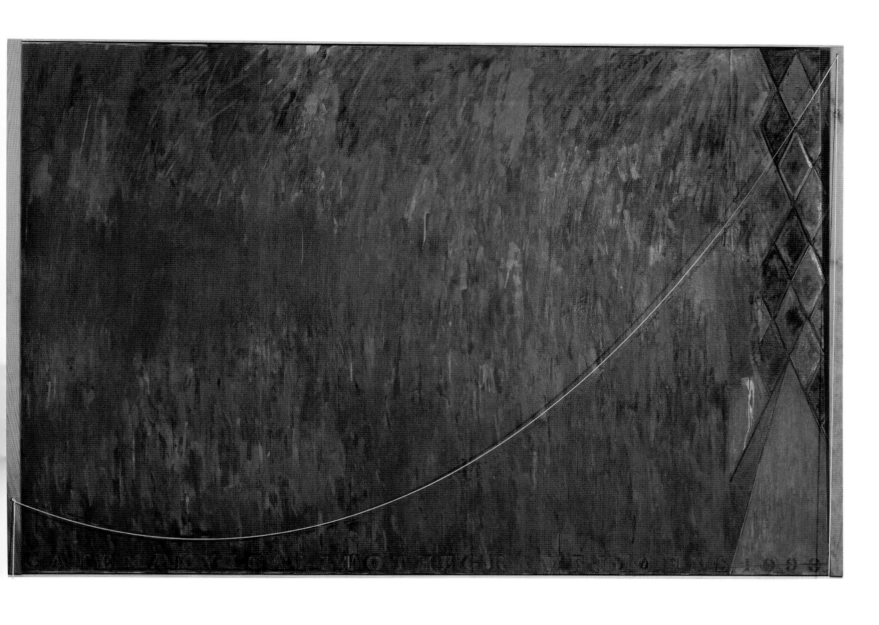

PLATE 195

Jasper Johns

Catenary (I Call to the Grave), 1998

Encaustic on canvas with wood and string
78 x 118 x 8 inches (198.1 x 299.7 x 20.3 cm)
Philadelphia Museum of Art. Purchased with funds
contributed by Gisela and Dennis Alter, Keith L. and
Katherine Sachs, Frances and Bayard Storey, The
Dietrich Foundation, Marguerite and Gerry Lenfest,
Mr. and Mrs. Brook Lenfest, Marsha and Jeffrey
Perelman, Jane and Leonard Korman, Mr. and Mrs.
Berton E. Korman, Mr. and Mrs. William T. Vogt, Dr.
and Mrs. Paul Richardson, Mr. and Mrs. George M.
Ross, Ella B. Schaap, Eileen and Stephen Matchett,
and other donors in honor of the 125th Anniversary of
the Museum, 2001-91-1

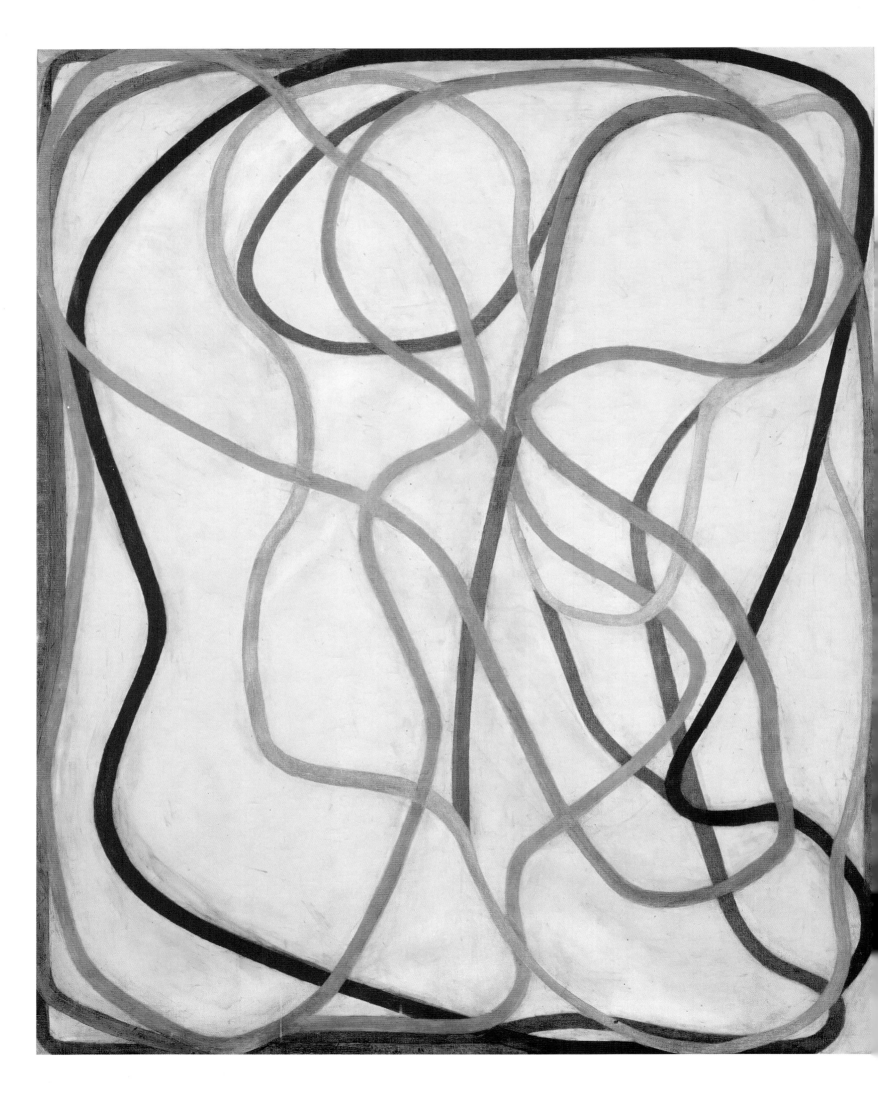

Cézanne and Marden: The Almost Perfect Painting

Katherine Sachs

In an interview in 2008, the American painter Brice Marden (born 1938), reflecting on his deep respect for Paul Cézanne, said: "Cézanne almost made the perfect painting. And the perfect painting would be the painting which makes it so no other painting would have to be made."[1] At the end of his life, however, Cézanne himself wondered whether he would ever realize his artistic desires. In 1906 he wrote to fellow painter Émile Bernard: "Will I ever attain the end for which I have striven so much and so long?"[2] In terms of his own work, Marden feels that "the whole thing about making a painting is that the next painting is supposed to be a better painting."[3] More generally, he said that "one of the most compelling aspects of modernism is its commitment to constant striving, to improve on what was there before."[4] For both painters the artistic process is a journey—there is no "getting there"; as Marden says: "Each work is part of a continuing quest. To be an artist is to do your work, and let your work express the evolution of a vision."[5]

Marden's admiration for Cézanne is made obvious by the announcement for his second one-man exhibition at the Bykert Gallery in New York in 1970, which shows the young artist sitting on the base of a commemorative monument to Cézanne by the French sculptor Aristide Maillol (fig. 18.1). The base had been separated from the statue during its move from the Tuileries to the Louvre, and Marden took the opportunity to have his photograph taken atop the inscription "À Paul Cézanne."

His lifelong engagement with Cézanne is not filtered through Pablo Picasso or Henri Matisse—although they, along with Jackson Pollock and other artists, Western and Eastern, have played an important role in the evolution of his work. To hear Marden talk about Cézanne's impact on his own paintings is to sense the direct connection he feels with the French artist. He has kept postcards of Cézanne's paintings in his studio for decades, and phrases invoking Cézanne's name and places identified with him appear often in Marden's notebooks. Cézanne's focus on the painting's support (its

PLATE 196

Brice Marden
American, born 1938

Skull with Thought, **1993–95**

Oil on linen
70⅞ x 57 inches (180 x 144.8 cm)
Private collection

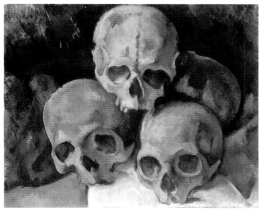

Paul Cézanne, *Pyramid of Skulls,* c. 1898
(plate 114, p. 325)

Fig. 18.1. Announcement for Brice Marden's second solo show at Bykert Gallery, New York, October 31–November 26, 1970. Courtesy of Matthew Marks Gallery, New York

two-dimensionality, or, in Marden's words, "the plane"), the intensity of his colors, and the overall harmony he achieved through a balance of paint (method) and form (motif) have strongly influenced Marden.

Marden recalls the first time he saw a painting by Cézanne, in his high school library in Briarcliff Manor, New York: "I had volunteered to clean the bookshelves and I found this book on Cézanne and opened it up and there was the *Bathers*, and I had no idea what this could possibly be. I remember being totally fascinated with it and stunned by it. . . . It is one of those things you see that just becomes a problem. It was very interesting. It is one of *the* most complex, weird paintings I have ever seen and I can never deconstruct it; I get it and I still just don't get it."[6]

Many years later, in 2000, Marden began a series of paintings called Red Rocks based on the proportions of that very same *Large Bathers* (plates 203, 204), during which time he kept a postcard of Cézanne's painting in his studio.[7] In the exhibition catalogue that accompanied the first showing of these works, Jean Pierre Criqui interprets the entangled colored lines of the Red Rocks paintings as an enigma or riddle.[8] That description applies as well to Marden's initial encounter with Cézanne's painting—an intrigue which seems, in this series, to have literally come to the surface in its interwoven painted lines. The fact that the title of his recent and very ambitious series of paintings, *The Propitious Garden of Plane Image* (fig. 18.2), is derived from a phrase he wrote on a drawing made during the preparatory phase for the Red Rocks series[9] brings us full circle from Marden's first experience with Cézanne in that high school library to the present day.

"Cézanne Plane"

In 1972 or 1973, Marden wrote the words "Cézanne Plane" on a page in his *Suicide Notes*, published in 1974.[10] *Suicide Notes* is a workbook of seventy pages, each containing a drawing of a rectangle with varying densities of line ranging from simple outlines to ones that are completely and energetically filled in (fig. 18.3). Sometimes these are compartmentalized into smaller rectangles, in what appears to be a concerted attempt to create form through drawing on a two-dimensional surface. According to Dieter Schwarz, "The so-called Cézanne plane . . . is in fact a construction within which the

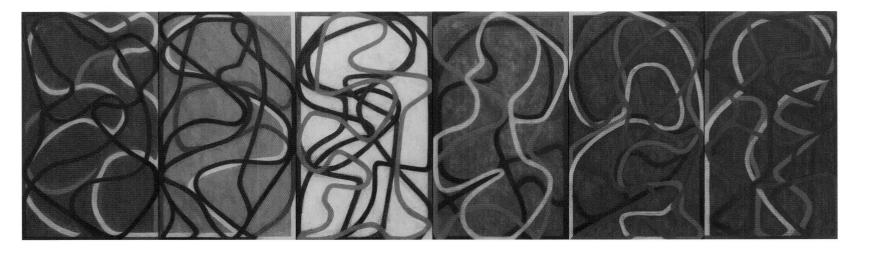

Fig. 18.2. **Brice Marden, *The Propitious Garden of Plane Image, First Version,*** 2000–2005. Oil on linen; six panels, each: 42 x 24 inches (106.7 x 61 cm); overall: 42 x 144 inches (106.7 x 365.8 cm). Private collection

clusters of lines form passages, meaning transitions from one subplane to another which always refers to the picture plane as a whole."[11] On the same page on which he wrote "Cézanne Plane," Marden also wrote phrases such as "search for form" and "the form of the plane"; at the bottom of the page he added, "explaining to myself what I have been doing—formal search for the romantic."[12] His fascination with rectangles started earlier; as a student at Yale, he said: "I'd work on these abstract drawings and I . . . noticed this tightening process that I'd started . . . that the things that kept recurring in paintings were rectangles."[13] These rectangles would become both the object and the subject of his work. For Marden, "The rectangle was the beginning of the separation from nature . . . an abstraction."[14] This awareness of and respect for the rectangular shape of painting had been passed down from Cézanne.[15]

Despite this relatively restricted form, Marden's work contains a very strong emotional content, which has been an important element in his work from the very beginning, as revealed in his Yale student thesis of 1963: "The paintings are made in a highly subjective state within Spartan limitations. Within these strict confines, confines which I have painted myself into and intend to explore with no regrets, I try to give the viewer something to which he will react subjectively. I believe these are highly emotional paintings not to be admired for any technical or intellectual reason but to be felt."[16] Cézanne also believed very deeply in the emotional nature of his own work. He said: "I believe in the logical development of what we see and feel through the study of nature, and concern myself with . . . method[,] being for us but the simple means by which we manage to make the public feel what we ourselves feel and so accept us."[17]

By highlighting the importance of the plane and connecting Cézanne's name to it, Marden acknowledges his debt to Cézanne in this regard, and like the French painter he has gone on to explore the possibilities an artist can bring to the plane without destroying its integrity in the process of creating a painting. His career has been and continues to be an exploration of that "propitious garden of plane image"—a study based on the expression of an optimistic look at the natural world and the creative possibilities inherent in its ultimate revelation on a two-dimensional surface.[18] The picture exists in this space, giving depth to the plane through the painting process. Marden has said: "The thing about painting is you make a mark and any mark you make creates some sort of space, illusion, it becomes part of an image—I wanted the plane to just be the image, so I painted the painting with the idea that color, physicality became the plane and that was also the image."[19] The picture and the paint on it were one and the same.[20]

Marden's early works in the 1960s were mostly single-colored (although that term is misleading, since the final color on the canvas was composed of many layers of paint) panels with an exposed band allowing the drips to suggest the layering process in the

picture's making. This band was at first delineated by a pencil line about one inch from the bottom, was later left vague, and then finally eliminated. Realizing that "color and surface must work together,"[21] Marden used oil and beeswax, which gave the panels a greater degree of materiality, reinforcing the reality of the plane, tightening the color to the surface, uniting the plane and the image. As he told John Yau in 2003, "The whole evolution of modernism is about getting up, up, up to the surface, tightening the surface to the plane."[22]

Marden has described Cézanne's artistic process as an attempt, "not to make [the painting] realistic," but "to realize it, make it real."[23] This idea can be seen as a precedent for Marden's focus on the surface as a way to intensify the integrity of the plane. He identified with Maurice Merleau-Ponty's comment that Cézanne "was pursuing reality without giving up the sensuous surface."[24] To fulfill his own desire to keep the integrity of the surface plane, Cézanne employed many techniques with which we have become quite familiar. In his paintings, the curve of the tree branches often echoes the outline of the distant mountain, and their trunks span the canvas from top to bottom, keeping everything on the surface. If his motif is of a road extending into the distance (see plate 206), we are quickly brought back to the surface through the vividness of the color and the overlapping brushstrokes. Colors in the background are often repeated in the foreground, compressing the space and intensifying the two-dimensionality of the picture plane. In a Cézanne painting, there is almost no atmospheric perspective to suggest depth. Cézanne's objects share their edges with their neighbors, prohibiting us from experiencing any negative space and keeping us on the resulting cohesive surface created by the interlocking relationships of the elements. Marden uses the edge of the entire painting to define, contain, and reinforce the image plane (or plane image).

"Making the Painting Disappear"

The Grove Group series of drawings and paintings, inspired by Marden's many trips to Greece beginning in 1971, was completed in 1973 but first exhibited in its entirety in 1991.[25] The Grove Group notebook, a collection of papers that parallel in time the cre-

Fig. 18.4. Page from Grove Group Notebook reproduced in *Brice Marden: The Grove Group* (New York: Gagosian Gallery, 1991), p. 14

ation of the series, was published the same year. On its pages are many passages that further reveal Marden's inspirational connection to Cézanne. For example, he wrote:

> Cézanne gets the weight
> of the sea in the Louvre
> view from L'Estaque.
> The airy weightyness of it.
>
> do a big sea painting
> dark reflecting bottom
> dark light blue grey top[26]

Grove Group IV (see fig. 3.16) looks just as he envisioned it would in the notebook. It has a dark, reflecting bottom and a light blue-gray top, and the weight of the water is very apparent against the lighter blue of the sky. The relationship between Cézanne's *The Gulf of Marseille Seen from L'Estaque* (see fig. 3.15), which Marden had seen at the Galerie nationale du Jeu de Paume in Paris in 1964, and the Grove Group series is illuminating.[27] By mentioning Cézanne's painting right before the description of his own, Marden reveals how the memory of this painting affected his own realization of his motif. The Grove Group is the physical embodiment of the spirit of Cézanne's L'Estaque. In the notebook (fig. 18.4), Marden goes on to describe the horizontal panels of *Grove Group V* (plate 198) and, later, *Grove Group IV* again:

Horizontal Grove Group

Redo the Grove horizontals with *tree* in mind
 roots in this earth joining to trunk to leaves of sky

leaves
olive & sky

trunk
black brown yellow cold dark

leaves – sky
trunk
earth[28]

In wanting to redo the horizontal Grove Group motif with a tree in mind, Marden was possibly again thinking of Cézanne and the essence of his re-materialization of the motif into a painting through the use of a tightly constructed composition.

Do water

Density through color
 surface
Air and water
Sky and water
Edge between weight and air[29]

These words reveal how, in these paintings, Marden's own motif of sky, air, and water disappears into a dense color surface delineated only by an edge that separates the material (earth) from the immaterial (sky). The painter Francesco Clemente said in 2006: "Marden's work seems to be a search for the essence of things, in his case the essence is color, also expressed by the surface of paintings, surface like the sea—mirror that absorbs everything and gives back everything in terms of light."[30]

Grove—all panels olive grove blue
 green—wide sensuous engulfment.[31]

The term "engulfment" here, perhaps a subconscious allusion to the Gulf of Marseille in Cézanne's painting, could also refer to being overwhelmed (engulfed) in paint, as one is in contemplating these large horiztonal canvases with their sensual surfaces. And the fact is that in Marden's work, as in Cézanne's, these amount to the same thing. As Marden put it, "Well, the point is that a thing takes on its own kind of life; you are making an abstraction of a view of a real situation; how do you transfer, how do you put that on a two dimensional surface?"[32] In this transfer from nature to paint, the real thing becomes the painting; the image that was the inspiration begins to disappear. Marden, in referring to Cézanne's later views of Mont Sainte-Victoire (fig. 18.5), says that Cézanne looked so hard at the mountain that he made it disappear.[33] Even Bernard said of Cézanne: "The more he works, the more his work removes itself from the external view [and] the more he abstracts the picture."[34] Cézanne wanted "to give the image of what we see, forgetting everything that appears in front of us."[35] This was the realization of his sensations that Cézanne struggled so hard to attain, the "Promised Land" he pursued to the very end of his career.[36] His paintings of Mont Sainte-Victoire become paintings of the sensations realized by, in Marden's own terminology, "the force of his looking."[37]

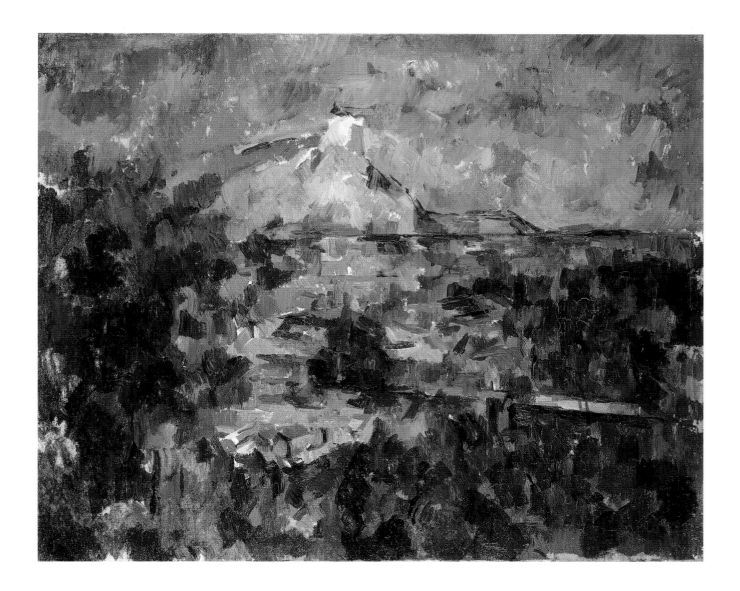

Fig. 18.5. **Paul Cézanne, *Mont Sainte-Victoire Seen from Les Lauves*,** 1902–6. Oil on canvas, 23⅝ x 28⅜ inches (60 x 72 cm). Kunstmuseum Basel

Just as Cézanne's mountain became consumed by the colored fractures of paint, in Marden's Grove Group series, the sea, the sky, and olive trees become opaque color surfaces filled with light. Like Cézanne, Marden made the motif "disappear"; from the natural scene before him, he took "only its energy . . . he did not want to reproduce it."[38] As he said in a 1976 interview: "The whole thing's about nature. You have to make it look like it's a flat painting and it isn't a landscape, at the same time using all this landscape stuff. So you sort of get a triple negation. You've got it, you want it, you've got to get rid of it because it has to reappear in a more intense manner because the painting's abstract."[39] The Grove Group's dynamism comes from the fact that these works are still referential in spite of their purity as objects in their own right. For both artists, the energy of the painting comes from the exposure of the process of its creation; but that spark of energy that grows into a powerful force in the process of its becoming a painting also comes from their strong connections to the places they have called home.

Brice Marden was born in Bronxville, New York. His father was "a mortgage servicer" whose work took him to "all these little towns up the [Hudson] river, and then he'd rave about the river. . . . I had the river drummed into me by my father."[40] After finishing school, in 1963 Marden moved to New York City, which became his home base. In 1971, he first visited the island of Hydra in Greece, to which he would return every summer. In 2002 he acquired a property in Tivoli, New York, near the river that so affected his father. Marden is very responsive to the places he calls home and appreciates the different influences each one has had on his work. This sensitivity is similar to Cézanne's, whose own identification with his native Provence had a powerful impact

Fig. 18.6. **Brice Marden, *Second Window Painting,***
1983. Oil on linen, five panels; 24 x 90 inches (61 x
228.6 cm). Daros Collection, Switzerland. Courtesy of
Matthew Marks Gallery, New York

on his work. Recalling his own trip to Provence, Marden said: "I went to Aix and I saw
Cézanne's studio and I saw Mont Sainte-Victoire. It was simply astonishing, so aston-
ishing. . . . You can *feel* Cézanne's identification with Provence, with his home, his
place, his being. . . . Only a person from Aix could have that kind of identification with
that monument."[41]

For Marden, however, this deep identification with the land is a way of seeing
that can also be experienced in locations beyond one's birthplace. "I get a lot out of
going to Greece because I then can look at Cézanne and see how he identifies . . . with
where he's from and how he can take certain universals and apply them to that specific
situation. When I am in Greece, I absorb what is there, the sitings, the landscape, the
colors, respect for the earth. It is all very real and it enters the work . . . Cézanne was
rooted, and that's in his work."[42]

"Sounding Boards for a Spirit"

In 1978, Marden began work on a commission for the stained glass windows in the
Basel Cathedral. His interest in expressing the spiritual in his art would find a new out-
let in the paintings and drawings related to this project. Using red, yellow, green, and
blue to represent the four elements—respectively, fire, air, earth, and water—Marden's
new paintings were very different in scale and composition from his previous works
(fig. 18.6). Horizontal and vertical planes appeared together, and diagonal lines were
introduced for the first time. The Elements series of the early 1980s, of which *Coda*
(plate 200) was the final work, was inspired by the classical post-and-lintel architecture
of Greece and possibly also by a trip Marden took to Pompeii in 1977. Through these
paintings, along with the experience of the Basel project and the works it engendered,
Marden arrived at a new phase in his work, in which he became more interested in
the translucent nature of his beloved plane, and in which light would become a more
active player.

The seeds of this change can be found earlier in his career. In his "Notes from
1970–71," Marden wrote: "The rectangle, the plane, the structure, the picture are but

sounding boards for a spirit."[43] The dense, multilayered paintings of the 1960s and 1970s would soon become more transparent and drawing and painting would enter into a new relationship in his work. After a trip to the Far East in 1983–84 and a visit to the *Masters of Japanese Calligraphy* exhibition at New York's Japan House Gallery and the Asia Society in 1984, Japanese and Chinese calligraphy became an influence in his work. "I wanted more expression. What I basically did was stop painting at a certain point and then follow the drawing and then work the drawings up into the paintings, which is how the whole calligraphic idea developed. It took me a while to figure out how to do that."[44]

To Marden these calligraphic characters were abstract shapes; with no idea of their meaning they became pure gestures. In response to their influence, the dense surfaces of the early gray and then more vibrantly colored panels gave way to a more transparent surface where drawing and painting merge. Line, which had previously existed in his work only at the periphery of the canvas, to separate one panel from another or the painting from the wall, now appeared as a vigorous component in the dynamic structure of the painting, and the line's relation to the edge became an important element in Marden's redefinition of his plane. The line now moved around the canvas, and following it makes us experience the painting in a whole new way.

As the calligraphic images became larger, they also became more figurative. Marden has always said that his horizontal pictures were landscapes, his vertical ones were figures, and his square ones were abstract. Now the figures were inside the canvas and moving around with a rhythm that paralleled the movement of the artist in the act of making the picture.[45]

Marden's sensitivity to place and to this new figuration in his work produced drawings and paintings that began to refer to Greek mythology, with titles such as *Aphrodite*, *Venus*, and *Muses*. As he started to loosen up the columns of calligraphic glyphs or characters, the shapes began to come together and give the appearance of figures. Inspired perhaps by Greek friezes and the memory of Cézanne's London *Bathers*, the postcard of which he still had in his studio, these more figurative Marden works seem to resonate with Cézanne's paintings and watercolors of bathers, as evidenced by

a comparison of Cézanne's Bridgestone *Bathers* (plate 201) with Marden's *Muses Drawing #4* (plate 202). In the Cézanne watercolor, the figures twist and turn with a high degree of activity given the very shallow space in which they have to move. The background is rendered more solidly than the actual bathers, whose "bodies are defined by bundled lines that vibrate . . . vividly around the edges of their forms."[46] In Marden's work, the triangular glyphs become figures that also move dynamically across the paper, but with a much sharper and more staccato rhythm. Like the Cézanne figures, their form is determined by outline only, and they are contained within the field of the paper. Beneath the black lines in the Muses are the ghostly remains of past lines that have been washed over, adding to the image the history of its making. Theirs is a syncopated, uneven, not yet fluid, dance across the surface.

Experiments in drawing have often been a catalyst for change in Marden's work. With the calligraphic paintings of the late 1980s and early 1990s, he had been experimenting with "drawing in paint." As he said in 1997, "I stopped working with the character idea and started working on the whole canvas."[47] Around 1995, his work took another turn, as color and line, field and gesture came into balance, and the rhythm of his painted lines became less frenetic and more fluid, as can be seen in *Skull with Thought* of 1993–95 (plate 196). The colored lines began to move across the richly translucent surface, going over, under, or near other lines, bouncing off the edge or lingering in its straightness for a moment before heading back into the painting, uniting surface and edge with an exuberance that energizes the plane. Maurice Merleau-Ponty's comments on Cézanne's use of colored outlines to create form finds a particular resonance with Marden's idea of drawing in paint: "For the world is a mass without gaps, a system of colors across which the receding perspective, the outlines, angles and curves, are inscribed like lines of force; the spatial structure vibrates as it is formed. . . . The outline and the colors are no longer distinct from each other. To the extent that one paints, one outlines; the more the colors harmonize, the more the outline becomes precise."[48] Yve-Alain Bois cites Cézanne's own comment: "Drawing and color are not separate at all; in so far as you paint, you draw."[49] Bois goes on to argue that it is because he "canceled the difference between these two historically heterogeneous registers, that Cézanne is the father of modern art."[50]

The harmony Marden has achieved in his paintings for more than the last decade comes from the delicate balance of the many forces involved in their making, and it reflects on the artist's understanding of Cézanne. Marden has called Cézanne "the greatest realist and the greatest abstractionist at the same time. In his still lifes, you've got all this movement and yet everything stops. It's so precarious, but then it just stops."[51] Cézanne's still lifes achieve an equilibrium that is both momentary and painterly. It all works together magically as a dynamic picture, but translated into reality it would fall apart. What Marden admires about Cézanne's technique is his ability to construct, out of tumbling fruit, up-ended perspective, or fractured brushstrokes, a harmonious yet active surface that reinforces the plane and feels taut with an energy that reveals its making. This energy represents the chaos at the core of the composition that has been brought to order and harmony by the artist. The work's physical presence and immediacy come from this underlying tension.

Marden's recent series of Red Rocks paintings reflects not only his interest in Cézanne, as mentioned earlier, but also his interest in Chinese art, and his belief that "the plane at one point is chaos . . . you work it up just so that there's an image."[52] This is very close to the idea of the "one brushstroke" as expressed by the Chinese artist Yuanji Shih-t'ao (1642–1707): "If it were not by the one brushstroke, how could one

ever tame the original chaos?" He wrote that the calligrapher must, "in the midst of the ocean of ink, firmly establish the spirit; at the point of the brush, let life affirm itself and come forth!"[53] Every stroke for Cézanne or Marden is an act of creation. In this spirit, to look at the Red Rock paintings is to see the reality and the realization all at once. This very much echoes Merleau-Ponty's statement that "to look at a Cézanne . . . is to see simultaneously its molecular surface and the depicted object in the act of germinating under our eyes."[54] In fact, Marden has explicitly compared the two artists: "I keep thinking I'm trying to channel Shih-t'ao, but then I see Shih-t'ao as being, when he's really good, . . . very much like Cézanne."[55]

For Marden and Cézanne, it is *in the process* of getting there that all their creativity occurs. They bring life to a painting by capturing the spirit of its making and letting that spirit work with them to complete it. As Marden said, "It works on me and I work on it. Give and take."[56] That force enables each of their works to have an immediacy and presence that is truly palpable, and an impact that is timeless. Marden, who has called Cézanne "my hero," noted: "I think with Cézanne that he's ageless and he keeps on going and he can always be. I see him as always being present, and because of all these things that you just can't figure out."[57]

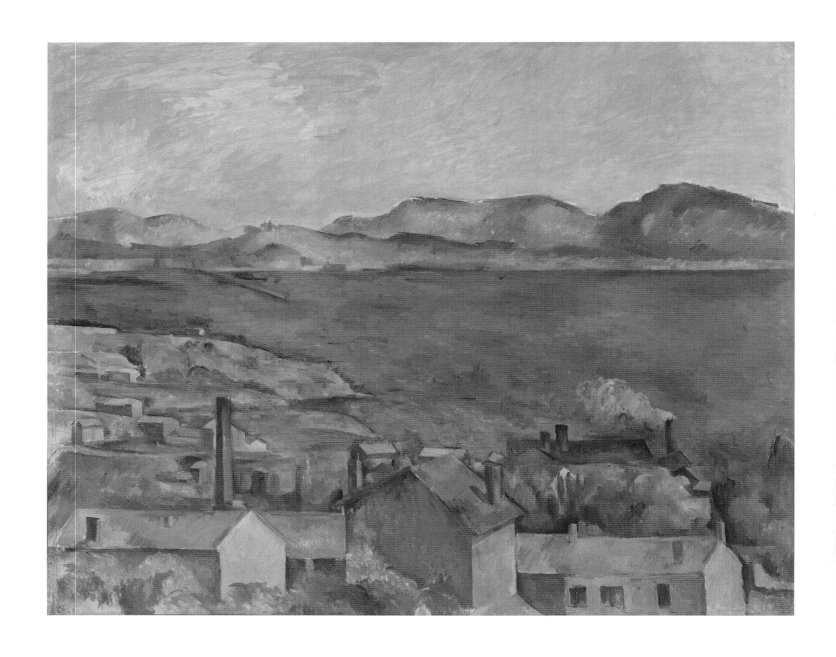

PLATE 197

Paul Cézanne

***The Bay of Marseille Seen from
L'Estaque**, c. 1885*

Oil on canvas
31¹⁵⁄₁₆ x 39⅝ inches (80.2 x 100.6 cm)
The Art Institute of Chicago. Mr. and Mrs. Martin A.
Ryerson Collection, 1933.1116

PLATE 198

Brice Marden

Grove Group V, 1976

Oil and wax on canvas
72 x 108 inches (182.9 x 274.3 cm)
Museum of Contemporary Art, Chicago.
Gerald S. Elliott Collection, 1995.67a–c

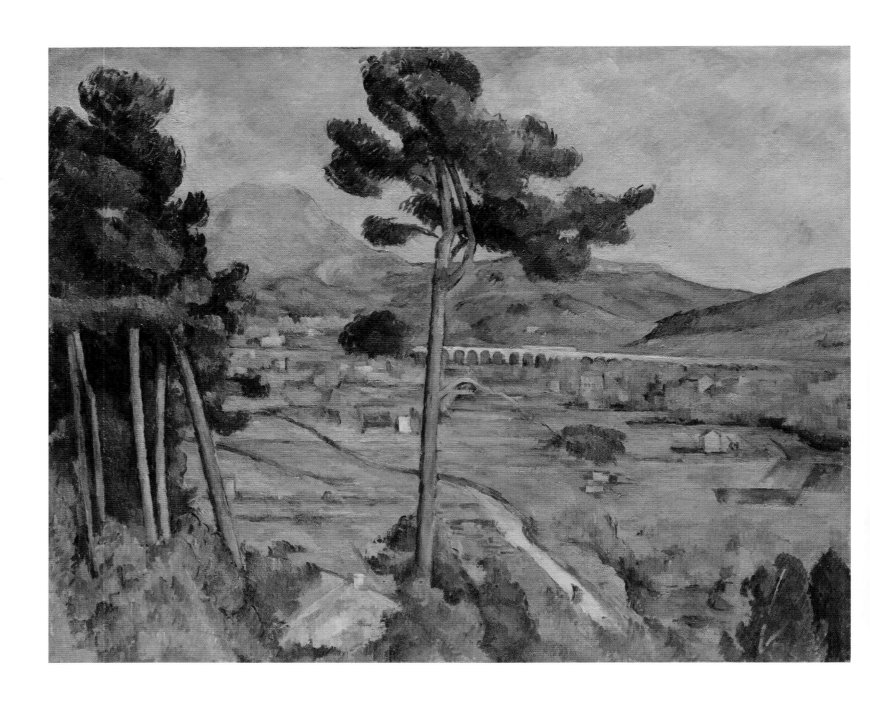

PLATE 199

Paul Cézanne

Mont Sainte-Victoire and the Viaduct
of the Arc River Valey, 1882–85

Oil on canvas
25¾ x 32⅛ inches (65.4 x 81.6 cm)
The Metropolitan Museum of Art, New York. H. O.
Havemeyer Collection, bequest of Mrs. H. O. Havemeyer,
1929 (209.100.64)

PLATE 200

Brice Marden

Coda, 1983–84

Oil and wax on canvas
120 x 39 inches (304.8 x 99.1 cm)
Philadelphia Museum of Art. Purchased with funds
contributed by the Daniel W. Dietrich Foundation in
honor of Mrs. H. Gates Lloyd, and gifts (by exchange)
of Samuel S. White 3rd and Vera White and Mr. and
Mrs. Charles C. G. Chaplin, 1985-22-1

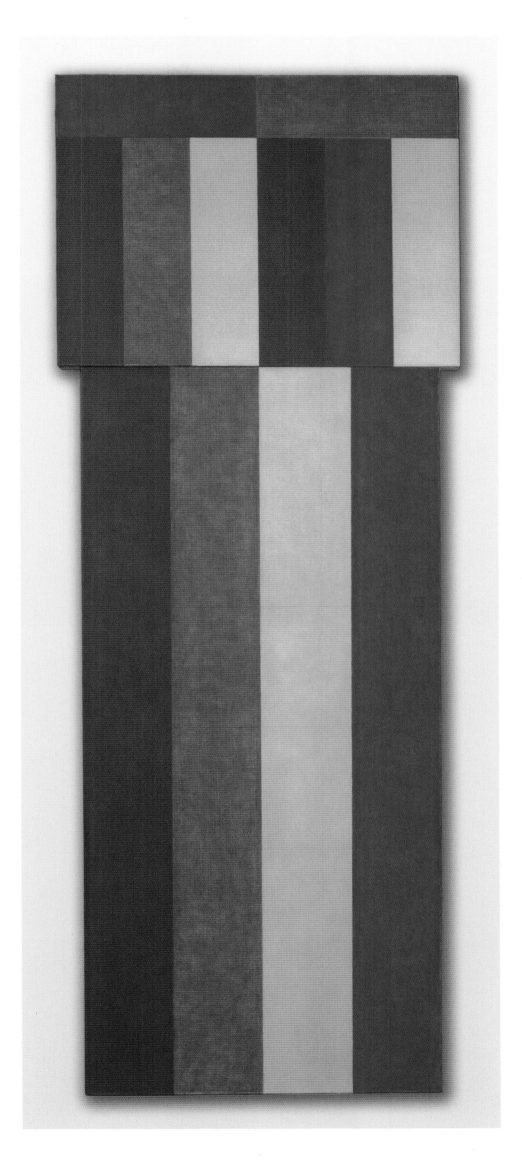

PLATE 201

Paul Cézanne

Bathers, c. 1890

Graphite and watercolor on paper
5 x 8⁷⁄₁₆ inches (12.6 x 20.8 cm)
The Bridgestone Museum of Art, Tokyo. Ishibashi
Foundation

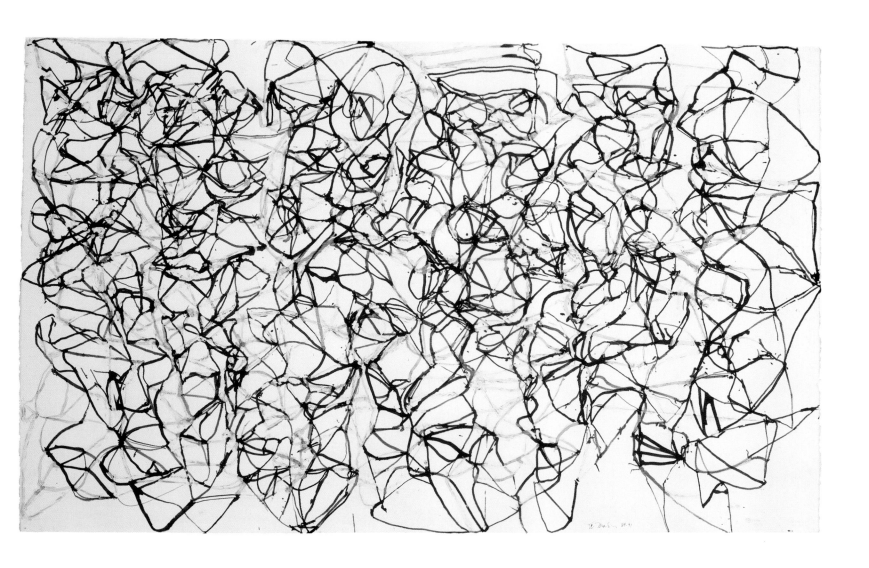

PLATE 202

Brice Marden

Muses Drawing 4, 1989–91

Ink and gouache on paper
26 x 40⅝ inches (66 x 103.2 cm)
Private collection

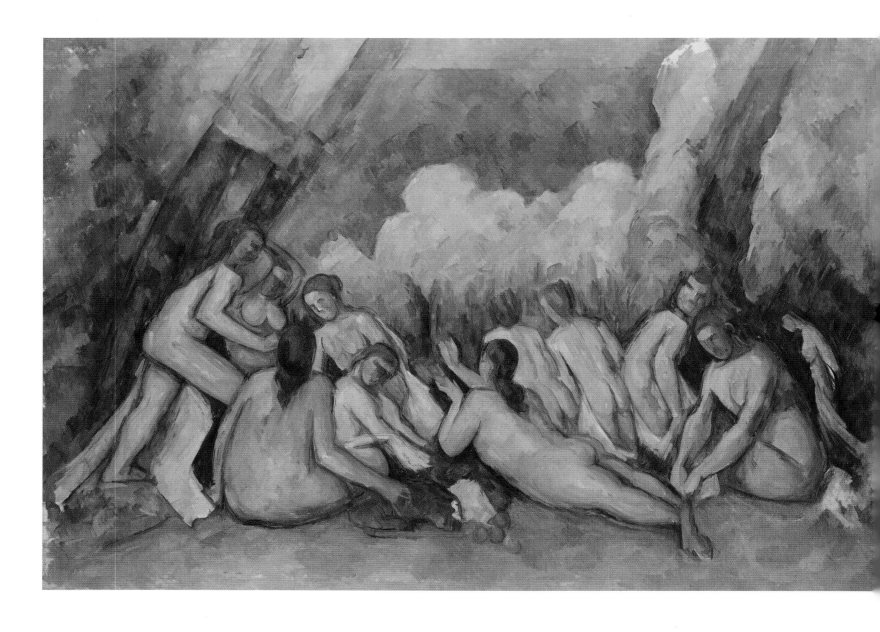

Paul Cézanne

The Large Bathers, 1894–1905

Oil on canvas
50¹⁄₁₆ x 77³⁄₁₆ inches (127.1 x 196 cm)
The Trustees of the National Gallery, London.
Purchased with a special grant and the aid
of the Max Rayne Foundation, 1964

PLATE 204

Brice Marden

Red Rocks (1), 2000–2002

Oil on linen
75 x 107 inches (190.5 x 271.8 cm)
Collection of the artist, courtesy of Matthew Marks
Gallery, New York

Jeff Wall: Within the View(ing), or The Spirit of Place

Jean-François Chevrier

Cézanne is working on the motif, between a low wall of dry stones, at his back to the left, and the easel, in profile before him; he looks into the distance, slightly stooped, a long brush delicately held in his right hand; he prepares to apply a new patch to the canvas (fig. 19.1). The gesture is suspended; the recording has fixed a singular moment repeated a thousand times. The reader has no doubt recognized one of the three pictures taken by the Nabi painter Ker-Xavier Roussel, who visited Cézanne in 1906 accompanied by Maurice Denis. The site is the hill at Les Lauves.

If we attempt to apprehend the relationship between Cézanne's experience and the possibilities of the photographic *tableau* as they emerge in the work of the Canadian photographer Jeff Wall (born 1946), Roussel's image is exemplary for at least three reasons. First, it recalls the importance to Cézanne of the "tableau of nature": "The real and prodigious study to undertake," he wrote, "is the diversity of the picture that nature presents [*le tableau de la nature*]."[1] The photograph also tells us that the idea of a tableau proceeds simultaneously from the *viewing* and the *view*: the ability or the act of seeing, on the one hand, and a fragment extracted from a landscape—a *veduta*—on the other. Lastly, the picture is exemplary in the equivalence that it establishes, or reveals, between the painter's (suspended) brushstroke and that fraction of space-time fixed by the *instantané*, or instantaneous recording.

Toward the end of his life, Cézanne spoke of the difficulty of pictorial *realization* when each patch matters, in interaction with all the others, over the entire surface of the tableau. He was suspicious of gestures that supposedly transmitted the artist's enthusiasm onto the canvas. Just as strongly, he repudiated the idea of a regular, mechanical brushstroke governed by any kind of scientific principle, as implemented by the Neo-Impressionists. He needed to constantly verify that the tableau suited the motif. He worked slowly, diligently, avoiding the routine of craft. To Cézanne the picture always seemed incomplete. He respected above all the (academic) ideal of a complete unity of the tableau—the opposite of the fragmentary nature of studies. But that ideal had to stand, consistently, the test of the multiple *sensations* produced by the experience of the motif. The unity Cézanne sought had to allow the linking

PLATE 205

Jeff Wall
Canadian, born 1946
Coastal Motifs, 1989
Transparency in lightbox
46⅞ x 57⅞ inches (119 x 147 cm)
Collection of the artist

Paul Cézanne, _Mont Sainte-Victoire_,
1902–4 (plate 182, p. 476)

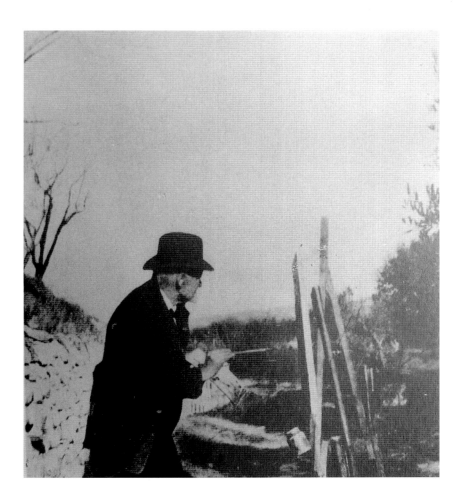

and the absorption of that multiplicity, and to convey the duration of the experience.

Critics have often noted the degree to which artists who have referenced Cézanne's example have tended to narrow his demand: They either isolate one parameter from the work on form, or eschew the motif, or do both simultaneously. The constructive dimension of his painting has often been preferred to its empirical component. Yet the latter has to do, first and foremost, with the patch(es), one and many. Like the instant fixed by the recording, the patch is *one*, and its effect can be likened to that of the line in drawing. But that unity is not synonymous with autonomy: The patch is not an autonomous thing; it is set down with diligence, regulated according to the information perceived, and a part of the colored whole that constitutes the tableau. For Cézanne the unity of the whole is that of the tableau. He did not seek to liberate the brushstroke; he sought to unify the surface of the tableau. But a surface can be unified without being uniform. Cézanne did not aim at the absorption of the brushstroke, nor its academic invisibility. Color, indeed, is not just coloring; it proceeds by areas but also and chiefly by patches of color. Cézanne thought in terms of *modulation* ("One should never say 'model'; one should say 'modulate.'"[2]). Modulation corresponds to "sensations of color." And the very idea of *sensation* indicates that the tableau is distinct from the objective view(ing): "To paint is to record the sensations of color."[3]

These indications of method are somewhat alien to the practice of the photographer, who works with a machine. "Photography," Jeff Wall has noted, "constitutes a depiction not by the accumulation of individual marks, but by the instantaneous operation of an integrated mechanism."[4] Nevertheless, the notion of recording employed by Cézanne was not a term chosen merely for convenience: For him it also implied the idea of a process for reconstituting a visual experience, analogous to the chemical fixing of captured optical data in the darkroom. The Cézannian definition suggested that the painter could possess the effectiveness of the recording machine (or, to take up the term used in the nineteenth century, the *process of reproduction*). The concept of *optics* was

current among painters in the late 1800s, testifying to the fact that physiological terminology had reached the ateliers. It allowed painters to set themselves apart from a romantic, literary culture of sentiment. In a letter to Émile Bernard of December 1904, Cézanne rebuffs the "aesthetic considerations" of his correspondent and asserts the primacy of "optical sensations."[5]

There is no shortage of quotations to support the notion that post-Romantic painting—whether one calls it realist or "actualist" (the latter term is Émile Zola's)—stemmed from *performances of the eye*. At no time was the acuity of the gaze so highly prized except perhaps, later, in reference to "connoisseurs," attribution experts, and photographers. Édouard Manet's art consolidated a critical cliché. In 1867 Zola wrote of the "clear and just eye" of the creator of *The Fife Player*.[6] Jules-Antoine Castagnary went one better in 1874: "Manet paints as he sees, he reproduces the sensation which his eye brings him: he is above reproach with regard to sincerity."[7] In 1895 the poet Stéphane Mallarmé summed it up in a single expression: "The eye, a hand."[8] There could have been no more concise description of the brushstroke as the extension of seeing. Lastly, the contribution of Neo-Impressionism, which replaced the pigmentary mixing of hues with the optical mixing of juxtaposed patches of pure colors, was to involve systematically the gazer in the performance of the eye.

In a fairly obvious manner Wall's *photographic tableaux* are in some aspects connected to this pictorial problem, and in others they stray from it. One must also consider the shifts in emphasis in the evolution of this artist, whose initial works date back to the late 1970s (ignoring the prior conceptual works, which he has left out of his catalogue raisonné).[9] There are two closely interconnected issues here. Wall positioned himself explicitly within a pictorial tradition, which he considered distinct from "conceptual," anti-pictorial, art. Yet he chose photography. Thus the question of Cézanne's *exemplarity*, when considering Wall's work, goes hand in hand with an investigation of the pictorial potential of photography.

Wall's initial position in the late 1970s, when he created *The Destroyed Room* (after Delacroix's *The Death of Sardanapalus*), was conditioned by two complementary, though seemingly contradictory, stances (fig. 19.2). He situated himself in the pictorial tradition, moving away from conceptual art, but *using photography*. In doing so he chose a cinematographic process and a medium (Ektachrome transparencies mounted on lightboxes) that contrasted with the norm of fine art photography, whose traditional benchmarks have been the performance of the gaze—the demonstration of a way of seeing—and the intimacy, if not the refinement, of small-format proofs, preferably black and white.

Wall himself has clearly explained his reasons; witness his statements from a 1984 conversation. The use of the lightbox appeared to him, he says, as the solution for revisiting—in the language of image technology—the tradition of the grand painting and the program of the "painting of modern life" stated by Charles Baudelaire. An initial series of remarks leads him to describe his pictures as "a specific opposite to painting":

> I think there's a basic fascination in technology which derives from the fact that there's always a hidden space—a control room, a projection booth, a source of light of some kind—from which the image comes. A painting on canvas, no matter how good it is, is to our eyes more or less flat, or at least flatter than the luminescent image of cinema, television, or the transparencies. One of the reasons for this is that the painting or the ordinary photograph is lit with the same light that falls in the room and onto the spectator him- or herself. But the luminescent image is

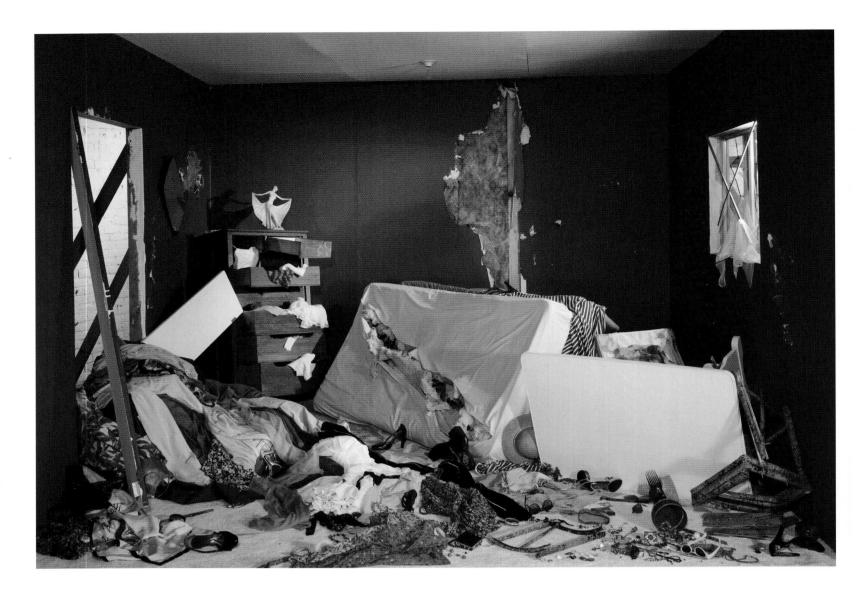

Fig. 19.2. **Jeff Wall, *The Destroyed Room,*** 1978.
Transparency in lightbox, 62½ x 92⅛ inches (159 x
234 cm). National Gallery of Canada, Ottawa

fascinating because it's lit with another atmosphere. So two atmospheres intersect to
make the image. One of them, the hidden one, is more powerful than the other. . . .

Furthermore, the fascination of this technology for me is that it seems that it
alone permits me to make pictures in the traditional way. Because that's basically
what I do, although I hope it is done with an effect that is opposite to that of tech-
nically traditional pictures. The opportunity is both to recuperate the past—the
great art of the museums—and at the same time to participate with a critical effect
in the most up-to-date spectacularity. This gives my work its particular relation to
painting. I like to think that my pictures are a specific opposite to painting.[10]

This lengthy quotation is necessary to properly grasp the meaning of Wall's expres-
sion "a specific opposite to painting." He does not mean to suggest that he wishes to
forsake painting and the art of the museums—on the contrary, he seeks to bring them
into the present using a powerful technique that, outwardly, casts them back into the
past. Placing oneself in opposition to painting involves acquiring the means to extend
the experience of painting using other methods. Cézanne himself was not exemplary
in his singularity because he was unique, or because he paved the way for a "modern
art" freed from the shackles of "tradition," but because he made it possible to ascribe
concrete experiential content to those notions and, especially, to understand how oppo-
sition, unlike a break with the past, allows one to work in continuity.

A second passage from Wall concerns the other tradition, that of photography,
which is sometimes described as being in opposition to the art of the museums. At the
time, inspired by filmmaking, he had opted for a progressive method of picture cre-

ation that he called, and continues to call, cinematography—in contrast to the photographic practice that favors spontaneity and improvisation. Cinema, he has said, with its economic constraints, involves a standard of production that one must work with, and against, to make a picture. The same was true for the academic painters:

> Both the corporatized painter of the past and the filmmaker now are obliged to transform the incessant abstractionism of the modern production process into a work of art. . . . To me, cinematography consists in this extreme paradox, this photographing of abstractions in the dream of producing the opposite out of them. This dialectic appeals to me because it isn't limited by any ideas of the spontaneous production of the effect of life in the image. . . .
>
> So I think that cinematography is aesthetically more developed than the more spontaneous photographic aesthetic, the one identified with Cartier-Bresson, for example. The reliance on immediate spontaneity thins out the image, reduces the level at which the permanent dialectic between essence and appearance operates in it. Although the picture which is made is often very meaningful and beautiful, I'm not convinced that the beauty isn't in a way limited by its dependence on the immediate surface of things. That kind of photography becomes a version of Art Informel; despite its formal richness, it is condemned always to gaze at the world in wonder and irony rather than engage in construction.[11]

In short, the reasoning is the same in the case of both painting and photography. Just as one must address the contradiction of the mass media to take up the pictorial tradition, in the same way, achieving "the effect of life" in photography presupposes cinematographic artifice. One process fits into the other.

Reactivating the pictorial tradition in the age of mass media requires an artistic medium, photography, that is positioned *between the beaux-arts and the media*—with that in-betweenness referring to a hybrid domain rather than to a historical intermediary between two cultural epochs. But modern art itself, insofar as it favors the performances of the eye—and optical manipulations—could be confounded with the epoch of photography. The danger lies in relegating the demand merely to a quest for performances. This is where cinematography comes into play, as a *dramatization* of the photographic image, above and beyond—it must be specified—the so-called staged genre of photography that pictorialism promotes. Here also, Cézanne's exemplarity comes into play, along with a demand of *viewing* that extends beyond the domain of performances of the eye.

For Wall, both today and in the late 1970s, the cinema had taken up the painter's usual struggle against the production standards of pictorial imagery. That struggle remains a matter of narrative; the visual arts cannot be dissociated from narrative, to which they are traditionally linked by representation. The narrative dimension and dramatic composition never disappeared from Cézanne's oeuvre—one need only think of his portraits or his Bathers. But dramatic composition is only one of the demands of the tableau, and the model for the tableau is not so much History (the directory of the acts and gestures of current, historical, or legendary humanity) as it is Nature, in terms of a principle of complex harmony. Moreover, the tableau is the common locus of the worlds that exist (in the current environment) and those that are possible (in fiction).

In the works of Jeff Wall, description and fiction co-exist, in alternating tableaux or in a single one. The fantastical content of *Dead Troops Talk* (1992) ostensibly relates to the art of painted drama, while his landscapes since *The Bridge* (1980; fig. 19.3) are part of the tradition of descriptive, topographical views. Both registers are combined in

Fig. 19.3. **Jeff Wall, *The Bridge*, 1980.** Transparency in lightbox, 23⅞ x 90 inches (60.5 x 228.5 cm). Friedrich Christian Flick Collection

The Flooded Grave (1998–2000), which inserts a hallucination into a realist landscape (fig. 19.4). But, as in Flaubert's *The Temptation of Saint Anthony*, the hallucination is largely a hypothesis in the service of plausibility, allowing for a justification (if not a reduction) of the arbitrary nature of the composition. The gazer has no need of it. He or she can accept the arbitrariness and take the montage of the two disparate planes at face value: as the inclusion of a piece of the ocean in a portion of territory, a luminous parable about the metabolic relationship between life and death, with the visible profusion of undersea life substituting for the invisible decomposition of the corpses buried in the ground.[12] As with Cézanne's most implausible still lifes, in which disparate objects defy the laws of gravity, the picture's quality stems from a feeling of unity that soaks up the ruptures of pictorial illusion and naturalist plausibility.

Description and fiction are two complementary parameters, but they bring about distinct notions of the figure and the character. Wall has long had a central interest in the representation of the living body, in the gestures of day-to-day life and the situations of meeting favored by urban settings (fig. 19.5). He has seemed to favor the idea of character, with its links to cinematic narrative. In the pictorial tradition of the descriptive view, however, the figure does not necessarily signify the primacy of the body over other elements of representation; it presupposes, first of all, the definition of a *place*. The *scouting* of locations in preparation for shooting a film reveals that, for the purposes of a narrative, any place, any piece of territory, is potentially a set. But the set can become an autonomous reality and take the form of a landscape; it can even acquire the value of figure in an artist's individual mythology—witness Mont Sainte-Victoire in the case of Cézanne. In this way the site represented in *The Drain* (1989) is a set (fig. 19.6), while in *Still Creek, Vancouver, Winter 2003* (plate 209) the characters have disappeared and the site has become a landscape.

Within Cézanne's remark that "the real and prodigious study to undertake is the diversity of the picture that nature presents," the key words occur in pairs: *Study* goes with *picture*, in the finest academic tradition (except that Cézanne positions the tableau in nature); *prodigious*, with *diversity*. There is indeed immense diversity in nature to the extent that it encompasses the totality of physical phenomena, along with spectacles and processes. But *prodigious* joined with *study*, as a complement to *real*, recalls another dimension: that which is prodigious also partakes of the marvelous. And what Cézanne marvels at is not so much the immensity of nature, or what it harbors in the way of sublime mystery, as the diversity of aspects assembled and visible in a space that nature offers up to one's view, like a tableau. Twentieth-century art has often sought to break free of the closed form of the tableau; the crisis in painting was perhaps above all a crisis of the tableau. But, to Wall as it was to Cézanne, the tableau is not an extraction or an abstraction; it is the *place* of the diverse—ordered, concentrated. It is the presentation of nature's exemplary diversity.

In Cézanne the model for nature is not naturalistic in the sense of an illusionistic rendering of appearances; it is the exemplar of a complete, complex form. In the nineteenth century *amateurs* of painting tended to be upset by "inaccuracies" in the rendering of forms, in the work of Cézanne as well as that of any other artist. Anatomical truth was the intangible principle of naturalism—the anchor of the ideal.[13] Cézanne abandoned that anchor in favor of the constructive truth of the tableau—architectonic, rhythmical. In doing so he expanded the anatomical metaphor of the landscape. In the Philadelphia *Large Bathers* (see plate 66), the figures are arranged (assembled) according to the ascending pyramidal movement of the composition, as if part of one large mystical body. Roger Fry denounced this constructive schematism.[14] But Cézanne was not worried about attenuating or masking a necessary artifice. Most of all he felt

Fig. 19.4

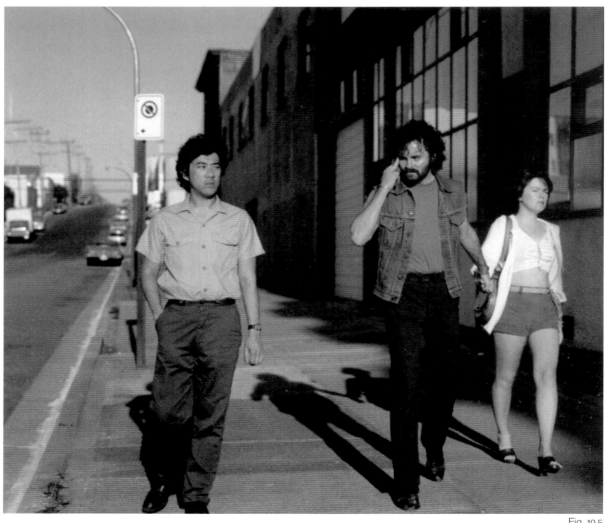

Fig. 19.5

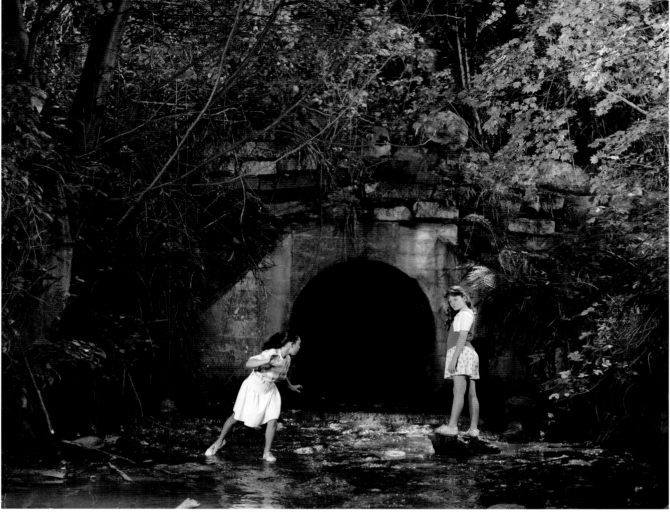

Fig. 19.6

Fig. 19.4. **Jeff Wall, *The Flooded Grave,*** 1998–2000. Transparency in lightbox, 90 x 111 inches (228.5 x 282 cm). Friedrich Christian Flick Collection

Fig. 19.5. **Jeff Wall, *Mimic,*** 1982. Transparency in lightbox, 78 x 90 inches (198 x 228.6 cm). Ydessa Hendeles Art Foundation, Toronto

Fig. 19.6. **Jeff Wall, *The Drain,*** 1989. Transparency in lightbox, 90 x 114⅛ inches (229 x 290 cm). Kunstsammlung Nordrhein-Westfalen, Düsseldorf

compelled, at the risk of deformation, to integrate artifice into nature's diverse unity. Indeed, since the invention of instantaneous recording, the spectrum of "natural" postures and gestures had broadened considerably. Cézanne situated it within the continuity of Baroque gesturality, itself an equivalent of the colored vibrations of his "tableau of nature."[15]

For Wall, Cézanne's exemplarity has less to do with its effects on twentieth-century art, as seen in the Cubist painters or in Jasper Johns, than with the way in which he transformed the legacy of the masters (the sixteenth-century Venetians, Nicolas Poussin, and Eugène Delacroix, for instance) to adapt it to his own ambition, beyond the "painting of modern life" imagined by Baudelaire and partially instigated by Manet. Thus this example takes on a distant character, of which the artifice of the *Large Bathers* is a part, as is the intimate, peculiar clearness of Cézanne's still lifes. Moreover, Cézanne had only a passing interest in the imagery of his time. His art eschews calendar time. The famous *sensations* that constitute its substance are not of the order of *facts*, to which photography, born at the same time as positivism, appears dedicated. For the Cubist painters—for Braque even more so than for Picasso—the Cézannian example functioned on a formal, iconographic level. They concentrated on landscapes, portraits, and still lifes, ignoring the spectacular motifs of modern life. The Baudelairian program recovered by Wall partakes above all of *actualism*, in the sense envisioned by Zola. But today it is the distancing in Cézanne that interests Wall, and he is increasingly seeking to integrate it in his work.

At the risk of appearing to be a new acolyte of illusionism, beginning in the late 1970s Wall did not hesitate to revisit the so-called *life-size* principle of figuration, scaling his compositions in relation to the body of the spectator and, in so doing, breaking

with the reducing/miniaturizing effect of the small-format proof (analogous to drawing and engraving). He has explained this choice by referring to his experience of Pollock's painting since he first discovered it in the late 1950s:

> I realized that the physical immediacy and scale of Pollock's work were qualities that, for me, established its affinity with photography. That affinity was the enigmatic element in my earlier fascination with his work, I now believe. When Frank Stella and Carl Andre, among others, extended aspects of Pollock's notion of scale, they separated the issue from the immediate context of Pollock's painting style and from many of the overly codified "'50s" values his work exemplified. That freed some formal and technical aspects and energies and made it possible for them to be taken elsewhere.[16]

But life-size figuration is also and chiefly a quality of a pictorial tradition that concluded, in a mundane form, in the academic naturalism of the second half of the nineteenth century (before the advent of cinema).

In Wall's work this stance has made visible and amplified the relationships between action and description, between the artifice of gestures and the cenesthesic unity of composition. Here Cézanne's exemplarity has to do with the idea of a *contemplative measure*, which allowed for the combination of seemingly opposing registers. Art since the 1960s, in emphasizing either phenomenological experience or operations of semiological decryption, in constituting either testimony or activity, has tended toward the worldly; contemplation has become a suspect attitude or been reduced to a kind of descriptive compulsion. Wall believes, on the contrary, that the tableau is the contemplative form par excellence, to be adjusted case by case, depending on the subject treated. It is not the subject that is important, but the *adjustment* that it brings about. When he revisits and rectifies his older pictures today, Wall seeks either a natural effect or an ambiguous, enigmatic clearness. The two qualities are complementary. The first is tangible in his retouching of *Eviction Struggle* (1988), retitled *An Eviction* (2004); the second, in his new figure of *Trán Dúc Ván* (1988/2003).

Here again one revisits the issue of the *view*, whether taken or composed, framed or modeled. When he painted Mont Sainte-Victoire from Les Lauves, Cézanne worked *within the view(ing)*: He modeled and modulated. From one picture to the next, the frame of the composition could be immutable; the movement and variations were internal. One tradition of instantaneous photographic vision, exemplified by Henri Cartier-Bresson's (in)famous "decisive moment," is all about framing. The photographer adapts his or her framing to the flow of visual events that shift and transform the constitutive elements of the picture. A good picture results from a performance of the eye extended by the machine. This principle engenders a mystics of improvisation analogous to that of the poet's inspiration: The picture is received, in the same way Paul Valéry considered that a line can be "given." Wall uses the word *reportage* to describe the anti-pictorialist mode of photography that relegates composition ("the property of the tableau") to decisions about framing.[17] For him this practice is one model among many, a rather ascetic one, for what he calls — using an all-encompassing term — "*the Picture*." And what Wall described in the 1980s as "a specific opposite to painting" is today, to him, a specific opposition to the tableau and to one variety of the view, as redefined by Cézanne.

In the diverse interpretations he has given of the *veduta* since *The Bridge*, the form is above all a constrained one, whose ostensible artifice refers to a pure visuality. The operator is defined exclusively by his point of view, itself rigorously conditioned by the frame. The expanse described in the picture is distant, disconnected from the percep-

tual field physically occupied by the operator; the visual apprehension of the landscape is dissociated from the tactile experience. Thus we are as far away as possible from a phenomenology of the painter's sensory and kinesic involvement, as mapped out by Maurice Merleau-Ponty in reference to Cézanne, and as it appears in Pollock (to whose oeuvre Wall attributed his revelation about the potential for expanding the picture). Conversely, the work of the view, and of viewing, has been freed of the requirement for mobility that determines the exercise of photography as a way of seeing. In his initial conceptually inspired photographic works, such as *Landscape Manual* (1969–70), Wall had embraced a cinematic romanticism ascribed to that tradition. Ten years later he needed something else. He had to find another frame that would enable him to overcome the nostalgia of continuous contact between the space of multisensory perception (immersed in the world) and that of the landscape as spectacle seen from a distance.

Here the example of Cézanne functions, paradoxically, as an intensification of the constitutive distance of the photographic image. But this paradox echoes the dual nature of the Cézannian *tableau*, which is at once a view and a plane—that is, the representation of a place (whether occupied by figures or not), transformed into an autonomous, self-sufficient, quasi-autistic picture. Wall thinks of the domain of the *Picture* as the field of a general activity—generic, even—designated by the term *depiction*. This idea encompasses, in his eyes, that of recording. The diversity of photographic pictures obviously stems from a multiplicity of uses of the medium that has nothing to do with Cézanne's pictorial attitude: Indeed it is hard to see what the Cézannian example would mean to a photojournalist or an advertising agency photographer. This example acts upon the history of pictures—be they painterly or photographic—not the history of the uses of a technique or that of the standards of visual communication. It asserts a criterion for the quality of the picture in and of itself, apart from communication.

Wall has progressively adopted a vast range of figurative and expressive *modes*, which correspond to pictorial (or photographic) *genres* and contrasting emotional registers. That diversity sets him apart from the majority of contemporary photographers, who tend to limit themselves to a single register. But it refers to a permanent condition of the tableau, common to all pictures, and to which the dominant mode of the contemplative attitude corresponds. This is particularly tangible in recent works such as *Concrete Ball* of 2002 (fig. 19.7) and *Rear View, Open Air Theatre* of 2005 (fig. 19.8)—which was shown alongside Cézanne's *The Pont de Maincy* (see plate 160) in an exhibition at the Musée d'Orsay in 2006–7. In both cases, the tableau is simultaneously monumental and intimate. One can ignore the documentary content of the picture or be interested in it: The open-air theater, located in a large park in Vancouver, is an attractive building, and the isolated (idealized) slice of urbanity in *Concrete Ball* recalls other, similar sites in the Vancouver landscape that Wall has photographed. Likewise, the bridge at Maincy is still known today—even to someone who is not familiar with the Cézanne painting—as one of the attractions of the protected site at Val d'Ancœur, in the Île-de-France region, near Melun. But these topographical qualities are the equivalent of the tableaux, not their raison d'être. They belong to a pictorial and picturesque culture that encompasses landscape art.

The sites Wall photographs resemble the Cézannian landscape because they involve the same contemplative, *pacifying* function of the tableau, a function that can also be applied to interpretation as well as the design of the environment (even if there are few urban planners or landscape architects who, since the breakup of the beaux-arts system, have been seriously inspired by this compositional model). Cézanne was not interested in the ephemeral character of natural phenomena, any more than he was interested in

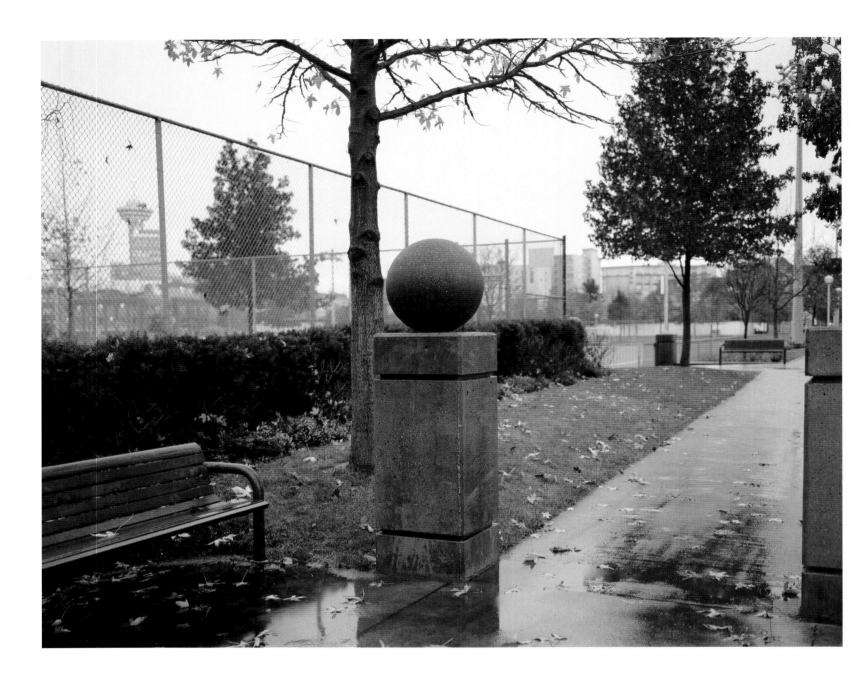

Fig. 19.7. **Jeff Wall, _Concrete Ball_,** 2002. Transparency in lightbox, 80½ x 102⅝ inches (204 x 260 cm). Private collection

events or _faits divers_. He represented the permanent, if not timeless, side of the "painting of modern life." He preferred the durable architecture of sites, their architectonic, geological quality. He was not an "actualist": To him the currentness of "modern subjects" was secondary, anecdotal. He favored the present of perception, or what is referred to as "aesthetic experience." The water flowing under the bridge at Maincy moved and raced along; but the mobility that mattered to him was the almost tactile quivering of a colored substance, decomposed and recomposed in a juxtaposition/ fusion of minute luminous blocks in an architectonic structure. He needed a certain stability of the figure to organize the exuberance of his "sensations of color."

Wall's open-air theater is a figure viewed from the rear: The opening at the front of the building is not visible. Similarly, in _Concrete Ball_ the eponymous motif replaces the human figure. In both cases the picture adjusts the arbitrariness that governs the visual manipulation of a motif to the spirit of place—or is it that the relationship works in the other direction, from _genius loci_ to arbitrariness? Here we return to the idea of contemplative measure; it corresponds to what Cézanne called "harmony" and locates its contribution to a figurative tradition in which landscape and still life belong to a general anatomy. Cézanne's attachment to the plasticity of the body, exalted in frozen movements and contained torsions, is borne out by the recurrence in his drawings of models borrowed from Baroque art (Peter Paul Rubens and Pierre Puget in particular).[18] "Cézanne,"

Fig. 19.8. **Jeff Wall, *Rear View, Open Air Theatre***, 2005. Transparency in lightbox, 89 x 115½ inches (226 x 293 cm). Courtesy of the artist

Lawrence Gowing has noted, "was a natural figure painter who produced landscapes — the reverse of Claude Gellée, who could not imaginably have painted or drawn anything else."[19] The statement can be qualified, but it has the advantage of showing how Wall, who in his early works favored dramatizations of the human figure (and who mostly looked in Manet's direction), eventually encountered the Cézannian example.

For the reasons outlined at the beginning of this essay, Cézanne was not a direct source of inspiration for Wall in the late 1970s and early 1980s when he chose to anchor his work in the history of painting — and in that of the cinema. The first intersections concerned reminiscences and the effect of compositional schemas that Cézanne had himself inherited. But beyond localized references, the Cézannian example appears to Wall today as the consummate form of a pictorial tradition in which the tableau constitutes an ideal place — stable, introverted. This definition of place, determined by the arrangement of the figures or their equivalents, enables the artist to work within the view(ing) and to overcome the old antinomies — composition/framing, dramatization/description — that define and too often limit the work of photographers. The Cézannian example enables the adjustment of the photographic image to a pictorial tradition that has been mapped out in reference to nature's (unsurpassed) model of complexity.

Translated from the French by Michael Gilson.

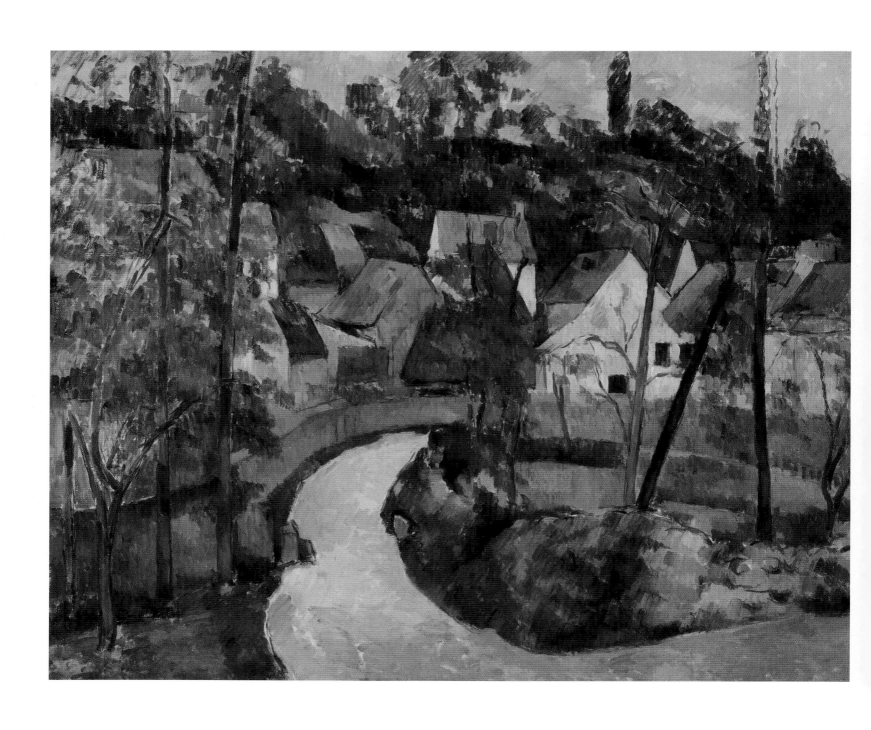

PLATE 206

Paul Cézanne

Turn in the Road, c. 1881

Oil on canvas
23⅞ x 28⅞ inches (60.6 x 73.3 cm)
Museum of Fine Arts, Boston. Bequest of John T.
Spaulding (48.525)

PLATE 207

Jeff Wall

The Crooked Path, 1991

Transparency in lightbox
46⅞ x 58¾ inches (119 x 149 cm)
Friedrich Christian Flick Collection

PLATE 208

Jeff Wall

Diagonal Composition, 1993

Transparency in lightbox
15¾ x 18⅛ inches (40 x 46 cm)
Tate Gallery, London. Purchased from Marian
Goodman Gallery, New York (General Funds), 2003

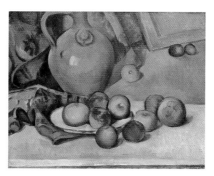

Paul Cézanne, *Stoneware Jug*, 1893–94
(plate 45, p. 200)

PLATE 209

Jeff Wall

***Still Creek, Vancouver, Winter
2003, 2003***

Transparency in lightbox
79½ x 102 inches (202.5 x 259.5 cm)
Collection of Glenn Fuhrman, New York

Paul Cézanne, ***The Pont de Maincy***,
c. 1879 (plate 160, p. 450)

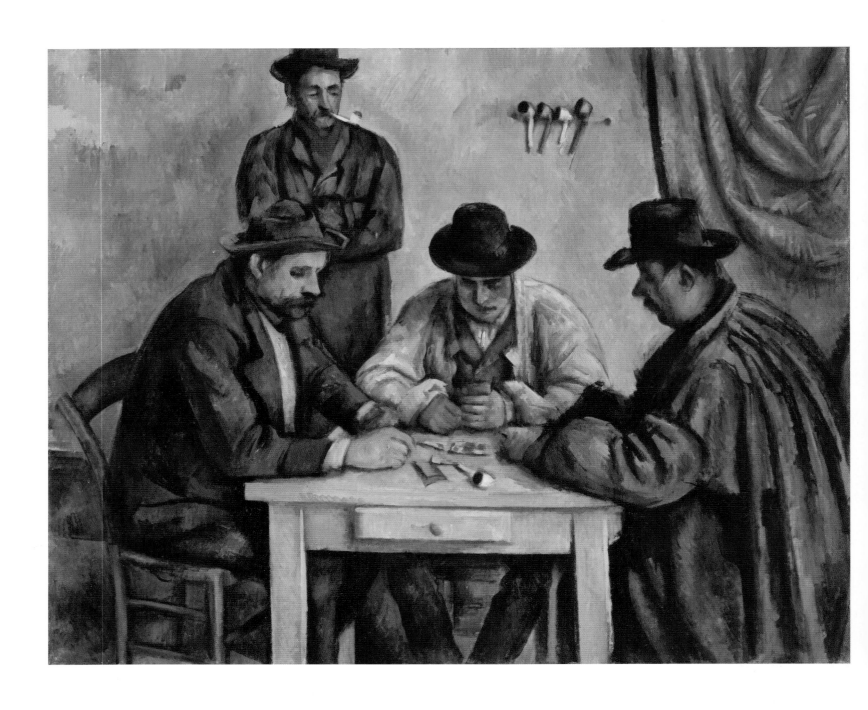

PLATE 210

Paul Cézanne

The Card Players, 1890–92

Oil on canvas
25¾ x 32¼ inches (65.4 x 81.9 cm)
The Metropolitan Museum of Art. Bequest of Stephen
C. Clark, 1960 (61.101.1)

PLATE 211

Jeff Wall

Card Players, 2006

Transparency in lightbox
45⅞ x 50 inches (116.6 x 127 cm)
Private collection

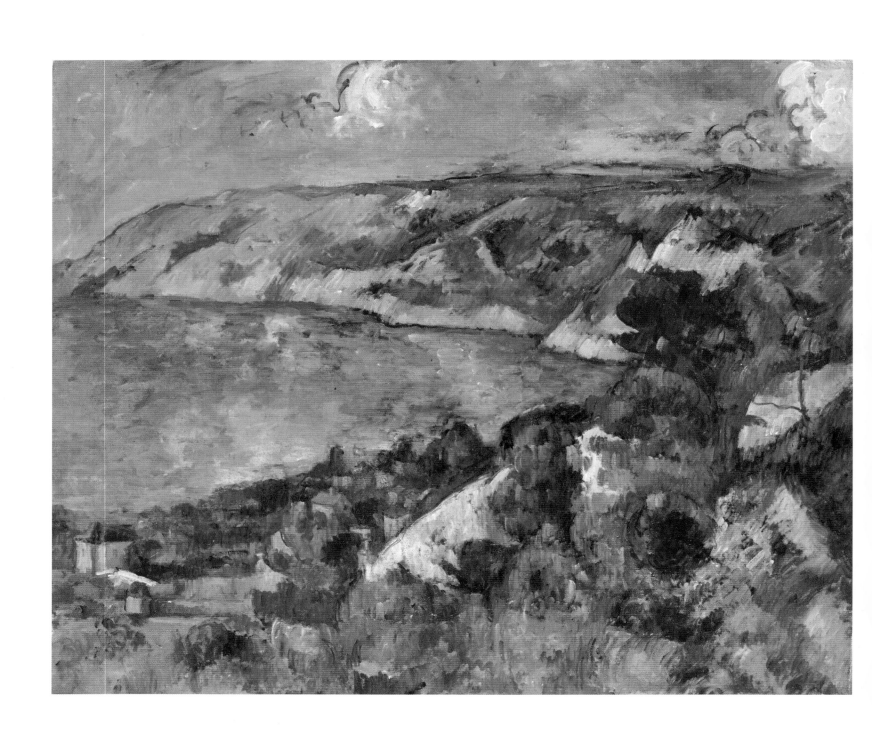

Checklist of the Exhibition

As of November 1, 2008

Paul Cézanne

(French, 1839–1906)

The Fishermen's Village at L'Estaque, c. 1870
Oil on canvas
16½ x 21¾ inches (41.9 x 55.2 cm)
Private collection
Plate 58, p. 232

Quartier Four, Auvers-sur-Oise (Landscape, Auvers),
c. 1873
Oil on canvas
18¼ x 21¾ inches (46.4 x 55.2 cm)
Philadelphia Museum of Art. The Samuel S. White
3rd and Vera White Collection, 1967-30-16
Plate 54, p. 228

Compotier and Plate of Biscuits, c. 1877
Oil on canvas
20¾ x 24⅜ inches (52.7 x 61.9 cm)
Private collection
Plate 81, p. 254

Madame Cézanne in a Red Armchair, c. 1877
Oil on canvas
28½ x 22 inches (72.4 x 55.9 cm)
Museum of Fine Arts, Boston. Bequest of Robert
Treat Paine, 2nd, 44.776
Plate 60, p. 234, and cover

Still Life with a Dessert, 1877 or 1879
Oil on canvas
23¼ x 28¹¹⁄₁₆ inches (59.1 x 72.9 cm)
Philadelphia Museum of Art. The Mr. and Mrs.
Carroll S. Tyson, Jr., Collection, 1963-116-5
Plate 78, p. 252

Five Apples, 1877–78
Oil on canvas
4¾ x 10 inches (12.1 x 25.4 cm)
Mr. and Mrs. Eugene V. Thaw
Plate 168, p. 458

Five Bathers, 1877–78
Oil on canvas
18¹⁄₁₆ x 21¹⁵⁄₁₆ inches (45.9 x 55.8 cm)
Musée Picasso, Paris
Plate 2, p. 65

The Pont de Maincy, c. 1879
Oil on canvas
23 x 28⁹⁄₁₆ inches (58.5 x 72.5 cm)
Musée d'Orsay, Paris (R.F. 1955-20)
Plate 160, p. 450

Three Bathers, 1879–82
Oil on canvas
20½ x 21⅝ inches (52.1 x 54.9 cm)
Petit Palais, Musée des Beaux-Arts de la Ville de Paris
Plate 10, p. 123

Bay of L'Estaque, 1879–83
Oil on canvas
23¾ x 29¼ inches (60.3 x 74.3 cm)
Philadelphia Museum of Art. The Mr. and Mrs.
Carroll S. Tyson, Jr., Collection, 1963-116-21
Plate 212, p. 530

Still Life with Three Pears, 1880–82
Pencil and watercolor on paper
5 x 8¼ inches (12.6 x 20.8 cm)
Museum Boijmans Van Beuningen, Rotterdam.
Koenigs Collection, inv. no. F II 210 (PK)
Plate 105, p. 304

Turn in the Road, c. 1881
Oil on canvas
23⅞ x 28⅞ inches (60.6 x 73.3 cm)
Museum of Fine Arts, Boston. Bequest of John T.
Spaulding (48.525)
Plate 206, p. 524

Landscape with House and Roof, 1882–83
Pencil and watercolor on white paper
15¾ x 17⅞ inches (32.5 x 40 cm)
Museum Boijmans Van Beuningen, Rotterdam.
Koenigs Collection, inv. no. F II 213 (PK)
Plate 97, p. 297

PLATE 212

Paul Cézanne
Bay of L'Estaque, 1879–83

Oil on canvas
23¾ x 29¼ inches (60.3 x 74.3 cm)
Philadelphia Museum of Art. The Mr. and Mrs.
Carroll S. Tyson, Jr., Collection, 1963-116-21

*Mont Sainte-Victoire and the Viaduct of the Arc River
Valley*, 1882–85
Oil on canvas
25¾ x 32⅛ inches (65.4 x 81.6 cm)
The Metropolitan Museum of Art, New York. H. O.
Havemeyer Collection, bequest of Mrs. H. O.
Havemeyer, 1929 (29.100.64)
Plate 199, p. 504

Bather with Outstretched Arms, 1883
Oil on canvas
13 x 9⁷⁄₁₆ inches (33 x 24 cm)
Collection of Jasper Johns
Plate 191, p. 485

Houses in Provence: The Riaux Valley near L'Estaque,
c. 1883
Oil on canvas
25⅝ x 32 inches (65.1 x 81.3 cm)
National Gallery of Art, Washington, DC. Collection
of Mr. and Mrs. Paul Mellon, 1973.68.1
Plate 125, p. 372

*View of the Bay of Marseilles with the Village of Saint-
Henri*, c. 1883
Oil on canvas
25¹⁵⁄₁₆ x 32 inches (65.9 x 81.3 cm)
Philadelphia Museum of Art. The Mr. and Mrs.
Carroll S. Tyson, Jr., Collection, 1963-116-3
Plate 109, p. 320

View of L'Estaque and the Château d'If, 1883–85
Oil on canvas
28 x 22¾ inches (71.1 x 57.8 cm)
Private collection, on loan to the Fitzwilliam
Museum, Cambridge
Plate 88, p. 274

View Across to the Heights of the Sainte-Baume,
1883–86
Pencil on paper
12 x 18¹¹⁄₁₆ (30.5 x 47.5 cm)
Private collection
Plate 213, p. 532

The Bather, c. 1885
Oil on canvas
50 x 38⅛ inches (127 x 96.8 cm)
The Museum of Modern Art, New York. Lillie P. Bliss
Collection, 1934 (1.1934)
Plate 64, p. 238

The Bay of Marseille Seen from L'Estaque, c. 1885
Oil on canvas
31⁹⁄₁₆ x 39⅝ inches (80.2 x 100.6 cm)
The Art Institute of Chicago. Mr. and Mrs. Martin A.
Ryerson Collection, 1933.1116
Plate 197, p. 502

Mont Sainte-Victoire, c. 1885
Graphite and watercolor on paper
12½ x 18 inches (31.8 x 45.7 cm)
Private collection, courtesy of Babcock Galleries,
New York
Plate 32, p. 173

Gardanne, 1885–86
Oil on canvas
36¼ x 29³⁄₁₆ inches (92.1 x 74.5 cm)
The Brooklyn Museum. Ella C. Woodward and
A. T. White Memorial Funds
Plate 56, p. 230

Chestnut Trees at the Jas de Bouffan, c. 1885–86
Oil on canvas
28 x 35½ inches (71.1 x 90.2 cm)
The Minneapolis Institute of Arts. The William Hood
Dunwoody Fund
Plate 156, p. 448

Apples and Biscuits, 1885–90
Oil on canvas
18⅛ x 21⅝ inches (46 x 55 cm)
Musée National de l'Orangerie, Paris. Jean Walter and
Paul Guillaume Collection (R.F. 1960-11)
Plate 189, p. 483

Madame Cézanne, c. 1886
Oil on canvas
49⅜ x 41½ inches (125.4 x 105.4 cm)
The Detroit Institute of Arts. Bequest of Robert H.
Tannahill (70.160)
Plate 36, p. 176; plate 135, p. 398

Mont Sainte-Victoire with Large Pine, c. 1887
Oil on canvas
26⁹⁄₁₆ x 36⁵⁄₁₆ inches (66.9 x 92.2 cm)
The Samuel Courtauld Trust, The Courtauld Gallery,
London
Illustrated on p. x

Landscape with Trees and a Small House, c. 1887–94
Black chalk and watercolor on laid paper
12¼ x 18½ inches
Museum Boijmans Van Beuningen, Rotterdam.
Koenigs Collection, inv. no. F II 149 (PK)
Plate 214, p. 533

Geraniums, 1888–90
Watercolor over graphite on laid paper
12 x 11¼ inches (30.5 x 28.5 cm)
National Gallery of Art, Washington, DC.
Collection of Mr. and Mrs. Paul Mellon, 1995.47.25
Plate 170, p. 460

Bathers, c. 1890
Oil on canvas
23¾ x 32⁵⁄₁₆ inches (60 x 82 cm)
Musée d'Orsay, Paris. Gift of Baroness Eva Gebhard-
Gourgaud, 1965 (R.F. 1965-3)
Plate 40, p. 180

Still Life, c. 1890
Oil on canvas
24 x 35½ inches (61 x 90.2 cm)
Pushkin Museum of Fine Arts, Moscow
Fig. 17.2, p. 467

The Card Players, 1890–92
Oil on canvas
25¾ x 32¼ inches (65.4 x 81.9 cm)
The Metropolitan Museum of Art, New York. Bequest
of Stephen C. Clark, 1960 (61.101.1)
Plate 210, p. 528

Portrait of Madame Cézanne, 1890–92
Oil on canvas
24⅜ x 20⅛ inches (61.9 x 51.1 cm)
Philadelphia Museum of Art. The Henry P.
McIlhenny Collection in memory of Frances P.
McIlhenny, 1986-26-1
Fig. 8.4, p. 211

The Smoker, c. 1890–92
Oil on canvas
36½ x 29 inches (92.7 x 73.7 cm)
State Hermitage Museum, St. Petersburg
Plate 155, p. 447

House among the Trees, c. 1890–95
Pencil and watercolor on white paper
12⅞ x 19¾ inches (32.7 x 50.2 cm)
Private collection, Germany
Plate 95, p. 296

Large Pine and Red Earth, 1890–95
Oil on canvas
28⅜ x 35¹³⁄₁₆ inches (72.1 x 91 cm)
State Hermitage Museum, St. Petersburg
Plate 24, p. 152; plate 162, p. 452

Study of Three Trees, 1890–95
Watercolor on paper
18⅞ x 12¼ inches (47.9 x 31.1 cm)
Collection of Kate Ganz
Illustrated on p. v

Man in a Blue Smock, 1892 or 1897
Oil on canvas
31⅞ x 25⁹⁄₁₆ inches (81 x 65 cm)
Kimbell Art Museum, Fort Worth, Texas. Acquired in
memory of Richard F. Brown, the Kimbell Art
Museum's first director, by the Kimbell Board of
Trustees, assisted by the gifts of many friends
Plate 62, p. 236

Curtain, Jug, and Compotier, 1893–94
Oil on canvas
23¼ x 28½ inches (59.1 x 72.4 cm)
Private collection, Chicago
Plate 90, p. 276

Still Life with Apples, 1893–94
Oil on canvas
25¾ x 32⅛ inches (65.5 x 81.5 cm)
J. Paul Getty Museum, Los Angeles
Plate 76, p. 250

Stoneware Jug, 1893–94
Oil on canvas
15 x 18⅛ inches (38.2 x 46 cm)
Beyeler Collection, Basel
Plate 45, p. 200

Forest, 1894
Oil on canvas
45¹³⁄₁₆ x 32 inches (116.4 x 81.3 cm)
Los Angeles County Museum of Art. Wallis
Foundation Fund in memory of Hal B. Wallis,
1992.161.1
Plate 141, p. 402

Winter Landscape, Giverny, 1894
Oil on canvas
25⅝ x 31⅞ inches (65.1 x 81 cm)
Philadelphia Museum of Art. Gift of Frank and Alice
Osborn, 1966-68-3
Plate 26, p. 154

The Large Bathers, 1894–1905
Oil on canvas
50¹⁄₁₆ x 77³⁄₁₆ inches (127.1 x 196 cm)
The Trustees of the National Gallery, London.
Purchased with a special grant and the aid of the
Max Rayne Foundation, 1964
Plate 203, p. 508

Bibémus Quarry, c. 1895
Oil on canvas
25⅝ x 31⅞ inches (65 x 81 cm)
Museum Folkwang, Essen
Plate 116, p. 342

Rose in the Greenery, 1895–1900
Pencil and watercolor on white paper
18¾ x 12¼ inches (47.6 x 31.1 cm)
Collection of Michael and Judy Steinhardt, New York
Plate 99, p. 298

Mont Sainte-Victoire Seen from the Bibémus Quarry,
c. 1897
Oil on canvas
25⅛ x 31½ inches (63.8 x 80 cm)
The Baltimore Museum of Art. The Cone Collection,
formed by Dr. Claribel Cone and Miss Etta Cone of
Baltimore, Maryland, BMA 1950.196
Plate 86, p. 272

Pyramid of Skulls, c. 1898
Oil on canvas
15⅜ x 18⅜ inches (39.1 x 46.7 cm)
Private collection
Plate 114, p. 325

Mont Sainte-Victoire Seen from Les Lauves, 1902–6
Oil on canvas
25½ x 32 inches (64.8 x 81.3 cm)
Private collection
Plate 184, p. 478

Mont Sainte-Victoire Seen from Les Lauves, 1902–6
Graphite and watercolor on paper
18½ x 12⅜ inches (47 x 31.4 cm)
Private collection
Plate 215, p. 534

The Large Bathers, 1906
Oil on canvas
82⅞ x 98¾ inches (210.5 x 250.8 cm)
Philadelphia Museum of Art. Purchased with the W. P.
Wilstach Fund, W1937-1-1
Plate 66, p. 240

Henri Matisse

(French, 1869–1954)

Le Luxe I, 1907
Oil on canvas
82⅝ x 54⅜ inches (210 x 138 cm)
Musée National d'Art Moderne, Centre Georges
Pompidou, Paris
Plate 9, p. 122

Bathers with a Turtle, 1908
Oil on canvas
78⅝ x 94 inches (199.7 x 238.8 cm)
Saint Louis Art Museum. Gift of Mr. and Mrs. Joseph
Pulitzer, Jr., 24:1964
Plate 6, p. 102

Back I, 1909
Bronze
74 x 44⅞ x 6½ inches (188 x 114 x 16.5 cm)
Hamburger Kunsthalle, permanent loan "Stiftung für
die Hamburger Kunstsammlungen"
Plate 11, p. 124

Bather, 1909
Oil on canvas
36½ x 29⅛ inches (92.7 x 74 cm)
The Museum of Modern Art, New York. Gift of Abby
Aldrich Rockefeller, 1936 (17.1936)
Plate 7, p. 121

Fruit, Flowers, and "The Dance," 1909
Oil on canvas
35 x 45⅝ inches (88.9 x 115.9 cm)
State Hermitage Museum, St. Petersburg
Plate 15, p. 128

The Geranium, 1910
Oil on canvas
17⅞ x 21⅝ inches (45.5 x 55 cm)
Private collection
Plate 16, p. 129

Millstone in the Park of the Château Noir, 1898–1900
Oil on canvas
28¾ x 36⅜ inches (73 x 92.4 cm)
Philadelphia Museum of Art. The Mr. and Mrs.
Carroll S. Tyson, Jr., Collection, 1963-116-4
Plate 19, p. 132

Seated Man, 1898–1900
Oil on canvas
40⁵⁄₁₆ x 29¾ inches (102 x 75.5 cm)
The National Museum of Art, Architecture and
Design, Oslo
Plate 38, p. 178

Oranges on a Plate, c. 1900
Watercolor and graphite on paper
11⅝ x 17⅞ inches (29.5 x 45.4 cm)
Philadelphia Museum of Art. The Mr. and Mrs.
Carroll S. Tyson, Jr., Collection, 1963-116-20
Plate 101, p. 300

Château Noir, 1900–1904
Oil on canvas
29 x 38 inches (73.7 x 96.5 cm)
National Gallery of Art, Washington, DC. Gift of
Eugene and Agnes E. Meyer, 1958.10.1
Plate 5, p. 93

Bottles, Pots, Spirit Stove, and Apples, 1900–1906
Pencil and watercolor on white paper
18½ x 22 inches (47 x 55.9 cm)
Private collection, Washington, DC
Plate 131, p. 378

Mont Sainte-Victoire, c. 1902
Oil on canvas
33 x 25⅝ inches (83.8 x 65.1 cm)
The Henry and Rose Pearlman Foundation, Inc.;
on long-term loan to the Princeton University Art
Museum
Illustrated on p. ii

Mont Sainte-Victoire, 1902–4
Oil on canvas
27½ x 35¼ inches (69.9 x 89.5 cm)
Philadelphia Museum of Art. The George W. Elkins
Collection, E1936-1-1
Plate 182, p. 476

Mont Sainte-Victoire Seen from Les Lauves, 1902–6
Oil on canvas
25⅛ x 32⅛ inches (63.8 x 81.6 cm)
The Nelson-Atkins Museum of Art, Kansas City.
Purchase Nelson Trust, 38-6
Plate 186, p. 480

Portrait of Olga Merson, 1911
Oil on canvas
39½ x 32 inches (100.3 x 81.3 cm)
The Museum of Fine Arts, Houston. Purchase with
Funds provided by the Agnes Cullen Arnold
Endowment Fund
Plate 3, p. 73

Mademoiselle Yvonne Landsberg, 1914
Oil on canvas
58 x 38⅜ inches (147.3 x 97.5 cm)
Philadelphia Museum of Art. The Louise and Walter
Arensberg Collection, 1950-134-130
Plate 17, p. 130

Bowl of Apples on a Table, 1916
Oil on canvas
45¼ x 35¼ inches (114.9 x 89.5 cm)
Chrysler Museum of Art, Norfolk, Virginia. Gift of
Walter P. Chrysler, Jr.
Plate 18, p. 131

Shaft of Sunlight, Woods of Trivaux, 1917
Oil on canvas
36¼ x 28¾ inches (92.1 x 73 cm)
Private collection
Plate 20, p. 133

Woman in Blue, 1937
Oil on canvas
36½ x 29 inches (92.7 x 73.7 cm)
Philadelphia Museum of Art. Gift of Mrs. John
Wintersteen, 1956-23-1
Plate 21, p. 134, and cover

Piet Mondrian
(Dutch, 1872–1944)

Tree, 1911–12
Oil on canvas
30 x 44³⁄₁₆ inches (76.2 x 112.3 cm)
Munson-Williams-Proctor Institute, Museum of Art,
Utica, New York
Plate 25, p. 153

Still Life with Gingerpot 2, 1912
Oil on canvas
36 x 47¼ inches (91.4 x 120 cm)
Gemeentemuseum, The Hague, S. B. Slijper Bequest
(since 1976 on loan to The Solomon R. Guggenheim
Museum, New York)
Plate 23, p. 136

Composition No. 11, 1913
Oil on canvas
34⅝ x 45¼ inches (88 x 115 cm)
Kröller-Müller Museum, Otterlo, The Netherlands
Plate 28, p. 156

Composition with Grid 4: Lozenge Composition, 1919
Oil on canvas
Diagonal 33½ x 33¼ inches (85 x 84.5 cm);
sides 23⅝ x 23¹¹⁄₁₆ inches (60 x 60.2 cm)
Philadelphia Museum of Art. The Louise and Walter
Arensberg Collection, 1950-134-151
Plate 27, p. 155

No. I: Opposition of Lines, Red and Yellow, 1937
Oil on canvas
17⅛ x 13¼ inches (43.5 x 33.6 cm)
Philadelphia Museum of Art. A. E. Gallatin
Collection, 1952-61-90
Plate 29, p. 157

Marsden Hartley
(American, 1877–1943)

Still Life No. 1, 1912
Oil on canvas
31½ x 25⅝ inches (80 x 65.1 cm)
Columbus Museum of Art, Ohio. Gift of Ferdinand
Howald
Plate 30, p. 158

New Mexico Landscape, 1919–20
Oil on canvas
30 x 36 inches (76.2 x 91.4 cm)
Philadelphia Museum of Art. The Alfred Stieglitz
Collection, 1949-18-10
Plate 31, p. 172

Mont Sainte-Victoire, 1927
Pencil on paper
21½ x 29¼ inches (54.6 x 61 cm)
Babcock Galleries, New York
Plate 33, p. 173

Mountains in Stone, Dogtown, 1931
Oil on academy board
18 x 24 inches (45.7 x 61 cm)
Collection of James and Barbara Palmer
Plate 43, p. 183

Young Hunter Hearing Call to Arms, c. 1939
Oil on masonite
41 x 30¼ inches (104.1 x 76.8 cm)
Carnegie Museum of Art, Pittsburgh. Patrons Art
Fund, 44.1.2
Plate 39, p. 179

*Canuck Yankee Lumberjack at Old Orchard Beach,
Maine*, 1940–41
Oil on fiberboard
40⅛ x 30 inches (101.9 x 76.2 cm)
Hirshhorn Museum and Sculpture Garden,
Smithsonian Institution, Washington, DC. Gift of
Joseph H. Hirshhorn, 1966
Plate 42, p. 182

Fernand Léger
(French, 1881–1955)

Compotier on the Table, 1911
Oil on canvas
32⅜ x 38½ inches (82.2 x 97.8 cm)
The Minneapolis Institute of Arts. The William Hood
Dunwoody Fund
Plate 46, p. 201

Woman in Blue, 1912
Oil on canvas
76 x 51⅛ inches (193 x 129.9 cm)
Öffentliche Kunstsammlung Basel, Kunstmuseum
Basel
Plate 44, p. 184

Village in the Forest, 1914
Oil on burlap
29⅛ x 36⅝ inches (74 x 93 cm)
Albright-Knox Art Gallery, Buffalo, New York. Gift of
A. Conger Goodyear, 1960:4
Plate 47, p. 202

The Mechanic, 1920
Oil on canvas
45⅝ x 35 inches (116 x 88.8 cm)
National Gallery of Canada, Ottawa. Purchased 1966
Plate 50, p. 205

Pablo Picasso
(Spanish, 1881–1973)

Self-Portrait, 1906
Oil on canvas
36¼ x 28¾ inches (92.1 x 73 cm)
Philadelphia Museum of Art. A. E. Gallatin
Collection, 1950-1-1
Plate 51, p. 206

Landscape, 1907
Gouache over charcoal on thick beige paper
18¾ x 24¼ inches (47.6 x 56.5 cm)
Collection of Kate Ganz
Plate 52, page 226

Nudes in a Forest, 1908
Watercolor, gouache, and graphite on wove paper
18¾ x 23¼ inches (47.6 x 59.1 cm)
Philadelphia Museum of Art. The Samuel S. White
3rd and Vera White Collection, 1967-30-68
Plate 69, p. 243

Still Life with Bowls and a Jug, 1908
Oil on canvas
32¼ x 25⅞ inches (81.9 x 65.7 cm)
Philadelphia Museum of Art. A. E. Gallatin
Collection, 1952-61-93
Plate 82, p. 255

Seated Female Nude, 1908–9
Oil on canvas
45⅞ x 35³⁄₁₆ inches (116.5 x 89.4 cm)
Philadelphia Museum of Art. The Louise and Walter
Arensberg Collection, 1950-134-164
Plate 68, p. 242

Carafe, Compote, and Candlestick, 1909
Oil on canvas
21½ x 29⁹⁄₁₆ inches (54.5 x 75 cm)
Private collection
Plate 79, p. 253

Fruit, Walnut, and Glass, 1909
Watercolor on paper
9⅜ x 12⅜ inches (24 x 31.5 cm)
Private collection
Plate 80, p. 253

The Glass of Beer, 1909
Oil on canvas
31⅞ x 25¾ inches (81 x 65.5 cm)
Musée d'Art Moderne de Lille, Villeneuve d'Ascq.
Gift of Jean and Geneviève Masurel, inv. no. 979.4.111
Plate 77, p. 251

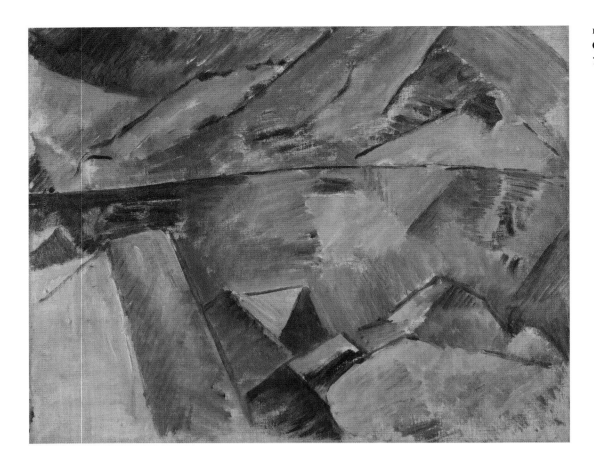

Santa Bárbara Mountain, 1909
Oil on canvas
15⅜ x 18⅝ inches (39.1 x 47.3 cm)
Private collection
Plate 53, p. 227

Still Life with Compote and Glass, 1914–15
Oil on canvas
25¼ x 31½ inches (64.1 x 80 cm)
Columbus Museum of Art, Ohio. Gift of Ferdinand Howald
Plate 74, p. 248

The Dream (Marie-Thérèse), 1932
Oil on canvas
51¼ x 38⅛ inches (130.2 x 96.8 cm)
From the Collection of Steve and Elaine Wynn
Plate 61, p. 235, and cover

Still Life with Sausage, 1941
Oil on canvas
36½ x 25⅞ inches (92.7 x 65.7 cm)
Collection of Gail and Tony Ganz, Los Angeles
Plate 75, p. 249

Winter Landscape, 1950
Oil on panel
40½ x 49½ inches (102.9 x 125.7 cm)
Collection of Kate Ganz
Plate 59, p. 233

The Bathers, 1956
Bronze
Height (largest figure) 103 inches (261.6 cm)
Kykuit, National Trust for Historic Preservation, Nelson A. Rockefeller bequest
Plate 67, p. 241

Georges Braque

(French, 1882–1963)

The Bay of L'Estaque, 1908
Oil on canvas
13 x 16⅛ inches (33 x 41 cm)
Harvard University Art Museums—Fogg Museum, Cambridge, Massachusetts. Purchase through the generosity of Emily Rauh Pulitzer, Myron Laskin, George David, Ellen Abbott Gilman Trust, Jessie Lie Farber, Frances H. Burr Memorial Fund and the Director's Discretionary Fund; and through the generosity of Philip and Lynn Straus, Marshall Field, Irvin and Rebekah Taube, John and Jill Walsh and Richard E. Oldenburg in honor of James Cuno, 2001.117
Plate 216, p. 536

Fruit Dish, 1908
Oil on canvas
20⅞ x 25¼ inches (53 x 64.1 cm)
Moderna Museet, Stockholm. Donation 1966 from Rolf de Maré
Plate 85, p. 271

The Table (Still Life with Fan), 1910
Oil on canvas
15 x 21¾ inches (38.1 x 55.2 cm)
The Museum of Modern Art, New York. Promised anonymous gift and bequest of Florene May Schoenborn (by exchange), 2006 (358.2006)
Plate 91, p. 277

Studio with Skull, 1938
Oil on canvas
36¼ x 36¼ inches (92.1 x 92.1 cm)
Private collection
Plate 83, p. 256

Studio V, 1949–50
Oil on canvas
57⅞ x 69½ inches (147 x 176.5 cm)
The Museum of Modern Art, New York. Acquired through the Lillie P. Bliss Bequest, 2000 (123.2000)
Plate 89, p. 275

Charles Demuth

(American, 1883–1935)

Mt. Gilboa #5, c. 1914–15
Watercolor on paper
10 x 14 inches (25.4 x 35.5 cm)
Hirshhorn Museum and Sculpture Garden, Smithsonian Institution, Washington, DC. Gift of Joseph H. Hirshhorn, 1966. 66.1318
Plate 93, p. 294

Bermuda, 1917
Watercolor and graphite on off-white wove paper
10 x 14 inches (25.4 x 35.6cm)
Philadelphia Museum of Art. The Louise and Walter Arensberg Collection, 1950-134-44
Plate 94, p. 295

Bermuda Landscape #2, 1917
Watercolor and graphite on wove paper
10 x 14 inches (25.4 x 35.6 cm)
The Barnes Collection, Merion, Pennsylvania
Fig. 10.7, p. 286

Red-Roofed Houses, 1917
Watercolor and pencil on thick off-white wove paper
9¾ x 14 inches (24.8 x 35.6 inches)
Philadelphia Museum of Art. The Samuel S. White 3rd and Vera White Collection, 1967-30-25
Plate 98, p. 297

PLATE 217
Charles Demuth
Bowl of Oranges, **1925**

Trees and Barns: Bermuda, 1917
Watercolor over pencil on paper
9½ x 13½ inches (24.1 x 34.3 cm)
Williams College Museum of Art, Williamstown,
Massachusetts. Bequest of Susan W. Street, 57.8
Plate 96, p. 296

Orange Tree and Primrose, 1920
Watercolor and pencil on paper
17½ x 11½ inches (44 x 29 cm)
Carnegie Museum of Art, Pittsburgh. Gift of Lee C.
Gordon. 85.31
Plate 92, p. 278

Bowl of Oranges, 1925
Watercolor over graphite on paper
13½ x 19¾ inches (34.3 x 50.2 cm)
Columbus Museum of Art, Ohio. Gift of Ferdinand
Howald
Plate 217, p. 537

Eggplant and Green Pepper, 1925
Watercolor and pencil on paper
18 x 11¹⁵⁄₁₆ inches (45.7 x 30.3 cm)
Saint Louis Art Museum. Eliza McMillan Trust
Plate 106, p. 305

Green Pears, 1929
Watercolor over graphite on paper
13⅞ x 19⅞ inches (35.2 x 50.5 cm)
Yale University Art Gallery, New Haven, Connecticut.
Philip L. Goodwin, B.A. 1907, Collection, Gift of
James L. Goodwin, B.A. 1905, Henry Sage Goodwin,
B.A. 1927, and Richmond L. Brown, B.A. 1907
Plate 104, p. 303

Three Red Apples, c. 1929
Watercolor and pencil on paper
10 x 14 inches (25.4 x 35.6 cm)
Debra Force Fine Art, New York
Plate 102, p. 301

Max Beckmann

(German, 1884–1950)

The Harbor of Genoa, 1927
Oil on canvas
35⅝ x 66¾ inches (90.5 x 169.5 cm)
Saint Louis Art Museum. Bequest of Morton D. May
Plate 110, p. 321

Seascape with Agaves and Old Castle, 1939
Oil on canvas
25⅜ x 32⅛ inches (64.5 x 81.5 cm)
Staatliche Museen zu Berlin, Nationalgalerie,
inv. no. B29
Plate 108, p. 319

Quappi in Blue and Gray, 1944
Oil on canvas
38¹⁵⁄₁₆ x 30³⁄₁₆ inches (99 x 77 cm)
Museum Kunst Palast, Düsseldorf
Plate 112, p. 323

Still Life with Three Skulls, 1945
Oil on canvas
21¾ x 35¼ inches (55.2 x 89.5 cm)
Museum of Fine Arts, Boston. Gift of Mrs. Culver
Orswell, 67.984
Plate 113, p. 324

Liubov Popova

(Russian, 1889–1924)

Pictorial Architecture, 1918
Oil on canvas
10⅞ x 13½ inches (27.6 x 34.2 cm)
Courtesy of Ivor Braka Limited
Plate 117, p. 343

Giorgio Morandi

(Italian, 1890–1964)

Landscape, 1942
Oil on canvas
14⅛ x 20⅝ inches (35.8 x 52.5 cm)
Pinacoteca Provinciale, Bari. Collezione Grieco
Plate 126, p. 373

Still Life, 1946
Oil on canvas
14¹⁵⁄₁₆ x 18⅛ inches (38 x 46 cm)
The Cartin Collection
Plate 130, p. 377

Still Life, 1947
Oil on canvas
8¹⁄₁₆ x 10¹³⁄₁₆ inches (20.5 x 27.5 cm)
The Cartin Collection
Plate 124, p. 350

Still Life, 1952
Oil on canvas
14³⁄₁₆ x 15¹¹⁄₁₆ inches (36 x 39.8 cm)
The Cartin Collection
Plate 132, p. 379

Cortile di via Fondazza, 1954
Oil on canvas
18⅞ x 19⅝ inches (47.9 x 49.8 cm)
Private collection
Plate 128, p. 375

Alberto Giacometti

(Swiss, 1901–1966)

Still Life with Apple, 1937
Oil on canvas
28¼ x 29½ inches (71.8 x 74.9 cm)
The Metropolitan Museum of Art, New York. The Pierre and Maria-Gaetana Matisse Collection, 2002 (2002.456.3)
Plate 134, p. 397, and cover

Bust of Diego, 1954
Painted bronze
15½ x 13¼ x 8¼ inches (39.4 x 33.7 x 21 cm)
Raymond and Patsy Nasher Collection, Dallas
Plate 139, p. 401

Diego in a Cloak, 1954
Painted bronze
15⅜ x 13½ x 8¾ inches (39.1 x 34.3 x 22.2 cm)
Raymond and Patsy Nasher Collection, Dallas
Plate 140, p. 401

Diego in a Plaid Shirt, 1954
Oil on canvas
31⅞ x 25¾ inches (81 x 65.4 cm)
Private collection
Plate 133, p. 380

Diego in a Sweater, 1954
Painted bronze
19 x 10¾ x 8¼ inches (48.3 x 27.3 x 21 cm)
Raymond and Patsy Nasher Collection, Dallas
Plate 138, p. 401

Landscape at Stampa, 1960
Oil on canvas
21¾ x 18¼ inches (55.2 x 46.4 cm)
Private collection
Plate 142, p. 403

Arshile Gorky

(American, born Armenia, 1904–1948)

Staten Island, 1927
Oil on canvas
16 x 20 inches (40.6 x 50.8 cm)
Private collection
Plate 150, p. 429

Still Life with Skull, c. 1927–28
Oil on canvas
33 x 26¼ inches (83.8 x 66.7 cm)
Private collection
Plate 146, p. 425

Pears, Peaches, and Pitcher, c. 1928
Oil on canvas
17¼ x 23⅝ inches (43.8 x 60 cm)
Private collection
Plate 145, p. 406

Crooked Run, 1944
Oil on canvas
19 x 28 inches (48.3 x 71.1 cm)
Private collection
Plate 151, p. 430

Dark Green Painting, c. 1948
Oil on canvas
43⅞ x 55⅞ inches (111.4 x 141.9 cm)
Philadelphia Museum of Art. Gift (by exchange) of Mr. and Mrs. Rodolphe Meyer de Schauensee and R. Sturgis and Marion B. F. Ingersoll, 1995-54-1
Plate 152, p. 431

Ellsworth Kelly

(American, born 1923)

Larry, 1947
Oil on paper
23¾ x 18¾ inches (60.3 x 47.6 cm)
Collection of the artist
Plate 154, p. 446

Apples, 1949
Watercolor and pencil on paper
24¾ x 19⅜ inches (62.9 x 49.2 cm)
Collection of the artist
Plate 169, p. 459

Three Trees (1), 1950
Pencil on paper
17½ x 12½ inches (44.5 x 31.8 cm)
Collection of the artist
Plate 157, p. 449

Three Trees (2), 1950
Pencil on paper
17½ x 12½ inches (44.5 x 31.8 cm)
Collection of the artist
Plate 158, p. 449

Three Trees (3), 1950
Pencil and ink on paper
17⅝ x 12½ inches (44.8 x 31.8 cm)
Collection of the artist
Plate 159, p. 449

Meschers, 1951
Oil on canvas
59 x 59 inches (149.9 x 149.9 cm)
Private collection
Plate 163, p. 453

Train Landscape, 1952–53
Oil on canvas (three joined panels)
44 x 44 inches (111.8 x 111.8 cm)
Collection of the artist. On loan to the Art Institute of Chicago
Plate 153, p. 432

Untitled, 1987
Bronze
104 x 79 x ¾ inches (264.2 x 200.7 x 1.9 cm)
Collection of the artist
Plate 161, p. 451

Mont Sainte-Victoire from Beaurecueil, 2000
Pencil on paper, two sheets
14½ x 35¾ inches (36.5 x 90.2 cm)
Collection of the artist
Plate 167, p. 457

Geranium, 2002
Pencil on paper
17 x 14 inches (43.2 x 35.6 cm)
Private collection
Plate 171, p. 461

Geranium, 2002
Pencil on paper
17 x 14 inches (43.2 x 35.6 cm)
Private collection
Plate 172, p. 461

Geranium, 2002
Pencil on paper
17 x 14 inches (43.2 x 35.6 cm)
Collection of the artist
Plate 173, p. 461

Lake II, 2002
Oil on canvas
95 x 149⅜ inches (241.3 x 379.4 cm)
Beyeler Collection, Basel
Plate 165, p. 455

Jasper Johns

(American, born 1930)

Drawer, 1957
Encaustic on canvas with objects
30½ x 30½ inches (77.5 x 77.5 cm)
Rose Art Museum, Brandeis University, Waltham, Massachusetts. Gevirtz-Mnuchin Purchase Fund
Plate 175, p. 466, and cover

Painting with Two Balls, 1960
Encaustic and collage on canvas with objects
66 x 54 inches (167.6 x 137.2 cm)
Collection of the artist, on loan to the Philadelphia Museum of Art
Plate 188, p. 482

Map, 1963
Encaustic and collage on canvas
60 x 93 inches (152.4 x 236.2 cm)
Private collection
Plate 185, p. 479

Dancers on a Plane, 1979
Oil on canvas with objects
77⅞ x 64 inches (197.8 x 162.6)
Collection of the artist
Plate 193, p. 487

In the Studio, 1982
Encaustic and collage on canvas with objects
72 x 48 inches (182.9 x 121.9 cm)
Collection of the artist, on loan to the Philadelphia
Museum of Art
Plate 192, p. 486

Fall, 1986
Encaustic on canvas
75 x 50 inches (190.5 x 127 cm)
Collection of the artist, on loan to the Philadelphia
Museum of Art
Plate 174, p. 462

Tracing after Cézanne, 1994
Ink on plastic
18¾ x 30⅜ inches (47.6 x 77.2 cm)
Collection of the artist
Plate 176, p. 474

Tracing after Cézanne, 1994
Ink on plastic
20½₆ x 28 inches (51 x 71.1 cm)
Collection of the artist
Plate 177, p. 474

Tracing after Cézanne, 1994
Ink on plastic
18⅛ x 28⅜ inches (46 x 72.1 cm)
Collection of the artist
Plate 178, p. 474

Tracing after Cézanne, 1994
Ink on plastic
17⅝₆ x 28⅕₆ inches (44.6 x 71.6 cm)
Collection of the artist
Plate 179, p. 475

Tracing after Cézanne, 1994
Ink on plastic
18⅛ x 29⅝₆ inches (46 x 74.8 cm)
Collection of the artist
Plate 180, p. 475

Tracing after Cézanne, 1994
Ink on plastic
18 x 28⅛ inches (45.7 x 71.4 cm)
Collection of the artist
Plate 181, p. 475

Brice Marden

(American, born 1938)

Grove Group V, 1976
Oil and wax on canvas
72 x 108 inches (182.9 x 274.3 cm)
Museum of Contemporary Art, Chicago. Gerald S.
Elliott Collection, 1995.67a–c
Plate 198, p. 503

Coda, 1983–84
Oil and wax on canvas
120 x 39 inches (304.8 x 99.1 cm)
Philadelphia Museum of Art. Purchased with funds
contributed by the Daniel W. Dietrich Foundation in
honor of Mrs. H. Gates Lloyd, and gifts (by
exchange) of Samuel S. White 3rd and Vera White and
Mr. and Mrs. Charles C. G. Chaplin, 1985-22-1
Plate 200, p. 505

Muses Drawing 4, 1989–91
Ink and gouache on paper
26 x 40⅝ inches (66 x 103.2 cm)
Private collection
Plate 202, p. 507

Skull with Thought, 1993–95
Oil on linen
70⅞ x 57 inches (180 x 144.8 cm)
Private collection
Plate 196, p. 490

Red Rocks (1), 2000–2002
Oil on linen
75 x 107 inches (190.5 x 271.8 cm)
Collection of the artist, courtesy of Matthew Marks
Gallery, New York
Plate 204, p. 509

Jeff Wall

(Canadian, born 1946)

Coastal Motifs, 1989
Transparency in lightbox
46⅞ x 57⅞ inches (119 x 146 cm)
Collection of the artist
Plate 205, p. 510

The Crooked Path, 1991
Transparency in lightbox
46⅞ x 58¾ inches (119 x 149 cm)
Friedrich Christian Flick Collection
Plate 207, p. 525

Card Players, 2006
Transparency in lightbox
45⅞ x 50 inches (116.6 x 127 cm)
Private collection
Plate 211, p. 529

Sherrie Levine

(American, born 1947)

Pyramid of Skulls: 1–12, 2002
Black-and-white photographs, set of twelve
Each 8 x 10 inches (20.3 x 25.4 cm); overall 52⅝ x
88⅝ inches (136.2 x 225.1 cm)
Collection of Wanda Kownacki; courtesy of Edward
Boyer Associates Fine Art Advisory
Fig. 1.2, p. 4

Luc Tuymans

(Belgian, born 1958)

Untitled (Still Life), 2002
Oil on canvas
136¹¹⁄₁₆ x 196⅞ inches (347 x 500 cm)
Courtesy of David Zwirner, New York, and
Zeno X Gallery, Antwerp
Illustrated on p. xiv

Francis Alÿs

(Belgian, born 1959)

After Cézanne, 2009
Not illustrated

Notes

Rishel and Sachs, "The Making of an Exhibition"

1. Our translation. See Charles Baudelaire, "Exposition Universelle de 1855," in *Oeuvres complètes de Baudelaire*, ed. Y.-G. le Dantec, rev. ed. Claude Pichois (Paris: Gallimard, 1961), p. 959: "L'artiste ne relève que de lui-même. Il ne promet aux siècles à venir que ses propres oeuvres. Il ne cautionne que lui-même. Il meurt sans enfants. Il a été son roi, son prêtre et son Dieu." Quoted in Venturi 1936, vol. 1, p. 15.

2. Venturi 1936, vol. 1, p. 13.

3. See Foster et al. 2004, vol. 1, p. 70.

4. See ibid.

5. See ibid.; also Matisse 1995, p. 80.

6. Cachin et al. 1996.

7. See Jean-Louis Prat, Caroline Edde, and Frank Schmidt, *Les peintres sculpteurs*, exh. cat. (Baden-Baden, Germany: Museum Frieder Burda, 2008).

8. See Rewald 1986a, p. 135.

9. Denis 1907, translated into English and published in *The Burlington Magazine* by Roger Fry in January 1910.

10. Bell 1922, p. 11.

11. A. G. Kostenevich, *Pol' Sezann i Russkii avangard nachala XX veka* (St. Petersburg: State Hermitage Museum, 1998).

12. See Albert Kostenevich, "Russia-France: A Meeting at the Crossroads," in *From Russia: French and Russian Master Paintings, 1870–1925, from Moscow and St. Petersburg* (London: Royal Academy of Arts, 2008), p. 47.

13. Between 1897 and 1899 Hoogendijk acquired thirty-one Cézanne paintings from Vollard. See Cachin et al. 1996, p. 572.

14. See Marianne W. Martin, *Futurist Art and Theory, 1909–1915* (Oxford: Clarendon Press, 1968), p. 184.

15. Rewald 1986b, pp. 16–18.

16. Haskell 1980, p. 74.

17. Philadelphia Museum of Art 1934; Art Institute of Chicago 1952; Rubin 1977.

18. See Michael Taylor, ed., *Arshile Gorky: A Retrospective* (Philadelphia: Philadelphia Museum of Art, forthcoming).

19. Galerie Bernheim-Jeune 1914, plate 3.

20. This relationship is discussed with particular insight by Suzanne Pagé and Yve-Alain Bois in Pagé et al. 2006.

21. Diego Rivera, "No More Cézannes," in *My Art, My Life: An Autobiography* (New York: Citadel Press, 1960), p. 33.

22. See Rewald 1996, cats. 115, 289–91.

23. Richard Hamilton, *Collected Works, 1953–1982* (New York: Thames and Hudson, 1982), p. 12.

24. In conversation, September 2008.

25. See Katherine Sachs's essay in this volume, pp. 491–509 below.

26. "Conversation: Richard Serra and Lynne Cooke; A Sachs Forum in Contemporary Art," Institute of Contemporary Art, University of Pennsylvania, Philadelphia, October 25, 2007 (transcribed by the authors).

Chronology

Paintings by Cézanne cited in the chronology are identified using numbers from Rewald's 1996 catalogue raisonné on the artist.

1. Matisse made conflicting statements about when his first exposure to Cézanne occurred; it is possible that this was the first time he saw the artist's work. See Baumann, Feilchenfeldt, and Gassner 2004, p. 214; Barr 1951a, p. 36; Rubin 1977, p. 195.

2. Pissarro to his son Lucien, November 21, 1895; English translation in Hoog 1994, p. 153.

3. See Flam 1995, p. 226, who states that the show did not have an "immediate effect" on Matisse, as he was "not yet 'ready' to understand Cézanne."

4. Natanson 1896, p. 517; English translation in Cachin et al. 1996, p. 554.

5. See Cachin et al. 1996, p. 555.

6. Ibid., p. 557.

7. See Rewald 1986a, p. 270.

8. Letters between Cézanne and Denis, June 1901; English translation in Cachin et al. 1996, p. 559.

9. Rewald 1996, pp. 224, 285.

10. Ibid., pp. 227–28.

11. Cézanne to Vollard, January 9, 1903, Vollard Archives, Musée d'Orsay, Paris; English translation in Cachin et al. 1996, p. 562; for an alternate translation, see Cézanne 1995, pp. 293–94.

12. Reinhard Piper, "Durch vier Jahrzehnte mit Max Beckmann," in Piper 1964, p. 328; English translation in Schulz-Hoffmann and Weiss 1984, p. 114.

13. See "First One-Man Show," in Barr 1951a, p. 45.

14. Bernard 1904; English translation in Doran 2001, pp. 38–40.

15. See Jill Kyle, "Paul Cézanne, 1911: Nature Reconstructed," in Greenough et al. 2000, p. 103.

16. Rewald 1996, p. 241.

17. Cézanne to Roger Marx, January 23, 1905; English translation in Cachin et al. 1996, p. 566.

18. "The Reminiscences of Max Weber," interview with C. S. Gruber, Columbia University Oral Research Collection, New York, 1958, pp. 18–19; cited in Kyle, "Paul Cézanne, 1911: Nature Reconstructed," p. 107.

19. See Matisse 1995, p. 32.

20. See Lassaigne 1973, p. xvi.

21. Norman 1938, p. 81; cited in Whelan 1995, p. 226.

22. Weber, "Rousseau and the Cézanne Memorial Exhibition, 1907," untitled typescript; cited in Leonard 1970, p. 22.

23. Léger to André Mare, 1907, Archive of the Association André Mare, Paris; English translation in Kosinski 1994, p. 40 n. 24.

24. See Claude Laugier, "Biography," in Centre Georges Pompidou 1997, p. 281.

25. Weber, "Rousseau and the Cézanne Memorial Exhibition, 1907," pp. 22–23.

26. Rewald 1989, p. 112.

27. Rilke 1985, pp. 42–43.

28. Cézanne to Émile Bernard, April 15, 1904; English translation in Cézanne 1995, p. 301.

29. Cézanne to Émile Bernard, July 25, 1904; English translation in Cézanne 1995, p. 306.

30. Huneker 1922, p. 76; cited in Rewald 1989, p. 112.

31. Max Weber, "On Matisse's School," text of a lecture given at the Museum of Modern Art, New York, October 22, 1951; cited in Flam 1988, pp. 101–2.

32. Weber, "Cézanne and the Crisis of 1907–1908," in Barr 1951a, p. 87.

33. Ottilie de Kozmutza, "The Art of Paul Cézanne," Burr-McIntosh Monthly, March 1908; cited in Rewald 1989, pp. 117–18.

34. Barr 1951a, p. 170.

35. Pica 1908; cited in Abramowicz 1981, p. 98; Philippe Daverio Gallery 1990, n.p.

36. Rubin 1989, p. 359.

37. Morice 1909, pp. 725–31; English translation in Rubin 1989, p. 360.

38. Apollinaire 1910, p. 150; English translation in Zurcher 1988, p. 25.

39. Roger Fry, in The Nation, December 4, 1911; cited in Baumann, Feilchenfeldt, and Gassner 2004, p. 223.

40. See "The Reminiscences of Max Weber," interview with C. S. Gruber, Columbia University Oral Research Collection, New York, 1958, pp. 248–49; cited in Jill Kyle, "Paul Cézanne, 1911: Nature Reconstructed," in Greenough et al. 2000, p. 103.

41. Remarks made during the show's opening, published in De Tijd, October 7, 1911; English translation in Janssen and Joosten 2002, p. 163.

42. "Cézanne Exhibition," Camera Work, no. 36 (October 1911), p. 30.

43. Hartley 1997, p. 66.

44. Alfred Stieglitz, letter to the editor, New York Evening Sun, December 18, 1911; cited in Whelan 1995, p. 297.

45. Quoted in Norman 1938, p. 81; see also Sarah Greenough, "Alfred Stieglitz, Rebellious Midwife to a Thousand Ideas," in Greenough et al. 2000, p. 32.

46. Claude Laugier, "Biography," in Centre Georges Pompidou 1997, p. 281.

47. Rainbird 2003, p. 264.

48. Hartley and Stieglitz 2002, p. 12.

49. "Somehow a Past," unpublished manuscript, Hartley Archive, Yale Collection of American Literature, Beinecke Rare Book and Manuscript Library, New Haven, Connecticut; cited in Ludington 1992, p. 78.

50. Hartley and Stieglitz 2002, p. 47.

51. Hartley 1989, p. 37.

52. Beckmann 1914; English translation in Beckmann 1997, pp. 131–32.

53. Max Beckmann, "Creative Credo" (September 1918); first published in Schöpferische Konfession, Tribüne der Kunst und Zeit 13 (Berlin: E. Reiss, 1920); English translation in Beckmann 1997, pp. 184–85.

54. Christian Geelhaar, "The Painters Who Had the Right Eyes: On the Reception of Cézanne's Bathers," in Krumrine 1989a, pp. 296–97.

55. See Rabinow 2000, p. 4.

56. Ibid., p. 7.

57. See Robbins 2006, p. 18.

58. Herrera 2003, p. 144.

59. Gorky, in Levy 1966, p. 15.

60. See Ludington 1992, p. 178.

61. Murdock Pemberton, "Soul Exposures," Creative Art, January 1929, p. xlviii; cited in Townsend Ludington, "Marsden Hartley: On Native Ground," in Greenough et al. 2000, p. 401.

62. Herrera 2003, p. 220.

63. Matisse to Raymond Escholier, director of the Petit Palais, Paris, November 10, 1936; English translation in Matisse 1995, p. 124.

64. See Robbins 2006, p. 18.

65. De Francia 1983, p. 63.

66. Beckmann, "Letters to a Woman Painter," February 3, 1948, in Beckmann 1997, p. 316.

67. Rainbird 2003, p. 237.

68. Loos 2003.

69. Jasper Johns, interview with David Bourdon, Whitney Museum of American Art, New York, October 11, 1977; cited in Varnedoe 1996b, p. 157.

70. Quoted in Rubin 1972, p. 44.

71. See Rossi 1998, p. 178.

72. "Entretien avec Alberto Giacometti," April 16, 1957, in Charbonnier 1959, p. 177 (my translation).

73. Daix 1993, p. 339.

74. Christian Geelhaar, "The Painters Who Had the Right Eyes: On the Reception of Cézanne's Bathers," in Krumrine 1989a, p. 296.

75. Bernstein 1985, p. 69.

76. Marden, in Sharp 1970–71, p. 42.

77. Newman 2007, p. 90.

78. Jasper Johns, Bourdon interview, p. 157.

79. Kelly 1990, n.p.

80. See Fairbrother et al. 1991, p. 30.

81. See Criqui 2006, back cover.

Storr, "La Famille Cézanne"

1. Dore Ashton, comp., Picasso on Art: A Selection of Views, The Documents of 20th-Century Art (New York: Viking Press, 1972), p. 162.

2. See Varnedoe 1996b.

3. See Chipp 1968, p. 364.

4. David Robbins, ed., The Independent Group: Postwar Britain and the Aesthetics of Plenty (Cambridge: MIT Press, 1990), p. 181.

5. John Rewald, Paul Cézanne: A Biography (New York: Simon and Schuster, 1939), p. 155.

6. See Chipp 1968, p. 18.

7. For a discussion of when this statement was first reported, and how Cézanne phrased it (the sources are all secondhand), see Richard Shiff, Cézanne and the End of Impressionism: A Study of the Theory, Technique, and Critical Evaluation of Modern Art (Chicago: University of Chicago Press, 1984), pp. 180–83.

8. See Chipp 1968, p. 19.

9. Ibid., p. 274.

10. Cézanne wrote to Bernard, "You will soon turn your back on the Gauguins and [van] Goghs," April 15, 1904; English translation in Cézanne 1995, p. 301."

11. Benjamin H. D. Buchloh, "Figures of Authority, Ciphers of Regression: Notes on the Return of Representation in European Painting," October 16 (Spring 1981: Art World Follies), pp. 39–68. Apparently traumatized by the confrontations between radical protestors and conservative government during the 1960s and 1970s when he was a student in Germany, and haunted like many in his generation by older generations' complicity with National Socialism, Buchloh does not make crucial distinctions between "progressive" and "regressive" tendencies in art and those in politics, and is thus inclined to see all representational art of the period—from Objectivism to Magic Realism, from Max Beckmann to Giorgio de Chirico—as crypto-fascist, even when a given artist belonged to the Communist party, as many Neue Sachlichkeit painters did, or avoided all party affiliations, as many others did. The glaring fact about fascism, and the fatal flaw in Buchloh's argument by extension, is how few artists of note it recruited or appealed to—the Italian Futurists, for instance, who, by the way, were not realists or for that matter Expressionists or Symbolists—not how many.

12. Harold Bloom, *The Anxiety of Influence: A Theory of Poetry* (New York: Oxford University Press, 1973).

13. Gerhard Richter, *The Daily Practice of Painting: Writings and Interviews, 1962–1993*, ed. Hans Ulrich Obrist (Cambridge, MA: MIT Press, 1995), pp. 216–17.

14. Ibid., p. 55.

15. Ibid., p. 139.

16. See "His Heart Belongs to Dada," *Time* magazine, May 4, 1959, p. 58; reprinted in Varnedoe 1996b, pp. 81–82.

17. Elizabeth Murray, interview with Robert Storr, in Storr, *Elizabeth Murray* (New York: Museum of Modern Art, 2005), p. 172.

18. Ibid.

Shiff, "Lucky Cézanne"

1. Adespoton 473, *Lyrica Graeca selecta*, ed. Denys L. Page (Oxford: Clarendon, 1968), p. 253 (translation courtesy Nassos Papalexandrou). The earliest references to Tyche, such as this quoted choral fragment (probably 5th century BCE), tend to present demonic chance as relatively beneficent. In later accounts, Tyche appears capricious and senseless, the cause of misfortune as much as of fortune. Our colloquial usage of *luck* and *fortune* seems to retain the early sense of tychic chance; when the word lacks a modifier (luck, not *bad* luck), we assume that the luck in question must be good—hence, the humor in the contemporary lyrical refrain, "If it wasn't for bad luck, I wouldn't have no luck at all." There remains the sense that every life is fated and has its fortune, whether or not justified by the individual's willful actions. Life without chance, life lacking spontaneity and unexpected turns of fortune, life neither comic nor tragic, is not human life.

I have written on Cézanne's practice, on his critical history, and on his relation to twentieth-century art on several other occasions. Three previous essays are the most relevant to this one: "Mark, Motif, Materiality: The Cézanne Effect in the Twentieth Century," in Baumann et al. 2000, pp. 99–123 (repr. in Lewis 2007, pp. 286–321); "Apples and Abstraction," in Rathbone and Shackelford 2001, pp. 42–47; "Risible Cézanne," in Kahng 2007, pp. 127–71. The present essay does not supplant earlier work but supplements it while moving in somewhat different directions with the aim of including (what are for me) new sources among the massive amount of available documentation. For broad, balanced accounts of commentary on Cézanne, see Françoise Cachin and Joseph J. Rishel, "A Century of Cézanne Criticism," in Cachin et al. 1996, pp. 24–75; Terence Maloon, "A Painter's Painter," in Maloon and Gundert 1998, pp. 169–81. The British critic Roger Fry is among those influential figures who play no role in "Lucky Cézanne," although he might have. On Fry, see my "From Primitivist Phylogeny to Formalist Ontogeny: Roger Fry and Children's Drawings," in *Discovering Child Art: Essays on Childhood, Primitivism, and Modernism*, ed. Jonathan David Fineberg (Princeton: Princeton University Press, 1998), pp. 157–200. With regard to a tychic factor in the history of art, I have explored this matter previously, but in a very different context: See my "Tychisches Motitiv. Baselitz in der Geschichte,"

in *Georg Baselitz, Bilder. Die den Kopf verdrehen*, ed. Susanne Kleine, exh. cat., Kunst- und Ausstellungshalle der Bundesrepublik Deutschland, Bonn (Leipzig: Seemann, 2004), pp. 164–85. I thank Caitlin Haskell for extensive aid in research. Throughout, unless otherwise noted, translations are mine. I have favored translation into idiomatic English as opposed to more literal phrasing.

2. On sidewalks, see Émile Bernard, "Souvenirs sur Paul Cézanne et lettres inédites," *Mercure de France* 69 (October 1, 1907), p. 403. (For the entirety of Bernard's "Souvenirs," see Bernard 1907.) On street lighting, see Cézanne to Paule Conil, September 1, 1902, in Cézanne 1978, p. 290; Gasquet 1926, p. 18. On young women, see the conversation of 1902 recounted in Borély 1926, p. 493.

3. Morice 1907, p. 593.

4. On Cézanne's religiosity, see Gasquet 1926, pp. 119–21; Morice 1907, p. 579; and the recollections of Charles Camoin as reported in Larguier 1925, p. 87. On Cézanne's retiring, reclusive nature late in life, Camoin observed: "When I knew Cézanne, I always found him completely alone, even though he had a wife and child"; Camoin to Henri Matisse, July 1941, in Camoin and Matisse 1997, p. 157. When Cézanne made trips to Paris during the 1890s, those few aware of his location had to promise not to tell. "The man? No one knew him"; Lecomte 1899, p. 82. Yet Cézanne had lasting friendships with a number of residents of Aix, as well as warm relations with the young painters and writers who visited him there; see, for example, the amusing accounts of his spirited interactions with Philippe Solari (an old friend) and Léo Larguier (a young admirer) in Provence 1939, pp. 23–29.

5. Cézanne, as recorded in Denis 1957–59, vol. 2, January 26, 1906, p. 29.

6. Morice 1907, p. 577. Compare Gasquet 1926, p. 71: "He worked. The word sums up his entire life. He painted." And Larguier 1928, p. 62: "Painting was his one and only concern, his perpetual preoccupation."

7. Lecomte 1899, p. 85.

8. On Cézanne's feeling for the land, see, for example, Provence 1939; Coutagne and Ely 1990; Smith 1998; Athanassoglou-Kallmyer 2003; Conisbee and Coutagne 2006. On Cézanne's custom of walking substantial distances, see Gasquet 1926, p. 95. Having missed a train connection from Marseilles to Aix, he thought little of hiking the nearly twenty miles home (Cézanne to Émile Zola, April 4, 1878, in Cézanne 1978, p. 164).

9. Cézanne to Émile Bernard, September 21, 1906, in Cézanne 1978, p. 327. See also Bernard's response to the report of Cézanne's death: Bernard 1907, p. 625. On the Cézanne–Bernard relationship, see Rapetti 2004.

10. Sérusier to Maurice Denis, November 27, 1907, in Sérusier 1942, p. 132. Sérusier's was a common opinion—here, a second example on a less positive note: "Cézanne holds little charm for me, but I reserve for him the great admiration we owe to precursors"; Jean Puy, statement in Charles Morice, "Enquête sur les tendences actuelles des arts plastiques," *Mercure de France* 56 (August 15, 1905), p. 554. For the entirety of Morice's *enquête* (survey of opinions), see Morice 1905a.

11. "Regardez la mer, c'est solide comme la pierre": Pablo Picasso, quoted in Esterow 1973, p. 44.

12. Other Cézannes from Picasso's collection, *Five Bathers* (plate 2) and *Château Noir* (plate 5), are similarly dense.

13. See Maurice Denis, "Cézanne" (1907), in Denis 1920, p. 250. Cézanne's "solidity" statement often became the central theme of twentieth-century accounts of his art; it appears, for example, as the first sentence of Emil Waldmann, "Cézanne," in Waldmann 1927, p. 105. On Picasso's perceived difference from Cézanne, see his remarks of 1946, as reported in Gilot and Lake 1964, pp. 118–19.

14. Cézanne's color was not unappreciated; critics associated its richness with Oriental carpets and faience. See Gustave Geffroy, "Paul Cézanne" (1894), in Geffroy 1892–1903, vol. 3, p. 259; Lecomte 1899, p. 86; Fagus 1905, p. 253. Jacques-Émile Blanche's comment indicates that by 1905 numerous imitators were appropriating the painter's color as well as his mark: "Cézanne's color charms me when it is in his canvases and disgusts me when it is in others"; Jacques-Émile Blanche, statement in Morice 1905a (August 15), p. 357. See also Jacques-Émile Blanche, *Propos de peintre. De David à Degas* (Paris: Émile-Paul, 1927), p. 229.

15. Paul Signac, *D'Eugène Delacroix au néo-impressionnisme*, ed. Françoise Cachin (1899; reprint, Paris: Hermann, 1978), p. 117.

16. Cézanne to Émile Bernard, October 23, 1905, in Cézanne 1978, p. 315.

17. Aphoristic statement from Cézanne, as reconstituted in Larguier 1925, p. 137.

18. Meier-Graefe 1904, vol. 1, p. 66.

19. Vollard 1919, p. 124.

20. On the positive side: "Some apples and a napkin on a table assume the same grandeur as a human head"; Duret 1906, p. 180. On the negative side: Cézanne "took no more interest in a human face than in an apple"; Morice 1905c, p. 552.

21. Lhote 1920, p. 665; Lhote 1922, p. 114. On the early twentieth-century association of emotional expression with form (as opposed to thematic subject), see Shiff, "From Primitivist Phylogeny to Formalist Ontogeny."

22. Braque 1917, p. 4.

23. Alberto Giacometti, statement in "Entretien avec Alberto Giacometti," in Charbonnier 1959, p. 177.

24. See Cézanne to Émile Bernard, May 26, 1904, in Cézanne 1978, p. 303.

25. For more on the play of the motif in Cézanne's art, see Richard Shiff, "Sensation, Movement, Cézanne," in Maloon and Gundert 1998, pp. 13–27. See also Georges Roque, "Au lieu du sujet, le motif. La quête des peintres depuis l'impressionnisme," *Ethnologie française* 25 (1995), pp. 196–204.

26. "In the final analysis, sensation in the Impressionist sense is an instant of a cinematographic film"; Denis 1957–59, vol. 2, September 9, 1915, p. 183.

27. On the interpretive complexities of Cézanne's portraits of his wife, see Sidlauskas 2004; Garb 2007, pp. 139–79.

28. Merleau-Ponty 1964a, pp. 10–11, 20.

29. Morice 1905b, p. 381.

30. Morice 1907, p. 593.

31. On the disjunction between Cézanne's actions and his beliefs, see Shiff 2008, pp. 95–105. See also André Malraux, *The Voices of Silence*, trans. Stuart Gilbert (1953; Princeton: Princeton University Press, 1978), pp. 335–59.

32. Robert Delaunay to Franz Marc, January 11, 1913, "Extraits de H[enri] R[ousseau], Le Douanier" (1913), in Francastel 1957, p. 189.

33. Cézanne to Émile Bernard, September 21, 1906, in Cézanne 1978, p. 327.

34. Maus 1907, pp. 63–64.

35. Mauclair 1906, p. 305.

36. See Ann Daly, "Isadora Duncan's Dance Theory," *Dance Research Journal* 26 (Autumn 1994), p. 25.

37. Mauclair 1906, pp. 306–8. For an example of ignorance regarded as a positive feature of Cézanne, see Fagus 1899, p. 627.

38. *L'antivirtuosisme*: Mauclair 1906, p. 309.

39. On wildness, see Shiff 2006, pp. 605–11.

40. Witness accounts suggest that the term *primitive* was Cézanne's, as quoted, for example, in Bernard 1907, p. 614: "I remain the primitive of the way I have discovered [*Je reste le primitif de la voie que j'ai découverte*]." In 1891 Bernard had already compared Cézanne to past "primitive masters," referring to the early Italian Primitives, such as Giotto; Bernard 1891, n.p. Cézanne's friend Joachim Gasquet, a young Provençal poet, provided a second account of the statement; Gasquet 1926, p. 70. Gasquet happened to be involved with a literary group whose motto was "We are no doubt the Primitives of a future race"; see Maurice Le Blond, "Le mysticisme de la génération nouvelle," *Le rêve et l'idée* 1 (May 1894), p. 1. It remains uncertain whether Cézanne made a habit of calling himself a primitive. If so, the idea might have stemmed from his conversations with Gasquet, despite Gasquet's having borrowed the phrasing back from Bernard. Gasquet did not claim to have heard the remark directly. Usually associated with Bernard's understanding, the sense of Cézanne as an unfulfilled, "primitive" initiator became one of the fundamentals of twentieth-century commentary; see, for example, Lhote 1920, p. 654.

41. This essay stresses the primitive and romantic end of the response to Cézanne, to which the "classical" end largely corresponds in terms of aesthetic practice, though not necessarily in terms of political implications. See Shiff 1984, pp. 162–84.

42. Cézanne, quoted in Denis 1957–59, vol. 2, January 26, 1906, p. 30.

43. Cézanne to Émile Bernard, September 21, 1906, in Cézanne 1978, p. 327.

44. Émile Bernard to his wife, October 25, 1906, in "Lettres inédites du peintre Émile Bernard à sa femme à propos de la mort de son ami," *Art-documents* (Geneva), no. 33 (June 1953), p. 13.

45. Gustave Geffroy, "Paul Cézanne" (1895), in Geffroy 1892–1903, vol. 6, pp. 219–20.

46. Geffroy, "Salon de 1901" (1901), Geffroy 1892–1903, vol. 8, p. 376. Geffroy's thinking agrees with pantheistic sentiments he expressed elsewhere; see

Geffroy, "Le symbolisme" (1892), Geffroy 1892–1903, vol. 2, p. 388. On the general question of finish and its lack in Cézanne, see Jean-Claude Lebensztejn, "Études cézanniennes" (2004), in Lebensztejn 2006, pp. 61–79.

47. See Christian Zervos, "Conversation avec Picasso" (1935), in Bernadac and Michael 1998, p. 36.

48. See de Zayas 1923, p. 315.

49. See Daix 1973a, p. 13; Daix 1973b, pp. 48–49.

50. Lhote 1920, p. 665 (original emphasis).

51. Merleau-Ponty 1964c, p. 45.

52. This distinction is implicit in writing about Cézanne through the decades. Clement Greenberg attributed the historical significance of Cézanne's technique to a kind of accident or misalignment of purposes, whereas Matisse and Picasso manipulated Cézannian qualities with self-conscious awareness of taking a position in cultural history; see Greenberg, "Henri Rousseau and Modern Art" (1946) and "Cézanne and the Unity of Modern Art" (1951), in Greenberg 1986–93, vol. 2, pp. 93–95, and vol. 3, pp. 82–91.

53. Compare Shiff 1984, pp. 114–15.

54. Georges Braque, statement in "Entretien avec Georges Braque" (1950–51), in Charbonnier 1959, p. 10.

55. Natasha Staller provides a good example: "Cézanne set up paradoxical inversions in which different elements exchanged their fundamental properties.... He allowed space [paint that signifies space] to overlap a glass—and become more material than the objects it enveloped"; Staller 2001, p. 66. We might question, however, whether Cézanne "set up" such a situation in a particular instance, as opposed to it having occurred as the byproduct of a working process. On this problem, see Shiff 1991, pp. 129–80.

56. Picasso, statement in Hélène Parmelin, "Picasso dit . . ." (1966), in Bernadac and Michael 1998, pp. 148–49.

57. "In the portraits of Madame Cézanne from the 1890s, the idle hands, unadorned and unfinished, a matter of colored patches and tentative strokes, seem to place both femininity and painting on the side of touch, dramatizing the permeability and instability of subjects and objects and the contested capacity of paint to capture them"; Garb 2007, p. 142.

58. Morice 1905c, p. 552; Morice 1905b, p. 390. Compare Clive Bell, *Art* (New York: Capricorn, 1958 [1914]), p. 142: "The real business of [Cézanne's] life was not to make pictures, but to work out his own salvation. Fortunately for us he could do this only by painting."

59. Bernard 1904, p. 21.

60. On studio "abstractions," see Cézanne to Émile Bernard, December 23, 1904, in Cézanne 1978, p. 308. On the experience of nature in relation to art, see Cézanne to Bernard, May 26, 1904, and undated 1905, in ibid., pp. 301–3, 313–14. Most of Cézanne's paintings of bathers—with the exception of some single male figures for which his son probably served as model—derived from his early life drawings, copies of masterworks he made in the Louvre, or illustrative prints and books he acquired. Cézanne also derived narrative and genre imagery from graphic illustrations

of various kinds. None of this deterred him from insisting that painting from nature was the foundation of his practice. See Bernard 1907, p. 395.

61. Charles Camoin to Henri Matisse, December 2, 1904, in Camoin and Matisse 1997, p. 15.

62. Picasso, in Zervos 1935, p. 33. Around the time of Picasso's statement, Lhote also related Cézanne's art to anxiety and human drama, noting in addition that the "expressive position of an object is never its precise position [in nature]"; Cézanne altered appearances freely, which made his approach to painting "pure": André Lhote, "Cézanne l'incompris" (1936), in Lhote 1942, pp. 122–23, 125. In Lhote's sense—and that of most others of the time—"pure" painting was not removed from human emotion but, because of its freedom from conventional illustrational demands, was intended to reveal and emphasize the emotional factor in experience. On seeing the photographs of Cézanne's sites taken by John Rewald, Lhote concluded, somewhat to his surprise, that the painter had adjusted compositional relationships to a minimal degree: "The extraordinary thing is that no significant natural element has been removed for the sake of another invented one"; Lhote 1939b, p. 729. Cézanne had managed to be faithful to nature and expressive at one go, which Lhote regarded as a remarkable achievement. For Maurice Denis and many others, this convergence of truth to nature and truth to self (to one's feelings) was a defining feature of a modern classicism in art: "We have discerned classical spontaneity in [Cézanne's] sensation itself"; Denis, "Cézanne," in Denis 1920, p. 254.

63. See Isabelle Monod-Fontaine, "Braque, the Slowness of Painting," in Monod-Fontaine and Carmean 1982, p. 55; Rubin 1989, pp. 32–34.

64. Picasso, probably 1971, quoted in Rubin 1972, p. 72. Rubin restricts the perfume metaphor to the diffuse Cubist images of the winter of 1911–12 (see ibid., p. 206 n. 3), but it could apply to all of Picasso's work, despite his rendering voids as solids. We should not expect literal reference to result when verbal metaphors are applied to visual images.

65. See Lhote 1920, p. 661; Lhote 1939a, p. 714; Lhote 1939c, p. 135.

66. Lhote 1939a, p. 714.

67. Ibid.

68. Lhote 1939c, p. 135. A feature of "Cézanne's lesson" was the technique known in French as *passage*; see Shiff, "Mark, Motif, Materiality," pp. 115–17.

69. Einstein 1929, pp. 153–54.

70. Braque 1917, p. 3.

71. On thematizing primitivism, see Patricia Leighten, "The White Peril and *l'Art Nègre*: Picasso, Primitivism, and Anticolonialism," *Art Bulletin* 72 (December 1990), pp. 609–30.

72. "The mysticism of a Picasso is the mood of deities borrowed from the ancient Mexicans and Aztecs, with a shot of Gothic"; Max Beckmann, diary entry, April 17, 1913, in Beckmann 1997, p. 128. On the terms of Beckmann's later involvement with Picasso, which may have been stimulated by Carl Einstein, see Didier Ottinger, "Beckmann's Lucid Somnambulism," in Rainbird 2003, pp. 132–34. In 1926, Einstein remarked on Beckmann's interest in recent French art, especially Cubist practice; Einstein 1931, p. 184.

73. Probably referring to the same effect, Carl Einstein noted the way that Beckmann enlivened the negative spaces of his composition; Einstein 1931, p. 184.

74. Lhote 1939a, p. 713 (emphasis eliminated).

75. Beckmann, "Thoughts on Timely and Untimely Art" (1912), in Beckmann 1997, pp. 115–16.

76. Beckmann, "The New Program" (1914), in ibid., p. 132.

77. Henri Matisse, "Entretien avec Jacques Guenne" (1925), in Matisse 1972, p. 84.

78. Matisse, quoted in Diehl 1943, p. 1. A less idiomatic variant of the same statement appears in Diehl 1954, p. 17. On Matisse and Cézanne, see also Benjamin 1987; Yve-Alain Bois, "Matisse and 'Arche-drawing,'" in Bois 1990, pp. 3–63; Gottfried Boehm, "A Paradise Created by Painting: Observations on Cézanne's Bathers," in Krumrine 1989a, pp. 18–23.

79. Raymond Bouyer, "Le procès de l'art moderne au salon d'Automne," Revue politique et littéraire [Revue bleue] 2 (November 5, 1904), pp. 604–5.

80. Puy 1939, p. 18.

81. Matisse, "Notes d'un peintre" (1908), in Matisse 1972, p. 42. Puy, too, suggested that artists yield to the personal, emotional experience of painting, that contemporary art should contribute more "to the intimate life of beings"; statement in Morice 1905a (August 15), p. 554.

82. For this example and others, see Flavio Fergonzi, The Mattioli Collection: Masterpieces of the Italian Avant-garde; Catalogue Raisonné, trans. Christopher Huw Evans and Jennifer Franchina (Milan: Skira, 2003), pp. 265–81. I thank Flavio Fergonzi for generously sharing recent, unpublished research.

83. Larguier 1928, p. 48.

84. Giacometti, statement in "Entretien avec Alberto Giacometti," p. 176. See also Baumann and Tøjner 2008.

85. See Hartley 1997, pp. 141, 205.

86. Hartley, "The MOUNTAIN and the RECONSTRUCTION" (1928), in Hartley 1982a, pp. 76–77.

87. Barr 1986, p. 11.

88. Marsden Hartley, "Whitman and Cézanne," in Hartley 1972, p. 33.

89. His competition with regard to this kind of sustained analysis would have been Novotny 1938.

90. Erle Loran, "Cézanne, 1839–1906," in Dorival 1948, pp. 296–97.

91. Hartley 1997, p. 138.

92. Willem de Kooning, statement in Rosenberg 1972, p. 55. The interview was recorded in 1971. Presumably Rosenberg, de Kooning's close friend, edited it; and both contributors may be responsible for the remarkable suggestiveness of some of the phrasing. It is unclear what bit of Cézanne lore might have led de Kooning to formulate his understanding of Cézanne as he did. The widely read essay by Merleau-Ponty, "Cézanne's Doubt" (Merleau-Ponty 1964a), esp. pp. 14–15, may have provoked some of de Kooning's thoughts.

93. De Kooning, interview, in Bibeb 1968, p. 3 (translation courtesy Mette Gieskes).

94. De Kooning, quoted in Hunter 1975, p. 69.

95. Johns, quoted in Grace Glueck, "The 20th-Century Artists Most Admired by Other Artists" (November 1977), in Varnedoe 1996b, p. 166.

96. Paul Valéry, "L'homme et la coquille" (1937), in Variété V (Paris: Gallimard, 1945), pp. 15, 29 (original emphasis).

97. Even certain landscapes, such as Quartier Four, Auvers-sur-Oise (see plate 54), have a decidedly casual appearance. A viewer will always be free to see Cézanne's paintings otherwise, explaining a given work as more deliberative and organized than spontaneous and happenstance. I interpret certain works in this fashion in recognition of the cultural significance that early twentieth-century critics attached to the matter-of-fact recording of appearances. For contrary examples of still-life compositions likely to have been contrived, including Stoneware Jug (see plate 45), see Shiff, "Risible Cézanne," pp. 152–57.

98. Lhote 1939a, p. 715.

99. Giacometti, statement in "Entretien avec Alberto Giacometti," p. 177.

100. Joseph Ravaisou, "Eloge funèbre de Paul Cézanne" (January 1907), in Ravaisou 2006, p. 287. See also Geneviève Creuset, Joseph Ravaisou, peintre du pays d'Aix (1865–1925) (Marseilles: La Savoisienne, 1975).

101. One of the (somewhat) later views, developed very differently, is Wassily Kandinsky, "On the Question of Form" (1912), trans. Klaus Lankheit, in Kandinsky: Complete Writings on Art, ed. Kenneth C. Lindsay and Peter Vergo (New York: Da Capo, 1994), p. 245.

102. Charles Blanc, Grammaire des arts du dessin (1867; Paris: Laurens, 1880), p. 337.

103. Cézanne to his son Paul, September 8, 1906, in Cézanne 1978, p. 324.

104. Gasquet 1930, p. 152.

105. Renoir, as recorded in Denis 1957–59, vol. 2, January 30, 1906, p. 34. Denis had just visited Cézanne in Aix, then went to Cagnes to visit Renoir.

106. Renoir's observations, as reported in Geffroy, "Paul Cézanne" (1894), in Geffroy 1892–1903, vol. 3, pp. 256–57. Compare Larguier 1925, p. 116: "I saw several [abandoned canvases] under the trees of the Château Noir." A similar witness account by Gasquet reads as if it were repeating the description formulated by Geffroy; Gasquet 1930, p. 99.

107. Charles Sanders Peirce, "The Law of Mind," Monist 2 (July 1892), p. 533.

108. "Slight tendencies to do otherwise than previously"—that is, instances of spontaneity—"would sometimes be strengthened by the opposite tendency, but the stronger they became the more they would tend to destroy themselves"; Charles Sanders Peirce, "To Christine Ladd-Franklin, on Cosmology" (1891), in Peirce 1960–66, vol. 8, pp. 214–15.

109. Tohu bohu: ibid., p. 214.

110. Peirce, "Scientific Metaphysics: The Architecture of Theories" (1891), ibid., vol. 6, p. 15; "To Christine Ladd-Franklin," p. 215.

111. Ibid., p. 215.

112. Peirce, "Mind and Matter" (c. 1893), ibid., vol. 6, p. 184.

113. Renoir, quoted in Denis, "Cézanne," Denis 1920, p. 252.

114. Peirce, "To Christine Ladd-Franklin," pp. 215, 214.

115. Merleau-Ponty 1964a, p. 20.

116. Merleau-Ponty 1964c, pp. 45–46.

117. Sérusier to Maurice Denis, November 27, 1907, in Sérusier 1942, p. 131.

118. Peirce, "Mind and Matter," p. 184; "To Christine Ladd-Franklin," p. 215.

119. Tychique: See Jacques Lacan, Le séminaire de Jacques Lacan, ed. Jacques-Alain Miller (Paris: Seuil, 1973), p. 74. Tychic: See Jacques Lacan, The Four Fundamental Concepts of Psycho-Analysis, ed. Jacques-Alain Miller, trans. Alan Sheridan (New York: Norton, 1978), p. 77.

120. Ibid., p. 114.

121. Geffroy, "Paul Cézanne" (1895), in Geffroy 1892–1903, vol. 6, p. 220.

122. See Richardson 1991, p. 391; Rewald 1986a.

123. Lecomte 1899, p. 86.

124. Ibid., pp. 85–86.

125. Lecomte 1910, p. 28.

126. Lhote 1920, p. 649.

127. Clovis Sagot, quoted in a letter by Jacques Rivière to André Lhote, January 9, 1908, in Lhote, Alain-Fournier, and Rivière 1986, p. 39.

128. Suarès 1939, p. 674. Compare Blanche 1931, p. 237: "The name Cézanne appears so often in this book—it dominates it!"

129. Denis 1939, p. 196.

130. Paul Sérusier, statement in Morice 1905a (August 15), p. 544. See also Denis, "Cézanne," in Denis 1920, p. 253.

131. Bernard 1891.

132. For details of Gauguin's involvement with Cézanne's art, see Richard Shiff, "The Primitive of Everyone Else's Way," in Gauguin and the Origins of Symbolism, ed. Guillermo Solana, exh. cat. (Madrid: Museo Thyssen-Bornemisza and Fundación Caja, 2004), pp. 64–79; see also the primary documentation cited there.

133. Denis, "L'influence de Paul Gauguin" (1903), in Denis 1920, p. 167.

134. Ibid., p. 169.

135. Denis, "Définition du néo-traditionnisme" (1890), in Denis 1920a, p. 1; Denis, "L'influence de Paul Gauguin," in ibid., p. 167.

136. Denis, "Définition du néo-traditionnisme," p. 10.

137. Cézanne's remark came in conversation at a lunch hosted by Monet in November 1894; see Octave Mirbeau, "Préface du catalogue du salon d'Automne 1909," in Michel and Nivet 1993, vol. 2, p. 485. See also Gauguin to Camille Pissarro, July 1881, in Gauguin 1984, p. 21; Denis, "L'influence de Paul Gauguin," p. 170. Cézanne disapproved of the linear "abstraction" and unmodulated color apparent in the style Gauguin derived from him; see his letters to Émile Bernard, April 15, 1904, and October 23, 1905, in Cézanne 1978, pp. 300, 315. See also Cézanne's words as reported in Bernard 1907, p. 400. When

Bernard visited Cézanne in 1904 and 1905, he was a willing receiver of complaints about Gauguin and may have solicited them; he had long before distanced himself from Gauguin's methods.

138. See Merete Bodelsen, "Gauguin, the Collector," *Burlington Magazine* 112 (September 1970), p. 606; Denis 1939, p. 195.

139. On paintings Monet sent to the gallery, see his letter to Paul Durand-Ruel, May 30, 1884, in Daniel Wildenstein, *Claude Monet. Biographie et catalogue raisonné*, vol. 5 (Lausanne: La Bibliothèque des Arts, 1975–91), p. 253. On Tanguy, see Émile Bernard, "Julien Tanguy dit le 'Père Tanguy,'" *Mercure de France* 76 (December 16, 1908), pp. 600–16.

140. Gauguin to Camille Pissarro, c. July 10, 1884, in Gauguin 1984, p. 65. See also Gauguin's complaint about those who "mess around with brushwork," seduced by it; Gauguin to Émile Bernard, late November 1888, in Gauguin 1984, p. 284. In a similar manner, Sérusier (in the words of his colleague Denis) objected to an "art of sensations and brushmarks . . . the excesses of sensibility . . . with no principle but that of individual whim"; Denis, "Paul Sérusier" (1908), in Denis 1920, p. 149.

141. According to one of Gauguin's somewhat younger contemporaries, Cézanne was a case of "an admirably endowed temperament and eye, in service to an unskilled hand"; René X. Prinet, statement in Morice 1905a (August 15), p. 67.

142. It hardly seemed so to Monet himself, who frequently referred to his frustration as he attempted "things impossible to do"; Monet to Gustave Geffroy, June 22, 1890, *Claude Monet. Biographie et catalogue raisonné*, vol. 3, p. 257.

143. Gauguin to August Strindberg, February 5, 1895, in Gauguin 1946, pp. 263–64.

144. Mauclair 1906, pp. 193, 309.

145. Braque, statement in "Entretien avec Georges Braque," pp. 8, 18.

146. Sérusier, quoted in Denis, "Cézanne," in Denis 1920, p. 252.

147. Natanson 1895, p. 500.

148. Gauguin to Émile Schuffenecker, January 14, 1885, in Gauguin 1984, p. 88; Paul Gauguin, "Notes synthétiques" (1885), *Oviri. Écrits d'un sauvage*, ed. Daniel Guérin (Paris: Gallimard, 1974), p. 24.

149. Gauguin to Émile Schuffenecker, January 14, 1885, in Gauguin 1984, pp. 87, 89.

150. "Emotion d'abord! compréhension ensuite": Gauguin to Charles Morice, July 1901, in Gauguin 1946, p. 301.

151. Denis, "L'influence de Paul Gauguin," p. 170.

152. On the political and religious beliefs factored into Denis's aesthetic theory, see Jean-Paul Bouillon, "The Politics of Maurice Denis," in *Maurice Denis, 1870–1943*, ed. Guy Cogeval (Ghent: Snoeck-Ducaju & Zoon, 1994), pp. 95–109; Jean-Paul Bouillon, "Le modèle cézannien de Maurice Denis," in Cachin, Loyrette, and Guégan 1997, pp. 145–64.

153. Denis 1957–59, vol. 2, autumn 1914, p. 172.

154. Denis 1922, p. 31. Denis's notes of 1915 refer to a descent into "the abyss of abstraction": Denis 1957–59, vol. 2, September 9, 1915, p. 183. Like Denis,

Bernard came to question the terms of his acceptance of Cézanne (and Denis's as well); "Gauguin and Cézanne were able to show a direction to those younger. . . . There comes a time when you have to renounce them to proceed, watching them disappear at the horizon like mere signposts"; Bernard 1909, p. 276.

155. Puy 1910, p. 260. Other references to Guérin are comparably restrained, not particularly enthusiastic: See Gustave Coquiot, *Cubistes, futuristes, passéistes. Essai sur la jeune peinture et la jeune sculpture* (Paris: Ollendorff, 1914), pp. 99–101; Blanche 1931, pp. 286–87.

156. Denis, "À propos de l'exposition de Charles Guérin" (1905), in Denis 1920, pp. 143–44.

157. Denis 1914, p. 260. Denis also wrote that Cézanne's "formulations are luminous, concise: never abstract," referring to an "abstraction" as an image grown too intellectual, overly complicated (ibid.). Like Cézanne himself, he tended to use *abstraction* in its various pejorative senses (as mental distraction and intellectual confusion); see Denis, "La réaction nationaliste" (1905), in Denis 1920, pp. 195–96.

158. "Paradox of feeling": Paul Ricoeur, "Le sentiment" (1950), *A l'école de la phénoménologie* (Paris: Vrin, 1986), p. 253. On the prevalence of phenomenologically oriented speculation among intellectuals acquainted with Cézanne in Aix during the 1890s, see Athanassoglou-Kallmyer 2003, pp. 176–81.

159. Lhote 1939a, p. 714; Braque, statement in "Entretien avec Georges Braque," p. 9.

160. Bell 1922, pp. 49–50. A note by Bell (p. 56) indicates that he composed this recollection of his early years in Paris in 1918.

161. Matisse, "Notes d'un peintre" (1908), in Matisse 1972, p. 42. A parallel statement from Bell might be this: "In the moment of aesthetic vision [the artist] sees objects, not as means shrouded in associations, but as pure forms. It is for, or at any rate through, pure form that he feels his inspired emotion"; Bell 1958, p. 45.

162. Matisse, "Interview with Clara T. MacChesney" (1912), in Matisse 1995, p. 66.

163. See Jacques-Émile Blanche, *Propos de peintre. De Gauguin à la Revue Nègre* (Paris: Émile-Paul, 1928), p. 18.

164. Gustave Kahn, "Revue de la quinzaine. Exposition Henri Rousseau," *Mercure de France* 164 (August 1, 1923), pp. 785–86. During the first half of the twentieth century, it was common for Cézanne and Rousseau to be invoked as parallel cases; see, for example, Wilhelm Uhde, *Henri Rousseau* (Paris: Figuière, 1911), p. 5.

165. Barr 1934, p. 11.

166. Delaunay to Franz Marc, January 11, 1913, "Extraits de H[enri] R[ousseau], Le Douanier" (1913), in Francastel 1957, p. 189. Delaunay's word for feelings was *sensibilités*—literally, sensitivities.

167. Lhote 1920, pp. 661–65.

168. See Provence 1939, p. 20; Athanassoglou-Kallmyer 2003, pp. 166–70.

169. Gasquet 1926, pp. 150, 153.

170. Coquiot 1920, p. 36.

171. Lhote 1920, pp. 662–63.

172. Ibid., p. 663.

173. Donald Judd, "Malevich: Independent Form, Color, Surface" (1974), Judd 1975, pp. 211–12. During the 1960s, Judd worked on a history of abstract art, never completed; he gave Cézanne a prominent place at the beginning.

174. See note 11.

175. Blanc, *Grammaire des arts du dessin*, p. 576.

176. Marden, statement in Sharp 1970–71, p. 42.

177. Brice Marden, "Grove Group Notebook" (c. 1974), reproduced in Marden 1991, p. 29.

178. Marden 1974, p. 40 (punctuation added). On the circumstances of the *Suicide Notes*, see Moore, deAk, and Robinson 1975, p. 40.

179. On Plimack Mangold's practice in relation to some of Cézanne's statements, see Cheryl Brutvan, *The Paintings of Sylvia Plimack Mangold*, exh. cat. (Buffalo: Albright-Knox Art Gallery; New York: Hudson Hills, 1994), pp. 42–44.

180. Gauguin to Émile Schuffenecker, August 14, 1888, in Gauguin 1984, p. 210.

181. Cézanne to Émile Bernard, October 23, 1905, in Cézanne 1978, p. 315.

182. Their opinion was reinforced by Loran's own photographs of the landscape sites and all the more by John Rewald's. Rewald himself often remarked in conversation that he marveled at the fact that so many quirky Cézannian irregularities turned out to be true to an existing object or view. See his early account in Rewald and Marschutz 1935, p. 18. On the question of photographic evidence as an indication of Cézanne's fidelity to a site, see Machotka 1996, pp. 3, 98; Richard Shiff, "Cézanne's Composition: Its Criticism, Its Art," in Loran 2006, pp. xii–xiii.

183. Cézanne to his son Paul, September 8, 1906, in Cézanne 1978, p. 324.

184. Peirce, "Telepathy and Perception" (1903), *in* Pierce 1960–66, vol. 7, p. 377 n. 12 (original emphasis).

Bois, "Cézanne and Matisse"

1. The statement about the painter cutting out his tongue was first publicly uttered in Matisse's first radio interview of 1942 (ibid., p. 145). A version of it was published in the very first paragraph of *Jazz* in 1949 (ibid., p. 171), and in an interview with Léon Degand, he said that it is advice he used to give his students—thus already in 1908 (ibid., p. 164).

2. The first occurred in a statement to Jacques Guenne in 1925 (see ibid., p. 80), the second was published in 1956 by Raymond Escholier in *Matisse, ce vivant* (Escholier 1956, p. 45). Flam translated "bon dieu de la peinture" into "god of painting," which is correct ("le bon dieu" is simply "God"), but I think it is important to know that the expression connotes a benign, kind God rather than a punitive or dictatorial one. It is to Escholier, who was then chief curator at the Musée du Petit Palais, that Matisse wrote in 1936 to announce his gift to the museum of his most prized painting by Cézanne, *Three Bathers* (plate 0032).

3. On the paucity of explicit references to Cézanne in Matisse's "Notes of a Painter," as opposed to the numerous implicit ones, see Benjamin 1987, pp. 178–84. On Matisse's copies of Chardin and others, see, by the same author, "Recovering Authors: the Modern Copy, Copy Exhibitions, and Matisse," *Art History* 12, no. 2 (June 1989), pp. 176–201. Matisse's statement on his copy of *The Ray* was published by Pierre Courthion in *Les Nouvelles littéraires* on June 27, 1931: "[T]hen there was *La Raie*, which I tried to paint by planes—Cézanne was there behind it" (following Benjamin's faithful translation, p. 182).

4. For MacChesney's interview with Matisse, conducted in June 1912 and published in the *New York Times Magazine* on March 9, 1913, see Matisse 1995, p. 68.

5. "Interview with Guillaume Apollinaire" (1907), in ibid., p. 29.

6. "Interview with Jacques Guenne" (1925), in ibid., p. 81.

7. Ibid., p. 80.

8. See "Observations on Painting" (1945), in ibid., p. 158. Flam translates 'Defiez-vous du maitre influent" as "Challenge the influential master," which is incorrectly based on the assumption that "se défier de" (reflexive and intransitive) has the same meaning as the transitive verb "défier" (to defy, to challenge). Matisse uses the verb "se défier" as a synonym of the verb "se méfier" (to beware of), which is perfect French. That said, Jack Flam's remark, in a footnote to this statement, that this closely relates to a passage from Cézanne's letter to Camoin on December 9, 1904, remains utterly valid; see Cézanne 1995, p. 309.

9. "Interview with Georges Charbonnier" (1950), in Matisse 1995, p. 189.

10. Quoted in Matisse 1972, p. 310 (in Escholier 1956). There are similar statements to Georges Duthuit in 1949 (Matisse 1972, p. 310) and to Courthion in 1941–42 (unpublished; see note 13 below).

11. See Fourcade 1976, pp. 103–6.

12. The numbers preceded by "R" in the text refer to John Rewald's catalogue raisonné of Cézanne's paintings (Rewald 1996).

13. Matisse said these things in an extraordinary series of interviews that Courthion conducted with him in 1941, while the painter was convalescent. These were to be published by Skira under the title *Bavardages* in 1942. Unfortunately, Matisse's friend, the mediocre poet André Rouveyre, obviously motivated by jealousy, persuaded him to cancel the project at the very last minute (the manuscript was going to press; Matisse had designed the book cover). The final manuscript (usually dated 1942) is in the collection of the Getty Research Institute in Los Angeles, and a publication is, at last, in preparation. See Courthion 1942, p. 42. Translations are mine unless otherwise noted.

14. Matisse mentions to Courthion (ibid., p. 46) that the version of *L'Arlésienne* he had wanted to buy had a pink background. There are four possible candidates, all painted after a drawing by Gauguin (F540–F543). For a good color reproduction of two of them, see Roland Dorn, *Van Gogh Face to Face: The Portraits*, exh. cat. (New York: Thames and Hudson, 2000), p. 204, cat. 184. As for *Les Alyscamps*, Matisse's statement to Courthion—"When Vollard brought [it] to me, I saw it as no more than a print" (p. 46)—would tend to indicate that it is either F486 or F487 (the latter, in particular, for its bold black outlines), rather than the most gestural F568. See Ronald Pickvance, *Van Gogh in Arles* (New York: Metropolitan Museum of Art, 1984), pp. 197–98. Numbers preceded by "F" refer to J.-B. de la Faille's *The Works of Vincent van Gogh: His Paintings and Drawings* (New York: Reynal, 1970).

15. Spurling 1998, pp. 180–81.

16. On the magnitude of the financial sacrifice, and the major role it continued to play for the Matisse family (which united in its refusal to sell the painting during difficult times), see Grammont 2006, p. 23.

17. The young painter Georges Florentin Linaret had brought with him (as a kind of "show and tell") a painting and a drawing by Cézanne that he was buying to Gustave Moreau's studio, but he had to give them back to Vollard because he could not keep up with the payments. Spurling refers to an unpublished memoir by Maurice Boudot-Lamotte to claim that the painting was the *Bathers* later purchased by Matisse. Grammont refers to Adolphe Basler and Charles Kunstler, *La peinture indépendante en France* (Paris: Crès and Cie, 1929), to make the same point. See Spurling 1998, p. 180, p. 446 n. 95, and Grammont 2006, p. 22. Basler and Kunstler date this event from circa 1900 and place it indeed in Gustave Moreau's studio. Alfred Barr (Barr 1951a, p. 530 n. 4), referring to Alexander Romm (*Matisse: A Social Critique* [New York: Lear, 1947], p. 26), also places the event in Moreau's studio (Romm writes: "Matisse was particularly impressed by two Cézanne pictures bought and brought to the studio by his friend Lenaret [*sic*]." There is no mention of this in Matisse's letters to Romm that have been published, but Romm must have received the information from Matisse himself). Curiously, the unpublished memoir cited by Spurling situates the event in Eugène Carrière's studio, where Matisse went to draw nude models in 1900. Moreau died in April 1898. Given that Matisse had left Paris in January (first for London, then for Corsica, where he would stay for six months), the last time he went to Moreau's studio was probably in the fall of 1897.

18. See Courthion 1942, p. 46.

19. For Matisse's comments to Gaston Diehl mentioning the soldiers, see Matisse 1972, p. 134 n. 103. It is amusing to think that on the rare occasions when the pious Cézanne got to see nudes *en plein air* they were also soldiers bathing.

20. For a discussion of Matisse's method in this painting, which he explicitly described to Courthion (Courthion 1942, p. 123) as done in reaction against Impressionism, see Flam 1986, p. 100. Matisse speaks of this work to Courthion in terms that are very close to the words Pissarro used with him, and which he often repeated, about what differentiated Cézanne (who "always paints the same picture") from an Impressionist painter (whose "paintings are all different" even if they depict the same motif, because their real subject is the light cast on the motif at different moments of the day).

21. Flam 1986, p. 110.

22. See Catherine Bock, *Henri Matisse and Neo-Impressionism, 1898–1908* (Ann Arbor, MI: UMI Research Press, 1981); and Yve-Alain Bois, "Matisse and Arche-drawing," in Bois 1990, pp. 3–63.

23. Paul Signac, *De Eugène Delacroix au néo-impressionnisme*, ed. Françoise Cachin (Paris: Hermann, 1964), p. 108.

24. Matisse 1972, p. 93.

25. The best transcription of this letter, and that on which I based my translation, is to be found in Rémi Labrusse and Jacqueline Munck, *Matisse, Derain: la vérité du fauvisme*, exh. cat. (Paris: Hazan, 2005), p. 231; I have included here the crossed-out words from the original text. The passage that Matisse wants Signac to copy from Bernard's 1904 *L'Occident* article is surprisingly banal—a belated iteration of the Ingres/Delacroix (or drawing/color) antagonism that had suffocated young painters practicing in the mid-nineteenth century: "Paul Cézanne believes that there are two 'plastiques,' . . . one sculptural or linear, the other decorative or coloristic. What he calls 'sculptural plastique' is fully exemplified by the *Venus of Milo*. What he calls 'decorative plastique' is connected to Michelangelo, to Rubens. One of these plastiques is servile, the other free; in one, contour prevails, in the other, brilliance, color, and spontaneity dominate. Ingres belongs to the first kind, Delacroix to the second." Bernard in Doran 2001, p. 38 (translation slightly modified).

26. Quoted in Labrusse and Munck, *Matisse, Derain*, p. 232.

27. See note 25 above.

28. See Doran 2001, pp. 38, 39. Signac was clever enough, when he finally found his copy of *L'Occident,* to send this last passage to Matisse rather than the stereotypical one the younger artist had asked for.

29. For a close reading of Le Bail's notes in relationship to Cézanne's aesthetic, see Terence Maloon, "Classic Cézanne," in Maloon and Gundert, 1998, p. 45.

30. This particular quote is from a statement published by Georges Duthuit in 1949 (Matisse 1972, p. 84), but there are many others of the same kind.

31. Bois 1990, pp. 48–49. See also the extraordinary account of Cézanne's working method made by Georg Schmidt in his 1952 book *Water-colours* (quoted in ibid., p. 276 n. 120).

32. "Interview with Jacques Guenne" (1925), in Matisse 1995, p. 82.

33. I should add that at least one of the rare unfinished canvases by Matisse, *The Abduction of Europa* (National Gallery of Australia, Canberra), certainly does not conform to the "economy of the sitting" I just evoked, in that it is ridiculously unresolved. Matisse started working on it in 1926–27, drawing a cartoon for it (apparently the first since the one he made for *Le Luxe* in 1907 [plate 1288]). He stopped working on it in 1929, a year when he found himself almost incapable of painting, but kept it in his apartment in Nice (where André Masson remembers seeing it in 1932), perhaps with the hope that he would one day go back to it, though he never did. The canvas is unsigned; it has an atelier stamp that was probably applied posthumously. On this work, see Michael Lloyd and Michael Desmond, *European and American Paintings and Sculptures 1870–1970 in the Australian National Gallery* (Canberra: Australian National Gallery, 1992), pp. 162–65.

34. Quoted in Louis Aragon, *Henri Matisse: A Novel*, trans. Jean Stewart (New York: Harcourt Brace Jovanovich, 1972), vol. 2, p. 308.

35. See Matisse 1972, pp. 93, 115, 131.

36. "The Role and Modalities of Color" (1945), in Matisse 1995, p. 155.

37. The two exceptions are the cartoon for the *Rape of Europa*, a painting left unfinished after 1929, and, more importantly, one for *Le Luxe* of 1907 (plate 1288). While tradition has it that this cartoon was made for *Le Luxe I* (plate 1243), I argue, on the contrary, that it was made for the realization, at exactly the same size, of *Le Luxe II* (plate 0493; an identical composition, but in tempera), almost as a demonstration piece. See Yve-Alain Bois, "A De Luxe Experiment," in *Matisse Masterpieces at Statens Museum for Kunst*, ed. Sven Bjerkhof (Copenhagen: Statens Museum for Kunst, 2005), pp. 108–30.

38. The letter to Escholier making the gift official dates to November 10, 1936. Matisse's wife recalled that she had suggested to her husband that they give their Cézanne *Bathers* to the city of Paris rather than to the state, in order to "give a lesson" to the latter. Matisse, at the end of 1936, was particularly irritated because he had not been commissioned to do a mural painting for the 1937 World's Fair, for which scores of artists had been solicited (including Dufy, whom he deeply despised, but also Fernand Léger and Robert Delaunay). See Grammont 2006, p. 23.

39. Quoted in Fourcade 1976, p. 104.

40. "On Modernisn and Tradition" (1935), in Matisse 1995, p. 120.

41. "Statement to Tériade: On Fauvism and Color" (1929), in ibid., p. 84.

42. "Statements to Tériade: Matisse Speaks" (1951), in ibid., pp. 201–2. The next sentence is, "This led me to painting with flat tones: it was Fauvism."

43. Matisse to Camoin, September 1915, in Camoin and Matisse 1997, p. 79.

44. Although it is a well-known statement, it is worth quoting here Matisse's definition of "expression" in his "Notes of a Painter": "Expression, for me, does not reside in passion bursting from a human face or manifested by violent movement. It resides in the entire arrangement of my picture: the place occupied by the figures, the empty spaces around them, the proportions, all of that plays its role. Composition is the art of arranging in a decorative manner the diverse elements at the painter's command to express his feelings. In a picture every part will be visible and will play its appointed role, whether it be principal or secondary. Everything that is not useful in the picture is, it follows, harmful. A work of art must be harmonious in its entirety: any superfluous detail would replace some essential detail in the mind of the spectator." "Notes of a Painter" (1908), in Matisse 1995, p. 38 (translation slightly modified).

45. "On Modernism and Tradition," in ibid., pp. 120–21.

46. On this particular aspect of the Cézannism of this painting, see my essay in *Henri Matisse: Bathers with a Turtle,* special issue of the *Saint Louis Museum of Art Bulletin* (Fall 1998), pp. 8–19.

47. See Yve-Alain Bois, "On Matisse: The Blinding," *October* 68 (Spring 1994), pp. 61–121.

48. "Notes of a Painter" (1908), in Matisse 1995, p. 40.

49. T. J. Clark's "Freud's Cézanne" first appeared in the journal *Representations* in the fall of 1995. Slightly revised, it became the third chapter of his book *Farewell to an Idea* (New Haven and London: Yale University Press, 1999); see p. 154.

50. As in the case of the grotesquely ill-formed hands of his figures, no one seems to have noticed: I could not find any explicit mention of this conflation of two heads into one in the large number of negative reviews published at the time of the exhibition of *Joy of Life* at the Salon des Indépendants in 1906, all painstakingly exhumed by both Margareth Werth (*The Joy of Life: The Idyllic in French Art, circa 1900* [Berkeley, Los Angeles, London: University of California Press, Werth 2002]) and Alistair Wright (*Matisse and the Subject of Modernism* [Princeton: Princeton University Press, 2004]).

51. On the construction of the "Classic Cézanne," see Maloon and Gundert 1998, and Jean-Paul Bouillon, "Le modèle Cézannien de Maurice Denis," in *Cézanne aujourd'hui* (Paris: Réunion des Musées Nationaux, 1997), pp. 145–64.

52. Grammont 2006, p. 25. Grammont does not give her documentation in her essay, but she graciously provided it to me. The sale of the watercolors is registered in Vollard's notebook (Fond Vollard, Bibliothèque centrale des Musées nationaux, Paris, MS 421: 5). Matisse's proposal is included in a letter belonging to the same archive (MS 421: 2, 4).

53. I thank Grammont for this information. The date of the purchase appears in the record of the financial transactions between Matisse and the Galerie Bernheim-Jeune up to May 1911 (Matisse Archives, Paris).

54. The Matisse lithograph is recorded (somewhat oddly) in the catalogue raisonné of Matisse's illustrated books, the first entry of which is devoted to this album (simply titled *Cézanne*). See Claude Duthuit, *Henri Matisse: Catalogue raisonné des ouvrages illustrés* (Paris, 1988), illustration on p. 7. On the album as a whole, see Benjamin, "Recovering Authors," in Benjamin 1987, pp. 192–93. The other participating artists were Pierre Bonnard, Maurice Denis, Ker-Xavier Roussel, Paul Signac, Félix Vallotton, and Édouard Vuillard.

55. Courthion 1942, pp. 106–7.

56. According to Fanny Turpin's master's thesis, "Matisse collectionneur" (Université de Paris IV, Sorbonne, 2001–2), p. 65, Matisse acquired the Musée d'Orsay portrait from Paul Rosenberg in November 1916. Once again I thank Grammont for this information.

57. The source here is again Fanny Turpin's master's thesis (via Grammont), ibid., p. 90. The dealer from whom Matisse purchased a Cézanne landscape (together with a snowy one by Courbet) was the Galerie Barbazanges.

58. The suggestion that the increase in Matisse's pentimenti in 1912–17 was due to the painter's attempt to respond to Cubism via the philosopher Henri Bergson was made years ago by Gaku Kondo in my graduate seminar at Harvard University. In his interesting "Mémoire de DEA" on Matisse's "process photographs" (master's thesis, École des Hautes Études en Sciences Sociales, 2002), Kondo again discusses Matisse's pentimenti during this "Cubist" period, but only alludes indirectly to Bergson (Bergson's surrogate in this thesis is Matthew Stewart Prichard, with whom Matisse indeed often debated about the philosopher).

59. Courthion 1942, p. 46.

Joosten, "Cézanne and Mondrian"

1. Piet Mondrian, "The New Plastic in Painting: 3. The New Plastic as Abstract-Real Painting; Plastic Means and Composition" (De Stijl, 1918), repr. in Mondrian 1986, pp. 37–39.

2. Mondrian, "The New Plastic in Painting: 5. From the Natural to the Abstract; From the Indeterminate to the Determinate" (De Stijl, 1918), repr. in Mondrian 1986, p. 63.

3. Mondrian: "The New Plastic in Painting: 7. Supplement; The Determinate and the Indeterminate" (De Stijl, 1918), repr. in Mondrian 1986, pp. 72–73.

4. Holty 1957, p. 18.

5. Mondrian 1945, p. 10.

6. Following a visit to Paris in 1907, Jan Sluyters (1881–1957) became the first Dutch painter whose work introduced Fauvism to the Netherlands.

7. Welsh and Joosten 1998, vol. 1, *Catalogue Raisonné of the Naturalistic Works of P. Mondrian (Until Early 1911)*, by Robert P. Welsh, pp. 129–30.

8. Kees Maas, "Herinneringen," unpublished interview, 1974. With thanks to Francisca van Vloten, who provided the author with the passage cited.

9. Piet Mondrian, "Natural Reality and Abstract Reality: A Trialogue (while strolling from the Country to the City) (De Stijl, 1919–20), repr. in Mondrian 1986, pp. 99–100.

10. Mondrian 1945, p. 10.

11. Ibid.

Rishel, "Cézanne and Hartley"

1. Hartley 1997, p. 5.

2. Hartley 1997.

3. Ibid., pp. 137–38.

4. The poet Seamus O'Sheel introduced Hartley to Stieglitz, who immediately arranged a show of his work at 291.

5. See Haskell 1980, p. 22. See also Rewald 1989, p. 151: "It was from Maine, during the summer of 1911, that he asked Stieglitz to send him a photograph of a typical Cézanne still life for study; Stieglitz may well have obliged with one of Weber's reproductions."

6. Kornhauser 2002, p. 2.

7. Hartley 1997, p. 66.

8. [Alfred Stieglitz], "Cézanne Exhibition," *Camera Work*, October 1911, p. 30, as cited in Rewald 1989, p. 146.

9. Ludington 1992, p. 94.

10. Ibid., p. 72.

11. Hartley to Norma Berger, April 12, 1912; cited in ibid., p. 73.

12. Hartley to Alfred Stieglitz, April 13, 1912, in Hartley and Stieglitz 2002, p. 12; see also Ludington 1992, p. 73.

13. Ludington 1992, p. 110.

14. Ibid.

15. Hartley 1997, p. 138.

16. Ibid.; it is not clear from this statement that Hartley actually visited Pellerin's, but he certainly knew the collection and its importance.

17. Hartley and Stieglitz 2002, p. 47; see also Ludington 1992, p. 87.

18. Ibid.

19. Elizabeth McCausland, *Marsden Hartley* (Minneapolis: University of Minnesota Press, 1952), p. 38, as cited in Rewald 1989, p. 76.

20. "Remembering Marsden Hartley," handwritten manuscript, Erle Loran papers, 1913–1991, Archives of American Art, Smithsonian Institution, Washington, DC. I thank Richard Wattenmaker for bringing this memoir to my attention.

21. Hartley's footnote to this poem reads: "This is not meant to be a legend, or a poetic effusion—it is intended merely as an association of fates, physical, intellectual, and spiritual, an association of entities in close relation with each other. Its chief reason for being is the quality of confession contained in it." New York, February 12, 1928, as reproduced in Hartley 1982b, pp. 74–77.

22. Ludington 1992, p. 232.

23. Lee Simonson, foreword to *Marsden Hartley*, exh. cat. (New York: The Intimate Gallery, 1929), as cited in Haskell 1980, p. 76.

24. Murdock Pemberton, "Soul Exposures," *Creative Art* 5 (January 1929), p. xlviii, as cited in Ludington 2000, p. 401.

25. Ludington 1992, p. 174.

26. See Sanford Schwartz, "Georgia O'Keeffe Writes a Book," review, *New Yorker*, August 28, 1978, pp. 87–93, as cited in Hole 2007, p. xv.

27. Scott 1988, p. 34.

Green, "Cézanne and Léger"

1. I borrow here the title of the exhibition devoted to *Documents* at the Hayward Gallery, London, May 13–July 30, 2006, *Undercover Surrealism*.

2. Einstein 1930, p. 191. Translations are my own unless otherwise noted.

3. *L'amour de l'art*, December 1926; Fry 1927.

4. I refer here to Bernard's two major pieces on Cézanne of 1904 and 1907, in the second of which some material from the first reappears but with nine of the artist's letters added, and Maurice Denis's piece of 1907, translated by Fry for *The Burlington Magazine* in 1910. See Bernard 1904 and 1907; Denis 1907. Both Bernard's and Denis's pieces are published in translation in Doran 2001. Bernard presents several passages by Cézanne on what the artist terms "sensa-

tion." Particularly telling is the fourth of the twenty "opinions" published by Bernard in his article of 1904: "Peindre d'après nature ce n'est pas copier l'objectif, c'est réaliser ses sensations" (To paint after nature is not to copy objective reality, it is to realize one's sensations). For a cogent critical discussion of these texts and their impact on twentieth-century understanding of Cézanne, see Françoise Cachin and Joseph J. Rishel, "A Century of Cézanne Criticism," in Cachin et al. 1996, pp. 24–75. For a recent discussion of the relationship between "sensation" and "realization" in Cézanne, see John House, "Cézanne's Project: The 'Harmony Parallel to Nature,'" in Buck et al. 2008. House's piece helped to clarify for me the terms in which to think through the Léger-Cézanne relationship.

5. Fry 1927, p. 2.

6. See especially the contributions of John House (note 4 above) and Elizabeth Reissner, "Transparency of Means: 'Drawing' and Colour in Cézanne's Watercolours and Oil Paintings in the Courtauld Gallery," in Buck et al. 2008.

7. Gasquet 1926.

8. Though not comprehensive, many of these are collected in Léger 1965a; 1965b.

9. See Léger's statements in Vallier 1954b, pp. 149–50.

10. Georges Bauquier, "L'atelier Léger," in Mathey 1956, p. 20.

11. Léger expresses his excitement in an unpublished letter to his Norman friend André Mare that is cited in Katharina Schmidt, "La Femme en bleu," in Kosinski 1994, p. 40 n. 24.

12. Apollinaire 1913, Apollinaire 1966, vol. 4; see Apollinaire 2002, p. 66. I first expressed my opinion that the gender of Léger's nudes is at the very least ambiguous in Green 1976, pp. 18–19, 318 n. 34. My analysis there, however, expands on the aptness of Apollinaire's woodcutters, at least on the level of metaphor, in the context of the then-contemporary vanguard's tendency to associate modernity with violence.

13. The still life, now in the Minneapolis Institute of Arts (plate 46), has traditionally been dated 1909 but is almost certainly a work of 1911, a probability supported by the late 1912 publication of a drawing of a nude accompanied by the very same still life in *Du "Cubisme"* (Gleizes and Metzinger 1912). As I have argued elsewhere, the captioning of this drawing *Étude pour un abondance* (Study for an Abundance) strongly suggests that it was done after the showing of Henri Le Fauconnier's *An Abundance* at the Salon des Indépendants of 1911, a suggestion corroborated by the appearance of elements from the still life in the painting *The Smokers* (Solomon R. Guggenheim Museum, New York), a work securely dated to that year. See Green 1976, pp. 319–20 n. 59. *Woman in Blue* has often been associated with Cézanne's *Woman with a Coffeepot*, c. 1895 (see plate 44; fig. 8.7). The glass and spoon seem directly to refer to the cup and spoon in that work, which was then in the collection of Auguste Pellerin. The first illustration in *Du "Cubisme"* is Cézanne's *Portrait of Mme. Cézanne*, 1893–95 (Venturi 1936, no. 573). See Gleizes and Metzinger 1912.

14. Fry is particularly eloquent on Cézanne's broken contour; see Fry 1927, pp. 49–50. For an extremely

revealing technical analysis of Cézanne's use of line and contour, see Reissner (note 6 above) in Buck et al. 2008.

15. This sentence opens the seventh of the twenty "opinions" published by Émile Bernard: Bernard 1904; English translation in Doran 2001, p. 38. It does not reappear, as other of the "opinions" do, in Bernard's 1907 "Souvenirs," but it is likely that Léger knew both articles (see note 23 below), and the opinions that are quoted in 1907 make Cézanne's exclusive focus on color at the expense of line clear enough.

16. Fernand Léger, "Les origines de la peinture et sa valeur représentative," *Montjoie!* (Paris), May 29 and June 14–29, 1913, in Léger 1965a, pp. 11–19.

17. Fernand Léger, "Les réalisations picturales actuelles," *Soirées de Paris* 25 (June 15, 1914), in Léger 1965a, pp. 20–29.

18. Léger, cited in Vallier 1954b, p. 150.

19. Cézanne is quoted on spheres, cones, and cylinders more than once. See his tenth "opinion" in Bernard 1904 and quoted again in Bernard 1907; English translation in Doran 2001, pp. 30, 63. See also a letter to Émile Bernard, April 15, 1904, reprinted in French and in translation by John House in Buck et al. 2008, pp. 148–49. Rewald's case is that Cézanne did not mean that there are actually spheres, cones, and cylinders in nature but is speaking of an underlying structure beneath the complexity of colored sensations. See Rewald 1948, pp. 31–32. Rewald's view is discussed by Rishel in the overall context of the post-1906 Cézanne literature in Cachin et al. 1996, p. 59.

20. Bernard's emphasis on the organization of "sensation," and hence the abstract and cerebral, is discussed by Cachin and Rishel in Cachin et al. 1996.

21. Léger refers to the book "si bien documenté d'Émile Bernard" (so well documented by Émile Bernard). Léger 1913, in Léger 1965a, p. 13.

22. The opening chapter of *Du "Cubisme"* begins: "Pour évaluer l'importance du Cubisme, il faut remonter à Gustave Courbet" (In order to judge the importance of Cubism, it is necessary to go back to Gustave Courbet). Gleizes and Metzinger 1912 (reprinted Saint Vincent-sur-Jabron Sisteron: Éditions Présence, 1980), p. 38.

23. He quotes the fourth of Cézanne's "opinions" (see note 4 above), as it appears in Bernard's article of 1904, adding "for an impressionist." See Léger 1913, in Léger 1965a, p. 14. Since this opinion does not reappear in the 1907 "Souvenirs," the implication is that he knew and used the 1904 piece as well, even though it is the second piece, with its addition of Cézanne's nine letters to Bernard, that he specifically acknowledges in the first Wassilieff lecture (see note 21 above).

24. Léger 1913, in Léger 1965a, p. 11.

25. My discussion places the starting point of the *Contrasts of Forms* suite of paintings in a small group of oils and gouaches, including the gouache *Contrasts of Forms No. 2* of 1913, which was recently shown in the exhibition *Fernand Léger: Paris— New York* at the Fondation Beyeler, Basel (2008), cat. no. 30. For my discussion, see Green 1976, pp. 61–69.

26. Léger 1913, in Léger 1965a, pp. 11–12.

27. Green 1976, p. 60.

28. Léger 1914, in Léger 1965a, pp. 24–26.

29. He accepts that line does not bound color zones in "l'atmosphère réel" but dismisses this from a painterly point of view as in the domain of "réalisme visuel," not "réalisme de conception." Ibid., p. 24.

30. Elizabeth Reissner's work is fundamental to the comprehension of this aspect of Cézanne's mature practice. See Reissner, "Transparency of Means."

31. Fry 1927, p. 51.

32. Ibid., pp. 58–59.

33. The statement comes in a letter from Cézanne to Joachim Gasquet dated September 26, 1897. See Cézanne 1978, p. 262. House (in Buck et al. 2008) argues that this statement is the key to grasping what he calls Cézanne's project.

34. Léger 1914, in Léger 1965a, p. 20.

35. Ibid., p. 21.

36. See note 29 above.

37. Léger 1914, in Léger 1965a, p. 26.

38. Ibid.

39. Léger 1913, in Léger 1965a, p. 14. Léger associates Cézanne's desperation with his reaction in front of drawings by Luca Signorelli (an artist whose line is especially decisive). Bernard does indeed mention that Cézanne was fascinated by Signorelli, though by his style, not his treatment of musculature, but in no way does he associate the quotation used by Léger with Cézanne's response to that artist. The two appear in different places in the text. See Bernard 1907; English translation in Doran 2001, pp. 67, 73.

40. Léger 1914, in Léger 1965a, p. 28. Léger's decision to set aside the "incomplete" and to focus on what he could believe in as "realized" in Cézanne, echoes Bernard's final judgment in his article of 1907. See Bernard 1907; English translation in Doran 2001, p. 78.

41. I deal with this change in Christopher Green, "Out of War: Léger's Painting, 1914–1920," in Kosinsky 1994, pp. 45–63.

42. Green 1976, p. 114, pl. 72.

43. Cited in English translation by Katharina Schmidt from an unpublished letter to André Mare of 1907, in Kosinski 1994, p. 40 n. 24.

44. Léger to Léonce Rosenberg, September 6, 1919, in Léger and Rosenberg 1996, p. 59.

45. Perhaps the most striking demonstration of this is a passage from an important letter to Léonce Rosenberg, which the dealer published in 1924 in his gallery periodical *Bulletin de l'effort moderne*, where Léger writes of the curves of women being taken over by the geometry of his new way of seeing. Fernand Léger to Léonce Rosenberg, September 4, 1921, in Léger and Rosenberg 1996, p. 90. It is translated into English by Charlotte Green in Golding and Green 1970, pp. 85–86.

46. Fernand Léger, "Kurzgefaßte Auseinandersetzung über das aktuelle künstlerische Sein," *Das Kunstblatt* (Berlin), 7, no. 1 (1923), pp. 1–4; in Léger 1965a, p. 46.

47. Ibid., p. 45.

48. See note 2 above.

49. Michelet was the proud son of an artisan, a printer. His elevated view of the artisan as a representative of the French people is to be found in Michelet 1974, which is based on the third edition (1846), pp. 108–9. "Cet homme," he writes, "c'est le fort, le patient, le courageux, qui porte pour la société le plus grands poids de la vie humaine. Véritables *compagnons de devoir* (…), il s'y est tenu fort et ferme, comme un soldat au poste" (That man is the strong, the patient, the courageous one, who carries the greatest weight of human life for society. Veritable *companions of duty* . . . , he holds his station strong and steady, like a soldier at his post). In the late nineteenth and early twentieth centuries, Michelet was the dominant figure in the shaping of French modern history and especially the French view of the "people" on the democratic left as well as the political center. This is something I discuss more fully in Green 2005, pp. 92–95, 107–13.

50. Léger to Léonce Rosenberg, September 6, 1919, in Léger and Rosenberg 1996, p. 58.

51. Cézanne, cited by Bernard 1907; English translation in Doran 2001, p. 63.

52. Fernand Léger, text of a lecture given at the conference "L'esthétique de la machine," in Fels 1925; see "L'esthétique de la machine: l'ordre géométrique et le vrai," in Léger 1965a, p. 63.

53. Léger to Léonce Rosenberg, September 6, 1919, in Léger and Rosenberg 1996, p. 59. For a well-researched and shrewd assessment of the discourse of North and South in Léger, see François-René Martin and Sylvie Ramond, "Les 'armes offensives' du peintre: l'histoire de l'art selon Fernand Léger," in Ramond and Widerkehr 2004.

Elderfield, "Picasso's Extreme Cézanne"

Acknowledgments: For their very helpful comments on the penultimate draft of this essay, I am most grateful to T. J. Clark, Kathryn Tuma, and Jeffrey Weiss, and, for her final review, to Jeanne Collins. I also wish to acknowledge the assistance of Lauren Mahony in preparation of the endnotes.

1. See Christian Geelhaar, "The Painters Who Had the Right Eyes: On the Reception of Cézanne's Bathers," in Krumrine 1989a, pp. 285–87.

2. See Richard Shiff, "Introduction," in Doran 2001, pp. xxiii, xxvi. See also Richard Shiff, "The Cézanne Legend," in Shiff 1984, pp. 162–74.

3. Elizabeth Cowling suggests that, since the artist's wife Jacqueline, who sited this work, only ever did what Picasso wanted, he must have chosen it himself for his grave; Cowling 2002, p. 537. However, Diana Widmaier Picasso observes (in conversation with the author) that this is very unlikely given her grandfather's fearfulness of even discussing his own mortality.

4. Ibid., p. 136.

5. Brassaï 1966, p. 79. Excerpts from the original French edition (Paris: Gallimard, 1964) appear in Bernadac and Michael 1998, pp. 104–14. Brassaï may have made his celebrated photograph of Picasso's *Head of a Woman* of 1909 in 1943 (see Weiss, Fletcher, and Tuma 2003, p. 18); it is possible that this was also a factor in returning Picasso's thoughts to the early years of Cézanne's influence on him and his colleagues.

6. Horne 2004, pp. 353–74, describes Paris under German occupation; Rubin 1980, p. 352, is the source of the information on Picasso's friends.

7. A summary of Picasso's statements on Cézanne, stressing their late date, appears in Steinberg 1978, pp. 123–24. Although Steinberg's summary covers the principal statements, a larger number is now known—see "Cézanne" in the index of Bernadac and Michael 1998—and the earliest is now dated to 1926, not 1930: see notes 23, 25 below.

8. Danchev 2005, p. 219.

9. According to Max Weber; see Barr 1951a, p. 87.

10. Shiff, in Doran 2001, p. xxiii.

11. Rubin 1980, p. 352; Brassaï 1966, p. 224.

12. It remains a matter of conjecture whether Matisse or Picasso associated striped clothes with Cézanne's paintings of his wife, on her taste for which see Cachin et al. 1996, p. 346.

13. Vollard's account appears in Vollard 1914, p. 105; I thank Kathryn Tuma and Jeffrey Weiss for pointing out its relevance to Picasso's statement.

14. This list, and the preceding sentence, conflates 1909 works by Picasso made before and during the summer, which he spent at Horta de Ebro. The most important account of Picasso's indebtedness to Cézanne in 1909—Kathryn Tuma, "La Peau de Chagrin," in Weiss, Fletcher, and Tuma 2003, pp. 127–63—so finely distinguishes between them that I feel free not to comment on them further here. However, it does need noting that Tuma sees the pastiche paintings (most of which are pre-Horta works) as Picasso flaunting a Cézannist technique, largely learned through the mediation of Braque, before turning at Horta to a more profound, which is also to say puzzled and discomforted, engagement with Cézanne, including with the melancholy of his late works and its complement, their artist's anxiety—of which Picasso famously spoke in 1935. I refer, in order, to these paintings of 1909 by Picasso: *Still Life with Hat (Cézanne's Hat)* (Zervos 1932–78, vol. 2, cat. no. 84); *Landscape (Santa Bárbara Mountain)* (not in Zervos 1932–78; illus. Rubin 1980, cat. no. 129); *The Reservoir, Horta de Ebro* (Zervos 1932–78, vol. 2, cat. no. 157); *Portrait of Clovis Sagot* and *Portrait of Manuel Pallarés* (Zervos 1932–78, vol. 2, cat. no. 129; vol. 26, cat. no. 425). And there are also the great, more complex 1909 works, *Bread and Fruit Dish on a Table* (Tuma, "La Peau de Chagrin," calls it "a veritable pastiche of diverse subjects within Cézanne's corpus") and *Woman with Fan* (Zervos 1932–78, vol. 2, cat. nos. 134, 137), whose Cézannism cannot be thought parodistic. These last two paintings and *Still Life with Hat* additionally make reference to Le douanier Rousseau; the Horta landscapes reference Braque; and the influence of Cézanne in the two portraits may have been mediated by that of Matisse's 1906 *Portrait of Albert Marquet* (Nasjonalgalleriet, Oslo).

15. I refer, again in order, to Picasso's 1909–10 variations on Cézanne's *Madame Cézanne in a Red Dress,* 1888–90 (Rewald 1996, vol. 2, cat. no. 655), illustrated and discussed in Karmel 2003, cat. nos. 70–72; and Picasso's 1914 variations on Cézanne's *Young Man with a Skull,* 1896–98 (Rewald 1996, vol. 2, cat. no. 825) such as *Seated Man at a Table* (Zervos 1932–78, vol. 6, cat. no. 1206.) I discuss some important Bathers paintings in what follows.

16. Picasso, *Le déjeuner sur l'herbe, after Manet,* February 29, 1960 (Zervos 1932–78, vol. 19, cat. no. 203); Cézanne, *Five Bathers,* 1872–83 (Rewald 1996, cat. no. 365).

17. What may seem to be an obvious source, Cézanne's *Three Skulls on a Patterned Carpet* of 1898–1905 (Rewald 1996, cat. no. 824), could have been seen by Picasso in Ambroise Vollard's stockroom, but there is no evidence for this.

18. Other works with comparable backgrounds include the portraits of the dealers Vollard and Wilhelm Ude (Zervos 1932–78, vol. 2, cat. nos. 214, 217), the former being especially intriguing since Vollard, with Bernheim-Jeune, owned this work by Cézanne for three months before selling it to Auguste Pellerin in July 1904; see Cachin et al. 1996, p. 403.

19. Lionello Venturi speaks of the subject as "firmly rooted like a powerful tower": see Cachin et al. 1996, p. 403.

20. Zervos 1935, pp. 173–78; Bernadac and Michael 1998, pp. 31–37 (quotation at p. 36).

21. Bernadac and Michael 1998, p. 5.

22. De Zayas 1923, pp. 315–26; the French text in Bernadac and Michael 1998, pp. 17–20, is translated from *The Arts*, the original Spanish text apparently not having survived.

23. "Lettre sur l'art," *Ogoniok* (Moscow), May 16, 1926, translated from the Russian into French by C. Motchoulsky, in *Formes*, no. 2 (February 1930), pp. 2–5; Bernadac and Michael 1998, pp. 21–25. The version in the parallel, English-language edition of *Formes*, said to have been "translated from the Russian," varies a little from the French translation. For the 1935 statement, see note 20 above.

24. Barr 1939, pp. 9–20; Barr 1946, pp. 270–71.

25. See note 23 above. The passage devoted to Cézanne was quoted, with acknowledgment of its (apparent) odd incompleteness, in Steinberg 1978, p. 23, after the text, said to date from 1930, included in Penrose 1967, p. 32, and that version—unsurprisingly, perhaps, given the authority of Steinberg's essay—has been repeated in succeeding literature, even after the publication by Bernadac and Michael of the full and uncorrupted *Formes* text. The version given below is a translation from Bernadac and Michael, cross-checked against both the English-language edition of *Formes* and a translation of the original Russian text made by Edward Kasinec, Director of the Slavic Library at the New York Public Library, whom I thank for finding for me the relevant part of the publication, as I do Marie-Laure Bernadac for applying to Moscow for the complete text. As Bernadac and Michael 1998 observe (p. 178 n. 2 to their *Formes* text), the authenticity of this text has been challenged by Daix 1995, as a pirated version of the 1923 de Zayas text with added inventions. While some sentences in it do, indeed, replicate the 1923 text, it nonetheless does seem to be Picasso's. I thank Bernadac and Jack Flam for discussing with me this peculiar situation. It remains to be discovered who commissioned the *Ogoniok* text and whether a Spanish- or French-language original of that can be found.

26. Barr 1946, pp. 270–71.

27. The painter Émile Bernard, for example, remarked that Cézanne "became enslaved to research." Bernard 1907 (in Doran 2001, p. 59).

28. Henri-Joseph Harpignies (1819–1916), a successful French landscape painter, was born in Valenciennes and was a friend of Corot.

29. Bernadac and Michael 1998, p. 22. The English-language edition of *Formes* gives the last phrase as "essential reality" (p. 2), which seems a shade off.

30. Cowling 2002, p. 22; see also the introductions to Bernadac and Michael 1998, pp. 5–15.

31. Picasso to Joachim Gasquet, September 26, 1897, in Cézanne 1995, p. 261. In providing possible ultimate sources of Picasso's sentences, I do not suggest that he actually consulted these texts. Nonetheless, although Picasso's grasp of the French language was not good in the years around 1906 when Cézanne's influence became pervasive, it is reasonable to assume that his deep interest in the artist led him to ask friends to explain to him salient points in the quickly growing literature. Of course, by the time he spoke publicly of Cézanne, his French was much improved, but he probably still relied upon hearsay; as he said to Zervos in 1935: "How many people have actually read Homer? All the same the whole world talks of him. In this way the homeric legend is created" (Barr 1946, p. 272).

32. Bernard 1904, in Doran 2001, p. 38; Bernard 1907, in Doran 2001, p. 60.

33. Bernard 1891, elaborated in Bernard 1904, p. 21. See Shiff, in Doran 2001, pp. xxix–xxx, for these references and how "the topic of 'abstraction' separated Cézanne from many of his admirers."

34. See the remarks in Bernard 1907, cited in Doran 2001, p. 63; and Joachim Gasquet, "Ce qu'il m'a dit," in Gasquet 1926, cited in Doran 2001, p. 134.

35. Barr 1946, p. 271.

36. Cowling 2002, p. 455.

37. Matisse's *Decorative Figure on an Ornamental Ground* of 1925–26 and Maillol's *Mediterranean* of 1905; see Cowling 2002, pp. 524–26.

38. Aragon recalled that his essay was written in February 1930 (the same month as the publication of Picasso's "Lettre sur l'art" in *Formes*) as a preface to Galerie Goemans 1930, pp. 26–27; see Aragon 1965, pp. 165–79. Therefore, it is possible that he was responding to Picasso's formalist text. According to Richardson 2007, p. 481, Picasso and Zervos began work on the first volume of the catalogue raisonné in 1929.

39. Another work that uses a stepping-forward pose is *Two Brothers, Gósol*, of summer 1906; see McCully 1997, p. 319, cat. no. 150.

40. This now common interpretation appears to date from Rubin 1972, p. 193, who also refers to the ultimate derivation of Picasso's painting from Paul Gauguin. Although Vollard owned Cézanne's painting in 1906, it was not exhibited until much later (see Rewald 1996, cat. no. 555). The pose does appear, however, in Cézanne's *Bathers in Repose* of 1876–77 (Rewald 1996, cat. no. 261), which Picasso would have seen at the Salon d'Automne of 1905; see note 54 below. One thing that seems certain is that the stepping-forward pose of the boy in *Boy Leading a Horse* was a late invention in the development of the composition; see, for example, Zervos 1932–78, vol. 22, cat. no. 270, illustrated and discussed, with other studies for the painting, in Rivero 1992, pp. 282–84.

41. Kathryn Tuma put it in this way, in a communication with the author, April 8, 2008. Tuma, in Weiss, Fletcher, and Tuma 2003, pp. 131–32, cautions about

attributing anything other than iconographic influence of Cézanne on Picasso to a too early date.

42. Jeffrey Weiss, "Bohemian Nostalgia," in McCully 1997, pp. 197–207.

43. Quoted by Robert J. Boardingham, "Gustave Coquiot and the Critical Origins of Picasso's 'Blue' and 'Rose' Periods," in McCully 1997, p. 143, after Stein 1938, p. 7.

44. On similar qualities also in the youthful Cézanne, see Gowing, Stevens, and Adriani 1988, p. 172.

45. It is tempting to see the odd juncture of leg and buttocks of this figure as deriving from that of leg and stomach in the figure at the right of Cézanne's *Five Bathers* of 1885–87, but there is no evidence that he could have seen this painting by then (see Rewald 1996, cat. no. 554). This figure is developed from one in *The Harem,* painted in the summer, a work that may be thought to show the influence of Ingres: see Robert Rosenblum, "Picasso in Gósol: The Calm before the Storm," in McCully 1997, p. 263.

46. See Cowling 2002, pp. 151–52. Especially Maillol-like is *Seated Nude with Crossed Legs* (Zervos 1932–78, vol. 1, cat. no. 373), which may be imagined as the *Mediterranean* having swung her legs off the sculptural base and getting ready to stand up.

47. See, for example, Kirk Varnedoe, in Rubin 1996, pp. 135–36; and Cowling 2002, p. 159, who points out that Picasso painted his work around the time of Cézanne's death on October 23, 1906, which fell just two days before his own twenty-fifth birthday. It is, however, difficult to believe that Picasso could have seen this work, given its history; see Rewald 1996, cat. no. 670.

48. The obvious comparison is with the *Portrait of Père Mañach* of 1901 (Zervos 1932–78, vol. 1, cat. no. 1459).

49. *Gil Blas,* March 30, 1907. See Elderfield 1976, p. 118, in a discussion of the reception of Cézanne.

50. *Gil Blas,* March 23, 1905; Elderfield 1976, pp. 32, 117.

51. Nonetheless, the neoclassicist interpretation was continuing, indeed growing among the critics—see Elderfield 1976, p. 118—and had a long life thereafter.

52. See note 49 above.

53. See Elderfield 1976b, pp. 112–19, where these works are illustrated, pp. 116–17. Picasso was thus effectively a third-generation Cézannist—the Nabis and then the Fauves, roughly speaking, forming the first and second generations—and would have been conscious of his belatedness: He must have seen his first Cézanne paintings shortly after he had installed himself in Paris in the spring of 1901, at the Galeries Vollard on rue Lafitte, where that June he had his first exhibition in the French capital. And that same spring he would very likely have seen exhibited at the Société Nationale des Beaux-Arts Maurice Denis's celebrated painting *Hommage à Cézanne* (1900), which depicted representatives of the then Parisian avant-garde, the Nabis, gathered in Vollard's premises and in the dealer's presence around the Cézanne classic *Compotier, Glass, and Apples* of 1879–80 (see plate 84). If anyone linked the three Cézannist generations it was Vollard.

54. Although Cézanne's most radical, large late Bathers compositions were not exhibited until the

great retrospective at the Salon d'Automne of 1907, interested Parisians would have seen the hardly less weird *Bathers in Repose* of 1876–77 (Rewald 1996, cat. no. 261) at the Salon of 1905, or in the spread of the popular paper, *L'illustration,* November 4, 1905, which featured it among the Fauve paintings that were the sensation of that Salon; see Elderfield 1992, p. 135.

55. The most relevant works are *Blue Nude* and *Standing Nude* (illus. Elderfield 1992, pp. 167, 169).

56. Rubin 1977, pp. 184–88, argued that it was initiated in the summer of 1908 and extensively reworked that autumn and winter after Picasso had seen Braque's Cézannist landscapes made at L'Estaque in the summer; this chronology was adopted by Tuma, in Weiss, Fletcher, and Tuma 2003, p. 148. However, it was challenged by Daix 1988; this chronology was modified by Karmel 2003, pp. 34–36, who suggests that the painting was made between late 1907 and spring 1908.

57. See note 7 above.

58. Kahnweiler 1949, p. 7. See also Karmel 2003, pp. 10–12, 34.

59. Ibid.; Karmel is extremely enlightening, and I have learned much from him, on Picasso's (and Kahnweiler's) announced antipathy to the decorative; see also Karmel 2003, p. 200 n. 88.

60. Tuma, in Weiss, Fletcher, and Tuma 2003, pp. 148–53.

61. See note 56 above.

62. See Jeffrey Weiss, "Fleeting and Fixed," in Weiss, Fletcher, and Tuma 2003, pp. 2–48; and Tuma, in ibid., pp. 128–63.

63. See Bernadac and Michael 1998, p. 22.

64. My account of the preparations for and reception of this exhibition is indebted to the chapter on this subject in Richardson 2007, pp. 473–89, who acknowledges, p. 556 n. 72, the research of Christian Geelhaar on the Zurich showing of the exhibition and its reception.

65. In a symposium of March 2003, held in New York in conjunction with the exhibition *Matisse Picasso* at the Museum of Modern Art, Jeffrey Weiss spoke of the possible impact of Picasso's preparations for his catalogue raisonné on the development of his art, and the relationship of this to Matisse's work; Weiss has since published an essay on the latter aspect, "The Matisse Grid," in Kahng 2007, pp. 173–93. The Picasso part will appear as "Picasso raisonné," in Patricia Berman and Gertje Utley, eds., *A Fine Regard: Essays in Honor of Kirk Varnedoe* (London: Ashgate, 2008).

66. Efstratios Tériade, "En causant avec Picasso," *L'intransigeant,* June 15, 1932, quoted in Bernadac and Michael 1998, p. 28.

67. Bernadac and Michael 1998, p. 27.

68. Blanche 1932. This review was excerpted in Rubin 1996, p. 277, but its context is now fully described in Richardson 2007, pp. 478–79.

69. See Pepe Karmel, "The Lessons of the Master: Cézanne and Cubism," in Baumann, Feilchenfeldt, and Gassner 2004, p. 192, defending Blanche; and Danchev 2005, p. 31, poking fun at him.

70. André Lhote, "Chronique des arts," *Nouvelle revue française,* August 1, 1932, p. 288. See "Chronology," in Cowling et al. 2002, p. 376.

71. Jedlicka 1934, pp. 46–55, recording a lecture of 1932. See also Cowling et al. 2002, p. 377.

72. O'Brian 1994, pp. 489, 492, which includes an English translation, pp. 488–92, of Jung's article from the French version in *Cahiers d'art* (see note 73 below). The German original appears in *The Collected Works of C. G. Jung,* vol. 15 (New York: Bollingen, 1966), pp. 138–40.

73. Zervos 1932, p. 352; see O'Brian 1994, p. 488; Richardson 2007, pp. 485–86.

74. Zervos 1935, pp. 173–78, repr. in Bernadac and Michael 1998, pp. 31–37, quoted here after the English translation, "Statement by Picasso: 1935," in Barr 1946, pp. 272–74. As Cowling 2002, p. 554, observes, Picasso's excitability in the 1930s is reflected especially vividly in this conversation with Zervos.

75. William Rubin, "Cézannisme and the Beginnings of Cubism," in Rubin 1977, p. 188.

76. Willem de Kooning, "A Desperate View" (lecture of February 18, 1949), quoted in Thomas B. Hess, *Willem de Kooning,* exh. cat. (New York: The Museum of Modern Art, 1968), p. 15.

77. Maurice Merleau-Ponty, "Le doute de Cézanne" (1945), in *Sens et non-sens* (Paris: Nagel, 1958), pp. 13–33.

78. The classic account of artistic temperament is Margot and Rudolf Wittkower, *Born under Saturn: The Character and Conduct of Artists; a Documented History from Antiquity to the French Revolution* (New York: New York Review of Books, 1963). I have questioned the overemphasis on anxiety in discussion of the relationship of Matisse's life and art in "Art before Heart" (review of Spurling 2005), *The Guardian* (London), March 19, 2005.

79. Quoted in Rubin 1977, p. 188.

80. See O'Brian 1994, pp. 298–301.

81. Rubin 1980, p. 307.

82. Danchev 2005, p. 277.

83. Cézanne to Joachim Gasquet, April 30, 1896, in Cézanne 1995, p. 245.

84. Lewis 1989, pp. 4–5. Nonetheless, as Lewis points out, it was not until the 1950s that the early work began to receive probing critical attention.

85. The bibliography in Gowing, Stevens, and Adriani 1988, pp. 221–23, gives a year-by-year listing of relevant publications, preceded, p. 220, by a similar list of exhibitions that have included Cézanne's early works.

86. Highly relevant to the subjects of Picasso's Surrealism, his interpretation of Cézanne's anxiety, and his distrust of but attraction to decoration, expressed in his 1926 statement and in comments to Kahnweiler (see note 58 above) is Clement Greenberg's chapter titled "Hedonism: The Terrible and the Comic," in his *Joan Miró* (New York: Quadrangle, 1948), pp. 40–44.

87. Picasso's possible indebtedness to specific early works by Cézanne, although not addressed here, is a subject well worth serious consideration. For example, while his *Nude with Drapery* of 1907 (Zervos 1932–78, vol. 2, cat. no. 47) has rightly been thought a response to the identically sized *Blue Nude* of 1907 by Matisse (illus. Elderfield 1992, p. 167), and while the figural poses of both works belong to a long tradition of *luxuria,* it has yet to be considered whether these harsh

versions of that theme may have been painted with knowledge of a discomforting reclining nude that Gauguin owned, and that influenced his *Nevermore* of 1897—namely, a painting by Cézanne of 1869 now lost and known only in a caricature that appeared in the *Album Stock,* showing the artist with two paintings rejected from the Salon of 1870. See Rewald 1996, cat. no. 140; Gowing, Stevens, and Adriani 1988, pp. 14–15, 162. Picasso would certainly have seen the second image in the *Album Stock* cartoon, Cézanne's great *Portrait of the Painter, Achille Emperaire,* also perhaps of 1869 (Rewald 1996, cat. no. 139; Gowing, Stevens, and Adriani 1988, p. 162), for it was shown in the important Cézanne retrospective at the Salon d'Automne of 1907. This is—as the lost, reclining nude must have been—a defiant, aggressive painting by a thirty-year-old artist. We all too easily look for influence in chronological adjacency—therefore, for the influence of the later Cézanne on early modernism. But, as Picasso's later curatorial practice demonstrates, he did not put too much weight on sequencing. So, perhaps we might be willing to allow that Picasso, in his late twenties in 1907, would have been taken by a painting made by Cézanne at a similar age. If so, Picasso's great, forthright, facing pictures like the *Woman in Yellow* of 1907 (Zervos 1932–78, vol. 2, cat. no. 43) or, even more to the point, his *Woman with a Fan* of 1908 (Zervos 1932–78, vol. 2, cat. no. 67), may be thought to draw on the sheer extremism of this particular Cézanne. And what should we make of the use of stenciled lettering in Boldini type for the inscription "ACHILLE EMPERAIRE PEINTRE" at the top of the canvas, when we consider Picasso's use of stencils, albeit after Braque's immediate example, in his paintings of 1911–12?

88. George 1930b, p. 8.

89. *Les pêcheurs-pournée de juillet* (Rewald 1996, cat. no. 237).

90. George 1930a, pp. 20, 21. This article was a review of the 1929 exhibition at Galerie Pigalle, Paris, organized by Vollard.

91. William Wordsworth, "Preface to *Lyrical Ballads,*" in *The Norton Anthology of English Literature,* ed. M. H. Abrams (New York: W. W. Norton), vol. 2, p. 151.

92. Picasso to Amélie Matisse, March 31, 1912, quoted in Spurling 2005, p. 115.

93. Rainer Maria Rilke, to whom all who write on Cézanne are indebted, wrote in a letter of October 21, 1907, in one of his many perspicacious insights on multiple viewings of the great retrospective, of how the artist should not become conscious of his own insights. See Rilke 1985, p. 66.

Golding, "Cézanne, Braque, and Pictorial Space"

1. In October 1888 Gauguin, working in Pont Aven, delivered one of the most famous painting lessons in the history of art, to the young artist Paul Sérusier: "How do you see those trees? . . . They are yellow. Then paint them yellow. And that shadow is bluish, so render it with ultramarine. Those red leaves? Use vermillion." Quoted in Sérusier 1942, p. 42 (translation by the author). The result of the lesson was Sérusier's *Talisman* of 1888 (Musée d'Orsay, Paris), so

called because of its impact on the emergent Nabis movement. It also looks forward directly to the Fauvism of 1905.

2. Only Camille Pissarro was his elder, and perhaps because of this Cézanne always held him in particular esteem and came to think of him as the movement's progenitor.

3. Gauguin to Émile Schuffenecker, January 14, 1885, in Gauguin 2003, p. 34.

4. Vallier 1954a, p. 16 (translation by the author).

5. Ibid., p. 14 (translation by the author).

6. Leymarie 1988, cat. no. 16 (repro.).

7. Braque gave Henri Cartier-Bresson a copy of the German philosopher Eugen Herrigel's *Zen in the Art of Archery* (1948), a book that helped popularize Zen Buddhism in Europe in the postwar years; the great photographer acknowledged that the book had a profound impact upon him.

8. Richardson 1955, p. 170.

Mitchell, "A New Tradition"

1. A. E. Gallatin, *American Water-Colourists* (New York: E. P. Dutton, 1922), p. 17. Gallatin was a leading American critic, collector, artist, and museum founder.

2. The retrospective exhibition of Cézanne's work at the Salon d'Automne included seven watercolors exhibited along with the artist's oils, building on a major exhibition of seventy-nine Cézanne watercolors at the Bernheim-Jeune Gallery in June of that same year (Rewald 1983, p. 469). Demuth arrived in Paris in October, in the midst of Cézanne's moment, but would have missed the June exhibition.

3. Maurice Denis (Roger Fry, trans.), "Cézanne," *Burlington Magazine* 16 (January 1910), reprinted in Frascina and Harrison 1982, p. 57.

4. Ibid.

5. Bell 1913, p. 207.

6. Farnham 1971, p. 88.

7. Marcel Duchamp, "A Tribute to the Artist," in Ritchie 1950, p. 17.

8. For a fuller description of the series, see Sherman E. Lee, "The Illustrative and Landscape Watercolors of Charles Demuth," *Art Quarterly* 5, no. 2 (Spring 1942), pp. 165–66.

9. Marsden Hartley, "'Farewell, Charles': An Outline in Portraiture of Charles Demuth—Painter" (1936), reprinted in Norton 1978, pp. 66–67.

10. Soby 1948, p. 12.

11. Hartley, "Farewell, Charles," p. 80.

12. Rewald 1989, p. 56. Ironically, Demuth's composition is reported to depict a sand dune at Province-town, Massachusetts, where the artist often summered, hardly a monumental landmark.

13. In his 1927 monograph on Demuth, Gallatin would more clearly differentiate between Marin's watercolors of lyricism and dynamism, and Demuth's of care, beauty, and "perfection." Gallatin 1927, p. 3.

14. Charles Daniel cited in Farnham 1971, p. 110. Of Demuth's first show in 1914, McBride wrote that

many viewers would ask, "Is [Demuth] sufficiently different from Marin?" and conclude that the works on view did "not answer with sufficient distinctness." McBride, "Demuth's First Exhibition," *The Sun*, November 1, 1914, reprinted in McBride 1975, p. 69.

15. Describing his struggles with Daniel, Demuth apologized, "Poor Stieglitz, some more outside trouble being again poured over you." Demuth to Stieglitz, August 31, 1921, in Kellner 2000, p. 20.

16. In 1925, citing (and perhaps exaggerating) abusive treatment and neglect by Daniel, Demuth again solicited Stieglitz, this time successfully. Demuth had complained about Daniel to Stieglitz for years, characterizing him as "a crook,— a nice fellow, but a crook" (ibid.). There is little evidence to suggest that Daniel was such a villain, though he openly professed his dislike of homosexuality, with which he (and many others) identified Demuth. To Daniel, Demuth "was a homo with all their characteristics," which bore negative connotations, as he later elaborated of the Museum of Modern Art: "The blight there is too many 'Homos.'" (Daniel to Dorothy C. Walker, May 4, 1950, Charles Daniel Papers, Archives of American Art, Smithsonian Institution, microfilm reel 1343, frames 2–3). Dislike does not equate with abuse, however, and Demuth's watercolors appear to have sold well throughout the period, giving the artist a privileged role at the gallery, one that the gallerist would have been unlikely to jeopardize. None of Demuth's friends or associates mentioned ill treatment or hard feelings, including Daniel himself, when interviewed by Emily Farnham in 1968.

17. Fahlman 2007, pp. 69–72, 80–81.

18. Barnes and de Mazia 1939, p. 127.

19. For Demuth's debt to Cézanne in that year, see Farnham 1965–66, p. 132.

20. Soby 1948, p. 9.

21. Farnham 1971, p. 125.

22. Fahlman 1983, p. 24 n. 9.

23. Soby 1948, p. 9.

24. On Demuth's mannerism, see ibid., p. 14.

25. Clive Bell, *Since Cézanne* (1922), cited in Cachin et al. 1996, p. 57.

26. See, e.g., Haskell 1987, p. 126.

27. Churchill 1932, p. 19. Richard Shiff has, more recently, elaborated on this emotive aspect of Cézanne's work, particularly as it inspired the Symbolists at the end of the nineteenth century. Shiff 1984, p. 188.

28. Wright 1916, p. cxxx.

29. Cited in Kellner 2000, p. 12 n. 1.

30. Carl Van Vechten, "Pastiches et Pistaches," *The Reviewer* 2, no. 5 (February 1922), pp. 269–70.

31. Gallatin 1927, p. 9.

32. Schapiro 1978, p. 5.

33. Charles Demuth, "On Forms and Body Forms," manuscript in the Alfred Stieglitz/Georgia O'Keeffe Archive, Yale Collection of American Literature, Beinecke Rare Book and Manuscript Library, box 98, folder 1974. Although the text likely describes the art of his friend Georgia O'Keeffe, the poet William Carlos Williams later corroborated that Demuth himself "was interested in the similarity between the forms of the flowers and the phallic symbol, the male

genitals." "Interview with William Carlos Williams at Rutherford, New Jersey, January 26, 1956," in Farnham 1959, vol. 3, p. 990.

34. "I'm glad you want the egg-plant,—I kept it here; it turned into a heart;—maybe mine; anyway I hope no one will discover 'Art' or 'Painting' engraved on it." Demuth to Alfred Stieglitz, January 29, 1923, Alfred Stieglitz/Georgia O'Keeffe Archive, Yale Collection of American Literature, Beinecke Rare Book and Manuscript Library, box 12, folder 302. Reprinted in Kellner 2000, p. 47.

35. Schapiro 1978, p. 6.

36. Lane 1936, p. 8.

37. Charles Demuth, "Across a Greco Is Written," *Creative Art* 5 (September 29, 1929), reprinted in Farnham 1959, vol. 3, p. 938.

Kienle, "Cézanne and Beckmann"

1. Beckmann's poetic yet forceful and carefully constructed lecture was written in German and translated into English by the director of the City Art Museum of Saint Louis, Perry T. Rathbone, and Beckmann's wife, Quappi, who also gave the lecture in her husband's presence at the University of Boulder, Colorado; Mills College in Oakland, California; the School of Fine Arts and Architecture, Boston; and Vassar College, Poughkeepsie, New York. For the original English translation, see "Contemporary Documents: Letters to a Woman Painter," *College Art Journal* 9, no. 1 (Autumn 1949), pp. 39–43.

2. For a study of Max Beckmann's critical reception and his stay in the United States, see Kienle 2008.

3. Beckmann's first retrospective exhibition in North America began at the City Art Museum of Saint Louis, May 10–June 28, 1948, and was subsequently shown in Baltimore; Cambridge, Massachusetts; Detroit; Los Angeles; San Francisco; Minneapolis; and Boulder, Colorado.

4. Max Beckmann, "Letters to a Woman Painter" (1948), in Beckmann 1997, p. 314.

5. Ibid., p. 315.

6. Ibid., p. 316.

7. Ibid.

8. Max Beckmann to Julius Meier-Graefe, May 10, 1919, in Beckmann 1993, vol. 1, p. 178, letter 173. Translations are my own unless otherwise noted.

9. Schmidt 1985, p. 45.

10. Rewald 1996, vol. 1, *The Texts*, p. 563.

11. Ibid., p. 562.

12. Minna Beckmann-Tube, "Erinnerungen an Max Beckmann," in Schmidt 1985, p. 172.

13. See Zeiller 2003, pp. 199–201; Joachim Poeschke, "Der frühe Max Beckmann," in Weisner and Gallwitz 1982, p. 131.

14. Max Beckmann to Minna Beckmann-Tube, May 13, 1907, in Beckmann 1993, vol. 1, p. 51, letter 34.

15. Marc 1912. Beckmann's response to Marc's text was published a week later; Beckmann, "Thoughts on Timely and Untimely Art" (1912), in Beckmann 1997, pp. 113–17; first published in the journal *Pan* as

"Gedanken über zeitgemäße und unzeitgemäße Kunst." For an analysis of the Beckmann–Marc controversy in reference to Cézanne, see also Poeschke 2000, p. 18; Barbara Stehlé-Akhtar, "Beckmann in Paris A–Z: Paul Cézanne (1839–1906)," in Bezzola and Homburg 1998, p. 180.

16. Beckmann, "Thoughts on Timely and Untimely Art," p. 117.

17. Ibid., p. 115.

18. Response to the survey "Das neue Programm," in *Kunst und Künstler* 12 (1914), p. 301; English translation in Beckmann 1997, pp. 131–32.

19. Max Beckmann to Reinhard Piper, August 17, 1912, in Beckmann 1993, vol. 1, p. 69, letter 55.

20. Rewald 1996, vol. 1, p. 564; Walter Feilchenfeldt, "The Early Reception of Cézanne's Work, with Emphasis on Its History in Germany," in Adriani 1995, pp. 303, 311 n. 37.

21. See Berliner Secession 1913, pp. 16, 18.

22. Beckmann to Meier-Graefe, May 10, 1919, in Beckmann 1993, vol. 1, p. 178, letter 173.

23. For discussions of Cézanne's influence on the young Beckmann, see Poeschke 2000, p. 15; Stehlé-Akhtar, "Beckmann in Paris A–Z," pp. 180–81; Lenz 1977, p. 237; Christoph Schulz-Mons, "Zur Frage der Modernität des Frühwerks von Max Beckmann," in Weisner and Gallwitz 1982, pp. 140–41.

24. Max Beckmann to Caesar Kunwald, August 4, 1905, in Beckmann 1993, vol. 1, p. 36, letter 18.

25. See Poeschke 2000, p. 15.

26. Beckmann's annotations and markings are recorded in Beckmann and Schaffer 1992, pp. 404–15.

27. The first *Temptation of St. Anthony*, now in the Foundation E. G. Bührle Collection, Zurich, and the second *Temptation of St. Anthony*, now in the Musée d'Orsay, Paris, were reproduced in Meier-Graefe 1918, pp. 97, 121, which Beckmann first read in 1919.

28. Felix Billeter, catalogue entry in Schulz-Hoffmann, Lenz, and von Bormann 2007, p. 138.

29. Beckmann, "Letters to a Woman Painter," in Beckmann 1997, pp. 314–15.

30. Max Beckmann to Mathilde Kaulbach, June 13, 1925, in Beckmann 1993, vol. 1, p. 301, letter 296.

31. Barbara Stehlé-Akhtar, "I Also Love Women," in Osterwold 2006, p. 77.

32. See Cornelia Homburg, "Beckmann and Picasso," in Bezzola and Homburg 1998, p. 61; Stehlé-Akhtar, "I Also Love Women," pp. 80–81.

33. Beckmann, "Letters to a Woman Painter," in Beckmann 1997, p. 316.

34. Paul Cézanne to Camille Pissarro, July 2, 1876; English translation in Cézanne 1995, p. 154.

35. Lackner 1967, p. 87.

36. Beckmann depicted the painters Friedrich Vordemberge-Gildewart and Otto Herbert Fiedler and the poet Wolfgang Frommel.

37. Rewald 1996, vol. 1, cat. 707, p. 444.

38. Beckmann 1955, p. 104.

39. Ibid., p. 295.

40. Max Beckmann, "On My Painting" (1938), in Beckmann 1997, p. 302.

Kostenevich, "Liubov Popova"

Editor's Note: Russian transliteration in the text uses the Library of Congress system, with the following modifications to improve readability: (1) the common name ending *–skii* is rendered *–sky*: thus Zhukovsky, not Zhukovskii; (2) soft and hard signs have been omitted; and (3) commonly accepted spellings have been used where such exist: thus Yuon, not Iuon; Ilya, not Ilia; Mayakovsky, not Maiakovsky; and Tretyakov, not Tretiakov.

1. Falk, who was only a few years older than Popova, recalled that when traveling in Italy in 1911 he had remembered Cézanne. See R. R. Falk, "Avtobiografiia" [Autobiography], in Falk 1981, p. 15.

2. I. A. Aksionov, "Zhizn izkusstva" [Life of art], in Moscow 1925, p. 5.

3. M. A. Vrubel to N. I. Zabela-Vrubel [Summer 1904?], in Vrubel 1976, pp. 84–85.

4. S. Iu. Sudeikin, "Dve vstrechi s Vrubelem" [Two meetings with Vrubel], in Vrubel 1976, p. 295.

5. *Zolotoe runo / La toison d'or*, nos. 7/9 (1908): nos. 15–17 in the French section (no. 15: *Portrait de la femme du peintre*; no. 16: *Nature morte*; no. 17: *Le château noir*).

6. Grabar to Alexander Benois, September 17, 1905, in Grabar 1974, p. 171.

7. Tugendkhold 1911, p. 78.

8. Ibid., p. 83.

9. It is hard to believe Udaltsova, who studied at the same school, when she said that Popova did not really understand what Le Fauconnier was talking about, while Udaltsova understood everything perfectly. See Voronova 1976, p. 27. Udaltsova's words are quoted unchallenged in John Bowlt, "Women of Genius," in Exter et al. 1999, p. 31.

10. The two pictures by Popova and Cézanne were shown together in the 1998 exhibition *Paul Cézanne and the Russian Avant-garde in the Early Twentieth Century* at the State Hermitage Museum in St. Petersburg and the Pushkin Museum of Fine Arts in Moscow.

11. The origin of the epithet "Amazons of the avant-garde" may be found in two paintings titled *Battle of the Amazons*, one by Georgy Iakulov (1884–1928) made in 1912 (State Picture Gallery, Erevan), and one by Vladimir Bekhteev (1878–1971) in 1914–15 (private collection, Paris).

12. Grishchenko spoke about Picasso's role in Russian artists' understanding of Cézanne as early as 1913; Grishchenko 1913, p. 33. For more recent discussions, see Albert Kostenevich and Gleb Pospelov in Kostenevich 1998.

13. Sarabianov and Adaskina 1990, p. 101 (repro.).

14. Suzdalev 1971, p. 7.

15. L. S. Popova, "O tochnom kriterii, o baletnykh nomerakh, o palubnom oborudovanii voennykh sudov, o poslednikh portretakh Pikasso i o nabliudatelnoi vyshke shkoly voennoi maskirovki v Kuntseve" [On the precise criteria, on ballet numbers, on the deck equipment of naval vessels, on the last portraits of Picasso and on the observational platform of the

school of military camouflage in Kuntsevo], in Sarabianov, Adaskina, and Zhukova 1989, p. 183.

16. Ibid., p. 184.

17. Ia. Tugendkhold, *Zhivopis revoliutsionnogo desiatiletiia (1918–1927)*. "Pechat i revoliutsiia," kn. 7 [Art of the revolutionary decade (1918–1927): "Print and revolution," book 7] (Moscow, 1927), quoted in Tugendkhold 1987, p. 232.

18. Tugendkhold 1925.

19. D. N. Ushakov, ed., *Tolkovyi slovar russkogo iazyka* [Dictionary of the Russian language], vol. 3 (Moscow, 1939), p. 934.

20. V. Mayakovsky, *Polnoe sobranie sochinenii* [Complete works], vol. 11 (Moscow, 1936), p. 72.

Hirsh, "For the Love, and Fear, of Painting"

Acknowledgments: Thanks are owed to the following individuals: Janet Abramowicz, Sharon Hecker, Kostis Kourelis, Allison Levy, Margherita Losacco, Francesca Morelli Romana, Jon Seydl, Donatella Trombadori, and Isabelle Wallace, as well as the staffs at both the Anne and Jerome Fisher Fine Arts Library at the University of Pennsylvania and the Marquand Library of Art and Archaeology at Princeton University. I am especially grateful to Mariana Aguirre, who generously shared with me her intimate knowledge of both Morandi and Soffici, as well as Joseph Rishel and his staff at the Philadelphia Museum of Art for providing me with this opportunity. This essay is dedicated to the memory of my grandmother, Bertha Hirsh, who always discouraged fear, especially of painting.

1. See Ardengo Soffici, "Paul Cézanne" (1908), reprinted in Museo Civico Giovanni Fattori 1997, pp. 172–74. Translations, unless otherwise indicated, are the author's.

2. Giorgio Morandi, "Autobiografia" (1928), reprinted in Cavallo 1989, pp. 43–53, which includes a facsimile of the newspaper.

3. Based in Paris, Giuseppe de Nittis and Federico Zandomeneghi, for example, showed with the Impressionists, and artist Telemaco Signorini traveled back and forth to Paris, but Diego Martelli was the critical voice most responsible for importing French Impressionism back to the Macchiaioli in Florence. See Norma Broude, *The Macchiaioli: Italian Painters of the Nineteenth Century* (New Haven: Yale University Press, 1987); and Albert Boime, *The Art of the Macchia and the Risorgimento: Representing Culture and Nationalism in Nineteenth-Century Italy* (Chicago: University of Chicago Press, 1993).

4. Alternatively, Italian artists could look to the German tradition, though few did with the exception of Giorgio de Chirico and his brother Alberto Savinio, both of whom spent some of their formative years in Germany with their mother, following their father's death in Greece.

5. For a more general discussion of Cézanne's reception in Italy, see Cardano, "Note sula fortuna critica di Paul Cézanne in Italia," pp. 168–84, in Ponente 1981. See also Claudio Strinati, "Cézanne in Italia. Fra amore e polemiche," in Benedetti 2002, pp. 31–34.

6. Vitali 1977, no. 53. Strinati made the point that critic Cesare Brandi (see Brandi 1942) identified Morandi as the modern Italian artist who followed Cézanne most closely. See Strinati, "Cézanne in Italia," p. 32. See also Miracco and Belli 2003, an exhibition catalogue that explores Morandi and his influence on the still-life genre in Italy from 1912 onward, taking as a point of departure Cézanne's pivotal role in revitalizing the genre, noting his shift away from romantic painting in 1870, and nominating him, above all other French painters, as the key to understanding twentieth-century Italian still-life paintings.

7. Vitali 1977, no. 396.

8. Italian artists, and Italians in general, experienced a surge in nationalism after World War I, especially since the Italians came up short; not only had they endured huge losses at Caporetto, but later the three allies (the United States, England, and France) barely acknowledged Italy's efforts on their behalf in the settlement at Versailles.

9. See Pica 1908. See also Lorenza Selleri, "La biblioteca di Morandi," in Pasquali 1996, p. 408, who claimed that this was one of the first art books Morandi would have read. Moreover, Selleri noted that there were twelve volumes on Cézanne in Morandi's personal library, including rare volumes such as Ambroise Vollard's 1915 monograph. Morandi also had significant holdings on Renoir and Corot; for the latter, Morandi also could consult Pierre Courthion's series *Pensées et ecrits du peintre*. As noted by Selleri (and elsewhere), Morandi's library seems to have comprised a combination of catalogues and critical monographs on fourteenth- and fifteenth-century painters such as Giotto, Masaccio, and Piero della Francesca, and eighteenth and nineteenth-century painters ranging from Chardin and Corot to Cézanne and Renoir. His personal library from the family apartment located on Via Fondazza is now preserved in a room of the Museo Morandi in Bologna. In 1991, the painter's sister Maria Teresa Morandi donated the collection, which contains more than 400 volumes (p. 407).

10. Pica 1908, p. 195.

11. Ibid.

12. Pica's eight selections included portraits, landscapes, and still lifes, all examples of Cézanne's works that would eventually influence Morandi. These images are listed with the following titles in Italian: *Autoritratto, Ritratto del Signor Chocquet, Cantuccio di tavola, Mele e pasticcini, Giovedì grasso, Un angolo di bosco, Il vaso di fiori,* and *Paesaggio a Pontoise.* Pica mentioned Maurice Denis's painting *Homage to Cézanne,* in which critics gather to admire Cézanne's *Apples and Pastries* (1877), the painting that would be important for Morandi in his metaphysical still-life paintings, to be discussed later in this essay. Pica's inclusion of Denis's canvas, though not reproduced as a plate, immediately memorialized Cézanne's contribution in the spirit of Henri Fantin-Latour's *Homage to Delacroix* (1864), which also pictured Manet. Thus, Morandi had a model to follow in terms of his "copying" of Cézanne. See Rossella Campana, "The 'Tuscans' and Cézanne: Itineraries," in Bardazzi 2007, pp. 183–99. Campana linked Denis to Soffici and Egisto Fabbri, the prominent Florence-based collector of Cézanne; she also attributed the connection between Cézanne and Masaccio to Denis. Campana further connected Soffici and Cézanne as two figures who willfully withdrew from Parisian life (p. 184).

13. See, in particular, Soffici 1909.

14. See Richter 2000. See also Campana, "The 'Tuscans' and Cézanne," p. 183, who noted that Soffici's paintings made immediately after returning from Paris constitute Tuscan reflections on the French master. See also Aguirre 2007, esp. pp. 23, 27–31, for a discussion of Soffici's return to Tuscany.

15. Soffici, "Paul Cézanne," p. 173.

16. Ibid., p. 174. Strinati, "Cézanne in Italia," p. 33, noted that critic Lionello Venturi (who would flee Italy with the rise of Fascism) also considered Cézanne an "Italian" artist.

17. Soffici, "Paul Cézanne," p. 174.

18. Ibid., p. 172.

19. See Ardengo Soffici, *Arthur Rimbaud* (1911; Florence: Vallechi, 2002). I thank Mariana Aguirre for this insightful observation; see Aguirre 2007, pp. 42–44. See also Soffici's *Lemmonio Boreo* (1912; rev. ed. Florence: Vallecchi, 1921). Boreo seems to be a stand-in for Soffici as a young intellectual who returns to Tuscany after a decade-long sojourn in the French capital. See Aguirre 2007, pp. 44–51, for a detailed analysis of this novel and how it not only reflects Soffici's identity but also stands as a pictorial analog for the Tuscan landscapes that he produced upon returning home to Tuscany.

20. Soffici's writings appeared in French magazines as well, including *La plume* and *L'Europe artiste,* and the Italian magazines *La voce, Lacerba, Rete mediterranea,* and *Valori plastici. Lacerba* was published by Soffici and had a Futurist flavor replete with a pro-interventionist bent vis-à-vis World War I. For more information on the stifling atmosphere of Bologna during Morandi's formative years, see Abramowicz 2005, esp. chap. 2.

21. See Soffici 1909; Soffici 1910; Soffici 1913.

22. *La voce* 2 (March 3, 1910) announced Soffici's upcoming exhibition, slated for April 15–May 15, 1910, hence building pre-exhibition excitement. See Eugenio Riccòmini, "Morandi e I suoi 'congeneri'," in Galleria Comunale d'Arte Moderna 1985, pp. 13–18. Riccòmini noted not only Morandi's exposure to Cézanne but also to Chardin and Corot. Less than two years later, Morandi would have read Henry des Pruraux's musings "Della natura morta," *La voce* 3 (June 22, 1911), which perhaps caught Morandi's eye just before he began his lifelong engagement with the genre. Abramowicz noted that the article by des Pruraux is rumored to have been written by Soffici himself. See Abramowicz 1983, p. 233 n. 3. See also Walter Adamson, "Modernism in Florence: The Politics of Avant-Garde Culture in the Early Twentieth Century," in *Italian Modernism: Italian Culture between Decadentism and Avant-Garde,* ed. Luca Somigli and Mario Moroni (Toronto: University of Toronto Press, 2004), pp. 221–42, for a general overview of how journals such as *La voce* and *Lacerba* imported and transformed modernism in the Florentine context during the years leading up to World War I.

23. Riccòmini, "Morandi e I suoi 'congeneri'," p. 16. Meier-Graefe's book was in fact the first monograph on Cézanne in any language and would have been critical for Morandi, since it contained 54 plates; see Meier-Graefe 1910. *La voce* first mentioned the monograph in a caption for one of Cézanne's self-portraits reproduced in *La voce* 5 (February 6, 1913). The monograph was subsequently mentioned several times in advertisements for modern art books carried by the *La voce* bookshop in Florence (Libreria La Voce), beginning in *La voce* 5 (May 8, 1913).

24. Riccòmini, "Morandi e I suoi 'congeneri'," p. 18.

25. Abramowicz 1983, p. 140.

26. The show was scheduled to be open from April 15 to May 15, 1910, at the Lyceum Club in Florence and was to include five Cézannes. As noted in an advertisement in *La voce,* the show opened five days late, on April 20, and included, according to Soffici's review, only four original Cézannes. See Riccòmini, "Morandi e I suoi 'congeneri'," pp. 13–18. As noted earlier, Soffici's articles were also a formal response to the virtual absence of French modernism at the 1908 Biennale. I mention Rosso here as a significant figure in bridging the gap between French and Italian modernism, since he lived in Paris, at least intermittently, from 1889 until 1917.

27. Abramowicz 2005, p. 43. The works by Cézanne were sent by the Galerie Bernheim-Jeune. In addition to attending the exhibition, Morandi submitted a spare winter landscape of 1913 (Vitali 1977, no. 10).

28. The mark of Cézanne can be detected in a handful of landscape paintings as early as 1912, though Morandi's full embrace of the French artist in his still lifes emerged later, around 1919. For more on the relationship between Italian Futurism and French Cubism, see Emily Braun, "Vulgarians at the Gate," in Mattioli Rossi 2004, pp. 1–21.

29. Vitali 1977, no. 19.

30. See Abramowicz 2005, who linked Morandi's Cubo-Futurist images (such as *Fragment,* Vitali 1977, no. 15) to an ink drawing by Picasso that Morandi would have seen as an illustration for Soffici's essay on "Ojetti e il cubismo," *La voce* 4 (November 21, 1912), pp. 936–37.

31. In 1914 Morandi participated in a Futurist exhibition held at the five-star Hotel Baglioni in Bologna. See "Biografia," in Pasquali 1990, pp. 379–80, which catalogued the various Futurist *serate* at which Morandi was present. See also Aguirre 2007, pp. 96–100.

32. See Aguirre 2007, pp. 40, 60–61. Soffici's production of *trofeini* roughly overlapped with his publication of the magazine *Lacerba* (1913–15), which adopted the pro-interventionist and bellicose rhetoric of the Futurists.

33. Given that this essay's focus is on the relationship between Cézanne and Morandi, I will not treat fully Soffici's pictorial absorption of Cézanne in terms of his own canvases, many of which successfully negotiate Cézannian themes and forms. In particular, in the early 1910s, Soffici reinterpreted the landscape à la Cézanne by nostalgically depicting the peasants at work in the land. Moreover, in the late 1910s he created a number of still-life canvases that impart a metaphysical sensibility to the genre. Several of these canvases were reproduced in the pages of *Valori plastici.*

34. Soffici would eventually write a monograph on Carrà. See Ardengo Soffici, *Carlo Carrà* (Milan: Hoepli, 1928). Carrà completed two portraits of

Soffici, a collage in 1914 and a pencil drawing in 1918 (illus. in *Carlo Carrà. Tutti gli scritti*, ed. Massimo Carrà [Milan: Feltrinelli, 1978]), pp. 31, 181.

35. "The Founding and Manifesto of Futurism" (1909), trans. and reprinted in Apollonio 1973, p. 22.

36. See Umberto Boccioni, "Futurist Painting and Sculpture" (extracts; 1914), in Apollonio 1973, pp. 172, 174.

37. Ibid., p. 176.

38. Ibid., p. 175.

39. Ibid., p. 176 (original emphasis).

40. Ibid., p. 177.

41. For an extended definition and analysis of the concept of the myth of national regeneration in Fascist Italy, see Emilio Gentile, "The Myth of National Regeneration in Italy: From Modernist Avant-Garde to Fascism," in *Fascist Visions: Art and Ideology in France and Italy*, ed. Matthew Affron and Mark Antliff (Princeton: Princeton University Press, 1997), pp. 25–45.

42. See Abramowicz 2005, chaps. 4 and 5. For an introduction to *Valori plastici*, see Fossati, Ferraris, and Velani 1998, pp. 284–87, as well as Aguirre 2007, pp. 115–18, 125–36.

43. For more on Morandi's general activities during this period, see Paolo Fossati, "Giorgio Morandi e gli anni di 'Valori plastici'," in Fossati 1981, pp. 35–46; Fagiolo dell'Arco 1980; and Storchi 2006. *Valori plastici* also published *Les artistes nouveaux* (1921–26), a series of artistic monographs that included volumes on Carrà, Corot, Courbet, Picasso, and Soffici.

44. *Valori plastici* was in fact the first magazine to reproduce Morandi's work. See Fossati, "Giorgio Morandi e gli anni di 'Valori plastici'," p. 35.

45. Carlo Carrà, "L'italianismo artistico" (1919), reprinted in *Carlo Carrà. Tutti gli scritti*, pp. 133–36.

46. Although my focus here is on Morandi's still-life compositions, it should be noted that as early as 1913 he seems to have looked back to Cézanne in his landscapes. See especially Vitali 1977, no. 16.

47. This has been published as no. 26, page from a sketchbook, recto: *Carafe and Knife* (*Carafe et Couteau*), c. 1882. Rishel 1983, p. 57.

48. See Soffici, "Paul Cézanne," p. 173.

49. For more on de Chirico's notion of a "return to the craft," see de Chirico, "Il ritorno al mestiere," reprinted in de Chirico 1985, pp. 93–99.

50. The work (Vitali 1977, no. 48) was reproduced in *Valori plastici* 1 (November–December 1919).

51. See M. L. Lamberti and Maurizio Fagiolo dell'Arco, eds., *Piero della Francesca e il novecento italiano. Prospettiva, spazio, luce, geometria, pittura murale, tonalismo, 1920–1938*, exh. cat., Museo Civico di Sansepolcro (Venice: Marsilio, 1991).

52. Vitali 1977, no. 51.

53. See Morandi, "Autobiografia," p. 49.

54. See Carlo Carrà, "Paul Cézanne" (1919), reprinted in *La ronda, 1919–1923*, ed. Giuseppe Cassieri (Naples: Liguori, 2001), pp. 95–102.

55. Ibid., p. 95.

56. Ibid., pp. 99–100. The full text reads: "Here resides perhaps the intimate and perfect value that

connects him to tradition, [and here] I mean our, Italian [tradition]. But to better explicate our idea, we ought to add that he resolves the plastic problem in the manner of the Venetians, that is to say, more so in [terms of] the color-tone than in the linear [manner] that comes from Giotto and from Masaccio."

57. Soffici's only mention of Cézanne's link to the Venetians was in terms of his looking to the contorted figures of Tintoretto. See Soffici, "Paul Cézanne," p. 174.

58. But de Chirico's decisive move away from his peers, Carrà and Morandi included, partly reflected his growing interest in the materiality of paint, a shift that in painterly priorities moved him closer to the Baroque than to the French Impressionists, or, by extension, Cézanne. De Chirico would eventually reject his own call for "plastic values" as his pictorial priorities shifted. His facture would become increasingly visible as his style grew more baroque. Beginning in the late 1920s, and especially the 1930s and 1940s, de Chirico generated baroque canvases with thickly applied paint that sought to mimic painters such as Veronese.

59. See Signac 1920, pp. 123–24. The only two images from the installation reproduced are *Mont S. Victoire* (1885) and *Portrait of Mme. Cézanne* (1875). See Giovanna De Lorenzi, "The Cézanne of the Fabbri and Loeser Collections at the 1920 Venice Biennale: Aspects of a Critical Debate," in Bardazzi 2007, pp. 239–55. Twenty-four of the paintings were from the collection of Egisto Fabbri and three from the collection of Charles Loeser (p. 239). De Lorenzi also noted that Pica, upon taking over the position as secretary of the Biennale, had pushed for the Cézanne installation in order to fill a well-known gap in terms of direct access to his paintings. For more information on the history of the assembly of the Fabbri and Loeser collections, see Francesca Bardazzi, "Cézanne a Firenze," in Museo Civico Giovanni Fattori 1997, pp. 26–39.

60. See Bandera 2005, pp. 16–17.

61. Aguirre 2007, pp. 141–48, noted that Morandi's self-portraits executed between 1924 and 1930 reference Cézanne's self-portraits; this gesture simultaneously solidifies Morandi's subscription to Soffici's theories related to Cézanne and also reiterates Morandi's decisive move away from the metaphysical school and toward a more regional, rural aesthetic.

62. See De Lorenzi, "The Cézanne of the Fabbri and Loeser Collections at the 1920 Venice Biennale"; pp. 281–89 reprinted reviews of the show by Ugo Ojetti, Lucien Henraux, Antonio Maraini, Soffici (p. 284), Margherita Sarfatti, and Emilio Cecchi, who in his review for *Il convegno* noted Cézanne's nervousness and fear.

63. See Braun 1995. See also Abramowicz 2005, pp. 117–33 (esp. for Morandi's associations with the movement from 1926 to 1929), and Aguirre 2007, pp. 151–54. For more on Morandi's relationship with Soffici, see Cavallo 1989.

64. See Giorgio de Chirico, "Giorgio Morandi" (1922), in de Chirico 1985, pp. 236–37.

65. See D. Medina Lasanksy, *The Renaissance Perfected: Architecture, Spectacle, and Tourism in Fascist Italy* (University Park: Pennsylvania State University Press, 2004), for an exploration of this theme through both architecture and civic festivals and events of the period.

66. See Abramowicz 2005, chap. 10; Braun 1995, pp. 91–92; Aguirre 2007, pp. 156–59. Morandi stopped painting landscapes altogether from about 1917 to 1925; however, he returned to the genre just as he joined Strapaese, a logical shift since promoting the rural landscape was central to the movement's goals.

67. The regime oversaw many organizations, such as the Opera Nazionale Dopolavoro (a government agency established in 1925); and programs like those run by the Ente Radio Rurale testify to the regime's interest in cultivating cultural activities for those in the provinces, a scheme designed, in part, to encourage people to resettle in the countryside to work the land. The regime's large-scale program for *bonifica*, or land reclamation, celebrated agrarian life both within Italy, as in the formerly marshy *agro pontino* south of Rome and in the north where rice was cultivated, as well as abroad, in the colonies and occupied territories.

68. Morandi, "Autobiografia," pp. 43–53. See also Morandi 2004, p. 41. See Aguirre 2007, pp. 174–77, for an excellent discussion of Morandi's autobiography.

69. Braun 1995, p. 92.

70. See Soffici 1932.

71. Ibid.

72. Vitali 1977, no. 170.

73. Abramowicz 2005, p. 168, noted that Morandi dedicated himself to exploring this dark, rich palette even more frequently in the 1940s.

74. Vitali 1977, no. 211.

75. See Museo Civico Giovanni Fattori 1997 for other artists influenced by Cézanne, including Oscar Ghiglia, and Ottone Rosai, as well as Soffici, Carrà, and Morandi. Miracco and Belli 2003 also reinforced this point. For a full account of Mario Sironi, see Emily Braun, *Mario Sironi and Italian Modernism: Art and Politics under Fascism* (New York: Cambridge University Press, 2000).

76. Although space does not permit a full consideration of the importance of Cézanne for Sironi, it would be interesting to compare the French artist's numerous canvases of bathers with Sironi's large-scale representations of archetypal images, such as *La famiglia* (1929), which feature triangular compositions of large, blocky figures that illustrate the regime's allegorical imaginary for building a new nation.

77. Giorgio de Chirico, "Vox Clamans in Deserto" (1938), in de Chirico 1985, p. 340.

78. Strinati, "Cézanne in Italia," p. 32, made this point.

79. Ibid., p. 33.

80. See Claudia Salaris, *La Quadriennale. Storia della rassegna d'arte italiana dagli anni Trenta a oggi / History of the Exhibition of Italian Art from the Thirties to Today* (Venice: Marsiglio, 2004), pp. 43–68; Abramowicz 2005, pp. 158ff; Aguirre 2007, pp. 202–15.

81. See Telesio Interlandi, "Straniera bolscevizzante e giudaica," *Il Tevere*, November 24–25, 1938. Interlandi published this daily Fascist newspaper and, in his editorial, railed against paintings by de Chirico and Carrà as well as buildings by Terragni and a sculpture by Fontana, claiming—in line with the German definition of degenerate art—that they were stylistically foreign, Bolshevik, and Jewish. Although Morandi's works were not illustrated in this article, the claims

of the editorial make clear the environment in which some conservative critics would find fault with him in the late 1930s on the grounds of his iconographic choices and movement toward abstraction.

82. See Pia Vivarelli, "La politica delle arti figurative negli anni del Premio Bergamo," in *Gli anni del Premio Bergamo. Arte in Italia intorno agli anni Trenta* (Milan: Electa, 1993), pp. 24–38. Vivarelli, pp. 29–30, cites A. F. Della Porta, "Esaltazione e denigrazione della razza," *Perseo* (October 1, 1938). See note 30 above for Abramowicz's connection of Morandi's *Fragment* to Picasso.

83. See Richter 2000, p. 110. Richter remarked that Cézanne served as Soffici's alter ego.

84. See Braun 1995, esp. pp. 89–91. Abramowicz 1983, p. 140, rejected the myth, though later, in Abramowicz 2005, esp. pp. 117–133, she methodically examined Morandi's associations with key players in the regime. See Aguirre 2007, esp. pp. 166–70, for a comprehensive evaluation of Morandi's connections to the regime with particular attention to his relationship with Soffici over time.

85. See Soffici 1950. His collection of "thirty Italian and foreign modern artists" reflected his postwar reconsideration of modernism insofar as he began the book with Picasso and closed with Cézanne, sandwiching the Italians in the middle. Soffici thus set up his own induction into and then reorientation within French modernism. At this point, he seemed comfortable defining Italian artistic identity through a French code, a strategy that perhaps allowed him to sidestep the Fascist politics attached to much of Italian modern painting of the interwar period. See also Aguirre 2007, pp. 218–24.

86. See Brandi 1939 and Brandi 1942. Interestingly, Brandi's cleaving of Morandi's art from his politics paved the way for postwar communist critics, such as Antonello Trombadori (son of Scuola Romana painter Francesco Trombadori), as well as international museums, such as the Museum of Modern Art in New York, to celebrate Morandi's life and work in the postwar, that is to say post-Fascist, moment. See, for example, Soby and Barr 1949, which classified Morandi as "the third member of the metaphysical school," along with de Chirico and Carrà. This reading of course hinges on the prize for Italian painting given to Morandi at the 1948 Venice Biennale, where he was represented in similar terms. Despite including several paintings and etchings executed by Morandi under Fascism, the New York exhibition interpreted him as someone who "worked independently" (Soby and Barr 1949, p. 132).

87. Arcangeli 1964 attempted to put the artist in context, a gesture that Morandi himself vehemently rejected. Arcangeli 2007 outlined the politics around Morandi, vis-à-vis Strapaese, although ultimately insisted that "Morandi did not participate politically, but knew that the custom, if not the substance, of his life was connected to a world that Strapaese defended" (p. 323). Braun 1995, Abramowicz 2005, and Aguirre 2007 all dug much more deeply into Morandi's elaborate social and professional networks to reveal the connections between his work, his patrons, and the regime.

88. See Abramowicz 2005, pp. 130, 132.

89. Vitali 1977, no. 305.

90. Ibid., pp. 170–71 and nos. 302–10.

91. Vitali 1977, no. 926.

92. See Beatrice Marconi's entry on this painting in *Scuola romana e Novecento italiano. Una collezione privata; collezione Claudio e Elena Cerasi*, ed. Maurizio Fagiolo dell'Arco and Valerio Rivosecchi (Milan: Skira, 2008), p. 32, for an inventory of the objects in the painting. I am grateful to Donatella Trombadori for discussing her father's painting with me. She kindly identified the Cézanne monograph as *Cézanne*, trans. from the German (Vienna: Phaidon, 1937), with an introductory text, "Paul Cézanne," by Fritz Novotny. The monograph includes reproductions of ninety-two paintings, twenty-two watercolors, and ten drawings. Trombadori regularly included haunting references to Cézanne images in his paintings. See Maurizio Fagiolo dell'Arco, *Scuola romana. Artisti tra le due guerre*, exh. cat. (Milan: Mazzotta, 1988), pp. 162–64, for a discussion of another Trombadori painting, *Begonia e libri* (c. 1937), that includes a book opened to a landscape by Cézanne. See also Fagiolo dell'Arco, *Scuola romana. Pittura e scultura a Roma dal 1919 al 1943* (Rome: De Luca, 1986), pp. 18–21; dell'Arco remarked that critic Roberto Longhi noted Trombadori's fusion of northern European elements and influences with what he called the Post-Impressionist lessons of Cézanne (p. 18).

93. Dell'Arco and Rivosecchia, eds., *Scuola romana*, p. 32.

94. Important players of the Scuola Romana included Afro Basaldella, Corrado Cagli, Mario Mafai, Antonieta Raphael, Fausto Pirandello Scipione, as well as Trombadori and many others. For a discussion of the artists now considered to have been part of the group, see dell'Arco and Rivosecchia, eds., *Scuola romana*. For an investigation of the cohesiveness of this group and the validity of the very term *Scuola Romana*, see Emily Braun, "Scuola Romana, Fact or Fiction?" *Art Journal* 76, no. 3 (March 1988), pp. 128–37.

95. "Paura della pittura" was a phrase that Carlo Levi had coined for an essay he wrote in 1942; see Carlo Levi, "Fear of Painting," in *Fear of Freedom*, trans. Stanislao G. Pugliese (New York: Columbia University Press, 2008), pp. 91–98. The 1942 issue of *Prospettive* did not, however, carry a contribution from Levi.

96. This issue of *Prospettive* contains a number of interesting essays on the contemporary state of painting by artists such as Renato Guttuso and Mario Mafai. Full discussion of the issue exceeds the limits of this essay and will be the subject of a forthcoming publication.

97. See Harold Bloom, *The Anxiety of Influence: A Theory of Poetry*, 2nd ed. (New York: Oxford University Press, 1997).

Lanchner, "Cézanne and Giacometti"

1. Merleau-Ponty 1964a, p. 9.

2. Lord 1985, p. 229.

3. Rilke 1985, p. 38, recounts how Cézanne instantaneously identified with the tormented painter Frenhofer from Balzac's story "The Unknown Masterpiece."

4. Quoted in Lord 1980, p. 72.

5. Ibid., pp. 10–11.

6. Ibid.

7. Rilke 1985, pp. 7–8.

8. Rilke quoted by Heinrich Wiegand Petzet in his foreword to Rilke 1985, p. xi.

9. See ibid., p. xxiii.

10. Merleau-Ponty 1964b, p. 163.

11. Giacometti 1990, p. 64.

12. Quoted in Megged 1985, p. 63.

13. Quoted in Vollard 1936, p. 184.

14. Quoted in Sylvester 1996, p. 90.

15. Ibid.

16. Ibid., p. 91.

17. Jacques Dupin, "Une écriture sans fin," in Giacometti 1990, p. xxiv.

18. Krumrine 1989a, p. 44.

19. Quoted in Sylvester 1996, p. 67.

20. Henri Loyrette in Cachin et al. 1996, p. 102.

21. Ibid.

22. Sylvester 1996, p. 43.

23. Salvador Dalí, "Objets surréalistes," p. 17; trans. by Haim Finkelstein in *Salvador Dalí's Art and Writing, 1927–1942: The Metamorphoses of Narcissus* (Cambridge: Cambridge University Press, 1996), p. 163.

24. Gowing, Stevens, and Adriani 1988, p. 11.

25. Quoted in Sylvester 1996, p. 91.

26. Quoted by Françoise Cachin in Cachin et al. 1996, p. 403.

27. Robert Rosenblum, *Paintings in the Musée d'Orsay* (New York: Stewart, Tabori and Chang, 1989), p. 363.

28. Quoted in Fletcher 1994, p. 106.

29. Quoted in ibid.

30. Schapiro 1978, p. 37 n. 65.

31. Quoted in Lawrence Gowing, "The Logic of Organized Sensations," in Rubin 1977, p. 57.

32. Since the original oil painting was in the Barnes Collection in Merion, Pennsylvania, Giacometti's model was most likely a print made after the painting.

33. Quoted in Krumrine 1989a, p. 297.

34. See ibid., p. 298.

35. Christian Klemm, in Klemm et al. 2001, p. 150.

36. Reff 1962, p. 173.

37. Klemm, in Klemm et al. 2001, p. 150.

38. Reff 1962, p. 174.

39. Ibid., p. 173.

40. Klemm, in Klemm et al. 2001, p. 150.

41. Rosenblum and Janson 1984, p. 387.

42. Gowing 1991, p. 58.

43. Quoted in Sylvester 1996, p. 10.

44. Quoted in Kimmelman 1998, p. 104.

45. Rosenblum and Janson 1984, p. 388.

46. Giacometti to Pierre Matisse, December 28, 1950, in Giacometti 1990, p. 59.

47. Rosenblum and Janson 1984, pp. 386–87.

48. Dupin 1991, p. 29.

49. Quoted in Gowing, "The Logic of Organized Sensations," p. 70.

50. Genet 1958, n.p.

51. Giacometti 1990, p. 293.

52. Cachin, in Cachin et al. 1996, p. 444.

53. Schapiro 1978, p. 37 n. 65.

54. Quoted by Cachin in Cachin et al. 1996, p. 372.

55. See Cachin et al. 1996, p. 49, for a reproduction of this painting.

56. Giacometti 1990, p. 293.

57. Ibid., p. 267.

58. "Eine gemalte Erkenntniskritik," Novotny 1932, p. 278.

59. Giacometti 1990, p. 273.

60. Vollard quoted by Joseph J. Rishel in Cachin et al. 1996, p. 50.

61. Lord 1965, p. 79.

62. Megged 1985, p. 10.

63. Cézanne to Roger Marx, quoted in Cachin et al. 1996, p. 17.

Taylor, "Learning from 'Papa Cézanne': Arshile Gorky"

1. Gorky's harshest detractor was Emily Genauer, the outspoken art critic of the *New York Herald Tribune*, who described his Cézanne-derived work as "second-rate" and "a blatant parroting of some one else's style"; see "Gorky: Was He Tops or Second Rate," *Art Digest* 25, no. 8 (January 15, 1951), p. 9.

2. Karlen Mooradian, "Interview with Willem de Kooning," in *Ararat* 12, no. 4 (Fall 1971), p. 49.

3. Rosenberg 1960, p. 103.

4. Meyer Schapiro, "Introduction," in Schwabacher 1957, p. 11. The artist's sister, Vartoosh, similarly recalled that during his early years in New York in the 1920s, Gorky would "always take me to museums and we would walk until our feet could move no longer. He would often simulate a telescope with his hands to study paintings. 'This way,' he told me, 'you can see only what you want, only the face, and you can study it more.' And he would sit and draw there and I would sit next to him and watch. His entire mind, morning and night, was concerned with art"; see Karlen Mooradian, "A Sister Recalls: An Interview with Vartoosh Mooradian," *Ararat* 12, no. 4 (Fall 1971), p. 16.

5. Gorky's knowledge of Cézanne was no doubt informed by the art criticism of his time, which tended to romanticize the life and work of the French artist, who emerges in these accounts as a mysterious, ill-tempered, and somewhat reclusive figure, oblivious to fame and utterly dedicated to his art. American critics in the 1920s discussed Cézanne's accomplishment almost exclusively in terms of a heroic struggle that was compounded by his tenacious and irascible personality. Forbes Watson, for example, highlighted the artist's "disheartening struggle," as well as his "social irritability and brusqueness" in a review of a Cézanne

exhibition at the Wildenstein Galleries in New York in 1928; see Watson, "New York Exhibitions," *The Arts* 13, no. 2 (February 1928), p. 107.

6. Meyly Chin Hagemann has identified most of the more than forty Cézanne paintings that Hemingway could have seen in Paris during the early 1920s; see Hagemann, "Hemingway's Secret: Visual to Verbal Art," *Journal of Modern Literature* 7 (February 1979), pp. 87–112.

7. Michael Reynolds, *Hemingway's Reading, 1910–1940: An Inventory* (Princeton, NJ: Princeton University Press, 1981), p. 197.

8. Lillian Ross, *Portrait of Hemingway* (New York: The Modern Library, 1999), p. 47. Hemingway made this statement in November 1949 during a tour of the Metropolitan Museum of Art, where he stopped to admire Cézanne's foreboding *Rocks in the Forest*.

9. Ernest Hemingway, *A Moveable Feast* (New York: Bantam Books, 1969), p. 13.

10. Ernest Hemingway, *The Nick Adams Stories* (New York: Bantam Books, 1973), p. 219. Hemingway expressed the same desire in a letter to Gertrude Stein and Alice B. Toklas, dated August 15, 1924, in which he described a short story ("Big Two-Hearted River") "where I am trying to do the country like Cézanne and having a hell of a time and sometimes getting it a little bit"; see *Ernest Hemingway: Selected Letters, 1917–1961*, ed. Carlos Baker (New York: Scribner's, 1981), p. 122.

11. Emily Stipes Watts, *Ernest Hemingway and the Arts* (Champaign: University of Illinois Press, 1976), p. 35.

12. Jill Anderson Kyle, "Cézanne and American Painting, 1900 to 1920" (Ph.D. dissertation, University of Texas at Austin, 1995), p. 326.

13. Lichtenstein 1964, pp. 55–67.

14. Ibid., p. 56. For more on Cézanne's copies at the Louvre, where he registered on November 20, 1863, and began copying Nicolas Poussin's *Shepherds of Arcadia* in 1864, see Theodore Reff, "Copyists in the Louvre, 1850–1870," *Art Bulletin* 46, no. 4 (December 1964), p. 555. As Reff correctly surmises, Cézanne's copies after Delacroix's *Dante and Virgil* and *Liberty Leading the People* were painted in the Musée du Luxembourg, as the originals did not enter the Louvre until 1874.

15. Rosemary Chapman, "Autodidacticism and the Desire for Culture," *Nottingham French Studies* 31, no. 2 (Autumn 1992), p. 84.

16. Ibid., p. 84.

17. The Self-Taught-Man's autodidactic project ends in shame and failure, after he commits an act of pederasty that leads to his ejection from the library, thus dashing his hopes for self-improvement. As Angela Kershaw has argued, Sartre's ever-blushing character is doomed to self-destruction from the start, "since bourgeois culture decrees that the autodidact should be ashamed of his attempts to accede to learning: the autodidact internalizes this shame, and recreates himself as a shameful individual in the persona of the criminal. It is almost a crime to be an autodidact, a crime against the bourgeoisie, an infraction of the bourgeois educational code." See Kershaw, "Autodidacticism and Criminality in Jean-Paul Sartre's *La Nausée* and Edith Thomas's *L'Homme Criminel*," *Modern Language Review* 96, pt. 3 (July 2001), p. 689.

18. Willem de Kooning told Harold Rosenberg that Gorky was "a Geiger counter of art. In a room in the museum, he always ran to the right painting, and in the painting he always picked the really interesting thing." See Rosenberg 1962, pp. 26–27.

19. While living in Boston, Gorky had briefly attended the New England School of Design at 248 Boylston Street, which was directed by Douglas John Connah. For more on Gorky's early years in Boston and New York, see Matossian 1998, pp. 113–91; Spender 1999, pp. 51–81; and Herrera 2003, pp. 107–216.

20. James E. B. Breslin, *Mark Rothko: A Biography* (Chicago: University of Chicago Press, 1993), p. 56. Gorky's *Lady in the Window*, which he based on a version of Frans Hals's *Malle Babbe* in the collection of the Metropolitan Museum of Art, may have been one of these works that he brought into the classroom. The artist's interpretation of Hals's famous painting of a leering, drunk woman with an owl perched incongruously on her shoulder, reveals his early interest in using works from public collections as formal exercises in which to discover the underlying structure of famous paintings, including the works by Cézanne that were available to him in public collections in and around New York in the mid-to-late 1920s.

21. Despite his teaching experience at the New School of Design, Gorky felt that he had more to learn as an artist. On January 9, 1925, he enrolled in a life drawing class taught by Charles Hawthorne at the National Academy of Design in New York. Although Gorky quit after the first session—presumably because he was so adept at working from the model that there was little else for him to learn—Hawthorne would play an important role in the artist's development. In the mid-1920s, Hawthorne participated in the Grand Central Art Galleries exhibitions, which were organized under the aegis of the Grand Central School of Art, and it was almost certainly Hawthorne who suggested to Gorky that he should study there. See Gorky's curriculum vitae, which he sent to the Museum of Modern Art in August 1945; Arshile Gorky file, Archives of the Department of Painting and Sculpture, Museum of Modern Art, New York.

22. Grand Central School of Art, *Annual Report, 1926–1927*, p. 19.

23. Gorky clearly based his claims to have studied at the Académie Julian on the real-life experiences of his former teacher in Boston, Douglas John Connah, who had studied with Jean-Paul Laurens, the father of Paul Albert Laurens (listed as Albert Paul Laurens in Gorky's dubious educational record in the Grand Central School of Art's *Annual Report*), at the small liberal arts school on the left bank of the Seine, which had been a haven for American Impressionist painters since the 1880s. Laurens, a narrative academic painter whose works were prominently displayed in the Pantheon in Paris, insisted on detailed drawing as the underpinning of all great painting, a lesson that was clearly passed on to Gorky through Connah. See Catherine Fehrer, "New Light on the Académie Julian and Its Founder (Rodolphe Julian)," *Gazette des Beaux-Arts* 103 (May–June 1984), pp. 207–16.

24. Gorky's fictional biography in the school's annual report was accompanied by an illustration of one of his recent paintings, which has previously been described as an academic study of female nudes, but

can now be securely identified as a 1925 painting of Auguste Rodin's marble figure group *Pygmalion and Galatea*, which had been on permanent view at the entrance to the Rodin Gallery at the Metropolitan Museum of Art since May 2, 1912. See Clare Vincent, "Rodin at the Metropolitan Museum of Art: A History of the Collection," *Metropolitan Museum of Art Bulletin* 38, no. 4 (Spring 1981), p. 7. As an instructor in "Antique, Still Life and Figure Composition," Gorky thus chose a canvas that demonstrated to his students how they could hone their skills by working from a painting or sculpture in a museum setting, while also paying homage to one of the greatest sculptors of the modern era.

25. "Fetish of Antique Stifles Art Here Says Gorky Kin," *New York Evening Post*, September 15, 1926, p. 17. This newspaper article identified the artist as the cousin of the great Russian writer Maxim Gorky, whose real name was Alexei Maksimovich Peshkov. For an excellent discussion of the multiple implications of the "Arshile Gorky" pseudonym, which the Armenian immigrant Vosdanik Adoian adopted in the early 1920s, see Theriault 2006, pp. 141–56.

26. Levy 1966, p. 15.

27. According to Weyhe, Gorky was so desperate to acquire an expensive art book that he asked the bookseller and art dealer to sell one of his paintings, which Weyhe did for around $750. Gorky was so pleased with the amount that he gave Weyhe a painting as a gift and began selling his work through the gallery. See Mooradian 1980, p. 216.

28. Gorky's library contained the following books on Cézanne: Julius Meier-Graefe, *Cézanne und sein Kreis* (Munich: R. Piper Verlag, 1922); Roger Fry, *Cézanne: A Study of His Development* (London: Hogarth Press, 1927); Fritz Novotny, *Cézanne* (Vienna: Phaidon Press; New York: Oxford University Press, 1937); Raymond Cogniat, *Cézanne* (New York: French Library of Fine Arts, French and European Publications, 1939); and Lionello Venturi, *Paul Cézanne Watercolours* (Oxford: Bruno Cassirer; Glasgow: Glasgow University Press, 1944). The artist also owned numerous reproductions of Cézanne's work, including the portfolio of fifteen high-quality facsimiles that were published in Munich in 1912 by R. Piper Verlag as *Paul Cézanne: Mappe*. Many of these facsimiles have Gorky's own drawings on the verso, confirming his excitement at seeing works such as *Madame Cézanne in a Red Armchair* and the final version of *The Large Bathers* for the first time. Gorky also owned a color reproduction, from an as yet unidentified Russian magazine, of Cézanne's *The Smoker*, c. 1890–92 (see plate 155). I am grateful to Agnes "Mougouch" Fielding, Matthew Spender, Maro Gorky, and Natasha Gorky for sharing this information on Gorky's library with me.

29. In February 1928, Weyhe paid for the German art historian to visit New York and other American cities to promote the English translation of his monograph on Cézanne. For more on Meier-Graefe's month-long trip to the United States, see Carl Zigrosser, *A World of Art and Museums* (Philadelphia: The Art Alliance Press, 1975), p. 46. Gorky may have attended some of the numerous dinners and events that Weyhe organized for Meier-Graefe during this publicity tour.

30. "When I went there in 1927, Gorky was already speaking about Cézanne, so we looked at the book by Meier-Graefe, the German critic who wrote on Cézanne." Quoted in Matossian 1998, p. 151. Sirun Mussikian, a model at the Grand Central School of Art, also recalled that the Armenian-born artist "talked a lot about cubes and cones and cylinders"; see ibid., p. 172. This recollection confirms Gorky's passion for Cézanne's work and compositional techniques. In an April 15, 1904, letter to Emile Bernard, Cézanne commented that "natural forms all tend to the sphere, the cone and the cylinder." See Fry 1927, p. 52.

31. Rewald 1989, p. 205. The Metropolitan Museum of Art received five more oil paintings by Cézanne in 1929 through Mrs. Henry O. Havemeyer and her son Horace, although this bequest, which included major works such as *Still Life with Green Jar and White Cup*, *The Gulf of Marseille Seen from L'Estaque* (see plate 164), and *Monte Sainte-Victoire and the Viaduct of the Arc River Valley* (see plate 199), came too late for Gorky, who had by that point moved on to the work of Matisse and Picasso.

32. The artist Saul Schary remembered meeting Gorky in 1927 and visiting his studio, "which fronted on Washington Square South. And you had to sort of go around the side to get to his studio entrance"; Mooradian 1980, p. 203.

33. This sculpture was said to have been found in the Tiber River and was imported to the United States around 1900 by the financier Charles T. Barney. While in his possession, the statue was damaged in a fire, hence its discoloration. From 1921 it was on loan to the Metropolitan Museum of Art, which acquired the statue in 1932. See Gisela M. A. Richter, *Metropolitan Museum of Art, New York, Catalogue of Greek Sculptures* (Oxford: Clarendon Press, 1954), p. 58.

34. Although Cézanne's painting *Still Life with Plaster Cupid* was widely reproduced at the time, Gorky's watercolor feels closer in spirit and execution to a sketch of the plaster cupid, surrounded by a halo of dark color, in which the small, armless figure appears to lurch forward, which was reproduced in his cherished copy of Meier-Graefe's *Cézanne und sein Kreis*, p. 206.

35. Jordan and Goldwater 1982, p. 137.

36. Schwabacher 1957, p. 66. Gorky's remark may have been prompted by Matisse's famous statement that "Cézanne is the father of us all"; see Barr 1951a, p. 87.

37. According to Stergis M. Stergis, a Greek artist Gorky befriended at the Grand Central School of Art, the Armenian-American artist had wanted to marry Nancy, but her father, a retired ocean-liner captain, put a stop to the relationship after taking note of Gorky's poverty. See Matossian 1998, p. 162.

38. De Kooning 1951, pp. 63–64. Fellow painter Václav Vytlačil recalled that Gorky liked to paint his Cézanne-inspired landscapes near the pond in Central Park, across from the Plaza Hotel. See Waldman 1981, p. 21. A photograph taken in the late 1920s of the artist hunched over a painting on an easel in front of one of the tunnels that run through Central Park confirms his presence there; see ibid., p. 18.

39. De Kooning 1951, p. 40.

40. Fry 1927; Meier-Graefe 1927.

41. Maud Dale, "Preface," in Wildenstein Galleries 1928, n.p.

42. C. J. Bulliet, *Apples to Madonnas: Emotional Expression in Art* (Chicago: Pascal Covici, 1927), p. 43.

43. Dale, "Preface," n.p.

44. Jim M. Jordan dated the work to 1927 on the basis that the artist may have seen the reproduction of Cézanne's *Portrait of Louis Guillaume* in Christian Zervos's article "Idéalisme et naturalisme dans la peinture moderne, II. Cézanne, Gauguin, Van Gogh," which was published that year in *Cahiers d'art*. See Jordan and Goldwater 1982, p. 22. Cézanne's painting was also reproduced as "Knabenbildnis / 1879" in Meier-Graefe 1927, p. 136. However, Gorky's painting suggests a familiarity with the original work's palette and finish, which would have been impossible for the artist to discern through black-and-white reproduction. I have thus dated the work to 1928, based on the inclusion of the Cézanne portrait in the Wildenstein exhibition that year.

45. Herrera 1976, pp. 58–59.

46. Frances Spalding, *Roger Fry: Art and Life* (London: Granada, 1980), p. 256.

47. That this pitcher was a studio prop for Gorky, rather than an object copied from a Cézanne painting, is confirmed by a photograph, taken around 1927, of the artist painting another Cézannesque still-life arrangement in his Sullivan Street studio (see fig. 13.3).

48. Willem de Kooning recalled that Gorky disdained originality in painting during the earliest years of their friendship: "Gorky used to say, 'very original' about some of my work but the way he said it didn't sound so good, you understand what I mean. Because you have a lot of original art which is not very good art. There's a difference between being original and being a great artist, or being original and breaking the rules." Mooradian, "Interview with Willem de Kooning," p. 50.

Sachs, "Cézanne and Kelly"

This essay is dedicated, with great admiration and deep affection, to Anne d'Harnoncourt.

Acknowledgments: I especially want to thank Ellsworth Kelly for his thoughtful contributions; Jack Shear for his support; and Sandi Knakel and Eva Walters at the Kelly Foundation for their help. I am also indebted to Adrianne Bratis for her invaluable research assistance and to Dave Updike for his skillful editing.

1. Rilke 1952, pp. 25–26.

2. Ellsworth Kelly, telephone conversation with the author, June 15, 2002.

3. Rockwell Kent, ed., *World-Famous Paintings* (New York: Kent, Wise and Co., 1939), n.p. The words may not be Kent's own; according to the introduction, Kent was assisted by Robert Heller in the critical commentary accompanying the pictures.

4. Ellsworth Kelly, conversation with Katherine Sachs and Joseph J. Rishel, Spencertown, New York, March 20, 2008.

5. Quoted in Baker 1979, p. 7.

6. Bois 1994b, p. 36.

7. Hans Sedlmayr, *Art in Crisis: The Lost Centre* (London: Hollis and Carter, 1957), pp. 129–32.

8. Robert Storr, quoted in Michael Brenson, "Attention's Span," *Artforum International* 35, no. 2 (October 1996), p. 89.

9. Goossen 1973, p. 14. Goossen goes on to note that "this involvement with form and shadow, with the construction and destruction of the visible, was a basic part of his education as an artist" (ibid.).

10. Kelly quoted in ibid., p. 103.

11. Ellsworth Kelly, "Boston, Beckmann and After," in Rainbird 2003, p. 237.

12. Goossen 1973, p. 16. Beckmann had written the lecture earlier that year at the invitation of Stephens College, a women's school in Missouri, and subsequently was invited to present it at a number of other colleges and art schools. See Kienle's essay in this volume, pp. 307–25.

13. Goossen 1973, p. 104.

14. Coplans 1972, pp. 20–21. In 1969 Kelly wrote: "My work is about structure. . . . My line of influence has been the 'structure' of things I liked: French Romanesque architecture, Byzantine, Egyptian and Oriental Art, Van Gogh, Cézanne, Monet, Klee, Picasso, Beckmann." Ellsworth Kelly, "Notes from 1969," in Stedelijk Museum 1973, p. 32.

15. Kelly, "Notes from 1969," p. 32.

16. Taylor 1992, p. 154.

17. Kelly, "Notes from 1969," p. 30.

18. Ibid., pp. 30–31.

19. Kelly 1990, n.p.

20. Kelly, "Notes from 1969," p. 30.

21. Grynsztejn and Myers 2002, p. 9.

22. This black study was re-created in a much larger wood version (fig. 16.12). Both are now in the collection of the Museum of Modern Art, New York. In 1982, it was reinterpreted into a bronze sculpture, which now hangs on an outside wall of the artist's studio in Spencertown, New York (plate 161).

23. Kelly, "Notes from 1969," p. 33.

24. Cézanne 1995, pp. 303–4.

25. Taylor 1992, p. 154.

26. Baker 1979, p. 7.

27. Kelly 1990, n.p.

28. Kelly, "Notes from 1969," pp. 32, 31.

29. "His painting was paradoxical: he was pursuing reality without giving up the sensuous surface, with no other guide than the immediate impression of nature, . . . with no outline to enclose the color, with no perspectival or pictorial arrangement." Merleau-Ponty 1964a, p. 12.

30. Ellsworth Kelly, conversation with Yve-Alain Bois, Philadelphia Museum of Art, October 30, 2007.

31. Greenberg 1986–93, vol. 3, p. 88.

32. As Yve-Alain Bois notes, the introduction of chance into his work was Kelly's response to the looming figure of Picasso in postwar Paris. "No artist could be more intimidating than Picasso, with his Protean inventive capabilities," writes Bois. Kelly's first task, therefore, was to "escape the weight of Picasso," and his solution was "to invent various ways of avoiding invention." See Yve-Alain Bois, "Ellsworth Kelly in France: Anti-Composition in Its Many Guises," in Bois, Cowart, and Pacquement 1992, p. 16.

33. Ellsworth Kelly, conversation with the author, October 30, 2007.

34. *Meschers* was exhibited in October 1951 in a group show at Galerie Maeght, Paris, where it was seen and admired by Braque. Kelly, a longtime admirer of Braque's work, was pleased that the painting attracted the attention of such an eminent artist. He recalls that Braque told the director of the gallery that Kelly's painting helped him solve a problem he was facing in a painting that he was working on at the time, *L'Atelier IX*, 1952–53." Waldman 1996, p. 21.

35. "He had left the colors their qualities but not all their associations, forcing them, so to speak, to come out naked." Goossen 1973, p. 80.

36. "Sculpture has always existed in its own space, whereas painting shares form and ground on the same surface. Therefore painting was an illusion and to get away from that illusion, I had to have each panel with its own color." Kelly, quoted in Taylor 1992, p. 155.

37. Clement Greenberg noted this in Cézanne's work as well: "Cézanne's desire to give Impressionism a solid aspect was thus shifted in its fulfillment from the structure of the pictorial illusion to the configuration of the picture as an object—as a flat surface." Greenberg 1986–93, vol. 3, p. 87.

38. In a conversation with the author and others on March 20, 2008, Kelly said that during this time he was looking at Cézanne's brushstrokes and how Cézanne put blues, grays, and greens together. In the chance paintings he was trying to do the same thing, but in a different way, by letting chance decide where all the colors went.

39. Commissioned for the lobby of the Transportation Building at Penn Center, 17th and Market Streets, Philadelphia (and now in the Museum of Modern Art, New York), *Sculpture for a Large Wall* "consists of 104 separate panels distributed over a ten-by-seventy-foot frieze with a double-bar grid apparatus. . . . Seventy-six of these panels are polished aluminum; of the remaining twenty-eight, groups of seven panels each were anodized black, blue, red, and yellow. Kelly distributed the colored elements intuitively across the piece." Sims and Pulitzer 1982, p. 60.

40. Kelly, conversation with the author and others, March 20, 2008.

41. Hindry 1992, p. 29.

42. Kelly, conversations with the author and others, June 15, 2002, and March 20, 2008.

43. Kelly 1990, n.p.

44. Kelly, conversation with the author, June 15, 2002.

45. In the spirit of this exhibition, it should be noted that these two paintings also resonate beautifully with Brice Marden's *Grove Group* (see fig. 3.16; plate 198) and the background of Pablo Picasso's *Pipes of Pan* (see plate 65).

46. Kelly, conversation with the author and others, March 20, 2008.

47. Henry Geldzahler, "Introduction," in Upright 1987, p. 5.

Bernstein, "Cézanne and Johns"

1. Bernstein 1985, p. 111.

2. Lewis 2000, p. 288.

3. Johns acquired his first work by Cézanne in 1981 and now has more works by Cézanne than by any other artist.

4. Reff 1962, p. 173.

5. Ibid., p. 174.

6. Christian Geelhaar, "The Painters Who Had the Right Eyes: On the Reception of Cézanne's Bathers," in Krumrine 1989a, pp. 297–98.

7. Johns, interview by David Bourdon, 1977, in Varnedoe 1996b, p. 157. See also Kathryn Tuma, "The Color and Compass of Things: Paul Cézanne and the Early Works of Jasper Johns," in Weiss et al. 2007, p. 173. Tuma presents a thorough summary of exhibitions and critical literature available to Johns during the 1950s and 1960s.

8. Jasper Johns, "Sketchbook Notes, c. 1963–64 [S-16. Book A]," in Varnedoe 1996b, p. 31, pl. 5, and p. 42, pl. 16.

9. Schapiro 1952, p. 10.

10. Jasper Johns, artist's statement, in *Sixteen Americans*, ed. Dorothy C. Miller, exh. cat. (New York: The Museum of Modern Art, 1959), p. 22; repr. in Varnedoe 1996b, pp. 19–20. Tuma writes that while Johns learned about the concept of "'the rotating point of view' from an influential early art teacher, he could also easily have come across the notion in one key source for this interpretation of Cézanne's work that became widespread in the 1940s: [Erle] Loran's *Cézanne's Composition* of 1943"; "The Color and Compass of Things," p. 177.

11. Johns, interview by David Sylvester, 1965, in Varnedoe 1996b, p. 116.

12. See Bernstein 1985, p. 35. Tuma also discusses Johns's *Drawer* of 1957 and compares it specifically to Cézanne's *The Card Players* of 1890–92, in the Metropolitan Museum of Art; "The Color and Compass of Things," p. 171.

13. Schapiro 1952, p. 68.

14. Grace Glueck, "The 20th-Century Artists Most Admired by Other Artists," *Artnews*, vol. 76, no. 9 (Nov. 1977), pp. 87, 89; repr. in Varnedoe 1996b, p. 166.

15. Geelhaar, "The Painters Who Had the Right Eyes," p. 298.

16. Bernstein, "Seeing a Thing Can Sometimes Trigger the Mind to Make Another Thing," in Varnedoe 1996a, p. 42. See also Tuma, "The Color and Compass of Things," pp. 184–85; and John Elderfield, "Diver: A Delay," pp. 190–205, in Weiss et al. 2007.

17. Reff cites Adrien Chappuis's suggestion that the figure "makes as if to plunge into the water at which he looks and toward which his left arm points . . ."; Reff 1962, p. 176. Tracing Cézanne's transformations of this motif and the art historical precedents Cézanne draws upon, Reff concludes that the figure embodies "an expression of anxiety and guilt about masturbation" (p. 181).

18. Paul Cézanne, quoted in Herschel B. Chipp, ed., *Theories of Modern Art: A Source Book by Artists and*

Critics, with contributions by Peter Selz and Joshua C. Taylor (Berkeley: University of California Press, 1969), p. 19.

19. Johns, interview by Ann Hindry, 1989, in Varnedoe 1996b, p. 233.

20. Johns, quoted in Crichton 1994, p. 64.

21. Bernstein, "Seeing a Thing," p. 63.

22. T. J. Clark, "Freud's Cézanne," *Representations*, no. 52 (Fall 1995), pp. 94–122.

23. Ibid., rev. and repr. in T. J. Clark, *Farewell to an Idea: Episodes from a History of Modernism* (New Haven: Yale University Press, 1999), p. 144. Clark reproduces two of Johns's *Tracings after Cézanne*; p. 144, fig. 82, and p. 146, fig. 83.

24. Krumrine 1989a, p. 241. Krumrine follows this assertion by writing that "such a conclusion is supported by . . . following the transformation of the sexes in Cézanne's figure paintings and drawings and his own autobiographical allusions in those works." Both Krumrine and Clark build upon earlier analyses by Reff, who was the first to discuss the ambiguous sexual identity of Cézanne's bathers. Others who have added substantively to the scholarly discussion of this aspect of Cézanne's work are Tamar Garb in *Bodies of Modernity: Figure and Flesh in Fin-de-Siècle France* (London: Thames and Hudson, 1998) and, most recently, Aruna D'Souza in *Cézanne's Bathers: Biography and the Erotics of Paint* (University Park: Pennsylvania State University Press, 2008).

Sachs, "Cézanne and Marden"

Acknowledgments: My sincere thanks to Brice Marden for his cooperation in the formation of this essay, to Jacqueline Tran at Matthew Marks Gallery for her assistance, and to Keith for everything else.

1. Brice Marden, interview with the author and Joseph J. Rishel, February 13, 2008.

2. Paul Cézanne to Émile Bernard, September 21, 1906, in Cézanne 1995, p. 329.

3. Richardson 1992, p. 46.

4. Ibid., p. 76.

5. Ibid., p. 81.

6. Marden, interview, February 13, 2008.

7. Criqui 2002, p. 3.

8. Ibid.

9. Ibid.

10. Dieter Schwarz, "Plane and Line: Structures of Drawing in the *Work Books*," in Schwarz and Semff 1997, p. 23.

11. Ibid.

12. Marden 1974, p. 40.

13. Cummings 1972.

14. Hay 1997, p. 20.

15. In a 1987 interview with the filmmaker Kim Evans, Clement Greenberg said: "To start with the shape—the format of the canvas as Cézanne had taught us all to do. Every paint stroke in a mature Cézanne, more or less, echoes the rectangular area." *Jackson Pollock* (1987; dir. Kim Evans).

16. Brice Marden, "Statements and Photographs submitted in partial fulfillment of the requirements for Master of Fine Arts degree," Yale University, May 1, 1963, pp. 3–4, cited in Garrels 2006, p. 14.

17. Paul Cézanne to Émile Bernard, September 21, 1906, quoted in Cachin et al. 1996, p. 18.

18. Gary Garrels notes that "Marden has used the phrase 'plane image' for decades. . . . For years the front-door buzzer of his studio on the Bowery was labeled 'Plane Image,' and his office and archives are organized under the same title." Garrels 2006, p. 25.

19. Gary Garrels, "Plane Image: A Conversation with Brice Marden," public interview at The Museum of Modern Art, New York, November 1, 2006.

20. Marden took this one step further in that he also believed that there was a correct color for each shape, and if you got the color right, that would be a way of attaining form. The structure of the painting and its color were so linked in Marden's practice that he related the following story to Paul Cummings to illustrate this codependence: "[After painting grey paintings] . . . I started getting more involved with color and I wanted to push the color thing. So the next show I had, all the paintings were the same shape. I would try to get the color that was specific for that shape, what I felt was right for that shape and so in the first one I had two paintings of the same shape. They were the most difficult paintings to make in the show because I kept ending up with the same color." Cummings 1972.

21. Marden 1991, p. 18.

22. John Yau, "An Interview with Brice Marden," in Keller and Malin 2003, p. 51.

23. Marden, interview, February 13, 2008.

24. Merleau-Ponty 1964a, p. 12.

25. Marden says that the series was completed in 1973; however, the paintings are dated 1976 and some of the workbook pages are dated 1974. See Marden 1991, p. 7.

26. Ibid., p. 29.

27. It is interesting to note here that in 1972 Marden recalled that while he was at Yale, "I just kept thinking some day when I'm old and retire, I'll start painting landscapes to try to figure out what Cézanne's really about." Cummings 1972.

28. Marden 1991, p. 14.

29. Ibid., p. 30.

30. Clemente's comments were made during an artists' panel discussion on Brice Marden at The Museum of Modern Art, New York, November 13, 2006, available online at http://moma.org/visit_moma/audio/2006/pub_prog/downloadAAPAA_2006.html.

31. Marden 1991, p. 15.

32. Robin White, "Brice Marden: Interview," *View* 3, no. 2 (June 1980), p. 14.

33. Marden, interview, February 13, 2008. In a 2006 interview with Gary Garrels, he said something similar: "The subject matter really became irrelevant. . . . What Cézanne was really doing was making a painting. The painting was much more important than the picture of the mountain." Garrels 2006, p. 13.

34. Bernard quoted in Shiff 2003, p. 40.

35. Paul Cézanne to Émile Bernard, October 23, 1905, quoted in Cachin et al. 1996, p. 17.

36. Cézanne to Bernard, September 21, 1906, in Cézanne 1995, p. 329.

37. Richard Shiff, "Force of Myself Looking," in Garrels 2006, pp. 28–75.

38. Marden, interview with Anouchka Ruggeman, "Des tremplins pour l'esprit," *L'oeil*, no. 577 (February 2006), p. 55.

39. McCann 1976, p. 15.

40. Richardson 1992, p. 78.

41. Ibid.

42. Ibid.

43. Marden, "Notes 1970–71," in Whitechapel Art Gallery 1981, p. 54.

44. Lee 1998, pp. 22–23.

45. Marden believes that "the whole thing about expression is there's no way you can make something that isn't yourself." Marden, interview, February 13, 2008. He has also said: "I think of painting as expression, it's intuitive, it just comes out of you. What you end up with is a reflection of yourself." Hay 1997, p. 22.

46. Rishel in Cachin et al. 1996, p. 253, cat. no. 141.

47. Hay 1997, p. 27.

48. Merleau-Ponty 1964a, p. 15.

49. Bois and Krauss 1998, p. 42.

50. Ibid., pp. 42–43.

51. Kimmelman 1998, p. 198.

52. Lee 1998, pp. 15–16.

53. Shih-t'ao, *Remarks on Painting*, chap. 7, quoted in François Cheng, *Empty and Full: The Language of Chinese Painting*, trans. Michael H. Kohn (Boston: Shambhala, 1994), p. 119.

54. Bois and Krauss 1998, p. 40.

55. Marden, interview, February 13, 2008.

56. Shiff, "Force of Myself Looking," p. 32.

57. Marden, interview, February 13, 2008.

Chevrier, "Jeff Wall"

1. Paul Cézanne to Émile Bernard, May 12, 1904. This statement is part of a warning addressed to Bernard in which Cézanne writes that he is wary of a surfeit of speculations and learned references to art history on the part of his correspondent. Immediately before this passage he writes: "The Louvre is a good book to consult, but it should only be an intermediary." Earlier he notes a contradiction between "the direct study of nature" and "intangible theories." Doran 2001, p. 30. [*Translator's note:* Cézanne wrote *le tableau de la nature,* or "the tableau of nature"; Ms. Cochran's translation of *tableau* is "picture." For the purposes of this essay, however, I have in several instances preferred to retain the term "tableau." Indeed, Jeff Wall's works have often been described by critics as "photographic tableaux."]

2. Reported by Bernard 1904, pp. 17–30; English translation in Doran 2001, p. 39. Cézanne in fact did not repudiate modeling; he rejected all art founded on delineation or flat blocks of color. When he contrasted *modulate* and *model,* he emphasized the fluid continuity of transitions as opposed to the idea of the

autonomous figure (closed upon itself) induced by the action of modeling.

3. Doran 2001, p. 38.

4. Jeff Wall, "'Marks of Indifference': Aspects of Photography in, or as, Conceptual Art," in Goldstein and Rorimer 1995, p. 260; Wall 2007, p. 158.

5. Cézanne to Émile Bernard, Aix-en-Provence, December 23, 1904; English translation in Cézanne 1995, pp. 309–10. Odilon Redon, meanwhile, associated optics with objectivity: "My contemplative attitude made my efforts toward an optics painful. At what point did I become objective—that is, enough of an observer of things, enough of a viewer of nature in itself—to move toward my goal and appropriate visible forms? This was around 1865." Redon, "Confidences d'artiste," in À soi-même: journal (1867–1915); notes sur la vie, l'art et les artistes (Paris: Floury, 1922; José Corti, 1979), p. 24.

6. Émile Zola, Le bon combat: de Courbet aux impressionnistes; anthologie d'écrits sur l'art, ed. Jean-Paul Bouillon (Paris: Hermann, 1974), p. 90.

7. Quoted in Shiff 1984, p. 23.

8. Stéphane Mallarmé, "Édouard Manet" (1895), repr. in Œuvres complètes, vol. 2, ed. Bertrand Marchal (Paris: Gallimard, 2003), p. 147.

9. Vischer and Naef 2005.

10. Jeff Wall, "Typology, Luminescence, Freedom: Selections from a Conversation with Jeff Wall," conversation with Els Barents, in Wall 1987, pp. 99–100; Wall 2007, pp. 193–94.

11. Wall 2007, pp. 194–95.

12. The Flooded Grave also speaks to a renewal of the common (literary and psychoanalytical) locus of death as a return to the oceanic setting of prenatality.

13. In his Journal (May 21, 1853), Delacroix notes the inaccuracies in the etchings of Marcantonio Raimondi after Raphael, compared to photographic nude studies by his friend Eugène Durieu.

14. "The point of departure is the pyramid given by the inclined tree trunks on either side. The poses of the figures are clearly dictated by this—too clearly, too obtrusively indeed do they adapt themselves to this elementary schema. In spite of the marvels of his handling and the richness and delicacy of the colour transitions he has not escaped the effect of dryness and willfulness which so deliberate a formula arouses." Fry 1958, p. 81.

15. In recounting the endless sittings for his portrait (1899, now in the Petit Palais–Musée des Beaux-Arts de la Ville de Paris) Vollard wrote: "Every afternoon Cézanne would go to the Louvre or to the Trocadéro [the Museum of Comparative Sculpture, which exhibited plaster casts] to sketch the old masters." Doran 2001, p. 9. The progress of the portrait the next day depended on how well that sketching session went. One day when Vollard pointed out that there were two small patches of unpainted canvas on the right hand (the only one visible) in his portrait, Cézanne replied: "If this afternoon's session at the Louvre goes well, maybe tomorrow I'll find the right tone to cover these white patches. But please understand, Mr. Vollard, if I were to put just any color there at random . . . I should have to go over the whole picture again starting from that spot." Doran 2001,

pp. 10, 192. Lawrence Gowing comments: "Cézanne was debarred from setting down anything but relationships, and for him relationships of colour were akin to the sequences of form that he could draw in line in the museum; they must have been tantamount to actual physical articulations. His concern was no longer with the style of baroque art as such, but with the reality of relationship which was the basic unit of style, and even more with the faculty that produced it, which could be learned and practised like a muscular co-ordination. For Cézanne at the age of 60 the Louvre and the casts at the Trocadéro were still a strenuous imaginative gymnasium." Laing Art Gallery 1973, p. 19.

16. Wall 2003, p. 190; Vischer and Naef 2005, p. 444.

17. "Acts of composition are the property of the tableau. In reportage, the sovereign place of composition is retained only as a sort of dynamic of anticipatory framing, a 'hunter's consciousness,' the nervous looking of a 'one-eyed cat,' as Lee Friedlander put it. Every picture-constructing advantage accumulated over centuries is given up to the jittery flow of events as they unfold. The rectangle of the viewfinder and the speed of the shutter, photography's 'window of equipment,' is all that remains of the great craft-complex of composition." Wall, "Marks of Indifference," in Goldstein and Rorimer 1995, p. 146.

18. It is worth recalling that one-fifth of the twelve hundred known drawings by Cézanne are studies of sculptures. Puget's Hercules at Rest, which Cézanne sketched several times in the late 1870s and more frequently still in the late 1880s, has virtually emblematic value as an image of contained, placated heroic power. In a late-1880s sketch conserved in Basel (Chappuis 1004), the muscular curves of the abdomen are strongly analogous to oil and watercolor studies of rocks painted around the same period or later, such as Trees and Rocks, in the Philadelphia Museum of Art (Rewald 328) and Rocks near the Caves above Château Noir, part of the collection of the Museum of Modern At, New York (Venturi 1043, Rewald 435). Theodore Reff noted the baroque characteristics of these watercolors and their affinities with the sketches of sculptures in Reff 1963.

19. Gowing 1988, p. 30. The author based his remark on the relative scarcity of landscapes in Cézanne's graphic work, clearly due to Cézanne's refusal to demarcate accents of the landscape using contour lines, and his systematically favoring the use of color. The watercolors, of course, are the domain in which the two techniques, painterly and graphic, come together.

Sources Cited

Abramowicz 1981
Abramowicz, Janet. "Vision and Technique: The Etchings of Giorgio Morandi, 1890–1964." *Print Collector's Newsletter* 12 (Sept.–Oct. 1981), pp. 97–103.

Abramowicz 1983
Abramowicz, Janet. "The Liberation of the Object." *Art in America* 71 (Mar. 1983), pp. 138–46.

Abramowicz 2005
Abramowicz, Janet. *Giorgio Morandi: The Art of Silence*. New Haven: Yale University Press, 2005.

Adriani 1995
Adriani, Götz. *Cézanne Paintings*. Essay by Walter Feilchenfeldt. Trans. Russell Stockman. Exh. cat, Kunsthalle Tübingen. Cologne: DuMont; New York: Abrams, 1995.

Aguirre 2007
Aguirre, Mariana. *Artistic Collaboration in Fascist Italy: Ardengo Soffici and Giorgio Morandi*. Ph.D. diss., Brown University, 2007.

Apollinaire 1910
Apollinaire, Guillaume. "Figures de Cézanne chez Vollard." *L'Intransigeant*, Sept. 27, 1910.

Apollinaire 1913
Apollinaire, Guillaume. *Méditations esthétiques. Les peintres cubists*. Paris: Hermann, 1913.

Apollinaire 1966
Apollinaire, Guillaume. *Oeuvres complètes de Guillaume Apollinaire*. Edited by Michel Décaudin. 4 vols. Paris: Balland et Lecat, 1966.

Apollinaire 2002
Apollinaire, Guillaume. *The Cubist Painters*, trans. Peter Read. Forest Row, East Sussex: Artists Bookworks, 2002.

Apollonio 1973
Apollonio, Umbro, ed. *Futurist Manifestos*. Trans. Robert Brain et al. London: Thames and Hudson, 1973.

Aragon 1965
Aragon, Louis. *Les collages*. Paris: Hermann, 1965.

Arcangeli 1964
Arcangeli, Francesco. *Giorgio Morandi*. Milan: Edizioni del Millione, 1964

Arcangeli 2007
Arcangeli, Francesco. *Giorgio Morandi. Stesura originaria inedita*. 1964. Turin: Allemandi, 2007.

Art Institute of Chicago 1952
Cézanne: Paintings, Watercolors, and Drawings. Exh. cat. Chicago: The Art Institute of Chicago, 1952.

Athanassoglou-Kallmyer 2003
Athanassoglou-Kallmyer, Nina Maria. *Cézanne and Provence: The Painter in His Culture*. Chicago: University of Chicago Press, 2003.

Baker 1979
Baker, Elizabeth C. *Ellsworth Kelly: Recent Paintings and Sculpture*. exh. cat. New York: Metropolitan Museum of Art, 1979.

Bandera 2005
Bandera, Maria Cristina, ed. *Morandi e Firenze. I suoi amici, critici e collezionisti*. Exh. cat., Fondazione di Studi di Storia dell'Arte Roberto Longhi, Florence. Milan: Mazzotta, 2005.

Bardazzi 2007
Bardazzi, Francesca, ed. *Cézanne in Florence: Two Collectors and the 1910 Exhibition of Impressionism*. Exh. cat., Palazzo Strozzi, Florence. Milan: Electa, 2007.

Barnes and de Mazia 1939
Barnes, Albert C., and Violette de Mazia. *The Art of Cézanne*. New York: Harcourt, Brace, 1939.

Barr 1934
Barr, Alfred H., Jr. *The Lillie P. Bliss Collection*. Exh. cat. New York: The Museum of Modern Art, 1934.

Barr 1939
Barr, Alfred H., Jr., ed. *Picasso: Forty Years of His Art*. New York: The Museum of Modern Art, 1939.

Barr 1946
Barr, Alfred H., Jr. *Picasso: Fifty Years of His Art*. New York: The Museum of Modern Art, 1946.

Barr 1948
Barr, Alfred H., Jr. *Painting and Sculpture in the Museum of Modern Art*. New York: The Museum of Modern Art, 1948.

Barr 1951a
Barr, Alfred H., Jr. *Matisse: His Art and His Public.* New York: The Museum of Modern Art, 1951.

Barr 1951b
Barr, Alfred H., Jr. "Matisse, Picasso, and the Crisis of 1907." *Magazine of Art* 44 (May 1951), pp. 163–70.

Barr 1986
Barr, Alfred H., Jr. *Cubism and Abstract Art.* 1936. Cambridge, MA: Harvard University Press, 1986.

Baumann et al. 2000
Baumann, Felix, et al., eds. *Cézanne: Finished Unfinished.* Exh. cat., Kunstforum Wien and Kunsthaus Zürich. Ostfildern-Ruit: Hatje Cantz, 2000.

Baumann, Feilchenfeldt, and Gassner 2004
Baumann, Felix A., Walter Feilchenfeldt, and Hubertus Gassner, eds. *Cézanne and the Dawn of Modern Art.* Exh. cat., Museum Folkwang, Essen. Ostfildern: Hatje Cantz, 2004.

Baumann and Tøjner 2008
Baumann, Felix A., and Poul Erik Tøjner, eds. *Cézanne and Giacometti: Paths of Doubt.* Exh. cat., Louisiana Museum of Modern Art, Humlebaek. Ostfildern: Hatje Cantz, 2008.

Beckmann 1914
Beckmann, Max. "Das neue Program." *Kunst und Künstler* 12 (1914).

Beckmann 1955
Beckmann, Max. *Tagebücher, 1940–1955.* Comp. Mathilde Q. Beckmann, ed. Erhard Göpel. Munich: Langen-G. Müller, 1955.

Beckmann 1993
Beckmann, Max. *Briefe.* Edited by Klaus Gallwitz, Uwe M. Schneede, and Stephan von Wiese. 2 vols. Munich: Piper, 1993.

Beckmann 1997
Beckmann, Max. *Self-Portrait in Words: Collected Writings and Statements, 1903–1950.* Edited by Barbara Copeland Buenger, trans. Barbara Copeland Buenger and Reinhold Heller with the assistance of David Britt. Chicago: University of Chicago Press, 1997.

Beckmann and Schaffer 1992
Beckmann, Peter, and Joachim Schaffer, eds. *Die Bibliothek Max Beckmanns. Unterstreichungen, Kommentare, Notizen und Skizzen in seinen Büchern.* Worms: Wernersche, 1992.

Bell 1922
Bell, Clive. *Since Cézanne.* New York: Harcourt Brace, 1922.

Bell 1958
Bell, Clive. *Art.* New York: Frederick A. Stokes, 1913. Repr. New York: Capricorn, 1958.

Benedetti 2002
Benedetti, Maria Teresa, ed. *Cézanne. Il padre dei moderni.* Exh. cat., Complesso del Vittoriano, Rome. Milan: Mazzotta, 2002.

Benjamin 1987
Benjamin, Roger. *Matisse's "Notes of a Painter": Criticism, Theory, and Context, 1891–1908.* Ann Arbor, MI: UMI Research Press, 1987.

Berliner Secession 1913
Katalog der XXVI Ausstellung des Berliner Secession. Berlin: Cassirer, 1913.

Bernadac and Michael 1998
Bernadac, Marie-Laure, and Androula Michael, eds. *Pablo Picasso. Propos sur l'art.* Paris: Gallimard, 1998.

Bernard 1891
Bernard, Émile. "Paul Cézanne." *Les hommes d'aujourd'hui* 8 (Feb.–Mar. 1891).

Bernard 1904
Bernard, Émile. "Paul Cézanne." *L'occident* 6 (July 1904), pp. 17–30.

Bernard 1907
Bernard, Émile. "Souvenirs sur Paul Cézanne et letters inédites." *Mercure de France*, Oct. 1, 1907, pp. 385–404, and Oct. 16, 1907, pp. 606–27.

Bernard 1909
Bernard, Émile. "La conversion de M. Maurice Denis." *La rénovation esthétique* 9 (Oct. 1909).

Bernstein 1985
Bernstein, Roberta. *Jasper Johns' Paintings and Sculptures, 1954–1974: "The Changing Focus of the Eye."* Ph.D. diss., Columbia University, 1975. Ann Arbor, MI: UMI Research Press, 1985.

Bezzola and Homburg 1998
Bezzola, Tobia, and Cornelia Homburg, eds. *Max Beckmann and Paris: Matisse, Picasso, Braque, Léger, Rouault.* Exh. cat. St. Louis: The Saint Louis Art Museum; Zurich: Kunsthaus Zürich; Cologne: Taschen, 1998.

Bibeb 1968
Bibeb. "Willem de Kooning. Ik vind dat alles een mond moet hebben en ik zet de mond waar ik wil." Interview. *Vrij Nederland* (Amsterdam) 5 (Oct. 1968).

Blanche 1931
Blanche, Jacques-Émile. *Les arts plastiques.* Paris: Éditions de France, 1931.

Blanche 1932
Blanche, Jacques-Émile. "Rétrospective Picasso." Review. *L'art vivant* 8 (July 1932), pp. 333–34.

Bois 1990
Bois, Yve-Alain. *Painting as Model.* Cambridge, MA: MIT Press, 1990.

Bois 1994b
Bois, Yve-Alain. "The Summons." In *Spencertown: Recent Paintings by Ellsworth Kelly.* London: Anthony d'Offay; New York: Matthew Marks, 1994.

Bois, Cowart, and Pacquement 1992
Bois, Yve-Alain, Jack Cowart, and Alfred Pacquement, et al. *Ellsworth Kelly. Les années françaises, 1948–1954.* Exh. cat. Paris: Galerie Nationale du Jeu de Paume and Ministère de la Culture et de la Communication, 1992.

Bois and Krauss 1998
Bois, Yve-Alain, and Rosalind Krauss. "Cézanne: Words and Deeds." *October* 84 (Spring 1998), pp. 31–43.

Borély 1926
Borély, Jules. "Cézanne à Aix." *L'art vivant*, no. 2 (July 1, 1926), pp. 491–94.

Brandi 1939
Brandi, Cesare. *Cammino di Morandi.* 1939.

Brandi 1942
Brandi, Cesare. *Morandi.* Florence: Le Monnier, 1942.

Braque 1917
Braque, Georges. "Pensées et réflexions sur la peinture." *Nordsud*, Dec. 1917.

Brassaï 1966
Brassaï. *Picasso and Company*, trans. Francis Price. Garden City, NY: Doubleday, 1966.

Braun 1995
Braun, Emily. "Speaking Volumes: Giorgio Morandi's Still Lifes and the Cultural Politics of *Strapaese*." *Modernism/Modernity* 2 (Sept. 1995), pp. 89–116.

Buck et al. 2008
Buck, Stephanie, et al. *The Courtauld Cézannes.* Exh. cat., Courtauld Institute Galleries. London: Paul Holberton, 2008.

Cachin et al. 1996
Cachin, Françoise, et al. *Cézanne.* Exh. cat. Philadelphia: Philadelphia Museum of Art; New York: Abrams, 1996.

Cachin, Loyrette, and Guégan 1997
Cachin, Françoise, Henri Loyrette, and Stéphane Guégan. *Cézanne aujourd'hui. Actes du colloque organisé par le museé d'Orsay.* Paris: Musée d'Orsay, 1997.

Camoin and Matisse 1997
Correspondance entre Charles Camoin et Henri Matisse. Edited by Claudine Grammont. Lausanne: La Bibliothèque des Arts, 1997.

Cavallo 1989
Cavallo, Luigi. "A Prato per vedere i Corot." *Corrispondenza Morandi–Sofici per un'antologica di Morandi.* Exh. cat. Prato: Galleria d'Arte Moderna Farsetti, 1989.

Centre Georges Pompidou 1997
Fernand Léger. Exh. cat. Paris: Centre Georges Pompidou, 1997.

Cézanne 1978
Cézanne, Paul. *Correspondance.* Edited by John Rewald. Paris: Grasset, 1978.

Cézanne 1995
Paul Cézanne, Letters. Edited by John Rewald, trans. Marguerite Kay. 4th ed., rev. and enl. New York: Da Capo, 1995.

Chappuis 1962
Chappuis, Adrien. *Les dessins de Paul Cézanne au cabinet des estampes du musée des beaux-arts de Bâle.* Olten: Graf, 1962.

Charbonnier 1959
Charbonnier, Georges. *Le monologue du peintre.* Paris: Julliard, 1959.

Churchill 1932
Churchill, Alfred Vance. "On Cézanne." *Parnassus* 4 (Oct. 1932), pp. 19–21.

Conisbee and Coutagne 2006
Conisbee, Philip, and Denis Coutagne. *Cézanne in Provence.* Exh. cat. Washington, DC: National Gallery of Art, 2006.

Coplans 1972
Coplans, John. *Ellsworth Kelly.* New York: Abrams, 1972.

Coquiot 1920
Coquiot, Gustave. *Les Indépendants, 1884–1920.* Paris: Ollendorff, 1920.

Courthion 1942
Courthion, Pierre. "Pierre Courthion interview with Henri Matisse," 1941–42. Typescript, Getty Research Institute, Los Angeles

Coutagne and Ely 1990
Coutagne, Denis, and Bruno Ely, eds. *Sainte-Victoire, Cézanne, 1990.* Exh. cat. Aix-en-Provence: Musée Granet; Paris: Réunion des Musées Nationaux, 1990.

Cowling 2002
Cowling, Elizabeth. *Interpreting Matisse Picasso.* London: Tate Publishing; New York: Abrams, 2002.

Cowling et al. 2002
Cowling, Elizabeth, et. al. *Matisse Picasso.* Exh. cat., Tate Modern. London: Tate Publishing, 2002.

Crichton 1994
Crichton, Michael. *Jasper Johns.* 1977. Rev. and exp. ed., New York: Abrams with Whitney Museum of American Art, 1994.

Criqui 2002
Criqui, Jean-Pierre. *Brice Marden: Attendants, Bears, and Rocks.* Sale cat. New York: Matthew Marks Gallery, 2002.

Criqui 2006
Criqui, Jean-Pierre. *Correspondances. Paul Cézanne/Jeff Wall.* Paris: Argol, 2006.

Cummings 1972
Cummings, Paul. "Interview with Brice Marden Conducted by Paul Cummings, October 3, 1972." Smithsonian Archives of American Art, http://www.aaa.si.edu/oralhist/marden72.htm (accessed September 25, 2008)

Daix 1973a
Daix, Pierre. "L'arrière-saison de Picasso, ou l'art de rester à l'avantgarde." *XXe siècle* 41 (1973).

Daix 1973b
Daix, Pierre. "For Picasso, Truth Was Art; and Falsity, the Death of Art." *Art News* 72 (Summer 1973), pp. 47–49.

Daix 1988
Daix, Pierre. "Les trois periods de travail de Picasso sur *Les Trois Femmes* (automne 1907–automne 1908), les rapports avec Braque, et les débuts du Cubisme." *Gazette des beaux-arts*, n.s. 6, vol. 3 (Jan.–Feb. 1988), pp. 148–51.

Daix 1993
Daix, Pierre. *Picasso: Life and Art*, trans. Olivia Emmet. New York: Icon, Harper Collins, 1993.

Daix 1995
Daix, Pierre. *Dictionnaire Picasso.* Paris: Robert Laffont, 1995.

Danchev 2005
Danchev, Alex. *Georges Braque: A Life.* New York: Arcade, 2005.

de Chirico 1985
de Chirico, Giorgio. *Il meccanismo del pensiero. Critica, polemica, autobiografia, 1911–1943.* Edited by Maurizio Fagiolo dell'Arco. Turin: Einaudi, 1985.

De Francia 1983
De Francia, Peter. *Fernand Léger.* New Haven: Yale University Press, 1983.

de Kooning 1951
de Kooning, Elaine. "Gorky: Painter of His Own Legend." *Art News* 49 (Jan. 1951), pp. 63–64.

de Zayas 1923
de Zayas, Marius. "Picasso Speaks." Interview. *Arts* 3 (May 1923), pp. 315–26.

Denis 1907
Denis, Maurice. "Cézanne." *L'occident*, Sept. 1907.

Denis 1914
Denis, Maurice. "Cézanne." *Kunst und Künstler*, 1914, pp. 208–17, 277–84.

Denis 1920
Denis, Maurice. *Théories, 1890–1910. Du symbolisme et de Gauguin vers un nouvel ordre classique.* 4th ed. Paris: Rouart et Watelin, 1920.

Denis 1922
Denis, Maurice. *Nouvelles théories. Sur l'art moderne, sur l'art sacré, 1914–1921.* Paris: Rouart et Watelin, 1922.

Denis 1939
Denis, Maurice. "L'aventure posthume de Cézanne." *L'amour de l'art* 20 (July 1939), p. 196.

Denis 1957–59
Denis, Maurice. *Journal.* 3 vols. Paris: Colombe, 1957–59.

Diehl 1943
Diehl, Gaston. "Avec Matisse le classique." *Comoedia*, no. 102 (June 12, 1943).

Diehl 1954
Diehl, Gaston. *Henri Matisse.* Paris: Tisné, 1954.

Doran 2001
Doran, Michael, ed. *Conversations with Cézanne*, trans. Julie Lawrence Cochran. Berkeley: University of California Press, 2001.

Dorival 1948
Dorival, Bernard, ed. *Les peintres célèbres.* Geneva: Mazenod, 1948.

Dupin 1991
Dupin, Jacques. *Alberto Giacometti. Textes pour une approche.* Paris: Fourbis, 1991.

Duret 1906
Duret, Théodore. *Histoire des peintres impressionnistes. Pissarro, Claude Monet, Sisley, Renoir, Berthe Morisot, Cézanne, Guillaumin.* Paris: Floury, 1906.

Einstein 1929
Einstein, Carl. "Notes sur le cubisme." *Documents* 1, no. 3 (1929), pp. 153–54.

Einstein 1930
Einstein, Carl. "Léger. Oeuvres récentes." *Documents* 2, no. 4 (1930).

Einstein 1931
Einstein, Carl. "Max Beckmann." *Die Kunst des 20. Jahrhunderts.* Berlin: Propyläen, 1931.

Elderfield 1976
Elderfield, John. *The "Wild Beasts": Fauvism and Its Affinities.* Exh. cat. New York: The Museum of Modern Art, 1976.

Elderfield 1992
Elderfield, John. *Henri Matisse: A Retrospective.* Exh. cat. New York: The Museum of Modern Art, 1992.

Escholier 1956
Escholier, Raymond. *Matisse ce vivant.* Paris: Fayard, 1956.

Esterow 1973
Esterow, Milton. "Visits with Picasso at Mougins." Interview with William S. Rubin. *Art News* 72 (Summer 1973), pp. 42–46.

Exter et al. 1999
Exter, Alexandra, et al. *Amazons of the Avant-garde.* Exh. cat., Deutsche Guggenheim et al. London: Royal Academy of Arts, 1999.

Fagiolo dell'Arco 1980
Fagiolo dell'Arco, Maurizio. *Giorgio de Chirico al tempo di "Valori Plastici."* Rome: De Luca, 1980.

Fagus 1899
Fagus, Félicien. "Quarante tableaux de Cézanne." *La revue blanche* 20 (Sept. 1, 1899).

Fagus 1905
Fagus, Félicien. "Au salon d'Automne." *L'occident* 8 (Nov. 1905).

Fahlman 1983
Fahlman, Betsy. *Pennsylvania Modern: Charles Demuth of Lancaster*. Exh. cat. Philadelphia: Philadelphia Museum of Art, 1983.

Fahlman 2007
Fahlman, Betsy. *Chimneys and Towers: Charles Demuth's Late Paintings of Lancaster*. Exh. cat. Fort Worth, TX: Amon Carter Museum, 2007.

Fairbrother et al. 1991
Fairbrother, Trevor, et al. *Brice Marden: Boston*. Exh. cat. Boston: Museum of Fine Arts, Boston, 1991.

Falk 1981
Falk, Robert Rafailovich. *Besedy ob iskusstve. Pisma. Vospominaniia o khudozhnike* [Conversations about art. Letters; Reminiscences of the artist]. Moscow, 1981.

Farnham 1959
Farnham, Emily. "Charles Demuth: His Life, Psychology and Works." Ph.D. dissertation, Ohio State University, 1959.

Farnham 1965–66
Farnham, Emily. "Charles Demuth's Bermuda Landscapes." *Art Journal* 25 (Winter 1965–66), pp. 130–37.

Farnham 1971
Farnham, Emily. *Charles Demuth: Behind a Laughing Mask*. Norman: University of Oklahoma Press, 1971.

Fels 1925
Fels, Florent. *Propos d'artistes*. Paris: La Renaissance du Livre, 1925.

Flam 1986
Flam, Jack. *Matisse: The Man and His Art, 1869–1918*. Ithaca: Cornell University Press, 1986.

Flam 1988
Flam, Jack, ed. *Henri Matisse: A Retrospective*. New York: Hugh Lauter Levin Associates, 1988.

Fletcher 1994
Fletcher, Valerie J. "Alberto Giacometti: The Paintings" Ph.D. diss., Columbia University, 1994.

Fossati 1981
Fossati, Paolo. *Valori Plastici, 1918–22*. Turin: Einaudi, 1981.

Fossati, Ferraris, and Velani 1998
Fossati, Paolo, Patrizia Rosazza Ferraris, and Livia Velani, eds. *Valori Plastici*. Exh. cat., XIII Esposizione Nazionale Quadriennale d'Arte di Roma. Milan: Skira, 1998.

Foster et al. 2004
Foster, Hal, et al. *Art Since 1900*. 2 vols. London: Thames and Hudson, 2004.

Fourcade 1976
Fourcade, Dominique. "Autres propos de Matisse." *Macula* 1 (1976), pp. 103–6.

Francastel 1957
Francastel, Pierre, ed. *Du cubisme à l'art abstrait*. Paris: SEVPEN, 1957.

Frascina and Harrison 1982
Frascina, Francis, and Charles Harrison, eds. *Modern Art and Modernism: A Critical Anthology*. New York: Harper and Row, 1982.

Fry 1927
Fry, Roger. *Cézanne: A Study of His Development*. London: Woolf, 1927.

Fry 1958
Fry, Roger. *Cézanne: A Study of His Development*. 1927. Reprint, New York: Noonday, 1958.

Galerie Bernheim-Jeune 1914
Cézanne. Sale cat. Paris: Galerie Bernheim-Jeune and Moderne Imprimerie, 1914.

Galerie Goemans 1930
Exposition de collage. Arp, Braque, Dali. Sale cat., Galerie Goemans. Paris: Corti, 1930.

Gallatin 1927
Gallatin, A. E. *Charles Demuth*. New York: William Edwin Rudge, 1927.

Galleria Comunale d'Arte Moderna 1985
Morandi e il suo tempo. I incontro internazionale di studi su Giorgio Morandi. Galleria d'Arte Moderna and Archivio e Centro Studi Giorgio Morandi, Bologna, Nov. 16–17, 1984. Milan: Mazzotta, 1985.

Garb 2007
Garb, Tamar. *The Painted Face: Portraits of Women in France, 1814–1914*. New Haven: Yale University Press, 2007.

Garrels 2006
Garrels, Gary. *Plane Image: A Brice Marden Retrospective*. Exh. cat. New York: The Museum of Modern Art, 2006.

Gasquet 1926
Gasquet, Joachim. *Cézanne*. 1921. Rev. ed., Paris: Bernheim-Jeune, 1926.

Gasquet 1930
Gasquet, Joachim. *Cézanne*. Berlin: Cassirer, 1930.

Gauguin 1946
Lettres de Gauguin à sa femme et à ses amis. Edited by Maurice Malingue. Paris: Grasset, 1946.

Gauguin 1984
Correspondance de Paul Gauguin. Documents, témoignages. Edited by Victor Merlhès. Vol. 1 (1873–1888). Paris: Fondation Singer-Polignac, 1984.

Gauguin 2003
Paul Gauguin: Letters to His Wife and Friends. Edited by Maurice Malingue, trans. Henry J. Stenning. 1949. Reprint, Boston: Museum of Fine Arts Publications, 2003.

Geffroy 1892–1903
Geffroy, Gustave. *La vie artistique*. 8 vols. Paris: Dentu; Floury, 1892–1903.

Genet 1958
Genet, Jean. *L'atelier d'Alberto Giacometti*. Décines: Barbezat, 1958.

George 1930a
George, Waldemar. "Chronicles. Cézanne 1930." *Formes*, no. 4 (Apr. 1930), pp. 19–22.

George 1930b
George, Waldemar. "The Passion of Picasso." *Formes*, no. 4 (Apr. 1930), pp. 8–9.

Giacometti 1990
Giacometti, Alberto. *Écrits*. Edited by Michel Leiris and Jacques Dupin. Paris: Hermann, 1990.

Gilot and Lake 1964
Gilot, Françoise, and Carlton Lake. *Life with Picasso*. New York: McGraw-Hill, 1964.

Gleizes and Metzinger 1912
Gleizes, Albert, and Jean Metzinger. *Du "cubisme."* Paris: Figuière, 1912.

Golding and Green 1970
Golding, John, and Christopher Green. *Léger and Purist Paris*. Exh. cat. London: Tate Gallery, 1970.

Goldstein and Rorimer 1995
Goldstein, Ann, and Anne Rorimer, eds. *Reconsidering the Object of Art: 1965–1975*. Exh. cat. Los Angeles: The Museum of Contemporary Art; Cambridge, MA: MIT Press, 1995.

Goossen 1973
Goossen, E. C. *Ellsworth Kelly*. Exh. broch. New York: The Museum of Modern Art, 1973.

Gowing 1988
Lawrence Gowing. *Paul Cézanne: The Basel Sketchbooks*. Exh. cat. New York: The Museum of Modern Art, 1988.

Gowing 1991
Gowing, Lawrence "The True Nature of Cézanne's Bathers." *Journal of Art* 4 (Apr. 1991), p. 58.

Gowing, Stevens, and Adriani 1988
Gowing, Lawrence, Mary Anne Stevens, and Götz Adriani. *Cézanne: The Early Years, 1859–1872*. New York: Abrams, 1988.

Grabar 1974
Grabar, Igor. *Pisma. 1891–1917* [Letters, 1891–1917]. Moscow, 1974.

Grammont 2006
Grammont, Claudine. "La raison du peintre: sur Matisse et Cézanne." In *Cézanne: Mythe et Pèlerins*, edited by Michel Bépoix. Exh. cat. Arles, France: Actes Sud, 2006

Green 1976
Green, Christopher. *Léger and the Avant-Garde*. New Haven: Yale University Press, 1976.

Green 2005
Green, Christopher. *Picasso: Architecture and Vertigo.* New Haven: Yale University Press, 2005.

Greenberg 1986–93
Greenberg, Clement. *The Collected Essays and Criticism.* Edited by John O'Brian. 4 vols. Chicago: University of Chicago Press, 1993.

Greenough et al. 2000
Greenough, Sarah, et al. *Modern Art and America: Alfred Stieglitz and His New York Galleries.* Exh. cat. Washington, DC: National Gallery of Art, 2000.

Grishchenko 1913
Grishchenko, A. "About the Jack of Diamonds Group of Artists." *Apollon* 6 (1913).

Grynsztejn and Myers 2002
Grynsztejn, Madeleine, and Julian Myers. *Ellsworth Kelly in San Francisco.* Exh. cat. San Francisco: San Francisco Museum of Modern Art, 2002.

Harrison and Wood 2003
Harrison, Charles, and Paul Wood, eds. *Art in Theory, 1900–2000: An Anthology of Changing Ideas.* Malden, MA: Blackwell, 2003.

Hartley 1972
Hartley, Marsden. *Adventures in the Arts: Informal Chapters on Painters, Vaudeville and Poets.* 1921. Reprint, New York: Hacker, 1972.

Hartley 1982
Hartley, Marsden. *On Art.* Edited by Gail R. Scott. New York: Horizon, 1982.

Hartley 1989
Hartley, Marsden. "Marsden Hartley's Letters to Franz Marc and Wassily Kandinsky 1913–1914." Edited by Patricia McDonnell. *Archives of American Art Journal* 29 (1989), pp. 35–44.

Hartley 1997
Hartley, Marsden. *Somehow a Past: The Autobiography of Marsden Hartley.* Edited by Susan Elizabeth Ryan. Cambridge, MA: MIT Press, 1997.

Hartley and Stieglitz 2002
My Dear Stieglitz: Letters of Marsden Hartley and Alfred Stieglitz, 1912–1915. Edited by James Timothy Voorhies. Columbia: University of South Carolina Press, 2002.

Haskell 1980
Haskell, Barbara. *Marsden Hartley.* Exh. cat. New York: Whitney Museum of American Art and New York University Press, 1980.

Haskell 1987
Haskell, Barbara. *Charles Demuth.* Exh. cat. New York: Whitney Museum of American Art, 1987.

Hay 1997
Hay, Jonathan. *Brice Marden: Chinese Work.* Exh. cat. New York: Matthew Marks Gallery, 1997.

Herrera 1976
Herrera, Hayden. "Gorky's Self-Portraits: The Artist by Himself." *Art in America* 64 (Mar.–Apr. 1976), pp. 56–64.

Herrera 2003
Herrera, Hayden. *Arshile Gorky: His Life and Work.* New York: Farrar, Straus and Giroux, 2003.

Hindry 1992
Hindry, Ann. "Conversation avec Ellsworth Kelly/Conversation with Ellsworth Kelly." *Artstudio* 24 (Spring 1992), pp. 6–37

Hole 2007
Hole, Heather. *Marsden Hartley and the West: The Search for an American Modernism.* Exh. cat. Santa Fe, NM: Georgia O'Keeffe Museum; New Haven: Yale University Press, 2007.

Holty 1957
Holty, Carl. "Mondrian in New York: A Memoir." *Arts* 31 (Sept. 1957), pp. 17–21.

Hoog 1994
Hoog, Michel. *Cézanne: The First Modern Painter,* trans. Rosemary Stonehewer. New York: Abrams, 1994.

Horne 2004
Horne, Alistair. *Seven Ages of Paris.* New York: Vintage, 2004.

Huneker 1922
Huneker, James. *Letters of James Gibbons Huneker.* Edited by Josephine Huneker. New York: Scribner's, 1922.

Hunter 1975
Hunter, Sam. "De Kooning. Je dessine les yeux fermés." Interview. *Galerie jardin des arts* 152 (Nov. 1975), pp. 69–70.

Janssen and Joosten 2002
Janssen, Hans, and Joop Joosten. *Mondrian, 1892–1914: The Path to Abstraction.* Exh. cat. Fort Worth: Kimbell Art Museum; Paris: Réunion des musées nationaux; Zwolle: Waanders, 2002.

Jedlicka 1934
Jedlicka, Gotthard. *Picasso.* Zurich: Oprecht and Helbling, 1934.

Jordan and Goldwater 1982
Jordan, Jim M., and Robert Goldwater. *The Paintings of Arshile Gorky: A Critical Catalogue.* New York: New York University Press, 1982.

Judd 1975
Judd, Donald. *Complete Writings, 1959–1975.* Halifax: Press of the Nova Scotia College of Art and Design, 1975.

Kahng 2007
Kahng, Eik, ed. *The Repeating Image: Multiples in French Painting from David to Matisse.* Exh. cat. Baltimore: The Walters Art Museum; New Haven: Yale University Press, 2007.

Kahnweiler 1949
Kahnweiler, Daniel Henry. *The Rise of Cubism.* New York: Wittenborn, Schultz, 1949.

Karmel 2003
Karmel, Pepe. *Picasso and the Invention of Cubism.* New Haven: Yale University Press, 2003.

Keller and Malin 2003
Keller, Eva, and Regula Malin, eds. *Brice Marden.* Exh. cat. Zurich: Daros Collection, 2003.

Kellner 2000
Kellner, Bruce, ed. *Letters of Charles Demuth, American Artist, 1883–1935.* Philadelphia: Temple University Press and Demuth Foundation, 2000.

Kelly 1990
Kelly, Ellsworth. *Artist's Choice: Ellsworth Kelly; Fragmentation and the Single Form.* Exh. broch. New York: The Museum of Modern Art, 1990.

Kienle 2008
Kienle, Anabelle. *Max Beckmann in Amerika.* Petersberg: Imhof, 2008.

Kimmelman 1998
Kimmelman, Michael. *Portraits: Talking with Artists at the Met, the Modern, the Louvre and Elsewhere.* New York: Random House, 1998.

Klemm et al. 2001
Klemm, Christian, et al. *Alberto Giacometti.* Exh. cat. New York: The Museum of Modern Art; Zurich: Kunsthaus Zurich, 2001.

Kornhauser 2002
Kornhauser, Elizabeth Mankin, ed. *Marsden Hartley.* Exh. cat. Hartford: Wadsworth Atheneum Museum of Art; New Haven: Yale University Press, 2002.

Kosinski 1994
Kosinski, Dorothy, ed. *Fernand Léger, 1911–1924: The Rhythm of Modern Life.* Exh. cat., Kunstmuseum Wolfsburg and Kunstmuseum Basel. New York: Prestel, 1994.

Kostenevich 1998
Kostenevich, Albert. *Pol'Sezann i russky avangard nachala XX veka. Katalog.* Exh. cat. St. Petersburg: State Hermitage Museum, 1998.

Krumrine 1989a
Krumrine, Mary Louise, ed. *Paul Cézanne: The Bathers.* Exh. cat. Basel: Museum of Fine Arts; Einsiedeln: Eidolon, 1989.

Krumrine 1989b
Krumrine, Mary Louise. "'Les baigneuses' de Cézanne du musée Granet." *Impressions du musée Granet,* no. 3 (Sept. 1989), pp. 4–9.

Lackner 1967
Lackner, Stephan. *Ich erinnere mich gut an Max Beckmann.* Mainz: Kupferberg, 1967.

Laing Art Gallery 1973
Watercolour and Pencil Drawings by Cézanne: An Exhibition Organized by Northern Arts and the Arts Council of Great Britain. Introduction by Lawrence Gowing. Exh. cat., Laing Art Gallery, Newcastle upon Tyne, and Hayward Gallery. London: Lund Humphries, 1973.

Lane 1936
Lane, James W. "Charles Demuth." *Parnassus* 8 (Mar. 1936), pp. 8 – 9.

Larguier 1925
Larguier, Léo. *Le dimanche avec Paul Cézanne. Souvenirs.* Paris: L'Édition, 1925.

Larguier 1928
Larguier, Léo. *Avant le déluge. Souvenirs.* Paris: Grasset, 1928.

Lassaigne 1973
Lassaigne, Jacques. "Entretien avec Georges Braque." *XXe siècle* 41 (1973).

Lebensztejn 2006
Lebensztejn, Jean-Claude. *Études cézanniennes.* Paris: Flammarion, 2006.

Lecomte 1899
Lecomte, Georges. "Paul Cézanne." *La revue d'art* 1 (Dec. 9, 1899).

Lecomte 1910
Lecomte, Georges. "La crise de la peinture française." *L'art et les artistes* 12 (Oct. 1910).

Lee 1998
Lee, Janie C. *Brice Marden Drawings.* Exh. cat. New York: Whitney Museum of American Art and Abrams, 1998.

Léger 1913
Léger, Fernand. "Les origines de la peinture et sa valeur representative." *Montjoie!* (Paris), May 29 and June 14 – 29, 1913.

Léger 1914
Léger, Fernand. "Les réalisations picturales actuelles." *Soirées de Paris* 25 (June 15, 1914).

Léger 1965a
Léger, Fernand. *Fonctions de la peinture.* Edited by R. Garaudy. Bibliothèque Médiations, no. 35. Paris: Gonthier, 1965.

Léger 1965b
Léger, Fernand. *Functions of Painting.* Edited by Edward F. Fry, trans. Alexandra Anderson. New York: Viking Press, 1965.

Léger and Rosenberg 1996
Correspondances. Fernand Léger, Léonce Rosenberg, 1917–1937. Edited by Christian Derouet. Paris: Centre Georges Pompidou, 1996.

Lenz 1977
Lenz, Christian. "Max Beckmann in seinem Verhältnis zu Picasso." *Niederdeutsche Beiträge zur Kunstgeschichte* 16 (1977), pp. 236 – 50.

Leonard 1970
Leonard, Sandra E. *Henri Rousseau and Max Weber.* Sale cat. New York: Richard L. Feigen, 1970.

Levy 1966
Levy, Julien. *Arshile Gorky.* New York: Abrams, 1966.

Lewis 1989
Lewis, Mary Tompkins. *Cézanne's Early Imagery.* Berkeley: University of California Press, 1989.

Lewis 2000
Lewis, Mary Tompkins. *Cézanne.* London: Phaidon, 2000.

Lewis 2007
Lewis, Mary Tompkins, ed. *Critical Readings in Impressionism and Post-Impressionism: An Anthology.* Berkeley: University of California Press, 2007.

Leymarie 1988
Leymarie, Jean. *Georges Braque.* Exh. cat. New York: The Solomon R. Guggenheim Museum; Munich: Prestel, 1988.

Lhote 1920
Lhote, André. "L'enseignement de Cézanne." *Nouvelle revue française* 15 (Nov. 1, 1920).

Lhote 1922
Lhote, André. "Les arts. Les dernières rétrospectives." *Nouvelles revue française* 18 (July 1, 1922).

Lhote 1939a
Lhote, André. "Cézanne et la lenteur." *Nouvelle revue française* 52 (Apr. 1939).

Lhote 1939b
Lhote, André. "Les arts. Les dernières rétrospectives." *Nouvelle revue française* 52 (Apr. 1, 1939).

Lhote 1939c
Lhote, André. *Traité du paysage.* Paris: Floury, 1939. Rev. and exp. as *Traité du paysage et de la figure.* Paris: Grasset, 1958.

Lhote 1942
Lhote, André. "Cézanne l'incompris" (1936), *Peinture d'abord. Essais.* Paris: Denoël, 1942.

Lhote, Alain-Fournier, and Rivière 1986
Lhote, André, Alain-Fournier, and Jacques Rivière. *La peinture, le coeur et l'esprit. Correspondance inédite (1907–1924).* Edited by Alain Rivière, Jean-Georges Morgenthaler, and Françoise Garcia. 2 vols. Bordeaux: Musée des Beaux-Arts and Blake, 1986.

Lichtenstein 1964
Lichtenstein, Sara. "Cézanne and Delacroix." *Art Bulletin* 46 (Mar. 1964), pp. 55 – 67.

Loos 2003
Loos, Ted. "Eminent but Broke: Max Beckmann's New York Years." *New York Times,* June 22, 2003.

Loran 2006
Loran, Erle. *Cézanne's Composition: Analysis of His Form with Diagrams and Photographs of His Motifs.* 1944. Rev. ed., Berkeley: University of California Press, 2006.

Lord 1965
Lord, James. *A Giacometti Portrait.* New York: The Museum of Modern Art, 1965.

Lord 1980
Lord, James. *A Giacometti Portrait.* Rev. ed. New York: Farrar, Straus, Giroux, 1980.

Lord 1985
Lord, James. *Giacometti: A Biography.* New York: Farrar, Straus, Giroux, 1985.

Ludington 1992
Ludington, Townsend. *Marsden Hartley: The Biography of an American Artist.* Boston: Little, Brown, 1992.

Ludington 2000
Ludington, Townsend. "Marsden Hartley: On Native Ground." In *Modern Art and America: Alfred Stieglitz and His New York Galleries,* by Sarah Greenough et al. Exh. cat. Washington, DC: National Gallery of Art, 2000.

Machotka 1996
Machotka, Pavel. *Cézanne: Landscape into Art.* New Haven: Yale University Press, 1996.

Maloon and Gundert 1998
Maloon, Terence, and Angela Gundert. *Classic Cézanne.* Exh. cat. New South Wales: Art Gallery of New South Wales, 1998.

Marc 1912
Marc, Franz. "Die neue Malerei." *Pan* 2 (1912), pp. 468 – 71.

Marden 1974
Marden, Brice. *Suicide Notes.* Lausanne: Éditions Massons, 1974.

Marden 1991
Marden, Brice. *Grove Group.* Sale cat. New York: Gagosian Gallery, 1991.

Mathey 1956
Mathey, François. *Fernand Léger, 1881–1955.* Exh. cat., Musée des Arts Décoratifs. Paris: Hazan, 1956.

Matisse 1972
Matisse, Henri. *Écrits et propos sur l'art.* Edited by Dominique Fourcade. Paris: Hermann, 1972.

Matisse 1995
Matisse on Art. 1973. Edited by Jack Flam. Rev. ed., Berkeley: University of California Press, 1995.

Matossian 1998
Matossian, Nouritza. *Black Angel: The Life of Arshile Gorky.* London: Chatto and Windus, 1998.

Mattioli Rossi 1998
Mattioli Rossi, Laura ed. *The Later Morandi: Still Lifes, 1950–1964.* Exh. cat., Galleria dello Scudo, Verona, and Peggy Guggenheim Collection, Venice. Milan: Mazzotta, 1998.

Mattioli Rossi 2004
Mattioli Rossi, Laura, ed. *Boccioni's Materia: A Futurist Masterpiece and the Avant-garde in Milan and Paris.* Exh. cat. New York: The Solomon R. Guggenheim Museum, 2004.

Mauclair 1906
Mauclair, Camille. *Trois crises de l'art actuel.* Paris: Charpentier, 1906.

Maus 1907
Maus, Octave. "L'art au salon d'Automne." *Mercure de France* 65 (Jan. 1, 1907).

McBride 1975
McBride, Henry. *The Flow of Art: Essays and Criticisms of Henry McBride.* New York: Atheneum, 1975.

McCann 1976
McCann, Cecile N. "An Interview with Brice Marden." *Artweek* 7 (Dec. 4, 1976), pp. 15–16.

McCully 1997
McCully, Marilyn. *Picasso: The Early Years, 1892–1906.* Exh. cat. Washington, DC: National Gallery of Art, 1997.

Megged 1985
Megged, Matti. *Dialogue in the Void: Beckett and Giacometti.* New York: Lumen, 1985.

Meier-Graefe 1904
Meier-Graefe, Julius. *Entwicklungsgeschichte der modernen Kunst.* 3 vols. Stuttgart: Hoffmann, 1904.

Meier-Graefe 1910
Meier-Graefe, Julius. *Paul Cézanne.* 3rd ed. Munich: Piper, 1910.

Meier-Graefe 1918
Meier-Graefe, Julius. *Cézanne und sein Kreis. Ein Beitrag zur Entwicklungsgeschichte.* Munich: Piper, 1918.

Meier-Graefe 1927
Meier-Graefe, Julius. *Cézanne,* trans. J. Holroyd-Reece. London: Benn, 1927.

Merleau-Ponty 1964a
Merleau-Ponty, Maurice. "Cézanne's Doubt." In *Sense and Non-Sense,* trans. Hubert L. Dreyfus and Patricia Allen Dreyfus. Evanston, IL: Northwestern University Press, 1964.

Merleau-Ponty 1964b
Merleau-Ponty, Maurice."Eye and Mind." In *The Primacy of Perception and Other Essays on Phenomenological Psychology: The Philosophy of Art, History and Politics.* Edited by James M. Edie. Evanston, IL: Northwestern University Press, 1964.

Merleau-Ponty 1964c
Merleau-Ponty, Maurice. "Indirect Language and the Voices of Silence" (1952). In *Signs.* Trans. Richard C. McCleary. Evanston, IL: Northwestern University Press, 1964.

Michel and Nivet 1993
Michel, Pierre, and Jean-François Nivet, eds. *Combats esthétiques.* 2 vols. Paris: Séguier, 1993.

Michelet 1974
Michelet, Jules. *Le peuple.* 1846. Introduction and notes by Paul Viallanaix. Paris: Flammarion, 1974.

Miracco and Belli 2003
Miracco, Renato, and Gabriella Belli, eds. *Il respiro dell'anima. Giorgio Morandi e la natura morta in Italia, 1912–1962.* Exh. cat., Groeningemuseum-Arentshuis, Brussels. Milan: Mazzotta, 2003.

Mondrian 1945
Mondrian, Piet. *Plastic Art and Pure Plastic Art, 1937, and Other Essays, 1941–1943.* New York: Wittenborn, 1945.

Mondrian 1986
Mondrian, Piet. *The New Art—The New Life: The Collected Writings of Piet Mondrian.* Edited and trans. by Harry Holtzman and Martin S. James. Boston: G. K. Hall, 1986.

Monod-Fontaine and Carmean 1982
Monod-Fontaine, Isabelle, and E. A. Carmean, Jr., et al. *Braque: The Papiers Collés.* Exh. cat. Washington, DC: National Gallery of Art, 1982.

Mooradian 1980
Mooradian, Karlen. *The Many Worlds of Arshile Gorky.* Chicago: Gilgamesh, 1980.

Moore, deAk, and Robinson 1975
Moore, Alan, Edit deAk, and Mike Robinson. "Conversation with Brice Marden." *Art-Rite/Painting,* no. 9 (Spring 1975), pp. 39–42.

Morandi 2004
Giorgio Morandi. Lettere. Edited by Lorella Giudici. Milan: Abscondita, 2004.

Morice 1905a
Morice, Charles. "Enquête sur les tendances actuelles des arts plastiques." *Mercure de France* 56 (Aug. 1 and 15, 1905), pp. 346–59, 538–55; 57 (Sept. 1, 1905), pp. 61–85.

Morice 1905b
Morice, Charles. "Le salon d'Automne." *Mercure de France* 58 (Dec. 1, 1905).

Morice 1905c
Morice, Charles. "Le XXIe salon des Indépendants." *Mercure de France* 54 (Apr. 15, 1905).

Morice 1907
Morice, Charles. "Paul Cézanne." *Mercure de France* 65 (Feb. 15, 1907).

Morice 1909
Morice, Charles. "La vingt-cinquième exposition des Indépendants." *Mercure de France,* 78 (Apr. 16, 1909), pp. 725–31.

Moscow 1925
Posmertnaia vystavka L. S. Popovoi [Posthumous exhibition of L. S. Popova]. Exh. cat. Moscow, 1925.

Museo Civico Giovanni Fattori 1997
Cézanne, Fattori e il '900 in Italia. Exh. cat., Museo Civico Giovanni Fattori. Florence: Artificio, 1997.

Natanson 1895
Natanson, Thadée. "Paul Cézanne." *La revue blanche* 9 (Dec. 1, 1895).

Natanson 1896
Natanson, Thadée. "Peinture. Á propos de MM. Charles Cottet, Gauguin, Édouard Vuillard et d'Édouard Manet." *Revue blanche* 11 (Dec. 1, 1896).

Newman 2007
Newman, Michael. "Towards the Reinvigoration of the 'Western Tableau': Some Notes on Jeff Wall and Duchamp." *Oxford Art Journal* 30 (2007), pp. 81–100.

Norman 1938
Norman, Dorothy. "From the Writings and Conversations of Alfred Stieglitz." *Twice a Year* 1 (Fall–Winter 1938), pp. 77–110.

Norton 1978
Norton, Thomas E. *Homage to Charles Demuth: Still Life Painter of Lancaster.* Ephrata, PA: Science Press, 1978.

Novotny 1932
Novotny, Fritz. "Das Problem des Menschen Cézanne im Verhältnis zu seiner Kunst." *Zeitschrift für Aesthetik und allgemeine Kunstwissenschaft* 26, no. 6 (1932).

Novotny 1938
Novotny, Fritz. *Cézanne und das Ende der wissenschaftlichen Perspektive.* Vienna: Schroll, 1938.

O'Brian 1994
O'Brian, Patrick. *Pablo Ruiz Picasso: A Biography.* New York: Norton, 1994.

Osterwold 2006
Osterwold, Tilman. *Max Beckmann: A Dream of Life.* Exh. cat., Zentrum Paul Klee. Ostfildern: Hatje Cantz, 2006.

Pagé et al. 2006
Pagé, Suzanne, et al. *Pierre Bonnard: The Work of Art; Suspending Time.* Exh. cat. Paris: Museé d'Art Moderne de la Ville de Paris, 2006.

Pasquali 1990a
Pasquali, Marilena. *Morandi.* Florence: Giunti, 1990.

Pasquali 1990b
Pasquali, Marilena, ed. *Morandi, 1890–1990. Mostra del centenario.* Exh. cat., Galleria Comunale d'Arte Moderna, Bologna. Milan: Electa, 1990.

Pasquali 1996
Pasquali, Marilena, ed. *Museo Morandi. Catalogo generale.* Bologna: Grafis, 1996.

Peirce 1960–66
Peirce, Charles S. *Collected Papers.* 8 vols. Edited by Charles Hartshorne and Paul Weiss (vols. 1–6); A. W. Burks (vols. 7–8). Cambridge, MA: Belknap Press of Harvard University Press, 1960–66.

Penrose 1967
Penrose, Roland. *Picasso*. Preface by Alfred H. Barr, Jr. Sale cat. Basel: Éditions Beyeler, 1967.

Philadelphia Museum of Art 1934
Cézanne. Essay by Jerome Klein. Exh. cat. Philadelphia: Pennsylvania Museum, 1934.

Philippe Daverio Gallery 1990
Giorgio Morandi. Nature morte. Sale. cat. New York: Philippe Daverio Gallery, 1990.

Pica 1908
Pica, Vittorio. *Gl'impressionisti francesi*. Bergamo: Istituto Italiano d'Arti Grafiche, 1908.

Piper 1964
Piper, Reinhard. *Mein Leben als Verleger. Vormittag, Nachmittag*. Munich: Piper, 1964.

Poeschke 2000
Poeschke, Joachim. "'Meinen Stil zu gewinnen . . .' Beckmann und Cézanne." In *Max Beckmann. Vorträge, 1996–1998*. Hefte des Max Beckmann Archivs, no. 3. Munich: Bayerische Staatsgemälde-sammlungen/Max Beckmann Archiv, 2000.

Ponente 1981
Ponente, Nello, ed. *Cézanne e le avanguardie*. Rome: Officina, 1981.

Provence 1939
Provence, Marcel. *Cézanne au Tholonet*. Aix-en-Provence: Société Paul Cézanne, 1939.

Puy 1910
Puy, Michel. "Le denier état de la peinture." *Mercure de France* 86 (July 16, 1910).

Puy 1939
Puy, Jean. "Souvenirs." *Le point* 21 (July 1939).

Rabinow 2000
Rabinow, Rebecca A. "Modern Art Comes to the Metropolitan: The 1921 Exhibition of 'Impressionist and Post-Impressionist Paintings.'" *Apollo* 152 (Oct. 2000), pp. 3–12.

Rainbird 2003
Rainbird, Sean, ed. *Max Beckmann*. Exh. cat. New York: The Museum of Modern Art, 2003.

Ramond and Widerkehr 2004
Ramond, Sylvie, and Léna Widerkehr, eds. *Fernand Léger*. Exh. cat. Lyon: Musée des Beaux-Arts, 2004.

Rapetti 2004
Rapetti, Rodolphe. "L'inquiétude cézannienne. Emile Bernard et Cézanne au début du XXe siècle." *Revue de l'art* 144 (2004), pp. 35–50.

Rathbone and Shackelford 2001
Rathbone, Eliza E., and George T. M. Shackelford, eds. *Impressionist Still Life*. Exh. cat. Washington, DC: Phillips Collection; New York: Abrams, 2001.

Ravaisou 2006
Ravaisou, Joseph. *Monsieur Paul Cézanne, rentier, artiste peintre. Un créateur au prisme des archives*. Edited by Jean-Luc Lioult. Marseilles: Archives Départementales des Bouches-du-Rhône and Images en Manoeuvres, 2006.

Reff 1962
Reff, Theodore. "Cézanne's Bather with Outstretched Arms." *Gazette des beaux-arts*, ser. 6, vol. 59 (Mar. 1962), pp. 173–90.

Reff 1963
Reff, Theodore. "Cézanne: The Logical Mystery." *Art News* 62 (Apr. 1963), pp. 28–31.

Rewald 1948
Rewald, John. *Pierre Bonnard*. New York: The Museum of Modern Art, 1948.

Rewald 1983
Rewald, John. *Paul Cézanne: The Watercolors: A Catalogue Raisonné*. Boston: Little, Brown, 1983.

Rewald 1986a
Rewald, John. *Cézanne: A Biography*. New York: Abrams, 1986.

Rewald 1986b
Rewald, John. *Cézanne, the Steins and Their Circle*. London: Thames and Hudson, 1986.

Rewald 1989
Rewald, John. *Cézanne and America: Dealers, Collectors, Artists, and Critics, 1891–1921*. Princeton: Princeton University Press, 1989.

Rewald 1996
Rewald, John, with Walter Feilchenfeldt and Jayne Warman. *The Paintings of Paul Cézanne: A Catalogue Raisonné*. 2 vols. New York: Abrams, 1996.

Rewald and Marschutz 1935
Rewald, John, and Léo Marschutz. "Plastique et réalité. Cézanne au Château Noir." *L'amour de l'art* 16 (Jan. 1935), pp. 15–21.

Richardson 1955
Richardson John. "The Ateliers of Braque." *Burlington Magazine* 97 (June 1955), pp. 164–71.

Richardson 1991
Richardson, John. *A Life of Picasso*. Vol. 1, *1881–1906*. New York: Random House, 1991.

Richardson 1992
Richardson, Brenda. *Brice Marden: Cold Mountain*. Exh. cat. Houston: The Menil Collection, 1992.

Richardson 2007
Richardson, John. *A Life of Picasso*. Vol. 3, *The Triumphant Years, 1917–1932*. New York: Knopf, 2007.

Richter 2000
Richter, Mario. *La formazione francese di Ardengo Soffici, 1900–1914*. 1969. Prato: Pentalinea, 2000.

Rilke 1952
Rilke, Rainer Maria. *Briefe uber Cézanne*. Wiesbaden: Insel, 1952.

Rilke 1985
Rilke, Rainer Maria. *Letters on Cézanne*. Edited by Clara Rilke, trans. Joel Agee. New York: Fromm International, 1985.

Rishel 1983
Rishel, Joseph J. *Cézanne in Philadelphia Collections*. Exh. cat. Philadelphia: Philadelphia Museum of Art, 1983.

Ritchie 1950
Ritchie, Andrew Carnduff. *Charles Demuth*. Exh. cat. New York: The Museum of Modern Art, 1950.

Rivero 1992
Rivero, Núria. *Picasso, 1905–1906: From the Rose Period to the Ochres of Gósol*. Exh. cat., Museu Picasso and Kunstmuseum, Berne. Barcelona: Electa, 1992.

Robbins 2006
Robbins, Anne, with an essay by Ann Dumas and contributions by Nancy Ireson. *Cézanne in Britain*. Exh. cat. London: National Gallery, 2006.

Rosenberg 1960
Rosenberg, Harold. "Arshile Gorky: The Last Move." *Hudson Review* 13 (Spring 1960), pp. 102–10.

Rosenberg 1962
Rosenberg, Harold. *Arshile Gorky: The Man, the Time, the Idea*. New York: Horizon, 1962.

Rosenberg 1972
Rosenberg, Harold. "Interview with Willem de Kooning." *Artnews* 71 (Sept. 1972), pp. 54–59.

Rosenblum and Janson 1984
Rosenblum, Robert, and H. W. Janson. *19th-Century Art*. New York: Abrams, 1984.

Rubin 1972
Rubin, William S. *Picasso in the Collection of the Museum of Modern Art*. New York: The Museum of Modern Art, 1972.

Rubin 1977
Rubin, William, ed. *Cézanne: The Late Work*. Exh. cat. New York: The Museum of Modern Art, 1977.

Rubin 1980
Rubin, William S. *Pablo Picasso: A Retrospective*. Exh. cat. New York: The Museum of Modern Art, 1980.

Rubin 1989
Rubin, William S. *Picasso and Braque: Pioneering Cubism*. Exh. cat. New York: The Museum of Modern Art, 1989.

Rubin 1996
Rubin, William S. *Picasso and Portraiture: Representation and Transformation*. Exh. cat. New York: The Museum of Modern Art, 1996.

Sarabianov and Adaskina 1990
Sarabianov, Dmitrii Vladimirovich, and N. L. Adaskina. *Liubov Popova*. New York: Abrams, 1990.

Sarabianov, Adaskina, and Zhukova 1989
Sarabianov, Dmitrii Vladimirovich, N. L. Adaskina, and E. M. Zhukova. *L. S. Popova, 1889–1924. Vystavka proizvedenii k stoletiiu so dnia rozhdeniia* [L. S. Popova, 1889–1924: Exhibition of works to mark the centenary of her birth]. Exh. cat. Moscow: State Tretyakov Gallery and APC Publications, 1989.

Schapiro 1952
Schapiro, Meyer. *Cézanne*. New York: Abrams, 1952.

Schapiro 1973
Schapiro, Meyer. *Paul Cézanne*, trans. Louis-Marie Ollivier. Paris: Nouvelles Editions Françaises, 1973.

Schapiro 1978
Schapiro, Meyer. "The Apples of Cézanne: An Essay on the Meaning of Still-Life." In *Modern Art, 19th and 20th Centuries: Selected Papers*, pp. 1–38. New York: Braziller, 1978.

Schmidt 1985
Schmidt, Doris, ed. *Max Beckmann. Frühe Tagebücher 1903/04 und 1912/13; mit Erinnerungen von Minna Beckmann-Tube*. Munich: Piper, 1985.

Schulz-Hoffmann, Lenz, and von Bormann 2007
Schulz-Hoffmann, Carla, Christian Lenz, and Beatrice von Bormann. *Max Beckmann: Exile in Amsterdam*. Exh. cat., Pinakothek der Moderne, Munich. Ostfildern: Hatje Cantz, 2007.

Schulz-Hoffmann and Weiss 1984
Schulz-Hoffmann, Carla, and Judith C. Weiss, eds. *Max Beckmann: Retrospective*. Exh. cat. St. Louis: Saint Louis Art Museum; Munich: Prestel, 1984.

Schwabacher 1957
Schwabacher, Ethel K. *Arshile Gorky*. Exh. cat. New York: Whitney Museum of American Art and Macmillan, 1957.

Schwarz and Semff 1997
Schwarz, Dieter, and Michael Semff, eds. *Brice Marden: Work Books 1964–1995*. Exh. cat. Munich: Staatliche Graphische Sammlun München; Winterthur: Kunstmuseum Winterthur; Cambridge, MA: Harvard University Art Museums, 1997.

Scott 1988
Scott, Gail R. *Marsden Hartley*. New York: Abbeville, 1988.

Sérusier 1942
Sérusier, Paul. *ABC de la peinture*. Paris: Floury, 1942.

Sharp 1970–71
Sharp, Willoughby. "Points of View: A Taped Conversation with Four Painters." *Arts Magazine* 45 (Dec. 1970–Jan. 1971), pp. 41–42.

Shiff 1984
Shiff, Richard. *Cézanne and the End of Impressionism*. Chicago: University of Chicago Press, 1984.

Shiff 1991
Shiff, Richard. "Cézanne's Physicality: The Politics of Touch." In *The Language of Art History*. Edited by Salim Kemal and Ivan Gaskell, pp. 129–80. New York: Cambridge University Press, 1991.

Shiff 2003
Shiff, Richard. *Inacabado y abstraído: Paul Cézanne, pintor del siglo veinte a pesar de sí mismo / Unfinished and Abstracted: Paul Cézanne, Twentieth-Century Painter in Spite of Himself*. Colección Cisneros, Cuaderno 7 / Notebook 7. Caracas: Fundación Cisneros, 2003.

Shiff 2006
Shiff, Richard. "Flicker in the Work: Jasper Johns in Conversation with Richard Shiff." *Master Drawings* 44 (Autumn 2006), pp. 275–98.

Shiff 2008
Shiff, Richard. *Doubt*. New York: Routledge, 2008.

Sidlauskas 2004
Sidlauskas, Susan. "Emotion, Color, Cézanne (The Portraits of Hortense)." *Nineteenth Century Art Worldwide* 3 (Autumn 2004), http://www.19th-art-worldwide.org/autumn_04/articles/sidl.shtml (accessed Sept. 9, 2008).

Signac 1920
Signac, Paul. "Mostra individuale di Paul Cézanne." In *Catalogo della XIIa Esposizione internazionale d'arte della Città di Venezia MCMXX*. Exh. cat. Rome: Bestetti and Tumminelli, 1920.

Sims and Pulitzer 1982
Sims, Patterson, and Emily Rauh Pulitzer. *Ellsworth Kelly: Sculpture*. Exh. cat. New York: Whitney Museum of American Art, 1982.

Smith 1998
Smith, Paul. "Joachim Gasquet, Virgil and Cézanne's Landscape: 'My Beloved Golden Age.'" *Apollo* 148 (Oct. 1998), pp. 11–23.

Soby 1948
Soby, James Thrall. *Contemporary Painters*. New York: The Museum of Modern Art, 1948.

Soby and Barr 1949
Soby, James Thrall, and Alfred H. Barr, Jr. *Twentieth Century Italian Art*. Exh. cat.. New York: The Museum of Modern Art, 1949.

Soffici 1909
Soffici, Ardengo. "L'impressionismo e la pittura italiana." *La voce* 1 (Apr. 1, 15, and 29; May 6, 1909).

Soffici 1910
Soffici, Ardengo. "L'impressionismo a Firenze." *La voce* 2 (May 12 and 19, 1910).

Soffici 1913
Soffici, Ardengo. "Arte francese e moderna." *La voce* 5 (Jan. 30, 1913).

Soffici 1932
Soffici, "Giorgio Morandi," *L'italiano* 10 (March 1932), pp. 3–11.

Soffici 1950
Soffici, Ardengo. *Trenta artisti moderni*. Florence: Vallecchi, 1950.

Spender 1999
Spender, Matthew. *From a High Place: A Life of Arshile Gorky*. New York: Alfred A. Knopf, 1999.

Spurling 1998
Spurling, Hilary. *The Unknown Matisse: A Life of Henri Matisse; The Early Years, 1869–1908*. New York: Alfred A. Knopf, 1998.

Spurling 2005
Spurling, Hillary. *Matisse the Master: A Life of Matisse; The Conquest of Colour, 1909–1954*. London: Hamish Hamilton, 2005.

Staller 2001
Staller, Natasha. *A Sum of Destructions: Picasso's Cultures and the Creation of Cubism*. New Haven: Yale University Press, 2001.

Stedelijk Museum 1973
Ellsworth Kelly. Schilderijen en beelden, 1963–1979/Paintings and Sculptures, 1963–1979. Exh. cat. Amsterdam: Stedelijk Museum, 1973.

Stein 1938
Stein, Gertrude. *Picasso*. London: Batsford, 1938.

Steinberg 1978
Steinberg, Leo. "Resisting Cézanne: Picasso's 'Three Women.'" *Art in America* 66 (Nov.–Dec. 1978), pp. 114–33.

Storchi 2006
Storchi, Simona. *Valori Plastici, 1918–1922. Le inquietudini del nuovo classico*. Reading, UK: Department of Italian Studies, University of Reading, 2006.

Suarès 1939
Suarès André. "Chronique de Caërdal." *Nouvelle revue française* 52 (Apr. 1, 1939).

Suzdalev 1971
Suzdalev, Petr Kirillovich. *Vera Mukhina*. Moscow: Izobrazit. Iskusstvo, 1971.

Sylvester 1996
Sylvester, David. *Looking at Giacometti*. New York: Holt, 1996.

Taylor 1992
Taylor, Paul. "Ellsworth Kelly: Interview." *Artstudio* 24 (spring 1992), pp. 148–57.

Theriault 2006
Theriault, Kim S. "Arshile Gorky's Self-Fashioning: The Name, Naming, and Other Epithets." *Journal of the Society for Armenian Studies* 15 (2006), pp. 141–56.

Tugendkhold 1911
Tugendkhold, Ia. A. *Frantsuzskoe iskusstvo i ego predstaviteli* [French art and its representatives]. St. Petersburg, 1911.

Tugendkhold 1925
Tugendkhold, Ia. A. "Po vystavkam" [Around the exhibitions]. *Izvestiia*, Feb. 1925.

Tugendkhold 1987
Tugendkhold, Ia. A. *Iz istorii zapadnoevropeiskogo i russkogo iskusstva* [From the history of Western European and Russian art]. Moscow: Sovetsky Khudozhnik, 1987.

Upright 1987
Upright, Diane. *Ellsworth Kelly: Works on Paper*. Exh. cat. New York: Fort Worth Art Museum and Abrams, 1987.

Vallier 1954a
Vallier, Dora. "Braque la peinture et nous. Propos de l'artiste recueillis." *Cahiers d'art* 29 (Oct. 1954), pp. 13–24.

Vallier 1954b
Vallier, Dora. "La vie dans l'oeuvre de Léger." *Cahiers d'art* 29 (Oct. 1954), pp. 140–77.

Varnedoe 1996a
Varnedoe, Kirk, ed. *Jasper Johns: A Retrospective*. Essay by Roberta Bernstein. Exh. cat. New York: The Museum of Modern Art, 1996.

Varnedoe 1996b
Varnedoe, Kirk, ed. *Jasper Johns: Writings, Sketchbook Notes, Interviews*. New York: The Museum of Modern Art, 1996.

Venturi 1936
Venturi, Lionello. *Cézanne. Son art—son oeuvre*. 2 vols. Paris: Rosenberg, 1936.

Vischer and Naef 2005
Vischer, Theodora, and Heidi Naef, eds. *Jeff Wall: Catalogue Raisonné, 1978–2004*. Basel: Schaulager; Göttingen: Steidl, 2005.

Vitali 1977
Vitali, Lamberto, ed. *Morandi. Catalogo generale*. Milan: Electa, 1983.

Vollard 1914
Vollard, Ambroise. *Paul Cézanne*. Paris: Vollard, 1914.

Vollard 1919
Vollard, Ambroise. *Paul Cézanne*. 1914. Rev. ed., Paris: Crés, 1919.

Vollard 1936
Vollard, Ambroise. *Recollections of a Picture Dealer*, trans. Violet M. MacDonald. London: Constable, 1936.

Voronova 1976
Voronova, Olga. *Vera Ignatevna Mukhina*. Moscow: Iskusstvo, 1976.

Vrubel 1976
Vrubel. Perepiska; Vospominaniia o khudozhnike [Vrubel: Correspondence; Recollections of the artist]. Edited by E. P. Gomberg-Verzhbinskaia, I.U.N. Podkopaeva, and I.U.V. Novikov. Leningrad: Iskusstvo, 1976.

Waldman 1981
Waldman, Diane. *Arshile Gorky: A Retrospective*. Exh. cat. New York: The Solomon R. Guggenheim Museum and Abrams, 1981.

Waldman 1996
Waldman, Diane, ed. *Ellsworth Kelly: A Retrospective*. Exh. cat. London: Tate Gallery Publishing; New York: The Solomon R. Guggenheim Foundation, 1996.

Waldmann 1927
Waldmann, Emil. *Die Kunst des Realismus und des Impressionismus*. 1926. Berlin: Propyläen, 1927.

Wall 1987
Jeff Wall: Transparencies; With an Interview. New York: Rizzoli, 1987.

Wall 2003
Wall, Jeff. "Frames of Reference." *Artforum* 42 (Sept. 2003), pp. 188–97.

Wall 2007
Jeff Wall: Selected Essays and Interviews. Peter Galassi and James Rondeau, eds. New York: The Museum of Modern Art, 2007.

Weisner and Gallwitz 1982
Weisner, Ulrich, and Klaus Gallwitz. *Max Beckmann. Die frühen Bilder*. Exh. cat. Bielefeld: Kunsthalle Bielefeld, 1982.

Weiss et al. 2007
Weiss, Jeffrey, et al. *Jasper Johns: An Allegory of Painting, 1955–1965*. Exh. cat. Washington, DC: National Gallery of Art; New Haven: Yale University Press, 2007.

Weiss, Fletcher, and Tuma 2003
Weiss, Jeffrey, Valerie J. Fletcher, and Kathryn A. Tuma. *Picasso: The Cubist Portraits of Fernande Olivier*. Exh. cat. Washington, DC: National Gallery of Art; Princeton: Princeton University Press, 2003.

Welsh and Joosten 1998
Welsh, Robert P., and Joop M. Joosten. *Piet Mondrian: Catalogue Raisonné*. 3 vols. in 2. Blaricum: V&K/Inmerc; Paris: Cercle d'Art, 1998.

Whelan 1995
Whelan, Richard. *Alfred Stieglitz: A Biography*. New York: Little, Brown, 1995.

Whitechapel Art Gallery 1981
Whitechapel Art Gallery. *Brice Marden: Paintings, Drawings and Prints 1975–80*. Exh. cat. London: Trustees of the Whitechapel Art Gallery, 1981.

Wildenstein Galleries 1928
Loan Exhibition of Paintings by Paul Cézanne 1839–1906, under the auspices of Mrs. Chester Dale, for the benefit of the French Hospital of New York. Sale cat. New York: Wildenstein Galleries, 1928.

Wright 1916
Wright, Willard Huntington. "Paul Cézanne." *Studio International* 57 (Feb. 1916), pp. cxxix–cxxxi.

Zeiller 2003
Zeiller, Christiane. *Max Beckmann. Die frühen Jahre, 1899–1907*. Weimar: Verlag und Datenbank für Geisteswissenschaften, 2003.

Zervos 1932
Zervos, Christian. "Picasso étudié par le Dr. Jung." *Cahiers d'art* 7, nos. 8–10 (1932), pp. 352–54.

Zervos 1932–78
Zervos, Christian. *Pablo Picasso*. 33 vols. Paris: Cahiers d'Art, 1932–78.

Zervos 1935
Zervos, Christian. "Conversation avec Picasso." *Cahiers d'art* 10, nos. 7–10 (1935), pp. 173–78.

Zurcher 1988
Zurcher, Bernard. *Georges Braque: Life and Work*, trans. Simon Nye. New York: Rizzoli, 1988.

Acknowledgments

We are indebted to the following people, without whom this exhibition and catalogue would not have been possible: Ruth Abrahams; William Acquavella; Ellen Adair; Mariana Aguirre; Francis Alÿs; Irina Antonova; Alexander Apsis; Bente Arnild; Sherry Babbitt; Anne Baldassari; Carlos Basualdo; Graham W. J. Beal; Alice Beamesderfer; Christoph Becker; Tiffany Bell; Catherine Belloy; Jennifer Belt; Brent Benjamin; Roger Benjamin; Irène Bizot; Irving Blum; Doreen Bolger; Richard Bonk; Suzanne Boorsch; E. Peters Bowron; Michael Brand; Adrianne O. Bratis; Moreno Bucci; Barbara Buckley; Bernhard Mendes Bürgi; Kate Butler; Françoise Cachin; Ashley Carey; Mickey Cartin; Mary Cason; Mark Castro; Philippe de Chaisemartin; Gilles Chazal; Angela Choon; Conna Clark; Guy Cogeval; Isabelle Collet; Philip Conisbee; Harry Cooper; Paula Cooper; Denis Coutagne; Geremy Coy; Charles Croce; Michael Culver; James Cuno; Stephanie D'Alessandro; Erin Danna; Jeannie Dean; Thomas Denenberg; Judith F. Dolkart; André Dombrowski; Richard Dorment; Douglas Druick; Peter Dunn; Claude and Barbara Duthuit; Gretchen Dykstra; Tara Eckert; Dan Elliott, Charlotte Eyerman; Savine Faupin; Richard L. Feigen; Walter Feilchenfeldt; Kaywin Feldman; Agnes Gorky Fielding; Michael Findlay; Hartwig Fischer; V. Susan Fisher; Robert Fitzpatrick; Stephen Flavin; Debra Force; Patrick Ford; Carter Foster; Kathy Foster; Robin Jaffee Frank; Flemming Friborg; Kate Ganz; Pierre Georgel; Derek Gillman; Lukas Gloor; Nan Goff; Jamie Goldblatt; Marian Goodman; Michael Govan; Louis Grachos; Adam Harrison; Gail Harrity; Sharon Hecker; Allis Helleland; William J. Hennessey; Steven Henry; Cathy Herbert; Catrina Hill; Steven Holmes; Katy Homans; Cornelia Homburg; John House; Claire Howard; Bellatrix Hubert; Edan Hughes; Marine Hugonnier; Mary-Jean Huntley; Jasper Johns; Paul Josefowitz; Emilia Kabakov; Ilya Kabakov; Zoe Kahr; Sara Kay; Lynn Kearcher; Sam Keller; Ellsworth Kelly; Ian Kennedy; George Keyes; Norman Keyes; Lyndel King; Sandi Knakal; Lilah Knox; Kathleen Krattenmaker; Betty Krulik; Mary Louise Krumrine; Elizabeth Kujawski; Anne Lampe; Maude Lavin; Cheryl Leibold; Michael Leja; Sherrie Levine; Mary Tompkins Lewis; Joanna Ling; Louise Lippincott; Dominique Lobstein; Nancy Locke; Glenn Lowry; Henri Loyrette; Martha Lucy; Nannette V. Maciejunes; Lori Mahaney; Camran Mani; Gianfranco Maraniello; Brice Marden; Sandra Markham; Matthew Marks; Betty J. Marmon; Deborah Marrow; Katherine Marshall; Georges Matisse; Jacqueline Matisse Monnier; Laura Mattioli Rossi; Mollie McNickle; Richard Meyer; Mark D. Mitchell; Charles Moffett; Isabelle Monod-Fontaine; Stasia Morone; Mary Morris; Jed Morse; Diane Mullin; Eileen Neff; Fran Nicosia; Lars Nittve; Patrick Noon; Sarah Noreika; Ann-Sofie Noring; Percy North; Andrea Nuñez; Kelly O'Brien; Alfred Pacquement; Matthew Palczynski; Janet Passehl; Avril Peck; Suzanne Penn; Jim Pettis; Élia Pijollet; Mikhail Piotrovsky; Joachim Pissarro; Christine Poggi;

Timothy Potts; Emily Rauh Pulitzer; Sean Rainbird; Katy Rawdon; Andrew Richards; Hilary Richardson; John Richardson; Christopher Riopelle; Andrew Robinson; David Rockefeller; Denise Rompilla; James Rondeau; Anne Rorimer; Norman Rosenthal; Katy Rothkopf; Neville Rowley; Angelica Zander Rudenstine; Neil Rudenstine; William K. Rudolph; Michael Rush; Philip Rylands; Viki Sand; Scott Schaeffer; Jack Schlechter; Page Schorer; Suki Schorer; David Scrase; Rebecca Sender; Nick Serota; George Shackelford; Jack Shear; Innis Shoemaker; Marla K. Shoemaker; Susan Sidlauskas; Patterson Sims; Jeffrey Sitton; Michael Slade; Andrew Slavinskas; Derek Sober; Guillermo Solana; Gail Stavitsky; James Stein; Mimi Stein; Andrew Stewart; Evert van Straaten; Carl Strehlke; Deborah Swallow; Sarah Taggart; John Tancock; Alain Tapié; Irene Taurins; Michael R. Taylor; Susan Taylor; Ann Temkin; Gary Tinterow; Carol Togneri; Evan Towle; Jacqueline Tran; Luc Tuymans; David Updike; Nerissa Vales; Jennifer Vanim; Silvio Veronese; John Vick; Sharon Rose Vonasch; Jeff Wall; Eva Walters; Jayne Warman; Malcolm Warner; Mary Wassermann; Richard Wattenmaker; Suzanne Wells; Margaret Werth; Warwick Wheeler; Sarah Whitfield; Jenny Wilker; Beat Wismer; Graydon Wood; James Wood; Barnaby Wright; John Zarobell; Wendy Zieger; David Zwirner.

JOSEPH J. RISHEL AND KATHERINE SACHS

Index of Works Illustrated

Photography Credits

Photographs have been supplied by the owners and/or the following:

Acquavella Galleries: plates 16, 81

Michael Agee: plate 96

Alinari / Art Resource, NY; photograph by George Tatge, 1997: fig. 13.2

© Muriel Anssens: plate 77

© The Art Institute of Chicago, All Rights Reserved: plates 153, 197; figs. 2.4, 2.8, 9.7 (photograph by Robert Hashimoto), 10.8

Artothek, © Walter Klein, Düsseldorf: fig. 13.1

Photograph © reproduced with the Permission of The Barnes Foundation™, All Rights Reserved: figs. 4.7, 4.15, 10.4, 10.9, 10.10, 14.9, 17.1

© Philip Bernard: plate 49

Bildarchiv Preussischer Kulturbesitz / Art Resource, NY; photo by Elke Walford: plate 11

Private Collection/The Bridgeman Art Library: plate 118; fig. 1.18

© 2009 Carnegie Museum of Art, Pittsburgh: plate 92; fig. 1.21

Studio Fotografico Luca Carrà: fig. 13.14

CNAC/MNAM/Dist. Réunion des Musées Nationaux / Art Resource, NY (photograph by Christian Bahier / Philippe Migeat): fig. 4.12

© The Samuel Courtauld Trust, Courtauld Institute of Art Galleries: plate 120; figs. 1.31, 8.6

Curtis Galleries, Minneapolis: fig. 6.10

D. James Dee: fig. 3.18

© 1997 by the Des Moines Art Center (photograph by Michael Tropea, Chicago): plate 35

© 1995 The Detroit Institute of Arts: plate 36; fig. 4.14

© Ursula Edelman – Artothek, © VG Bild-Kunst Bonn: fig. 3.4

Syndics of the Fitzwilliam Museum, Cambridge: plate 88

Foto Marburg / Art Resource, NY: page 24 (right)

Jim Frank: fig. 6.14

© Lucian Freud: fig. 1.24

Galleria Nazionale d'Arte Moderna, Rome, Italy / The Bridgeman Art Library International: fig. 1.11

© Robert Gober, Courtesy Matthew Marks Gallery, New York; photograph by Russell Kaye: fig. 1.29

© The Solomon R. Guggenheim Foundation, New York, photograph by David Heald: plate 23

Haags Gemeentemuseum, The Hague, Netherlands / The Bridgeman Art Library International: fig. 1.9

© President and Fellows of Harvard College: plate 216; fig. 10.11

Hermitage, St. Petersburg, Russia © DACS / The Bridgeman Art Library International: fig. 3.2

Luiz Hossaka: fig. 6.12

Sidney Janis Gallery, New York: plate 142

© Ellsworth Kelly: page 36 top; plates 153, 154, 157–59, 161, 163, 165, 167, 169, 171–73; figs. 16.1–16.12

Kimbell Art Museum, Fort Worth, Texas / Art Resource, NY: fig. 6.7

© Kings College, Cambridge: fig. 14.1

Kolbrenner: plate 53

Kraushaar Galleries, photograph by Geoffrey Clements Photography: fig. 6.13

Kunstmuseum Basel; photograph by Martin Bühler: plate 44; figs. 7.2, 7.7

© 2008 Museum Associates/LACMA: plate 141

© Lefevre Fine Art Ltd., London / The Bridgeman Art Library International: plate 194

Erich Lessing / Art Resource, NY: plate 10; figs. 1.3, 1.7, 3.1, 3.15, 10.3, 11.7, 14.5

© S. Levine. Courtesy of Paula Cooper Gallery, New York: fig. 1.2

The Lewitt Collection, Chester, Connecticut; photograph by R. J. Phil: fig. 3.17

© Man Ray Trust / ADAGP / ARS / Telimage – 2008: fig. 6.4

Marlborough Fine Art (London) Ltd.: fig. 1.22

Robert Mates: fig. 1.14

Matthew Marks Gallery, New York: plates 196, 202

© The Metropolitan Museum of Art / Art Resource, NY: plate 210; figs. 6.5, 14.14

Bernard C. Meyers/meyersphoto.com: plate 48

Eric Mitchell: plates 94, 98, 109

Museum de Fundatie, photograph by Hans Westerink, Zwolle: fig. 5.3

© Museum of Contemporary Art, Chicago; photograph by Joe Ziolkowski: plate 198

© Museum of Fine Arts, Houston: plates 3, 111

© Museum Folkwang Essen: plate 116

© The Museum of Modern Art / Licensed by SCALA / Art Resource, NY: plate 57; figs. 3.13, 16.2, 17.4

Image courtesy Board of Trustees, National Gallery of Art, Washington: Plate 170

Board of Trustees, National Gallery of Art, Washington, DC: fig. 1.20

© National Gallery of Canada: plate 50

© National Museums Liverpool: fig. 14.3

Photographic Archive. The Museum of Modern Art Archives (photograph by Katherine Keller), © The Museum of Modern Art: page 39

Andrea Nuñez: figs. 1.1, 3.3, 15.12

Reto Rodolfo Pedrini, Zurich: plates 79, 114, 213

Philadelphia Museum of Art Photography Department: plates 4, 12, 19, 26, 27, 29, 54, 69, 101, 182, 212; figs. 1.15, 1.18, 4.8, 6.2, 7.8, 8.4, 13.7

Réunion des Musées Nationaux / Art Resource, NY: pp. 18, 23 top (photograph by Hervé Lewandowski), 24 middle; figs. 6.4, 8.1

Rheinisches Bildarchiv Köln: plate 119

The Robert Gore Rifkind Foundation: fig. 11.3

Rijksbureau voor Kunsthistorische Documentatie; photograph by R. Drektraan, 1909: fig. 5.4

Rockefeller Archive Center: plate 67

Lynn Rosenthal: plates 68, 82; fig. 9.5

Scala / Art Resource, NY: plates 40, 73; figs. 8.7, 13.8

© Scottish National Gallery of Modern Art: fig. 1.4

Lee Stalsworth: fig. 6.11

© Tate, London 2008: fig. 1.26

Tretyakov Gallery, Moscow, Russia / The Bridgeman Art Library International: fig. 1.6

© VEGAP / Provenance: Museo Thyssen-Bornemisza: plate 87

© VG Bild-Kunst Bonn: figs. 5.9 (photograph by Peter Willi/Artothek), 11.4

Ville de Nice – Service Photographique: fig. 4.6 (photograph by Bayer & Mitko/Artothek)

Bruce M. White: plate 103

© 1996 Whitney Museum of American Art, New York; photograph by Jerry L. Thompson, N.Y.: fig. 16.3

Graydon Wood: plates 17, 21, 31, 51, 66, 78, 152, 174, 188, 192, 195, 200; figs. 3.14, 6.1

Yale Collection of American Literature, Beinecke Rare Book and Manuscript Library: page 33